# MODERN EUROPEAN HISTORY

## 2nd Edition

### John R. Barber, Ph.D.
Ball State University
Muncie, IN

### Contributing Editor
Thomas Earl Porter, Ph.D.
North Carolina Agricultural and Technical State University
Greensboro, NC

**Collins**

*An Imprint of HarperCollinsPublishers*

**An American BookWorks Corporation Production**

HarperCollins books may be purchased for educational, business, or sales promotional use. For information please write: Special Markets Department, HarperCollins Publishers, 10 East 53rd Street, New York, NY 10022.

Library of Congress Cataloging-in-Publication has been applied for.

ISBN: 13: 978-0-06-088153-5
ISBN: 10: 0-06-088153-4

06 07 08 09 10 CW 10 9 8 7 6 5 4 3 2 1

# Contents

# Preface

Fred Grayson, president of American BookWorks Corporation, asked in 1989 if I would like to write a history of Modern Europe, a textbook that his company would produce for HarperCollins Publishers, Incorporated. The description of the book he wanted left me with no doubt about the answer to his question. I would do it.

His guidelines essentially called for my idea of the ideal text for introductory history classes full of students who did not want to be there. In my cooperative effort with American BookWorks staff members during the next three years to produce the first edition of *Modern European History,* their complete respect for my independence as an author and shared commitment to my obsession with writing in a down-to-earth style made the project suit me even better than I expected at the outset.

The text that American BookWorks helped me present in 1993 and improve in this second edition is a volume that should provide the most essential information for understanding the history of Modern Europe, an account of events that greatly influenced people everywhere. I designed it for use as a core text studied in conjunction with documents, monographs, and other more narrowly focused sources. *Modern European History* also should well serve beginning students who need a short text to help them master the contents of a longer one. Advanced students who want a review of modern European events in preparation for an upper-division course or graduate-placement examination should also find this text very beneficial.

*Modern European History* depicts concisely the main events of the period from the 1400s to the present, concentrating on the material common, to the leading texts in the field. This volume, therefore, is above all an outline history. It differs, however, from typical review texts in that it devotes greater attention to often neglected topics and regions. This text emphasizes more than most similar works the socioeconomic and technological history of the era during which European industry emerged and matured. The volume also focuses more on European society and culture and on Scandinavia, Iberia, and the smaller states of Europe than does the usual brief history.

This text differs in another important way from most introductory histories. Books of this kind often leave the meaning of critically important words unclear. *Modern European History* does not. The vocabulary and writing style should make this volume comprehensible and pleasantly readable to people with widely differing levels of verbal ability. Chapter introductions, summaries, chronologies, and the structure provided by headings and subheadings should further increase the ease with which readers can grasp and retain this information. (An additional chronological aid is the inclusion of the life-span years for many important people and the years of monarchs' reigns. Also note that the text follows the current standard practice of using B.C.E. and C.E. in place of B.C. and A.D. in date references.)

In the years since publication of the original text, I have traveled much more widely and frequently in Europe than I had before 1993. I have taken many groups of students on study tours, guided friends and family members on a few vacation jaunts, and gone for several extended solitary professional visits. These experiences have convinced me that a text of this kind also can be a great travel companion in Europe.

People like me who rarely sleep on long overnight flights can read and land with information in mind that should help them to learn more about and better enjoy the places they visit. The book also can serve as a handy reference throughout a trip. HarperCollins did a magnificent job of making the first edition compact, durable, and affordable. This new version should travel well too in shoulder bags or backpacks.

The first date that I can remember writing is 1944, the year the Western Allies landed on Normandy beaches. I walked alone there on a peaceful day in 1998. In the fifty-four years between these dates, Europeans have demonstrated an exceptional ability to turn from an era of horror toward peace and prosperity. The Modern European past and the people of Europe today offer much that can benefit the world of Molly, Laura, Joshua, Michaela, Roseanna, Nathaniel, Gabriela, and Jonah, my grandchildren.

With special thanks to Thomas Earl Porter, Ph.D. who reviewed the chapters and, for a second time, to Fred Grayson, in my book a model publishing professional who always knew exactly when to get in touch and what to say,

John F. Barber
February 2006

# Introduction

European nations had advantages in power that gave them dominance over much of the world from the 1700s through the latter 1900s. By the late 1800s, the culturally related United States joined the Europeans in their structure of global control and had added special strength to it by the mid-twentieth century. In a sense, therefore, the last three hundred years have comprised the age of Modern Europe, a period when people in any part of the world might find themselves under the sway of one or more nations of European culture.

By the mid-1900s, all but two of these countries rapidly began to lose their military and political grip on the world, but cultural and economic influence diminished little, if any. The decline in power, furthermore, did not mean an end to European supremacy. The Union of Soviet Socialist Republics (USSR) and the United States continued to dominate global affairs until the 1980s, despite their own hostile relationship. In the 1990s, however, the global political and military supremacy of Europe appeared to be ending.

## ■ EUROPE TODAY

Europe and Asia form a single land mass ("Eurasia") that includes much of the earth's dry surface and contains the majority of its people. Eurasia extends toward the west, ending in a triangle that is, often called the "continent" of Europe. The Ural Mountains in central Russia stretch south to north as the broad eastern base of the European triangle. The tip of Europe lies to the west in Spain and Portugal.

Since no oceans or other bodies of water set it apart from Asia, Europe is not technically a continent. But the way of life (that is, the culture) of the people who live west of the Urals is common enough to distinguish them from those who live in eastern Russia and Asia, and so Europe is a culturally defined territory.

The borders of Europe encircle an area slightly larger than the United States and contain about one-sixth of the world's people, a population of about eight hundred million. All these Europeans share enough characteristics to justify speaking of Europe as a cultural region or continent, but at the same time they exhibit in certain respects a great diversity. In fact, in the Modern period the tendency of Europeans to emphasize these differences among themselves has been an influential historical circumstance.

### The States of Europe

Historians and social scientists use the word *state* as a label for a territory organized under a government that recognizes no higher political authority over it. More than fifty units of this kind form a patchwork European political map. It contains such very small pieces as the Republic of San Marino, less than twenty-four square miles in area, perched in the scenic highlands of north-central Italy. Many others are relatively small, but the borders of Russia encompass enough of the earth's land surface (about one-eighth) to make it the largest country in the world.

The political map of Europe has been unusually fluid recently. Within three years after the collapse of the East European Communist governments during the autumn of 1989, East and West Germany reunited, the USSR divided into fifteen states, civil war took Yugoslavia from the map and left five new countries in its place, and Slovakia voted to separate from the Czech lands. Other states, including several of the new ones, show signs of splintering along ethnic lines. Since the mid-1980s, there also has been a countertrend toward greater unity among states, a development noticeable above all in the expansion of the European Union. (See Chapters 14 and 15.)

## European Cultures

The people in these numerous European states have certain cultural characteristics that especially distinguish them. Most inhabitants of the continent, for example, speak an Indo-European language and profess Christianity as their faith. Machine technology also pervades life in much of Europe to a greater extent than in other regions. Despite these and other common bonds, the multiplicity of states suggests the numerous subgroup identities also typical of the continent. Ethnic diversity is of special significance in Europe.

When aspects of culture such as language, religion, rituals, and clothing, and adornment identify a collection of people, they comprise an ethnic group. The variations in these aspects of European culture encourage divisions, sometimes very sharp ones. Although most Europeans speak an Indo-European language, the differences, between English and Russian, for example, still can seriously hinder communication. Furthermore, certain of the languages, such as Hungarian and Finnish, are not Indo-European. Similarly, the predominant Christian religion exhibits subdivisions, and sizable numbers of people are Jews, Muslims, or members of other non-Christian faiths.

The members of ethnic groups have much more in common than do Europeans as a whole and, therefore, tend to have a greater sense of identity with people in their part of the continent. These ethnic divisions exist within all European states and are especially evident in several, such as Belgium and Switzerland. Even though diverse cultural groups exist today within various countries, by the late 1800s it became especially typical of Europeans to organize states based on ethnic identity.

## Nations and the Nation-State

Nations are ethnic groups that have become acutely aware of their identity. They usually are also relatively large cultural groups and make up a high percentage of the people within a territory. When an ethnic group of this kind organizes as a sovereign political unit, it becomes a nation-state. Europeans invented this kind of state early in their history, and made it characteristic of their cultural region during the last two centuries. Nationalism, a strongly held system of beliefs about the nation, also gripped Europe by the 1800s. This commitment of Europeans to the nation-state strongly influences the unity and power of their countries, increasing or decreasing the cohesion and strength within each one, depending on the presence or absence of alienated ethnic minorities. Throughout the twentieth century, devotion to the nation-state principle has affected even more drastically the relations among countries both at the European and global levels.

# Early Modern Europe: The Foundations for World Supremacy (Mid-1400s–Late 1600s)

**1450:** Johannes Gutenberg invents the moveable-type printing press.

**1500:** Erasmus criticizes Catholic Church hypocrisy with his work, *In Praise of Folly*.

**1508–1512:** Michelangelo paints Biblical scenes on the ceiling of the Sistine Chapel in Rome.

**1513:** Machiavelli writes *The Prince*, advocating governance in the interest of state power without regard for morality.

**1517:** Martin Luther launches the Protestant Reformation with his call for a debate on Church practices and beliefs.

**1520–1521:** Ferdinand Magellan makes the first voyage around the world.

**1643–1715:** Louis XIV reigns as "The Sun King" in France.

**1649:** Cromwell leads an English Parliamentary revolt that climaxes with the execution of King Charles I.

*Although European Civilization began to emerge in the 300s C.E., the people who developed this way of life over the next one thousand years did not think of their homeland as Europe or of themselves as European. Maps used during these ten centuries listed the area north of the Mediterranean Sea as "Europe," but the people who wrote about their place in the world referred to their region as "Christendom," Christ's kingdom on earth, inhabited, of course, by Christians. Others in Europe who thought about such matters probably had this same attitude.*

*The people of Christendom belonged to the Roman Catholic Church. They thought that their faith would spread, taking in the many Christians of the Eastern Orthodox Church that predominated in Greece and the region northeast of the Mediterranean. Roman Catholics believed that from Christendom their church ultimately would reach out to enfold the entire human race.*

*By the 1300s, however, Roman Catholics and Eastern Orthodox Christians became more sharply divided, and more distant Christian groups were shrinking in size, losses caused in part by people turning to Islam. Even in Europe, the secular grip of Roman Catholic leaders weakened, and the increasingly powerful monarchical states began to overshadow the church. The idea of Christendom lost its hold on the civilization north of the Mediterranean in the 1400s and 1500s, and people in this region became self-consciously European. This sense of being a European Civilization emerged as societies on this continent became more secular and modern. Christendom had not taken in the world. As the Early Modern era dawned, however, Europe began to conquer the globe.*

*This chapter briefly reviews the origins of European Civilization and describes in greater detail the history of the Early Modern era, the years from the 1450s to the latter 1600s when Europeans completed the foundations for the following three hundred years of Modern Europe's world power.*

## ■ THE ORIGINS OF EUROPEAN CIVILIZATION

European civilization began to emerge north of the Mediterranean Sea in the 300s C.E. The cultures of the Ancient Mediterranean world that had developed during the preceding five thousand years strongly influenced early European life. This heritage included contributions from the first human civilizations that appeared in the region of the Tigris and Euphrates Rivers, the locale of present-day Iraq. Ancient Hebrews, Greeks, and Romans shaped European culture even more directly. The Romans ensured this ancient influence on European civilization by joining all the societies that surrounded the vast Mediterranean Sea and much of Europe into a single imperial state during the reigns of Caesar (49–44 B.C.E.) and Augustus (44 B.C.E.–14 C.E.).

### Western Romans becoming Europeans

Roman emperors allowed the varied societies within their realm to keep their differing ways of life, so long as their beliefs and practices did not threaten imperial authority. This tolerance also extended to religion. The Jews of Palestine could worship as they did before the Romans came, once the imperial legions had brutally forced them into political submission. When Christianity began to rise as a new faith in the 100s C.E., first among Jews then among other peoples of the empire, the Romans also allowed this religion to flourish, except when insecure times made Christian pacifism and opposition to emperor worship seem a threat. The periods of harsh persecution of Christians ended with formal imperial tolerance of the faith in 313 C.E. and acceptance of Christianity as the state religion in 392. This development strengthened the hold of Christianity on the region in which European civilization was then emerging.

Ancient Germans also exercised a powerful shaping influence in the early history of European civilization. In the 200s C.E., German tribes began to leave their original north European homeland (where modern Germany, Denmark, Norway, and Sweden are located) and move to the northwestern frontiers of the Roman Empire. Romans viewed these illiterate people, typically clothed in bark or crude fur wraps, as barbarians. German kings and aristocrats, however, sometimes dressed in colorful, luxurious garments and organized ceremonial events that deeply impressed the Romans. Germanic hair and clothing styles even gained popularity within the empire. Roman cultural leaders, moreover, sometimes wrote in praise of the primitive virtues of these "savages" from the north. Still, the Roman government generally resisted the movement of the Germans into the empire. The attempts to stop or at least slow the infiltration of Germans

failed. They came in ever greater numbers, and their presence sped the modification of Roman (Latin) culture, especially after massive German invasions began in the 370s. The western part of the Roman Empire assimilated these newcomers, and that part of the realm developed a culture that blended Latin, German, and Christian influences. This three-part amalgam became European civilization in the 300s and 400s.

## ■ THE EUROPEAN MIDDLE AGES

During the first five hundred years of the **European Middle Ages** (the medieval era overall lasted from about the 400s to 1400s C.E.), a multitude of German tribal kingdoms emerged in the western portion of the Roman Empire. Roman emperors continued to rule an Eastern Mediterranean state, centering on Constantinople, until the 1400s, but the western imperial realm no longer existed. Germanic kingdoms in this European region remained weak, and in many parts of the continent government hardly existed at all. European countries did not always have clearly defined borders in the feudal phase of the Middle Ages (late 800s to 1000s). In the feudal era, European urban life also virtually ended. Cities shrank drastically in size, and little if any trade took place within them. They became simply local administrative centers in which secular and religious officials struggled to meet little more than the most fundamental community needs such as keeping roads passable, maintaining the jails, and feeding people during hard times. A high level of violence and warfare added to the woes of Europeans during these founding centuries of their civilization.

### The High Middle Ages

Political recovery, then, came quickly in England and more slowly in France. Intermittently, significant political power centers also appeared in Germany. The popes who led the western Christian church (the Roman Catholic Church), furthermore, became very effective monarchs with authority that touched all of Europe but was especially strong in Italy. This political recovery that began in the early 1000s continued throughout the **High Middle Ages** (mid-1000s to latter 1200s). Conditions in this era improved markedly in other ways. Violence subsided, agriculture rebounded, town life began to revive, population increased, and an impressive cultural revival occurred.

### The Late Middle Ages

Europeans suffered many hardships in the **Late Middle Ages** (1300s and 1400s). Even though people accomplished and experienced much that they and others since have viewed very favorably, this period of history is remembered mostly as a time of troubles. In this era, crop failures, hunger, long and destructive wars, a century of economic depression, and brutal sieges of disease struck Europe.

A duel plague (bubonic and pneumonic) began to sweep through Europe in 1348. This extremely devastating pandemic perhaps took as much as one-third of the European population within two years. For several centuries, the plagues returned to Europe time after time. The diseases became less deadly over the years but still killed huge numbers of people in some regions even in the mid-1600s. The death toll in the 1300s was so great that it took nearly two hundred years for population levels to return to the point they had reached in 1300.

Wars, especially the series of battles between France and England known as the Hundred Years War (1337–1453), also cost many lives, especially among the noble warriors. Warfare caused civilian casualties

too, but its greater effect was the suffering that resulted from the destruction and economic burdens that came with these military actions. In addition to the hardships that war brought to the peasants, they continued to suffer from food shortages caused by a multitude of poor crop years. Even when bread, the most important foodstuff, was available, common people had great difficulty in getting adequate money to pay for necessities. When food shortages and inadequate pay caused increased numbers of peasants to flee the farms and head to the cities, new rules in some regions denied their right to move. Such circumstances drove the peasants to rebellion in northwestern Europe in the 1320s, in France in 1358 (a revolt called "the *Jacquerie*"), and in England in 1381. John Ball and Wat Tyler, who led the English peasants' revolt, intended to kill all the nobles.

The Catholic Church, one of the leading unifying institutions of European civilization throughout the Middle Ages, became divided at the top in the 1300s as two, then three, rival popes appeared, a result in part of the papacy's involvement in the monarchical rivalries of the time. One effect of this "Great Schism," or split in the Church, was increased criticism of the papacy and the growth of movements and ideas that would permanently divide the Church in the 1500s. John Wycliffe in England and Jan Hus in Bohemia were the most important spokesmen for new Christian beliefs that threatened to undermine the authority of the clergy in the Late Middle Ages. For his challenge to the Church, Hus was called before a Catholic council in 1415, condemned as a heretic, and burned at the stake.

Even in these troubled times, rulers of the great European states continued to build stronger centralized governments with increasingly powerful armies and navies. The kings of Spain, France, and England had the ability by the mid-1400s to make their authority over their subjects felt as never before. They also had greatly increased the potential to exercise influence beyond their borders in Europe and in the larger world.

In spite of the gains in governmental strength in the latter Middle Ages, non-European powers—especially Arabic, Mongolian, and Turkic—overshadowed and threatened Europe as they had for almost a thousand years. New directions taken by the Europeans in the High Middle Ages, however, ensured that their relative weakness among global competitors would end. From the 1100s to 1400s, Europeans accomplished a shift in outlook, technology, military abilities, and political organization that set the stage for Europe to achieve world supremacy in the **Modern era** (1400s to the present).

## ■ THE RISE TO MODERNITY

The surge in the strength of Europe that completed the shift to global power came about in the **Early Modern period** (mid-1400s to latter 1600s), especially because of changes that occurred during movements known as the Renaissance and Reformation.

### The Renaissance

An active effort to bring back to life the ancient culture of "classical" Greece and Rome began in Italy during the 1300s. This movement to accomplish a rebirth—a **Renaissance**—of the human-centered ideas and arts of antiquity lasted from about the mid-1300s to the mid-1600s and gradually spread from Italy northward across Europe. Renaissance leaders not only emphasized human affairs in the natural world and focused on the "humanist" Greek and Roman civilizations, they also exhibited a more secular and individualistic outlook than had people of preceding generations. Such attitudes gave Renaissance thinkers a negative opinion of the Middle Ages with its emphasis on the "other" world of spiritual matters.

### Humanism in Italy

Renaissance humanists concentrated on restoring and building on what they thought of as the values of ancient Greece and Rome. One of the specific steps they took to accomplish this goal was the effort to find and preserve ancient writings, structures, and artifacts. They hoped to use this recovered heritage to teach people of their own times how to advance toward replacing a medieval way of life with a new one. For many humanists, this new thinking and acting would include living in a way that was more true to original Christian teachings.

Certain Renaissance thinkers, however, believed in living *without* holding to Christian principles. Niccolò Machiavelli (1469–1527), for example, in his work titled *The Prince* (1513), rejected the idea that Christian morality should guide rulers; instead, he argued that circumstances at times required government leaders to ignore ethics and do *anything* to preserve the state and its citizenry. Other currents within the humanist movement simply had no relationship to religion. In Florence, Italy, in the 1300s and 1400s, wealthy business leaders rose to power who were devoted to applying ancient political values to their governance of the city. This era of "civic humanism" in Florence climaxed in the 1400s, when members of the famous Medici family dominated city life.

### The New Art and Architecture of the Italian Renaissance

Florentine civic humanists believed not only in ruling in a way true to the spirit of ancient humanists, but also in supporting the development of new forms of art and architecture that agreed with Greco-Roman artistic principles. The rich ruling classes of Florence, therefore, invested large sums of money to pay for the work of the architects, artists, and sculptors who began the truly revolutionary change in the arts that occurred during the Renaissance.

First in Florence, beginning in the 1300s, and then throughout Europe thereafter, sculptors, painters, and architects attempted to adjust their expressions to a world of human forms and feelings. Early Florentines who led the way in this artistic movement included the sculptor Donatello (1386–1466), and the architect Filippo Brunelleschi (1377–1446). Artists also struggled with new media and other elements of technique, with perspective, composition, and realism becoming special concerns of great painters such as Masaccio (1401–1428), Leonardo da Vinci (1452–1519), Michelangelo Buonarroti (1475–1564), Raphael (1483–1520), and Caravaggio (1573–1610).

Michelangelo produced perhaps the greatest art of the modern age in his paintings on the ceiling of the Sistine Chapel in Vatican City (the papal territory in Rome). Yet this exceptional artist considered himself to be a sculptor rather than a painter, and his work in this art form was magnificent. Few, if any, sculptors have surpassed his achievements in works such as *David, Moses,* and the *Pieta.* Michelangelo also gained fame for his accomplishments as an architect. His genius in this field can still be seen in the designs of a central city square in Rome and St. Peter's Cathedral in Vatican City.

### The Northern Renaissance

Desiderius Erasmus of Rotterdam (1466–1536) differed from most other Renaissance scholars in his opposition both to ills of the social order, such as violence and war, and to personal failings, such as crude and vulgar behavior. In most ways, however, his life and works reflected especially well what his fellow North European humanists thought and wanted to accomplish. Erasmus shared with other humanists the love of

classical Greek and Roman ideas, and he displayed the characteristic Northern Renaissance dedication to the restoration and study of early Christian sources in order to build a purer Catholic Church and a better world.

Erasmus also pursued his goal of a reformed Catholicism through publications such as *In Praise of Folly* (1500). This widely popular book offered in a biting humorous form an objection to the Church's straying from original principles into materialism and hypocrisy. He produced a Greek translation of the New Testament (1516) to serve as a better guide than the medieval Catholic versions to an understanding of early Christianity. The revolutionary potential of this biblical translation and this attitude about its purpose became evident very soon in the movement begun by Martin Luther in Germany. Erasmus' English humanist friend, Sir Thomas More (1478–1535), contributed with wit and intelligence to this cause of fostering a truly Christian society. In his *Utopia* (1516), More depicted a community perfected by carefully following New Testament principles. His imaginary society contrasted starkly with the world as it was.

Renaissance literature in North Europe focused especially but not exclusively on religion. In England, William Shakespeare (1564–1616) produced a large number of plays, poems, and other works that reflect his special insight into human traits and behavior. The quality of this body of literature is such that he stands as the greatest writer of the late Renaissance. Shakespeare's genius profoundly influenced the language of his homeland and the culture of England and the world beyond.

Stunning works of art added to the grandeur of the Northern Renaissance. Albrecht Dürer (1471–1528) traveled in his early years from his home in the German Imperial Free City of Nürnberg to Italy to study art. He learned from the Italian masters how to apply anatomical science to his depictions. With this knowledge and his special talents, Dürer brought vivid life to his paintings. His works, such as *Four Holy Men* (1526), often presented Biblical images, as had medieval art, but Dürer painted with a realistic and warmly human spirit that was strikingly modern.

Another German artist, Hans Holbein (1465–1524), brought a similarly real quality to the portraits he painted for the royal court of Henry VIII of England. The new sense of life in Renaissance art appeared also through the attention given to previously neglected subjects, such as peasant life. Visual displays of this rural world became a part of high culture in *The Peasant Wedding Feast* (1567) and other works by the Flemish artist, Pieter Brueghel (1525–1569). Religion remained in the ideas and art of Renaissance Europe. This cultural movement, however, helped to foster a transformation of European Christianity.

## The Protestant Reformation

For more than one thousand years before 1500, Roman Catholic Christianity truly had gathered most Europeans into a universal church. This religion so thoroughly dominated the medieval sociopolitical order that writers referred to Europe as "Christendom," Christ's earthly Catholic realm. Then, at the dawn of the Modern age in the early 1500s, a dramatic growth in the awareness of Catholic shortcomings led to protests against the Church and the demand for drastic reforms that Catholic leaders refused to accept. This religious rebellion gained special power because reformers and political leaders were becoming more dedicated to their national societies than to European Christendom. These circumstances led to a shattering of the structure of medieval Catholic Christianity, a series of events known as the **Protestant Reformation.**

### The Emergence of the Lutheran Church

An especially important moment in this Reformation era came in October 1517. Martin Luther (1483–1546), a German Catholic monk, had composed a list of points, the **ninety-five theses,** critical of

Church beliefs about indulgences, a practice that involved giving a gift to the Church in order to lessen the time a soul had to suffer in purgatory for unforgiven sins. At the end of October, Luther sent his document to a few bishops and friends as an invitation to debate the issues he raised.

This attack on indulgencies revealed Luther's alienation from sixteenth-century Catholicism. His different conception of how salvation occurred indicated even more vividly the extent of this separation. Luther denied the fundamental Catholic principle that people had to have the spiritual services of the clergy (church priesthood) in order to avoid the eternity in hell that awaited non-Christians and the punishment for sin that believers could suffer. Each person, unaided by anyone, he argued, could use the word of God (by which he meant especially the statements of Jesus recorded in the Bible) to find salvation from the consequences of sin. The sinner accomplished this rescue from damnation, moreover, through an act of faith and not by living a priest-guided good life, as current Church belief suggested.

### The Multiplication of Protestant Churches

The rise of **Lutheran Christianity,** the first Protestant church, and the conditions that caused this break from Catholicism, inspired a spreading revolt. Masses of people similarly alienated from the Catholic Church responded to Luther and other Reformation leaders. The invention of Johannes Gutenberg's moveable-type printing press in 1450, which greatly speeded and cheapened publication, made Bibles and the writings of these religious rebels widely available and did much to ensure a shattering transformation of European Christianity.

John Calvin (1509–1564) stands with Luther as an especially important Protestant church founder. This religious reformer fled his staunchly Catholic homeland in France to avoid persecution, and, probably execution. In Geneva, Switzerland, Calvin established his church. He, too, emphasized salvation as a matter of a personal relationship between God and the believer. Unlike Luther, however, Calvin taught that God predestined who would be saved to enjoy eternal life and who would be damned to everlasting hell. Despite such an idea that might have encouraged a fatalistic acceptance of a life of either sin or godliness, Calvin's followers tended to bend every effort to show by their lives that they were saved. **Calvinists** also took a very legalistic approach to their faith. They emphasized the importance of carefully following the principles that Calvin, with his lawyer-like mind, laid down.

Over the centuries that followed the Reformation, a gradually moderating Calvinism spawned many modern Protestant movements such as **Presbyterianism.** Other Christian churches that exist in the twenty-first century also emerged from Reformation roots such as those planted by the **Anabaptists,** Christians who denied the validity of infant christening and taught that baptism had to follow a conscious decision to turn to Jesus for salvation. Present-day Mennonites still follow the teachings of Menno Simons (1469–1561), a Dutch Anabaptist leader who became widely known in his lifetime. In Switzerland in the next century, Jacob Amman emphasized aspects of Simons' beliefs that led to the emergence of the Amish movement.

### The Emergence of State Churches

The Protestant Reformation received support from rulers who benefited from religious divisions that allowed them to begin organizing states united under them religiously as well as politically. Luther avoided being seized, tried, and executed because it served his German ruler's interests to protect him and help create a church under a leader who supported rather than challenged state authority, as the popes often had done. Calvin ruled in Geneva, his adopted Swiss home, as a dictator over both his own church

and city-state. In England in this era, however, the more typically modern tendency to have the state leader dominate the church became evident during the first half of the 1500s.

### Henry VIII and the Creation of the Church of England

Political motives more than any others caused the break from the Catholic Church in England. From 1455 to 1485, two families fought a civil war to gain control of England. The Lancasters won over the Yorks, and the Lancastrian King Henry VII became the founder of the new Tudor dynasty. When the second Tudor, Henry VIII, took the throne in 1509, the family still had to worry about rivals overthrowing them. The Tudors needed an undisputed heir to the crown at the end of each king's life. In England at that time, kings knew that a legitimate son had the best chance of succeeding to the throne. Thus, in the 1530s, Henry VIII decided to have his marriage nullified so that he could take a new wife whom he thought would better ensure the birth of a male heir. The pope refused to annul the marriage, so Henry declared himself to be the supreme head of the Church of England, or **Anglican Church.**

Anglicans believed much the same as Catholics, but the English king had ended papal power in the land and taken charge of both church and state. Certain people, such as the great Renaissance scholar and devout Catholic Thomas More, who would not publicly declare their acceptance of the king as church leader, were executed. Henry's religious revolution, the killing of insufficiently loyal subjects, and six marriages did not enable him to establish a very stable Tudor monarchy. One of the marriages produced a son, but he died young after a short reign. Henry's Catholic daughter, Mary I (reigned 1553–1558), then took over and began to execute Anglicans and other Protestants. (She said she burned their bodies to save their souls. The killings caused her to be remembered as "Bloody Mary," although she deserved the executioner's label no more than many other rulers of her day.) Henry VIII's second daughter, Elizabeth, followed Mary on the throne in 1558 and reigned until 1603. She returned the kingdom to Anglicanism and eventually brought relative peace and stability to England.

### The Catholic Response to Protestantism

The Catholic Church responded to the Protestant revolt in several ways. A new order of clergy, the **Jesuits,** emerged and became the leading spirit in the effort to reform the Church from within. Catholic leaders used the **Inquisition,** a system of Church courts and trials, with more vigor than in the past to seek out and punish, sometimes cruelly, the heretics who challenged the faith. (Protestants treated Catholics in a similar fashion.) Roman Catholics also convened the Council of Trent (1545–1563) in an effort to alter doctrines and end some of the abuses that had helped to cause the Protestant Reformation.

## ■ EARLY MODERN EUROPEAN GOVERNMENT

Kings in Early Modern times usually had much greater central authority than had rulers during the Middle Ages. Church leaders and feudal aristocrats generally lost power and came increasingly under monarchial control. A corps of supporting royal bureaucrats helped to make the clergy, nobles, and commoners throughout the realm feel the king's authority. Standing armies greatly enhanced the power of this new bureaucratic monarchical state. Although the effectiveness of the bureaucracy and the force of the armies might have been sufficient to bring about the success of Early Modern monarchies, new ideas, such as the divine right theory of kingly authority, helped to ensure their triumph.

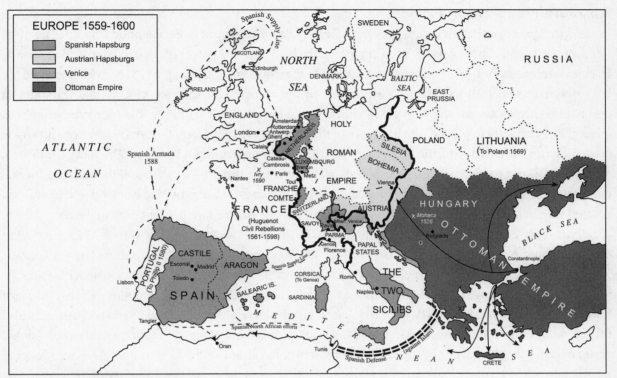

**Figure 1.1: Early Modern Europe**

## The Spanish Monarchy

Spain in the late 1400s and early 1500s witnessed the rise of a very successful Early Modern monarchy. In 1469, the rulers of the two most important Spanish states, Ferdinand of Aragon and Isabella of Castile, married. They jointly ruled Spain from 1479 to 1516 and turned the kingdom toward its greatest era. These monarchs not only faced no opposition from religious leaders, as had many medieval rulers, they enjoyed the increased power that resulted from the vigorous support of a loyal Spanish Catholic Church. The king and queen also commanded military forces that could impose their will on Spanish nobles or conquered inhabitants of colonies. The wealth that derived from a successful mercantile economy enabled these rulers to strengthen almost every foundation of state power. Ferdinand and Isabella had every advantage as they turned to a quest for global supremacy. A New World empire was theirs for the taking.

The next king of Spain, Charles (1516–1556), also held the crowns of several central European states, such as Austria. He ruled states in Italy as well. In 1519, Charles gained the additional title of Holy Roman Emperor. Thereafter known as Charles V, he reigned over an unusually vast realm and exercised great power, but it was an awkwardly large state. His son, Philip II (1556–1598), still appeared supreme among European monarchs as he led Spain in a battle against Protestantism everywhere. This great strength did not last, however. Philip's failure against rebels in his Dutch territories and the defeat of his Spanish Armada by the English fleet (1588) foreshadowed the decline in power that Spain would later experience. Costly wars and persistent economic problems combined to diminish Spanish influence in the 1600s.

## Absolute Monarchy in France

As in Spain, the Early Modern French monarchy tied its fortunes to the Catholic Church. The institutions of state and church supported each other to the benefit of the power of each. Under the Valois king Francis I (reigned 1515–1547), the Church agreed to the Concordat of Bologna (1516), which granted the king power to select all the important members of the clergy. This alliance of king and Catholicism ensured that Protestantism and political rebellion would become almost inseparable. The simmering religious rage eventually exploded into a series of religious wars (1562–1598) that gradually wore down the power of the monarchy during the reigns of the last Valois kings (1547–1589). King Henry IV (1589–1610), the founder of the Bourbon dynasty, renewed the process of strengthening the French monarchy. He accomplished this resurgence in part by issuing the Edict of Nantes (1598), a decree that granted somewhat more tolerance to Protestants and thus helped restore the kingdom to peace.

Two other early Bourbon rulers, Louis XIII (1610–1643) and Louis XIV (1643–1715), and their chief assistants, Cardinals Richelieu (1624–1642) and Mazarin (the latter led the French state while Louis XIV was too young to govern), guided France to supremacy in Europe. The French state under Louis XIV illustrates especially well the institutions and practices that intensified the strength of Early Modern European governments. Louis XIV built a huge and lavish palace at Versailles near Paris and used it to awe French nobles and foreign rulers. He worked energetically as the leader of an increasingly professional group of governing bureaucrats to extend his control over the affairs of the French state. The wide-ranging jurisdiction of royal courts, built up over many generations, and the expansive authority of the king to tax, proved his strength and added to it. Above all, the monarch could demonstrate his power with his large military force. He had a massive and permanently organized army and navy, a special instrument of power unknown to medieval European rulers.

Louis XIV announced his sense of his importance as a ruler by calling himself the "Sun King" and using the slogan, *"L'état, c'est moi"* ("I am the state"). The extent to which this "absolute" monarch subordinated the medieval aristocracy and used his standing armies to strike out in numerous wars of conquest abroad gave some meaning to such a description of his place in the French state.

## Toward Parliamentary Government in England

In the Middle Ages, the **English Parliament** began as a conference of royal officials and others, such as leading members of the warrior aristocracy, summoned by the king. Monarchs convened these assemblies especially when they needed a group to serve as a high court, but they typically used the sessions to present royal policies, seek advice, or conduct other business of government. Eventually, it became the practice to call to Parliament members of the lower nobility and representatives of the towns. Centuries of development in this way produced the Parliament of the 1600s, a law-making body with a House of Lords for the aristocracy and a House of Commons for non-nobles.

The Tudor line of rulers had by the reign of Elizabeth built a vigorous and stable monarchical government, but they had not ended the murderous religious strife caused by the English Reformation. Elizabeth arranged a religious settlement that removed this problem from the center of monarchial attention during her reign and made it a much less serious concern for most of her successors. The queen reversed Mary's decision to crush Protestantism and restored the Anglican Church with doctrines and rituals acceptable to most of the English Christians who had battled over reformation issues. This Church of England then endured through the centuries, and the head of it in 2006 is Queen Elizabeth II.

A new dynasty, the Stuarts, came to the throne after Elizabeth I. They pressed for absolute royal authority and supported Catholicism as well. English Parliamentary traditions and the religious changes of the Tudor era, however, ensured strong resistance to the designs of Stuart kings such as James I (reigned 1603–1625) and Charles I (reigned 1625–1649). Under the leadership of Oliver Cromwell (1599–1658), the **Puritans** (staunch Calvinist Protestants) emerged as the militant force behind the movement to counter the Stuarts' royal and Catholic designs. Cromwell's Parliamentary and Protestant defenders turned to open rebellion against the Stuarts in 1640. After victory on the field of battle, the rebels executed Charles I in 1649, as crowds of people in the heart of London looked on.

A subsequent royalist resurgence under James II (1685–1688) revealed that the monarchy was not dead and even raised fears of a return to Catholic supremacy. The Parliamentarians, however, had the strength to resist this challenge. In 1689, they arranged the beginning of a new line of more submissive rulers by replacing James with his daughter, Mary, and her husband, William of Orange (who already ruled the Netherlands). Without warfare, this **Glorious Revolution** of 1688–1689 completed the establishment of constitutional monarchy in England. Thereafter for many years, kings shared power with Parliament, and through Parliament the propertied elements of the nation exercised increasing authority.

## Germany—Modernizing but Divided

Territorial fragmentation and political decentralization typified Europe in the Early Middle Ages (500s to 1000s), especially in the Germanic regions. The rise of united kingdoms under increasingly effective central monarchies that began in France and England by the 1000s, and somewhat later and less successfully in Spain, did not occur in Germany. After the great advance in centralized state-building in large West European monarchies in the Early Modern era, the contrasting pattern of politically divided territories to the East in Germany seemed a medieval political relic. Even the Reformation, which enhanced the power of monarchies in West Europe, heightened the barriers to German unity. Political and religious antagonisms in Germany as well as other conflicts combined to produce an extended season of combat, the **Thirty Years War** (1618–1648).

As the dawn of a truly modern political era in Europe approached, Germany thus faced it disunited and scarred by a generation of brutal combat. In a less apparent way, however, Germany also moved from the medieval political world to a new one. Within certain German states, if not in a united Germany, patterns of monarchial development paralleled trends elsewhere in Europe. The Prussian king, for example, wielded total authority with the support of the land-owning aristocracy (the Junkers) who, in turn, enjoyed a life of privileges while peasants remained oppressed and poor. Even without a modern social order, Prussia had the essential traits of the new monarchical political system.

## The Russian Monarchy's Struggle for Security

Russia in the Early Modern period somewhat resembled West European states in that the kingdom became more unified and the monarchy more centralized and powerful. This increased solidity and strength of the monarchy came during the era of the Romanov dynasty that began with Michael in 1613. His reign marked the end of an era of vicious civil conflict and invasion (**The Time of Troubles, 1605–1613**). One of his successors in particular (Peter the Great, 1689–1725) built strongly on these foundations by more thoroughly suppressing noble opposition to the king's power, by establishing culturally transforming relationships with European societies to the west of Russia, and by leading his country into

battles that added to the realm's territory, especially in the northwest. The motivation for these conquests probably included not only the desire for glory and power, but also the urge to make Russia less vulnerable to the foreign invasions that so often had struck in the past.

# ■ EUROPEAN EXPANSION—THE BEGINNING OF GLOBAL CONQUEST

In the mid-1400s, Europeans began to travel overseas, where they had never before gone. They moved in ever greater numbers to lands formerly accessible only by much slower land routes. They found worlds new to them, too. As the Europeans moved into this larger world, they conquered it. Four centuries of European imperialism thus began.

This reach for exotic lands did not occur only for such obvious reasons as the desire of rising powerful monarchies to build greater strength, gain more wealth, and shine with increased glory. Others within their kingdoms felt driven to seize and use these new worlds for differing reasons. Land-owning aristocrats wanted more land. Merchants dreamed of gaining greater profits by controlling their own direct sea trade with Africa and Asia rather than depending on independent traders who used land routes. Christians welcomed the opportunity to enter new lands and conquer souls never before touched by their faith. Once they had a foothold in the Americas, Europeans saw the promise of unexpected riches from gold, silver, and slave-produced sugar crops. European technical achievements, such as the cannon-armed sailboat, gave them the power to take with relative ease whatever regions they wanted and use them for their chosen purposes.

## Portugal as Imperial Vanguard

Portugal led the way into the Atlantic and around Africa. In the 1400s, the Portuguese took the islands of Madeira, the Canaries, and the Azores in the Atlantic. They also reached southward along the west coast of Africa to the Congo River, setting up trading posts as they went. They traded in the slaves and gold of Africa and the sugar cane of the Atlantic islands. Prince Henry the Navigator (1394–1460) was a leading figure in these ventures, an explorer probably driven by a "crusading" Christian impulse. Other prominent explorers included Bartholomeu Dias (1450–1500), who reached the southern tip of Africa in 1488, and Vasco da Gama (1460–1524), who went around that African cape to India a decade later.

## Spain's Grander Empire

Spain surpassed Portugal as an empire builder and eventually conquered the most extensive and valuable colonial realm of the European imperial era. Christopher Columbus (1451–1506), although Italian, took the first important step when he sailed for the Spanish monarchy and reached the Caribbean islands in 1492. Then, in 1513, Vasco Núñez de Balboa (1475–1519) traveled to Central America and crossed the relatively narrow strand of land to go on to the Pacific Ocean. Thereafter, Ferdinand Magellan's expedition completed the first earth-encircling trip (1520–1521). By this time, Hernando Cortés (1485–1547) had conquered the Aztecs in Central America and taken Mexico for Spain. Before another decade passed, Francisco Pizarro defeated the Incas and added Peru to the empire. Spain also laid the foundations in the 1500s for what would later be a grand imperial reach in the early 1700s into the western half of the North American region that lies between present day Colorado and the California coast.

Into their new holdings the Spanish took new diseases and the practice of using forced labor. The native death rate soared. Spain also took slaves from Africa into an existence in the New World even more horrible than the one experienced by the Native Americans under European enslavement. European imperialism in Central and South America created a small and very rich upper class that dominated a mass of extremely poor lower-class people. This sharp and oppressive social division became a long-lasting heritage of Early Modern European imperialism in this part of the world.

English and French imperial ventures into the Americas in the 1500s and 1600s gave these countries control over Caribbean islands and portions of North America from the Mississippi valley to the eastern coast. In the 1700s, England and France would struggle with each other for complete dominance of this continent, and the grip of Spain on North American lands would weaken. In the Early Modern era, however, Spain and Portugal stood as the masters of the New World.

## Mercantilism

Rulers who were engaged in building central authority, fighting rival European states, and taking colonies had to devote special attention to the economy of their government and country. Under these circumstances, a typical pattern of attitudes and policies emerged. Many government leaders in the 1500s and 1600s believed that the amount of trade possible for Europeans had fixed limits. They assumed also that the power of their country depended on trade-produced wealth, especially in the form of gold and silver. European rulers wanted to surpass rival governments in wealth and power, which meant that they had to win control of more of the markets for trade.

Political involvement in economic development made sense for people with such attitudes. Governments thus tried to lessen tax barriers to trade inside their countries and erect tax blocks to commerce from the outside. They improved roads and waterways and set up industries and trading companies. In general, these commercially oriented governments tried to spur trade with the intention of enriching the state and increasing its power. Later observers named these attitudes and practices **mercantilism,** a policy characteristic of this era, and one that helped cause trade expansion to hold an especially important place in Early Modern economic growth.

## ■ EARLY MODERN EUROPEAN ECONOMY AND SOCIETY

Much of the world felt the power of the Europeans by the 1700s. Economic developments became central to the transformation that gave Europeans globe-controlling power, a transformation usually called **modernization.**

### Agriculture and the People of the Country

Few Europeans in the 1500s and 1600s lived and worked in ways now viewed as "modern." Almost everyone survived on the fruits of farm labor, as they had since European society emerged in the 300s to 400s C.E. The workers who tended the fields of Europe from about 1500 to 1800 plowed with animal-drawn equipment, but did almost everything else with simple tools or with their hands.

Typically, peasants of each rural village labored in teams on schedules set by the sun, weather, and tradition. They worked under the dictates of nature and community. Through much of the Early Modern era, European agricultural laborers thus supplied almost all of their own needs and, to a great extent, also

supported the non-farm workers and the non-laborers of their locale. In most respects, then, peasant agricultural life continued as it had for generations.

## The Peasants

England, the most urban European country, was still about four-fifths rural in the 1700s. Across Europe at that time, farming peasants made up two-thirds or more of the population of the rural areas. The social status of these rural folk varied somewhat, depending on how much land they had. People in the lowest positions had none and worked the land of others. Regardless of social rank, peasants lived in villages that rarely included more than five hundred people and had little contact with the world beyond their settlements. A relatively small number of people who did not farm resided in these settlements, too. The latter included mainly artisans, who were craft workers producing tools, utensils, and other articles that required special skills. Non-laborers who served other community needs—priests, for example—also lived in many agricultural villages.

## The Aristocrats

The Early Modern European aristocracy enjoyed special legal privileges and exercised power over their society even though they comprised only one to two percent of the population. This small upper class also had many exclusive rights. These nobles usually depended on agriculture to supply their needs, as did the peasants, but very few members of the aristocracy farmed or worked physically in any way. In most places, they alone could arm themselves with swords or hunt for game. Legal disputes among aristocrats brought them into their own noble courts, but the aristocracy ordinarily conducted the trials of peasants.

Nobles exercised control not only through the courts but also as leaders in government, the churches, and the military. Aristocrats sometimes held their top social position as descendants of the feudal nobility. Others gained the distinction by government service in Early Modern times. Most nobles exercised authority at the local level. They all tended to oppose strong central government. But from the 1000s onward, aristocrats gradually lost authority as kings increased central political power, especially in West Europe. By the 1700s, the nobility faced still more serious challenges. Aristocratic supremacy came to an end during the 1800s and early 1900s.

## Business

Money-making business became one of the important forces that eventually ended aristocratic power. The nobles' leadership depended especially on their place in an agricultural economy that shunned change. A more innovative and expansive economic system developed from the influence of trends that began as early as the 1000s but especially from changes after the mid-1600s. Aristocratic supremacy lasted many more generations, but signs of a new economic climate that eventually favored other social groups became increasingly clear in the century before the 1750s.

## New Financial Procedures

The emergence of modern business required many changes in economic operations. Credit letters and other such banking devices to pay debts, although used for centuries, took on a more advanced form and became more widespread in Early Modern times. These banking instruments made the exchange of

money more efficient and safe. Merchants could not so easily reduce the risks involved in the transport of goods, but insurance for shipping ventures became common by the 1400s and provided the necessary protection.

Reduced chances for business losses also resulted from the practice of shared investment, an arrangement achieved through joint-stock companies. Europeans first established such companies on a significant scale in the 1500s. These investor groups also served another important purpose. They made possible the accumulation of much larger sums of money for business operations on a grander scale. The circumstances of the period virtually demanded these different business practices.

## The Price Revolution

In the 1500s, a price rise greater than Europe had ever experienced strongly influenced the changes that produced the new economic climate of the late 1600s and early 1700s. Annual inflation rates of three percent, extreme for that era, drastically elevated prices, especially for bread, the mainstay of almost everyone's diet. A sudden surge in population since the mid-1400s and the flow of gold and silver into Europe from the newly discovered Americas probably caused this price revolution.

### Farming for Money

The great inflation prompted action by a portion of the farmers who saw a chance for huge profits. Landowners in northwestern Europe and England led all others in the expenditure of energy and funds on farming innovations such as crop rotation and animal breeding. They sometimes reaped tremendous returns on such investments.

Because these ventures required the alteration of very old and widely revered rural customs, the changes did not come quickly or over a wide area. Much of Europe experienced almost no alteration in its agricultural ways until the mid-1700s. But during the century before that, a few rural nobles had begun commercial agricultural practices that foreshadowed a modern economic world that aristocrats would not control.

### Trade

The unusual climb in population and prices stimulated trade as well as commercial farming. The booming demand for food and other goods meant that the merchants who transported and sold these products had the opportunity for exceptional profits, just as farmers did. Early Modern governments often promoted the expansion of trade in the belief that the inflow of wealth from commerce heightened state power. With growing bureaucracies, armies, and navies, these governments also spent heavily. In many ways, therefore, government helped drive trade forward. Population, prices, and governmental action also affected industry.

## Manufacturing

To manufacture literally means "make by hand." Most Early Modern European industry still depended on human or animal effort instead of the less frequently applied wind or water power. Furthermore, new processes and devices seldom appeared during this era. In these respects, manufacturing showed few signs of a coming "modern age." But certain important advances in production methods did take place, especially in luxury industries that marketed silk, lace, china, and glass.

## The Cottage System of Production

Much of the manufacturing in Early Modern Europe took place in the cottages of workers. Merchants delivered raw materials, such as wool or some other fiber, and later picked up finished products, such as cloth. This "putting-out" or **cottage system** of production enabled merchants to evade the rigid medieval controls on craftwork in the towns. At the same time, it indicated a further movement away from the much more thoroughly agricultural socioeconomic order of pre-Modern Europe. The laboring population was slowly shifting from farming to manufacturing.

## The Cities

Urban Europe exerted a powerful influence on the change to modern ways. Beginning around 1000, trade and cities revived rapidly, after a long period in which commerce and town life diminished to very low levels. Between 1000 and 1500, many new towns sprang to life and older ones grew. The establishment of new cities occurred much less frequently by the 1500s. They grew more rapidly in size, however, creating or adding to the ring of dwellings (the suburb) gathered around the older urban center. By the 1600s, these trends gave Europe an urban population that varied from somewhat less than five percent in some areas to just over ten percent in others. Urbanization before the mid-1700s also spawned a few large cities, with London, for example, growing to about three-quarters of a million.

## The Bourgeoisie

The commercial populations that reigned supreme in the cities of the Middle Ages and Early Modern period comprised a **middle class** between the aristocrats and peasants. In addition to their description as a middle class, these city dwellers acquired labels derived from the words for "town" in the various languages. In France, and eventually everywhere, they became known as the **bourgeoisie.** This relatively new social group included merchants, bankers, lawyers, doctors, skilled craft workers, and various urban residents of similar status. Servants, unskilled laborers, and others also lived in cities but did not belong to the middle class. The word "bourgeoisie" does not refer to these unskilled urban workers.

## The Bourgeois Hierarchy

With their widely different occupations and incomes, middle-class people formed a **hierarchy,** a pyramid-like social structure. The few with the most prestige and wealth held the upper positions, places that rich merchants or lawyers, for example, might achieve. They tended to imitate the aristocracy's lifestyle and sometimes became titled nobles. People such as artisans filled the more numerous lower ranks of the bourgeoisie.

## Middle-Class Attitudes

The acceptance of hierarchy and longing for aristocratic titles indicate that bourgeois attitudes in certain ways differed little from the outlook of others in the Middle Ages and Early Modern period. The middle class distinguished itself, however, by its powerful devotion to work. This trait set the bourgeois apart from the typical aristocrat who avoided labor and from the working poor whose tasks were less likely to inspire praise of the effort. The particular work that the middle classes did marked them as unique, too.

Unlike most aristocrats and farm laborers, the life of the bourgeoisie centered on moneymaking enterprise rather than on the land. Their attitudes and activities, therefore, contrasted with those of the social leaders and working masses of the Middle Ages and Early Modern era.

### The Influence of the Commercial Classes

The business-minded bourgeoisie remained a minority in numbers and influence before the Modern period. Even in pre-Modern times, however, they strongly affected society and influenced the movement toward a very different way of life. By the early 1700s, the European bourgeoisie stood on the threshold of a modern world that they would come to dominate during the next century.

## ■ EARLY MODERN SCIENCE AND TECHNOLOGY

Europeans of the 1500s and 1600s not only went through a drastic religious and socioeconomic transformation but also accomplished a **Scientific Revolution.** Many leading thinkers of the era became devoted followers of the ancient Greek philosopher Plato. They accepted his idea that natural laws of mathematic precision and simplicity apply to the entire universe and thus explain its operations. Francis Bacon (1561–1626) pioneered the Early Modern movement to take this reasoned Platonic approach to knowledge. He and rapidly multiplying numbers of intellectuals in the 1600s tried to reject all assumptions and draw conclusions about the universe solely from their observation of facts. This more complete shift to a scientific rather than a religious approach to understanding the world finished the transition to a modern outlook that began with Renaissance humanism.

### A New Place for the Sun

One especially important step in the Scientific Revolution came when Copernicus (1473–1543) rejected the idea of the earth as the center of the universe and the related belief that planets did not move. His conclusion that all planets, including the earth, traveled around the sun directly contradicted the medieval conviction that the earth was the focus of God's drama of human salvation. Copernicus' theory further implied that very old scientific sources revered by the Church were incorrect.

### The New Scientists

Galileo (1564–1642) built telescopes and developed a body of clearly observed facts to support Copernicus' theories. He also rejected the long-held dogma that heavenly bodies other than the moon were pure and superior to the impure earth. Johann Kepler (1571–1630) drew on a multitude of detailed astronomical observations compiled by Tycho Brahe (1546–1601) to develop mathematical explanations for the movement of planets. He thus confirmed by numerical calculations Galileo's view that natural rather than supernatural forces governed the universe. These early modern scientists prepared the way for the work of Sir Isaac Newton (1642–1727), generally accepted as the supreme mathematical genius of his era. Newton combined and added to the ideas of his early modern predecessors to achieve an explanation of the structure and forces of the universe, most of which appears valid more than three hundred years later.

## Secularism

Educated Europeans in the Middle Ages, most of whom belonged to the Catholic clergy, had a religious worldview. They urged everyone to devote their lives to the fulfillment of God's will as revealed by the Church. These intellectuals contended, furthermore, that people could gain an understanding of the conditions, forces, and occurrences of the natural world only by turning to God.

By the 1200s, a few prominent intellectuals argued that humanity could discover the truth about the makeup and operation of the earthly environment by scientific means. They insisted, that is, on explaining the world around them by careful observation and a systematic study of facts. This tendency to view life in a secular rather than a spiritual way strengthened during the late Middle Ages and after. By the 1500s and 1600s, most leading scientists had accepted this modern view of nature. Universities quickly came under the influence of such thinking. As a consequence, the educated modern European public in general began to acquire this new, distinctly secular spirit.

In the mid-1600s, after the early modern transition, the new secularism helped to ensure that non-religious leaders, especially the people in charge of the increasingly powerful modern central states, would exercise greater authority over European societies. Economic changes and technological advances in the 1500s and 1600s contributed in a special way to the might of European state leaders, and they began to conquer the world. The **Age of Modern Europe** had dawned.

*Trends that began in the Middle Ages and became especially evident after 1500 not only brought the bourgeoisie into power during the 1700s, but also changed the overall nature of European life. These tendencies that emerged before the 1700s also carried Europeans to world supremacy in the Modern era. In short, before the 1700s, Europeans began an internal transformation that also affected the world structure of power. The term "modernization" summarizes this process of change that became significant in the Early Modern era.*

*This modernization of Europe entailed changes in the structure, attitudes, and material culture of society. The modern direction in social organization involved a shift from the dominance of local structures (such as family, clan, or tribe) over government, economy, and culture to the centralization of power over these aspects of life. One change in outlook especially associated with becoming modern was increased secularism, at least in the sense of a subordination of religion to or a separation of religion from government and economy. A closely associated transformation of attitudes was the turn away from reverence for tradition toward a glorification of change, particularly in technology—the making and use of mechanical devices. The dramatic transformation of the European machine world in the 1700s and early 1800s, remembered as the Industrial Revolution, made this region socially and economically modern and the unrivalled power center of the world.*

## Selected Readings

Cipolla, Carlo M. *Before the Industrial Revolution: European Society and Economy, 1000–1700,* 2nd Edition. New York: W. W. Norton and Company, 1980.

Hay, Denys. *Europe: The Emergence of an Idea.* New York: Harper & Row, 1966.

Jordan, Terry G. *The European Culture Area: A Systematic Geography.* New York: Harper & Row, 1973.

Koenigsberger, H. G., and Asa Briggs. *Early Modern Europe, 1500–1789.* New York: Longman, 1987.

Zophy, Jonathan W. *A Short History of Renaissance and Reformation Europe: Dances over Fire and Water.* Upper Saddle River, NJ: Prentice Hall, 1996.

## Test Yourself

1) Cultural leaders of the Early Modern European Renaissance wanted to bring about a rebirth of the ideas and arts of
   a) ancient Greece and Rome
   b) the Carolingian Renaissance
   c) the High Middle Ages
   d) all their most talented predecessors

2) One "modern" principle that the Reformation helped to establish
   a) state supremacy over the church
   b) state equality with the church
   c) church supremacy over the state
   d) state neutrality toward the church

3) A lasting European imperial legacy in Central and South America resulted in
   a) a society with virtually no native peoples
   b) a society with virtually no one of African ancestry
   c) a region divided between the few rich and the many poor
   d) a region in which a majority lives under monarchical government

4) If you were a monarch in the Early Modern era, whom should you fear most?
   a) a Reformation-era Pope
   b) Cardinal Richelieu
   c) Martin Luther
   d) Oliver Cromwell

5) The price revolution in the 1500s
   a) caused trade to become very unprofitable
   b) encouraged new farming methods
   c) drove the Spanish government into bankruptcy
   d) raised bread prices almost 300 percent a year for several decades

6) To say that "secularism" became typical of the outlook of European intellectuals means that they
   a) quit believing in God
   b) abandoned their belief in strict moral standards
   c) used factual study to explain events and conditions
   d) actively tried to destroy most religious institutions

7) As it emerged in the late Middle Ages and Early Modern era, the bourgeoisie was distinguished from other groups by its devotion to
   a) wealth
   b) religion
   c) family values
   d) work

## Test Yourself Answers

1) **a.** European intellectuals and artists from the 1400s to 1600s greatly revered the human-centered culture of the Greek and Roman people who lived before 500 C.E. and rejected what they saw as a kind of heaven-centered thinking in the medieval world.

2) **a.** One of a small number of characteristics that marks Modern Europe as different from Medieval Europe is the clear subordination of religious institutions to secular governing power.

3) **c.** Although in many global regions societies have masses of poor people and few very rich, this condition in Central and South America seems especially extreme and persistent as a result of Early Modern imperial conquests.

4) **d.** Cromwell led a violent revolt of forces that wanted to establish legislative power over English monarchs. It climaxed in a most drastic step for the Early Modern era, the execution of a king.

5) **b.** The sharp price rise did not cause a widespread drastic alteration of European farming ways in the Early Modern period, but the chance for great crop profits led to improved methods of land use.

6) **c.** The popular meaning of the word *secular* perhaps misleads people about the actual nature of the modern change in outlook. The shift in thinking really emphasized avoiding superstition and old dogmas, and taking a realistic, factual approach to understanding circumstances in the world.

7) **d.** As important as money, family, and religion might have been to the bourgeoisie as it emerged, this social group was most clearly distinguished from others by its devotion to work.

# The Industrial Revolution (Early 1700s to Mid-1800s)

**1701:** Jethro Tull invents the seed drill and greatly improves crop planting.

**1712:** Thomas Newcomen builds the first modern steam-powered pumping engine.

**1717:** One of the first true factories begins operation.

**1733:** John Kay devises the flying shuttle for cloth weaving.

**1767:** Richard Reynolds builds the first cast iron railway.

**1768:** Richard Arkwright devises the water frame for powered thread production.

**1769:** James Watt patents a much-improved version of the steam engine.

**1784:** Henry Cort develops "puddling," a better iron processing method.

**1807:** Robert Fulton's steamboat, the *Clermont,* first plies rivers in the United States.

**1825:** The British Parliament legalizes the incorporation of businesses.

**1829:** George Stephenson's *Rocket,* a steam locomotive for railroads, completes a successful trial.

**1834:** Several German states organize the Zollverein, a customs union led by Prussia.

**1844:** The first telegraph message is sent over a line between Baltimore, Maryland, and Washington, D.C.

**1856:** Henry Bessemer improves steel processing.

*A number of the new technological, economic, and social changes that remained subordinate in Early Modern Europe became prominent and had a drastic effect in England and northwestern Europe between the early 1700s and mid-1800s. As a result, people of that time and since have described this occurrence as an industrial revolution.*

*Many of the technological instruments fashioned during this industrial revolution differed from the machines of the previous era in that inanimate power drove them. This transition from a predominantly*

*human- and animal-powered agricultural life to a more urban economy of machine production and trans-portation was an outstanding trait of the Industrial Revolution. A multitude of sometimes hulking and noisy inventions thus appeared as typical elements of the new economic order.*

*Important changes in economic practices and social conditions accompanied this technological transformation. Commercial innovators established the first factories, and business leaders developed new forms of organization and finance. As this economic revolution spread from England to Belgium, France, the German states, and beyond, a modern European society of urban workers and business people replaced the world of peasants and aristocrats.*

*These wide-ranging and swift alterations of life heightened the differences between the economy of Modern Europe and that of earlier European society. The revolution in economic and social life also increased the contrast between Europe and other world regions. With this new technology and economy, Europe could gather the materials and fashion the devices to ensure their global supremacy until the end of the millennium. The Age of Modern Europe had begun.*

## ■ THE POPULATION EXPLOSION

Europe experienced especially high levels of growth from the latter 900s C.E. to the early 1900s, when compared to other regions and its own earlier history. An explosive advancement in numbers that began in the 1700s helped to launch the **Industrial Revolution.** The new economy then boosted the population growth rate for several decades.

Europeans probably numbered fewer than fifty million in 1000 C.E. It took almost six hundred and fifty years for this population to increase to one hundred million. Then, in only one century (1650–1750), Europe grew by another fifty million. In the following century, the first of the industrial era, Europeans multiplied to an additional one hundred million. This surge from one hundred and fifty to two hundred and fifty million between the mid-1700s and the mid-1800s was a remarkably fast increase, a truly explosive gain of about sixty-seven percent.

### Causes of the Increase

The **population explosion** that began in the 1750s may have resulted from an increasing birth rate, from a declining death rate, or from the combined effect of both trends. Expert opinions on the reasons for the pattern remain in conflict.

### Effects of the Population Explosion

An industrial revolution requires a rapid expansion of the labor supply and the market for goods. The sudden leap in European population provided the workers and buyers necessary for the new economy. At the same time, the surge in numbers changed the age-group proportions. Europe became younger, with many more children and young adults. This development expanded the market for the goods needed by this segment of society. The sudden increase in numbers of people and the enlarged percentage of youths spawned problems as well as benefits for European society. The older generation, for example, could not expand and adjust educational practices rapidly enough to meet the needs of this changing population.

# ■ THE MODERNIZATION OF AGRICULTURE

Europe's population surge could have caused famine. Unusually effective improvements in agriculture that occurred with exceptional speed from the mid-1600s to mid-1700s prevented this consequence, however, and also contributed to the industrialization of Europe. The **agricultural modernization** that brought these benefits involved changes in farming methods, in the organization of the agricultural economy, and in the devices used to exploit the land.

## New Farming Methods

The early modern turn toward commercial agriculture became even sharper in the mid-1600s as growing populations raised the demand for farm products and increased the opportunities for profit. The circumstances encouraged much greater spending to increase yields and spurred farmers to use land more efficiently. The Netherlands and England led the way in such modernizing steps.

### New Developments in Cropping

Earlier, Europeans overcame the depletion of farm soil by periodically allowing sections of land to lie fallow (unused). Farmers in the Netherlands by the 1700s made more efficient use of land by **rotating crops.** After harvesting grains that reduced soil nutrients, they then planted crops such as clover that increased land fertility.

**Turnip Townsend and Thomas Coke.** Two Englishmen enhanced rotation practices. By the second decade of the 1700s, Charles Townsend began to popularize the practice of sowing turnips as a restorative crop and thus gained his nickname, "Turnip" Townsend. Turnips both replenished fields and had the soil-loosening effects of a large root plant. Townsend and Thomas Coke subsequently further improved land use methods with a four-crop rotation plan that multiplied productivity by about one thousand percent.

**New Crops.** Tomatoes, potatoes, and sugar beets first began to grow in Europe in the Modern era. The first two of these foods improved the vitamin content and increased the calorie level of the Europeans' diets. Sugar beets both provided the sweets that they had come to crave since the opening of the New World and ended their dependence on sugar cane from the Americas. In 1784, Arthur Young first published *Annals for Agriculture,* a journal that increased the probability that a widening circle of farmers would learn of these new farming practices and crops and thereby raise the productivity of their land.

### Improvements in the Use and Breeding of Stock

Certain crops introduced for rotation served as good food for farm stock. Farmers could plant crops on more of the land, because they used less land for pastures to feed animals. Enclosing the stock in pens increased the supply of manure and thus provided more fertilizer for croplands. At the same time that these changes in stock use raised the yields of the fields, Thomas Coke and Robert Bakewell led the development of more advanced breeding practices that improved the quality and increased the supply of meat.

## New Forms of Land Organization

Lingering medieval land-use practices presented problems for the commercially inclined modern farmers. The tradition of dividing the village fields into strips and having a family's holdings scattered around the farmlands stood in the way of new rotation and field preparation methods. Unfenced common pastures had made controlled animal breeding virtually impossible. Thus innovations in cropping, cultivation methods, and stock-breeding required new approaches to land organization.

### *The English Enclosure Movement*

A movement by landlords to take land from tenants and enclose it, usually for sheep farming, began in England in the early 1500s. The more rapid conversion to commercial agriculture in the 1600s sped this shift away from the strip-division field system. During the last fifty years of the 1700s, land owners enclosed and consolidated more than two million acres of previously open, divided fields. They consolidated additional, previously uncultivated, common plots.

### *The Consequences of Reorganization*

Landlords and well-to-do tenants who had the means to adopt the new farm methods, the wealth to purchase land, and the influence to arrange enclosures reaped the rewards of the new agriculture. This change, furthermore, expanded the yields of the English countryside and brought farmers who lost their plots into the cities looking for work. The food and labor force for industrialization thus became more readily available. Many displaced tenants, however, suffered extreme hardship from this reorganization of the farm economy. A part of society realized profits from the emergence of modern commercial agriculture, but another segment paid a price.

## New Implements

The machinery for farming also changed, along with cropping methods and land organization. The especially important new implements included a seed drill invented in England by Jethro Tull in 1701, an iron plow built in the Netherlands by Joseph Foljambe in 1730, and a threshing machine designed by Andrew Meikle in Scotland in the late 1700s. This equipment magnified the effects of crop rotation and the use of new plants in many regions of Europe and beyond. This increasingly mechanized agriculture, moreover, was well suited to the arrangement of fields on enclosed farms. The compatibility of these changes ensured the multiplication of machines on the rural landscape, a clear sign of the industrial times.

## ■ THE BRITISH INDUSTRIAL REVOLUTION

The Industrial Revolution of the 1700s and early 1800s began in Britain and developed further there than anywhere else for about one hundred years. (From the early 1700s to early 1900s, the word *Britain* refers to England, Scotland, Wales, and Ireland.) The quick advancement of the British into the agricultural revolution provided part of the momentum for the broader process of change to an industrial economy. From the countryside came part of the supply of material and laborers vital to a more far-reaching modernization. Several other circumstances made it possible for Britain to industrialize first.

## Population Growth and the Labor Supply

Another trend of the times expanded the number of potential workers in the nation. The population explosion in England, Scotland, and Wales increased the total of inhabitants from about eight million to more than twenty-five million in the ninety years after 1760. This multiplication of people added to the forces that enabled Britain to rush into the Industrial Revolution ahead of all other nations.

## Geographic Advantages

For the early industrial giants to rise, they had to have an abundance of coal and iron. Relatively large and accessible stores of both raw materials were available to industry in several parts of Britain. New enterprises sprang to life, especially in these areas or at points where industrialists could profitably move iron and coal by canal, river, or sea. The island geography that facilitated the shipping of these and other raw materials also gave the British an edge in the distribution of manufactured goods.

## Favorable Sociopolitical Conditions

Early modern European governments did much to drive economic developments as the region turned toward industrialization. The British political system of the 1700s affected the change to a modern economy in a somewhat different way. Because the government did not establish legal monopolies or taxes on domestic trade, people who turned to new business pursuits encountered relatively few obstacles to their ambitions. At the same time, tariffs on certain goods from abroad presented barriers to potential foreign competitors. Government trade tax policies thus gave British business advantages by both freeing and restraining enterprise. British society in those years also prized inventiveness and opened the way to the social advancement of successful industrialists. Such attitudes and conditions further encouraged a transformation of the economy.

## Markets and Capital

Another attitude helped to turn Britain toward economic revolution. An urge to buy grew in the part of this society made increasingly rich by the fortunes of commercial agriculture and the wealth extracted from colonies and trade. This mood among wealthy people created market conditions that enticed producers. Other factors also affected demand. The population boom of the 1700s influenced industrialization not only by its enlargement of the labor force, but also by expansion of the market for goods—in every social class, there were more people to make purchases. The rising wealth of the British had a dual effect as well. It both increased the market for products and provided capital for industrial expansion. Britain's rapidly expanding banking system yielded additional investment funds. British economic conditions in general thus favored drastic change.

## ■ THE MACHINES OF INDUSTRY

Tools, machines… the multitude of contraptions by which people magnify their power to build, produce, travel, communicate, and carry on all the other activities that strike their fancy. Such implements abounded in Modern Europe. Most Europeans and North Americans have carried this tendency toward mechanization to an extreme compared to people elsewhere.

In Europe before the 1700s, devices powered by animals, water, or wind served the needs and whims of people for many generations. With industrialization, people in Europe began to turn to machines that operated with the special force of energy sources, such as steam. These industrial inventions unleashed a technological revolution, producing even the unanticipated instruments for global supremacy. Inventors in several nations on both sides of the Atlantic Ocean fashioned these new machines, even though the technological transformation during the first industrial decades centered on Britain.

## Coal and Iron—Raw Materials of the Machine Age

The use of coal and iron began long before the Industrial Revolution. At the dawn of the Modern age, however, these minerals became much more important factors in the economy. Europeans increasingly used **coal** as the source for heat to warm structures, produce glass and metals, and drive the engines of industry. A worsening shortage of wood in the 1600s had encouraged this change, but the advantages of coal in industrial applications sped the transition still more.

### Iron-Processing Improvements

Through the use of coke, which is coal in a heat-altered form, Abraham Darby in the early 1700s found a way to smelt **iron** of greatly enhanced quality. This improvement soon led growing numbers of builders to erect structures of iron. In the latter 1700s, Henry Cort devised a smelting method that yielded still better iron, a discovery important to the production of machines for a factory age. He began with a furnace of French design and added the idea of stirring or "puddling" the melted iron in order to speed the processing and make a purer metal. These metallurgical advances heightened the demand for iron and thus also for coal.

### Improvements in Mine-Pumping Devices

The growing need for coal in the 1700s drove miners deeper underground and into wetter strata. Although vacuum and steam pressure pumps had served to keep underground workers' heads above water during the 1600s, the mines of the next century required more effective machines. The technology of early German, French, and British pressure pumps, one of which involved a piston-cylinder interaction, provided the fundamentals for a device of improved design first constructed in England in the early 1700s. Thomas Newcomen and an associate invented a machine in which steam from a boiler forced a piston through a cylinder in one direction, after which the entry of cold water condensed the steam, causing a partial vacuum that reversed the action. This motion powered a suction mechanism that lifted water from mines. The Newcomen pump, however, was more than a pump. It was a steam engine as well.

## James Watt and the Steam Engine

Faced with the task of providing a working Newcomen **steam engine** for the university at Glasgow, Scotland, where he was employed as a technician in the 1760s, James Watt made a better one instead. Whereas Newcomen's pump had a single cylinder made alternately hot and cold, Watt crafted an engine with two connected chambers: one always hot for the steam drive, and the other cold for condensation and the counter-drive. The change increased both the efficiency and force of the machine. In the 1800s, this improved steam engine became one of the most profound influences in shaping the industrial socioeconomic system.

## The Mechanization of the Cotton Textile Industry

When economies leave the agricultural stage, they typically move into the manufacture of textiles. In early modern Britain, the **woolen industry** was second only to agriculture in importance to the economy. Modernization brought another cloth-making business to the commercial forefront, and simultaneously, industry strode toward dominance over agriculture. Cotton textile producers formed the vanguard that marched ahead of the ranks of other industrialists into this economic revolution. They went armed with an array of relatively simple market-conquering inventions.

### John Kay's Flying Shuttle

Before 1733, in order to weave cloth of any but very narrow widths, two people had to work the shuttle that carried the thread across the loom. John Kay, a craftsman in British Lancashire, in that year invented a shuttle that would fly across the loom under the control of a single worker. This wheeled device driven by string-tripped hammers not only raised the operator's output by one hundred percent but soon increased by similar proportions the pressure for faster thread production.

### Spinning Jennies, Water Frames, and Spinning Mules

Kay's invention did not appear in many factories until the 1760s, when James Hargreaves eased the thread-shortage problem. In 1768, this British inventor finished his improvement of the **spinning jenny,** a human-powered mechanism that enabled one worker to produce thread on multiple spindles. Soon thereafter, Richard Arkwright brought out his **water frame**, an invention that harnessed the power of either water or animals to the spinning of thread. Within eleven years from the appearance of the jenny, Samuel Compton conceived another multiple-spindled machine, the **spinning mule,** which further advanced the operator's capacity to produce with human power. Thread production increased yet again when industrialists used the energy of animals and water to drive the spinning mules.

### Looms and Gins at the End of the Production Loop

This cascade of thread presented a problem for weavers. They worked at the end of the production process and finished the work at their looms. The shuttles of old no longer flew across looms fast enough to convert the abundance of thread to cloth. Edmund Cartwright found a solution. His **power loom** appeared in 1787, and with it the final stage of textile manufacturing once more could keep pace with the spinning, until another advance in thread-making occurred. The productive escalation continued.

If the suppliers of raw fiber for this booming textile industry had gone on removing the seeds from cotton by hand, a difficult and thus labor-intensive process, the production of cloth could not have grown so rapidly. But the producers in the United States sent the bales of fiber across the ocean in adequate numbers, because they could extract the seed with remarkable speed after 1793 by using Eli Whitney's relatively simple invention, the **cotton gin.**

## Trains, Steamboats, and Bicycles

The presence or absence of transportation adequate to the needs of industry helped to determine when and where economic modernization began. Certain of the products of the Industrial Revolution then became the means to a further remarkable advance in transportation. The revolution in mobility at first

came in forms such as canals and hard-surfaced or **macadamized** roads. During the 1800s, however, railroads became the most important means of industrial-age transportation.

### Railroads

Rails of wood had eased the job of hauling a small part of Europe's commerce throughout the Early Modern period. For the most part, in pre-industrial rail transport, vehicles pulled by horses had taken coal from mines to ships. By the 1700s, wagons on rails also profitably served the needs of the iron industry. The latter industry, in turn, made improvements in rails possible, as metal plate was added to sections of the wood rail lines that were subjected to the greatest wear.

A still more significant advance occurred when Richard Reynolds built the first all-cast-iron line in southwest England in 1767. Other enhancements followed. By the early 1800s, railways started to meet the needs of society more generally, an industrial age feat made possible by a new use of the steam engine.

### The Locomotive

The **locomotive,** a steam engine on wheels built especially for railroad use, carried this form of transportation to its place of supremacy among industrial conveyances, a position that it kept from the mid-1800s into the twentieth century. Inventors first tried a locomotive on the roads of Britain as early as 1803, but its size, noise, and sooty plume of smoke made it an unwelcome companion to other vehicles. It suited iron railways quite well, however. After George Stephenson's locomotive, the *Rocket,* plummeted across twelve miles of track at about ten miles an hour in 1829, the special roadways for steam-powered trains rapidly multiplied. At the time of the *Rocket's* miracle trip, all of Britain had less than five hundred miles of track. By mid-century, the rail net extended nearly seven thousand miles. The railroad had become more important to industrial Europe's transportation than canals and roads.

### Steam-Powered Water Transportation

Despite the influence that the availability of serviceable water transportation had on the early emergence of industrialization in Britain, relatively few steamboats churned through British or other European rivers. Robert Fulton's successful trial of his steam-driven *Clermont* on the Hudson River in the northeastern United States in 1807 did not affect river transportation in Europe as the *Rocket* had influenced railways. This slower change in water travel probably resulted from the scarcity of waterways suited to steamboat travel in the regions of Europe that industrialized before the 1850s.

At sea, the sailing ship remained more efficient and profitable than the steamship until the advent of new engine and propeller designs in the latter 1800s. Even so, Samuel Cunard of Scotland began to offer steamship transportation across the Atlantic in 1840. Passengers and mail began to move over oceans under industrial power. The ships could carry little freight in their holds so long as their engines required the huge quantities of coal typical in the years before the 1860s.

### Bicycles

Before the 1700s, a French artisan built a four-wheeled, human-powered vehicle. The industrial revolution made it possible to produce more effective types of self-propelled vehicles and to mass-produce them. A Scottish craftsman constructed a two-wheeled device that outran a horse-drawn mail coach in

1842. This handmade bicycle differed a great deal from the twentieth-century version, however. It also was less truly a product of the industrial revolution than the types manufactured a few years later.

In the 1860s, a French bicycle firm began operation and reached an annual production rate of four hundred vehicles in 1865. This bicycle, and others made in France during the decade, had components much more like the ones familiar to present-day riders. Bicycle builders of the mid-1800s thus had begun an enterprise that would mature later. But these early developments indicated the broad scope of the influence of industry on society, from work to play and beyond.

## Machinery for a Still Greater Revolution

The devices and related economic changes that propelled Britain ahead in the industrial revolution during the century after 1760 did not provide the means for unchallenged leadership after the 1850s. Machine-age technology began to drive nearby nations toward industrial power; then Britain and other European countries surged into a more advanced stage of the economic revolution. The force behind this further rush toward industrialization came in part from new technologies of the mid-1800s. Other innovations would speed the economic transformation in the latter decades of the century.

### Electrical Communication

One of the important new inventions, the telegraph, conveyed the first speed-of-light message over approximately thirty miles of wire from Baltimore, Maryland, to Washington, D.C., in 1844. An underwater telegraph cable across the English Channel linked Britain to the European mainland by 1851. Such lines of electrical communication signaled the opening of a new era in the transmission of messages, a change of special significance to government and business.

### Steel

Iron with high carbon content is very hard but also brittle. These are valuable qualities for certain metal products. Ironworks of the early industrial era, however, made more extensive use of the metal in a low carbon, and thus much more malleable, form. The workers needed this purified iron so that they could pound and bend it into desired shapes. When the carbon content of iron is partly restored by a special heating process, the resultant alloy, steel, has a combination of properties of strength, flexibility, and malleability that makes it a superior metal for most tool-making and building purposes. Until 1856, the technology did not exist for the production of large quantities of reasonably priced steel. Henry Bessemer at that juncture discovered a processing method that was an important step toward ensuring that the industrial age would rely on the strength of steel.

## ■ THE FACTORY SYSTEM

Industrialists intended to mold, bend, and control workers as well as machines. Thus they ushered in more genuinely revolutionary changes than if they had concentrated mainly on technology. Gigantic economic opportunities and risks loomed before these investors. They needed maximum productivity from their employees. The factory system emerged as the organizational embodiment of these business purposes and attitudes.

## The First Factories

Modern European industrialists developed a mostly new system of labor organization when they established the first factories. They built central work sites to which their employees came for the supervision of their activities. Often, the workers labored under a single roof; at times, one power system drove all the machines in the factory. Conditions in these workplaces—ventilation, lighting, temperature, noise level—usually made the labor difficult, uncomfortable, and, sometimes, dangerous. The first place to combine all these productive advantages and disadvantages, a silk factory built in Britain in 1717, did not inspire the erection of many others during the next fifty years. Craft shops and cottage producers still manufactured most goods.

## The Spread of the Factory System

A shortage of cheap labor in Britain during the 1760s and 1770s made cottage production less profitable than before and, therefore, became an incentive to set up factories. This development coincided with the appearance of new labor-saving devices for cotton textile production. As a result, the new form of work organization became especially attractive to the manufacturers of cotton fabric. Thereafter, many more factories appeared in Britain, although they continued to be mainly a phenomenon in the cotton textile industry until the 1820s. From that decade onward, the factory system expanded more rapidly. It became increasingly typical in other British industries and began to become a more significant feature of industrialization in other European countries as well.

## Factory Work

Systems with powerful authority had a strong appeal to Europeans in the 1700s. A portion of the early factory managers, in fact, explicitly compared their tasks as labor organizers to the work of military commanders, prison wardens, or even slave owners. The outlook of the age encouraged the perception of workers as lazy creatures in need of a hard discipline that would meet the economic requirements of employers and also benefit the employee morally. Employers viewed their employees as troops or inmates in need of regimentation.

These workers had descended from generations of farmers and cottage producers who were accustomed to hard but loosely scheduled labor and extended periods of leisure. They did not readily conform to the demands of the industrialists that they arrive on time, at hours precisely marked by clock, bell, or whistle. Laborers also tended to resist the pressure to exert maximum effort throughout a long day. Thus, given the mood of the times and the conflict between employer and employee attitudes, factories became places in which bosses minutely organized labor and gave orders. Workers performed specified tasks and obeyed the rules or suffered the consequences. The factory emerged as an austere reflection of a prison or military establishment.

### The New Jobs—Highly Structured and Less Skilled Work

Workers during the Middle Ages and Early Modern period produced their goods in small craft shops or in cottages. In the shops, a master of the craft supervised a small skilled group. In the cottage system, **putters out** gave some direction to individual laborers or families. These cottage workers even experienced the division of a production process into a series of simple steps, each to be performed by a different laborer.

The factory, however, intensified this tendency toward fragmentation into a multitude of routine rather than skilled tasks; bosses arranged employees in a machine-like setup. In the early years of the industrial revolution, employers established these highly structured procedures in relatively unmechanized factories. Increasingly, however, people labored in plants at machines that exercised greater power over factory conditions than did the workers. The demands of the equipment and the orders of the industrialist reigned supreme.

### Rules and Regulations

The employers' commands took generalized form as lists of obligations for the laborers. These rules specified work schedules and other behaviors on the job. They might, for example, ban talking, singing, and eating. The regulations could apply also to life outside the factory, with stipulations about acceptable marriage age and numbers of offspring.

### Punishment

Workers paid for any failure to adhere to the rules. Employers levied fines, fired offenders, and at times resorted to physical punishment. A report to the British Parliament on conditions in factories during the early decades of the 1800s contained descriptions of the injurious means of control. Witnesses told government investigators that children sometimes returned to the textile mills after only four hours in bed, fell asleep on the job, and then suffered blows from supervisors wielding rollers from the machines.

### Benefits and Reforms

Despite the prevalence of bad physical conditions and harsh discipline in the plants, not all factory workers encountered these hardships. A minority of industrialists considered it their responsibility to provide a good work environment, comfortable housing, and for young laborers, education. Reformers also emerged very early to begin campaigns to improve working conditions in factories and mines. They showed a special interest in the protection of groups viewed as the most vulnerable: children and women. In this quest for change, reformers usually pressed for public or private action that would ensure survival necessities for the very poor, establish limitations on work hours, and in other ways better the lives of those detrimentally affected by industrialization. (See Chapter 5.)

## ■ THE EVOLUTION OF INDUSTRIAL FINANCE

Economic leaders more often exhibited concern for the costs of their business pursuits than for the social costs of the economic transformation. Early in the Industrial Revolution, the acquisition of money to cover the expenses of manufacturing ventures posed no serious problems. But as industrialization accelerated in Britain and began on the continent, it became more difficult to secure enough investment funds.

Other developments made the capital supply problem still worse. The increased mechanization of industry caused the price of establishing and operating a company to rise sharply. Furthermore, the founding of new types of enterprises, such as railroads, involved astronomical costs and heightened the demand for capital funds still more. Both government and private interests responded to this need by developing the financial institutions and practices for the further growth of European industry.

## Funds from Individuals and Banks

People with wealth from trade or land ownership continued to provide capital for industry, as they had before the 1700s. Britain in particular remained a dependable source of such funding; entrepreneurs in other European countries turned to the British for loans to build industry. Additional capital funds came from banks as in the past, but the burgeoning industrial economy required changes in the system. In Britain, the government promoted bank mergers and thus the growth of larger and stronger institutions suited to the times. Alterations in British law improved the system in another way. The government allowed banks to issue paper currency, a response to the sometimes critical shortage of cash caused by rapidly expanding business. The banks themselves acted on this problem by supporting the wider use of checks and other paper transactions.

## Incorporation—the Company as Person

The practice of pooling funds through investment in a joint-stock company facilitated the rapid growth of trade during the Early Modern period, but this business arrangement entailed great risks. Each investor took on full responsibility to pay a company's creditors. Industrial Europe found ways to make investment more appealing. In Britain in 1825, lawmakers reduced this financial threat by opening the way to the establishment of a special type of business organization. Investors could arrange for an important degree of protection by **incorporation,** an act that made a company into a **legal individual.** Once incorporated, the creditors of a company could pursue funds from shareholders only to the extent of their ownership percentage. This protective arrangement drew investment money into many companies. By the 1840s, over two hundred incorporated firms operated in France, and Britain had almost five times that number.

## ■ THE ONSET OF INDUSTRIALIZATION ON THE CONTINENT

Compared to Britain, other European countries had very few industrial enterprises by the 1840s. In parts of the European mainland across the Channel from Britain, the region that commentators usually call **the Continent,** conditions in the late 1700s and early 1800s did favor the emergence of the new economy. Once the change began, it moved in some regions with the same revolutionary force as it had in Britain. Industry advanced first in the areas of northwest Europe adjacent to Britain. This region included northern France, Belgium, and the northern part of the Germanic Confederation, which contained such countries as Prussia.

## France—Millions of Farms, Thousands of Steam Engines

Social revolution struck France in 1789. By the 1790s the nation plunged into a war against most of Europe that lasted until 1815. (See Chapter 4.) Among continental nations, France stood in the forefront of the march toward industrialization by the end of the war. This transition had begun before 1789 and accelerated during the years of Napoleonic warfare. Even as a leader in the mainland's still infant industry, however, France had not moved very far from its agrarian economic heritage by 1815.

### *A Small Farm Economy*

Most of the nearly thirty million French citizens worked on small farms in the early 1800s. They exhibited a strong commitment to agriculture on this scale rather than to consolidation for commercial

purposes. Many farmers also remained unaffected by the efforts of the advocates of scientific agriculture who wanted to promote the new methods of cropping and stock breeding. The French countryside produced abundantly and profitably most of the time in this era, but without a revolution in land organization, in farm practices, or in the use of contraptions.

## Infant Industry

During the first half of the 1800s, as the British cotton textile industry began to clothe people in many parts of the globe, the younger and smaller system in France prospered with sales in its own protected domestic market. French linen textile manufacturing thrived as well in the years after 1815. It benefited from the government tax on competitive imports, as did the cotton cloth business. Another fabric enterprise boomed, however, without the tariff-sheltered market. French silks flowed from the most mechanized textile industry in the country, at a time when cotton and linen cloth still came largely from cottage production. Other similar signs of youthful industries that were growing appeared before mid-century with the establishment of new iron and machinist enterprises, the improvement and expansion of canals and roads, and the construction of the first miles of a rail net (about three thousand miles completed or under way by the 1840s). Above all, the sounds of the more than five thousand steam engines in operation before 1850 signaled the Industrial Revolution that had begun.

## Belgium—Continental Machine Shop

France's textile production far exceeded Belgium's during the first decades of industrialization. But even with the impressive multiplication of steam engines into the thousands in France, Belgium surpassed all other continental countries in machine technology. The central place of mining in the economy of this country encouraged this early progress in engineering; it also accounted for Belgian interest in the particular kind of steam engine developed by Newcomen.

## The Promotion of Steam Power

The Belgians had a Newcomen engine in operation by 1721. Within thirty years, they established a factory to produce them. Thereafter, the machines at work in the country rapidly increased in number. Belgian engineers began to influence the mechanization of other European states, especially the Germanic ones.

## The Second Most Industrialized Nation

Measured by industrial output per person, Belgium and Britain led all other European states by 1850. In that year, Belgian iron use per person was ninety pounds, about sixty percent of the British average, but more than twice the French rate and three times the German usage.

## Industry in Germany

During the 1700s and early 1800s, Prussia and Austria dominated the many independent states into which Germanic Central Europe was divided. Industrialization affected these two countries significantly if less than it had Britain, Belgium, and France.

### Prussia—Land and a Little Iron

For the most part, Prussia before the 1850s remained a rural society. A relatively few powerful land-owning nobles (the **Junkers***)* held sway over the masses of farm workers and lived on the wealth of a mostly agricultural economy.

Industrialists, financiers, and government leaders, however, put the first pieces of an economy of iron in place beginning in about the 1820s. They established machine and engineering enterprises, produced steam-powered riverboats, and began their rail net. Iron had much to do with the strength of the emerging industrial order, but the economy already included other important components. Soon after 1815, entrepreneurs labored to raise the first parts of a textile industry designed on the British model. Workers in this growing business at first used the old technology. By 1850, however, machines made their noisy entry into the textile enterprises of northern Germany. This largely agricultural German state at least had begun to make more and more iron and a little industrial-age cloth.

### The Zollverein—a Prussian Customs Association

**Customs duties,** which are taxes on trade, formed a strong barrier to commerce within Prussia in the late 1700s and early 1800s. The government nullified all such tariffs on domestic trade in 1818. This change helped to speed the transition to an industrial economy in the decades thereafter. Circumstances became even more conducive to this transformation with the establishment of a customs association, the **Zollverein,** in 1834. This organization brought most of the German states into a Prussian-led commercial union and resulted in greatly increased trade for this dominant member of the Zollverein.

### Austria—Enough Factory Workers for a Fight

Austria remained outside the Zollverein, kept the tariff barriers to internal trade in place, and made only weak efforts to stimulate the development of railroads. Not surprisingly then, the country turned toward industrialization even more slowly than Prussia. The economic adventurers who established a few enterprises in the first decades of the 1800s concentrated mostly on textiles and usually set up operations in the northwestern third of the Empire. When economic hard times struck in the 1840s, the factory workers in one of the industrializing cities of that area rioted.

### Russian Industry—a Few Giant Factories

Russia experienced rebellions during the first century of the European industrial revolution. Violence erupted hundreds of times. But unlike the outbreaks in Austria in the 1840s, in Russia, farmers, not factory workers, rampaged. Russian outbreaks differed in part because almost no one worked in industry. In the 1850s, when British population was over fifty percent urban, only about five percent of the seventy million Russians lived in cities. Within this vast East European empire, fewer than three thousand factories with sixteen or more employees operated by 1850. The number of industrial workers had not reached one million by that date, and they turned out only ten percent of Russia's total economic production.

These figures, although indicating a low level of industrialization, reveal that economic modernization at least had begun. As in Britain, industry advanced most noticeably in the production of cotton textiles. A few new enterprises such as beet sugar manufacturing also appeared in the first half of the 1800s. The factories that Russians put into operation in these decades tended to be very large, sometimes employing hundreds of workers. This pattern of industrialization on a gigantic scale became characteristic of Russia.

## ■ EARLY INDUSTRIAL SOCIETY

A multitude of changes in European society before the 1700s exercised a powerful influence on the coming of an industrial revolution. The multiplication of cities and the growth of urban populations from 1000 C.E. onward had an especially strong effect on the beginning of industrialization. The economic revolution from the 1760s on then brought further dramatic changes in European society. The most striking and important of these social effects, perhaps, was accelerated urbanization.

### Urbanization

As Europe industrialized, a growing percentage of people worked in factories, shops, and offices rather than on farms. The concentration of these economic institutions in urban centers made good business sense. Technology influenced this process of centralization. The steam engine, for example, provided great flexibility in the location of factories by virtually ending the dependence on fixed waterways for power. **Urbanization** came quickly. Whereas nine-tenths of all Europeans lived in rural areas throughout the 1700s, by the 1850s, more than half the British, over one-third of the Germans, and about one-fourth of the French resided in cities.

### *The Big-City Phenomenon*

At the same time that new economic and technological influences encouraged the movement from countryside to city, the population of Europe rapidly expanded. Because the founding of new towns became rare during the industrial revolution, Europeans migrated to and expanded their numbers mostly in previously established centers. These trends brought about a remarkable growth in the size of European cities.

London led the way with an increase from about seven hundred thousand in the early 1700s to one million before 1810 and two million by the 1850s. By the latter date, the population of Paris reached one million. No other European cities were so large, but many others experienced phenomenal growth. The age of the European metropolis had dawned with the Industrial Revolution.

### *Physical Traits of the Industrial City*

Earlier cities functioned mainly as centers of government, religious administration, and commerce. Europeans designed buildings, monuments, and other structures to serve these purposes and honor important people or agencies. Therefore, the Europeans sometimes consciously developed cities with a widely recognized beauty. Still, the cities tended to be crowded; they contained many sections, such as residential areas for the less wealthy, that were dark and dirty.

The Industrial Revolution caused these cities to take on a new function as manufacturing centers. This change brought very rapid growth and the construction of factories and housing for industrial workers. The appearance of the urban landscape declined a great deal as a result.

**The Industrial District.** Factories often stood near the center of the city. The inadequacy of urban transportation at the dawn of the industrial age encouraged the growth of laborers' housing areas very near the workplace. Factory workers and their families thus crowded into mid-city dwellings built as **row houses,** with shared walls in structures several floors high. Residents typically found their water supply at a common well in a dirt or stone-covered yard between sections of houses. A gutter in the

middle of the street drained away whatever waste they produced to the extent that its consistency and the terrain permitted. Mid-town was not a pleasant place to live.

**The Better Neighborhoods.** Craft workers usually lived better than factory laborers. The dwellings of these more skilled artisans varied in type from row houses to single-family residences on separate lots. In cities with industry and worker housing at the center, the artisans' houses usually stood in a circle just beyond this area. People with still greater wealth enjoyed the finer and more spacious homes they often built in the suburbs at the edge of the industrial city. Most of these urban dwellers, from rich suburbanites to poor laborers, to some degree struggled with the problems of inadequate city lighting, poor transportation, and polluted air and water. These blights marred the appearance of the early industrial cities and threatened the well-being of virtually all urban citizens.

## Social Classes in the Early Industrial Age

The economic transformation that got under way in the 1700s and early1800s quickly accelerated the march of the bourgeoisie toward greater wealth and power. Industrialization had a similarly drastic effect on the social position of the European nobility and lower classes, but the movement in their case was not toward supremacy.

### *The Rising Middle Classes*

Despite the expansion in the size and wealth of the middle classes during the Industrial Revolution, the social supremacy of the aristocracy usually did not come to an abrupt end. In most of Europe, the **bourgeoisie** (middle class) climbed gradually. The change involved the adoption of middle class ways by a few aristocrats, the acquisition of noble status by some members of the bourgeoisie, and the conversion of growing numbers of people to the idea that aristocracy in the old sense was wrong. The French social transformation differed. It climaxed abruptly. In 1789, revolution broke out, and that same year, a bourgeois legislature decreed an end to noble privilege. (See Chapter 4.)

This process of social change created a diverse middle class made up of industrialists, bankers, merchants, small business owners, doctors, and lawyers; the wealthiest were usually the first three on this list. Despite the identity of these groups as a "middle" class in certain senses, the bourgeoisie became supreme, at least economically, in most regions of Europe as industry came to predominate.

### *The Urban Working Classes*

The growth of bourgeois wealth and power reduced, even if it did not end, the social distance between middle and upper classes. As the middle classes advanced, however, the gap widened between the members of the bourgeoisie and people who worked in their factories, made their clothes and other articles, and served them in their homes.

**Industrial Laborers.** Industrialization encouraged the development of a virtually new social class, the factory workers or **proletariat.** Like the bourgeoisie, these proletarians' lives were closely tied to the Industrial Revolution, but by 1850 the new economic age had improved conditions for only a small portion of these workers. Most factory employees during the first century of industrialization suffered

the pain of losing close village social relationships, the discomfort of sweatshops, the disadvantages of illiteracy and poverty, and the bleakness of life in row house or slum neighborhoods. They soothed the effects of lower-class city life to a degree by the pleasures of working-class taverns, the public houses or **pubs.** Many also enjoyed sports either as participants or spectators.

By the 1850s, these inhabitants of factories, slums, and pubs were a class growing faster than any; but at that time the proletariat remained a minority everywhere in Europe. Lack of organization as well as minority status ensured the weakness of this group. Only a relative handful of factory workers had joined unions, even in the few places where such associations were legal. For most of these laborers in industry, the benefits of the Industrial Revolution lay in the future.

**Artisans.** Another segment of the working class, most of whom lived in urban areas, were the artisans. Their special skills in carpentry, clothes making, luxury crafts, and similar pursuits gave most members of this group a better income and a higher status than the factory workers. Artisans also outnumbered other urban working-class groups throughout the first half of the 1800s. These craft workers enjoyed the benefits of being the best educated urban laborers. They maintained a degree of organizational strength through their guilds, except in Britain and France, where the influence of these groups had withered by the 1800s. In places where such advantages left them with sufficient power, artisans fought the threats posed to them economically by industrial mass production and socially by the growth of the proletariat.

**Domestic Servants.** The largely female force that worked in the wealthier city homes increased in number as the Industrial Revolution progressed, but not as rapidly as did the proletariat. These servants typically lived in their employers' homes; they seem to have accepted quietly the extensive control by—and, at times, physical and sexual abuse from—their masters. Their functions and attitudes thus ensured the presence of much social distance between them and the other members of the urban working class.

### The Aristocracy

Industrialization hastened the economic displacement of the hereditary upper class. Aristocratic political power diminished more slowly, however, leaving the nobles still superior to the bourgeoisie in governing influence in nearly all of Europe in the mid-1800s. The aristocracy in most European countries held even more securely to their social privileges and prestige. Nobles sometimes even avoided the relative economic decline by turning to trade or industrial pursuits to protect or increase their wealth.

The economic tide of an industrial age, however, ran against the continued supremacy of the aristocracy as a whole. Furthermore, soon after the onset of industrialization, the forces of sociopolitical revolution began to surge across France, and then through much of Europe. Aristocratic privilege and political influence virtually disappeared wherever this new and broader revolution spread.

*The pounding and fuming machines of industry dramatically revealed the obvious and drastic reconstitution of European technology and economy between the early 1700s and mid-1800s. Machines produced goods and carried material and people in quantities and at speeds that amazed contemporary observers. The landscape in many areas showed equally striking signs of the new order as industry swelled the limits and raised the skylines of Europe's cities.*

*A great degree of change in the work, social relationships, and lifestyles of Europeans accompanied the economic transformation. The bourgeoisie advanced in wealth and soon reached for the levers of political power. Aristocrats felt an acceleration in their descent from the heights of privilege and influence. The lower classes still mostly lived and worked on farms, but growing numbers of laborers converged on industrial towns to work in the expanding factory system. This relatively small urban proletariat remained weak in the mid-1800s, but it became an industrial-age social force that would seriously challenge the established order beginning in the latter 1800s.*

*By 1850, industrialization had spawned a new technological and economic order in Europe. But during the middle decades of the industrial revolution, still another vital force had helped to reshape Europe. In 1789, as industrialization spread with increasing speed, a modernizing sociopolitical revolution erupted in France, and within months it destroyed the old social and political system of that country. Adherents of the new order for the next twenty-five years fought violently to develop it within France and spread it throughout the continent. The French Revolution changed Europe profoundly by 1815; it virtually ensured that as European civilization industrialized, it would use the power of its machines and technology to complete a drive to global domination.*

## Selected Readings

Blackwell, William L. *The Beginnings of Russian Industrialization, 1800–1860.* Princeton, NJ: Princeton University Press, 1968.

Briggs, Asa. *The Age of Improvement.* New York: Longman S. Green, 1965.

Deane, Phyllis. *The First Industrial Revolution, 1750–1850.* 2nd Edition. Cambridge, U.K.: Cambridge University Press, 1979.

Gerschenkron, Alexander. *Economic Backwardness in Historical Perspective.* Cambridge, MA: Belknap Press, 1962.

Gillis, John R. *The Development of European Society, 1770–1870.* Boston: Houghton Mifflin Co., 1977.

Henderson, W. O. *The Industrialization of Europe, 1780–1914.* New York: Harcourt, Bruce, & World, 1969.

Landes, David S. *The Unbound Prometheus: Technological Change and Industrial Development in Western Europe from 1750 to the Present.* London: Cambridge University Press, 1969.

McKeown, Thomas. *The Modern Rise of Population.* New York: Academic Press, 1976.

Morgan, Kenneth. *The Birth of Industrial Britain: Economic Change, 1750–1850.* New York: Longman, 1999.

Pollard, Sidney. *Peaceful Conquest: The Industrialization of Europe, 1760–1970.* New York: Oxford University Press, 1981.

Price, Richard. *British Society, 1680–1880: Dynamism, Containment, and Change.* Cambridge, U.K.: Cambridge University Press, 1999.

Thompson, E. P. *Making of the English Working Class.* New York: Pantheon Books, 1964.

## Test Yourself

1) The machines of the Industrial Revolution gave Europeans the power to control
   a) the boom-bust economic cycle that had plagued medieval society
   b) everything but their own greed
   c) the world
   d) the evolution of the continent's environment

2) Early factory operators sometimes described their way of organizing and working laborers as similar to the methods of
   a) priests
   b) parents
   c) monarchs
   d) prison wardens

3) Industrialization came first and, until the latter 1800s, developed most fully in
   a) Prussia
   b) Britain
   c) Belgium
   d) France

4) The social effects of the Industrial Revolution included
   a) closer social ties between the bourgeoisie and proletariat
   b) a rapidly widening social gap between the bourgeoisie and the aristocracy
   c) a close harmony in attitudes among factory workers, artisans, and domestic servants
   d) an increased social distance between the middle classes and urban workers

5) Which of these statements does the history of the Industrial Revolution suggest is more valid?
   a) Invention spurs invention
   b) Technical and economic change usually occur more slowly than sociopolitical change
   c) Geography has relatively little influence on economic history
   d) The large quantity of natural resources in large countries makes rapid technical and economic innovation more likely than in smaller states

6) By 1850, a person probably could best determine how far industry had spread by considering
   a) where the railways were
   b) which nations had standing armies
   c) where petroleum refineries were located
   d) how far electric power lines extended

7) What are the important cause-effect relationships among these aspects of European history: imperial expansion, the population explosion, the agricultural revolution, and the Industrial Revolution? (Write an essay answer using the information in Chapters 1 and 2.)

8) What inventor or invention most influenced the Industrial Revolution? (Write an essay answer using the material in Chapter 2.)

## Test Yourself Answers

*The first four quiz items require a recall of facts.*

1) **c.** The chapter provides no information about the boom-bust cycle, and although it suggests that a greed for profits existed, it does not indicate whether the Industrial Revolution enabled control of "everything" except that attitude. The chapter also does not imply that industry affected the environment while leaving the question of "control" unanswered. The text clearly does emphasize the global power that would result from industrialization.

2) **d.** The self-confessed attitude of factory owners and supervisors that their work was like that of prison wardens is an important indication of the drastic shift to rigidly regimented labor that came with industrialization.

3) **b.** The correct completion is especially clear-cut for this item—Britain's leadership is an unusually well established and important historical conclusion.

4) **d.** The increasing wealth and social prestige of the industrial-era bourgeoisie or middle class, and the work and living conditions of urban workers in this period widened the gulf between these two social groups. These same changes in socioeconomic circumstances for the middle classes moved them closer to the historic European upper classes. The movement of a number of middle-class people into noble ranks and the business pursuits of certain members of the nobility also reduced the social distance between the bourgeoisie and aristocracy. Artisans and domestic servants, though members of the working classes, generally had a different social outlook than factory laborers in this period.

*The next two multiple choice items call for the use of memory as well as a somewhat higher order of thinking skill.*

5) **a.** The pattern of inventions used in cotton textile production offers especially clear evidence that "invention spurs invention," but there are indications of this process in other aspects of industrial history such as the development of steam power technology. The history of the era of the European Industrial Revolution as described in the text does not make the other possible completions defensible.

6) **a.** The distribution of steam engines and other information might reveal the geographic spread of industry quite well also, but the rail net pattern is especially indicative and the only reasonable completion in the list of options offered.

*Because of the open nature of the responses allowed by the two essay questions, the objective is to demonstrate skill in historical thinking by the way information in the text is used to develop reasonable and effectively supported conclusions. Reading subsequent chapters or material in other sources on the Early Modern era and the Industrial Revolution might lead to different conclusions, so answers should be offered in light of text in Chapters 1 and 2 for Question 7, and Chapter 2 for Question 8.*

7) A response might note that imperial conquests brought to Europe great wealth and a price revolution, new tastes (such as for sugar), and new vegetation. Discussion could continue with commentary on the several ways in which these effects of imperialism provided an impetus to commercial farming and manufacturing: expanded investment capital; new crop options; and a promise of new profitable economic ventures. Certain of the new crops also could have affected population growth, a speculative view worth offering as such in an essay. Other apparent cause-effect connections that warrant discussion: The population boom and the reduced need for farm laborers brought by the agricultural revolution produced a supply of workers for the manufacturing tasks of the industrial age and multiplied the number of consumers who could make commercial farming and industry profitable. The Industrial Revolution then produced machines that fostered further changes in the rural economy, and, as text generalizations indicate, that promised the technical means for greater imperial power.

8) The special utility of the steam engine for pumping water from mines, powering factories, and driving trains and, eventually, shipping vessels, makes this invention or, perhaps, James Watts himself, an obvious focus of an answer to this question. Discussing the machine instead of the inventor offers the advantage of avoiding the complication of deciding whether Newcomen or Watts was more important to the Industrial Revolution. (Text content suggests that Watts deserves to be singled out, but an essay on Newcomen might show special thinking skill.) Because cotton textiles dominated manufacturing during the Industrial Revolution, several inventors or inventions important to that enterprise also might offer the possibility of an impressive essay answer. There are still other options to consider.

# The *Ancien Regime* and the Enlightenment (1650s–1789)

**1643:** Louis XIV becomes king of France.

**1649:** The English Parliament carries out the execution of Charles I.

**1651:** Thomas Hobbes publishes *Leviathan.*

**1682:** Peter I, the Great, begins his reign as Tsar of Russia.

**1690:** John Locke publishes *Two Treatises of Government* and *Essay Concerning Human Understanding.*

**1721:** Montesquieu publishes his *Persian Letters.*

**1748:** Montesquieu's *The Spirit of the Laws* appears in print.

**1751:** Diderot produces the first volume of the *Encyclopedia.*

**1756:** The Seven Years' War breaks out.

**1762:** Catherine II, the Great, becomes Empress of Russia, and Jean-Jacques Rousseau publishes *Emile* and *The Social Contract.*

**1776:** Adam Smith publishes *Wealth of Nations.*

**1781:** Immanuel Kant publishes *The Critique of Pure Reason.*

**1792:** Mary Wollstonecraft publishes *Vindication of the Rights of Woman.*

*Economic and technological change in Europe over many centuries led to the emergence of history's first industrial economies, beginning in the mid-1700s. This revolution fostered a strengthening of the economic forces that had made industrialization possible. Thus, the historic trends that produced this technological transformation intensified after 1760; by the latter 1700s, they ushered in modern life at the most fundamental level, powerfully affecting the technology of communication and the way Europeans nourished, housed, clothed, and transported themselves.*

*From the 1680s to the 1700s, as Europe moved toward the Industrial Revolution, the already notice-able contrast between an emerging new economy and an aging social structure became a glaring differ-ence. In France, this divergence between the old social order (called the* Ancien Regime *in French) and the changing economic system was especially sharp. A small, privileged French aristocracy looked down on the masses of commoners, a group that included not only the poorest peasants, but also rich business-people whose lack of noble status hindered their economic activity and angered them. All of Europe chafed under a similarly restraining* Ancien Regime.

*The people who shaped European thought from the mid-1600s to the late 1700s fashioned it into a frame of mind that was much more modern than the social system of the era, a new outlook more nearly consistent with the emerging industrial economic order. Knowledge of the universe advanced so rapidly beginning in the 1500s that theorists by the 1600s came to believe that they had entered an era of special intellectual brilliance. This period became known as the* Enlightenment *or* Age of Reason.

## ■ THE *ANCIEN REGIME*

Although the contrast between social conditions and the expectations of intellectuals gave France the most vivid image as an *Ancien Regime,* the problem of antiquated social systems went far beyond France. The label *Ancien Regime* thus applies to European society as a whole or even to all the region's social and political institutions during the two centuries before 1789. Although early modern European society had changed significantly since the Middle Ages, the lingering institutions of this old regime became increasingly ill-suited to modern needs through the 1600s and 1700s.

### Aristocratic Privilege and Irresponsibility

The European aristocracy originated during the feudal phase of the Middle Ages (late 800s to early 1000s). In that era, the members of this upper class enjoyed special rights and held grants of land in return for which many owed military and other services to a higher noble. All were obligated to govern their region and protect it from invasion.

The political and social changes involved in the rise of centralized government brought an end to the service functions of the warrior nobility. This aristocracy nevertheless kept its privileges, including, in many countries, freedom from taxation and the power to force non-nobles to provide personal services. Hostility toward the nobility thus grew. Even a few intellectual aristocrats joined the chorus of complaint against noble privilege.

### Social Stratification—the French Example

The *Ancien Regime* included not only a heritage of special aristocratic rights, but also a legacy of the-ories that justified a pyramid-like structure of classes. These beliefs about social hierarchy communicated the same social message conveyed by noble privilege: the superiority of the people at the top.

### The Upper Classes in France

European systems of social stratification varied, but most were similar to the one in France. It divided the nation into three **estates.** Church leaders and nobles comprised the **First** and **Second Estates,** respectively. Each of these groups numbered about two hundred thousand in a nation of twenty-

five million. This small fraction of the population enjoyed the privileges typical of the European aristocracy, including ownership of one-third of the land. With few exceptions, members of the upper clergy and nobility meant to perpetuate their social supremacy. Even though they belonged to the First Estate, the local priests who made up the lower clergy often identified with the millions of **commoners** in the Third Estate. Most priests came from that class.

### The French Third Estate

Because industry had advanced very little in France by the latter 1700s, almost everyone still farmed for a living. Peasants, therefore, greatly out numbered all other social groups in the **Third Estate.** Rural commoners in France lived better than peasants elsewhere in Europe. Still, they had a dismal existence compared to the circumstances of the aristocracy.

The other people who shared Third Estate status with the peasants were the urban working classes and the bourgeoisie. Laborers in the cities held jobs at varied skill and income levels, which meant that living conditions differed considerably among them. All faced the danger of starvation whenever hard times struck. Merchants, bankers, lawyers, owners of small shops, and others in similar pursuits who made up the bourgeoisie disliked the disadvantages of their low social position, but hunger did not haunt these middle-class members of the Third Estate.

### The Estates General in France

During the Middle Ages, rulers in central and western Europe began to meet periodically with members of the various social classes. In France, kings gathered representatives of the three estates in meetings called the **Estates General.** Each estate had one vote when the monarch asked these assemblies to express approval of his actions. The two aristocratic upper estates thus won on any issue if they so desired. The masses of people in the Third Estate carried little weight.

For 175 years after 1614, none of the classes in France exercised power through the Estates General, because the kings did not convene an assembly between 1614 and 1789. In these years, the independent authority of the monarchy greatly increased. Noble privileges and the theories that honored them remained, but the authority of the aristocracy virtually disappeared. The Third Estate continued without the dignities of nobility and lost the small influence it had exercised in the assemblies.

### Special Interest Groups

Noble privileges had angered non-aristocrats during the Late Middle Ages and Early Modern period. By the 1700s, many other *Ancien* traditions and institutions burdened and enraged social critics. The medieval craft guilds established to protect artisans by controlling prices and production monopolies frustrated dynamic bourgeois entrepreneurs. During the Middle Ages, **corporations** with special rights and powers also had emerged. The Catholic Church, the oldest of these corporate institutions, possessed great wealth and exercised several exceptional powers. For example, Church agencies, such as the **Inquisition,** severely punished variations from approved belief, especially in Spain and parts of Italy. In France, bishops could have people imprisoned for making their confessions to priests who were considered unorthodox.

These and other privileged groups had remained securely in place for centuries. Many of the less privileged Europeans during the 1600s and 1700s became devoted to their own climb to power and decided to bring down this *Ancien Regime.*

# ■ THE ENLIGHTENMENT—IDEAS AGAINST THE OLD REGIME

Discoveries during the Scientific Revolution about the operations of the natural world (see Chapter 1) encouraged many thinkers in the 1600s and 1700s to have great optimism about their ability to understand any kind of problem—social as well as scientific—and solve it. Ignorance, rather than fate or other supernatural forces, appeared to account for the misery in which many people lived under the old regime.

In the 1500s, only a few intellectuals accepted this idea of progress through the application of scientific knowledge. During the 1600s, however, many educated Europeans came to believe that reason could produce the good society, perhaps a flawless system. They exuded supreme confidence in the possibility of virtually eternal progress. If natural laws had produced a universe that operated with mechanical precision, living in keeping with natural laws could bring "a more nearly perfect" social system. This **enlightened** thinking that emerged in every European state became apparent first in Britain.

## The Early British Enlightenment

The new intellectual movement in its British form originated in the mid-1600s. At that time, cultural trends and the turmoil produced by the struggle between kings and the legislature encouraged theorists to shift attention from scientific to social issues.

### *Thomas Hobbes (1588–1679)*

In 1651, Thomas Hobbes expressed in *Leviathan* a thoroughly secular view of the origins and nature of government. His publication marked a sharp turn away from traditional thinking and reflected the modern contempt for the idea of supernatural influence in worldly affairs.

Hobbes formulated his views in the era when civil war raged between the supporters of royal absolutism and the advocates of parliamentary authority. His experience of such turmoil led him to reason that earthly conditions, not divine will, necessitated the reign of kings. Only an all-powerful monarch, a **leviathan,** could subdue self-centered humans and keep peace for the common good. Over the course of human history, societies had recognized the wisdom of royal authority. In effect, a contract had evolved between the monarch and the people that justified the sovereignty of kings. This political contract stood for eternity and denied the right of revolt.

### *John Locke (1632–1704)*

John Locke warmly approved Hobbes's secular perspective on government. The idea of a political contract appealed to him also. Locke, however, gave the latter notion a very different twist. Kings ruled, he agreed, because the people of the realm granted them that power, but this political contract was not necessarily permanent. The citizenry might determine that royal behavior had dissolved the agreement.

Locke advanced the startling belief that the people possessed absolute rights that rulers could not violate. Natural laws that governed the physical universe also guaranteed the right of all people to life, liberty, and property. Societies should inscribe these and other fundamental principles of government in a **constitution,** a body of law to which even rulers must submit. Rulers who infringed on property rights, encroached on personal liberty, and unjustly took lives nullified the political contract. No law protected the reign of such despots. Their tyranny justified violent revolution.

Locke expressed his political views in *Two Treatises of Government, a* work published in 1690 but composed before the battle between the legislature and the king climaxed in 1688 and 1689. A second

important publication by Locke in 1690, *Essay Concerning Human Understanding,* presented his views on the learning process, a conception of psychology that further justified his preferred form of government.

In his psychological essay, Locke concluded that the human mind at birth was a **tabula rasa** (blank slate). He believed that people learned as their experiences, acting on the five senses, wrote on this slate. No one, therefore, entered the world innately superior as a thinking creature. Nature prepared everyone for equality, but flawed systems denied certain members of society the experiences needed for advancement.

### Pantheism and Materialism

The reverence for nature reflected in Locke's views was typical of Enlightenment theorists. In a sense, they had turned to **pantheism,** the belief that God is found in nature. The Enlightenment dedication to science and reason also resulted in a **materialist** outlook, the tendency to think of everything in the world as being composed of and explained by matter. This philosophical position denies the possibility of supernatural forces influencing the world. Materialism is the essence of the Enlightenment version of secularism.

### David Hume (1711–1776): Skeptic

David Hume showed an especially strong commitment to the Enlightenment principle of **skepticism,** the rejection of all dogmas. Such an attitude led Hume to go even further than Locke and advance materialist theories not only about human psychology but also about religion itself. He denied the validity of a religion founded on divinely inspired truths and advocated the use of reason to establish a system of worship for all humanity.

In one of Hume's most important publications, *Inquiry Concerning Human Understanding* (1748), he expressed the ultimate skeptical attitude with his denial that supernatural powers of any kind controlled history. He argued that the idea of cause and effect in human affairs was simply a figment of the imagination. Hume and others in his day had reached the conclusion that human events developed at random.

## The Enlightenment in France

During the 1700s, France became the most active center of Enlightenment intellectual activity. One indication of the special importance of French theorists is that commentaries on Enlightenment intellectuals usually refer to them by the French word *philosophes.*

### The Philosophes and the Salons

The French *philosophes* expressed many of the same attitudes as British Enlightenment writers. The social critics in France distinguished themselves, however, in a variety of important ways. For example, they developed the practice of gathering for discussions, **salons,** that enabled them to spread their ideas among intellectuals and test their views before publication. Women, moreover, moderated most of these salons and, thus, exercised an important influence on the French Enlightenment. This female contribution made the movement in France still more distinctive.

The *philosophes* intended to arouse enough people to change the world. In their salon discussions and publications, they used widely appealing means of expression as they presented plans for a new order. They spoke out persuasively for an enlightened world that required sweeping reform of the existing systems. The

*Ancien* religious establishment, in particular, became the target for much of their criticism. Certain of the *philosophes* launched especially vicious attacks on Christianity.

### Deism

Pierre Bayle (1647–1706) pioneered the early modern intellectual assault on Christian churches. He saw them as the breeding grounds for the intolerance and superstition that he so hated. Many Enlightenment social critics who shared his rejection of traditional religion turned to deism. **Deists** thought of God as the great force that had fashioned the universe, a clocklike mechanism that continued after creation to operate according to its own inner principles—a typical **Natural Law** idea. The deity did not intervene once the clock of the universe began to tick. Deists saw no way in which religion and science could disagree, and so anything seen as scientifically proved had to be accepted. Contradictory religious notions had to be rejected.

### Voltaire (1694–1778)

François-Marie Arouet, known as Voltaire, shared Bayle's view of Christianity. The theology of this faith struck Voltaire as an example of human madness. This essayist and poet became an especially prominent member of the French salons and a master of French language expression. He communicated his views to great effect in discussions among intellectuals and in print.

Newton's conception of a mechanistic universe and Locke's belief in the mind as a blank slate strongly influenced Voltaire's ideas. On such intellectual foundations, he elaborated his criticisms not only of clerical intolerance but also of other social errors of the day. With respect to the latter, Voltaire concluded that reason indicated the necessity of systematic and effective government controlled by law rather than the whims of rulers. Under an enlightened ruler, people would enjoy freedom of religion and the press, and cruel punishment of criminals would end.

### Montesquieu (1689–1755)

The Baron de Montesquieu's *Persian Letters* (1721) reflected an attitude toward established religious institutions much like Voltaire's. He also disapprovingly considered certain new developments in Europe. The use of gunpowder weapons worried him, for example, and he pondered the horrors of forces that might be developed to kill on an even more massive scale.

At about age forty, Montesquieu began work on his most important publication. He was almost sixty when this volume, *The Spirit of the Laws,* appeared in print in 1748. This monumental publication systematically described the fundamental types of political systems, explained how such different forms of state emerged, and evaluated a number of their practices.

Montesquieu proposed that states are always one of three types—**despotic, monarchical,** or **republican.** In the first two of these, a single person rules but a despot exercises much more complete and unshared power than does a monarch. A non-despotic king, for example, might possess ultimate authority but govern in association with the nobility, urbanites, or the church. The greatest division of authority occurs in republics, a system that lacks any central figure with the power of despot or king.

A complex interaction of influences produces a particular form of state in Montesquieu's view. He contended that common historical experiences, religious institutions, climate, and other influences combine to shape a society and incline it toward one of the three state forms. In the case of Britain, a country Montesquieu much admired, he proposed that the climate there prevented the public from having the submissive attitudes necessary for a despot to rule. Whatever might cause a society to oppose despotism, Montesquieu believed its avoidance requires the separation and balancing of powers among the branches of government—legislative, executive, and judicial. This latter idea directly influenced the plan for government in the United States.

In his analysis of political systems, Montesquieu expressed several other judgments. He concluded that the size of a society determines the extent of freedom needed by the population. Large states need a despot, small states function better as republics, and states of medium proportions fare best as monarchies. Montesquieu also recommended certain policies, including the toleration of religious diversity and the promotion of a commercial economy. His concern about a state's business conditions surfaced also in his comments on slavery; he preferred to keep this labor system so that the price of sugar would remain low. In several respects, the Baron de Montesquieu loved the *Ancien Regime*.

### Enlightened Despotism or Democracy?

Montesquieu admired certain forms of monarchy. Voltaire did not believe that the people as a whole possessed the competency to develop and operate the ideal society that he envisioned. In short, these two *philosophes* did not trust democracy. This attitude was typical of Enlightenment thinkers who until the latter 1700s directed their arguments for reform to the great monarchs. Many of the *philosophes* longed for a despot who could absorb light from critical intellectuals, and then lead everyone out of the darkness of the *Ancien Regime*.

The faith of the *philosophes* in enlightened despotism was not wholly misplaced. Several monarchs in the 1700s made a conscious effort to learn from the Enlightenment. With varying degrees of success, these rulers applied their knowledge within their realms.

## ■ THE EUROPEAN STATE SYSTEM IN THE LATTER 1700s

In the 1780s, kings or emperors reigned over all the large European countries. Only a few states described themselves as **republics,** indicating government by representatives of some portion of the citizens. Most republics were small countries such as the Netherlands, Switzerland, and the Italian principalities of Venice and Genoa. At that time, even republics did not necessarily allow more than a very small percentage of people to exercise power. Among the four countries listed, a tinge of democracy existed only in parts of one, Switzerland.

Near the end of the 1700s, therefore, monarchs sat securely on their thrones nearly everywhere in Europe, and many enjoyed virtually unrestrained power. Historians call this early modern form of kingship **absolute monarchy.**

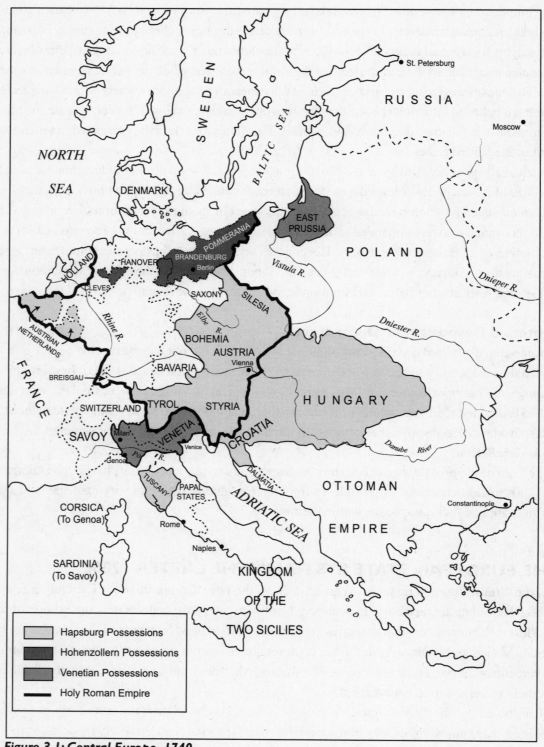

*Figure 3.1: Central Europe—1740*

## The States of East and Central Europe

Sweden, Denmark, Poland, and the various states of the Italian peninsula exercised much less influence in the affairs of East and Central Europe than did the other countries in that region. Swedish power had declined from the great heights it reached in the 1600s in part as a result of costly wars with Russia.

The weakening of Sweden's monarchy that came with a resurgence of noble strength both contributed to the lessened influence of this state and reduced the effectiveness of the government in domestic affairs. King Gustavus III (reigned 1771–1792) took advantage of factional strife that developed among nobles and reversed the declining fortunes of the government at least within Swedish borders.

The Danes and the Italians experienced even less success than did the Swedes. In Denmark as in Sweden, the monarchy took action against the nobility. But the Danish government failed in its attempt to overcome aristocratic power and reform the state. The Italian states experienced a continuing decline in international standing. This weakening position resulted especially from the domination of Italy by Austrian and Spanish rulers.

Most of the vast expanse of land from the eastern border of France to the Siberian coastline of Russia on the Pacific Ocean fell within the borders of three empires: Russia, the Holy Roman Empire, and the realm of the Ottoman Turks. The Turkish Empire included vast non-European territories that extended from Asia across the Middle East to Egypt. The Ottoman rulers held European principalities in the Balkan Peninsula, but these concerned them much less than the rest of their realm. The Holy Roman Empire had emerged during the Middle Ages. By the latter 1700s, it existed as little more than an almost meaningless border that surrounded important German states such as Prussia and Austria and other smaller states, most of them also Germanic. Russia, Prussia, and Austria dominated affairs within East and Central Europe.

### The Russian Empire

In the mid-1400s, the rulers of a small Russian state centering on Moscow began to use the title **tsar,** the Russian word for Caesar. The title implied that these leaders were emperors carrying forward the traditions of ancient Rome. In the 1500s, Russian tsars also began to call themselves **autocrat.** They added this title to suggest that they were godlike rulers in the tradition of the Byzantine Empire (an eastern Mediterranean state with Greek culture that lasted from the 300s to 1400s C.E.).

The tsars acted on their imperial ambitions and eventually created a state that truly was an empire, because these rulers conquered not only relatively open lands in the east but also previously independent states to the west. (A ruler over a collection of states is an **emperor.**)

**Peter I, the Great.** Peter I (reigned 1682–1725) emphasized the Russian vision of imperial grandeur in 1721 by adopting an additional title, emperor, and by annexing still more territory. His forces had defeated Sweden, and the resultant Treaty of Nystadt in 1721 added holdings in the northwest on the Baltic Sea coast (the location of present-day Estonia and Latvia). Russian rulers during the rest of the 1700s continued their march into new lands to the east and west, with especially important acquisitions from Finland in the north, Poland and Lithuania to the west, and Turkey in the southwest.

### Catherine II: Enlightened Despot

Catherine II (reigned 1762–1796), although an ethnic German who married into the reigning Romanov dynasty during her teen years, became one of Russia's most revered rulers. She diligently studied the ideas and arts of the Enlightenment and, to a limited extent, attempted to apply the principles of

this movement as she governed Russia. Her reforms included measures to improve the operation of local government, encourage manufacturing, promote medical advances (such as the use of small pox vaccinations), and make the treatment of criminals more humane. Catherine's strong advocacy of these changes helped establish her reputation as an enlightened despot. A few observers have praised the great advances that she brought in the rights and privileges of the nobles as a first step toward giving civil liberties to all Russians and thus another indication of her enlightened outlook.

**Catherine II, the Great: Oppressor and Conqueror.** Although Catherine improved life in Russia in several important ways, her treatment of the nobles and peasants indicate that she turned toward a more oppressed rather than a more liberated society. At the end of Catherine's reign, almost everyone in Russia lived as impoverished peasants who, in local matters, owed full obedience to the nobility. She took the small land-owning aristocracy to an even higher social realm than they had previously enjoyed and drove more of the peasantry into the lowest status, **serfdom.** About half of the peasants were serfs by the end of her reign. Although technically not slaves, **serfs** often had no choice but to do the aristocracy's bidding in everything from manual labor to sexual favors. But all of society, whether noble or peasant, were expected to look to the tsarina-empress as the all-powerful ruler who "spoke as the most high God" when issuing governing decrees, including calls to war. The use of this almost unlimited authority to take the country into successful wars of expansion probably had more to do with this ruler's remembrance as Catherine the Great than did her support of Enlightenment ideas and reforms. The imperial triumphs perhaps also made the oppressive aspects of her reign less prominent in recollections of her era.

### The Austrian Empire

The Hapsburgs ruled a collection of states, most of them in East Central Europe, from the 1200s to 1918. In the latter 1700s, this Austrian dynasty held an empire of scattered and ethnically diverse territories. Hapsburg possessions centered on Germanic Austria, but also included Hungary (Magyar culture), Bohemia (ethnically Czech), Belgian lands, and several Italian territories. This lack of geographic and cultural unity made effective government difficult and somewhat lessened the state's weight in international affairs. Still, no other power controlled as much of Central Europe as did the Hapsburgs, and they exercised significant influence in international affairs.

The character of the imperial bureaucracy in the 1700s gave the Hapsburgs an opportunity to increase their power over the state and modernize it. Over the years, administrators had struggled to reduce the privileges of the aristocrats and the oppression of the serfs. Officials also promoted population growth and a more just and effective tax system. The two rulers who led the Austrian state from 1740 to 1790 attempted to use these foundations of modernity to launch an even more vigorous reform program.

**Empress Maria Theresa.** Maria Theresa (reigned 1740–1780) was another of the monarchs of the Early Modern period who gained a reputation as an enlightened despot. She attempted to encourage industry, develop a more rational and effective central government, promote a primary commitment of all the people to central authority rather than to the local community, reduce the privileges of the upper classes, and lessen the obligations of peasants to the nobility. Even though Maria took all these steps toward a

modern society, she moved with great caution. Joseph II, her son, who ruled jointly with her in the last years of the empress's reign, wanted to overcome such hesitancy about reform and even advocated the revolutionary step of ending the division of society into hereditary upper and lower classes.

**Emperor Joseph II.** Joseph (reigned 1780–1790) believed that a monarch should rule with unrestrained power, and once he took exclusive possession of the throne in 1780, he modeled and commanded drastic innovation. This enlightened despot took action against the old social system by freeing the serfs on his royal estates. Joseph failed, however, to get aristocrats elsewhere in his realm to follow his example. Still, he persisted in his drive for enlightened reform, especially by a forceful attack on Catholic Church traditions. The Emperor ended the power of the Church to censor the press, converted a number of its properties into funds for the advancement of education, and declared greater freedom for the practice of varied religions. His other efforts to improve the imperial system included steps to reduce wasteful spending and streamline government operations. These innovations provoked a hostile reaction within some of Joseph's territories, and most of his reforms did not last long after his reign.

### The Kingdom of Prussia

Prussia, the other leading state of Central Europe, lay to the north of Austria. This kingdom also had scattered territory, but less so than Austria, and enjoyed the advantage of having a mostly German rather than ethnically diverse population. Furthermore, the Prussian Hohenzollern dynasty had developed a government financial system that strengthened the state. More ominously, the strength of Prussia's military and a social tradition of strict obedience to ruling authority gave the state a special potential for control at home and influence abroad.

**Frederick II: King as Public Servant.** Frederick II (reigned 1740–1786), another enlightened despot, inherited the throne of a rising German kingdom in 1740. He proclaimed that a ruler was the "first servant of the state" and became a model of civic diligence. Frederick read widely, wrote profusely, and worked energetically at the tasks of government. His political actions suggested that he cared for the welfare of the Prussian people, even though he thought their interests were best served by freezing them in their social positions—the peasants in rural servitude, the middle class barred from buying noble lands, the aristocrats secure in their special rights. In several respects, however, Frederick showed that he could flout tradition. He ignored the customary ceremony and grand style associated with monarchy. More significantly, Frederick instituted the most open policy toward the practice of religion of any ruler in his century.

**Frederick II, the Great: A Warrior King.** Europeans ordinarily add the descriptive "Great" to a ruler's name when he or she energetically pursues conquests. Frederick II acquired this label. Through much of his reign, the king led Prussia into costly battles, usually involving competing coalitions but with Austria as the chief adversary. The human cost of these wars for his own country, according to Frederick himself, was 300,000 soldiers and possibly more than thirty percent of noncombatant Prussians. Once victorious, this king believed in dictating a severe settlement to the defeated state, a traditional Prussian practice that Frederick probably intensified.

## The French Monarchy—Absolute and Bankrupt

Europeans had established the traditions of a warrior state and despotic rule long before the rise of a militant Prussia under Frederick the Great. France epitomized this combination of military aggressiveness and royal absolutism throughout the reign of Louis XIV (1643–1715). This "Sun King" took European monarchical absolutism to its zenith and left to his heirs an extremely powerful state, but also a government deeply in debt from nearly constant warfare.

### *Louis XV: An Unconcerned King*

Louis XV took the throne, but not real authority, at the age of five, when his great-grandfather died in 1715. In the first years of the new king's reign, officials reduced the tendency of the government to overspend. Louis personally controlled the French state from the late 1730s until his death in 1774. During his years in charge, the country plunged into war again, and by 1763, had lost its North American empire to Britain. Taxes and government debts spiraled upward once more. The king took the desires of his female acquaintances into account as he formulated government policies in these years. He ignored, however, the worsening economic condition of the masses.

### *Louis XVI: An Inadequate Ruler*

When the nineteen-year-old Louis XVI claimed the throne from his grandfather in 1774, he exhibited deep concern about the mounting problems of France and launched a promising reform program. His progressive goals included public debt reduction, fewer regulations on commerce, a lighter tax burden for peasants, and a degree of public participation in government.

The privileged classes stopped this reform effort when it succeeded only in raising the expectations of the non-nobles without bringing satisfaction. Then, in the 1780s, the aristocrats launched an attack on the king's power. They meant to restore the authority they had lost to monarchy in the Early Modern period. Unknowingly, the nobles had taken a step that led to the destruction of both the French monarchy and aristocracy by the early 1790s.

In this last reign before the revolution, the king continued traditional courtly practices even as he worked for reform. For example, Louis sometimes spent nearly an hour going through the ritual of preparing for bed, in the presence of all the royal guests of the moment. As a final part of this ceremony called **coucher,** the king walked to each of the visitors, who encircled him, and he moved awkwardly in a night robe with breeches dropped to his ankles.

The queen, Marie Antoinette, influenced royal policies and participated in monarchical ceremony, but also found a less courtly activity that she enjoyed. Louis and his wife had a model peasant hut constructed on the royal estates so that the queen could have the pleasure of playing the role of commoner. But neither the king's ritual associations with the nobility nor the queen's peasant games adequately prepared them to bridge the gulf that, by the 1780s, separated the monarchy from both the aristocracy and the commoners. By 1789, the crisis of society and government reached cataclysmic proportions. A king who could not carry out a program of moderate reform now faced a much more difficult challenge.

## The Iberian States

The two countries on the Iberian Peninsula, Spain and Portugal, had passed their days of greatest glory by the 1700s. Both states, however, enjoyed improved fortunes for a time after the early years of this century.

### Spain

Charles III (reigned 1759–1788) inherited a more highly centralized and effective state as a result of the reforms enacted by a previous king, Philip V (reigned 1700–1746). The loss of holdings in Italy and North Central Europe during Philip's reign also benefited Charles by leaving him a more compact and less expensive state. The new king advanced the fortunes of his monarchy still further by his subordination of the Catholic Church. The gains helped future monarchs very little, however. The greatest menace to the kings remained unchanged. At the end of Charles's reign, the aristocracy still had the same formidable power to challenge royal authority that it had enjoyed when he took the throne.

### Portugal

The resurgence of the Portuguese state came under the guidance of the Marquis of Pombol, the head of the government bureaucracy from 1751 to 1777 during the reign of Joseph I. Reforms that Pombol instituted reflected the attitudes of the *philosophes*. As chief royal minister, he reduced the power of the nobles and the Catholic Church, adopted a policy of free trade, improved governmental operations, and made top state positions open to non-aristocrats. These changes made Portugal more politically modern. So, too, did Pombol's establishment of a secret police agency. But the vigor that Pombol brought to the Portuguese system did not last. By the late 1700s, both Iberian states remained in the shadow of the greater powers to the east and north.

## Parliament and Monarchy in Britain

In the 1600s, the defenders of parliamentary authority fought a civil war, beheaded King Charles I, and removed James II from the throne in a successful battle to stop royal absolutism. (See Chapter 1.) Thereafter, the British viewed Parliament as an agency empowered to act for all the people of the kingdom, even against the monarch, if he or she overstepped the proper limits of royal authority. Despite this image of Parliament as an institution that spoke for everyone, the early modern British legislature actually represented the interests of the aristocrats, well-to-do country landowners, prosperous merchants, and others of similar socioeconomic standing.

### George III (1760–1820): His Quest for Greater Power

George III, the king who ruled Britain at the time of the American Revolution, launched a struggle to wrest from Parliament certain of the powers lost by the monarchy since the 1600s. He intended neither to subdue Parliament nor regain absolute power. The king meant, however, to have the heads of the divisions of government report to him instead of to the House of Commons, a change that would restore monarchical control over administration. George achieved his dream of power during the 1770s, but the results seemed a nightmare to many critics, especially to his opponents in Parliament: With the king fully in charge of policies, Britain lost the American colonies and then continued to suffer from the financial costs of the conflict.

### William Pitt the Younger

King George's selection of William Pitt the Younger as prime minister in 1783 opened the way to much improved governmental and economic conditions. Pitt, whose father of the same name had been prime minister twenty years earlier, took the top administrative office at the age of twenty-four. Parliament as well as the king viewed this young but politically experienced leader favorably. He lived up to their expectations. Pitt dealt effectively with the problems of excessive government debt. He also arranged a trade agreement with France that benefited both nations. For Britain, the treaty provided the especially important advantage of an expanded market for products of the new and growing industrial system.

## Diplomacy and Warfare in the Age of Reason

Even though rival states such as Britain and France reached accord on certain issues, and despite the image of this era as an age of reason and enlightenment, it was also a time of persistent warfare. Standing armies with the ranks filled by non-noble soldiers had become a fact of European life by the 1600s, but an aristocratic military and political leadership still guided European states as they interacted and made war.

### The Diplomatic Revolution

One of the main conflicts of the era was between France and Britain. These countries fought over dominance in North Europe, and, because of their determination to have colonial empires, they battled in North America and India. Austria and Prussia engaged in another persistent conflict as they struggled for supremacy in Central Europe. France and Britain sometimes became entangled in the Austro-Prussian battles.

At first, Austria had the support of Britain, largely because of Austria's historic rivalry with France. But after a serious loss in a war with Prussia in the 1740s, Austria turned to France for support. At this juncture, Britain dropped Austria and sided with Prussia. This reversal of relationships became known as **The Diplomatic Revolution.**

### The Seven Years' War

This new alignment of powers fought in the **Seven Years' War** (1756–1763). The balance of forces and distribution of territories changed little as a result. Still, Prussia's ability to fight so well without a major ally on the continent showed that this country had become a leading force in Europe. During the Seven Years' War, France and Britain fought in North America as well as in Europe, a conflict called the **French and Indian War** in the New World. This military conflict on two fronts was typical of struggles between these two nations in this period.

Britain won the upper hand in North America by 1763, and, as a result, became more actively involved in the affairs of its New World colonies. The Americans soon turned rebellious, often expressing their discontents and dreams in a manner typical of Enlightenment reformers and rebels.

### The Partitions of Poland

Although Poland ranks as a leading power in its region during most of European history, the country did not exist as an independent state from the latter 1700s to 1918. Weakened in the early 1700s by aristocratic actions against the central government, Poland fell prey to its grasping neighbors beginning in the 1770s.

As Russia, Prussia, and Austria struggled for dominance in East Europe during the 1700s, they threatened one another and competed to take land from lesser states. With relatively weak governments and armies, the Ottoman Turkish Empire and Poland became favored targets of their aggression. The forces of Catherine II of Russia struck the Ottomans in 1768. Soon, disaster loomed over the Turks.

An impending Russian land grab north and west of the Black Sea at the expense of the Ottomans meant a defeat of sorts also for Austria and Prussia. Catherine's strategic gain would leave her two rivals relatively weaker. Russia and Austria moved toward war. Prussia feared that an Austro-Russian conflict might end with these two countries taking Turkish land and growing in power. In the political calculus of the age, such an outcome would constitute a loss for Prussia.

Russia, Prussia, and Austria found a solution to the conflict generated among them by the Russo-Turkish war. They decided to take land from Poland. In 1772, the aggressors each seized a piece of Poland—a sector from the north for Prussia, from the south for Austria, and from the east for Russia. Poland lost control of half its people and one-third of its land. The diminished state suffered two similar dismemberments in 1793 and 1795 and disappeared, absorbed in a process begun by three "enlightened" despots.

## ■ THE HIGH ENLIGHTENMENT—AN INTELLECTUAL ASSAULT ON DESPOTIC MONARCHY

By the mid-1700s, the *philosophes* had largely completed the intellectual framework begun by early Enlightenment theorists. Their refinement of thought climaxed during the years from 1750 to 1790, the era of the **High Enlightenment.**

In these decades, several critics used Enlightenment principles in their descriptions of specific evils of the *Ancien Regime.* The demand for reform and the resistance to change both intensified. Other intellectuals continued the more comprehensive work of criticizing entire social systems and describing the ideal or "just" society as a guide to the complete revision of the human order. These *philosophes* of the High Enlightenment thought, wrote, and felt passionately about reform. Their ideas bred revolution.

### Diderot and the *Encyclopedia*

An active effort to publish the views of Enlightenment critics of the established order flooded France in the mid-1700s with pantheist and materialist writings supporting the new outlook. The *Encyclopedia* became a large and important stream in this deluge of material. This publication appeared as a series of volumes produced during two decades beginning in 1751. Denis Diderot (1713–1784) wrote articles for and edited the *Encyclopedia.* Virtually all the other leading French thinkers contributed sharp attacks on government, the social system, and religion. *Encyclopedia* essays also included praise-filled discussions of advances in biology and chemistry. Authors used the premises of these sciences to justify their scorn for Christianity.

During the early Enlightenment, when the *philosophes* had advocated moderate reform, the educated public viewed them as a dangerous fringe element. Now, as they expressed radically rebellious thought, their appeal to this larger literate world grew. The mood of discontent had grown broader and deeper, especially in France.

## Quesnay and the Physiocrats

The **Physiocrats,** a group of bourgeois reformers in France, advocated the establishment of a purely agricultural capitalist system free of all controls except nature. They thus denounced both their government's mercantilist practices and the nonagricultural business pursuits of the bourgeoisie. In the opinion of these reformers, only farming generated wealth, because agriculture actually expanded anything of value invested in it. François Quesnay (1694–1774) expressed these physiocratic views in his 1758 publication, *The Economic Table.* Ironically, urban industrial entrepreneurs used modified versions of the pro-agrarian theories of Quesnay and the Physiocrats to argue for policies favoring capitalist manufacturing pursuits.

## Jean-Jacques Rousseau

Enlightenment critics thought alike in many respects. Yet they also expressed divergent ideas. Jean-Jacques Rousseau's (1712–1778) differed in one very special way: He had a radically new perception of the logical implications of many fundamental Enlightenment beliefs. To Rousseau, the principles of the Enlightenment brought a vision of a society led neither by a revived rural elite, as Quesnay hoped, nor by the recently advancing urban industrial class that found Locke's ideas so appealing. Rousseau looked forward to a society of equals.

### *Rousseau's New Critique of the* Ancien Regime

Rousseau distinguished himself from other social critics in another important way. More strongly than any other leading Enlightenment theorist, Rousseau advanced the claim that the quest for truth required the guidance of emotion and not just the powers of the reasoning mind.

Rousseau presumably searched with both feeling and thought for an understanding of the ills of the old order and the necessary cure. He concluded that the very nature of humanity required the establishment of a truly free society. In agreement with High Enlightenment thought, he condemned despotic monarchy for its denial of this necessary liberty. Yet Rousseau also partly blamed literature, the arts, and science for the enslavement of humanity. This condemnation of aspects of culture that the *philosophes* revered as the way to human perfection set Rousseau still further apart from many Enlightenment theorists.

Rousseau believed that the most important reason for the failure to establish freedom was not the arts or science but private property. Originally, he reasoned, the land on which people lived belonged to no single person. When primitive humans first took property for themselves, greed became an influence in society. A struggle for material superiority began. The dedication to the truly natural needs for love and friendship weakened. By the 1700s, this flawed way of living produced a society constructed by the wealthy to preserve and justify their status. Such a civic order made fulfillment of the need for caring relationships difficult to realize. Rich and poor alike suffered from the denial of love and friendship in the world as it was. The impoverished masses felt the additional pain of oppression—a life without freedom.

## Emile—*Learning by Heart*

The formation of a society that provided the freedom to satisfy universal inclinations of heart and mind in Rousseau's view required a new form of education. In *Emile* (1762), he presented the then-revolutionary idea that children were not miniature adults who needed an authority to stuff information into them. Rousseau insisted that children had to explore the world and discover its truths under the guidance

of intelligent and sensitive adults in order to develop their minds to full potential. Learning in this way would prepare people for citizenship in a civic order best suited to common human needs.

## The Social Contract—*Free Association*

Rousseau did not think that education alone could produce the transformed society that he so desired. People had to build a new political order as well. In *The Social Contract* (1762), Rousseau presented his views on the voluntary association of equal citizens that he believed should replace the despotic *Ancien Regime.*

He rejected the widely held Enlightenment idea of sociopolitical liberation achieved by the establishment of a body of constitutional law to protect what Natural Laws justified: the right to life, liberty, and property. Rather, he advocated the formation of a society not in harmony with imagined Natural Laws pertaining to human rights but consistent with truly natural human traits as he saw them. These characteristics, he affirmed, included an urge to self-preservation, an ability to care about the suffering of others, and an inborn sense of how to achieve the common good.

Given these qualities, humanity needed and had the potential to establish a system in which the power of the collective citizenry would provide the freedom to act on natural impulses. Such a civic order also would protect the life and possessions of all people. A society of this kind could exist when its members willingly surrendered certain individual prerogatives and gained an equal share in social authority. That is, people would enter a social contract among equal citizens rather than a political contract between ruler and citizens.

Despite this submission to the collective, individuals would not lose their freedom, Rousseau argued. Indeed, the liberty that everyone needed and a society that benefited all people could exist beyond primitive times only in a new system under laws consistent with natural human traits.

When citizens maintain conditions right for all members of society, they are expressing the **general will,** according to Rousseau. The prevalence of private interests that favor certain individuals or factions to the harm of others is a corrupt civic system. The operation of the general will brings the pure and good society to life. This ideal state, moved by the general will, can exist only when all members of society enjoy equality and every citizen participates in government through a representative. Rousseau thus had gone far beyond the typical Enlightenment idea of a society that guaranteed equal legal rights to the principle of an equal distribution of power. He advocated both liberty *and* democracy. Ironically, though, his idea of general will also could justify brutal repression of individuals viewed as committed to "private interests."

Rousseau presented *The Social Contract* as his plan for the thorough reform of society. It did become a rich source of inspiration for generations of political thinkers. Not all of them, however, saw this publication as a directive for reform of states distorted by monarchical despotism. Even before the end of the century, it became for certain rebellious leaders a blueprint for violent action to destroy such systems, to destroy anyone, in fact, who seemed to threaten the revolution.

## Beccaria on Crime and Punishment

Cesare Beccaria (1738–1794), an Italian contributor to High Enlightenment thought, offered a less comprehensive analysis of society than did Rousseau. He presented, however, a bold condemnation of criminal punishment, including execution, and a provocative commentary on the causes of crime.

Beccaria's ideas about this latter issue had radical implications for the same reason that portions of Rousseau's thought did. Like Rousseau, Beccaria saw private property as an evil influence. He blamed the greed of "the haves" for the tendency of "the have-nots" to violate social codes. According to Beccaria's argument, the rich made the laws and in so doing favored themselves, thus creating injustices that provoked others to crime.

Because of his views on the evil of property ownership, opponents called him a **socialist,** and thus coined a new word. They believed that chaos would result from acting on his ideas. Supporters, however, saw his work as aimed at going beyond simple reform of the legal system and removing the fundamental causes of crime.

### Adam Smith and the Wealth of Capitalists

Most Enlightenment theorists held a very different view of property than did Rousseau and Beccaria. Among the natural rights that seemed so important to most of these thinkers, property rights usually were the most honored. No one wrote more effectively in behalf of the Enlightenment idea of property rights than did Adam Smith (1723–1790).

In his *Wealth of Nations* (1776), this English theorist spoke out for the operation of natural laws in the economic world. He believed that government should leave business alone (a *laissez-faire* economic policy), because the free operation of economic laws would lead to the best of all possible worlds. Like many in his era, Smith had not only a powerful faith in natural laws but also a strong conviction that living in harmony with nature ensured progress.

Smith anticipated that this process would lead to a society blessed with small competing businesses, each producing what it made best at a fair price. Nations also would make and trade the goods that they were most suited to manufacture and would buy from other countries the specialties each turned out. The resultant societies should have no great disparity between rich and poor, and there should be no impoverished masses. Although it is contrary to this vision of Smith's, his ideas acquired an image as the doctrine of rich, heartless capitalists.

### Wollstonecraft and Women's Rights

Despite the passionate commitment of Enlightenment intellectuals to a struggle against social injustice, they largely ignored slavery and many of the unprivileged, including women. In the case of European women, it appears that their lives had worsened in the Early Modern era. Unlike almost all her male contemporaries, Mary Wollstonecraft (1759–1797) took a stand against the worsening oppression of women. This British advocate of female rights contended that Enlightenment conceptions applied to women as well as men, and that women should bring about a reformation in their social circumstances. They had to end the male-imposed subordination, she argued, and claim their natural human rights. The ideas she presented in *Vindication of the Rights of Woman* (1792) became important influences in the 1800s and thereafter.

## ■ THE WANING OF THE ENLIGHTENMENT

Enlightenment intellectuals usually exhibited a supreme confidence in the existence of changeless natural laws. They also generally championed the values of the bourgeoisie. Rousseau and Beccaria

displayed many typical Enlightenment attitudes. To Rousseau, however, the idea of natural laws was an invention used selfishly to justify an individual's or group's values. Both men condemned the principle of private property that was so sacred to the rising industrial middle class. The works of Rousseau and Beccaria thus indicate a shift away from central Enlightenment beliefs.

## The Marquis de Sade

For the Marquis de Sade (1740–1814), not only was nature unworthy of faith, it deserved contempt. Humanity, he believed, could find no guide to correct behavior in either divine or natural law. Therefore, Sade considered moral codes and laws to be devices used by the rich and powerful to exploit and abuse the poor and weak.

The proper response to such a miserable circumstance, Sade proclaimed, was to violate all social principles whether they pertained to property rights, sexual behavior, or other aspects of conduct. The horrible injustices of society made any attack on it appropriate. Above all, he sanctioned an assault on the established order through sexual offenses, for then the rebel struck at the evil social system and at nature itself, the creator and deserter of a hopeless humanity. Few of the typical features of Enlightenment thinking remained in Sade's ideas. Because of his views and behavior, the word "sadism" eventually entered many languages.

## Immanuel Kant

Like Sade, Immanuel Kant (1724–1804) believed that no natural laws existed to guide the course of human affairs. For Kant, however, a humanity orphaned by nature was mentally equipped to take charge of its own destiny and move toward the most highly moral social order. Kant thus denied the central Enlightenment tenet that nature provided laws for life, but he kept the faith in reason and progress. Indeed, Kant presumed that humanity could struggle *against* impulses instilled by nature and discover a way to approach individual and social perfection. The knowledge and moral insight that *all* rational beings possessed made such a quest possible, according to Kant.

Kant offered his views on universal human traits and on the way these potentials could produce a better world in two works, *The Critique of Pure Reason* (1781) and *The Critique of Practical Reason* (1788). The new social order that he anticipated would be one in which people were free and self-governing. The universal characteristics of humankind made such a system appropriate for them and possible. Kant anticipated that this rational and emancipated humanity could even establish global peace.

*In many respects, the works of Kant represent the ultimate achievement of Enlightenment thought. This philosopher demonstrated his profound understanding of the ideas and methods of this Age of Reason. He displayed with exceptional brilliance the special value that he saw in many of them. Kant's writing also paradoxically contained evidence of the weakening hold of Enlightenment thought on the minds of leading European intellectuals. For even though Kant gave powerful support to the idea of human reason, he blasphemed nature, a virtual god for many philosophes. Furthermore, Kant pointed toward a new way of thinking that the next generation of theorists, ironically, would use to deny the intellectual supremacy of reason.*

*This waning of the Enlightenment at the end of the 1700s is significant in part because the movement had lasted so long (about one hundred years) and had affected European life so deeply. Even in its last*

*phase, the High Enlightenment (1750–1789), this mentality of the Age of Reason entered the throne rooms of Europe and inspired rulers such as Catherine II of Russia, Frederick II of Prussia, and Joseph II of Austria to carry out remarkable programs of reform. Even if they might have done so mainly to enhance monarchical power, these "enlightened despots" consciously tried to modernize the* Ancien Regimes *they had inherited.*

*The weakening of the intellectuals' faith in the dogmas of the Enlightenment in no way indicated that the principles of the movement would no longer influence Europe. The Enlightenment outlook became a very prominent, if not always dominant, feature of Western intellectual life throughout the coming years. Moreover, these ideas continued to affect the attitudes and behavior of societies both within and beyond Europe.*

*In addition to these persistent direct effects of the Enlightenment, this movement profoundly influenced modern history in a number of indirect ways. The French Revolution (1789–1815) was a medium of special importance through which the Enlightenment permeated European history. This great political upheaval began to a great extent as the result of the modernizing forces of the Industrial Revolution and the Enlightenment. Industrialization changed the way Europeans lived. The Enlightenment transformed the way they thought. The French Revolution ushered in a new social and political system that still functions today.*

## Selected Readings

Anchor, Robert. *The Enlightenment Tradition.* Berkeley: University of California Press, 1979.

Becker, Carl. *The Heavenly City of the Eighteenth-Century Philosophers.* New Haven, CN: Yale University Press, 1932.

Hampson, Norman. *The Enlightenment.* London: Penguin, 1982.

Jacob, Margaret C. *The Enlightenment: A Brief History with Documents.* New York: St. Martin's Press, 2001.

Ogg, David. *Europe of the* Ancien Regime, *1715–1783.* New York: Harper & Row, 1965.

Rude, George F. E. *Europe in the Eighteenth Century: Aristocracy and the Bourgeois Challenge.* London: Weidenfeld and Nicholson, 1972.

Spencer, Samia I., ed. *French Women and the Age of the Enlightenment.* Bloomington, IN: Indiana University Press, 1984.

Williams, E. Neville. *The* Ancien Regime *in Europe: Government and Society in the Major States, 1648–1789.* London: Bodley Head, 1970.

## Test Yourself

1) The United States government's division into executive, legislative, and judicial branches reflects the thinking of
   a) Locke
   b) Voltaire
   c) Rousseau
   d) Montesquieu

2) The reasoning behind Locke's belief in human equality included the idea that everyone was born with
   a) a mind like a blank slate
   b) an instinctive sense of how to govern one's personal behavior
   c) the right to own enough property to produce the food supply for a single person
   d) the learning from nine months of prenatal experience

3) Which country disappeared (its territory divided among other countries) in the latter 1700s?
   a) Austria
   b) Hungary
   c) Denmark
   d) Poland

4) One of the first theorists to believe that men oppressed women and that women had to free themselves
   a) Rousseau
   b) Wollstonecraft
   c) Diderot
   d) Hobbes

5) Which of these individuals or groups most definitely favored equal rights?
   a) the *philosophes*
   b) Montesquieu
   c) Rousseau
   d) Locke

6) Which of the following blamed the greed of the rich for the crimes of the poor?
   a) Montesquieu
   b) Locke
   c) Beccaria
   d) Hobbes

7) If you are committed to monarchy, aristocracy, and a land-based rather than an industrial economy, you should love
   a) the *philosophes*
   b) the *Ancien Regime*
   c) *The Social Contract*
   d) Adam Smith's *Wealth of Nations*

*Enlightenment Europe's population included about equal numbers of women and men, but most rulers and publishing writers were men. Consider this statement as you decide on the next two completions:*

8) Men were more often rulers and writers because they were more capable
   a) logically follows
   b) does not logically follow

9) Conditions favored men becoming rulers or writers
   a) logically follows
   b) does not logically follow

*Experts during the Scientific Revolution used astronomical observations and mathematics to prove for the first time that planets moved in ellipses, not perfect circles as previously believed. In light of this information, decide the completion of each of the following:*

10) Some experts knew what ellipses were
   a) logically follows
   b) does not logically follow

11) Some experts could draw ellipses
   a) logically follows
   b) does not logically follow

12) Enlightenment experts who made the discovery of elliptical orbits possible were exceptional mathematicians
   a) logically follows
   b) does not logically follow

## Test Yourself Answers

1) **d.** The influence of Montesquieu's idea of separation of governmental powers on the system in the United States is one of many important ways that Enlightenment political thought helped to shape the modern Western world.

2) **a.** Locke's conclusion that minds empty at birth developed from subsequent experiences illustrates the tendency of Enlightenment thinkers to emphasize natural forces controlling human development and behavior.

3) **d.** The rare phenomenon of the lengthy disappearance of an influential state such as Poland reveals an important trait of European imperial behavior in this era.

4) **b.** The strong tendency of Enlightenment leaders to speak out against social injustice without recognizing female subordination as unjust prompted Mary Wollstonecraft's challenging call for equal rights for women as well as men.

5) **c.** Enlightenment reformers usually wanted political authority extended to a somewhat larger proportion of society than in the past. Rousseau, however, advanced the exceptionally radical idea of giving political power to all, or at least to all men. Wollstonecraft had logic on her side in the argument for giving women power as well, but Rousseau's view gained a significant following more quickly.

6) **c.** Beccaria gained the distinction of being the first person called a socialist because of his attack on private property and wealth. He charged that the injustice of having few wealthy people while the masses are desperately poor drove the suffering lower classes to crime.

*The first six quiz items emphasized thinking in the form of fact-recall. The next six, and especially questions 8–12, require higher-order thinking in the selection of the best answer. They depend, that is, on the use of reason, an intellectual capacity especially valued in the Enlightenment.*

7) **b.** Little beyond a good recollection of chapter content might lead to the best answer, but more than in items 1–6, the question seems to call for a consideration of several facts and drawing the conclusion that the opening line of the item describes the *Ancien Regime*.

8 and 9) The item 8 statement does not logically follow, but the conclusion noted in 9 does follow. The introductory information for these items makes it evident that circumstances of some kind must have favored males ruling and publishing, conditions that might have but would not necessarily have included inherent ability. The item 9 statement also allows for many other causes of male dominance in these pursuits, including gender bias.

10–12) It clearly does follow from the introductory information that certain of the experts had to understand what ellipses were in order to prove that planets moved in orbits of that kind. Common sense leaves little doubt that some of these people also could draw an ellipsis, but the information provided does not make "logically follows" the correct completion for item 11. Even if none of the experts could draw anything at all, they could have proved the shape of the orbits. The best answer for item 12 is "does not logically follow," especially because the opening line is too sweeping in the use of the words "Enlightenment experts," which suggests too strongly that *all* the experts were skilled in mathematics. The introductory information leaves no doubt that some experts had to be skilled in mathematics, but certain astronomers might have made observations only. Brahe, for example, contributed much with his observations, but little, if anything, with his knowledge of mathematics.

# The French Revolution and Napoleonic Empire (1789–1815)

| | |
|---:|---|
| **May 1789:** | Louis XVI convenes the French Estates General. |
| **July 1789:** | The Bastille falls to French rebels. |
| **August 1789:** | French revolutionaries proclaim the Declaration of the Rights of Man. |
| **January 1793:** | Louis XVI is executed in Paris. |
| **October 1793–July 1794:** | The Reign of Terror takes place in France. |
| **December 1799:** | Napoleon becomes dictator of France. |
| **October 1805:** | Britain controls the seas after victory over France at Trafalgar. |
| **July 1807:** | The Treaties of Tilsit mark Napoleon's triumph on the Continent. |
| **June 1812:** | Napoleon begins the invasion of Russia; ends in defeat in December. |
| **March 1814:** | Napoleon abdicates after his loss to a monarchical coalition. |
| **March 1815:** | Napoleon escapes from exile and resumes war. |
| **June 1815:** | Napoleon suffers his final defeat at Waterloo. |

*Europe became economically and intellectually modern as the changes engendered by the industrial revolution and the Enlightenment spread over the region in the 1700s and after. New political currents joined those that brought industry into European civilization. As these political, economic, and intellectual forces converged in the 1780s, an even more tumultuous transformation began to sweep across the continent.*

*In France, these movements brought about a modernizing political revolution that burst to the surface in 1789. Within that nation, rebels quickly completed the destruction of the old social structure and governing system. The revolution soon spread into other European states. For twenty-five years, the violence of rebellion and revolutionary wars accompanied the birth of a more fully modern European political system.*

# ■ THE ORIGINS OF THE FRENCH REVOLUTION

From the latter Middle Ages onward, economic modernization caused the bourgeoisie to grow increasingly rich and ambitious without equivalent gains in political influence or social privilege. This dynamic segment of society thus felt more and more hostile toward the *Ancien Regime*. When bourgeois leaders began their overt political attack, the specific target at first was the monarchy. The government faced a dangerous foe.

## Revolutionary Trends

Intellectual currents that originated in the 1600s also helped to foster a rebellious mood by the latter 1700s. Enlightenment theorists had poured out increasingly hostile commentaries on the *Ancien Regime*. Ultimately, the critics, who hated despotism whether enlightened or not, became the leading voices of the modernizing intellectual movement. Their weapons against aristocracy, monarchy, and the established churches were mostly spoken and published assaults. By the late 1700s, revolutionaries used these Enlightenment ideas, but they also wielded the executioner's blade in their attack on the *Ancien Regime*.

Long-term political trends combined with socioeconomic and intellectual developments to bring France to the point of violent revolution by 1789. The era of warfare launched in the reign of Louis XIV (1643–1715) continued through the 1700s and plunged France so deeply into debt that it invited political chaos. When France provided money and troops to help the American colonists in their revolt against the British (1775 to 1783), the expenditures pushed the government to the brink of financial disaster.

The French monarchy's huge war debt gave the long subdued nobility its chance to challenge royal authority. Aristocrats used their control of judicial agencies to block the king's attempt to increase taxes in order to pay royal debts. They hoped by this move to force convocation of a policy-making assembly that they intended to dominate. Their goal was a weakened monarchy and greater aristocratic power. Ironically, this upper-class action opened the way for a middle-class revolutionary triumph over both the king and the nobles.

## French Society on the Eve of Revolution

The formal structure of French society as revolution neared in the late 1780s remained unchanged from the shape it had taken in the Middle Ages and Early Modern period.

### *The Clergy and Nobility*

According to the long-held traditional view, the four hundred thousand members of the First Estate (clergy) and the Second Estate (nobility) deserved an honored place at the top of the social order, and they had many special rights. Despite their prestige and privileges, without power over the king, the aristocrats and members of the upper clergy felt deeply dissatisfied.

### *The Commoners*

The twenty-five million people who belonged to the Third Estate included more than two million bourgeois financiers, industrialists, merchants, and professionals, many of whom were rich and well educated. About ten million peasants in the Third Estate owned land in the 1780s. Another ten million farmers worked either as sharecroppers or hired laborers. Approximately two million artisans, unskilled

laborers, and servants who lived in cities also ranked among the commoners who comprised the socially diverse Third Estate. Regardless of wealth, education, or other distinctions, the masses of people who belonged to this Estate held an inferior position.

The French bourgeoisie harbored deep resentment toward the privileged upper estates. Members of this dynamic middle class also became increasingly disturbed by the way both monarchical government and the traditional estate structure prevented the realization of their economic and political ambitions. The explosive potential of this attitude was all the greater because certain aristocrats had the same progressive outlook. Even the less reform-minded nobles could find common ground with the bourgeoisie in their opposition to monarchical power.

French peasants lived better than any other European rural folk. This circumstance, however, did not make them contented. Peasants felt hostile toward nobles who still could demand fees for necessities such as the use of a mill, who could raise rents arbitrarily, and who had the exclusive right to hunt on farms where the rural commoners lived. Furthermore, a series of bad crop years in the 1780s, persistent inflation, and an unfair tax burden intensified the bitterness of the peasantry. Similar conditions oppressed urban commoners. The rising prices that brought higher incomes for businesspeople and landlords in the latter 1700s confronted city workers with economic disaster. Rents more than doubled in Paris, and the bread that provided most of their calories also took as much as half their income. Wages rose much more slowly than living costs. Then a depression struck in the late 1780s.

By 1789, the aristocracy stood ready to attack the monarchy to regain lost power. The Third Estate at that point had strong grievances against both the monarch and the aristocrats. The potential for revolution in France was unusually high.

## The Financial Crisis (1786–1789)

For the government of King Louis XVI (reigned 1774–1792) a massive debt rather than social issues or the price or availability of bread was the most critical problem in 1789. The amount owed by the monarchy had surged upward from less than two billion livres in the mid-1770s to more than four billion by the late 1780s. As always, the government's military spending accounted for most of the debt. The recent drastic deficit increase resulted from the cost of aid to the American revolutionaries.

The king could have paid his debts by establishing a more equitable tax system that tapped the wealth of the first two estates and the upper bourgeoisie. Instead, he avoided a confrontation with these now more assertive classes and borrowed heavily at high interest. Then, in 1786, the banks stopped the loans. Charles de Calonne, the royal controller-general or treasurer, decided that government finance required sweeping reform. His plan included provisions for increased taxes on the first two estates and the bourgeois business community, a step these groups would vigorously resist.

### Confrontation with the Aristocratic Parlements

In early 1787, when an assembly of leading aristocrats and clergymen called by the king to consider Calonne's plan rejected it, Louis had to try another approach to find a solution to the crisis. By long tradition, French kings could establish new policies by presenting decrees to thirteen aristocratic judicial bodies, the **Parlement of Paris** and the twelve **parlements** of the subdistricts (provinces) of the kingdom.

The Parisian *Parlement* accepted parts of Calonne's proposal but rejected the critical element, taxes on the rich and privileged. Louis ordered the establishment of his policies against the will of the *Parlement*,

as tradition allowed, and disbanded the Parisian group. He then presented his financial decree to the provincial *parlements,* but they proved to be more hostile to the reform than the *Parlement* of Paris.

Even though the king had the right to override the decision of the *parlements,* he could not end their resistance. The rebellious judicial aristocrats called for a convocation of the Estates General (see Chapter 3), which had not met since 1614. When it convened, these aristocrats intended to dominate it and establish changes that would increase noble influence in government. Facing financial collapse and a possible rebellion at every level of society, the king yielded. In August 1788, Louis appointed a new controller-general, Jacques Necker, and charged him with the task of arranging for the Estates General to meet.

## ■ MODERATE REVOLUTION

The aristocracy welcomed the calling of the Estates as an opportunity to restore some measure of the power that they had enjoyed in the Middle Ages. Louis accepted the convocation of this assembly as a way to stifle revolt and end the financial crisis. Unknowingly, the nobles and the king had launched a revolution that quickly gave the upper bourgeoisie control over France and, soon thereafter, led to a violent destruction of the old order.

### The Estates General

The perception of royal despotism that had somewhat closed the ranks of all three estates against the king could not keep them together after elections to the assembly got under way. The Third Estate and a significant minority of reformist clergy and nobles demanded a break from traditional procedures for the Estates General. In earlier assemblies, the three estates had an equal number of delegates, they met as separate units, and each group arrived at a single vote on an issue, a procedure that gave control to the two upper estates. One clergyman, Abbé Emmanuel Sieyès, wrote a pamphlet titled "What Is the Third Estate?" in which he argued that the mass of commoners who made up this class was the nation and should decide every question. Most members of the two upper estates held a different view. They insisted on the old system that ensured their victory on every vote.

### *The Election of Delegates*

Louis agreed to double representation for the Third Estate (about three hundred delegates for each of the upper estates; approximately six hundred for the Third). He would not, however, allow votes in the assembly by head, a method that would enable Third Estate delegates and their progressive aristocratic supporters to win on virtually all issues.

In the ensuing elections, all the adult male nobles and most of the clergy had the right to vote and directly selected their representatives. The government restricted the vote of the Third Estate by gender and economic status—only male taxpayers could cast ballots. The lower estate also selected representatives by voting for electors who then chose estate delegates. Urban businesspeople and lawyers won a disproportionate share of Third Estate seats as a result of these procedures.

### *The Cahiers*

Election rules also allowed voters to compose ***cahiers de doleances,*** grievance statements. The *cahiers* indicated a strong consensus among all estates for an end to careless government spending and

the abuse of power. Furthermore, the statements revealed wide agreement on the need to have a constitution that maintained royal authority but gave the estates influence over laws and guaranteed certain liberties, such as freedom of the press. The *cahiers* reflected conflicts, too. The upper estates spoke out for a continuation of their historic privileges, while Third Estate *cahiers* demanded the abolition of special upper-class rights.

## The Formation of the National Assembly

Conditions in France rapidly worsened in the months before the Estates General met. Many businesses failed, masses of urban workers lost their jobs, prices shot up, and riots erupted. In an atmosphere thus charged, the representatives of the Estates convened on May 5, 1789. Deadlock immediately developed.

Third Estate delegates refused to conduct business unless they voted by head. The monarchy, clergy, and nobility demanded adherence to the tradition of one vote per estate. The Third Estate responded with a truly revolutionary step. On June 17, 1789, it acted in the spirit of Abbé Sieyès' tract and declared that the Third Estate was the **National Assembly.** A few days later, the clergy voted to join this Assembly.

### The Tennis Court Oath

When the Third Estate representatives gathered on June 20, 1789, their hall was locked. They mistakenly assumed that the government had closed the chamber as an act of opposition and convened in a nearby indoor tennis court. There, the delegates pledged not to disband until they completed a constitution for the nation. Three days after the Third Estate took this **Tennis Court Oath,** Louis ordered the three estates to gather in their separate chambers as before. The privileged estates' delegates complied. Rebellious Third Estate representatives spurned the decree. As rumors of mob action against the king began to spread, he issued a new decree. On June 27, Louis told the three estates to merge. France now had a National Assembly dominated by the mostly bourgeois Third Estate delegation.

### The Fall of the Bastille

The royal government and the aristocrats, most of whom now forgot their opposition to monarchy and sided with the king, still had the power to stop the revolt. Royal troops posed an especially terrifying threat to the rebels. The Bastille, a fort built to protect Paris in the Middle Ages, housed a few of the king's troops. Parisians believed it held stores of guns and ammunition as well. They knew that the king imprisoned his enemies there and that its cannon could blast one of the most rebellious working-class districts. Even though the citizens of Paris had these reasons to consider the Bastille a practical danger, they despised it more as a symbol of monarchical and aristocratic power.

Soon after Louis' concessions to the National Assembly on June 27, the multiplication of royal troops near the king's palace indicated that he was ready to use force to regain full control. Then, on July 11, Louis heightened fears by his dismissal of Necker, the reform-oriented controller-general.

Parisians responded forcefully to apparent threats and hard times. A year earlier, they had spent half their income on bread. Now it took more than three-fourths of their earnings to purchase this essential food. Mobs raided bakeries and stole bread. Seized by fear of an attack by royal troops, they also invaded shops and government centers in search of weapons.

In one such weapons raid on July 14, several hundred citizens converged on the Bastille, with its forbidding double ring of ninety-foot high walls. They called for the surrender of gunpowder and the

redirection of the threatening cannon. Negotiations with de Launay, the commander of the Bastille, quickly broke down. Bastille troops killed nearly one hundred rebels and more than seventy others suffered wounds.

As the crowd threat grew, de Launay's troops convinced him to open the fort rather than continuing the fight. The enraged crowd, even though allowed entry, broke into frenzy, and the Bastille fell. Six of the approximately one hundred defending troops and de Launay died as the Parisians took the fort. The invaders then decapitated the dead commander and troops and displayed their heads, impaled on pikes, as a sign of their victory over despotism. This great symbolic triumph caused July 14, 1789, to become celebrated as the first day of French liberty.

In response to this mob action, Louis visually expressed his acceptance of the National Assembly and its revolution. He entered Paris wearing a hat decorated with the three colors associated with the city's revolt—the red and blue that symbolized Paris and the white of the royal family's flag. Royalist nobles began to leave the country.

The business and professional elements who had launched the revolution intended to have decisions made by them and not by street crowds as in the Bastille raid. They organized for control of the city by selecting a mayor, Jean Bailly, and placing the marquis de Lafayette in charge of a revolutionary French Guard loyal to bourgeois leaders. Lafayette, as a moderately reformist aristocrat who had joined the American revolutionaries in their struggle for liberty, made an ideal leader for this bourgeois security force.

### The Great Fear

Events in other French cities somewhat paralleled developments in Paris. In the countryside in mid-July, peasants began to dismantle the old aristocratic system. In some areas, when the peasants demanded it, the clergy simply surrendered their right to collect tithes, and the nobles gave up their power to take fees. More radical action sometimes took place, as when the peasants seized and burned the records of their obligations to the lords.

These conditions bred hysteria as members of all social factions feared violence by their enemies. The extreme anxiety that gripped the French people for three weeks in late July and early August 1789 became known as **the Great Fear.**

### The August Decrees

As the peasant revolt and the Great Fear climaxed, actions by the National Assembly indicated the revolutionary leadership's acceptance of the spontaneous rebellion sweeping the country. In a single night, August 4, 1789, the delegates' **August Decrees** proclaimed an end to all noble privileges. More dramatic steps followed in the Assembly.

### The Declaration of the Rights of Man and of the Citizen

The responsibilities of the National Assembly included the production of a constitution, a duty that caused this body of representatives to become known also as the **Constituent Assembly.** Its members began this work with a statement of political principles on August 26, 1789. In the "Declaration of the Rights of Man and of the Citizen," the Assembly affirmed that government belonged to the people rather than the king. The document further declared that all citizens had natural and irrevocable rights to liberty,

equality, property ownership, security, and freedom of thought and expression. The Declaration of Rights completed the process begun in the August Decrees of formally ending the *Ancien Regime.*

### The Women's March on Versailles

Louis XVI turned resistant again at this point. He issued no approval of the measures the Assembly passed in August. Popular fear of repression rose. So did the price of bread, to even more prohibitive levels than before. A group of Parisian women responded to these circumstances on October 5, 1789, with a mass march to the king's palace twelve miles away in the suburb of Versailles. A small contingent of men went along. Within hours, Lafayette and several thousand troops of his French Guard followed to maintain control in the interest of the bourgeoisie.

Once at Versailles, the protesters demanded reduced bread prices, to which the king agreed. His verbal submission failed to satisfy them, and they forcibly entered the palace, killing several guards in the process. Lafayette helped convince the king to comply with the wishes of the crowd and relocate in Paris. On October 6, the royal family and the commoners of Paris went together to the more revolutionary environment of the capital city. The king soon accepted the August Decrees and the Declaration of the Rights of Man.

### The Civil Constitution of the Clergy

The August Decrees ended clerical privileges. Lawmakers soon took additional steps against the Church. In November 1789, they seized clerical lands and began to sell government notes, **assignats,** with this property as collateral. Thereafter, they drew up a Civil Constitution of the Clergy (July 1790), a document that thoroughly subordinated the Church to the state. Under its provisions, the government reorganized the Church, gave the election of its leaders over to the citizens, and placed the clergy on the state salary rolls. Most of the clergy refused to accept this new religious constitution. As a result, many Catholic commoners changed from supporters of revolution to opponents.

### The Constitution of 1791

The National Assembly adopted a new constitution in September 1791. It formally nullified the absolute authority exercised by French kings for generations. A **unicameral** (one-house) legislature, the Legislative Assembly, would decide all matters of taxation and spending. The monarch could temporarily veto assembly actions, but votes against the king in three subsequent legislatures could override his will. The ruler remained in charge of foreign policy and the military.

**Limited Democracy.** The constitution gave the vote to all males who paid taxes equivalent to three days' wages. But citizens voted for electors, who then chose legislators. Furthermore, the constitution allowed only the richest men to become electors or members of the legislature. Only about 50,000 of the approximately twenty-five million citizens could qualify. Even with such limitations on citizen power, this constitution promised France the most democratic system in Europe.

**A Bourgeois Economic Order.** The new system granted economic as well as political dominance to upper middle-class business and professional people. The tariffs, tolls, and organizations that might

restrict trade within France were nullified, allowing the business community to trade more profitably. Taxes on foreign goods to reduce competition from abroad and laws against labor unions further ensured the success of French businesspeople. The constitution did give the workers something, however: the freedom to choose their jobs.

**Administrative and Judicial Modernization.** Constitutional provisions for the new bureaucracy and court system also reflected the attitudes of the now dominant middle class. Political leaders streamlined the administrative structure of France, establishing eighty-three uniform governing territories. These **departments** contained smaller units: districts, cantons, and communes. Citizens elected the officials who governed these local political divisions. The constitution provided for a similarly rational reorganization of the courts, provided for jury trials in criminal cases, and outlawed the use of torture.

### Liberalism

In the Constitution of 1791, the Assembly wrote into law the High Enlightenment vision of an ideal system. It guaranteed freedom of thought and expression, individual liberty, legal equality, property rights, and government by the people, or at least by the bourgeois-defined citizenry. In the 1800s, this new creed of individual rights became known as **liberalism,** a modern political ideology that would well suit European states as they industrialized.

### The Political Left, Center, and Right

Despite the many common attitudes of the liberal bourgeois leadership, factions appeared as the Assembly debated the constitutional issue of a royal veto. **Radicals,** those in favor of the most drastic change, wanted the king to have no veto power at all. In keeping with European practice, this group in favor of the most sweeping change sat on the left side of the hall, viewed from the platform at the front. The most conservative faction sat on the right, and on this issue took a stand for a royal veto that the legislature could not override. Members seated in the center advocated a veto by which the king could suspend a law until legislators repeatedly reversed it. The moderate **Center** had its way.

In this and subsequent debates, the **Left** distinguished itself by its stand for popular sovereignty— the sharing of political power by *all* the people. Leftists showed their commitment to this principle especially in the arguments over voting rights. They advocated the vote for every adult. The Center opposed popular sovereignty, but favored the extension of political power to more of the people than did the **Right.** The Constitution of 1791 completed a moderate revolution that the bourgeois liberal Center had led. The Left lost on most issues but had not suffered a permanent defeat.

## ■ THE ORIGINS OF THE RADICAL REVOLUTION

The administrative and judicial reforms, the Constitution of 1791 as a whole, and much else done by the National Assembly promised a better life for most French people. The revolution thus far, however, embodied the values of the upper bourgeoisie and opened the way for this predominantly business class to pursue its dreams. Before the National Assembly adjourned, September 30, 1791, the delegates voted to bar themselves from the new Legislative Assembly. They expected their successors to perpetuate the moderate revolution. But many people did not share this vision of the new order. They wanted more drastic change.

### The *Sans-Culottes*

Male French aristocrats in the 1700s wore knee-length breeches. Wealthy members of the bourgeoisie tended to copy the styles of the nobles. Poorer male commoners, however, donned full-length trousers, and thus became known as the people "without breeches" *(sans-culottes* in French). In the cities, and especially in Paris, the *sans-culottes* provided vital support for the revolution of 1789–1791. Even so, the new regime severely limited their political role and remained unresponsive to their insistent demand for economic relief, especially affordable bread.

Thus, the lower bourgeoisie, craft workers, unskilled laborers, and servants who comprised the *sans-culottes* became a force for a radical revolution. This left-wing contingent wanted an equal voice in government and an increase in their relative wealth. Members of the aristocracy and upper bourgeoisie who sympathized with the cause of the lower classes greatly strengthened the drive for drastic change.

### The Legislative Assembly

When the Legislative Assembly convened in October 1791, the prospect of war as well as radical revolution loomed on the horizon. King Louis had tried to escape from France in June 1791, supposedly with the intention of helping to organize an invasion by *émigré* French nobles and foreign enemies of the revolution. The Assembly had heard warnings that Austria now intended to launch such a counter-revolutionary assault on the new regime. As the legislature confronted critical issues, especially the consideration of war, several factions and political clubs struggled to carry votes their way.

### The Political Clubs

In 1789, groups of activists had formed associations in order to influence the course of events. These **political clubs** gradually increased in power as the National and Legislative Assemblies proceeded with their work.

**The Jacobins.** The most radical of the leading clubs met in Paris in a monastery located in the Rue St. Jacques. Because of the street name, club members became known as **Jacobins.** Maximilien Robespierre led this group as it developed a network of clubs across France. Even though as advocates of popular sovereignty the Jacobins belonged to the Left, this mostly bourgeois club wanted to maintain control over the more radical *sans-culottes,* with whom they sympathized. Jacobins also struggled for central government supremacy over local political authority.

**The Girondins.** The delegates to the Legislative Assembly included a contingent from the department of the Gironde, a district in the Bordeaux region. These **Girondins** shared the Jacobin hostility toward aristocratic and monarchical power but opposed popular sovereignty. **Girondin federalism**—a belief in strong local government—also clashed with Jacobin centralizing ideals. On the question of war, the Girondins favored a very aggressive response to the foreign danger. They urged a war against Austria both to defeat this enemy and encourage popular revolutions against monarchy in other countries. The Assembly declared war on Austria on April 20, 1792. Both Austrian and Prussian troops thereupon invaded France and drove back the revolutionary armies.

## The Brunswick Manifesto

The Duke of Brunswick, who led the Austro-Prussian invasion, proclaimed on July 25, 1792, that any injury to Louis and his family would result in harsh reprisals when his forces reached Paris. In early August, the Parisians responded to this **Brunswick Manifesto** by setting up a more radical city government, the **Paris Commune,** and invading the king's residence. The royal family rushed to the Legislative Assembly to escape this threat. They gained momentary security, but the legislature revoked all the constitutional powers of the king. Soon, the Legislative Assembly voted to call a convention to write a new constitution; it then disbanded.

## The September Massacres

The Brunswick Manifesto provoked widespread fear of counter-revolutionary violence. The hysteria focused on nobles and members of the clergy imprisoned by revolutionary leaders for offenses against the new regime. In the first days of September 1792, groups broke into jails in Paris, hastily tried the people they seized, and immediately executed them. More than one thousand presumed upper-class counter-revolutionaries died in these **September Massacres.**

# ■ THE NATIONAL CONVENTION

Civil violence and the revolutionary war created a crisis atmosphere during the elections to the constitutional assembly, or **National Convention,** as it came to be called. Fear and coercion kept the more moderate citizens from casting ballots. Representatives opposed to monarchy in any form won decisively. Now they would carry out a radical revolution.

## The Execution of Louis XVI

Delegates to the National Convention gathered on September 20, 1792, to the heartening news of a great victory against the Prussians at Valmy. Soon, the French reoccupied the lands lost earlier to the invaders. The Convention turned its attention to the fate of its imprisoned king.

In Convention sessions, the Jacobins filled the seats on the left in a section of chairs positioned above all others. These most radical delegates thus became known as the **Montagnards** or men of the Mountain. Girondins occupied the right side of the chamber, a position indicative of their relative conservatism. Delegates of less extreme left or right opinion sat in the center of the hall in the lowest seats, the **Plain** or **Marsh.**

These factions united to abolish monarchy and establish a republic, a representative government with no king. They clashed, however, over what to do with Louis XVI, whom they now called **Citizen Capet.** (The name referred to the first French royal family that began its reign in the Middle Ages.) From the Mountain, the Jacobins poured down their arguments for execution—a living king would continue to inspire counterrevolution, they insisted. The deputies knew that the mobs of *sans-culottes* cried for Louis's blood, too. Girondins resisted and pled for the king's life. The center delegates yielded to the Jacobins and the Parisian radicals. The king would die.

On January 21, 1793, rows of troops stood in the Parisian cold, shrouded in mist. They formed a pathway to the **guillotine,** a recently invented device designed to accomplish more humane beheadings. Clad in plain clothes rather than royal trappings, Louis walked through the lines of soldiers to the block.

## The Reign of Terror

The Jacobin-dominated republic faced serious threats from foreign invasion, an economic crisis, and internal opponents of revolution. After the execution of the king, hostility toward the revolution intensified within France, especially in the *Vendée* region, where peasants felt a strong attachment to royal government and Catholicism. Monarchists outside France also reacted to the king's death. The enemy force abroad grew to gigantic proportions as Britain, Spain, the Netherlands, Sardinia, Austria, and Prussia formed an anti-French coalition. Stricken by reversals on the war front, French leaders resorted to a military draft. Resistance in the *Vendée* turned violent. At the same time, rampant inflation and food shortages sparked revolts against the government in cities across the nation. The Jacobins were determined to save the new system by whatever means necessary.

### The Committee of Public Safety

By April 1793, a Committee of Public Safety emerged in the Convention and began to exercise executive authority. Georges Jacques Danton, a *Montagnard,* led the nine-member Committee at first. The radical *Montagnards* soon not only dominated the executive committee but also took complete control of the assembly. With the backing of the Parisian masses, the predominantly Jacobin forces of the Mountain purged the Girondins from the Convention in June.

### The Constitution of 1793

With the deputies from the Right out of the way, the Convention wrote the supreme principle of the Left, popular sovereignty, into a new constitution. Previously, only people with a specified minimum of property could vote. The Constitution of 1793 extended the vote to all adult males.

### Robespierre and the Republic of Virtue

By July 1793, Danton shared control in the Committee of Public Safety with three radical *Montagnard* deputies—Maximilien Robespierre, Louis de Saint-Just, and Georges Couthon—who had joined the executive group. These leaders reacted to the crisis of war and civil unrest. They decreed a **Levy-in-Mass,** a draft of all males capable of fighting, and issued a plea for the entire nation to support the war by helping with supplies and inspiring the troops. Because chaotic wage and price fluctuations heightened the economic crisis, the government also began to issue regulatory decrees. The draft proved more effective than the economic controls.

During the crisis-ridden summer, Robespierre established his supremacy within the Committee of Public Safety, now a mostly Jacobin group of twelve people. In September 1793, the Committee began to exercise dictatorial authority. Their **Law of the Maximum,** for example, fixed prices on most necessities and on wages. Robespierre also turned the Committee and the Convention toward the achievement of his great cause, the establishment of a **Republic of Virtue.** He proclaimed that democracy could not exist without **public virtue,** by which he meant absolute dedication to the revolutionary nation and its new laws. Robespierre resorted to terror against all enemies of the revolutionary republic in order to create that spirit of total loyalty.

### Jacobin Terror

Robespierre and the Jacobins intended to form an emergency dictatorship and launch a campaign of state terror in order to establish complete democracy. The leaders insisted that they exercised absolute

power in keeping with the will of the sovereign people. Anyone who opposed the revolutionary government thus threatened popular sovereignty and deserved no mercy.

This paradoxical dictatorial-democracy began to cut down assumed enemies in October 1793. During a ten-month Reign of Terror, the former queen, Marie Antoinette, and other nobles died on the guillotine. Most Jacobin Terror victims, however, were not aristocrats. Advocates of federalism, such as the Girondins, and supporters of a more extreme democracy than the Jacobins could tolerate also suffered the same fate. No one was safe. The revolutionary courts even ordered the execution of Danton and Jacques Hébert, a leader of the *sans-culottes*. A wave of violence swept across France. Victims of the Jacobin Terror died not only on guillotines but also in mass drownings, before firing squads, and, sometimes, by cannon shot. The revolutionaries slaughtered thirty to forty thousand before the Terror ended in July 1794.

## The Jacobin Republic

The Convention never implemented the democratic Constitution of 1793. Confronted with crises from the outset, the delegates to the constitutional assembly began to act as a representative legislature. In practice, it became a **Jacobin Republic,** in which one political faction not only executed assumed traitors but also enacted a revolutionary program. Legislation ended imprisonment for debt, abolished slavery in French colonies, and outlawed the granting of noble titles. The Convention also established the metric system, a new calendar with ten-day weeks and a ten-month year, and, as a blow against the conservative power of the Catholic Church, a state Religion of Reason. Metric weights and measurements became popular and permanent. The new calendar and religion did not. The peasants, the vast majority of the French population, held lowly social rank, but their resistance to the latter two anti-church reforms made certain that these changes could not succeed.

### *Carnot, the Organizer of Victory*

The Jacobin republic achieved its most unqualified success on the battlefield against the European coalition. In mid-1793, the Convention selected Lazare Carnot as its Organizer of Victory. He lived up to his title. The Levy-in-Mass gave France an army of more than one million by the early months of 1794. With this largest army in European history, Carnot's generals rolled back the forces against them. The march toward victory abroad reduced the crisis atmosphere in France enough to make the dictatorship of the Jacobins and their reign of terror intolerable to the nation.

### *The Thermidorean Reaction*

The ten months of the new calendar had vividly descriptive names. On the ninth day of Thermidor ("heat") of Revolutionary Year II (July 27, 1794), Convention delegates reacted against the Terror and Robespierre. They clamored so loudly that he could not speak to the assembly, and then voted for his arrest. Within a day, this **Thermidorean Reaction** brought Robespierre's death on the guillotine.

**The Demise of the Jacobin Republic.** Radical revolution ended with the execution of Robespierre. A much more moderate republican spirit prevailed thereafter. The Thermidoreans brought the Girondins back into the governing assembly and eased restrictions that the radicals had placed on the press, the

economy, theater productions, and Catholic worship. **Reactionaries,** people who want to reverse the process of social change, took more drastic counterrevolutionary steps in the southwestern districts of France. The new Thermidorean government, however, continued its moderate bourgeois liberal course for the country as a whole.

**The Constitution of 1795.** The Thermidorean reaction ensured that the radical Constitution of 1793 would remain a dead document forever. The revolutionary assembly that had created it remained committed to republican government but not to popular sovereignty. A new body of law, the Constitution of 1795, denied the vote to the twenty-five percent of the people at the bottom of the economic scale. It also called for a **bicameral** (two-house) legislature, a structure less susceptible to the influence of the masses than a unicameral assembly. As a further guarantee of political moderation, the Convention stipulated that upper-house (Council of Elders) members be at least forty years old and married or widowed. Finally, Thermidoreans arranged for a restrained executive by planning a five-member **Directory** to be nominated by the lower house (Council of Five Hundred) and elected by the Council of Elders. France still had its modern state but a very different one than the Jacobin democrats had intended. The government of the Directory that began to operate would look less to the masses and more to the military for its support—a fateful redirection.

## ■ THE DIRECTORY

The new government under the Constitution of 1795, known as the Directory, emphasized order rather than revolutionary change. At the outset, however, this law-and-order government faced turmoil. The requirement that two-thirds of the members of the new legislature be people who had served in the National Convention sparked outbursts in Paris. General Napoleon Bonaparte commanded a revolutionary army force that suppressed the Parisians with a "whiff of grapeshot," a form of cannon fire. More disorder followed.

The new republic represented the interests of a rich minority—the bourgeois business classes. The Directory forcefully displayed its opposition to actions in support of the masses when Jacques Babeuf, a journalist, attempted to carry out his **Conspiracy of Equals.** Babeuf intended to overthrow the infant capitalist regime, outlaw private property, and distribute wealth equally among the people. The Directory discovered this plot to establish socialism, thwarted it in May 1796, and executed Babeuf the next year.

Opponents of the moderate republic who struck from the Right used different methods than had Babeuf on the Left. Monarchists campaigned for election to the legislature and the Directory in 1797. Enough royalists won to shock the Directory into defensive action. Once more the government turned to the army, this time to bar royalists from the government.

### The Militarization of the Revolution

The necessity of having a powerful military to fight European enemies of revolutionary France and the dependence of the Directory on the army to suppress opposition on the Left and Right in France made young generals popular prospects for government leadership positions. By the latter 1790s, no military figure could equal the appeal of Napoleon Bonaparte (1769–1821).

### The Rise of Napoleon

In 1768, France annexed the culturally Italian island of Corsica, Napoleon's homeland. He began military training in the schools of France at age nine, the beginning of his preparation to conquer Europe. Early in the revolutionary wars, Napoleon displayed exceptional talent as an artillery lieutenant, and he advanced in rank with remarkable speed. He became a brigadier general at age twenty-six and took command of the French armies in Italy two years later (1796). The young general led his forces to victory over the Austrian army there by 1797.

After a triumphal visit to France, Napoleon opened a campaign in Egypt in July 1798. He planned to strike a devastating blow against Britain by seizing the route to that enemy's imperial riches in India. Instead, the British navy blocked Napoleon's access to supplies from France. In August 1799, the general deserted his men and fled home. He suffered no damage to his reputation and soon thereafter took over the government.

### The Eighteenth Brumaire

In late 1799, the Directory gave the nation little hope for success in the dream of spreading the ideals of 1789 to all of Europe. Life also had become increasingly miserable within France. As support for the moderate republic virtually disappeared, Napoleon arrived from Egypt. Two members of the Directory, Roger Ducos and Abbé Sieyès, plotted with the general to overthrow the government. Their coup succeeded, and on November 9, 1799 (18th Brumaire on the revolutionary calendar), the rule of the Directory ended. Republican government also ended as Napoleon established his military dictatorship.

## ■ THE NAPOLEONIC DICTATORSHIP

Napoleon issued a new fundamental law for France, the **Constitution of the Year VIII** (1799, the eighth year of the revolutionary calendar). The constitution deceptively appeared to create a representative republic. Despite giving the right to vote to all males over twenty, a radically democratic step for a European state at that time, the electorate did not directly select legislators. Napoleon could choose the representatives he wanted, so voters had no real power.

The constitution further limited popular influence by having one representative house, the Tribunate, discuss laws without voting, while the Legislative Chamber had to vote on legislation without debate. Napoleon also organized the executive body, the three-member Consulate, in a way that gave him dominance as "First Consul." Napoleon had ensured his personal authority over all government action.

In February 1800, the French, by a margin of three million eleven thousand one hundred seven to one thousand five hundred sixty-two, accepted the constitution of the Consulate and, thus, Napoleon's absolute power. Two years later, another **plebiscite** (a yes-no vote on an issue) approved by an even larger margin the extension of Napoleon's term as First Consul, from ten years to life, and allowed him to choose his successor.

### Government under the Consulate

Napoleon achieved broad popular support for the Consulate by his quick and effective response to the problems of France. He began by taking steps to restore order, dispatching forces to end banditry in southern France and the royalist rebellion that had continued for years in the *Vendée*. Napoleon also initiated reforms that within four years made him almost universally popular.

### Administrative, Judicial, and Educational Reform

Revolutionaries had combined the reorganization of France's administrative system with election procedures that enabled the citizens to select local officials. A law of February 1800 left this bureaucratic structure unchanged but gave Napoleon the power to appoint all the system's leaders.

Early the next year, Napoleon revised the court system and took responsibility for selecting most judges. His expansion of the educational system in 1802 brought more students into the schools, but central control over their learning also greatly increased. With loyal subordinates in charge of an efficiently organized governmental, judicial, and educational machine, Napoleon could control the nation as no king ever had. He began to rule with appealing effectiveness over a modern but despotic system.

### The Concordat of 1801

Land-hungry peasants, resentful of the property-rich and privileged aristocrats, had carried out a revolution in the countryside in 1789. They took the farms and nullified noble rights, and then became a conservative force. When the revolutionaries launched their attack on the Roman Catholic Church, much of the peasantry turned actively counter-revolutionary. Napoleon shared the *philosophes'* dislike of religion, but he won the hearts of the rural masses by concluding a settlement with Catholic leaders on July 16, 1801.

The **Concordat of 1801** allowed the Church to resume the practice of public processions and the operation of its seminaries. It also proclaimed that Roman Catholicism was the faith of most citizens and accepted the right of the Pope to dismiss bishops. The battle between the Church and the revolutionary state had ended with the Napoleonic state victorious: The compromise did not accept Catholicism as the state religion, as it had been before the revolution. Furthermore, the government kept the power to appoint bishops, left the clergy on state payrolls, and extracted an agreement that the church would accept the loss of its lands. With few concessions, Napoleon had converted the Church and its followers into his allies.

### Honors and Jobs

Napoleon found ways to appeal to others than loyal Catholics. He established the Legion of Honor in 1802 to provide a system for rewarding exceptional accomplishments in public or military affairs, an indication of his agreement with the bourgeois idea of "careers open to talent." Members of the middle class who longed for a new "aristocracy" not determined by family bloodline thereafter could anticipate satisfaction of their desires. For workers with the less grandiose dream of having employment, the First Consul had a reward as well. Napoleon launched a program of government-funded projects that multiplied the number of jobs. The Consulate's military needs also guaranteed that certain industries would thrive and create both greater business profits and still more work.

### The Code Napoléon

In a single decade, the French Revolution added an avalanche of laws and several constitutions to the confusing accumulation of codes from previous centuries. Thus far, the revolution had not provided the integrated national legal code that France needed.

The revolutionaries made law reform possible by removing the structure of the old regime. Efforts to develop a coherent system of legal codes then began in the mid-1790s; the work was incomplete when Napoleon seized power. By 1804, however, he had guided the reorganization process through a successful

first stage with the production of the Civil Code. Four additional sections emerged during the next six years to complete a unified body of national law.

This five-part **Code Napoléon** reflected the authoritarian and regressive spirit of the French dictator. It legalized the supremacy of bosses over workers, men over women, and fathers over families. Male family heads could even send their teenaged offspring to jail. The new law did not establish the greater democracy promised by rebels in the mid-1790s, but it remained true to other revolutionary principles. The Code ensured equal treatment under the law for most people as well as personal career choice, religious toleration, private property rights, and minimal restrictions on business. Overall, Napoleon had established a legal system that embodied bourgeois liberal principles. Most French citizens and many people in regions conquered by France found this new order appealing.

### Peace in Napoleon's European Realm

In December 1798, a Second Coalition against France emerged. It included Russia, Austria, Great Britain, and several smaller states. The ability of France to endure against European alliances in the 1790s could not forever justify the costs of the war. The nation wanted peace. Napoleon delivered that and new territories as well.

Soon after the First Consul took power, Napoleon directed an overwhelming campaign against Austrian forces in Italy, climaxing in a victory at Marengo in June 1800. General Jean Moreau then led further attacks that took Austria out of the war. In February 1801, the Austro-French Treaty of Lunéville left Italy and extensive German territory under Napoleon's sway.

Because policy differences with Britain already had caused Russia to quit the Second Coalition, after Lunéville, Napoleon faced only the British. The war continued. When neither power could win decisively, they resorted to peace. The Peace of Amiens (March 1802) let France keep its conquests in Europe: Belgium, the Netherlands, Italy, and parts of Germany. The treaty also provided for the return of French colonies that Britain had taken. At the end of a decade of struggle, France stood supreme in Europe.

## The Empire

The Consulate had taken self-government away from the French citizens, but it provided satisfying compensation: domestic and international peace, an effective governing administration, a system with new personal rights guaranteed, a more prosperous economy, and a large European empire. In 1804, Napoleon offered the nation another prize—himself as emperor and the founder of a new dynasty.

### Popular Monarchy

By the early 1800s, the revolution had removed a widely despised king and brought a new but immensely popular despot to power. The First Consul arranged his transition to greater majesty by writing still another constitution that made him Napoleon I, Emperor of the French. It also specified that a Bonaparte male heir would inherit his throne. More than three million and five hundred thousand voted for the new constitution; only two thousand and five hundred sixty-nine opposed it. A lavish ceremony in the cathedral of Notre-Dame on December 2, 1804, formally established the new empire.

### The Conquest of Europe

Napoleon had established peace, but he longed for a larger European empire. The Peace of Amiens had stopped the war with Britain but not Napoleon's drive for more power beyond France. He tightened his grip on Switzerland and Italy and attempted to end British commercial activity within his vast continental holdings. Great Britain responded with a declaration of war on France, May 16, 1803. By 1805, the British had drawn Austria, Russia, and Sweden into the Third Coalition against France.

Napoleon reacted swiftly with an attack on Austria at Ulm in Bavaria. In this battle, October 17, 1805, the emperor's armies won decisively and took thirty thousand prisoners. A simultaneous attempt to overwhelm Britain failed miserably. Napoleon positioned his forces for a cross-Channel invasion of Britain, and then sent his fleet toward the Caribbean. He expected British Admiral Lord Horatio Nelson to pursue his navy westward while the fleet secretly doubled back to join the attack on Britain.

**Trafalgar.** Lord Nelson followed his adversaries, caught them off the southwest coast of Spain at Trafalgar, and defeated the combined French and Spanish navies (October 21, 1805). Nelson died of injuries sustained in the Battle of Trafalgar, but his fleet triumphed so completely that France could no longer challenge Britain at sea. His victory left Napoleon with no way to reach Great Britain except in a fantasy of digging a passageway for his troops under the English Channel.

**The Battle of Austerlitz.** The Austrians continued to fight after their defeat at Ulm. The French marched to engage the armies of both Russia and Austria in the latter's territory in late 1805. On December 2, Napoleon led his forces to their most stunning victory as the French army devastated the Russians at Austerlitz before they joined ranks with the Austrians. The French suffered about nine thousand killed or wounded, but Russian casualties numbered thirty thousand. The outcome convinced Austria to quit the war, a decision formally arranged on December 26, 1805, in the Treaty of Pressburg. Despite the heavy losses, Russia refused to sign the peace agreement.

**The Battles of Jena and Auerstadt.** Before Austerlitz, Prussia contemplated joining the Third Coalition. Instead, after the French victory in Austria, the alliance dissolved. Months of diplomatic maneuvering followed as Napoleon tried to arrange treaties with Prussia and Russia that would give France a still stronger hold on Central Europe. This grab for greater power inspired Prussia to declare war on France, October 1, 1806. Because Russia and France remained enemies, the Prussian action marked the formation of a Fourth Coalition, but this new alliance posed no serious threat to Napoleon. On October 14, he turned his two hundred thousand battle-hardened warriors against the ill-prepared Prussians at Jena and Auerstadt. A single day of combat crushed the Prussians. Twenty-six days after the declaration of war, Napoleon held the Prussian capital of Berlin. King Frederick William III of Prussia (reigned 1797–1840) fled to Memel, seven hundred miles to the east at the edge of his realm.

**The Treaty of Tilsit.** Prussia had not surrendered to Napoleon, but only Russia remained actively in the war. Napoleon's armies marched northeast and subdued the Russians at Friedland on June 14, 1807. Tsar Alexander I (reigned 1801–1825) accepted defeat on June 21. He and Napoleon met June 25 on a raft in

the Nieman River to sign the Treaty of Tilsit. As the emperors agreed to peace terms, King Frederick William waited apprehensively on the bank for Napoleon's decision about the fate of Prussia.

### The Grand Empire of France

By late 1805, Napoleon had gained control over most of the continent. At Pressburg (December 1805), Emperor Francis II of Austria surrendered several of his Italian territories. Other Italian rulers suffered losses to France as well. Napoleon gave his brother Joseph the throne of Naples in southern Italy in 1806.

The French emperor expanded his authority northward also. He gave his brother Louis the newly created Kingdom of Holland in June 1806. On July 12, Napoleon established the Confederation of the Rhine, which consolidated and subordinated most of the states of Germany. This extension of French power into Germanic territories brought an end to a very old, if symbolic, European institution. It prompted Francis II to become simply the Emperor of Austria on August 6, as he dropped his title to the Holy Roman Empire, a formal union of the German lands founded in the 900s but a virtual fiction in modern times.

At Tilsit, the Russian emperor accepted the new map of Europe established by Napoleonic conquests up to that time, July 1807. The treaty dictated to Frederick William of Prussia at Tilsit that he also recognize these territorial arrangements and limit the Prussian army to forty thousand. Prussia subsequently received notice of requirements to pay 120 million francs to France and surrender additional territory on the Elbe River.

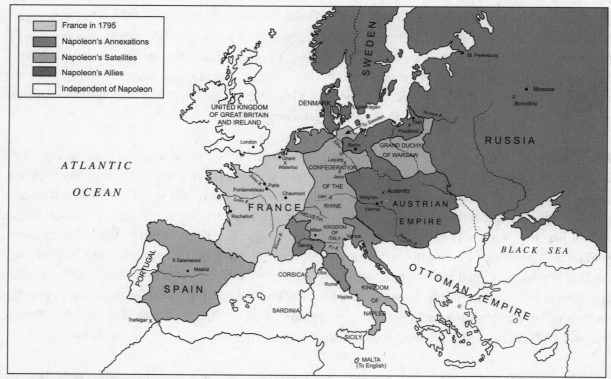

*Figure 4.1: Europe in 1810*

**The Continental System.** Napoleon then turned his attention westward to the Iberian Peninsula. His Berlin Decree, November 21, 1806, had ordered an end to trade between continental countries and Britain. This **Continental System** could not prevent the entry of British goods, because Europeans

needed the products of British industry and France could not control all borders. When Portugal refused to comply with this policy, Napoleon responded by dispatching an army of occupation in November 1807. The emperor reaffirmed in his Milan Decree, December 17, 1807, that commerce between Britain and the continent was forbidden. His word, however, still did not stop the movement of British goods.

**The Bonaparte Kingdom of Spain.** Emperor Bonaparte continued his westward advance. A French army of 100,000 swept into Spain in March 1808 and drove Charles IV from his realm. Subsequently, Napoleon gave the Kingdom of Naples to General Joachim Murat and brought Joseph Bonaparte from that southern Italian state to the throne of Spain.

## The Fall of Napoleon

The European monarchies' fierce military resistance to France had proved futile against a nation aroused by revolutionary zeal and intense patriotism. The patriotic spirit that the French exhibited seemed not to exist in other European nations. The conquest of Spain, however, brought a foreboding change for Napoleon. An opposing patriotic tide began to rise in Iberia that would eventually sweep him from Europe.

### The Peninsular War (1808–1813)

The mostly peasant population of Spain supported its monarchy and despised the alien French regime. Nobles similarly hated the elements of bourgeois liberal doctrine that Napoleon extended throughout his Grand Empire, and Spain had no significant middle class to which French bourgeois ideals might appeal. Finally, the Continental System, which Napoleon's armies came to enforce, worsened economic conditions for the Spanish. They rebelled.

**Guerrilla War against the French.** Napoleon now faced a new kind of enemy. The Peninsular War did not take place between state armies massed on battlefields. Independent Spanish warrior groups called **guerrillas** (the word entered the English language at this time) struck without warning against Napoleon's troops as the French moved about the country. The guerrillas attacked them in their camps, killed the wounded in their beds, poisoned their water supply, and then disappeared into hideouts. Vicious suppression tactics failed against the patriotic Spanish warriors.

**Spanish Victory.** Still, in the opening years of this fight, Napoleon continued to dominate the continent as completely as Britain did the European seas. The Peninsular War, however, ended the standoff. Sir Arthur Wellesley brought a British force into Spain, and by August 21, 1808, it won a battle over the French at Vimeiro. After a brutal struggle, the Spanish guerrillas and British troops drove Joseph Bonaparte from the Spanish throne in 1813. The war had kept four hundred thousand French warriors south of the Pyrenees. Napoleon needed them elsewhere.

### Patriotic Rebellion and War in Germany

The lessons of the Peninsular War led the Archduke Charles, commander of the Austrian army, to call for Germans to unite in a war of national liberation. He invaded French-held Bavaria with an army of nearly two hundred thousand in April 1809. A few Germans responded to the Archduke's patriotic plea, but not enough. Napoleon left Spain and took Vienna, Austria, by mid-May. Seven weeks later, he

won a victory at Wagram that ended the war. The Treaty of Schönbrunn on October 14, 1809, took thirty-two thousand square miles and three-and-a-half million people away from the Austrian Empire.

Patriotism in Prussia inspired a much more serious threat. The fondness for French liberalism had waned in Central Europe as Napoleon exploited conquered territories economically to strengthen his empire. The example of French invaders deeply devoted to their own country also had begun to encourage the growth of Prussian or, more broadly, German, patriotism.

Prussian leaders took advantage of the new climate of opinion. They freed the serfs, ended the practice of allowing only nobles to serve as military officers, established a national draft to raise a citizen army, improved the treatment of recruits, and carried out other reforms that advanced Prussia toward the Enlightenment's modern vision of the state. When the Prussian government completed its program of change in 1813, it stood as a formidable enemy for Napoleon. It could fight with popular support.

## The Deadly Invasion of Russia

The Treaty of Tilsit (1807) ended warfare between Russia and France but did not bring harmony. Many differences troubled Franco-Russian relationships, but none so much as conflicts over the Continental System. This policy struck Russia with special severity, because its highly agricultural economy required active trade with industrial Britain. Tsar Alexander finally refused to submit to the Continental System.

Napoleon decided to smash Russia. He marched four hundred thousand men to the country's border at the Nieman River during the last weeks of spring in 1812. Behind France's Grand Army came another two hundred thousand reserves. In late June, Napoleon took the first of his troops across the river. His forces poured over the border for the next three days.

About half the men who trekked toward Moscow were French; the rest came unwillingly from client states such as Sweden, the Netherlands, Prussia, Poland, Switzerland, Austria, and Italy. The Russians retreated before them, destroying almost everything in the areas they evacuated. Napoleon had planned to live off the land.

**The Battle of Borodino.** Seventy miles west of Moscow, Russian general Mikhail Kutusov commanded the forces that stood and fought Napoleon at Borodino, September 7, 1812. The Russians lost but took a very heavy toll among the French. Napoleon entered Moscow's Kremlin one week later. No leaders met him to surrender, and the city surrounding the Kremlin's walls lay virtually empty. Fires erupted in Moscow the next day and burned for nearly a week, taking still more of the supplies that Napoleon needed.

**Russian Victory.** No word of submission came from Tsar Alexander during the next five weeks. French troops lacked the supplies to occupy Moscow through the winter. They began to withdraw on October 19, returning along their invasion route already stripped of resources. During the retreat from Moscow, early snows and an unusually harsh winter brought misery to Napoleon's men. They fell from hunger, exhaustion, and cold. Guerrilla bands and the tsar's Cossack cavalry inflicted still more casualties. Fewer than fifty thousand (about ten percent) of Napoleon's troops survived to cross the western Russian border in mid-December 1812. By then, Napoleon was in Paris raising an army to replace the one he had lost. The emperor filled its ranks with many who were adolescents.

### The Conquest of France

A new and ominous coalition confronted Napoleon in 1813. Austria, Prussia, Russia, and Sweden converged on the unseasoned French warriors in Prussia at Leipzig. The battle raged for three days in mid-October and ended in a devastating defeat for Napoleon. British and Spanish invaders struck France from the south the next month. The Coalition's armies seized Paris at the end of March 1814. Napoleon abdicated. The victors permitted him to retain his imperial title but placed the emperor on Elba, an Italian coastal island. In France, they also enthroned Louis XVIII, a Bourbon and the brother of Louis XVI.

**The Hundred Days.** Exile and the restoration of the Bourbon dynasty failed to remove the threat of Napoleon to Europe. On March 1, 1815, the emperor invaded southern France with fewer than two thousand men. King Louis sent an army to defeat Napoleon, which met the exiled emporer and swore allegiance to him. Napoleon took Paris on May 20 and began a second reign, this time for only one hundred days.

**Waterloo.** Napoleon soon raised still another army and invaded Belgium. He made progress at first against the coalition, which now included most of the leading European states. His attack on the British at Waterloo, June 18, 1815, brought him close to another victory. But the British army under the Duke of Wellington held throughout the day, and the Prussians arrived to ensure Napoleon's defeat. He would fight no more battles. Napoleon surrendered to the British, who rejected his request for retirement in Britain. They took him instead to the island of St. Helena, more than one thousand miles from the southwest coast of Africa. Napoleon died there in 1821.

*French revolutionaries in 1789 destroyed the old sociopolitical order in their own country, an act of modernization that immediately threatened aristocratic and monarchical institutions all over Europe. The inherent conflict between France and the royalist states led to bitter war that persisted throughout the 1790s. The inability of the revolutionary government to win either the war or wide support at home in the late 1790s led the French to turn to Napoleon, a military hero, for victory abroad and an end to domestic chaos.*

*Napoleon fashioned a new system, a dictatorship made popular with widely appealing reforms and imperial triumphs. His conquests gave France control of most of the land from the Atlantic Ocean to the western borders of Russia by 1808. The French took many of their bourgeois liberal reforms with them into the territories they seized, and many people there welcomed the revolutionary changes the invaders brought.*

*When Napoleon extended control into the Iberian Peninsula in 1808, however, popular resistance erupted, especially among the Spanish. They preferred their king and traditional ways. Central European people turned more hostile, too, as French liberalism seemed increasingly alien and exploitative. A new coalition of European monarchical states, led by Britain, then emerged and pursued Napoleon to his final defeat at Waterloo in 1815. The monarchies had stopped Napoleon, but not the forces of political modernization that he unleashed in Europe.*

## Selected Readings

Bergeron, Louis. *France under Napoleon*. Princeton, NJ: Princeton University Press, 1981.

Doyle, William. *Origins of the French Revolution*. New York: Oxford University Press, 1988.

Godineau, Dominique. *The Women of Paris and Their French Revolution*. Berkeley: University of California Press, 1998.

*www.fordham.edu/halsall/mod/modsbook.html* (At this site, click on the link for "Three Revolutions," and then choose one of the two French Revolution links.)

*http://history.hanover.edu/project#modern* (Documents available include several *cahiers* and the Civil Constitution of the Clergy.)

Jordan, David P. *The Revolutionary Career of Maximilien Robespierre*. New York: Free Press, 1985.

Kennedy, Michael L. *The Jacobin Clubs in the French Revolution, 1793–1795*. New York: Berghahn, 2000.

Markham, Felix. *The Bonapartes*. New York: Taplinger Publishing Company, 1975.

Rothenberg, Gunther E. *The Art of Warfare in the Age of Napoleon*. Bloomington: Indiana University Press, 1978.

Sutherland, Donald M. G. *France, 1789–1815: Revolution and Counterrevolution*. New York: Oxford University Press, 1986.

## Test Yourself

1) Robespierre intended for the reign of terror to
   a) create the conditions required for democracy to exist
   b) end lower-class influence on the revolution
   c) subordinate the lower bourgeoisie to the upper bourgeoisie
   d) stop the rising power of the French military

2) The way the Directory (French government, 1795–1799) suppressed its enemies resulted in
   a) the closing of the Catholic Church
   b) strengthened military influence in French government
   c) aristocratic support for the Directory
   d) the Reign of Terror

3) Judging by social circumstances in France that brought the first acts of political rebellion in May and June 1789, the people who are the most likely to launch a revolution are
   a) economically comfortable, well-educated people who lack privileges and power
   b) urban mobs of hungry, frightened, lower- and lower-middle-class people
   c) rising young military leaders from the lower classes
   d) aristocrats who have lost traditional powers in government

4) In the following list, which is the most important reason for Napoleon's disastrous failure in his invasion of Russia in 1812?
   a) the loss of French troops at Borodino
   b) the refusal of the Tsar to appear and admit defeat after the seizure of Moscow
   c) the guerrilla raids on the French during Napoleon's withdrawal from Russia
   d) the inability of Napoleon to get supplies for his troops

5) The way in which Napoleon governed shows that he recognized the necessity for a fully modern state to
   a) practice unlimited democracy
   b) maintain at least a moderate degree of genuine democracy
   c) keep broad popular support for government
   d) avoid deceiving the public about the true extent of its influence

6) Revolutionary violence most clearly affected the actions of Louis XVI immediately after
   a) the September Massacres
   b) Napoleon's whiff of grapeshot
   c) the Reign of Terror
   d) the fall of the Bastille

7) The principles acted on by the people who most influenced France from June 1789 to the fall of Napoleon indicate that, overall, it is most reasonable to conclude that the goal of the French revolution was government of, by, or for
   a) the bourgeoisie
   b) urban workers
   c) peasants
   d) the Third Estate

8) Working from the text rather than memory, write a fact-supported essay justifying your answer to multiple-choice item 7.

## Test Yourself Answers

1) **a.** It appears certain that Robespierre used dictatorship and terror in the belief that he could make the revolution lead to democracy. Other optional completions have a hint of accuracy but are not good choices. For example, Robespierre would use terror against lower-class rebels that he thought threatened his control, but he did not want to end the influence of that whole social category.

2) **b.** The text emphasizes the importance of the militarization of government that resulted from Directory actions, but suggests nothing about influences on aristocratic attitudes. The Reign of Terror happened before the Directory existed, and the Churches never closed.

3) **a.** Aristocrats unintentionally helped set the stage for revolt, and city crowds affected events, but mostly after the first acts of rebellion. The best choice for a completion recognizes the direct control of the bourgeoisie in the "first acts" of revolution.

4) **d.** All the optional completions indicate an influence on the French failure in Russia, but the problem of supplies hurt Napoleon's forces on the march to Moscow, made it impossible to wait out the Tsar over the winter, and ensured great losses during the retreat. Much else influenced the French loss, but the answer that refers to supplies is the best option in this list.

5) **c.** Napoleon established certain rights that liberals wanted, but the nature of his government and the letter of the law in his codes left no hint of popular sovereignty. The first two optional completions, therefore, cannot be correct. The ways that Napoleon so effectively courted popular support included giving a false sense of representative government in the Consulate and the probably deceptive hint of democracy shown in holding plebiscites. Napoleon did not seem to think that being honest with citizens was a necessity, but he obviously knew the value of popular support.

6) **d.** The text gives no indication of the effect of the September Massacres on the king, and his execution took place before the terror or the "whiff of grapeshot." The crowd's seizure of the Bastille directly led to Louis XVI's public actions, suggesting his acceptance of the revolution.

7 and 8) **a.** The principles and actions aimed at determining who controlled and benefited from government throughout the 1790s, as diverse as they were, mostly favored bourgeois power and interests. When Napoleon took charge as dictator, he built a system very much in keeping with many bourgeois ideals. He gave the French orderly government, equal treatment for people under the law, policies friendly to business, honors for people because they showed their worth to society rather than because of aristocratic family history, and much more that the bourgeoisie believed in and that others had come to value. Thus, the text indicates that Napoleon provided government "for" the bourgeoisie and suggests that middle-class people also had a better chance than before of becoming leaders in Napoleonic France—meaning that to a certain extent it was government "of" even if not "by" the bourgeoisie. An analysis and discussion of revolutionary leaders and actions during the 1790s and a more detailed treatment of the Napoleonic system along the lines suggested here could hardly make a stronger case for any of the four completions other than the bourgeoisie. Urban workers and peasants certainly influenced the revolution, but it would be difficult to support the conclusion that it was "government of, by, or for" city workers, peasants, or even the Third Estate as a whole.

# Modern Ideologies and the *Ancien* Resurgence (1815–1829)

**1770:** The eminent composer Ludwig van Beethoven (1770–1827) is born.

**1776:** Bentham advances his idea of utilitarianism.

**1790:** Burke's *Reflections on the Revolution in France* is published.

**1798:** Malthus presents his *Essay on the Principle of Population.*

**1809:** Metternich becomes Foreign Minister of Austria.

**May 1814:** The Treaty of Paris is completed after the first defeat of Napoleon.

**September 1814:** The Congress of Vienna begins.

**1815:** The Final Acts of the Vienna Congress are adopted.

**1817:** Ricardo publishes *On the Principle of Political Economy and Taxation.*

**1820:** A liberal revolt begins in Spain.

**1821:** The Greek independence rebellion breaks out.

**1829:** Greece wins independence from the Turkish Empire.

*The exceptionally brutal conflicts unleashed by the French Revolution continued as a war of both ideas and politics through much of the 1800s. At the intellectual level, many foes of tradition after the 1790s attacked the old order with somewhat new forms of liberalism and nationalism. Others turned to an even more radical modern doctrine—Socialism.*

*Despite the persistence of Enlightenment ideas during and after the French Revolution, from the 1790s to the 1850s, growing numbers of intellectuals and artists rejected the Age of Reason outlook emphasizing logical thought and Natural Law. They became Romantics, theorists who believed that emotion could reveal more about their world than the logical methods of the Enlightenment. Although Romantics had much in common intellectually, they divided on issues related to revolution, with some supporting new sociopolitical systems and others opposing them.*

*As an intellectual attack on the Enlightenment, romanticism somewhat countered the thinking that fostered hostility to the* Ancien Regime. *A direct and conscious effort to restore a tradition-oriented outlook came, however, in the form of conservatism, a new body of ideas that emerged in the 1790s. At Vienna in 1814, political leaders took up the more concrete tasks of conservatism, restoring as much of the* Ancien Regime *as possible after twenty-five years of revolution and war. At the same time, enemies of the old regime worked to win the political battles begun during the French Revolution. By 1815, the forces for the ideologies of change—liberalism, nationalism, and Socialism—and the conservative opposition stood ready for many more years of bitter struggle.*

## ■ MODERN EUROPEAN IDEAS

Although differences existed within intellectual groups, such as liberals or conservatives, the most serious conflicts in the first half of the 1800s were between theorists in clearly separable intellectual factions. Adherents of liberalism, socialism, and nationalism held beliefs that pitted them against defenders of the old order. Romantics scorned Enlightenment principles and advocated a very different outlook on life. Conservatives devised a modern theoretical justification for the traditional social system and forcefully confronted liberalism. Thus, by the early 1800s, the war of ideas occurred between competing modern beliefs rather than between old and new views, as had been the case in the Enlightenment.

### Liberalism in the Early 1800s

The liberal creed that emerged by the early stages of the French Revolution suited the bourgeoisie especially well. The advocates of liberalism favored opening the way for the most dynamic and talented individuals to rise to the top of society and run the government or operate freely in business without the interference of traditional or legal restraints. During the early 1800s, liberals in France and elsewhere typically began to concentrate on the establishment of parliaments to implement bourgeois self-government and constitutions to guarantee the individual rights in which they so strongly believed—personal liberty, freedom of opinion and expression, and, especially, the profitable use of property.

### *Thomas Malthus*

Confronted with the hard realities of the Industrial Revolution, British intellectuals in the late 1700s and early 1800s sometimes gave a new direction to the liberal creed that members of the bourgeoisie used as they tried to shape governments and laws. Early in his career, Thomas Malthus (1766–1834) presented a liberal vision of industrial-age economics that strongly influenced economic and political thought for generations thereafter. His *Essay on the Principle of Population* (1798) argued that the food supply and other life necessities increase arithmetically, adding a little at a time, while humans reproduce geometrically—they *multiply.* As a result, he argued, the laboring masses must always live in poverty. At best, they could hope for a slight improvement of their lot by controlling their sexual urges. Bourgeois liberal industrialists welcomed this argument against government aid for the poor. Malthus thus provided important support for *laissez-faire* liberalism, a theory justifying business uncontrolled by government.

### David Ricardo

David Ricardo (1772–1823), another liberal economist, spelled out the hard fate of industrial workers even more dramatically in his 1817 publication *On the Principle of Political Economy and Taxation.* He expanded on the views of Malthus with the assertion that whenever wages improved, laborers responded sexually, producing more children, who then flooded the labor market and forced wages down. This **Iron Law of Wages** justified paying workers as little as possible.

### The Utilitarianism of Jeremy Bentham

In works he produced beginning in 1776, Jeremy Bentham (1748–1832) also responded to industrial realities, but in a different way than Malthus and Ricardo. Bentham denied the existence of Natural Laws that determined human affairs but asserted that an inherent tendency to seek pleasure and avoid pain controlled social development. Consequently, Bentham concluded, leaders should use the principle of **utility,** governing in a way that gave "the greatest good to the greatest number of people." He affirmed that statistical data could guide governments toward this utilitarian goal.

This doctrine of utilitarianism varied from earlier liberal ideas in turning away from Natural Law arguments and in its emphasis on actions to benefit "the greatest number." Bentham's concern for the welfare of the masses modified but did not reject liberal individualism. His ultimate objective still coincided with the fundamental goal of liberalism: individual freedom. Bentham also thought that government for the "greatest good" did not require regulation of business. *Laissez-faire* economics suited him quite well.

## Socialism

A few social critics in the early 1800s rejected both the old regime and liberalism. Instead of supporting either traditional aristocratic society or a modern bourgeois alternative, they spoke for the laboring masses. These self-described **socialists** blamed the suffering of the working masses on societies that emphasized production rather than the fair distribution of goods, competition rather than cooperation, and individualism rather than community. The founders of modern socialism proposed a variety of solutions.

### Henri de Saint-Simon

Henri de Saint-Simon (1760–1825) had the typical socialist faith that humans are naturally kind, a trait that offered the potential to build a truly just society. If people who already lived well became fully informed by the science of the day about the circumstances of the unfortunate, Saint-Simon asserted, their inborn goodness would inspire them to provide all the material and spiritual needs of others. Then everyone would enjoy a modern industrial paradise, a utopia born of science and socialism.

### Charles Fourier

Charles Fourier (1772–1837), another French socialist, thought that small communities rather than ideal industrial cities would naturally foster the kind of sharing that would bring ultimate happiness. Many small communities or **phalanges,** each with about four hundred families who jointly owned institutions such as schools and health facilities, would make up his more perfect socialist world. *Phalange* citizens would take turns doing unpleasant but necessary work. Fortunately for the adults, their occasional

distasteful tasks would not have to include trash disposal. Fourier assumed that children so enjoyed filth that they would be the *phalange's* sanitarians.

### Robert Owen

Robert Owen (1771–1858), a prosperous Scot textile mill owner, felt distressed about the misery of the working class and turned to socialism, despite his bourgeois career. He proposed small cooperative industrial communities as a model, and so somewhat combined the visions of the two French socialists. Owen applied his ideas quite successfully in New Lanark, Scotland, in the early 1800s, but his experimental industrial socialist community in New Harmony, Indiana, lasted only a few years in the 1820s before conflicts ended the effort.

Relatively few people adopted the beliefs of these first **utopian** socialists. Most enemies of the *Ancien Regime* before the 1850s found liberalism, nationalism, or a combination of these ideologies more appealing.

## Nationalism

Before the French Revolution, a widely shared language and a unifying culture born of a long common history had laid the foundations for nationalist ideology in that country. Once these conditions existed, **nationalism** emerged, as the French began to think of themselves as a nation with a unique heritage.

French nationalism evolved in association with the belief that the nation and its government were the rightful possessions of all citizens. This nationalist spirit strengthened dramatically during the radical phase of the revolution, as royalist foes fought to destroy the new French system. The masses and their leaders had a common and distinctly French cause for which they struggled to the utmost.

This belief in a special historic mission, often found in nationalist thinking, inspired France as this revolutionary nation conquered Europe. French imperialism then triggered nationalist reactions throughout the continent. Nationalism matured in Britain at about the same time as in France and soon thereafter in other countries in somewhat the same way that it had in France. Nationalists everywhere in Europe had learned much from revolutionary France about the nature and power of modern nationalism.

### Liberal Nationalism

Liberal and national sentiments blended compatibly during the French Revolution in the thinking of the Girondins and others. They wanted a united nation governed by all French citizens. **Liberal nationalists** called for a constitution that ensured universal individual rights. They also expected the entire citizenry to mobilize for national defense or the spread of the country's way of life. The nationalists of East and Central Europe from 1815 to 1848 had a very similar outlook. They had no nation-state; therefore, they fought for its formation and for the establishment of a liberal system of government within the new nation. Throughout the first half of the 1800s, liberal nationalism was an explosive revolutionary blend across all of Europe.

## Romanticism

Liberal ideas grew out of the Enlightenment, with its emphasis on reason as the preeminent human trait. Although liberalism continued to appeal to many theorists between the late 1700s and mid-1800s, the rationalism of the Enlightenment lost its supremacy among European intellectual and cultural leaders in

these years. The Enlightenment gave way to the Age of **Romanticism,** an era when most artists, writers, and theorists denied that humanity could discover truth by reason.

Enlightenment rationalists had despised the Middle Ages for its mystical, superstitious character. Romantics considered the Middle Ages a wonderful era and disparaged the Enlightenment's overly intellectual and mechanistic view of humanity and nature. The fondness of Romantics for that earlier age is even indicated in the origin of the word used to describe their outlook. It is derived from the label for a form of medieval literature, the narrative romance poetry of the 1100s.

Romance literature in the Middle Ages displayed a writer's emotions, all of them. Frivolity, sadness, hate, love—whatever the poet felt deserved expression. Modern Romantics identified closely with this emphasis on emotions. The reasoning mind, they believed, served humanity in the quest for knowledge and insight, but feelings revealed far more. From the romantic point of view, therefore, the *philosophes* had both ignored the most important human quality and missed the best route to truth.

### The Romantic View of the Individual, Nature, and Society

Romantics disagreed with the Enlightenment view of humanity in other respects, too. In the Age of Romanticism, the individual remained a vital concern. The newer perception of individualism differed sharply, however, from the Enlightenment idea. Romantics saw everyone as unique. People did not have universally similar endowments. Variations among humans were inevitable, for they were not intellectual machines but beings with emotions and souls. These infinitely diverse and spiritual individuals required liberty, not as an inherent right under Natural Law, but in order to explore their inner world and experience nature. In this way, the truly creative human could emerge.

Nature, from which the individual could learn so much, also appeared vastly different to Romantics than to the *philosophes.* An organic natural world—one with emerging life, growth, and mystery—appeared in the ideas of this new cultural generation. Gone were the clockwork images of the Enlightenment. God, an involved and spiritual being, made and moved this universe.

Romantics found as much error in the *philosophes'* idea of society as in their notion of God. In the world as conceived by Romantics, societies and nature had organic characters. They grew over time, each different from all others. Intellectuals, therefore, could not categorize them scientifically, analyze their flaws, and make plans for a more perfect new society. An understanding of the social order required the study of particular peoples and the examination of their outward and inner traits through folklore and history.

### The Arts in the Age of Romanticism

A reformist impulse followed naturally from the Enlightenment outlook. Eventually, even a revolutionary mood became somewhat typical of Enlightenment thinkers. Romanticism lacked such a clear-cut inclination on social issues. Several leading Romantics rejected Enlightenment premises but adopted liberalism and even supported revolution to achieve its goals. Others ardently opposed liberalism, reform, and revolution.

A more consistent contrast existed between the *philosophes* and Romantics in the works through which they expressed themselves. Enlightenment intellectuals usually offered dispassionate treatises on politics, society, and human nature. Romantics more often turned to the arts, especially poetry, to pour out their feelings and ideas.

**Literature.** When romance dominates ideas and the arts, the works that appear emphasize emotion but not necessarily love. Romance literature, however, frequently does focus on love, as in the poetry of the Russian writer Alexander Pushkin and Johann von Goethe's German novel *Sorrows of the Young Werther* (1774). For many Romantics, however, a love affair with the opposite sex evoked less passionate expressions in their writing than love for nature. They wrote with intense emotion about their devotion to the natural world. The poetry of the British writers George Gordon, Lord Byron (1788–1824) and Percy Bysshe Shelley (1792–1822) vividly illustrate this love for the beauties and forces of nature.

Romantics perhaps did not love the unnatural quite so well, but they found it deeply interesting, an attitude reflected in Goethe's *Faust (1808),* Mary Shelley's *Frankenstein (1818),* and Michael Lermontov's *The Demon* (1841). Whatever they wrote about, Romantics consciously violated the rigid standards of composition adhered to in previous generations. Artistic revolt had a universal appeal to them that social reformism did not.

**Music.** The consistent tendency toward cultural rebellion affected Romantic music as well as literature. Tradition dictated that musical expression had to take certain precise forms governed by intellect rather than emotion. Ludwig van Beethoven (1770–1827), Franz Schubert (1797–1828), Robert Schumann (1810–1856), Frédéric Chopin (1810–1849), and other Romantic musicians shattered this tradition. They wrote in the highly individualistic style that has come to be expected of all true artists in modern times. Above all, in contrast to the works of their predecessors, Romantic compositions conveyed feelings in reaction to exotic places, moving experiences, or whatever generated emotions worthy of expression.

**Art.** The same culturally rebellious and emotional spirit prevailed in the art of this era. Artists ignored the standards of the past and portrayed their diverse visions of what they saw or imagined. In response to the real sights of his times, Théodore Gericault (1794–1824) depicted his feelings about the Napoleonic wars in paintings such as *Wounded Soldiers in a Cart.* Eugène Delacroix (1798–1863) imagined the Middle Ages in his *Entrance of the Crusaders into Constantinople.* The works of these and other Romantic painters indicate the emergence of a much more modern idea of artistic expression.

## Conservatism

Despite its culturally rebellious character, Romanticism emerged as a reaction *against* intellectual trends that contributed to the highly revolutionary social conditions of the late 1700s and early 1800s. The trauma of social upheaval and war that strengthened the tendency of cultural leaders to question Enlightenment principles encouraged a more general reaction against the French and Napoleonic revolutions. The ideology of **conservatism** arose as the strongest and most direct condemnation of revolution and the most complete depiction of an alternative social vision.

### Edmund Burke

French royalists had scarcely had time to realize the horrible times that awaited them when Edmund Burke (1729–1797) published his damnation of the rebel cause and predicted the terror to come. In *Reflections on the Revolution in France* (1790), this English theorist and political leader urged the British

to recognize the madness of the notion that the old social order should be destroyed and replaced by one of new invention. Burke asserted that an attempt to follow the dictates of human reason rather than tradition would lead to slaughter on a vast scale and to military despotism.

Burke demanded reverence for tradition. Whatever had evolved from the distant past became part of a living society. The removal of anything from such an organic structure, even an obviously defective institution or practice, threatened disaster. Improvement could come only by a cautiously slow process, as in the cultivation of a plant. Burke's ideas became the foundation for a widely influential ideology that flowered more fully in the 1800s.

### The Principles of Conservatism

Conservatives diametrically opposed every central idea of liberalism and, as in the writings of Edmund Burke, demanded worship of the traditional order. In keeping with long-standing custom, they therefore insisted that everyone accept his or her inherited position in the social hierarchy. The principle of hierarchy as well as historic precedent indicated that people must revere authority. From the masses at the bottom to the aristocrats at the top, all people had to obey their superiors, especially God's anointed supreme ruler, the king. The rejection of this tradition would lead to chaos, according to the conservatives.

The arguments for the general principles of hierarchy and authority indicated the primary concerns of conservatives in this era—the maintenance of aristocracy and monarchy. In keeping with both the abstract doctrines and their specific social values, conservatives also insisted that the historic Christian church must regain its spiritual supremacy. God willed that humans live in a system of moral as well as social and political authority and hierarchy. Following the dictates of the clergy would prevent the destructive behavior of inherently evil humanity.

Most conservative ideas blended into a coherent anti-liberal doctrine, a justification for thwarting the liberals who wanted to usher in a society consistent with their own new doctrines. Until after the mid-1800s, conservatives also fought tenaciously against another force for change in the traditional European order—nationalism. The rising sentiment among East and Central Europeans for the formation of states on the basis of nationality evoked an intensely hostile reaction from the defenders of the *Ancien* tradition, because the establishment of a nation-state system would obliterate the political structure on which they thought their way of life depended. To make matters even worse, nationalists in these decades wanted their new regimes to be liberal.

## ■ THE CONCERT OF EUROPE

Royal and aristocratic devotees of conservatism from every state that had been at war in Europe in 1814 converged on Austria's capital in September of that year. With Napoleon on Elba and Louis XVIII enthroned (see Chapter 4), the coalition that overthrew the emperor had invited all countries involved in the recent war, even France, to send representatives to Vienna.

The delegates who went to Vienna assembled as a "congress" to decide the fate of post-Napoleonic Europe. Before this **Congress of Vienna** adjourned in June 1815, representatives agreed on redrawn postwar borders, and Britain, Russia, Prussia, and Austria pledged to maintain their **Quadruple Alliance** to enforce Vienna agreements. After the formal meetings ended, the leaders of the **Concert of Europe** or **Congress System,** as the new double-named counter-revolutionary system came to be known, agreed to

work together to stop rebels from further altering monarchical Europe. The Concert of Europe intended to change from an alliance to defeat France into an institution to preserve peace in the interest of aristocratic social supremacy and royal political authority. The work of the Congress and the Concert helped to bring about forty years without a war between European states.

## The Congress of Vienna

The members of the Coalition that led the battle against France—Britain, Russia, Austria, and Prussia—dominated the proceedings at Vienna. These nations intended to balance power in Europe as a way to maintain peace. In keeping with this principle, they began their work by concluding a lenient treaty with France so that the restored kingdom would have the strength necessary to ensure international equilibrium.

The Treaty of Paris (May 1814) that ended the war between France and the Coalition redrew French borders as they had existed on November 1, 1792. This provision gave France newly acquired areas such as the Austrian Netherlands, and returned most of the colonies lost to Britain during the wars. France also paid nothing for the destruction and expenditures caused by warfare since 1792. These peace terms indicate that conservative leaders in this era intended to restore the old order but not precisely as it had been. They would accept significant changes and adopt new policies in order to preserve the *kind* of society they preferred.

### The Great Power Leaders

The representatives of Austria, Britain, Russia, and Prussia conducted their deliberations in secret. The Austrian Emperor, Francis, provided lavish entertainment for delegates to the Congress who were excluded from the talks, but this failed to placate them. Their protests, however, accomplished little. They went on with their dinners and dances while a handful of men decided the fate of Europe.

**Metternich: Foreign Minister of Austria.** The carefully groomed and self-assured aristocrat, Prince Klemens von Metternich (1773–1859), took charge of Austrian foreign relations in 1809. When the Congress convened in Vienna, he brought it under his command and continued to dominate relations among European states until the mid-1800s. In his conduct of the Congress of Vienna, the Austrian leader followed a policy of legitimacy to a certain extent—he tended to support the enthronement of traditional dynasties. Yet he ignored legitimacy when this policy would not help to ensure Austria's survival. In defense of the imperial realm, Prince Metternich intended above all to contain France, balance power among states so that none could conquer others, and suppress liberalism and nationalism. He pursued these latter goals even if that meant straying from the principle of legitimacy.

**Castlereagh: Foreign Minister of Britain.** In 1812, as the final drive against Napoleon began, Viscount Castlereagh (1769–1822) became British foreign minister. As a result of Britain's leadership in the war against Napoleon after 1812, Castlereagh had great influence at the Congress of Vienna. He used his authority for the most part to support Metternich in the effort to restore most monarchies and pursue European stability through balanced international power. In keeping with the balance-of-power policy, Castlereagh stood firmly with Metternich on the question of whether countries in the monarchical states should expand. Russia and Prussia came to Vienna hungry for land, but Britain and Austria resisted their

ambitions, even to the point of threatening war. Castlereagh differed from Metternich and the other conservative powers on one important issue. He opposed intervention to repress liberal and nationalist movements. The British knew that the collapse of old regimes sometimes opened doors to their trade in this era of booming industry.

**The Russian Tsar and the Quest for Poland.** Tsar Alexander I (1777–1825) of Russia, rather than one of his officials, served as his country's negotiator at Vienna. The partitions of Poland (see Chapter 3) had divided that country's land among Austria, Prussia, and Russia. Now, Alexander wanted all of Poland. The tsar indicated that his control over that state would benefit its people. Although he ruled as an absolute autocrat in Russia, Alexander proclaimed his commitment to Enlightenment ideals and even to aspects of liberalism. He pledged to give independence and liberal government to Poland. Suspicions that madness gripped Alexander circulated in Vienna, however, and doubts also persisted that he intended anything nobler than grabbing Poland.

**Prince Karl von Hardenberg of Prussia.** The Prussian king, Frederick William III (1770–1840), left diplomatic discussions at Vienna to his representative, Prince Karl von Hardenberg (1750–1822). Frederick William's support for Alexander's ambitions, however, governed Hardenberg's actions. Prussian leaders anticipated a considerable reward for their commitment to Russia. They would surrender to Russia the Polish territory taken during the partitions but wanted to acquire Saxony. Austria and Britain raised vehement objections to both plans for expansion, and the representative of the restored French monarchy also entered the diplomatic fray against Russia and Prussia.

**Prince Charles de Talleyrand of France.** Prince Talleyrand (1754–1838), who represented the new French king Louis XVIII, worked as adroitly at Vienna as he had for the highly varied governments of France between 1789 and 1814. He had served as a diplomat for nearly all of them. The great powers planned no role for him in their negotiations, but that did not prevent his influence on events. Talleyrand became the unofficial spokesman for the delegations left out of the discussions. The French prince influenced certain agreements in this way but had a more dramatic effect when he sided with Britain and Austria on the Polish-Saxon issue.

### The Conflict over Poland and Saxony

Congress leaders could have completed a settlement quickly if not for disagreements over the fate of Poland and Saxony. By late 1814, that conflict led to the brink of a new war. Talleyrand drew Castlereagh and Metternich into a secret agreement to ally against Russia or Prussia if either state attacked one of the three partners. Russian and Prussian leaders soon had general knowledge of the understanding among their opponents and assumed they faced a risk of war. They compromised.

### The Final Acts of the Congress of Vienna, June 9, 1815

Before diplomats arranged the formal settlement, Napoleon began his one-hundred-day resurgence in March 1815. Negotiations stopped for a time as the Alliance resumed the war with France. The four great-power leaders still completed their diplomatic tasks in time to present the Final Acts of the Congress to all the delegations for formal signing nine days before Napoleon's defeat at Waterloo.

**Russia and Scandinavia.** The Acts allowed Russia to take charge of somewhat less of Poland than Alexander wanted, leaving smaller parts under Austria and Prussia. Russia also acquired Finland from Sweden. In return for the concession to Russia, Sweden annexed Norway, a Scandinavian country that had backed Napoleon.

**Germany.** When Napoleon gained control of much of Central Europe during the wars of the early 1800s, he consolidated the three hundred independent German states that then existed into fewer than fifty. The Congress did not restore pre-revolutionary circumstances in Germany. Instead, the Vienna settlement enlarged Prussia as a safeguard against French expansion. The Congress also organized Prussia and thirty-seven other German states into a loose-knit confederation under the presidency of Austria. Members of the **German Confederation** remained independent countries joined mostly for defense. In effect, the Congress of Vienna had accepted Napoleon's consolidation of scores of German principalities into fewer than fifty states. The settlement largely nullified, however, the overall unity that he had brought to the German principalities, because the Confederation lacked real political cohesion.

**The Netherlands, Austria, and Italy.** In order to create another barrier to possible French aggression, the Vienna negotiators joined the Kingdom of Holland and the Austrian Netherlands to form an enlarged Kingdom of the Netherlands. For the loss of territory in the Netherlands, Austria gained Venetia and Lombardy in Italy and an area on the Adriatic Sea. The Final Acts also expanded Piedmont-Sardinia, a northwestern Italian kingdom that included an adjacent Mediterranean island. Finally, the Vienna settlement organized an enlarged south Italian state by merging Naples and the island of Sicily to form the **Kingdom of the Two Sicilies.**

**Royal Restorations.** The Congress showed little concern for the principle of legitimacy in Germany, but it did restore several ruling families that Napoleon had overthrown. During the Peninsular War, the British took the crown of Spain from Napoleon's brother and returned it to the Bourbon king, Ferdinand VII. The Congress confirmed this restoration. It also sanctioned the return of displaced ruling dynasties in Portugal, the Netherlands, Piedmont-Sardinia, and the Sicilies.

### The Holy Alliance

After the acceptance of the Final Acts, Alexander I of Russia pursued one of his mystical schemes. The tsar wooed his fellow rulers with a vision of European monarchs allied in a commitment to reign in a spirit of Christian love, peace, and justice. Pope Pius VII considered such an alliance a useless attempt of secular leaders to provide religious guidance. Castlereagh dismissed it as "sublime mysticism and nonsense," and the British did not sign the agreement. The Muslim ruler of Ottoman Turkey spurned membership in a Christian alliance. The other heads of state, however, agreed in September 1815 to join Russia, Prussia, and Austria in their Holy Alliance. This agreement had no practical effect on European diplomacy, and only Alexander made any attempt to apply this mystical idea in his state.

### The Second Treaty of Paris

The Quadruple Alliance drew up a new and more punishing peace agreement with France after Napoleon's one-hundred day military campaign and his defeat at Waterloo. It somewhat revised the borders it had previously arranged at Paris and Vienna in 1814 and 1815. This second treaty (November 20, 1815) required boundaries approximately as they had been in 1790 rather than 1792. France lost territory in the Netherlands and elsewhere. The allies also stationed troops in French territory and arranged for them to stay five years. France had to pay the cost of this occupation force and an additional penalty of 700 million francs.

## The Congress System (1815–1829)

On the day the four great powers concluded the Second Treaty of Paris with France, they also agreed to continue the Quadruple Alliance as insurance against French aggression. The allies promised joint military action again if necessary to prevent French conquests. As a complementary step in pursuit of European tranquility, the Alliance decided to convene regularly as a congress to discuss mutual concerns. This unprecedented plan for a congress system converted the Concert of Europe into a more formal organization.

The British fully supported the congress system as a way to maintain a peaceful balance in Europe but refused to assist the other three powers in their efforts to suppress liberals and nationalists. On this latter issue, Britain moved further and further from Austria, Russia, and Prussia as these conservative partners conducted their campaign against change after the Vienna Congress adjourned.

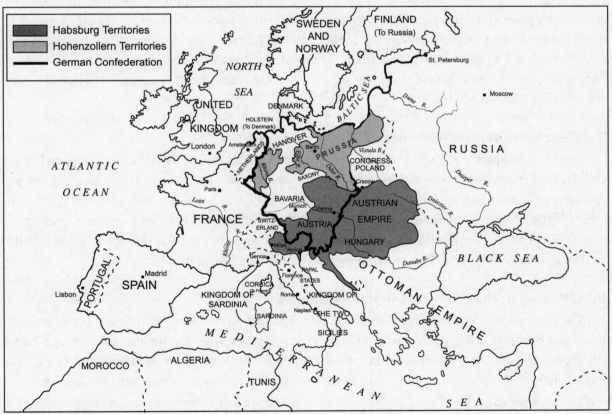

*Figure 5.1: Europe in 1815*

### The Congress of Aix-la-Chapelle (October 1818)

The Concert of Europe recognized within a very short time that the behavior of France under the restored Bourbon monarchy differed greatly from the actions of its Napoleonic predecessor. Alliance members decided to gather for their first regular congress to respond to the new conditions. They met at Aix-la-Chapelle near the western border of Prussia and nullified the punishments arranged in the Second Treaty of Paris. Bourbon France then became a member of the Concert of Europe as the group expanded into the Quintuple Alliance.

### The Congresses of Troppeau and Laibach (1820–1821)

Ferdinand VII of Spain took his restoration to heart. When the Congress of Vienna gave him his throne, he canceled a liberal constitution that the Bonapartes had devised for the kingdom. The king then prepared to retake the Spanish American colonies, which were in the last stages of a successful revolt for independence. His order for the army to go to the Americas provoked a rebellion among his own miserably treated troops. Riots soon erupted in cities across the kingdom. Ferdinand attempted to placate the rebels by restoration of the liberal constitution.

The Russian tsar urged suppressive action in Spain by the Concert. Britain opposed him. When revolt exploded also in the Kingdom of the Two Sicilies in Italy and led its ruler, Ferdinand I, to grant a constitution, Metternich joined the chorus for repression. The Alliance members went to Troppau in central Prussia for another Congress (October 1820). There, over Britain's objection, they adopted Metternich's proposition that the Concert should intervene to stop revolutions anywhere in Europe. After an adjournment, the Congress reconvened farther south at Laibach. The Alliance dispatched Austria to save Ferdinand I of Sicily from liberalism. Metternich's forces rushed to the rescue, empowered Ferdinand to rescind the constitution, and on the way back through north Italy struck down liberal nationalist rebels in Piedmont-Sardinia.

### The Concert of Verona (October 1822)

Rebellion in Spain continued. Another Congress opened, this time at Verona in northeastern Italy, to consider further repressive moves. Castlereagh committed suicide shortly before this Congress and was replaced by George Canning, who vehemently expressed British opposition to intervention in Spain. The other Congress powers commissioned France to crush the rebellion. One hundred thousand French troops invaded Spain and accomplished this task by mid-1823. The Spanish king, Ferdinand VII, again nullified the liberal constitution. After Verona, Britain ended its participation in the Concert.

### Rebel Victory in the Spanish-American Colonies

The conservative continental powers succeeded in putting down the revolt in Spain despite Britain's strenuous objections. They could not stop rebellion, however, in Spain's American colonies against the will of the nation that ruled the seas. Britain asked the United States to express a common policy of opposition to European intervention in the Americas. Instead, U.S. President James Monroe announced his own policy separately (December 1823), declaring that European states must not become involved in affairs in the American hemisphere. Because Britain wanted this **Monroe Doctrine** to take effect, it did. With no chance of European intervention, the rebels in the Spanish colonies triumphed.

### The Liberal Nationalist Revolt in Greece

The Greeks struck their first blows for national independence and a more liberal government in 1821. Even though the Ottoman Turkish Sultan was the legitimate ruler of Greece, the conservative European monarchies responded quite differently than they did to the Spanish revolt. The Russian tsar, Alexander I, advocated aid to the Greek rebels, who were led by Alexander Ypsilanti. These were Christian revolutionaries battling a Muslim Sultan. The Russian emperor stood ready to support people of his Christian faith, and perhaps extend the influence of Russia southward at the same time. Metternich refused intervention on the side of revolution, but he also favored no assistance to the established government.

**The European Attack on Turkey.** When the Ottoman Empire neared victory over the Greek rebels in 1825, Russia had a new ruler, Nicholas I (reigned 1825–1855). He committed Russian forces to the rebel cause. In order to control the involvement of Russia and protect their own interests in the region, Britain and France entered the conflict, too. Austria objected but to no effect. A combined allied fleet won decisively over the navy of the Sultan's ally, Egypt, in Navarino Bay on October 20, 1827. Then the French defeated Turkish forces in Greece as the Russians advanced into the Ottoman Empire itself. Turkey submitted.

**The Treaty of Adrianople (September 14, 1829).** The peace settlement arranged for Russia to give up most of the territory it had conquered. But the Russians annexed some land along the Danube River and also occupied additional Danubian areas, pending Turkey's payment of war damages. The treaty ended Turkish control over Greece. Members of a disunited conservative coalition had helped a liberal nationalist rebellion succeed.

*By the late 1820s, Europe's modern ideologies had taken shape. Theorists expanded and adjusted liberalism or turned to socialism. Intellectuals and activists transformed patriotic sentiment into an ideology of nationalism. Writers and artists established Romanticism, a new cultural movement that emphasized emotion and dominated the arts during the first half of the 1800s. Enthusiasts for the* Ancien Regime *devised conservatism as a new complex of theories for the justification of the old social order. Thus enlarged and diversified, Modern European thought now included virtually all its main currents.*

*The struggle to defend or destroy traditional systems involved much more than intellectual conflict. At the end of their fight against revolutionary France, the conservative powers convened a congress of European states in Vienna, Austria (1814–1815) and took steps to restore as much of the old order as possible. In its Final Acts (June 1815), the Congress of Vienna rearranged the map of Europe to hem in France and bring more balance to the international system. The great powers also pledged to take military action in the future if necessary to suppress threats from liberal forces. As a further guarantee of their security, the Quadruple Alliance agreed to meet in regular congresses to consider problems of mutual concern.*

*After the great powers reached agreement at Vienna, they entered an era of unusually cooperative and peaceful relationships, despite conflicts, as when the British refused to support counter-revolutionary intervention. The other monarchies succeeded in crushing rebellions in Spain and Italy in the 1820s. They failed, however, to prevent the Spanish-American colonies from winning independence. Unusual circumstances and conflicting great power interests in the region where the rebellion occurred not only prevented*

*repressive intervention in a Greek revolt for independence from Turkey but also led Russia, Britain, and France to support the Greek war of national liberation. The liberal nationalist movement in Greece triumphed.*

*Spaniards, Italians, and Greeks had challenged the European status quo between 1820 and 1829. During the next two decades, liberal and nationalist rebels would repeatedly confront their conservative governments across the entire breadth of the continent. Despite its resurgence after the defeat of Napoleon, the* Ancien Regime *had not ensured its survival in Modern Europe.*

## Selected Readings

Artz, Frederick B. *Reaction and Revolution, 1814–1832*. New York: Harper and Brothers, 1934.

Fasel, George W. *Edmund Burke*. Boston: Twayne Publishers, 1983.

Honour, Hugh. *Romanticism*. New York: Harper & Row, 1979.

Kohn, Hans. *Nationalism, Its Meaning and History. Revised Edition*. Princeton, NJ: Van Nostrand, 1965.

Nicolson, Harold G. *The Congress of Vienna: A Study in Allied Unity, 1812–1822*. New York: Viking Press, 1961.

Schroeder, Paul W. *The Transformation of European Politics, 1763–1848*. New York: Oxford University Press, 1994.

Seidman, Steven. *Liberalism and the Origins of European Social Theory*. Berkeley: University of California Press, 1983.

Viereck, Peter R. E. *Conservatism Revisited,* Revised Edition. New York: The Free Press, 1966.

*www.fordham.edu/halsall/mod/modsbook15.html* (this site has links to a wealth of verbal and visual sources on Romanticism.)

## Test Yourself

1) Liberals of the early 1800s were devoted to
   a) government regulation of business
   b) extensive welfare programs for the poor
   c) political power for all members of society
   d) the profitable use of property

2) Romantics value
   a) feelings over intellect
   b) the present over the past
   c) ancient over medieval ways
   d) universal traits over individual differences

3) Jeremy Bentham differed from many liberals of his day because he believed in
   a) a universe controlled by Natural Law
   b) prosperous people helping the needy
   c) parliamentary government and constitutionally guaranteed rights
   d) freedom of expression

4) The international intervention in Spain in the 1820s revealed that most members of the Concert of Europe had a strong hostility toward
   a) royalism
   b) Catholicism
   c) liberalism
   d) aristocracy

5) Judging only by the reasons for *lack* of cooperation among the conservative monarchies between 1814 and 1829, the international behavior of these countries was most strongly influenced by
   a) religion
   b) economic and territorial ambitions
   c) the principle of legitimacy
   d) the balance of power principle

6) The aspects of European history covered by this chapter would best support the conclusion that commitment to strong government authority is typical of
   a) liberals
   b) socialists
   c) Romantics
   d) conservatives

7) What does the history of Europe, 1792–1829, suggest about the causes of war and ways to maintain peace? (Use Chapters 4 and 5 to write an essay in response to this question.)

## Test Yourself Answers

1) **d.** Many years after the emergence of liberalism in the latter 1700s and early 1800s, liberals typically but not universally turned toward support for certain forms of business regulation, welfare programs, and democratic government. When liberals changed their outlook in this way, they remained true to their much older central commitment to "the profitable use of property," as the text information on liberalism before 1830 indicates.

2) **a.** All the options for completion, except the one that refers to the emphasis on emotion, suggest views that are the opposite of the ones noted for Romantics.

3) **b.** Bentham differed from typical liberals of his time because he *did not* think that Natural Laws governed human affairs and because he urged people who were living well to help the unfortunate. He and other liberals generally shared a devotion to parliamentary government and freedom of expression.

4) **c.** The conservative powers formed the Concert of Europe because they wanted a return to royalism, established churches (Catholic in Spain, for example), and aristocracy. For all of these states except Britain in certain circumstances, this defense of *Ancien* traditions meant, above all, fighting against liberal revolts, as they did in Spain, without the aid of Britain.

5) **b.** This question calls for historical analysis of a particular body of information—the points in the text that have to do with the monarchical powers failure to work together from 1814 to 1829. To a certain extent, the item tests recall and understanding of the past, but the more important purpose of it is to assess historical thinking skill. Analysis of the specified material should lead to a recognition that religion had a certain level of influence on state policies and perhaps also balance of power concerns (the differing reactions to the Greek revolt). Much more evident, however, is the conflict among the monarchies in case after case when Britain's economic and perhaps territorial interests led to refusal to support interventions against liberal revolts. The strongest influence on state behavior thus appears to be economic and possibly related territorial ambitions.

6) **d.** Whatever might be true of the beliefs of conservatives in other times and places, during the formative period of European conservatism covered in this chapter the ideology opposed individual rights, supported aristocracy, and insisted that traditional authority should not be questioned. The main theme of the chapter is that during the first three decades of the 1800s, conservative governments were in power and worked more or less consistently to use whatever level of strength necessary to enforce their authority against rebels

within their territories or abroad. If the rulers of the time had been reformist or revolutionary, conservatives would have felt differently about "strong government authority."

7)   This question requires an analysis of the text's depiction of events, 1792–1829, in order to draw conclusions about how to promote peace or about how wars come about. The information in this source suggests that peace is likely when all the leading states have a similar outlook, when power among these states is relatively balanced, and when countries have recently experienced long and costly wars. The absence of these same conditions, therefore, might make war more likely, but international military conflicts certainly appear to come about when rulers think that enemy states in some way pose a threat to their power at home or abroad, or when they believe that war can give them new territory and the domestic and international advantages thought to come with expansion. An essay should use concrete historical details to support reasoning of this kind or other conclusions about what encourages peace or war.

# The Age of European Revolution (1815–1848)

**1814:** Louis XVIII is given the throne of France.

**1819:** The Peterloo Massacre occurs in England.

**1825:** The Decembrist revolt occurs in Russia as Nicholas I begins his reign.

**1830:** Revolutions erupt in France, Italy, Belgium, and Poland.

**1832:** The English Reform Bill of 1832 extends voting rights.

**1833:** The Factory Act limits hours of labor for British children.

**1838:** The British Chartist Movement begins.

**1848:** Revolutions break out in France, Italy, Austria, and Germany.

**1851:** Napoleon III establishes the Second French Empire.

*The revolution of 1789–1815 had so thoroughly demolished the* Ancien Regime *in France that conservatives there could not restore the old system. The installment of a Bourbon monarchy at the end of the revolution, however, provided a semblance of traditional government for fifteen years. Circumstances for French aristocrats also improved, but the property and most of the privileges they had lost were gone forever.*

*Elsewhere in Europe, the old regime returned to or lingered uninterruptedly in power immediately after the defeat of Napoleon. The economic, social, and cultural conditions on which the traditional elite depended, however, continued to change in ways that undercut more of the foundations of the old order. It soon became clear that the end of the French revolutionary era simply marked the beginning of the age of European revolution.*

*Violent protests in Britain and revolts in Spain, Italy, Russia, and Greece between 1815 and 1830 suggested that the area susceptible to revolution had widened beyond France. Then liberal and nationalist revolutionaries struck with great force at multiple centers in the heartland of Europe during the crisis*

*years of 1830 and 1848. In this age of European revolution, the second phase of sociopolitical modern-*
*ization, the struggle between the old and new regimes climaxed but did not end.*

## ■ DEEPENING REPRESSION IN RUSSIA (1796–1855)

Even though Peter the Great (reigned 1682–1725) accelerated the transition to new ways in Russia, the country had made little progress toward economic or sociopolitical modernization by the late 1700s. A mood somewhat more conducive to progressive reform developed, however, before the turn of the century and for about twenty years affected both government programs and the behavior of small but significant social groups. Then a reactionary campaign began that virtually stopped the modernizing process until after the mid-1800s.

### The Autocracy at the Accession of Paul (1796)

The nature of Russia's government gave its monarchs the power to determine whether reform or reaction prevailed. Paul I (reigned 1796–1801) had inherited this ultimate form of absolute monarchy from his mother, Catherine the Great, a system called an **autocracy** because one of the ruler's titles was "autocrat." The gargantuan size of his state and the relatively low level of technology placed practical limits on Paul's authority, but he still exercised extreme power over his realm. An elaborate bureaucracy, the Russian Orthodox Christian Church, and a massive army all stood ready to communicate and enforce the tsar's will.

### *Russian Society in the 1790s*

During the 1700s, Russian rulers greatly increased the social benefits of the gentry (the upper class) and removed virtually all aristocratic obligations of service to the state. Tsars also vastly expanded the nobility's already extreme authority over peasants. Specific gains for the gentry in the latter 1700s included their exemption from court-ordered physical punishment, freedom from all taxes, and greater power to exile peasants to Siberia. The government also ended the right of peasants to bring official complaints against nobles.

### *Paul: Reformer and Counterrevolutionary*

Paul took charge when his mother died in November 1796, and soon set about correcting the flaws he thought she had left in the system—Catherine had not improved the cumbersome machinery of government, and she had markedly increased noble power and privileges. Paul tried to establish a more coherent and highly centralized bureaucracy and to reduce aristocratic authority over the peasantry. He accomplished little in these attempts to improve the government and change the aristocratic power structure.

Despite his interest in altering the system in certain ways, Paul passionately opposed the spread of revolutionary influences in Russia. As a defense against contagion from the West that might inspire rebellion, the tsar tried to prevent contact between Russia and the world beyond its lengthy borders. He failed. Even his son Alexander funded the publication of a journal filled with articles by reform-minded western and Russian thinkers. The heir to the throne also planned for the implementation of such ideas when he ruled the empire.

Alexander did not have a long wait for his opportunity to transform Russia. A few of the many enemies that Paul made during four years of rule assassinated him in March 1801. One of the leading coup plotters, Nikita Panin, probably expected Alexander to lead Russia into a new era.

## Alexander I: Liberal Autocrat

Circumstances somewhat justified the anticipation of such reform under Emperor Alexander I (1777–1825). Paul's twenty-three-year-old son had made known his intention to liberalize Russia. He had agreed, moreover, to Paul's removal but probably not to his father's murder. Alexander's attitudes and involvement in the revolt suggested a strong commitment to change. Soon the new tsar's actions seemed to confirm the hopes of those who wanted Russia transformed.

### Alexander against Autocracy and Serfdom

Alexander's plan for political and social reform was astounding. He began his reign as an absolute ruler over a society made up mostly of serfs, and his declared intention was to end absolute monarchy and serfdom. But the young emperor's reforms during his first four years of power had no clear relationship to the goal of doing away with autocracy and the serf system. He continued the effort of recent tsars to convert old monarchical institutions into a more modern professional bureaucratic structure and proclaimed his willingness to assist any nobles who volunteered to free their serfs. Government and society changed very little.

### Michael Speransky's Draft Constitution

A relatively peaceful relationship with Napoleonic France after 1807 enabled Alexander to devote more attention to the issue of autocracy. He commissioned his top governmental official, Michael Speransky (1772–1839), to compose a draft constitution for Russia. Speransky recommended a gradual evolution to a very limited parliamentary system of government, which left control of legislation in the hands of an executive group (the State Council) and the tsar. Implementation of the plan got no further than the establishment of the State Council.

### Reversion to Absolutism and Repression

The Final Acts of the Congress of Vienna in 1815 (see Chapter 5) converted Napoleon's Duchy of Warsaw into the Kingdom of Poland, but provided for the Russian tsar to serve as the Polish monarch. Alexander gave Poland what he refused to allow in Russia, a liberal constitutional system designed according to Speransky's plan. Unfortunately for the Poles, Alexander tended to act as though the constitutional law did not apply to him, an attitude typical of absolute monarchs.

After 1815, the tsar governed Russia in an increasingly repressive way. Religious fanatics began to act as monitors of the universities and could arrange the dismissal of professors thought to be too radical or otherwise unfit. The government restricted expression for a much larger part of the educated public by tightening controls on the press.

## The Decembrist Revolt (1825)

Russia had a long history of peasant revolts and palace coups. The rebels in these historic forms of attack, however, never attempted to overthrow the system of government. In December 1825, when Alexander I died, revolutionaries struck with the intention of destroying the autocracy.

### The Decembrists

Education, from minimal literacy to the most advanced level, was a privilege limited almost exclusively to the nobility in Russia. This intellectual elite in the 1700s came under the influence of French thought, and many nobles adopted Enlightenment attitudes. When the Napoleonic wars erupted, educated aristocrats comprised the officer corps in charge of campaigns in the French Empire. Thus members of the best educated and most liberal groups in Russia came into contact with life in the West, an experience that intensified their desire for sociopolitical modernization. After the officers returned home, a portion of them organized secret societies committed to such a change. These conspirators became the **Decembrists** of 1825.

### The Rebellion

Upon the death of Alexander I, his younger brother, Nicholas I (1796–1855), claimed the throne. Uncertainty about the legality of Nicholas's accession gave the rebels their opportunity. When government leaders in St. Petersburg called a troop of three thousand to the Winter Palace plaza to take their public oath to Nicholas, army officers involved in the conspiracy convinced the soldiers to refuse to state the pledge. The rebels expected the stalemate to enable them to extort an agreement to constitutional monarchy.

After several hours of inaction, loyal troops opened fire with cannon, killing sixty to eighty people. The rebellion at the capital ended at once. Soon the conspiracy was suppressed everywhere. The government executed four Decembrist leaders and sent hundreds to prison or exile. The Decembrists became heroes to many Russians in subsequent decades, but in 1825, few people cared about their cause.

### Nicholas I: Guardian of the *Ancien Regime*

Even though the repression during Alexander I's last years helped cause the Decembrist revolt, Nicholas I (reigned 1825–1855) responded to it by increasing repression in Russia. He also became a leader in the effort to defend *Ancien* institutions all over the continent. European opponents of the old regime described him as the **Gendarme of Europe,** the guardian against change everywhere.

### His Majesty's Own Chancery and the Third Section

Nicholas reorganized the government executive council, His Majesty's Own Chancery, into **Sections** with specified responsibilities. The Third Section's duties included the creation and direction of a new security force, sometimes called the "secret police," even though they wore sky-blue uniforms. Nicholas commissioned the Third Section to watch and investigate everything so that it could stop any activity that might threaten the autocracy.

### The Doctrine of Official Nationality

Nicholas implemented strict press censorship and presented standards for defining loyal citizens. The government's doctrine of **Official Nationality** depicted these true Russians as a people dedicated to Autocracy, Orthodoxy, and Nationality. The creed meant that loyal Russians supported the absolute power of the autocrat, accepted the exclusive spiritual leadership of the Russian Orthodox Church, and, as an inherent trait of their Russian nationality, felt an unqualified devotion to the imperial family and its government. Anyone who advocated change in these fundamental Russian ways was deemed a traitor.

### The Intelligentsia

The **intelligentsia** (intellectual class) of the 1800s and early 1900s produced an unusual abundance of outstanding literature and influential social thought, much of it demanding change. In their critique of Russian life, a number of these observers expressed adoration of traditional institutions, but most condemned the old order. Among the critical intelligentsia, two main schools of thought emerged during the late 1700s and early 1800s.

The **Westernizers** were those who had concluded that the way of life in West Europe and the United States was vastly superior to theirs and advocated modernization along Western lines. The other group, called **Slavophiles,** because they loved Slavic (ethnic Russian) culture, leveled an equally sharp attack on both existing Russian institutions and Western culture. They called for a return to ancient Slavic ways. Nicholas's government worked diligently to suppress both these groups.

## ■ THE TRANSITION TO REFORM IN BRITAIN

Economic conditions after 1815 fostered a growing public demand for reform in Britain. When the need for British goods on the continent dropped sharply after the war, the economy slumped badly. Many workers lost their jobs. Plunging grain prices threatened upper-class landowners, and the government rushed to their aid with the **Corn Laws** of 1815. This legislation virtually prohibited grains from abroad and enabled the landlords to keep prices high. The Corn Laws thus raised the cost of bread and made hard times for the poorer classes harder still.

Because the few who controlled the government took care of their own needs and ignored the problems of others, postwar economic conditions provoked movements for political change. Discontented people wanted to share in government power so that they could help themselves as the elite did. The reformers thus set out to change parliamentary institutions.

### Parliamentary Government in the Early 1800s

Parliamentary leaders (the prime minister and the other ministers of the executive Cabinet) dominated British government during the latter Napoleonic war years and after. Changing sociopolitical conditions and King George III's intermittent insanity had stopped his attempt to reestablish monarchical control of policy. His son, George IV (reigned 1820 to 1830) left the monarchy still weaker. The factions that ran Parliament, therefore, again increased their power over the country.

### The Political Parties

The **aristocracy** (the titled nobles, or "peers") automatically became members of the upper parliamentary chamber, the House of Lords. Property owners elected the House of Commons. Relatively wealthy country gentlemen (the **gentry**) and titled nobles dominated both houses and the two political parties that operated within them, the Tories and Whigs.

**The Tories. Tories** strongly favored religious conformity under the Anglican Church, but their main concern after the appearance of Jacobin republicanism in France was opposition to revolutionary views.

For many years, the party was in a position to impose its creed on Britain. Lord Liverpool served as Tory prime minister from 1811 to 1828, and his party continued to control the government until 1830.

**The Whigs.** Very wealthy landowning aristocrats traditionally dominated the **Whig Party** and so held many principles in common with the Tories. But the Whigs also represented the interests of the rising industrial business class and Protestant dissenters who refused to conform to Anglican beliefs. Thus this party would defend many traditions, took a cautious approach to innovation, but inclined much more toward reform than did the Tories.

### The Peterloo Massacre (August 1819)

The economic suffering that followed the Napoleonic wars inspired some political activists outside the mainstream parties to demand drastic change in Britain. The plight of the lower classes moved these **Radicals,** as they came to be called, to form organizations and produce publications insisting on reforms. The government had virtually no patience with such agitators.

Public protests became widespread by 1817. British leaders intensified the repression with measures such as outlawing public meetings. The dissent virtually stopped for a time. Then a worsening depression again inspired the discontented to act. The desperate conditions brought thousands of protesters to St. Peter's Fields in Manchester, England, in August 1819. Mounted troops arrived to seize the speaker. They rode into the crowd, killed eleven people, and injured four hundred others. This **Peterloo Massacre** demonstrated the government's brutally determined commitment to preservation of the status quo. Parliament further confirmed this attitude by the passage of still more rigid laws against dissent, the Six Acts of November 1819.

### Tory Reform

Both parliamentary parties included people who favored at least cautious reform. The uproar over Peterloo and fears of more serious popular action encouraged still more parliamentary support for corrective legislation. George Canning, who replaced Castlereagh as foreign minister in 1822, and other new members who soon entered the Cabinet, believed more in change than had their predecessors. Cautious reform followed.

### Adjustments in Law Enforcement

Sir Robert Peel, the new Tory secretary for domestic affairs in the 1820s, took charge of matters such as criminal law. Existing codes prescribed harsh punishments; for example, they provided death penalties for over two hundred crimes, even for offenses such as damaging Westminster Bridge. Peel had the laws revised so that about one hundred fewer statutes called for execution. He also established a civilian police force to keep order with less chance of military violence as at Peterloo. Because Sir *Robert* organized the police, they became known as *bobbies*.

### Economic Reform

Parliament passed a series of economic reforms in the 1820s. Until that decade, Tory leaders clung tenaciously to the import taxes and other regulations that benefited the gentry. Then the government

yielded slightly to pressure from business interests and consumers for reduced tariffs on certain goods, but the Corn Laws remained untouched. In 1824, the legislators nullified the **Combinations Act,** a law that had prohibited the formation of labor unions. Parliament soon qualified this concession to workers by denying the right to strike. Near the end of the 1820s, the Tories even modified their stand on the Corn Laws, changing from a near prohibition of imports to a tax on such foreign products. This tariff still protected the landlords and kept bread prices high.

### The Catholic Emancipation Bill (April 1829)

English law denied Catholics the right to vote, hold public office, or serve in Parliament. A vigorous movement to end this discrimination arose in mostly Catholic Ireland in the 1820s. The more liberal Tories favored this reform but other party members staunchly resisted. The Duke of Wellington, prime minister from 1828 to 1830, and Peel secured passage of the act in 1829 after a difficult fight against stubborn Tory associates and the king. With the innovations they accepted in the 1820s, the Tories had begun the transition toward reformist politics in Britain.

## Whig Reform

The Whig Party and the businesspeople who favored free trade posed the main threat to the traditions and laws that maintained the old elite of titled nobles and country gentlemen. Because the Tories who represented these traditional upper class groups thoroughly dominated the British Parliament, reform of the election system became the central concern of opposing forces.

### The Rotten Boroughs

Members of Parliament entered the legislature as the representatives of rural counties or town boroughs. Each such district sent two people to Parliament. Procedures for the selection of these representatives had remained unchanged for one hundred and fifty years.

Shifts in population growth rates and settlement patterns lowered the numbers in certain districts and even emptied a few. This condition made control of elections by bribery very easy. Each of these **rotten boroughs** still had two representatives in Parliament. Rapidly growing industrial cities, in contrast, elected relatively few members to Parliament. A few cities chose none. Tradition also allowed landlords to select the representatives from certain districts, the **pocket boroughs.** So long as this system remained intact, the defenders of rural aristocratic ways could keep control of Parliament and legislation.

### The Reform Bill of 1832

Parliamentary elections in 1830 gave fifty seats formerly held by Tories to reform-minded Whigs and others with similar attitudes. Before the end of the year, Earl Grey (1764–1845) replaced the Duke of Wellington as prime minister. A Whig now headed the government, backed by a House of Commons with a strengthened contingent of reformers. British voters and leaders might have taken this turn toward more active reform as a way to avoid the violent drive for change that spread from France across the continent in 1830.

In 1831, the anti-reform Tories in the House of Lords blocked a lower legislative chamber bill that provided for a redistribution of House of Commons seats and the extension of voting rights to more people. Prime Minister Grey persuaded the king to threaten to give new noble titles to enough people, thus

adding them to the upper chamber, to carry the vote there. The House of Lords surrendered on the issue rather than suffer the influx of new aristocrats.

The Reform Bill of 1832 took almost one hundred and fifty seats from over-represented districts, such as the rotten and pocket boroughs, and gave them to inadequately represented areas. The law also lowered property requirements for voters sufficiently to give that right to one-fifth of the people. The body of voters thus expanded by fifty percent. These changes increased the influence of the rising urban-industrial middle class and set a precedent for such socioeconomic electoral adjustments. The law also gave Britain the most democratic government in Europe, even though a minority still ruled.

## The Acceleration of Reform

By the early 1830s, government leaders, instead of protesters, took charge of the campaign to revise the parliamentary system. These officials then completed the transition from repression to reform with passage of the election reform law in 1832. Despite occasional lapses, British government remained reformist thereafter.

The Reform Bill of 1832 that marked the completion of this transition also provided the momentum for an accelerated pace of reform that lasted nearly twenty years. The industrial-age business interests that fought for a more democratic political system usually opposed laws designed to improve factory working conditions. Ironically, some of the Tories who ordinarily resisted political reform favored legislation to control industry. Despite their contradictory objectives, the efforts of these factions combined to launch a series of legislative innovations.

**The Sadler Report.** A parliamentary investigation led by Michael Sadler provided abundant evidence that large numbers of young children worked extremely long work weeks at rigorous jobs. Sadler also discovered that cruel treatment by supervisors was all too common. Such revelations brought a growing public demand for reform, and in 1833, Parliament passed the Factory Act.

**The Factory Act of 1833.** The factory reform bill outlawed the employment of children under nine years old in the textile industry. It limited the hours of labor for other age groups—eight hours per day for children under thirteen, and twelve hours for youths fourteen to eighteen years old. As a step toward enforcement, Parliament provided for a small group of inspectors to visit textile enterprises. Finally, provisions of the reform also required factory owners to arrange two hours of education daily for children under thirteen.

**Repeal of the Corn Laws.** In 1839, the forces for free trade in grain formed the Anti-Corn Law League. John Bright and Richard Cobden added to the power of this coalition with extremely effective public speeches against the grain tariff. When the potato crop failed in Ireland in 1845 and the threat of famine haunted Britain, Prime Minister Robert Peel led a minority of his Tories to support the Whig campaign for repeal. In 1846, Parliament nullified the Corn Laws. The era of free trade had dawned in Britain, a sign of further gains in power by the bourgeoisie and of decline in aristocratic influence.

**The Ten-Hours Act of 1847.** The Factory Act of 1833 had not satisfied reformers who wanted to protect women as well as children and to apply the regulations to all industries. In 1847, they induced Parliament to pass the **Ten-Hours Act** to set the daily maximum for women and children in factory work of all kinds. With their standard six-day week they still would carry a heavy burden of labor, but the government had drawn a line where none had existed, and in practice it quickly became the standard for men as well.

### The Chartist Movement

Reform in the 1820s and 1830s still left many workers deeply discontented. A labor organization in London drew up a charter in 1838 that reflected the fundamental concern of the poorer classes: a sense of political powerlessness. Designed as a petition to Parliament, this document advanced by the **Chartists** demanded voting rights for all males, equally sized voting districts, secret balloting, annual sessions of Parliament, removal of property ownership requirements for members of Parliament, and pay for legislators. The first two demands would increase worker voting power, the third would prevent powerful interests from intimidating voters, the last two would give the poor access to legislative seats, and annual sessions would increase the power of a reformed Parliament.

In June 1839, the House of Commons received the Chartists' petition with well over one million names. The legislators expressed their contempt for the charter by voting against it two hundred and thirty-five to forty-six. The petitioners took their demands to Commons again in 1842 with more than double the previous number of signers. The vote against this charter was larger than in 1839. A similar Chartist campaign in 1848 failed again, and the movement ended. Even so, by that year, reformers had accomplished enough change to ensure against revolution in Britain during a year in which rebels toppled governments all across the continent.

## ■ THE TURN TOWARD REVOLUTION IN EUROPE

The conquering troops of revolutionary and Napoleonic France transported their new ways into many parts of Europe between 1789 and 1815. During these years, Europeans other than the French showed little inclination toward revolution. Their attitudes changed quickly, however. By the 1820s, events indicated clearly that significant forces committed to a new social order had become native to virtually every society on the continent.

### Metternich's Struggle for Control in Central Europe

As foreign minister and then chancellor (prime minister) for the Austrian Hapsburg emperors Francis II (reigned 1804–1835) and Ferdinand I (reigned 1835–1848), Prince Klemens von Metternich's supreme concern was the perpetuation of his rulers' Central European state. The special menace that liberalism and nationalism posed for this aristocratic, monarchical, and multi-ethnic realm inspired Metternich's direction of domestic policies within the Hapsburg Empire. The Austrian leader also exercised a dominant influence in neighboring Italian and German states after 1815, and he stubbornly resisted liberalism and nationalism in these regions as well.

### The Austrian Empire

The Hapsburg domains contained nearly a dozen ethnic groups—Germans, Hungarians, Czechs, Slovaks, Poles, Romanians, South Slavs, Italians, and others. National sentiments stirred these social elements after the intrusion and withdrawal of French revolutionary forces, and Metternich feared nationalist revolts. He scattered spies everywhere to watch potential rebels, sent soldiers to intimidate people in areas of unrest, established tight control over publications and university instruction, banned student organizations, and jailed dissidents. Metternich thus controlled his people, but their anger grew.

### Italy

After Napoleon's conquest of a much-divided Italy, he merged principalities and left it in three larger divisions with somewhat liberalized institutions. The Congress of Vienna divided the peninsula into nine states, including the Kingdom of the Two Sicilies in the south, the Papal States in central Italy, and, in the north, Piedmont, Lombardy, Venetia, and several other small territories. Austria directly ruled Lombardy and Venetia and dominated the entire peninsula.

Although relatively few Italians cared about unity and expelling foreigners, liberalism and nationalism inspired a part of the educated minority to action against the restored system and Austrian domination. They formed secret rebel groups that sometimes met on the beaches around charcoal fires, a practice that yielded their name—the charcoal burners or **Carbonari.** Metternich's forces kept these opponents of the old regime in check in the 1820s, but discontented Italians increased their potential to begin a revolutionary conflagration.

### The German Confederation

When the leaders of Austria, Britain, Russia, and Prussia reorganized Central Europe at Vienna (1814–1815), they did not re-create the more than two hundred separate German states that had existed before 1789. Neither did they leave Germany almost fully unified as it had been briefly under Napoleon. Instead, they established thirty-eight completely independent states and provided for their membership in a new German Confederation.

Austria and Prussia were the largest and most powerful states in the Confederation. Because the Industrial Revolution had made much more progress in Prussia than in Austria, the Prussians had the potential for supremacy within the Confederation. Prussia strengthened its economic advantages still more by arranging a commercial union that included eighteen German principalities but not Austria. This *Zollverein* ended all trade barriers among the member states.

Despite Prussia's apparent advantages, Austria became the dominant influence in German affairs until after the mid-1800s. The Congress of Vienna had stipulated that Austria preside over the only significant institution of the Confederation, an assembly called the **Diet.** The very weak structure of the Confederation left the thirty-eight states with no central government, but the feeble apparatus helped Metternich keep Austria supreme.

Conservatism among Confederation leaders and their generally submissive attitude toward the Austrian chancellor made Metternich's task easy at first. In the years just after the Congress of Vienna, he successfully pressured Frederick William III (reigned 1797–1840), the Prussian king, and his fellow German rulers into refusing the liberal constitutions that many of their subjects demanded.

The *Burschenschaften.* In the German universities, where the ideals of liberalism and nationalism had many followers, dissidents formed *Burschenschaften* (student associations) committed to the cause of unity and liberal government. On October 31, 1817, massive demonstrations by these nationalist organizations climaxed with a ceremonial burning of conservative books. In 1819, August von Kotzebue, a well-known author of such publications, died at the hands of an assassin who belonged to a student nationalist society.

The Carlsbad Decrees. Metternich took swift and decisive countermeasures. Through the Confederation Diet, he issued the Carlsbad Decrees in September 1819. This set of proclamations outlawed *Burschenschaften,* clamped stringent controls on publications, and launched an intensive campaign to drive the troublemakers from German universities. Overt liberal and nationalist activity stopped in the Confederation for several years after 1819. Despite this calm atmosphere, liberalism remained very attractive to many people within the Confederation.

## The Reigns of the Last Two Bourbons in France

The coalition of European states that defeated Napoleon restored the Bourbon monarchy in France by placing Louis XVIII (1755–1824) on the throne in 1814. The new king avoided a thoroughly reactionary policy and chose instead only a partial reconstruction of the system that had existed before the revolution.

### The Charter of 1814

Louis XVIII formally established his government by presenting a new constitution for France, the **Charter of 1814.** This document provided for a legislature elected by a very limited body of voters, the 100,000 richest people in a nation of nearly thirty million. The Charter perpetuated Napoleon's Civil Code and the religious settlement he had arranged, kept education under state rather than church control, guaranteed equality before the law, and allowed those who had purchased church and noble lands to keep them.

Although Louis's constitution did not indicate that his ministers (the executives who headed the government and its various departments) would act in compliance with the will of the parliamentary majority, the prime minister eventually did govern in this way. This policy of **responsible government** became a very important political issue. Liberals favored the policy, conservatives opposed it.

### The Ultra-Royalist Push for a More Reactionary Government

Louis's acceptance of a very few liberal changes went much too far to suit the extreme traditionalists. They rejected the king's moderately reactionary policy and worked for a complete restoration of the old aristocratic and monarchical order. Louis's own brother, the count of Artois, stood at the forefront of these ultra-royalists. When the king died in 1824, Artois took the throne as Charles X (1757–1836). Revolutionary France had acquired a fervently reactionary master.

### Charles X against the Revolutionary Tide

The new ruler soon attempted to turn France more directly toward the past. Within a year, his aristocratic compatriots who had lost their lands received compensation from the government. He then

attempted to restore religious control over education. France erupted in protest. Opposition lessened in 1827, when Charles agreed that government executive policy should reflect the will of the parliamentary majority. Two years later, however, he reversed his stance on this issue. The Chamber of Deputies objected, and Charles responded by dismissing the legislature. If Charles expected this action to produce a more compliant Chamber, he erred.

## The Revolutions of 1830

The revolution that began in 1789 had forced the modernization of the French state. Rebels struck again in France, in 1830. The bourgeoisie returned to the streets to destroy a Bourbon monarchy that had begun to reverse the process of political modernization.

When Louis XVI's *Ancien Regime* toppled in the early 1790s, the surrounding monarchical states took up arms and attacked to destroy the French Revolution. In 1830, however, the conservative monarchies of East and Central Europe had to fight at home for their own survival, for now they faced a European and not just a French revolution.

### The July Revolution in France

Charles X sparked revolution when he dissolved the legislature and forced the election of a new one. The enemies of royal power took more seats instead of growing weaker. Charles then issued the July Ordinances, a series of decrees meant to nullify the recent parliamentary elections, place tight controls on the press, and take the vote away from seventy-five thousand of the one hundred thousand eligible citizens. Most of the king's rich middle-class opponents would have had no political voice if these decrees had gone into effect.

The bourgeoisie and their supporters among the workers of France took over the streets of Paris. The rebels ripped up paving stones, carted furniture and other objects into the narrow thoroughfares, and erected barricades. With many of their number clad in typical business attire, including top hats, the revolutionaries gathered behind their battlements and in windows along the streets to fight approaching troops. Royal forces dwindled as contingents of troops took sides with the rebels. The revolutionaries won Paris. As their red, white, and blue banner fluttered over the cathedral of Notre-Dame, Charles X surveyed the scene through a telescope. France's last Bourbon ruler decided to leave for Britain, and a "bourgeois monarch"—Louis Philippe—soon became "King of the French."

### The Belgian Revolt

A spirit of rebellion had burned in many Belgians almost from the moment the Congress of Vienna forced the merger of Belgium and the Netherlands. The July Revolution in neighboring France intensified the Belgian desire for liberation from the dominant Dutch. Rebellion followed the next month, and Belgian nationalists won their victory by October.

Dutch opposition to Belgian independence delayed the formal recognition of the new state for almost a decade. In 1839, British and French diplomacy finally brought Dutch acceptance of the Treaty of London, which admitted Belgium to the circle of European states. The London agreement also attempted to protect the new nation from invasion by officially recognizing it as neutral.

### Liberal Nationalist Rebellion in Germany and Italy

By 1830, the rulers of several German states already had yielded to increasing liberal pressure and granted constitutions. The French victory over the reactionary Charles X prompted German liberals to step up their demands for political liberties. Public protests quickly led rulers in four more principalities to concede constitutional rights. More than one-fourth of the Confederation states now had constitutions. Metternich's grip on the German territories had weakened but only temporarily.

In Italy, more than a decade of *Carbonari* effort had stimulated a **Risorgimento** (resurgence). This resurgence was a movement for political union that took its name from the view that Italians must regain the sense of common identity that held together the people of the peninsula in ancient times. Small but dedicated bands inspired by such ideas stood ready for their heroic venture.

The victory over royal absolutism in France in July 1830, provoked Italian nationalists to action. Rebels struck and took charge in the principalities of Parma and Modena in the north and in the Papal States in the peninsula's center. They anticipated victory over local rulers, freedom from Austrian dominance, and the eventual unification of Italy under a more liberal system of government.

With sentiments so similar to those of the new regime in France, the rebels expected French King Louis Philippe to join their battle against Metternich. They dreamed and fought in vain. France offered nothing, and Austria attacked. Hapsburg forces quickly defeated the rebels and enthroned the rulers displaced by the nationalists.

### The Failure of Revolution in Poland

The Russian tsars who ruled as kings in Poland after 1815 had always allowed significantly greater liberty for the Poles than for the people of Russia. Foreign rule bred resentment anyway, secret revolutionary organizations emerged, and Polish rebels awaited their moment. It came. Waves of revolution and protest moved out from France after July and rebellion spread into the streets of Warsaw in November. Then the forces demanding liberation began to strike elsewhere in the kingdom. The Polish legislature acted, too. It declared an end to Tsar Nicholas's reign in their country.

Nicholas reacted at once. He nullified the relatively liberal Polish constitution he had granted earlier, rushed in an army of conquest and occupation, and launched a campaign to jail or exterminate suspected rebels. It took months to subdue Poland, but the tsar won. The suppression was ruthless and complete. The uprising in Poland had ended in failure, but the European revolution would continue.

## ■ THE CLIMAX OF THE EUROPEAN REVOLUTION

Europeans committed to liberal transformation of the sociopolitical order or to national unity created turmoil on the continent in 1830 and revealed how widely revolutionary sentiment had spread since the 1790s. Yet when the conflicts subsided, little had changed.

### The Reign of Metternich in Central Europe

In the Central European realms over which Metternich held sway in the 1830s, the Austrian chancellor intended to ensure that nothing about the sociopolitical system would change.

### The Austrian Empire and German States

Metternich gained the ultimate power to implement his negative policy within the Austrian Empire between 1835 and 1848, because Ferdinand I, the emperor during these years, lacked the mental capacity to exercise any authority at all. Metternich bent every effort to suppression of the discontented: the peasant masses still oppressed by obligations to the aristocracy, small contingents of miserable industrial workers, middle-class liberals, and the nationalists in every ethnic subdivision of the state.

In most respects, the sources of discontent that generated opposition to Metternich's policies in Germany, where he had much influence through the German Confederation, were the same as in Austria. In the German states, he faced an increasingly distressed peasantry, urban workers battered by the effects of first-stage industrialization, and a growing middle class committed to liberal principles and national unity. The Austrian chancellor confronted problems in Germany as he did elsewhere—with repression. He induced rulers in several states to nullify the constitutions granted in 1830 and kept potential trouble spots under watch and the threat of force. The level of public hostility continued to rise.

### Italy

The movement for Italian unity splintered after the failure of the 1830 revolts. *Risorgimento* leaders still beckoned Italians to march together toward nationhood, but three factions emerged. Giuseppe Mazzini (1805–1872) challenged patriots to join his organization, **Young Italy,** and follow him in the formation of a fully democratic country. This kind of government, a nation-state with popular sovereignty, eventually would exist everywhere in Europe, Mazzini believed. He expected these free and self-governing nations then to recognize their common duty to serve the universal needs of humanity.

Mazzini's commitment to the Left's belief in popular sovereignty set him sharply apart from Italian nationalists attracted to liberalism but not to democracy. They placed their faith in a struggle for unity led by the **Kingdom of Sardinia.** According to these nationalists, a Sardinian victory would give Italians a constitutional monarchy with protected liberties, especially property rights.

Other nationalists rejected both democracy and liberal monarchy. Like the Guelf movement in the Middle Ages, they believed that the Roman Catholic Church offered Italy its best hope for security and progress. These **Neo-Guelfs** called for the faithful of the entire country to submit to the pope as their ruler, who then would grant their liberties. This diversity among the nationalists probably weakened the unification movement, but their common dream of liberation posed the most serious threat to Metternich south of the Alps.

## The Bourgeois Monarchy in France

Charles X's abdication in July 1830 left power in the hands of the Chamber of Deputies. This legislature selected the Duke of Orleans, the former king's cousin, as the new monarch. King Louis Philippe, whose royally related family had supported the overthrow of Louis XVI (1792), ruled in the interest of the upper bourgeoisie throughout his years in power (1830–1848). The rich business and professional classes had kept their grip on the socioeconomic system after 1815. In 1830, they again supplanted the aristocrats and made the government theirs, as it had been in 1789.

### Revisions in the Constitutional Charter of 1814

Louis Philippe shunned royal garb, donned the business frock of the day, and regularly joined his fellow citizens on the streets. But the king offered the French more than symbolic association. He and the bourgeois leaders of the revolt that put him on the throne reestablished the Charter of 1814 that Charles X had nullified.

In its original form, this document guaranteed equal legal rights, permitted personal career choice, and gave the vote to the richest one hundred thousand. In order to empower the rest of the upper bourgeoisie, the new leaders adjusted the electoral provisions of the 1814 Charter and gave the vote to about 200,000 people, which was still less than two percent of the adult population. One of Louis Philippe's ministers said there were fewer than 200,000 who had the intelligence to vote.

### The Opponents of the Bourgeois Monarchy

Parisian workers, members of the lesser bourgeoisie, and republican idealists had joined the upper bourgeoisie on the barricades in 1830 to fight Charles X. The upper bourgeoisie then took power from Charles and gave their allies somewhat greater liberty. But when the rich elite refused to allow other social groups a part in the government, they turned against the bourgeois monarchy. The much more rapid growth of industry, beginning in the 1830s, expanded this hostile force by multiplying the number of workers and worsening their lives.

When citizens criticized the Charter provisions that gave the vote only to the very wealthy, Prime Minister Francois Guizot reportedly answered, "get rich." Political leaders watched the suffering that came with the onset of industrialization with the same cold detachment. When misery inspired rebellious behavior, the government responded with military force and strict censorship of publications. The bourgeois monarchy yielded nothing to its enemies. The rebels prepared to take everything.

### 1848: The Year of Revolutions

The expanded attack on the *Ancien Regime* that began in 1830 climaxed in 1848 when the most massive revolutionary storm of the period swept over Europe. Once more, it struck first in France.

### The Fall of the Last French Monarchy

As the economy worsened in the mid-1840s, suffering and discontent increased rapidly. Restrictions on public demonstrations led rebellious citizens to the evasive expedient of holding large banquets at which they vented their rage. When Guizot decreed that such a gathering scheduled for February 21, 1848, could not be held, incensed demonstrators poured into the streets of Paris.

The king removed Guizot from office, but mob action continued. Louis Philippe dispatched troops to quell the crowds on February 23. A shot of unknown origin rang out and the royal force fired at the clustered rebels. Sixteen fell dead. The suppressive violence transformed the protest into a republican revolution. Military units demonstrated increasing sympathy for the revolutionaries, and the rebels soon had the strength to take Paris. Louis Philippe and Guizot found refuge in Britain. The nation's first bourgeois monarch thus became its last king.

**The Second Republic.** Revolutionaries, who remembered the First Republic of the 1790s, hastily assembled to declare establishment of the **Second Republic.** They announced the immediate organization of a provisional government. This temporary political organization proclaimed the right of all adult males to vote in the election of a constituent assembly that would set up the permanent government—a response to the lower bourgeoisie and labor demand for the right to vote. As a further reward to workers, the provisional leadership also officially recognized everyone's right to a job. Many laborers insisted on more concrete benefits.

**The National Workshops.** Workers played a larger role in the revolution of 1848 and its aftermath than they had in 1830. Most of the 1848 revolutionaries came from other social classes, but they could not ignore the now more powerful lower classes. In the provisional government, Louis Blanc, a socialist, championed the cause of these people. He insisted on the adoption of his plan for the establishment of national workshops to provide employment for the many workers without jobs. The government complied but never put sufficient resources into the project to develop the system of thriving factories that Blanc had planned. The workshops gained reputations as centers that doled out money for needless labor. They failed.

**Closure of the Workshops.** The provisional government's decrees multiplied the number of voters thirty-five times. In May 1848, about eighty-five percent of the nine million eligible men voted for deputies to the constitutional convention. The assembly they elected cared deeply about bourgeois economic and professional interests but little about the plight of urban workers. The deputies voted to close the national workshops.

**The June Days.** Enraged laborers answered with public protest and calls for violent action. Government forces attacked them. The street combat continued for four days in late June, killing nearly 1,500 workers and 1,000 soldiers. The government arrested thousands of suspects and sent many to foreign penal colonies. These actions by the Second Republic displayed the power of a united middle class and peasantry and their contempt for industrial workers.

**The Constitution of 1848.** When the assembly presented the Second Republic's constitution in November 1848, its provisions indicated that the entire bourgeoisie now ruled, not just the rich middle class. It guaranteed the vote to all males, established a unicameral legislature and an executive branch with extensive powers, and gave absolute protection of property rights. The constitution also protected other personal rights that liberals valued, but it rejected the idea of a right to work. As in the June Days repression, a social class line had been drawn.

## A Fleeting Revolutionary Victory in the Austrian Empire

News of the French rebels' triumph in February 1848 immediately moved liberal and nationalist subjects of the Hapsburg Empire to action. In a speech on March 3 in Budapest, Louis Kossuth challenged the Magyars (Hungarians) to follow him in a battle for liberal government and freedom from Austrian

authority in their part of the Hapsburg Empire. Ten days later, Austrian liberal protestors confronted the parliament in Vienna with demands for reform. An attempt to suppress the protest by force led to chaos in the streets of the imperial capital. Fear gripped the Austrian ruler, and Metternich lost his emperor's support. Metternich quit his position as chancellor and hastened to Britain, ending forty years of struggle against revolution. Emperor Ferdinand then proclaimed that he would submit to every demand of the people of his empire.

Kossuth's liberal national forces in Hungary seized their opportunity. They enacted the March Laws providing for an end to Austrian control over government within Hungary, while also allowing the Austrian emperor to keep his title as monarch of the realm. The legislation called for a representative Hungarian parliament, promised democratic elections, abolished serfdom and aristocratic privileges, and established freedom of the press. By early April, the Czechs who populated Hapsburg Bohemia had won concessions from Emperor Ferdinand that granted a moderate shift toward special rights for them within the empire.

At the time of the March outbreaks in Budapest and Vienna, Ferdinand had pledged to allow his subjects to write their own constitution. Despite this promise, on April 25 he issued a document of his own for the Austrian part of his realm. It granted a representative parliament, responsible government, and voting rights for all males. Ferdinand had yielded too little to placate rebellious liberals, however. The mood of revolt simmered on, and the emperor finally left Vienna in May for refuge in the calmer atmosphere of Innsbruck, Austria. The rebels took charge and by July, decreed the nullification of all peasant responsibilities to their lords.

### The Triumph of an Ancien Government

The revolutionaries in Hungary, Bohemia, and Austria had won their separate victories by May 1848, but because they formed no united front against the Hapsburg imperial government, the victors quickly lost political power. In June, Ferdinand's armies attacked the Bohemian capital of Prague and overwhelmed the Czech rebels.

Bourgeois liberals and peasants in Austria relished their new freedom from the social and economic restraints of the old regime, but they opposed the more democratic rebels who had helped them win control in that part of the empire. This division made the forces that wanted to continue the revolution easy prey to imperial troops as they retook Vienna in October 1848. With the Austrian part of the empire thus subdued, Hungarian nationalists faced the imperial government alone.

Before the end of 1848, an enfeebled Ferdinand surrendered the throne to his nephew, Francis Joseph (reigned 1848–1916). The young Emperor then joined his new chancellor, Prince Felix von Schwarzenberg, in a reinvigorated campaign against the last rebel center in the empire.

Francis Joseph nullified the liberties that Ferdinand had granted to Hungary and invaded the region. Hungary repelled the attack and faltered only after Nicholas I dispatched a Russian force of more than 100,000 to support the Austrian Emperor. By mid-1849, Francis Joseph reigned supreme over all of his suppressed empire.

### The Struggle for Liberation in Italy

In January 1848, liberals in southern Italy wrested a constitution from the ruler of the Kingdom of the Two Sicilies. The rise of the French Second Republic in the following month encouraged rebels

throughout the peninsula to take action. Quickly, rulers in the Papal States and Tuscany in west central Italy and Piedmont-Sardinia to the northwest yielded to demands for liberal constitutions.

Revolution immediately followed in the Austrian-dominated states of Lombardy and Venetia in the northeast. By March 22, the rebels had expelled Austrian forces from these two principalities, and Italians from many other states joined a war of national liberation against the Hapsburgs.

A bitter seventeen-month struggle ensued. The revolution at first lost momentum, and Austria retook Lombardy. Then liberals won a dramatic victory in Rome in early 1849, as they expelled the pope and established a republic led by Mazzini. The war between Austria and Piedmont-Sardinia raged on in the north, until Francis Joseph's forces crushingly defeated the Italians at Novara on March 23, 1849. Republican France, after a rapid shift toward conservatism, dealt the final blow to Italian liberal nationalists with an invasion that conquered the Roman republic and restored the pope. The summer of 1849 ended with *Ancien Regime* governments reestablished in most of Italy.

### The Liberal Nationalist Revolt in Germany

The fall of the French monarchy in February 1848 intensified the revolutionary mood in Germany as it had elsewhere in Europe. In mid-March, Prussian liberals called for Frederick William IV (reigned 1840–1861) to reform the state according to their principles. The king yielded nothing, however, and demonstrations immediately rocked Berlin. Frederick William then sent troops into the capital to confront the crowds. The soldiers resorted to deadly fire, and the rebels countered with barricades and violence. This chaos jolted Frederick William, and he ended it with a pledge to call a constituent assembly. During March and April, the rulers of several other German principalities granted constitutionally guaranteed liberal rights.

**The Frankfurt Assembly.** Government liberalization pleased most German reformers, but without national unity, they remained dissatisfied. The revolutionary environment of 1848 inspired nationalists to dramatic action. A group of reformers with no legal standing met in Heidelberg and devised plans for a special assembly to consider a course of action. They proclaimed that all adult males in the German Confederation could vote for representatives to this national body. The assembly of 830 mostly middle-class deputies gathered in Frankfurt on May 18, 1848.

**The *Grossdeutsch-Kleindeutsch* Issue.** The assembly struggled through extended debates about the best form of government for a united Germany and the territories it should contain. The latter issue caused an especially sharp division. Delegates clashed over proposals for a Big German *(Grossdeutsch)* state that would unite all Germanic territories, including those in the Austrian Empire, and a Little German *(Kleindeutsch)* state that excluded Austrian lands. The assembly adopted a compromise that required a drastic restructuring of the Austrian Empire in order to bring Germans there into the new nation. The rejection of this plan by Emperor Francis Joseph ended Austria's participation at Frankfurt, dashed the hopes of the Big Germany faction, and left the advocates of a Little German state in charge of the assembly.

**The Triumph of Prussian Monarchy.** In May 1848, Frederick William IV kept his promise to convene delegates to write a Prussian constitution. The Prussian king reverted to repressive policies in the autumn, however, and the assembly adjourned in December without producing a constitution. Frederick

William then offered Prussia a narrowly liberal constitution from the throne. He also used military force to coerce the nullification of most of the liberal gains made in other German states. In March 1849, the Frankfurt Assembly completed its plan for a German state that excluded Austria. The delegates agreed to form a constitutional monarchy with a parliament elected by all adult males. Then, despite the Prussian monarch's recent reactionary behavior, they invited him to become "Emperor of the Germans." Frederick William found this offer of "a crown from the gutter" easy to refuse. The assembly dissolved, its efforts to unify Germany a failure.

### The Modern State after the Revolutions of 1848

The European revolution that climaxed in 1848–1849 did not replace the *Ancien* sociopolitical order with the one promised by the rebels. Although they had destroyed serfdom in the Hapsburg Empire, the old government remained in power. Piedmont-Sardinia kept the liberal constitution it had won, but the middle-class revolutionaries succeeded in no other Italian state. All the German principalities acquired parliaments but not truly representative government, and the French Second Republic reflected the narrowly liberal attitudes of the middle class and peasants.

In reality, the failure of the liberal nationalist European revolution did not mean that *Ancien* government and society had survived. The revolts, on the contrary, had ensured the eventual completion of sociopolitical modernization. Since the 1400s, all European states had modernized, in part through the secularization of social institutions, the development of professional government bureaucracies, and the establishment of standing armies under the control of the central executive. By 1848, Britain and France were fully modern, which meant that each had the following characteristics: consolidated territories, middle-class or joint bourgeois-aristocratic leadership; a government committed to industrialization; and an adequately large minority of the working populace mobilized in support of the state.

The revolts of 1848 at once brought the bourgeoisie of Germany and Austria into a ruling partnership with the old elites, induced governments of the region to adopt the middle-class policy of industrial development, and accelerated the movement toward German and Italian unification. Germany and Italy would complete political modernization in the early 1870s. Although several European countries at that time still did not have all the traits of a modern sociopolitical system, the transformation had proceeded far enough so as to conclude that the new form of state had become typical of the region.

*Violent revolts against European governments have occurred rarely in the Modern era. When such events have taken place, they usually have broken out within a single country. The history of the years from 1815 to 1848 contrasts sharply with these typical patterns and marks this as an age of European revolution. Rebellion became both frequent and widespread, especially in 1830 and 1848.*

*Revolutionaries in this era came from varied social backgrounds, but most were middle-class businesspeople and professionals. In keeping with bourgeois liberal ideals, they fought for self-government and personal liberty, demanding above all freedom to express their opinions and pursue business interests. In regions that lacked unity, such as Germany and Italy, revolutionaries also struggled to organize nation-states.*

*Liberals and nationalists won scattered victories in the 1820s and 1830s and then shocked the old regimes with smashing successes all across Europe in 1848. For the rebels, defeat followed swiftly, too. Bourgeois revolutionaries in France turned against their more radical lower-class supporters when the*

*old government fell. The new French Second Republic became a government of and by the bourgeoisie and for themselves and the peasants, but not for others near the bottom of society.*

*Reactionary governments in Germany, Austria, and Italy also struck back with vengeance against liberal nationalist revolt, finally unleashing their vastly superior military power. Rebels in these Prussian and Austrian dominated territories fled or were seized, and rulers nullified most of the recently granted constitutions. Soon, the political and social structures of Europe showed little evidence that the revolution had taken place.*

*The conservative regimes standing in majestic victory after 1848 hid the true significance of the age of European revolution. New liberal or nationalist institutions had not suddenly replaced* Ancien *structures as the rebels had intended, but by mid-century the demise of old regimes and the triumph of modern state systems in both liberal and unexpected new forms was certain in the near future.*

## Selected Readings

Brock, Michael. *The Great Reform Act*. London: Hutchinson, 1973.

Gildea, Robert. *Barricades and Borders: Europe, 1800–1914*. Oxford, UK: Oxford University Press, 1996.

Hobsbawm, Eric J. *The Age of Revolution: Europe 1789–1848*. New York: Praeger Publishers, 1969.

*Internet Modern History Sourcebook: 1848*. (The following site has links to a wealth of secondary sources and documents on the 1848 revolts: *www.fordham.edu/halsall/mod/modsbook19.html*.)

Kraehe, Enno E. *Metternich's German Policy*. Princeton, NJ: Princeton University Press, 1963.

Langer, William L. *Political and Social Upheaval, 1832–1852*. New York: Harper & Row, 1969.

Lincoln, W. Bruce. *Nicholas I: Emperor and Autocrat of All the Russias*. Bloomington: Indiana University Press, 1978.

Robertson, Priscilla S. *Revolutions of 1848, a Social History*. Princeton, NJ: Princeton University Press, 1952.

Rude, George F. E. *The Crowd in History: A Study of Popular Disturbances in France and England, 1730–1848*. New York: Wiley, 1964.

Sperber, Jonathan. *The European Revolutions, 1848–1851*. 2nd Edition. Cambridge, UK: Cambridge University Press, 2005.

## Test Yourself

*If the completion of one of the following quiz items requires only remembering facts, simply select the answer. For questions that depend on analysis of text information, choose a completion and write a few sentences supporting the choice.*

1) A group that campaigned for greater democracy in Britain before the mid-1800s
   a) the Chartists
   b) the charcoal burners
   c) the bobbies
   d) the suffragists

2) The history of Europe, 1815–1848, best supports the theory that upper middle-class people at that time
   a) were conservatives who opposed revolution in any form
   b) favored a liberal revolution that would give them dominance in society
   c) wanted a liberal-democratic revolution that would give the vote to all adult males
   d) reluctantly supported a revolution that would give equal political power to all citizens

3) Which person's actions most clearly favored upper-bourgeois businesspeople?
   a) Louis Blanc
   b) Louis Philippe
   c) Louis XVIII
   d) Charles X

4) An important characteristic of European history in the years from 1815 to 1848:
   a) many wars resulting from conflicts among leading European governments
   b) many sharp economic swings from very prosperous to terrible times
   c) a trend to real democracy until most adults in most countries could vote
   d) many large-scale revolts

5) One of the distinguishing traits of nationalists, 1815–1848, was their tendency to believe in
   a) women's liberation
   b) socialism
   c) liberalism
   d) royalism

6) After passage of the British Reform Bill of 1832,
   a) fifty percent of adults could vote.
   b) Britain became Europe's most democratic country.
   c) the working class gained power almost equal to the middle class.
   d) the House of Lords had no real power.

7) The first attempt to destroy autocracy in Russia was made by
   a) aristocratic military officers
   b) peasant rebels
   c) upper-middle-class business people
   d) radical urban workers

8) Britain's history, 1815–1848, indicates that
   a) reformers want change for the sake of change.
   b) upper-class people oppose reform.
   c) reformers ignore the suffering of working people.
   d) reform makes revolt less likely.

## Test Yourself Answers

1)  **a.** The answer mostly requires the recollection of the goal of the Chartist movement. Memory, rather than analysis, also would suffice to decide that the nickname for British police officers (bobbies), Italian student rebels (charcoal-burners or *Carbonari*), and a word not mentioned in the chapter (suffragists) would not correctly complete this item.

2)  **b.** Detailed fact-recall alone should leave little doubt that it is correct to conclude that the history of the years 1815–1848 shows that the upper bourgeoisie in Europe wanted revolts that would extend power to their social class but not necessarily to other segments of society. The introductory line of this quiz item, though, could make a cautious person decide to use an analytical approach. An assessment of chapter contents would provide information that indicates the validity of completion *b* and the error of choosing other completions. For example, the French revolt in 1848 shows support for giving the vote to all males, which might suggest *c* as a correct completion. Careful analysis, however, indicates that the rebels who wanted this change had attacked an upper bourgeois government that opposed that degree of democracy.

3)  **c.** All the possible completions relate to French history. Louis XVIII and Charles X are post-Napoleonic kings who differed in their degrees of hostility to bourgeois ideals and influence. Louis Blanc was a socialist and, so, hardly a friend of bourgeois businesspeople. An upper-bourgeois–led revolt brought Louis Philippe to power and gave them a government that strongly favored this social class. Text content makes this a simple fact-recall item.

4)  **d.** Close attention to the theme of the chapter could lead a reader to decide that recollection clearly indicates that this is a period somewhat unusual in the frequency of revolts. Still, the quiz item offers a good opportunity for a written display of inductive thinking skill, a method of special value in historical study that involves analysis of information to draw conclusions. Inductive thinking in this case supports completion *d* because of the wealth of information about events such as the Peterloo Massacre, the Russian Decembrist revolt, and the numerous rebellions in 1830 and 1848. Inductive reasoning might also prompt attention to the repeated use of military intervention to suppress revolts, which suggests that warfare is common in these years, but it is not warfare "resulting from conflicts among leading European governments." During these years, economic hardship at times affected events and, as the Question 2 answer indicates, French rebels in 1848 wanted the vote for all adult men, but neither of these possible completions, upon full analysis, stands as valid.

5) **c.** The text directly states that in the first half of the 1800s, nationalists usually also showed their commitment to liberal ideals.

6) **b.** The information in this chapter specifies that the 1832 voter reform in Britain left elections in the hands of a minority and yet also made this country the most democratic state in Europe. Knowledge of this circumstance sheds important light on the traits of European government in this era.

7) **a.** Logic uninformed by the historic details of this period would not suggest that the first revolt in the modern period aimed at destroying Russia's system of government would come from "aristocratic military officers," but the text explicitly indicates this unusual and significant fact.

8) **d.** Because segments of the upper class certainly opposed reforms such as the repeal of the Corn Laws and because the plight of the workers was largely ignored by business interests, the selection of *d* rather than *b* or *c* to complete this quiz item probably deserves a written explanation. The support of upper-class Whigs for political reform and of upper-class Tories for factory reform makes both *b* and *c*, with their sweeping statements, poor choices for completion. The tendency of Whig and Tory reformers to support certain reforms and oppose others also indicates the error in completion *a*. Overall, the text information about Britain, especially when considered in the larger context of events elsewhere in this rebellious era, strongly supports the conclusion that "reform makes revolt less likely." This conclusion might not hold up in light of historic circumstances in other times and places.

# The Culture and Economy of Industrial Europe (1848–1914)

**1842:** Comte presents his positivist theory.

**1853:** Courbet paints *The Wrestlers* and *The Bathers*.

**1854:** Dickens publishes *Hard Times*.

**1859:** Darwin presents his *On the Origin of the Species, by Means of Natural Selection*.

**1863:** Tolstoy begins publication of *War and Peace*.

**1865:** Lister introduces antiseptic surgery.

**1848:** Marx and Engels publish *The Communist Manifesto*.

**1856:** Bessemer introduces his new method of steel processing.

**1859:** John Stuart Mill publishes *On Liberty*.

**1876:** Alexander Graham Bell tests the first telephone.

**1887:** Daimler demonstrates the first gasoline-powered automobile.

**1894:** Freud presents his views on the human unconscious.

**1899:** Marconi transmits the first wireless telegraph message.

**1903:** The Wright brothers complete the first airplane flight.

**1905:** Albert Einstein publishes his *Special Theory of Relativity*.

**1906:** The British Labour Party emerges.

**1913:** Stravinsky's ballet *Rite of Spring* provokes a riot.

*Between 1815 and 1848, liberal and national idealism inspired many Europeans to struggle to complete the dismantling of the* Ancien Regime. *Their campaign led to revolutionary conflicts with the defenders of the old order. By the late 1840s, this era of European revolution ended, with the vision of a*

*liberal nation-state system for the continent unrealized. The revolts, however, had advanced the modernization of European institutions, even if these emerging social structures differed in important ways from liberal national ideals.*

*The distinctively modern features of European civilization continued to develop in the decades after 1848 in directions set much earlier. The environment in which modern ways took further shape changed, however, in one especially important respect in the mid-1800s. The turmoil and destruction of the revolutionary era and the circumstances that resulted by the end of the 1840s largely killed the spirit of idealism that had driven many Europeans since the Renaissance. A hard and less hopeful spirit had emerged in Europe. The diminished idealism of many European liberals and nationalists after 1848 and the increasing acceptance of brute military force as the means to goals such as nationhood coincided with a striking shift in European thought and the arts in the 1850s and 1860s.*

*A multitude of startling discoveries in the natural sciences induced leading social theorists to conclude that neither the reason of the* philosophes *nor the intuition of the Romantics led to truth. Science alone, in their opinion, could answer all questions about reality and thus give the only worthy guidance to human endeavors. People with this outlook frowned on idealism. Literature and art quickly began to reflect this realist attitude that dominated both the politics and the formal thought of Europeans in the first two decades after mid-century.*

## ■ THE AGE OF REALISM

Throughout the 1850s and 1860s, the dominant attitude among Europeans was a commitment to whatever was practical, unemotional, and scientific. Realism in this sense characterized thought, the arts, and government. Remarkable progress in science during the 1800s strongly influenced this change in outlook.

### Science—a Hard Look at Earth

The scientists who jolted the minds of Europeans in this period focused attention especially on the forces and substances of the material world. Thinkers in the past had adequately explained much about the earth as a planetary body, but they provided little information about the physics, chemistry, and biology of the sphere they inhabited. Europeans in the 1800s ardently studied this neglected realm and reached conclusions about these issues. Many of their answers remain fundamental to science in the twenty-first century.

### *The Material World*

European scientists in 1800 had a vast store of inherited data on the natural world. In the first half of the century, they continued to collect information in experiments such as Michael Faraday's demonstration that magnets could produce electricity. A few scientists even began to use their findings to support broad theories. Until about 1850, however, they usually left grand generalizations about the world and life to the philosophers and political thinkers who conjured up ideologies such as liberalism, conservatism, nationalism, and socialism.

**The Foundations of Evolutionary Theory.** The few scientists who advanced broad theories in the early 1800s included two who offered important arguments about biological and geological change. Soon after 1800, Jean Baptiste de Lamarck proposed a theory of biological evolution that challenged the dominant view of changeless plant and animal forms. Similarly, Sir Charles Lyell's compilation of geological data in the early 1830s contradicted the traditional idea of an earth created suddenly in a permanent form less than 10,000 years earlier. Lyell's evidence indicated a much older planet that had changed greatly since its origins.

**The Study of Matter.** As geologists considered the earth's gross features and structures, other scientists contemplated the elements of which it was composed and the forces that affected them. In the late 1700s, Antoine Lavoisier presented evidence that matter was indestructible. John Dalton pursued the related problem of the structure of matter. In the early 1800s, he used modern experiments to verify the ancient theory that all matter was made up of tiny particles (atoms). The approach to the study of matter typical of this century climaxed in 1869 with Dmitri Mendeleyev's development of a table of elements based on properties such as atomic weight. A theory about the forces of nature that paralleled Lavoisier's view of matter appeared in the late 1840s. Ludwig Helmholtz concluded that the energy in nature could never increase or decrease.

### Darwin's Theory of Evolution

By the mid-1800s, science had placed Europeans on the threshold of a new form of secularism that viewed the earth and all its creatures as totally material, but made up of "immortal" substances, and moved by "unalterable" forces. This intellectual climate encouraged the presentation of comprehensive theories such as Charles Darwin's conception of biological evolution.

In 1831, when the British navy dispatched the *Beagle* to South America and the adjacent Pacific waters carrying specialists to study the lands and life forms of the region, Darwin (1809–1882) was among the scientists. Information gathered on this expedition significantly influenced Darwin's thinking, but years of study followed before the publication of his conclusions.

Darwin's first comprehensive theoretical work, *On the Origin of the Species by Means of Natural Selection* (1859), argued that when life began on earth, there were only a few types of plants and animals. He reasoned that blind natural forces over an extremely long period of time acted on these original plants and animals to produce the great variety of species that inhabited the modern world.

According to evolutionary theory, the individual members of all species vary slightly in strength, size, health, attractiveness, and other traits. Certain individual plants or animals thus are better suited to their environments than others of the species. The less fit die younger and so produce fewer offspring. Eventually, the less-favored types cease to exist, and the longer lived and more fertile organisms produce so many descendants that only their new form continues. It becomes a new species. In *The Descent of Man* (1871), Darwin applied his theories to humanity. He supported these views not only with his own research, but also with recent studies by other scientists and social theorists.

Darwin neither accepted nor rejected the possibility of divine influence, but his theory of evolution directly contradicted the previously dominant conviction that God had instantly and purposely created all

currently living species. Evolutionary theory also was not easily reconciled with the belief that people had been made in the image of God. Such views stirred a heated debate among supporters and foes of evolutionary ideas.

### The New Biology

Darwin's provocative theory somewhat overshadowed other important achievements of the new biology after 1850. In 1861, Louis Pasteur revealed to Europeans that microorganisms caused disease, a discovery that led him thereafter to devise vaccines capable of preventing certain illnesses. Another revolutionary step in medical science followed in 1865, when Joseph Lister began the practice of conducting surgery in a sanitary room with sterile implements. Gregor Mendel in this same decade carried out tests with varieties of peas that enabled him to penetrate many of the mysteries of the process of heredity.

### The Arts

The new scientific theories strengthened the realist mood by mid-century, the point at which artists and writers began to display a similar spirit as they rejected the Romantic outlook. Cultural leaders wanted to portray the world as they actually saw it rather than through the distortion of emotions or ideals. As early as 1850, critics in France began to describe the paintings of Gustave Courbet as "realistic." Within five years, it became typical for commentators to apply the word to this new form of art and literature.

### Realistic Painting

**Realism** in art emerged and developed mostly in France. The works by Courbet that established this movement included *The Wrestlers* and *The Bathers,* both produced in 1853. In these paintings, the artist purposely violated the standards of the Romantics and their cultural predecessors by depicting grimy and tense fighters and the bodies of ordinary bathers rather than idealized men and women. Such portrayals horrified traditional observers but drew numerous young artists to him to learn.

Other important painters developed their own versions of realism. By the 1860s, the guardians of the galleries had to struggle to suppress not only Courbet's works but also those of Edouard Manet, Claude Monet, and Edgar Degas. Monet's paintings especially reflected the connection between the science and art of the day. He painted scenes with a multitude of areas of color brought together in a way intended to capture the momentary impression of sight caused by nature's light and the biology of his eyes. He meant, that is, to use the science of optics as one of his artistic tools. In his quest to capture in paintings his realistic science-informed visions of reality, Monet in the late 1860s helped to found a new movement in art called **impressionism.**

### Literary Realism

Works of realistic literature as well as art appeared in profusion all over Europe beginning in the 1850s. Leading writers attempted to convey in the most vivid way their precise observations of life around them, especially the difficulties and suffering they saw. Novels served such artistic purposes much better than the poetry that Romantics had favored for artistic expression in the previous generation.

Russian novelists in the latter 1800s lived in a very troubled society and gave the world unusual insights into human experience. Ivan Turgenev's *Sportsman's Sketches* (1852) displayed the crushing

oppression of the serfs who made up half the rural population in his country. His renowned *Fathers and Sons* (1862) contained a graphic story of a rebellious younger generation's reaction to social evils such as the misery of the rural poor.

Other Russians produced even more famous works. Leo Tolstoy used novels such as *War and Peace* (1863–1869) and *Anna Karenina* (1873–1877) to provide a sensitive consideration of difficult questions about life. In *Notes from the Underground* (1864), *Crime and Punishment* (1866), and *The Idiot* (1869), Feodor Dostoevsky depicted the emotional toll of Russia's hard reality.

West European novelists reflected both the shock of social and economic revolution and the tedium of life in an industrial world. In France, Gustave Flaubert captured this latter mood with special power in *Madame Bovary* (1857), a supreme example of realist fiction. This novel contained a detailed picture of a bourgeois husband's meaningless life and his wife's use of adulterous adventures to escape her dull existence and punish her boring spouse.

Several European realists wrote about the struggles and suffering of suppressed social classes. In *Les Miserables* (1862), Victor Hugo gave a moving account of the 1830 Parisian revolt. Charles Dickens in *Hard Times* (1854) and Elizabeth Gaskell in *North and South* (1855) similarly expressed their passion-ate reactions to the misery of the poor in Britain's industrial cities. Despite the powerful emotions that appeared to inspire realist authors, they expressed their views of society as though they were scientists obligated to report their observations exactly.

## Social Thought

The scientific enthusiasm that encouraged the bold generalizations of the new biology and the star-tling realism of the arts also affected social theorists after 1850. They assumed that as thinking animals living in a fully material universe, the time for a science of society had arrived.

### Materialist Philosophy

European philosophers, as they considered the nature of humanity and the universe over the cen-turies, developed a tradition of accepting either the spiritual or material realm as ultimate reality. In any period, certain theorists incline toward idealism while others are materialists, but one of these schools of thought usually achieves dominance. The scientific environment of the mid-1800s inspired a strong move-ment away from the idealism of the Romantic era and toward a new form of materialist philosophy.

Leading intellectuals who considered the nature of life in this period took into account the new scien-tific view of matter and physical forces. By the early 1850s, one chemist had published his conclusion that matter endlessly changed from inorganic to organic and back, with life simply being the organic stage.

Materialist philosophers stated their similar conceptions of life in an especially emphatic way. Ludwig Feuerbach became a leading voice among theorists who proclaimed that nothing except matter could possibly exist anywhere. The universe contained no God, nothing spiritual. Humans had no soul. What a person ate, in Feuerbach's view, determined what the individual became. Human nature and behavior were a matter of chemistry and nothing more.

### Positivism

Feuerbach thought that nutrition determined the chemical content of human minds and muscles which, in turn, decided the outcome of events such as the revolutions of 1848. He even contended that if

the rebels had eaten protein-rich food, such as beans, they would have had the muscle to win their revolts. He thus offered a materialist explanation for specific historic occurrences.

In 1842, Auguste Comte presented a materialist theory of knowledge that he believed would serve as a tool to control the very course of history. Humanity in the 1800s, according to Comte, had reached the ultimate stage of development, since people in his era at last had the ability to observe society scientifically and acquire positive (that is, absolutely correct) knowledge of social processes.

Comte assumed that humans had entered this positive stage of intellectual evolution after a long struggle through two previous phases of history, the theological and metaphysical stages. In the first era, observers held the most backward view of events. They believed in a world controlled by supernatural forces. Life in the metaphysical (philosophical) stage seemed less mysterious than in the age of theology. With this advance in outlook, reason provided explanations of reality that at least excluded the superstitions of the past. The completion of this great intellectual journey in the 1800s brought to humanity a most wonderful prospect. Now, scientific understanding in the positivist stage would lead to the perfection of society.

Comte's **positivism** influenced specialists in history and other fields that focus on human behavior and relationships. It encouraged such scholars to use the methods typical of science. The **social scientists** inspired by positivism committed themselves to a quest for complete information about human issues and to an objective study of their findings. The nature of Comte's theories and the effects of his work have led scholars to consider him a principal founder of sociology.

## Social Darwinism

While many European scholars in the mid-1800s tried to study human affairs scientifically, other theorists simply borrowed and distorted aspects of the new science to justify their convictions. Social commentators of the latter kind in the 1860s began to draw especially heavily on the works of Darwin. Walter Bagehot, for example, inserted Darwinian phrases into his works on international relations. He depicted nations as locked in a struggle that results in the dominance of the most powerful state. The victor thus proves its superiority, almost like a surviving species. Such misapplications of biological theory became known as **Social Darwinism.** Ideas of this kind became increasingly common after 1870.

## Realpolitik

Social Darwinist notions of a brutal power struggle well suited the mood among European political leaders after 1850. They strikingly altered their principles of governance and became devoted to the advance of their countries almost without concern about morality or ethics. Highly deceitful diplomacy became typical. Officials, in fact, generally pursued the interests of their states both at home and abroad with these same coldly realistic considerations of power.

This approach in politics meant that nothing mattered about policies except whether they enhanced the position and strength of the government at home and the nation abroad. Leaders with such views took great pride that they had advanced from the idealism of the liberal nationalist era (1815 to 1848) to this new practice of realism in politics. German officials such as Prussian Chancellor Otto von Bismarck became the most dedicated followers of this policy, which they called *Realpolitik.* The merger of the spirit of *Realpolitik* and nationalism in the latter 1800s helped to make nationalism one of the most powerful forces in modern European history.

# ■ THE MATURATION OF THE INDUSTRIAL ECONOMY (1848–1914)

In the mid-1800s, the startling changes caused by the industrial revolution made both the intensification of scientific study and the admiration of realistic arts quite natural. Industry needed and stimulated science. A dramatically changing industrial world drew the attention of creative and thoughtful people. This scientific and realistic inclination that strengthened through the first decades of the industrial revolution probably helped spur industrialization to a more mature stage of development in the latter 1800s.

By the 1850s, the circle of economic modernization extended from the most developed countries, Britain and Belgium, southward through the heart of the continent to northern Italy. Industrialization continued to spread into new areas thereafter. By the 1890s, the economic transformation had begun in Europe's most agricultural nation, Russia. The states with the most developed economies rapidly expanded their industrial systems and advanced in technology during the latter 1800s. Before the end of the century, Germany replaced Britain as the leader in Europe's industrial race.

## The Industrial Productive System

Between 1848 and 1914, industry continued its remarkable progress as the machines and processes discovered in the previous century came into much wider use. The development of new devices and methods also sped the economic revolution ahead in the latter 1800s. At the same time, the new science began to influence industry more directly and increased the effect of inventions on production. One important result of this continuing economic transformation was a two hundred and sixty percent expansion of industrial output between 1870 and 1914. This great leap would have been impossible without a remarkable advance in the power that drove the machines of industry.

### Power Sources and Engines

The number of steam engines grew rapidly in the latter 1800s. The multiplication of these machines occurred both as more factories installed them for traditional operations and as inventors discovered new applications. The innovations included a steam-driven plow, the rotary printing press, steam rollers for packing roads, and, in 1857, a steam dynamo to generate electricity.

Coal fired most of the steam engines and heated many buildings in the 1850s. By then, natural gas also had become a significant heating fuel and light source. Soon, however, industrialists began to use other forms of energy that in the next century became more important than coal and natural gas. Edwin Drake founded the new petroleum industry when he drilled a well in Titusville, Pennsylvania, in 1859. Oil use increased slowly thereafter until its boom era began in the 1920s. The electric industry advanced more swiftly. Technological improvements in the 1870s and 1880s so revolutionized this industry that by 1914, electricity provided heat and light in more urban structures than did natural gas.

### Textiles and Industrial Chemicals

The most revolutionary changes in productive systems before 1850 took place in the British cotton textile industry. In the 1850s, Isaac Singer, an American, promoted the sewing machine. New wool processing devices became available. These technological developments encouraged a rapid modernization of the textile and clothing industries.

Scientists gave textile manufacturing a further boost by ending the industry's dependence on natural dyes. In 1856, W. H. Perkins, a teenaged British chemist, discovered a way to produce synthetic purple

from coal tar. German scientists invented a chemical form of red dye in 1869 and won a patent for such products one day ahead of Perkins.

By the 1860s, chemical discoveries sped the growth of many industries. Ernest Solvay, a Belgian scientist, patented a process in 1861 that reduced the cost of producing alkali. His achievement benefited glass, soap, and textile manufacturing. Alfred Nobel's invention of dynamite in 1867 provided a low-risk way to produce an explosive of great value to the weapons industry. Dynamite also proved to be useful in construction and other non-military activities.

### Iron and Steel

Europeans produced steel before the 1850s, but this more purified form of iron cost too much to manufacture in commercially significant quantities at that time. Iron, therefore, remained the primary industrial metal until the latter 1800s, even though steel was stronger and had other superior properties. The work of several technicians in the 1850s and 1860s, however, ended the supremacy of iron.

Henry Bessemer discovered in 1856 that forcing air streams through molten iron produced more and cheaper steel. This process greatly increased the metal's commercial value. An even more significant improvement came in 1865 when Pierre Martin used Wilhelm von Siemens's gas furnace design to develop the open-hearth method of steel production. As a result of these discoveries, a tenfold increase in production of the metal occurred between 1865 and 1880. The era of steel had arrived.

## Transportation

Only one modern form of transportation had become widely prevalent as the industrial revolution climaxed in the 1850s—the railroad. Many lines then spanned the leading industrial states; nearly all countries had begun their systems. With the introduction of the Bessemer process, Europeans began to lay steel instead of iron rails. They completed the main strands of their rail nets with a total length of more than one hundred and seventy thousand miles by 1900.

The railroad industry also vastly improved the safety, quality, and profitability of service during these years. Inventors and technicians introduced the Westinghouse air brake (1869), sleeping and dining cars, and refrigerated freight cars. Despite these continuing improvements, other modern forms of transportation gradually began to rival trains.

### Steamships

Steamships remained a novelty in the mid-1800s. During the latter 1800s, the development of a more efficient engine and the replacement of the paddle wheel by the screw propeller brought the new vessel into its own. It began to rise to dominance over the sailing ship on the world's seas. Steam powered more than ninety percent of the ships built in 1914. Construction materials for these vessels changed drastically, too, in these years. Most ships in the 1840s were wooden. Iron became the primary material in new construction by the 1860s. Shipbuilders made almost ninety-nine percent of their vessels of steel in 1898 and 1899.

### Urban Transit

Steam and steel revolutionized sea travel. Somewhat more slowly, rails and electricity began to transform urban transportation as the horse-drawn cars on rails (introduced in the 1860s) gave way to

electric-powered versions in the 1880s. In 1887, Gottlieb Daimler built the first successful automobile propelled by a gasoline-fueled internal combustion engine. Less than a decade later, Rudolf Diesel invented an oil-burning engine that also could be used in automobiles.

Vehicles powered by electricity, gasoline, or diesel fuel would reign supreme a few decades in the future. In the latter 1800s, however, they did not truly rival the new bicycles of the day. Inventions such as rear-wheel drive and air-filled tires greatly improved the performance, safety, and comfort of bicycles and increased their popularity. By 1900, Britain, France, and Germany each had over four million bicycles. Italians then owned two million, and other countries also had large numbers. Sixty of these millions of cyclists entered the first great multi-stage race, the *Tour de France,* a one-thousand-and-four-hundred-fifty-seven-mile event held in 1903.

### Air Travel

The production of marvelous new contraptions for travel on land and sea left a few inventive people dissatisfied. Six men suspended in a container beneath a hydrogen-filled balloon used oars of silk to move their aircraft through the first human flight in history in 1784. For more than a century thereafter, the technology of air travel progressed very little.

Then science and industry quickly made flights of fancy a reality. Count Ferdinand von Zeppelin invented a balloon with an interior frame in 1898, a design so effective that such airships began passenger service in 1910. By then, a new device that showed an even greater potential to open the skies had taken flight. Wilbur and Orville Wright had completed their first successful airplane tests at Kitty Hawk, North Carolina, in 1903. The longest of the Wright brothers' first test flights lasted fifty-nine seconds and achieved a speed of thirty miles per hour. Six years later, Louis Blériot piloted his aircraft across the English Channel in thirty-seven minutes. With their incredible machines, humans had entered a new realm.

### Communications Technology

Astonishing progress occurred in communications as well as transportation in the mid-1800s and after. The invention of the telegraph in 1844 encouraged Europeans and Americans to lay cables between countries. They completed one from England to France in 1851. Within two decades, cables also linked continents—Europe and North America in 1866, then Europe and Asia by the early 1870s.

### The Telephone and Wireless Telegraph

Alexander Graham Bell sent the first voice message over wire with the telephone that he invented in 1876. The popularity of the new device grew rapidly. By the end of the 1800s, many government agencies and businesses regularly used telephones. In the 1890s, as the telephone became a practical tool in offices, Guglielmo Marconi invented a wireless means of sending telegraphic signals. The first coded electronic transmission flashed across the English Channel in 1899 and across the Atlantic in 1901.

### Business Communication and the Mass Media

A variety of technological and organizational achievements further transformed business communication and opened the way for the development of the mass media. Typewriters and improved postal systems, for example, enhanced the operation of many enterprises by the 1870s. A series of printing press inventions that began in that decade and the cheaper paper that chemistry made possible led to the founding of the first

mass-circulation newspapers in the latter 1800s. The government leaders who wanted a mobilized citizenry had the means of public communication they needed.

# ■ INDUSTRIAL SOCIETY

The progress of industry depended on and encouraged a wide variety of social changes. Especially dramatic alterations occurred in population trends and living conditions.

## The Urban and Rural Populations

The rate of population increase that began in the Early Modern period surged higher in the latter 1800s. Between 1870 and 1914, the total number of Europeans expanded by fifty percent, from 300 to 450 million. This climb resulted in part from improved nutrition and a declining rate of death from infectious diseases. The pace of urbanization quickened even more in these years. London grew from five to seven million in the thirty-five years before 1914. Paris and Berlin experienced a similar rate of increase and in the same year, had populations of three and two million, respectively.

Despite urbanization, most Europeans still lived in the country. Traditional ways changed more slowly there than in the cities, but the social influence of both peasants and landed aristocrats diminished as Europe became increasingly industrial and urban. At the same time, the urban middle classes gained in political power in several of the West European countries. In every society, the wealth of the bourgeoisie increased.

### Factory Work and Family Income

The widening gap between the wealth of the business classes and workers increased labor discontent. Other conditions also disturbed poorer urbanites. Machines in the factories required a faster pace of work and more strength to operate than in previous decades. Work was harder. This change led to a reduction in the percentage of women and children in industrial occupations. As a result, family incomes sometimes dropped. The more drastic swings in business cycles during the first two centuries of industrialization added to these financial woes. Inflation raised costs from the late 1840s to the early 1870s. Then, for two more decades, economic depression caused many workers to lose their jobs.

### Working-Class Neighborhoods

The working classes responded to these problems in a variety of ways. Neighborhoods developed a sense of identity, sometimes provided emotional support, and offered leisure activities both constructive and detrimental. Among these diversions, socializing at the local pub became especially popular among working people. Laborers also reacted to urban-industrial conditions by establishing formal institutions such as aid societies and unions.

## Labor and Business Organizations

Early Modern European governments usually declared labor unions and strikes to be illegal. Britain began to ease such restraints in the 1820s by allowing workers to organize but not to strike. Parliament finally removed these restrictions on union action in 1876. France canceled the laws against strikes twelve years later. By then, Austria and the Netherlands had legalized unions, as did Germany in 1890.

## The Labor Union Movement

During the latter 1800s, workers did more than struggle to end laws against unions. They also found ways to form more powerful associations than in the early years of the labor movement. In the past, they had established unions limited to skilled workers in a particular craft. Laborers now began to build organizations open to all the workers of an entire industry, such as railroading.

With changes such as these, labor soon emerged as a leading social force, especially in the two most industrialized countries. The German working class became strong and aggressive. Laborers there developed the most formidable socialist movement in Europe. British working-class power grew rapidly, too. By the 1890s, laborers in Britain elected their first parliamentary representative. In 1906, they formed the Labour Party to ensure a still stronger voice in government.

## Corporate Business Organization

The economic and political strength of business interests spiraled upward even more swiftly than did that of labor. Governments established laws that limited the liability of company owners to the amount they had invested, thus protecting them from personal ruin if the enterprise failed. In Britain, such companies were designated by adding "limited" or the abbreviation "ltd." to the corporate title. A firm with this status usually attracted greater numbers of investors.

These financial improvements gave business leaders increased power. Organizational changes during this period boosted their strength still more. Before 1850, single-owner and partnership firms were typical. Thereafter, larger bureaucratic enterprises owned by numerous stockholders gradually replaced smaller businesses. Groups of trustees and a corps of managers directed these new business organizations.

Corporate forms of business tended to expand in size and become highly centralized. They also frequently attempted to establish monopolies controlling an entire industry. The influence of these wealthy giants in government, and in society more generally, far exceeded that of the rising labor organizations.

# ■ IDEOLOGICAL RESPONSES TO INDUSTRIALIZATION

In the first decades of the 1800s, liberal and socialist theorists revised systems of thought in response to the rise of bourgeois power and the effects of industrialization. Ideological reactions to economic modernization turned in a more radical direction from mid-century onward.

## The Diversification of Liberalism

Many liberals in the latter 1800s held to the traditions of Adam Smith and other founders of the ideology. They preferred to keep government involvement in the economy very limited. A leading nineteenth-century theorist, however, devised a form of liberalism with a distinctly new attitude toward the role of government in society.

## John Stuart Mill's Revision of Liberalism

John Stuart Mill (1806–1873), a British scholar, argued strongly for the necessity of personal liberty, including the freedom to own and use private property. He repeated these views in several editions of his *Principles of Political Economy,* the first of which appeared in 1848. *On Liberty,* published in 1859, became an even more famous argument for these central ideas of liberalism.

**The General Welfare State.** Despite his commitment to such long-standing liberal beliefs, Mill's ideology differed greatly from the *laissez-faire* liberalism of his predecessors. Mill believed, as did liberal theorists in the early 1800s, that all the new machines had brought new suffering into the lives of the lower classes. He did not argue, however, that attempts to help would only worsen their lot. Instead, Mill urged government action to end the misery. His idea that the general welfare of the people sometimes required political intervention reduced the distance between liberalism and socialism and put him in conflict with liberals who wanted an uncontrolled business class. In ordinary usage, twenty-first century commentators have in mind John Stuart Mill's idea of the general welfare state when they refer to **liberalism.**

## Marxist Socialism

Karl Marx (1818–1883) and Friedrich Engels (1820–1895) offered a socialist response to industrialization. They rejected, however, the theories of Proudhon, Fourier, Owen, and other founders of Socialism. Marx and Engels condemned these earlier socialists' ideas as "utopian," as idealistic dreams of a society with equally shared wealth created by reform.

In place of these utopian theories, Marx and Engels offered "scientific" socialism. They called their doctrines "scientific" because they believed they had arrived at their conclusions through a scientific study of society. Marx and Engels also claimed that, as scientists, they faced the hard reality that justice for the working class could come about only through a violent revolutionary struggle, not by reform.

### The Early Years of Marx and Engels

Marx and Engels devoted their lives to this battle against the miseries of the urban working classes. Neither of them ever experienced that life. As children, they lived in middle-class German homes— Marx's father practiced law, and Engels enjoyed the wealth from his father's textile business. Marx earned a doctorate in philosophy in Berlin. Then, under pressure from authorities who disliked his atheism, he moved to Paris in 1843. Engels eventually took charge of branches of the family business in Britain, but he, too, was in France in the 1840s.

### The Communist Manifesto

These exiles met in Paris during the troubled years before the 1848 revolts. They formed a close friendship and intellectual association that lasted throughout their lives. Engels accepted Marx as the senior theorist and supported him financially for most of his life with funds from Engles' family enterprises. This dependence on capitalist profits did not lessen the rage the two socialists felt toward the bourgeois industrial system. In 1847, they began to compose a short book summarizing their theories. They published this *Communist Manifesto* in 1848.

### Dialectical Materialism

The *Communist Manifesto* and *A Contribution to the Critique of Political Economy* (1859) contain the fundamental Marxist ideas about society and the forces that control its development. Their theories include materialist principles similar to Feuerbach's. Beginning with such assumptions, Marx and Engels developed their doctrine of **dialectical materialism.** They incorporated into this theory Hegel's idea that

social change is a dialectical process: an existing condition (thesis) causes the emergence of its opposite (antithesis), and the two develop in conflict until they form a new condition (synthesis).

### Historical Materialism

Marx and Engels used dialectical materialism as a framework for their view of history, known as **historical materialism.** According to this doctrine, humanity began as primitive communists working together to secure the needs of life. People shared all goods equally. Life thereafter evolved through three more stages: an era of slave production; the feudal age, with its farm economy and serf labor; and the present-day capitalist industrial phase. Tools, technical procedures, and economic relationships (between worker and boss, for example) formed the material basis of society in each of these stages. This material foundation caused the formation and determined the nature of a social superstructure that included ideas, beliefs, art, and human institutions such as the family and social classes.

### The Class Struggle

Marxist doctrine asserted that change in the substructure of tools, technology, and economic relationships fully controlled the development of society from one stage (thesis) to the next (synthesis). Conflict accompanied the transitions. These sometimes ruthless battles erupted because one class ruled during each stage and resisted the rise to supremacy of the next group. This inevitable **class struggle** continued, however, until the changing **means of production** (tools, work procedures, and so on) gave economic control to a new class. Revolution usually brought each new class to power.

**Toward Bourgeois-Proletarian Class War.** Marx believed that bourgeois capitalists reigned supreme in his time because of industrialization and related political upheavals such as the French Revolution. The bourgeois ruling class, like all previous ones, had seized the state during its rebellion. Their governing power thereafter enabled the bourgeoisie to control and profit from the labor of everyone else. The subordinate non-capitalists eventually would form a single oppressed **proletariat** (urban working class). Ultimately, everyone in the industrial world would be either bourgeois or proletarian, and they would stand ready for class war.

**The Communist Revolution.** The prophets of Marxist socialism predicted that the capitalists would grow richer and fewer in number as the proletarians multiplied and sank into deeper poverty. Inevitable victory awaited the proletariat, however, for this factory working class truly *possessed* the productive means in this industrial age, even if it did not own them. This economic reality guaranteed that during a subsequent class war, workers would seize the state. Then the toiling masses would take the first step toward a classless and materially equal society—the use of state power to seize everything the bourgeoisie owned.

**Disappearance of the State.** After the loss of all their wealth, the business class would become proletarians or die, and only the working class would remain. Since the state, in Marx's view, was nothing but a political machine through which the ruling class controlled and used other classes, no state

would exist once society became classless. Democracy in its purest form would emerge, as government simply withered away.

### Das Kapital

Marx moved to London in 1849 and remained in this capitalist capital until his death thirty-four years later. He relentlessly probed sources in the British Museum's library to discover data that supported the "scientific" revelations presented in his *Manifesto*. The first volume of his detailed analysis of the industrial economy appeared as *Das Kapital* in 1867. Engels and another Communist used Marx's notes to publish three additional volumes after his death.

*Das Kapital* revealed Marx's acceptance of classic liberal ideas such as Adam Smith's theory that labor alone gives value to the products of industry. Marx used these theories, however, to support his version of socialism. He claimed, for example, that although industrial workers give products their worth, capitalists sell the goods for profit (the **surplus value**) and thus steal from the proletariat.

### The Communist International

Marx and Engels offered more than scholarly volumes to help the proletariat. Convinced that class loyalties rather than national feelings would seize the hearts of civilized people, Marx and Engels threw themselves into a campaign to organize a global working-class movement. They achieved a single unimpressive result before Marx died, the establishment of The First International Workingmen's Association in 1864. This loose confederation of Socialist groups collapsed in 1876. Marxists thereafter organized a more successful Second International that lasted from 1889 to 1914.

Ironically, the Marxist version of socialism exhibited more strength in movements at the national than at the global level. It also affected social thought and action far beyond the confines of Marxist organizations. By the end of the 1800s, Marxism had won enough followers not only to haunt capitalists but also to overshadow all other Socialist ideologies on the continent.

## Anarchism

Most Socialists urged state intervention to force a transition to complete political and economic equality. Even though anarchists shared the Socialist and Communist commitment to economic and political leveling, they considered the immediate dissolution of all governments to be the only route to social justice.

### Mikhail Bakunin and Terrorism

In the latter 1800s, increasing numbers of anarchists began to believe in terrorist violence as the best instrument to destroy the state. This ideology of violence appealed most strongly in the industrially undeveloped regions of Spain, Italy, and Russia. Mikhail Bakunin (1814–1876), a Russian theorist, bluntly expressed this anarchist commitment to violence. He defined any destructive deed as a "creative act." Such ideas helped to give anarchists the image of being assassins and terrorists, always ready to use dagger, pistol, or bomb.

## Syndicalism

The vision of anarchism as a terrorist movement blurs a much more complex reality. There were, for example, anarchists who believed in nonviolence. Sometimes, militants favored massive economic demonstrations rather than individual terrorism. This idea of large-scale collective action gained a significant following in France, where Georges Sorel (1847–1922) led the call for the destruction of the state by means of a general strike. Specifically, he urged a nationwide work stoppage by all labor syndicates (unions). Because theorists such as Sorel believed that the masses could join worker syndicates and use a general strike to crush the state, their ideology became known as **anarcho-syndicalism** or simply **syndicalism.**

# ■ MODERNISM IN THE ARTS, FORMAL THOUGHT, AND SCIENCE

The most important characteristic of a modern society is an industrial economy. The supremacy of the middle classes is a closely related trait of European modernity. Paradoxically, a great deal of the most distinctly modern literature, art, music, and philosophy during the late 1800s and early 1900s indicated that artists and writers despised the consequences of industrialization and bourgeois social dominance.

The scientists of the 1880s and after who shaped a new conception of the physical world did not intentionally reject a bourgeois outlook. Yet their ideas contradicted the Enlightenment conceptions that had profoundly influenced the middle-class frame of mind. This sharp contrast between the mentality of the European bourgeoisie and the intellectual elite first became apparent in literature.

## The Arts

During the 1850s and 1860s, writers and artists in their realist novels and impressionist paintings sometimes depicted the bourgeoisie as a worthless class and industrial society as bleak, even horrifying. By the mid-1860s, younger members of the artistic community also adopted non-traditional lifestyles that were purposely intended as an attack on bourgeois values. These cultural leaders thus expressed their rejection of middle-class society by the way they lived as well as through their creative works.

Many of these youthful rebels moved to Bohemia, in the Austrian Empire. **Bohemian** writers and artists soon launched a movement to produce "art for art's sake." This new creed meant that more of the future creative works would aim to convey beauty or other sensations and nothing more.

### Literature: Rebellion against Bourgeois Society

The realist style that became dominant in literature in the 1850s continued in the latter 1800s but in an altered form. This modified version came to be called **naturalism.**

**Emile Zola and Naturalist Prose.** The French author Émile Zola (1840–1902) claimed that his scientific or experimental novels contained the perfect description of humanity. Zola believed that chemists and biologists described the merely physical traits of humans. The naturalist writer, however, could use the insights of these scientists and careful observation of life to develop a complete scientific description of what he called natural man. Zola offered his many novels as reports of his findings. In them, he considered the lives of prostitutes, drunkards, servants, and others who experienced the worst conditions in France. *Germinal* (1885), his most praised novel, describes the suffering of miners and a strike caused by their misery.

**Decadence.** Several authors made the message of bohemian lifestyles more direct by writing novels with heroes who lived decadent lives. One of these decadence novels, *Against the Grain* by J. K. Huysmans presents bourgeois society as so uncomfortable for the best people that it drives them to live only for pleasure.

**Symbolism.** Henrik Ibsen, a Norwegian dramatist, wrote plays that combined the characteristics of several late nineteenth-century literary movements. In *A Doll's House* (1879) and *Ghosts* (1881), for example, he blended decadent, naturalist, and symbolist traits. Observers describe these works as partly **symbolist,** because Ibsen included symbols (brief vivid descriptions of scenes from life) that were meant to reveal truths about inner human nature. The emergence of symbolism indicated that the spirit of Romanticism had strengthened again in literature.

The combined effect of all these modern trends in writing was to widen the gulf between the literary elite and the leaders of government and business. By the late 1800s, the interests and attitudes of people in the arts differed much more from the outlook of the political and economic elite than had been the case in the 1850s in the age of realism.

### Art: A Cultural Revolution

Leading composers and painters in the half century before 1914 also confronted the conventional bourgeois world with stunning violations of cultural tradition. In contrast to Richard Wagner and other prominent composers of the period who did not seriously violate established standards, several composers produced radically discordant creations. Claude Debussy, Igor Stravinsky, Sergei Prokofiev, and Arnold Schoenberg sounded the first notes of this musical revolution. By 1913, Stravinsky measured the limits of contemporary tolerance with a ballet, *The Rite of Spring,* that provoked an audience to violent protest.

**The Emergence of Abstract Art.** The revolt in modern art went to even greater extremes than it had in music. Painters made an especially radical cultural turn as they abandoned standards that had held sway in Europe since the Renaissance. Developments in the physical sciences had influenced the direction taken by Manet, Monet, and other impressionist artists in the mid-1800s. The science of the time, however, had not encouraged them to produce works of photographic realism. Instead, they painted to reveal a deeper, even scientific understanding of what they saw in the real world. This tendency toward a varied or abstract depiction of the actual world increased in the latter decades of the 1800s. By the 1890s, an advanced guard of cultural rebels painted with little attention to reality and intensified the concentration on ideas or moods. These **post-impressionists** accelerated the movement of European art toward pure abstraction.

**Post-Impressionism.** Paul Cezanne (1839–1906), Paul Gauguin (1848–1903), Vincent van Gogh (1853–1890), and other post-impressionists blatantly violated the rules of perspective and color. For them, the realistic pictures that pleased the bourgeoisie had little to do with true art. Post-impressionists believed that their works had to be a creation of the soul unaffected by the inhibitions of industrial society. Tribal people, especially South Pacific islanders, fascinated Gauguin and van Gogh. These artists thought that such unindustrialized societies allowed the free expression of creative urges and produced art works that

could inspire painters of the urban industrial world in an especially valuable way. Van Gogh's self-portraits and his work *Sunflowers* illustrate the emotional and colorful results of this approach to art.

**Cubism.** Post-impressionist paintings contain recognizable people, scenes, and objects, but the pictures have a distinctly abstract quality. In 1905, Pablo Picasso (1881–1973) began to develop **cubism,** a still more abstract style that emphasized the geometric surfaces of people or objects. In his cubist works, Picasso presented whatever he painted as though it could be seen from many sides at once. The viewer of his *Damsels of Avignon* (1907), for example, sees one figure that simultaneously displays both a full face and a profile. Many traditionalists despised this radically different art. Its appeal and influence, however, deeply affected painting both at once and throughout the twentieth century.

**Pure Abstraction.** A few artists rendered the final revolutionary strokes against artistic tradition with paintings that contained virtually no recognizable hint of the real world. Wassily Kandinsky (1866–1944), a Russian painter, wielded the brush at the beginning of this most extreme attack on the cultural old regime, but a fellow countryman, Marc Chagall (1887–1985), soon joined the movement to **pure abstraction.** The ranks of European artists committed to visual representations of mysteries from their souls swelled endlessly thereafter. By 1914, modern art indicated in an especially vivid way the extreme contrast between attitudes of the cultural and bourgeois elites.

## Formal Thought

In the 1870s and after, a few influential scholars began an attack on dominant intellectual traditions that equaled the strength of the artists' assault on established values. Friedrich Nietzsche (1844–1900), a German philosopher, showed the most complete contempt for the ideas of the European bourgeoisie and, more generally, for modern European culture.

### Nietzsche's Philosophy of the Irrational

Most European intellectuals throughout the Modern period assumed the superiority of logic and reason in the search for truth and principles of life. They expressed a much more limited appreciation for irrational approaches that depended on intuition, emotion, or instinct. For brief periods, as during the Age of Romanticism (1790s to 1850s), cultural leaders doubted the supremacy of reason but even then regarded it highly.

When Nietzsche published *The Birth of Tragedy* (1871), *Thus Spake Zarathustra* (1885–1891), and *Beyond Good and Evil* (1886), he started a new wave of attacks on reason that became the strongest and most lasting in European history.

**Condemnation of Reason and Christian Morality.** Nietzsche damned the greed of the industrial bourgeoisie and warned that European civilization was in sharp decline. He charged that this cultural plunge was caused by a spiritual sickness that began with the ancient Greek worship of reason. These philosophers had led Europeans to reject what was most essential for the health of their souls—following primitive human instinct. Nietzsche thought that Christianity had a similarly bad influence. The moral principles of this faith encouraged humility and meekness in a creature that was naturally proud and

power-hungry. Nietzsche concluded that Europe's salvation required the nullification of Greek rationality and Christian morality.

**Affirmation of Elitism.** Parliamentary government and democracy enraged Nietzsche also. These devices of popular government perpetuated mediocrity. They discouraged people of superior talents and power from gaining their rightful place at the top. The superior minority who should govern were the people capable of allowing their will to power to direct their lives. These instinct-driven **supermen** could lead Europeans in the creation of a superior civilization. This philosophy of primitive spiritual elitism lent itself to use by racists and aggressive nationalists, including Adolf Hitler, although Nietzsche despised racism and nationalism.

### Psychology—the Reasoned Study of the Irrational

As Nietzsche preached the virtues of irrationality, others plunged into the first scientific studies of both human emotions and the mind. Work of this kind by Wilhelm Wundt (1832–1920) in Germany, Sigmund Freud (1856–1939) in Austria, and Ivan Pavlov (1849–1936) in Russia produced a wealth of new behavioral theory and a new scholarly field, **psychology.** During its first decades, this new academic discipline was dominated by Freud's theories and methods.

**The Supremacy of the Unconscious.** Freud, a Viennese physician, specialized in the treatment of nervous disorders. At first, he attempted traditional biological and chemical cures. He abandoned these approaches, however, when he became convinced that neurological maladies resulted from non-physical causes. Freud's work with his patients indicated to him that unconscious forces within people exercise supreme control over their mental states and behavior; the reasoning mind does not. After 1894, Freud developed his theories in more detail.

**Id and Superego.** Freud conjectured that as a species with a long evolutionary history, humans inherited a powerful instinctive nature (**id**) that compels a person to want instant satisfaction of appetites for sex, food, or whatever provides comfort and pleasure. This irrational unconscious, however, yields somewhat to **superego,** a critical and punishing aspect of personality instilled early in life by society mainly through the influence of parents. Superego struggles against the urges of id, an action required if civilization is to exist. Unfortunately, this suppression of natural impulses also produces emotional disorders (neuroses) that can wreck lives and society.

**Ego.** The personality is completed by **ego,** the conscious controlling mind. Ego must serve the difficult function of containing the inevitable war between id and superego so that the needs of both the irrational self and civilization can be adequately met. Freud devoted his life to a reasoned study of the irrational because he believed that without scientific knowledge of the unconscious, humanity certainly would fail in its ego task of managing id and superego. Despite his confidence in the value of these insights, Freud remained doubtful that irrational creatures could maintain civilization.

**Psychoanalysis.** Freud had greater faith in the possibility of restoring the emotional health of troubled individuals. In **psychoanalysis,** the corrective method he conceived, a therapist guides patients to an

understanding of the disorders that lie hidden in the unconscious. In this procedure, the psychoanalyst elicits free-flowing conversations and dream descriptions, and then interprets them to provide self-knowledge and, thus, a sound personality.

## Science

Despite Freud's qualified affirmation of the value and power of reason, he contributed to a growing sense of uncertainty among Europeans about their ability to understand human nature and the social order. The work of physicists in the late 1800s and early 1900s even more thoroughly undermined long-established convictions about an orderly and knowable universe.

### Redefining Matter

The frontiers of knowledge in geology, biology, and chemistry expanded with unprecedented speed throughout much of the 1800s. A similarly explosive rate of discovery began in physics in the 1890s and almost immediately changed the scientific view of matter that had prevailed throughout the century. The transformation in this aspect of science resulted from these developments: Wilhelm Roentgen's discovery of X rays in 1895; subsequent investigations by Henri Becquerel, and Marie and Pierre Curie into the nature of radioactive emissions; and in 1897, Joseph J. Thomson's proof of electrical particles (electrons) within atoms.

In combination, the work of these physicists confirmed that electricity is a component of all matter. This conclusion led scientists to view atoms as tiny solar systems rather than as impenetrable solids. This revised notion of the structure of matter at the end of the 1800s left scientists still highly confident that atoms are indestructible and, with further study, fully understandable.

Ernest Rutherford's discovery in 1911 that atoms contained a center or nucleus composed of positive electrical particles (protons) around which electrons revolved seemed to justify the belief that science might soon yield complete knowledge of matter. The mood of high confidence, however, would not last much longer.

### Quantum Theory—a Science of Probable Truth

Max Planck (1858–1947) ushered in the twentieth century with a refutation of a fundamental natural law—the conviction that energy release, as in heat from matter, always flows evenly. The quantum theory that he presented in 1900 held that energy bursts from its source not as an unbroken line but like a series of dashes or packets (quanta) of power.

Thirteen years later, Niels Bohr (1885–1962) used quantum theory to support his conclusion that Newtonian physics, established in the latter 1600s, explained the movement of planets but not of electrons. Bohr affirmed that the motion of particles inside the atom cannot be predicted. Physicists can do no more than estimate the action of subatomic particles within certain limits of probability. Further consideration of the implications of quantum physics during the next fifteen years indicated that science yields only probable truth, not absolutely correct answers.

### Relativity Theory—a Science of Temporary Truth

Planck's revelations dissolved scientific certainty about the smallest particles in nature. Other scientists demonstrated that an honest science requires an equally imprecise idea of the larger universe.

**The Michelson-Morley Experiment.** For over two hundred years, experts had assumed that the movement of objects such as planets in space could be measured with perfect accuracy because they traveled through ether, a motionless substance. A single test, the Michelson-Morley experiment in the United States in 1887, simultaneously proved that ether does not exist and that the earth's rotation does not influence the speed of light.

**Einstein's Theory of Relativity.** In his *Special Theory of Relativity* (1905), Albert Einstein (1879–1955) contended that no object or force in the universe affects the speed of light, that light's rate of motion is the single absolute in nature, and that all scientific laws are valid for objects traveling at the same speed. This comprehensive proposition confirmed and expanded on the Michelson-Morley discovery and required a radically new view of reality.

**The Implications of Relativity Theory.** Einstein's calculations indicated that as speeds increase, objects shorten and time slows. For example, a person moving at nine-tenths the speed of light ages half as fast and is half as tall as at ordinary speeds. Relativity theory, furthermore, revealed that space and time do not exist apart from objects. If matter disappears from the universe, so do space and time. Every fact and law in the natural world, therefore, has validity only under specific conditions of space, time, and speed. All truth is temporary. With the new physics of Planck and Einstein, the modern scientific view of reality had become as divorced from the common sense world of bourgeois industrial Europe as abstract art.

*Most of Europe's industry remained concentrated in Britain, the Netherlands, Belgium, Prussia, and France in 1848. During the next sixty-six years, this region became much more highly industrialized. Meanwhile, the new productive system began to emerge in the rest of the continent. Technology advanced rapidly as industry intensified and expanded across the continent. Europe entered an age of steel, synthetic chemicals, petroleum, electricity, electronic communication, automobiles, and airplanes.*

*A social transformation accompanied the maturation of the industrial economy. Urbanization proceeded at a rapid pace. In the growing cities, the middle classes continued to gain social and political influence, and their power, or at least their values, became dominant in most of Europe. The working classes remained subordinate but became better organized and more politically active than ever.*

*In the fifty years before 1914, even more drastic change occurred in the realms of art and science than in the socioeconomic order. Leading writers and painters turned to realism and then to such extremely personal and abstract expressions that they alienated the middle and upper classes who usually patronized the arts. This consequence suited many in the cultural elite, because they had come to despise the bourgeoisie and the effects of industrialization.*

*Scientists and industrialists formed a lasting partnership in these years, much to the benefit of modern business. At the same time, however, new developments in physics created an abstract perception of the material world that was as incomprehensible to the bourgeois mind as the revolutionary new art.*

*Several leading intellectuals also produced social theories alien to the contemporary middle-class way of life. Nietzsche described and attacked a bourgeois-dominated civilization made sick by a rational and Christian approach to life. The Marxist assault on the bourgeois system included a demand for a revolution that would complete the modernization of the human order through the establishment of a classless society of workers, who shared authority and wealth equally.*

*The artistic elite's rejection of the middle class and the harsh anti-bourgeois attacks of Nietzsche and the Marxists hinted at the very troubled times that would come in a more distant future, after 1914. More immediately, the socioeconomic trends between 1848 and 1914 revealed the nearly complete triumph of the modernizing bourgeoisie. These were, on the whole, glorious times for the European middle classes. The history of government affairs in Europe, 1848 to 1914, further confirmed this pattern of bourgeois triumph.*

## Selected Readings

Berlin, Isaiah. *Karl Marx: His Life and Environment,* 4th Edition. Oxford, UK: Oxford University Press, 1978.

Boston College. *The Digital Archive of Art: Online Images from Boston College.* (Find links to artists at *www.bc.edu/bc_org/arp/cas/fnart/art.*)

Eisenman, Stephen F. *Nineteenth Century Art: A Critical History.* London: Thames and Hudson, 1994.

Gay, Peter. *Freud: A Life for Our Times.* New York: Norton, 1988.

Hamilton, George H. *Painting and Sculpture in Europe, 1880–1940.* Baltimore, MD: Penguin Books, 1972.

Hayes, Carlton J. H. *A Generation of Materialism, 1871–1900.* New York: Harper and Brothers, 1941.

Henderson, W. O. *The Industrialization of Europe, 1780–1914.* London: Thames and Hudson, 1969.

Howe, Irving, ed. *The Idea of the Modern in Literature and the Arts.* New York: Horizon Press, 1967.

Hughes, H. Stuart. *Consciousness and Society: The Reorientation of European Social Thought, 1890–1930.* New York: Vintage, 1961.

Kaufmann, Walter. *Nietzsche: Philosopher, Psychologist, Antichrist.* 3rd Edition. Princeton, NJ: Princeton University Press, 1968.

Kocka, Jurgen and Allan Mitchell, eds. *Bourgeois Society in Nineteenth Century Europe.* Oxford, UK: Berg, 1993.

Millward, Alan S. and S. B. Saul. *The Development of the Economies of Continental Europe, 1850–1914.* Cambridge, MA: Harvard University Press, 1977.

## Test Yourself

1) Darwin's theory assumes that the individual plants and animals of a species
   a) cannot vary from each other, because they are shaped by blind natural forces
   b) exhibit slight variations
   c) are produced without variations until conditions cause a sudden drastic alteration in characteristics
   d) are living proof that God does not exist

2) *Le Monde* (a long-established French newspaper), the color in twentieth-century clothing, and the steel in the 100-year-old Tower Bridge in London all suggest
   a) pre-1914 changes associated with industry
   b) the effects of *Realpolitik* since the 1800s
   c) the influence of Marxism on modern life
   d) the plot of a nineteenth-century realistic novel

3) In the late 1800s and after, abstract art, quantum physics, and relativity theory were developments that marked the rising barrier between Europe's intellectual-artistic elite and this especially influential social group:
   a) humanities scholars
   b) Marxist socialists
   c) anarchists
   d) the middle class

4) Darwin, Marx, and Freud were alike in that all three
   a) gave a new direction to modern thought
   b) were active supporters of atheism
   c) believed in philosophical materialism
   d) wanted some form of socialism

5) An attitude of disgust toward idealism and a commitment to government practices simply because they increase the power of the state is known as
   a) modernism
   b) anarchism
   c) Realpolitik
   d) dialectical materialism

6) The best example of a realist novel is
   a) *On Liberty*
   b) *Madame Bovary*
   c) *On the Origin of the Species by Means of Natural Selection*
   d) *Thus Spake Zarathustra*

7) Who most thoroughly rebelled against European culture as it was in the years, 1848–1914? Discuss three people who turned sharply against fundamental aspects of European life in this period and explain why one deserves to be singled out as the most thoroughly rebellious.

## Test Yourself Answers

1) **b.** Darwin emphasized the important influence of slight, gradually developing variations, not the lack of variance among specie individuals or sudden drastic variance in specie traits. Darwin's theory assumed nothing about whether God did or did not exist.

2) **a.** Technological developments between 1848 and 1914 made it possible thereafter to have mass publication newspapers, artificial dyes, and the common presence of steel structures, as the text makes evident. The completions that refer to *Realpolitik* and a realistic novel are not relevant to the opening problem line. Information in the text also offers nothing clearly to suggest Marxism's influence as a valid completion.

3) **d.** Chapter commentary emphasizes the widening gap between the outlook of the intellectual-artistic elite and the middle class in the latter 1800s and early 1900s. Any other group, such as humanist scholars, might have felt a similar increasing alienation in attitudes from leaders in the new world of ideas and arts, but the reference to an "especially influential social group" makes "the middle class" the only good choice to complete the quiz item.

4) **a.** The text offers no evidence that Darwin or Freud supported atheism, materialism, or socialism, all of which were part of Marx's belief system. All three definitely did give modern thought new directions.

5) **c.** The German word *Realpolitik* effectively expresses the cold power considerations that tended to guide government leaders in the latter 1800s and after, an important aspect of Modern European history underscored by text commentary. Both anarchism and theoretical Marxism, referred to in choice *d*, aimed at doing away with government altogether, although Marx favored using state power as brutally as necessary during the transition to a stateless utopia. Still, *d* remains a poor option for completion compared to *c*, and neither modernism nor anarchism suffices at all as an answer.

6) **b.** The opening line of the item calls for a "novel." That consideration alone makes *Madame Bovary* the only option, and the text does single out this work as a prime example of literary realism.

7) Hasty choice might result in a discussion of Marx as the most thoroughgoing cultural rebel—not the best selection. He wanted to end forever the existence and influence of bourgeois industrial capitalism, the socioeconomic system rising to its zenith in Europe during his time. Yet this revolutionary theorist clung to central aspects of European culture, such as many Enlightenment ideas and methods, the supreme faith in science, and even to certain specific liberal views of Adam Smith and others. The anarchist Bakunin might seem a better choice to hold top rank as the ultimate rebel against European culture because of his praise of destruction, but his terrorist phrase misleads about the extent to which he is as much a European cultural heir as Marx. Nietzsche definitely stands apart as the person who most thoroughly denounced the most fundamental aspects of European culture—everything ancient classical in spirit, the Enlightenment outlook, and Christian (really Judeo-Christian) ethics. He wanted to destroy completely most of the main aspects of European culture. Discussion thus should focus on Nietzsche as the central figure, and Marx and Bakunin would make good secondary candidates worthy of commentary.

# The Era of the Nation-State (1848–1914)

**1852:** Napoleon III establishes the Second French Empire.

**1861:** Emperor Alexander II emancipates Russia's serfs.

**1867:** The Austrian Empire becomes the Dual Monarchy of Austria-Hungary.

**1870:** The French Third Republic is established, and Italy unites.

**1871:** The German Empire forms.

**1884:** Parliament establishes male suffrage in Britain.

**1906:** The British Labour Party emerges.

**1928:** British women twenty-one and over gain the vote.

*The reformers and revolutionaries of Central Europe, who struck their blows for liberal government and national unity in 1848, lost decisively. The middle-class rebels who led this attempt in Italy and Germany saw unification achieved within the next two decades, however, by compromising liberal political principles as they turned to the methods of* Realpolitik *and to a joint effort with upper-class traditionalists to establish Italian and German nation-states.*

*Beyond Italy and Germany, after mid-century, the new bourgeois liberal ruling elite showed this same tendency to merge with people of the* Ancien Regime's *upper cast as a new ruling force. The bourgeois leadership wanted to keep its sociopolitical dominance and the personal freedoms it had won since the French Revolution, but the growth of a more powerful spirit of nationalism—no longer closely linked to liberalism—appealed to both the bourgeois and* Ancien *elites and enabled them to work together better than before 1848 in the governance of their countries.*

*The members of the old elite not only accepted nationalism, but also learned from the revolts in the first half of the 1800s that they must court the masses and that nationalism could serve this purpose. These conservatives now recognized that a people aroused in loyalty to the country could accept nobles and kings as their national leaders if not as a hereditary upper class. Members of the traditional ruling caste gained the*

*potential to win a still broader following by their greater willingness to take steps to ease the suffering of the masses and to set up institutions that would give at least the appearance of citizen influence in government.*

*The shared interest in giving some help to the poor and winning the political support of the masses not only drew the bourgeois and Ancien elites closer together but also tightened the ranks of all classes within European societies in the latter 1800s. Europeans, furthermore, had come to believe that the national group should form the basis of the state and that citizens owed absolute loyalty to the country. This attitude both encouraged solidarity within states and tended to foster acceptance of the ruling elites. A new nationalism had emerged, different in nature and effect from the liberal and sometimes revolutionary nationalism of the early 1800s.*

*The new nationalist spirit helped finish the reshaping of the entire industrial heartland of Europe into nation-states by 1871. The countries that had not taken this form by then at least adjusted their institutions to draw on the power of nationalism. The emergence of the mass supported nation-state left little of the Ancien Regime's political order intact. This nationalist state system is the hallmark of modern government, a development that was the central feature of European public affairs between 1848 and 1914.*

## ■ THE TRIUMPH OF NATIONALISM

Idealism and revolutionary methods failed the rebels who fought for national unity and liberal government in Italy and Germany during the revolts of 1830 and 1848. Hard political realism and state military power quickly built the modern Italian and German nations in the two decades after 1850. These victories through power politics inspired a transformation of nationalism.

The liberal nationalism of the years before 1848 included a commitment to individual rights and citizen self-government. Liberal nationalists expected to put these principles into effect by the action of the masses. After 1850, nationalists became increasingly willing to approve of expanded government authority and to accept the denial of personal liberty in order to ensure national unity. Nationalists also showed much less confidence that the masses could help achieve the goals of nationhood. Instead, they placed their faith in the power of the state, especially in its armies.

### The Unification of Italy

Nationalist uprisings continued after 1850 but not as a grassroots liberal movement in the spirit of 1848. Instead, they supported a drive for nationhood led by a single powerful state under coldly realistic leadership.

### *Cavour and the Kingdom of Piedmont-Sardinia*

The Kingdom of Piedmont-Sardinia, situated in northwest Italy and on a large island off its west coast, entered the national liberation struggles in 1830 and 1848. After the defeat by Austria in 1849, Piedmont's newly crowned king, Victor Emmanuel II (reigned 1849–1878), kept the liberal form of government his father had established. As a progressive and relatively large state willing to fight for union, Piedmont had won a strong following among Italian nationalists by the early 1850s. The king appointed Count Camillo di Cavour (1810–1861), a master of *Realpolitik,* as his prime minister in 1852. Backed by the power of the Piedmont state, Cavour's methods enabled him to become the builder of the Italian nation.

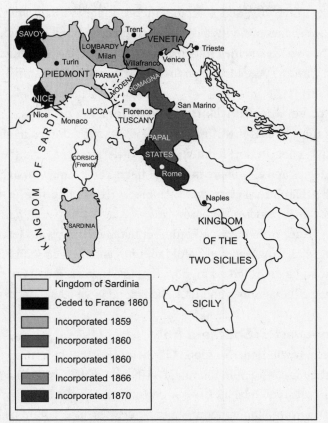

*Figure 8.1: The Unification of Italy: 1859–1870.*

Cavour typified the increasingly numerous European aristocrats who accepted moderate political liberalism and bourgeois economic values. He immediately began to govern in accordance with these modern principles as a step in his plan for Piedmont's advance. The government actively encouraged trade and industry, expanded its railway net, and promoted agricultural production. Thus a state that already protected individual liberties, at least to a certain extent, soon had a prosperous economy and became doubly attractive to neighboring states willing to accept annexation as a step toward nationhood. Economic modernization also prepared Piedmont to produce a larger and more lethal army. Cavour knew that power would decide the battle that had to come with Austria.

The prime minister understood as well that his state needed formidable European allies to ensure victory over the Hapsburgs. Thus in 1855, he accepted an invitation to join Britain and France against Russia in the Crimean War. (See Chapter 9.) Cavour correctly assumed that even though he could send only a token force, this venture would increase the possibility of support from Britain and France when Piedmont clashed with Austria.

### The Pact of Plombières and War with Austria

Emperor Napoleon III, Emperor Napoleon I's nephew, governed France with dictatorial authority beginning in the early 1850s, but he followed policies that in many respects were similar to those of Piedmont's rulers. He also shared the desire of Italian nationalists to expel Austria from the peninsula.

In July 1858, Napoleon and Cavour met at Plombières and arranged a secret pact. The French emperor pledged to support Piedmont in a war if the Austrians struck first, agreed that Piedmont could annex Austria's

north Italian lands such as Lombardy, and accepted a loosely unified Italy with significant influence for Piedmont in the north. Cavour, in return, offered to give Napoleon III the ethnically French Piedmont territories, Savoy and Nice. The two leaders then settled down to study a map and decide where and how Austria might be tricked into war. Cavour succeeded in getting Austria to attack in April 1859.

### War and Movement toward Italian Unity in the North

Battles in May and June proved the effectiveness of Cavour's domestic and international preparations. The Austrians lost Lombardy to Piedmont after costly struggles. As the war continued, Italians revolted in the papal territories and elsewhere in central Italy. They wanted to overthrow the rulers of their principalities and join the march to nationhood. Napoleon III became fearful of this rising nationalist Italy, broke his pact with Cavour, and made peace with Austria in July 1859.

Despite France's departure from the war, Piedmont marched on toward leadership of a unified Italy. Three northwestern Italian states overthrew their old regimes and merged with Piedmont-Sardinia. Victor Emmanuel II and Cavour suddenly ruled a kingdom that encompassed most of northern Italy. Napoleon III accepted this step toward Italian unity and took Savoy and Nice as his undeserved reward.

### Garibaldi and the Conquest of Southern Italy

In the age of European revolution, Giuseppe Garibaldi had fought to unify Italy under a more radical form of government than Cavour could tolerate. Garibaldi wanted a republic that guaranteed personal rights to everyone on a virtually equal basis. Cavour preferred a constitutional monarchy that provided for individual liberties but empowered the upper and middle classes. The failure of Italy's liberal nationalist revolt in 1848 prepared Garibaldi to accept unification on Cavour's terms.

Nationalist victories in the north in 1859 fed the flames of patriotism in the Kingdom of the Two Sicilies, a state made up of the southern part of the peninsula and the island of Sicily. As spontaneous revolts threatened the old regime there in 1860, Garibaldi responded to directions from Cavour and led one thousand red-shirted volunteers in an attack on the island of Sicily. They won within weeks and then invaded southern Italy. Soon, the **Red Shirts** threatened to wrest central Italy from the pope.

Cavour wanted to maintain Piedmont's control of the unification process, to be sure that monarchical institutions and moderate liberalism would prevail in the new state. He also knew that Napoleon III might use his forces to stop the threat to the papacy. Cavour's armies invaded central Italy, papal forces did not resist, and most of the pope's territory became part of the Piedmont kingdom. Garibaldi then accepted Piedmont King Victor Emmanuel as ruler of the southern Italian lands he had conquered. On March 17, 1861, a new Italian parliament proclaimed the founding of the Kingdom of Italy with Victor Emmanuel as its king. Only a small papal territory and Austrian Venetia remained outside the new kingdom.

### The Completion of Italian Unity

When war erupted between Prussia and Austria in 1866, the Kingdom of Italy grasped the opportunity to support Prussia against the Hapsburgs. Prussia won, with Venetia falling to Italy. A military conflict followed in 1870 between Prussia and France, which drew French forces defending the pope away from the Italian peninsula. The Kingdom of Italy then seized the last of the papal territories and before the end of the year established Rome as the capital of a fully unified nation.

## The Unification of Germany

A monarchy and rural aristocracy (the **Junkers**) with strictly *Ancien* values reigned almost unchallenged in the North German state of Prussia in 1850. Prussian liberals in the revolts of the 1830s and 1840s had won a constitution that established a parliament for Prussia, which they dominated. Yet there was little of the personal liberty and popular involvement in political affairs that characterizes modern government. Although Prussia was politically similar to the thirty-eight other German principalities, its *Ancien* government had built a modern economy and dominated the *Zollverein,* a commercial organization that included all German states except Austria.

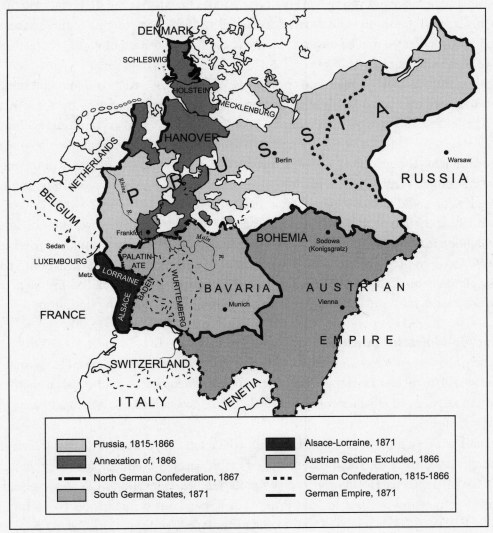

*Figure 8.2: German Unification: 1866–1871*

By the 1850s, economic modernity and the *Zollverein* gave Prussia the potential to dominate Germany either as a confederation or a nation-state. The king, however, had proved completely unwilling to challenge the control of Austria over the German Confederation. Furthermore, Prussia's reactionary government made many nationalists despise the idea of a German nation under Prussian rule. Prussia could not lead the way to nationhood until a German version of Cavour emerged.

### The Rise of Bismarck

The accession of William I (reigned 1861–1888) to the Prussian throne upon the death of Frederick William, his brother, at first dimmed the prospects that this state could lead German unification. His very conservative image gave King William little appeal to nationalists. He added to Prussia's political handicaps by provoking a battle with the parliament. The legislative conflict erupted when William attempted a large-scale military modernization program. Parliamentary liberals denied him the new taxes to pay for his venture. The conflict between the king and the liberals became a struggle for legislative supremacy.

In 1862, William appointed Otto von Bismarck as prime minister to lead his counterattack on parliament. Bismarck, a relatively young (he was forty-seven) but experienced diplomat, had distinguished himself by his strong opposition to German liberal rebels in 1848. The struggle of this Junker against the liberal nationalists indicated that he meant to maintain the social position of the aristocracy and the governing power of the monarchy.

Yet Bismarck differed from other Junkers in many ways. He rejected their traditional submissiveness toward Austria and wanted to exclude Hapsburg influence from Germany, by force if necessary. Bismarck's belief that Prussian success required middle-class support also contrasted with the attitudes of most Junkers. He would promote continued economic modernization, accept the trappings of parliamentary government, and lead the campaign for German unification in order to win this middle-class backing. This supreme practitioner of *Realpolitik* accepted many aspects of modernity as a way to preserve as much as he could of the *Ancien* institutions that he most loved.

Bismarck quickly demonstrated the effectiveness of his conservative power politics. Although the parliament continued to deny royal requests for taxes to support the military program, Bismarck had the funds collected anyway. The citizens paid, and parliament yielded to this unlawful action. Thus the middle classes had their constitution and their representative body, but Bismarck had his way. This victory strengthened the monarchy and sped the Prussian climb to military leadership in Europe.

### The Schleswig-Holstein Question

Bismarck had to use *Realpolitik* abroad as well as in Prussia in order make his state a leading European power. He got the first opportunity to apply his methods beyond Prussian borders in 1863 when Christian IX, King of Denmark (reigned 1863–1906), proclaimed his intention to annex the Duchy of Schleswig.

This small territory directly south of Denmark contained a mixture of Danes and Germans. On its southern border lay Holstein, a duchy that belonged to the German Confederation even though a sizable Danish minority lived there. Holstein vigorously protested the annexation of Schleswig, and Bismarck responded by convincing Austria to join Prussia in a war with Denmark. German forces entered Schleswig in February 1864, marched into Denmark in April, and quickly subdued King Christian's armies. The peace treaty permitted Austrian troops to occupy Holstein, allowed Prussian forces to hold Schleswig, and yielded the two duchies to joint Austro-Prussian control.

### The Seven Weeks' War

The circumstances in Schleswig-Holstein at the end of the Danish war provided an ideal setting for Bismarck to provoke a battle with Austria that could yield Prussian supremacy in Germany. The prime minister prepared diplomatically by winning the friendship of Russia, getting Napoleon III of France to

agree to stay neutral if an Austro-Prussian war came, and securing a promise that the Italian Kingdom of Piedmont-Sardinia would join Prussia in a war against Austria. The deal with Piedmont broke Prussia's pledge as a member of the German Confederation not to form alliances against other German states. Bismarck operated by new rules—*Realpolitik* had isolated Austria.

As Bismarck set the stage diplomatically for war, he used the joint Austro-Prussian control over Schleswig-Holstein to push the Hapsburgs toward military conflict. The Prussian leader repeatedly clashed with the Austrians over procedures in the duchies, and during one dispute in June 1866, Bismarck sent troops into Holstein. Austria got the **German Confederation Diet** (the assembly of delegates) to agree to intervene militarily against Prussia, and Bismarck chose to interpret the vote as an Austrian declaration of war.

**Prussian Military Superiority.** Although the Hapsburgs and other European leaders thought otherwise, Austria had almost no chance of winning. King William's military reforms had created an expanded and well-organized army. Prussia's industrial modernization had provided a rapid-fire rifle, the needle gun, and a railway system well suited to the deployment of troops. Austria had only one railway to the Prussian front and very little industry to produce its old-style muskets and other weapons. Furthermore, the Italian attack on the Hapsburgs' southern border meant that Austria had to fight on two fronts.

**The Battle of Sadowa.** The critical engagement of the war occurred at Sadowa on the Austro-Prussian border. In July 1866, two armies with a combined strength of nearly five hundred thousand fought there in a brutal struggle. Austria suffered almost forty-five thousand casualties, while Prussia lost less than one-fourth that many. Austria also had lost the war.

**The Peace Settlement.** Despite the smashing victory, Bismarck offered a generous peace settlement. He did not want a bitter enemy on his southern border as he pursued other Prussian triumphs. Thus he only required Austria to make a small war damages payment, yield Venetia to Italy, and accept the breakup of the German Confederation. In the afterglow of this remarkable military success, the Prussian parliament voted to legalize the unconstitutional actions Bismarck had taken in the earlier struggle with the assembly over taxes for military spending. The victories over Denmark and Austria thus increased Prussia's strength abroad and the monarchy's power over its citizenry.

### A New German Confederation

Austria had dominated the Diet of the German Confederation sufficiently to have it vote for war against Prussia in June 1866. The Germans in many states of the Confederation, however, had very different attitudes toward Prussia than did their delegates to the Diet. Bismarck's acceptance of the forms of parliamentary government, Prussia's thriving economy, and, above all, the successes of the prime minister's aggressive foreign policy strongly appealed to German nationalists, especially in the north.

With Austria excluded from German affairs and Prussia's prestige among nationalists rising dramatically, Bismarck proceeded in 1867 to organize the new North German Confederation, a union of all German states except the southern principalities—Hesse-Darmstadt, Bavaria, Württemberg, and Baden. Prussian King William became Confederation president and had full authority over the union's foreign affairs and military forces. Bismarck became chancellor of the Confederation and actually governed it.

## The Franco-Prussian War

The three Lutheran and more liberal south German states had little interest in a merger with the north German states under Catholic and monarchist Prussian dominance. Intense nationalist passions could cause the south to forget these traits of the north, but that mood did not exist at the end of the 1860s. Bismarck thought that a war with France could inspire such nationalist sentiments in the south. He began to plot a diplomatic collision course that would bring about a conflict with France.

**The Spanish Succession Crisis.** The dramatic expansion of Prussian territory and military prowess alarmed Napoleon III and French nationalists. Sentiment for a war to stop the rising German threat grew in France. Bismarck was delighted. In June 1870, he intensified French fear and rage by convincing Leopold of Hohenzollern-Sigmaringen, a relative of the Prussian monarch, to accept the throne of Spain. If this arrangement stood, it would place France between two Hohenzollern states. The French fever for war rose.

**The Ems Dispatch.** Because war interested King William less than it did Bismarck, he tried to placate France. At the king's request, Leopold agreed not to accept the Spanish crown. William's action left Napoleon III dissatisfied. In July, he sent a representative to meet the Prussian king at Ems and demand a pledge that no Hohenzollern would ever take the throne of Spain. William would not comply and telegraphed a message about the event to Bismarck. In Berlin, the prime minister released a report on the Ems message to the press, worded such that William and the French ambassador appeared to have had a mutually insulting encounter. They had not. The revised Ems dispatch, however, intensified the demands for war in both countries.

**The Outbreak of War.** On July 19, 1870, France declared the war that Bismarck wanted. The south German states joined the war against France. Napoleon III's troops marched into German territory and enjoyed success in one small-scale encounter. Then three modern armies of the German alliance responded with a stunning assault. As August ended, German forces overwhelmed the French at Sedan and captured the French emperor.

**A New Nation, Born in War.** The war continued into mid-January. By then, German control in the heart of France was so secure that the Prussian king could venture into the French royal palace at Versailles. In the Hall of Mirrors on January 18, 1871, the leaders of all the German states met to declare William the emperor of their now unified German nation. France suffered that humiliation, and then had to surrender to this new German Empire ten days later. Bismarck showed no leniency to this victim; France had to give Germany two hundred million francs and the important border territories of Alsace and Lorraine. The new nationalism brought great rewards for some and great losses for others.

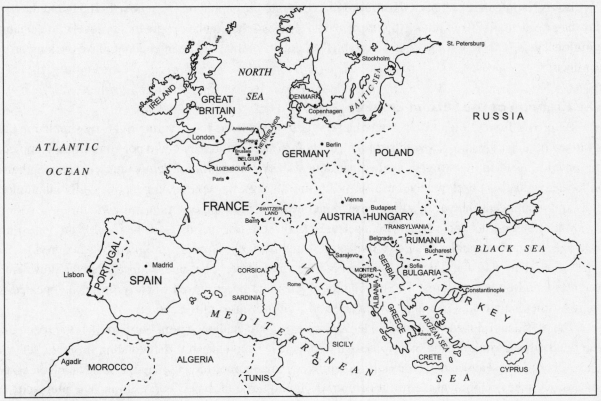

*Figure 8.3: Europe 1871–1914*

## ■ THE NATION-STATE UNDER POPULAR DICTATORSHIP

The capture of Napoleon III by the Prussians at Sedan ended the twenty-year rule of a man who had given Europe, for a time, a model of one effective form of nation-state: popular dictatorship.

### The Second Empire in France (1848–1870)

The revolutionaries who toppled the upper-bourgeois monarchy of Louis Philippe in 1848 produced a plan for a second French republic. They arranged for a parliamentary government led by a president who could serve only one four-year term. The revolutionary assembly also gave the vote to all adults and arranged for a presidential election in December 1848. All the candidates except one had unfamiliar names. Louis Napoleon Bonaparte, Emperor Napoleon's nephew, did not suffer that handicap. He won decisively.

The next spring, voters elected a legislature dominated by monarchists. A democratic vote produced this result because most citizens were peasants who revered tradition, and still more of the electorate feared further rebellion by urban lower classes. Although President Bonaparte's family heritage suggested that he might be an authoritarian willing to suppress rebels, monarchist legislators wanted a genuine king, not a Napoleonic emperor. Thus when the president asked for a constitutional change so that he could stand for reelection, the assembly refused.

Louis Napoleon struck back. His troops marched into the capital on December 1, 1851, and the next day the president dissolved the legislature. Then he turned to the French people for approval of his unconstitutional acts. The new Napoleon had established a dictatorship, but he intended to have the support of the masses.

### The Creation of the Second Empire

Before its dissolution, the legislature had decreed an end to universal voting rights by stipulating that if citizens changed residences within three years before an election they could not vote. Louis Napoleon presented himself in the struggle against parliament as the champion of democratic elections and also advocated industrial development, farm subsidies, and an aggressive international policy. Liberal intellectuals and republicans, however, still opposed him because of his authoritarianism.

Within days after Louis Napoleon's seizure of power, a few members of the republican opposition organized disruptive public protests. Swift and brutal military suppression killed two hundred of the ruler's foes. This slaughter alienated and embittered some citizens, but rural France liked the president's tough law-and-order measures. The economic policies that he promised to carry out also appealed to many businesspeople and peasants. Bonaparte had won over most of the nation.

The president reigned supreme. No legislature existed to challenge him. Furthermore, the specter of two hundred dead intimidated other potential opponents. This makeshift dictatorship, however, left the leader dissatisfied. He wanted a formally structured popular authoritarian system. Louis Napoleon asked for a public vote of approval that would empower him to write their new constitution. The **plebiscite** (a yes-no vote on an issue) on December 21, 1851, granted this authority to the president with the support of more than ninety percent of the eight million voters.

**A New Constitution.** The new law extended Louis Napoleon's presidential term from four to ten years, established a legislature, and gave the vote to all males, but it also provided authority for Louis Napoleon that left the voters and their representatives powerless. Constitutional provisions indicated that the president had to answer to the people, a duty that he would meet in part through plebiscites.

**A New Emperor.** Louis Napoleon's willingness to appeal to the masses indicated his desire both to rule in the public interest and to involve the people in political life. The French responded warmly. On November 21, 1852, in a plebiscite on whether France should become an empire, again more than ninety-nine percent of the voters favored the change. The French who longed for an emperor considered Napoleon I's son, who never reigned, to have been the second Bonaparte dictator; thus the president became Emperor Napoleon III on December 2, 1852.

### Dictatorship and Modernization (1852–1860)

Although the new dictator made meaningless the practices that suggested democracy, he sincerely intended to be a ruler who governed for the people. He demonstrated this attitude by effectively modernizing the French commercial credit system. The Napoleonic state accelerated the growth of a more modern economy by supplying huge sums of government money to two private financial institutions, *Credit foncier* and *Credit mobilier.* Farmers and entrepreneurs could borrow from these sources to fund their commercial ventures. Utilities, railroads, and other transportation facilities especially benefited from this program.

**Public Works.** Napoleon III launched government projects to improve both rural and urban life. In the countryside, he took action to reclaim abused land, drain swamps, protect forests, and promote farm modernization. Baron Georges Haussmann directed Napoleon III's largest single urban public works project, the **renewal of Paris.** The imperial government cleared away vast sections of old buildings and restructured the city along widened streets and attractive new boulevards, perhaps in part to make it extremely difficult for rebels to build street barricades. Haussmann's project also provided beautiful new public buildings and modernized the water and sewage systems, improvements that had little to do with the suppression of opposition. The reconstruction created a healthier environment and made the capital a showplace of Europe by the end of Napoleon III's reign. The sewers, in fact, are now a popular tourist attraction.

### The Liberal Empire (1860–1870)

In the 1850s, the French economy advanced and life generally improved. Yet citizen support for Bonaparte weakened sufficiently by 1860 to concern him, and so he liberalized the state. Napoleon III expanded rights of expression, legalized unions and strikes in 1864, surrendered part of his authority over the budget to the Legislative Body, and in other ways shared power with appointed and elected officials.

### Imperial Adventures

True to the traditional spirit of empire, Napoleon III dreamed of pursuing power and glory beyond the borders of his state. One of his ventures had lasting effects. In 1854, Napoleon III began to support Ferdinand de Lesseps' plans for a canal to connect the Mediterranean to the Red Sea. This **Suez Canal project,** completed in 1869, helped to make France a leading influence in eastern Mediterranean affairs until the 1950s.

Napoleon III's imperial forces in 1859 began a ten-year drive into Asia that gave him lordship over Indochina, a peninsula that encompasses today's countries of Laos, Cambodia, Thailand, and Vietnam. In these same years, France developed small settlements and spheres of influence in East and West Africa that became the foundations for a vast empire on that continent in later years. The African-Asian empire that Napoleon III began to conquer lasted for almost a century.

The emperor's attempt to extend his realm into the Americas in the early 1860s led to a fiasco. During a military excursion to Mexico to collect unpaid debts, his forces overthrew the government and enthroned the Austrian archduke Maximilian in an effort to establish a French-influenced empire in Central America. The United States could not react to the French arrival in its sphere of interest until the Civil War ended in 1865, then Napoleon III faced military enforcement of the Monroe Doctrine that barred European powers from the Americas. France responded to this threat by withdrawing troops in 1866. The Mexicans then executed Maximilian.

The outcome of the Mexican imperial attempt damaged Napoleon III's image in France, but the dictator remained quite popular. Over the course of two decades, Bonaparte had succeeded in further modernizing the French political system by tying the national masses more tightly than ever to the state.

## The German Empire (1871–1914)

Otto von Bismarck, as chancellor of the new German Empire, developed a popular authoritarian system similar to Napoleon III's and ran it for Emperor William I from 1871 to 1890. The German constitution, adopted in April 1871, established a parliamentary structure that gave the appearance of representative government. The constitution also provided the legislators a limited degree of influence over public affairs. Representatives of the separate German states, such as Prussia and Saxony, which had united in 1871, comprised the upper house, the *Bundesrat.* Prussia dominated this body. Representatives in the lower chamber *(Reichstag),* elected by universal male suffrage, had the power to approve or reject the national budget and could amend or stop legislation. This system left the chancellor and emperor with a limited dictatorship, but a dictatorship nevertheless.

### Bismarck's Policy Orientation

Bismarck had used diplomacy and warfare with little regard for ethics in order to form a German nation-state dominated by Prussia that was true to its somewhat modernized aristocratic traditions. As chancellor, he intended to preserve the new empire without further expansion of its borders. War no longer suited his purposes, so he maneuvered to keep peace in Europe. Bismarck also expanded the German army to almost five hundred thousand to make possible enemies cautious.

Within the new Germany, as within Prussia before, Bismarck accepted the need for certain adjustments in *Ancien* tradition, such as allowing a more active political role for people previously ignored by the aristocracy. The chancellor meant to ensure, however, that the Junker aristocracy and monarchical dynasty reigned supreme. He stood ready to fight diligently against any threat he perceived to these interests.

### The Anti-Catholic Kulturkampf

Bismarck considered Lutheran Christians, the religious majority in Germany, to be devoted citizens, and he viewed the almost equally numerous Catholics as a treasonous menace whose first loyalty might be to their church and the pope. Bismarck thus launched the **Kulturkampf** (a struggle for civilization) in 1872 to ensure that Catholics would submit to the German ruler.

The chancellor's steps to nullify the influence of the Catholic church included denial of the right of the clergy to criticize the government and the expulsion of the Jesuit teaching and missionary order from the country. The government also closed Catholic seminaries and forced the clergy to study in secular educational institutions. These and other anti-Catholic measures continued throughout the 1870s.

### The Anti-Socialist Campaign

Despite the moderate behavior of German socialists, their revolutionary ideology made them an easy target for Bismarck when he wanted to encourage citizen loyalty by attacking a "public enemy." The chancellor charged the socialists with plotting to assassinate the emperor and demanded the dissolution of their Social Democratic Party. With some difficulty, Bismarck secured passage of **The Anti-Socialist Law** in 1878. It remained in effect until Bismarck left office in 1890. These crusades against Catholics and socialists might have encouraged stronger loyalty to the state, but they did not weaken the movements that Bismarck attacked.

### Bismarck's Welfare-State Program

Bismarck not only fought against potential competitors for German citizen loyalty but also enticed support with the most generous welfare program in Europe. Laws passed in the 1880s required sickness insurance and old-age pension programs for all workers to be paid for jointly by employees and employers. The government also established accident insurance for laborers in 1884, with all costs to be covered by employers.

### Germany without Its Founder

In 1890, William II (1859–1941) took the imperial throne. This brash young grandson of William I pressured Bismarck into retirement before the end of the year. The emperor's chancellors thereafter took instructions from the throne and were directed to continue certain Bismarckian policies. Workers still enjoyed the welfare program begun in the 1880s and witnessed the passage of more laws to protect laborers and advance their influence in the workplace.

William II also took up Bismarck's campaign to strengthen the military. In this case, however, the emperor's expansion of the army and drive to build a navy superior even to Britain's made Germany seem aggressive, an image that Bismarck had avoided after 1871. The emperor intensified the fear of Germany with belligerent public statements. Britain responded by turning from its traditional pro-German policy and cultivating closer ties to France.

Although William II caused problems for Germany after 1890, the popular authoritarianism of Bismarck and his successors had quickly built a remarkably prosperous and strong modern state. The British, and eventually other West Central European states, followed a different course to political modernization and power.

## ■ THE DEMOCRATIC NATION-STATES

Before 1851, France sporadically used democratic institutions to achieve the modern political goal of citizen involvement in public affairs. Britain became the first European state, however, regularly to maintain a system with a significant degree of democracy. Parliament built an important part of the British structure of popular sovereignty as early as the 1830s, and then continued this work of democratization into the next century.

### Parliamentary Democracy in Britain (1848–1914)

Both Whig and Tory Party leaders contributed to the carefully limited expansion of popular authority in the1830s. The process of democratization languished thereafter, however, as the two parties went through a period of reorganization.

### Emergence of the Liberal and Conservative Parties

Restructured and reinvigorated political organizations emerged under effective new leaders in the 1860s. John Bright (1811–1889) and William Gladstone (1809–1898) reshaped the Whigs into the Liberal Party, at the same time that Benjamin Disraeli (1804–1881) molded his Tories into the Conservative Party. Liberals and Conservatives alike then promptly entered a campaign to extend voting rights, with the expectation that this effort would win stronger support for their parties.

### The Reform Bills of 1867 and 1884

Once the parties had emerged in their new form, Liberals under Gladstone entered the battle for democratization. A Conservative-dominated Parliament at first blocked this effort. Prime Minister Edward Derby, however, eventually yielded to Disraeli's call for Conservatives to support expansion of voting rights rather than allow the Liberals to use this issue to win the masses.

The **Reform Bill of 1867** that Parliament adopted approximately doubled the size of the electorate. It allowed all males who owned a house to vote. Men in the cities who rented homes also gained the franchise. The act was thus more restrictive for rural than urban males, but it discriminated against poor men of both the countryside and the city, and it excluded women completely.

During the next seventeen years, both the Gladstone and Disraeli administrations failed to extend voting rights any further. Then Gladstone's Liberals secured passage of the **Reform Bill of 1884,** an act that applied the same standards to rural males that were established for urban men in 1867. This new law enfranchised all males except migrant workers, servants, and single men living with their parents. Because women still could not vote, these two reform bills made Britain more democratic, but without creating a democracy.

### A New Tide of Reform

The special interest in the franchise question persisted in the latter 1800s, but other matters gained more attention in these years than in the early 1800s. In 1870, with Gladstone and the Liberals in power, an executive decree opened government jobs to all citizens, with selection determined by examinations. This reform reduced the tendency to hire people because of their connections. The government also loosened the control of the social elite over access to higher education and the military officer corps.

Laborers benefited from the Liberals' interest in disadvantaged groups. A secret ballot law passed in 1872 freed workers from the risk of economic reprisals when they voted against the interests of employers. After the Conservatives won control of Parliament in 1874, Prime Minister Disraeli and his party continued this trend of reform in the interest of the masses, with two laws in 1875 aimed at improving public sanitation and the housing of the poor.

### Emergence of the British Welfare State

Conservatives lost much of their drive for innovation when Disraeli's leadership ended in 1880. Gladstone dominated his party until 1894, but he guided the Liberals toward causes that produced little reform legislation. Thus, the pace of reform slowed by the 1880s. Reform resumed, however, when a new generation of Liberal Party leaders took control of Parliament in 1905. These Liberals turned away from the party's *laissez-faire* traditions and advanced a sweeping program of welfare legislation similar to Germany's. Between 1906 and 1912, they established worker accident insurance, an old-age pension plan, health insurance for all citizens, unemployment insurance, and a minimum-wage law.

### The Triumph of the House of Commons

The expense of this welfare-state program helped to provoke a budget crisis, the resolution of which elevated the House of Commons to full supremacy over the House of Lords. This struggle erupted when Chancellor of the Exchequer (treasury minister) David Lloyd George (1863–1945) introduced the **People's Budget** in 1909. His proposal included progressive income and inheritance taxes designed to

take money from the richer citizens to pay for the cost of welfare programs. The House of Commons passed the bill, but the House of Lords blocked it for eighteen months.

Commons resorted to a formidable weapon. In 1910, the lower house proposed to end the Lords' power to stop budget laws and leave them with the authority to do no more than delay other legislation. The upper house accepted this measure as the Parliament Bill of 1911. The Lords yielded when Liberal Prime Minister Herbert Asquith (1852–1928) warned that, if necessary, the king would appoint enough new nobles to secure passage. The popularly elected house had completed its long transition to supremacy.

### Emergence of the Labour Party

A group of intellectuals who did not believe that the two leading parties responded adequately to working class needs formed the **Fabian Society** in 1883. This organization then led a campaign for complete democracy and a socialist economy. Fabians also insisted that workers should establish their own party and support this drive for social equality.

In 1893, Keir Hardie (1856–1915), a Scottish miner, had organized a fledgling pro-labor political group. His followers merged with the rapidly growing forces of the labor union movement and formed the **Labour Party** in 1906. Liberals and Conservatives now faced an organization devoted to the cause of the working class. Within two decades, this moderate socialist party and the Conservatives dominated Parliament.

### The Movement for Women's Rights

When the Labour Party emerged to support the interests of workers, women still could not vote in national elections. Advocates of women's rights hardly accepted their disenfranchisement quietly. The men and women who took up the feminist banner met stubborn—even brutal—resistance and resorted to militant tactics.

Emmeline Pankhurst and numerous determined women, including her two daughters, emerged as early leaders of the attack on British male supremacy. They voiced their demand for the right to vote by such actions as storming Parliament, chaining themselves to government buildings, and burning mailboxes. Opponents answered their protests by jailing and beating the feminists. When imprisoned women used hunger strikes to protest this treatment, authorities sometimes force-fed them, using tortuous methods to do so.

Victory still eluded feminists when Britain entered the World War in 1914. The remarkable contribution of women to the four-year campaign against Britain's enemies convinced the men in Parliament that voting rights should be extended to the females they deemed worthy. In 1918, they granted the franchise to women thirty and over. The same law allowed all men twenty-one and over to vote, thus extending the right to previously excluded male groups, such as migrant workers. Legislation in 1928 lowered the voting age for women to twenty-one, at which time British political democracy was complete.

### The Deep and Bitter Roots of the Troubles in Ireland

A century before Britain ended the exclusion of women from national politics, the government abolished laws denying all political rights to Catholics. The 1828 act that ended political discrimination against Catholics especially affected Ireland, because most people there were of that faith. This change meant that for the first time, Irish citizens could vote on members of the House of Commons. The opportunity to send

a few representatives to Parliament, however, meant little to a people who considered themselves victims of centuries of English economic exploitation. The sense of abuse by the English resulted especially from extremely high rents and other absentee-landlord practices that for many generations had kept Irish tenants impoverished. Irish anger deepened in the 1800s when famines struck and caused thousands to starve while English leaders refused to change trade policies so that food prices would drop.

Gladstone opened his first administration in 1868 with an energetic effort to overcome Ireland's suffering. Life improved somewhat, but discontent persisted, and Irish immigrants to the United States began a movement for home rule of Ireland. They wanted their native country to have its own separate institutions of government. The Finian movement in Ireland took up this cause. Soon, Charles Stewart Parnell joined the home-rule struggle as leader of the small Irish contingent in Commons. These home-rule advocates gained a formidable ally when Gladstone sided with them in 1886. Success still eluded them when his career ended a decade later, but other Liberals continued the campaign for Irish home rule beyond the turn of the century.

The Conservative Party opposed this reform. The predominantly English and Protestant region of Ulster in Northern Ireland also staunchly resisted allowing Irish Catholics to govern the island. These forces stalled successive home-rule bills in Parliament until the outbreak of war in 1914 overwhelmed the legislature with other concerns.

## Democracy in the European Heartland (1870–1914)

France restored republican government for a third time in 1870 and, thereafter, gradually empowered its citizenry through legislative institutions, as had Britain. Italian unification efforts finally succeeded in the same year that the Third Republic emerged in France. Italy also inclined toward a parliamentary government that responded to popular forces. Democracy in these two West Central European states evolved somewhat differently than in Britain, but the tendency in Italy and France was toward self-government.

### The Collapse of the Second French Empire

Despite domestic successes, Napoleon III's foreign adventures eventually brought disaster. The Emperor expected a glorious military triumph in the Franco-Prussian War in 1870, but he quickly became a captive of the Prussians. Upon release, Napoleon fled into exile in Britain. A provisional government immediately took charge in France and resumed the war against Prussia. France still failed miserably in battle.

### The Revolt of the Paris Commune (1871)

When the French provisional government began to plead for peace, militant patriots in the capital attempted to continue the war with Germany. The Parisian rebels also wanted a republic and considered provisional leaders to be against popular government. Like the zealots of 1792, these determined republicans organized as the **Paris Commune** and prepared to fight against Germany and for democratic government.

By February 1871, the provisional leaders had arranged a humiliating treaty with Germany and, in March, sent troops to disarm the Paris Commune. Parisians resisted these forces and killed the commander of the military group. Adolphe Thiers, the head of the temporary national government, responded with a military assault on the city in May. More than a week of ferocious combat left thousands dead and

the Commune smashed. Provisional forces then executed thousands without trial, took others to court and sentenced them to death, and imprisoned still more. In the turmoil of war and civil rebellion, a new French government had begun to emerge.

### The Third French Republic

After arranging peace with Germany, the temporary political leadership had to form a permanent government. Monarchists held a majority of the seats in the provisional government assembly, but a split in their ranks enabled a republican minority to take control of writing a new constitution. They established the **Third Republic** and arranged a government similar to Britain's.

In the structure established in 1875, the president formally ranked as head of state but had no more power than a British monarch. Legislation also provided for a powerful parliamentary body that included an upper house (Senate) and a Chamber of Deputies. All males had the right to vote for Chamber members, a degree of democracy not achieved in Britain until a decade later.

Once the system was in operation, the party, or more typically the coalition of parties that held a majority in the legislature, selected an executive body. This cabinet of ministers included a chief executive, the prime minister. These executives held positions of great authority, but the Chamber remained supreme. With a multitude of parties rather than two clearly dominant ones as in Britain, French prime ministers often could not maintain a stable governing coalition and win votes for legislation. Third Republic ministries thus frequently collapsed to be replaced by a cabinet supported by a new combination of deputies. In this respect, French government differed markedly from Britain's in this era.

### The French Republic at Risk

Executive instability troubled the new republic in France, and many other problems compounded the threat to popular government. Discoveries of corrupt financial practices involving Chamber members, for example, weakened public support for the system. This discontent with republican leadership strengthened the tendency of French citizens to long for popular authoritarianism. In the latter 1880s, a wide following developed for a famous military leader, General Georges Boulanger. The expectation grew that he would seize power. Instead, he left the country in 1889 and killed himself on his mistress's grave in Brussels in 1891.

### The Dreyfus Affair—a Trial for the Third Republic

Army Captain Alfred Dreyfus faced charges in 1894 that he had spied for Germany. The actual traitors in the officer corps had framed Dreyfus, a deceit that worked well because he was a Jew among anti-Semitic associates. The conviction of this innocent officer and his imprisonment on Devil's Island provoked a crisis that threatened the existence of the republic.

Defenders of the captain fought not only for his release but also for the survival of the government, because Dreyfus's opponents used his case in an anti-republican smear campaign. These anti-Dreyfusards—monarchists, anti-Semites, Catholic leaders, and conservative members of the armed forces—kept Dreyfus imprisoned and the Third Republic on trial for years. Dreyfusards could not win his pardon until 1899, and it required another seven years to have the conviction nullified. The Third Republic had suffered but triumphed.

## Laws of the New Order in France

Victory for the Dreyfusards encouraged the republic's supporters to strengthen laws against one opposition faction, the Catholic clergy. Legislation passed in the 1880s had weakened church influence by restricting its organizations and establishing a system of free public education in which religious teaching was banned. New measures in the early 1900s further limited Catholic secular activities and decreed the full separation of church and state.

The government exhibited a more benign attitude toward the working class and legalized unions in 1884. The labor movement then regained momentum after years of weakened influence. Socialism also made progress in the Third Republic and increased the pressure on the government for welfare-state programs. The forces of labor failed, however, to win the kind of public aid provided in Germany and Britain.

Disappointed labor activists turned to direct-action tactics, especially after 1906. Strikes multiplied and syndicalism emerged with its demand for a general strike as an instrument of revolution. Obviously, the democratic nation-state, as it evolved in the Third Republic, had politically mobilized the masses, but not always in support of the government. The commitment of the citizenry to France had strengthened dramatically, however, as they would demonstrate in a great war that loomed before them in 1914.

## Divisions in a United Italy (1870–1914)

Revolutionary France had given German and Italian nationalists lessons in the power and glory that a united and politically aroused people could achieve. In 1870, therefore, a new Kingdom of Italy anticipated such rewards for its generations of sacrifice for unification. A multitude of social divisions, however, prevented the realization of these dreams during the next forty-five years and raised questions about the reality of Italian nationhood.

Many leaders in the drive for unity had intended to establish a secular state true to the principles of liberalism. Catholic clerics staunchly opposed such a nation, which weakened the loyalty of the Catholic peasant majority to the new Italy. Peasant alienation also posed a special problem, because rural Italians lived mostly in the poorer south. Religious, regional, and socioeconomic influences tripled the strength of this barrier to unity. It still stood as a serious problem in 1914.

## Italy's Infant Democracy

Whatever the social divisions, Italian government embarked on an experiment in democracy that affected people all over the peninsula. Many of them remained more loyal to their separate states than to Italy as a whole, but the nation had a common system of government with a structure much like that of the French Third Republic.

The king, Victor Emmanuel II, held a position equivalent to that of the French president. The Senate had a unique composition in that its members were either relatives of the king or his appointees. The Chamber of Deputies, however, was elected, as in France, although the electorate remained very small until 1912. In that year, Italy instituted universal male suffrage, a right established in France in 1848 and in Britain in 1884.

Because Italy's limited democracy gave little power to the lower classes before 1914, social legislation received even less attention than in France. Instead, leaders devoted their efforts to controlling militant labor and attracting a devoted following to the glorious cause of empire building, mostly in North Africa. The young Italian nation did not succeed as well as Germany, Britain, and France in activating its

citizenry, even when imperial adventures brought a measure of success. Despite their problems, by 1914, Italians had laid the foundations of a more fully modern nation-state.

# ■ MULTINATIONAL AND DYNASTIC NATIONAL STATES

The countries on Europe's eastern and western borders responded to the social forces that reshaped governments in Britain and the continental heartland after 1848. Leaders in these bordering regions, for example, recognized the need to elicit mass political support. In various ways, they utilized nationalism in their efforts to engage the citizenry. Yet these countries—Portugal, Spain, Austria, and Russia—did not become modern nation-states. Spain and Portugal had made only the first faltering steps toward sociopolitical modernity by the second decade of the twentieth century. Older political institutions remained even more firmly entrenched in the Austrian Hapsburg and Russian Romanov multinational empires.

## The Iberian Kingdoms

Social divisions similar to Italy's hindered the progress of sociopolitical modernization in Portugal and Spain between the 1848 and 1914. Still, both nations established self-governing institutions that had begun to have significance before 1914.

### Portugal: From Authoritarian Monarchy to Republic

Years of social strife ended in the early 1850s in Portugal, but rigidly authoritarian rulers kept this civil peace. A government much like Britain's constitutional monarchy in appearance did not give the reality of political modernity. Either the kings themselves or their appointed prime ministers reigned as dictators over the nation until 1908.

From 1908 to 1910, a new ruler, Manuel II, provided genuine constitutional monarchy. Then a revolt drove him from power and established a republic. The new government ended the civic power of the Catholic Church and enacted a truly liberal constitution. After the founding of this modern national structure, attacks from royalists and a still dissatisfied working class hindered its further development.

### Constitutional Monarchy in Spain

Spain suffered the strain of civil conflicts almost continually from the 1830s to 1870s. The reign of the Bourbon king Alfonso XII (reigned 1874–1885) finally brought a period of political stability and a return to constitutional monarchy, a system tried intermittently earlier in the century. The government issued a new constitution in 1876 that specified restrictions on royal authority, provided for an executive cabinet, and established a two-house legislature. Property limitations on the right to vote, however, excluded all but a tiny minority from participation in legislative elections.

This essentially royalist and aristocratic system remained intact under the king's son, Alphonso XIII, who held the throne until the monarchy fell in 1931. Leftist rebels grew increasingly vicious from the 1890s onward, with assassination attempts, especially by anarchists, becoming almost commonplace. Alphonso XIII survived at least ten such attacks by these violent foes of authoritarianism, but he did not yield additional power to the citizens. Spain moved toward modern self-government between 1874 and 1914, but not very far.

## The Establishment of Dual Monarchy in Austria

When the new German nation emerged in 1871, the Austrian Hapsburg emperor was left in charge of an empire with a large German population in the north, but with many other national groups in his realm. The most powerful non-German nationality, the **Magyars,** in 1867 gained the special right of control over internal affairs within their section of the empire. This Magyar region, known as Hungary, accepted the Hapsburg ruler as king. In Austria, the same person ruled as emperor and so governed a **Dual Monarchy:** Austria-Hungary.

### Discrimination against Minorities in the Dual Monarchy

Once the Magyars won rights for their nationality, they forcefully denied the same privileges to all other ethnic minorities (Croats, Romanians, Serbians, Slovaks) within the Hungarian kingdom. In fact, they vigorously pursued efforts to impose the Magyar language and culture on these groups, a policy of **Magyarization.**

The German majority in the Austrian part of the empire followed a more tolerant minorities policy. Hapsburg leaders adamantly refused, however, to grant other groups the special status enjoyed by Magyars. The Czechs (a Slavic people) struggled valiantly but in vain for such a privileged position. Various South Slavic nationalities in Austria also fought for more nearly equal rights. These South Slavs posed a special problem for Austria because people of this same ethnic group had formed the nation-state of Serbia on the southern border of the Hapsburg realm. Many Austrian Slavs thus longed to separate from the empire and merge with Serbia. Austrian imperial leaders would go no further than they had in 1867 to placate the political aspirations inspired by the age of the nation-state. This national minorities problem before many more years would spell the doom of the 700-year-old empire.

## Romanov Russia—Crisis in an Empire of Two Hundred Nations

When Alexander II (reigned 1855–1881) became tsar of Russia, he ruled the largest state in the world and governed an estimated population of seventy-four million. Unfortunately, his empire was less socially united than any other country on the European continent. This disunity resulted in part from the great cultural diversity of the tsar's subjects. The nationalities within imperial borders numbered from 120 to 200, depending on the defining criteria.

The majority nationality, the Great Russians, had forged the empire over many centuries, and its ruling class was largely Russian. By the 1700s, the Great Russian tsars adopted a policy of sociocultural conversion, or **Russification,** of the minorities to better ensure the unity of the empire. No other European national minorities in the modern era felt more pressure to surrender their culture to the majority.

### The Peasant Problem

Social fragmentation of another kind concerned Alexander II even more than did the national divisions. The new ruler believed, in fact, that the split between the masses of impoverished peasants and the small, highly privileged aristocracy might destroy the empire if he did not carry out sweeping social reforms.

The Emperor, the intelligentsia, and many aristocrats knew that the increasingly rapid industrialization of most European states had encouraged prosperity there and greatly increased the power of these countries abroad. These Russians believed that the peasant problem prevented the modernization so desperately needed by their nation in order to become a leading European state.

Reform advocates saw conditions in rural Russia as a problem in part because the farmers (over eighty percent of the population) produced far too little to feed an urbanizing society. With their old-fashioned ways, peasants also could never grow a surplus to sell for industrial investment funds. Half these peasants, moreover, lived in the virtual slavery of serfdom and worked even less effectively than free farmers. Worst of all, without an end to serfdom and other steps to modernize agriculture, the empire could not find enough workers for a factory system.

By the mid-1800s, many Russians asserted that the horrible immorality of possessing serfs demanded action, regardless of political or economic considerations. This argument certainly intensified the demand for emancipation. So, too, did fears of massive serf revolt. The tsar himself warned aristocrats that the liberation of the serfs would come "from below," if others did not liberate them "from above."

### Emancipation of the Serfs (1861)

A decree of emancipation in 1861 freed all serfs, but it responded to the economic concerns of their former masters by paying the aristocracy for the land and workers they surrendered. This money for the nobles came from the government, but freed serfs had to repay the state in annual fees for forty-nine years, more than a lifetime for them. The heavy debt and the allotment of about twenty percent less land to the peasants than they had farmed as serfs made their freedom mean much less. Even though Alexander II went on to complete a series of reforms that increased popular influence at the local level, modernized the military, and expanded educational opportunities, many opponents of the system denounced emancipation and raised the cry for revolution.

## The Growing Revolutionary Forces in Russia

Conditions during the reigns of Alexander II and his son, Alexander III (reigned 1881–1894), encouraged the growth of an unusually large force of activists determined to destroy the old regime.

### The Populist Movement

Until after the mid-1800s, rebellious leaders had no popular following. In the 1860s, such movements broadened as idealistic university students and others became committed to the theory that Russian peasants had a natural ability to create a rural socialist society. The intellectuals who held this belief became known as **populists.** In the 1870s, some of them attempted to go to the countryside and inspire revolution. Rural Russians did not understand the intentions of these strange newcomers when they arrived and sometimes turned the populists over to the police.

The populist movement fragmented after the failure of their idealistic notion of "going to the people." Many of these reformers still believed that the rural masses could be enlightened and join the peaceful transformation of Russia. Others insisted that only violence could destroy the evil system. In 1881, members of a militant faction, the **People's Will,** succeeded in assassinating Tsar Alexander II. Brutal repression followed under the new emperor, Alexander III, but during his reign, the movements for revolution continued, usually working in secret or in exile.

### Russian Marxism

Georgi Plekhanov established the first **Russian Marxist** organization in 1883. By the 1890s, Marxists had become a significant element among Russian revolutionaries and a communist party, the

**Social Democratic Workers Party** (SDs), emerged in 1898. They promoted their ideas through underground publications such as their journal *Iskra (The Spark).* The views of these SDs varied, but in the 1890s and early 1900s, most of them probably believed the traditional Marxist theory that Russia's still infant capitalism would mature and bring the rise of a massive proletarian class destined eventually to march to victory in a communist revolution.

### Lenin's Radical Russian Marxism

Vladimir Ilyich Ulyanov (1870–1924) took the pseudonym **Lenin** during his early years of revolutionary activity. Although he came from a middle-class family (his father was a school administrator), Lenin's older brother identified with the suffering masses. The government executed him in 1887 for involvement in a conspiracy to kill the tsar. This event perhaps contributed to Lenin's lifelong commitment to revolution. He became the leader of a distinctly Russian and radical variety of Marxist communism.

Lenin plunged into anti-government activities as a young law student. After several arrests and imprisonments, he fled abroad. At various sites in Europe, Lenin worked by organizational effort and writing to advance from that safe distance the cause of communism in his homeland. In 1902, he wrote *What Is to Be Done?* This famous booklet enthralled the radicals in his country. It rejected the soft theory held by most Russian SDs that suggested a long wait for proletarian revolution. Instead, Lenin offered instead a hard communist doctrine. He contended that victory could come soon if a small, secret party stood ready to obey an enlightened revolutionary leadership. Such an elite force could at once begin to draw Russia's few urban proletarians and the masses of poorest peasants into an armed struggle leading to the destruction of the autocratic, aristocratic system. Then the communist era would dawn.

### The Communist Split—Bolsheviks and Mensheviks

The Russian Social Democratic Workers Party held its second conference, or Congress, in 1903. The meetings began in Brussels, Belgium, and finished in London. By the time of this Congress, Lenin had become a leading figure in the Party. He had a strong following during the debates and votes as the conference proceeded through about thirty of almost forty sessions, but most participants did not support Lenin's radical approach to revolution. They did not agree with his emphasis on building a party with very limited membership under extreme leadership authority ready to drive agrarian Russia at once into proletarian revolution.

In the last few conference sessions, Lenin's faction did have a decisive majority in votes on the selection of leaders for Party agencies. Consequently, his supporters acquired the label **Bolsheviks,** Russian for "people of the majority." The group that opposed Lenin's hard conception of revolutionary methods and favored more traditional Marxist ideas became known as **Mensheviks,** or "people of the minority." Despite the names, the Bolsheviks remained the smaller of these two Marxist groups for more than a decade after the Brussels/London Congress as they became rival Russian communist parties.

### The Socialist Revolutionaries

Although the Bolsheviks won strong support from city workers, another group appealed more to the peasant masses. In 1902, populists organized the **Socialist Revolutionary** *(SR) Party,* and it soon became a leading enemy of the autocracy. The SRs kept the populist commitment to the creation of a peasant socialist Russia rather than the urban industrial socialist society favored by Marxists. The party also generally

inclined toward terrorist tactics instead of the elitist revolutionary methods of Lenin. SRs especially favored the assassination of government officials as a way to destroy the system.

### Russian Liberalism

In the 1880s, Russia lacked the usual conditions necessary for the emergence of liberalism—it had little industry and only a shadow of a middle class. The local government reform during the reign of Alexander II, however, produced a core of political professionals who adopted views typical of nineteenth-century liberals. In 1905, this small movement established a political party, the **Constitutional Democrats** (Kadets, or KDs, in Russian), which began to support thorough reform of the old order.

## The Soldiers of the Russian Revolution on the Attack

Harsh living conditions, advances in the educational level of workers, the increased political awareness of peasants, and the effects of rapid industrialization prepared the Russian masses for revolution by the late 1800s.

### Russia's Late Industrial Revolution

The beginning of rapid industrialization resulted mostly from government programs instituted in the reign of Nicholas II (1894–1917). This last tsar, a devoted father and well-intentioned ruler, lacked the talent to govern, especially in an autocracy. At first, however, he appointed a few capable officials, such as Sergei Witte, who laid the foundations of modern industry early in the tsar's reign.

Despite the industrial growth fostered by Witte, the factory workforce remained small (only about two to three percent of the population even in 1917). Surprisingly, however, urban labor became a significant revolutionary influence by the early 1900s. This radical potential resulted from the proletariat's close ties to the revolutionary peasantry and the Russian practice of building huge factories. Many plants employed over one thousand workers, and, with the horrible conditions of industry at that time, these large factories offered excellent opportunities and motivation for radical organization.

### The Revolution of 1905

Imperial rivalry in Asia brought war between Russia and Japan in 1904, and by the next year, the tsar's forces had suffered a humiliating defeat. The burden of war intensified the suffering of the Russian masses and dramatized the inadequacy of the country's leadership. Petersburg workers responded to this increased misery in January 1905 by joining a peaceful demonstration intended as a plea to the tsar for factory reforms (such as an eight-hour workday). Under the leadership of a priest, Father Gapon, two hundred thousand people marched to the tsar's palace in the heart of Petersburg. Slaughter ensued. Nicholas's troops killed about five hundred people and injured thousands. The day became known as **Bloody Sunday.**

Widespread rebellion resulted. Strikes and street violence gripped Russia, and revolutionaries in the large cities organized to seize political power. They formed workers' councils (**soviets**) that rivaled government authority in Petersburg and other urban centers.

Finally, Nicholas II issued a manifesto in October 1905, declaring his intention to bring drastic reform. The **October Manifesto,** which indicated that Russia would become a constitutional monarchy, helped to calm the revolt in the cities by early 1906, but not in rural areas. The government continued to work to end the rebellion by presenting the details of a reformed system in the **Fundamental Laws** (May 6, 1906).

Nicholas still would have sweeping authority to implement all legislation, control the military and direct foreign relations, lead the Russian Orthodox Church, and convene or disband the new legislature (**Duma**) called for by the Fundamental Laws. He even would have the right to nullify any laws passed by the Duma. But there was to be an elected Duma. No Russian national parliament, however limited, had ever existed before.

## The Last Gasp of the Russian Autocracy

The First Duma seemed to promise real change. Nearly all males gained the right to vote for assembly members, and they elected a strongly reformist legislature instead of the conservative one the government expected.

### Subduing the Duma

Duma members proposed giving government, church, and noble lands to the peasants, and writing a new constitution. Nicholas II would have none of this, and he dismissed the assembly. The government worked diligently thereafter to control Duma elections but still could not get a submissive assembly until the Third Duma convened in 1907. Even though supporters of the tsar dominated the Third Duma (1907–1912) and the Fourth (1912–1917), moderate liberals had considerable influence. These liberals of sorts were the **Octobrists,** a party that accepted the constitutional monarchy promised in the October Manifesto of 1905. They spoke for moderate reformist nobles and businesspeople. The few Kadets in the Duma became the main outspokenly liberal critics of the government in the assembly. Despite the Octobrist and Kadet presence, the Duma never had a real share in the control of Russia.

### Terror and Repression

Revolutionaries continued their assault on the system in the early 1900s. Their terror killed fourteen hundred in 1906 and three thousand in 1907. The rebels went after all government figures, with little regard for innocents who might die in their attacks. An explosion they set off in one of Prime Minister Peter Stolypin's homes in 1906, for example, took more than thirty lives. Two of Stolypin's children died in this blast, but not the prime minister.

Stolypin answered with both repression and reform. He established virtual martial law in part of Russia and set up courts there to carry out trials. Hastily conducted judicial proceedings led to the execution of more than one thousand. (Russians began to refer to executioners' nooses as **Stolypin's neckties.**) Terrorist acts diminished during the Stolypin repression, but revolutionaries still prepared to destroy the autocracy.

By long tradition, the Russian peasantry had worked scattered strips of land under the control of **"mir"** (village) leaders. Circumstances elsewhere in Europe indicated that a rural society comprised of independent small farm households would support the ruling system instead of revolution. Stolypin's reforms focused especially on encouraging peasants to merge and take control of their land parcels so that the Russian agrarian masses would become a dependable conservative force. Almost half the farm households had begun the process of separation from the *mir* by 1914, but Russia then entered the Great War (see Chapter 9), and the land reform effort ended before agrarian Russia had changed significantly. The revolutionary mood persisted in the countryside. An ironic climax came to the Stolypin era of repression, when a secret police agent working in a revolutionary group shot and killed the prime minister on

September 14, 1911. Thereafter, much less effective officials struggled to hold a vast, diverse, and troubled empire together. Then, in 1914, the Romanov dynasty led a weak and divided Russia into an exceptionally deadly and destructive four-year European war.

*By the latter 1800s, nationalism enthralled Europeans and inspired each country to believe in its superiority to all other states. This spirit drove Italians and Germans to finish the struggle for national unity by the early 1870s, and encouraged unusually drastic changes in government organization and policies in the rest of Europe. Especially important changes included the development of democratic or seemingly democratic institutions and the establishment of reforms to ease the plight of the masses. Such steps toward popular government and social improvement seemed essential to Europeans, who now tended to believe that each nation of people should be an independent country, that every member of a nation owed obligations to it, and that national leaders had to see to a secure life for all citizens.*

*Developments during this era of the nation-state brought the countries of this region to the zenith of their power, despite serious problems that persisted, especially in the Russian and Austrian Empires. Most states used this exceptional strength to conquer vast realms in Asia and Africa between 1870 and 1914. Then, in the four years that followed, they unleashed their forces and their spirit of burning, combative nationalism within Europe to wage a war on one another that wreaked more destruction than any in previous history.*

## Selected Readings

Coppa, Frank J. *The Origins of the Italian Wars of Independence*. New York: Longman, 1992.

Figes, Orlando. *A People's Tragedy: The Russian Revolution*. New York: Viking, 1997.

May, A. J. *The Hapsburg Monarchy, 1867–1914*. Cambridge, MA: Harvard University Press, 1951.

Miller, Forrestt A. *Dmitri Miliutin and the Reform Era in Russia*. Nashville, TN: Vanderbilt University Press, 1968.

Robinson, Geroid T. *Rural Russia Under the Old Regime*. Berkeley: University of California Press, 1967.

Spartacus Educational (at this site, *www.spartacus.schoolnet.co.uk*, use the *Parliamentary Reform* link, and then links under *Parliamentary Reform Acts* for information on British electoral reform).

Strümer, Michael. *The German Empire, 1870–1918*. New York: Modern Library, 2000.

Thompson, David. *Democracy in France since 1870,* 5th Edition. Oxford, UK: Oxford University Press, 1969.

Tombs, Robert. *The Paris Commune, 1871*. New York: Longman, 1999.

## Test Yourself

1) Which of these suggests that government leaders might not feel obligated to tell citizens the truth?
   a) The British Reform Bill of 1884 as released to the press
   b) Alexander II's serf emancipation decree
   c) The posted version of the Parliament Bill of 1911
   d) The Ems dispatch as publicly reported

2) Camillo di Cavour was to Italy as who was to Germany?
   a) Otto von Bismarck
   b) Georg Haussmann
   c) Emperor William I
   d) Emperor William II

3) The British Reform Bills of 1867 and 1884
   a) reduced democracy
   b) still left urban working males with no vote
   c) did not give the vote to women
   d) gave women the vote

4) The revolutionary urban councils called soviets first appeared in Russia
   a) during the Revolution of 1905
   b) during the Populist "going to the people"
   c) when the Bolsheviks and Mensheviks split
   d) when the Socialist Revolutionary Party held its first national meeting

*For the following quiz items, decide whether the information in the text for the period 1848 to 1914*
   a) *strongly supports the statement*
   b) *adequately supports the statement*
   c) *inadequately supports or somewhat contradicts the statement*
   d) *offers little or no support or strongly contradicts the statement*

5) The period from 1848 to 1914 deserves to be called the Era of European Reform.

6) The existence of nation-states from 1848–1914 was a more prominent feature of European history than the establishment of political and socioeconomic reforms by states in the region.

7) Liberalism and nationalism are virtually the same ideologies with different names.

8) The history of Russia from 1848 to 1914 indicates that neither repression nor reform significantly discourages revolutionary activity.

## Test Yourself Answers

1) **d.** The British Reform and Parliament Bills themselves have no relevance to the question, and they were not portrayed in distorted form to the public. Although the tsar's declaration of serf freedom might have deceptively left the liberated peasants economically enslaved, it hardly qualifies as the kind of purposeful falsification for which Bismarck's distorted report of the Ems dispatch is famous.

2) **a.** The answer to this analogy question gives little to ponder, because the roles of Cavour and Bismarck in their countries' unification movements are so similar. William I, as Prussian emperor when the unification process climaxed, might deserve some thought as a possible completion, but not much, given Bismarck's leadership in bringing German unity and the particular way in which he did it. Haussmann and William II have nothing to do with the question posed.

3) **c.** The correct completion requires only recollection of an important fact about the gender-related history of Modern Europe—women did not get the right to vote in national elections in Britain, or anywhere in Europe, until after 1900.

4) **a.** The local revolutionary council ("soviet" in Russian), the multiples of which the rebels of 1905 intended to convert into the building blocks of a new socialist and democratic governing system, became the key word in the name of the Russian Communist state after the Bolsehvik revolution of 1917. The long-term significance of the word *soviet* makes this point worth remembering. The text did not mention a Socialist Revolutionary national meeting, but did refer to the other two possible completions, which still had nothing to do with the first appearance of the soviets.

*The answers and annotations offered for the following quiz items reflect one historian's opinion. Different answers, within certain limits, not only might be judged "correct," but in fact would agree with the important premise underlying this part of the chapter test—the answers to significant historical questions are debatable.*

5) **a.** Because the very different state systems across the entire continent—from imperial Russia to Britain with its Parliament and constitutional monarchy—established numerous political and socioeconomic reforms in this period, the evidence strongly supports referring to this period of European history as an Era of Reform.

6) **c.** Despite the title chosen for the chapter, the information inadequately supports the opening statement for this quiz item. The nation-state had a long history in West Europe and was particularly well-developed in France and Britain by this period, but it was a new political phenomenon in Germany and Italy, and East European multinational empires, not nation-states, covered most of the continent. Furthermore, the text noted the serious divisions that hampered the cohesiveness of the European nation-states that did exist. These circumstances and the points made for Item 5 suggest "inadequate support" as the best completion for the Item 6 statement. The chapter emphasis on the nation-state has to do with certain climactic developments in the latter 1800s, such as Italian and German unification, and with the dramatic effect of the nation-state system and nationalism on European history throughout the coming century.

7) **d.** In certain respects, nationalism is a most malleable kind of belief system, easily adjusted to work in varied historical environments and to fit together with other ideologies. Before the mid-1800s, nationalism and liberalism probably seemed almost inseparable, perhaps almost identical to many contemporaries. The history covered in this chapter, however, clearly contradicts the statement that liberalism and nationalism were "virtually the same ideologies." A thoughtful reader of the chapter, however, might also justifiably decide that choice *c* is a better completion.

8) **b.** The continued vigorous growth of revolutionary movements in Russia, despite reforms such as those of Alexander II and Stolypin and diligent repressive efforts by Alexander III and Stolypin, indicates that the evidence at least adequately supports the statement. "Strongly supports" seems less justified as a completion because of the effects that the October Manifesto (a reform of sorts) and Stolypin repressions did have on lessening the level of rebellion.

# Marching into the Great War (1848–1918)

**1857:** The Sepoy Mutiny against the British takes place in India.

**1859:** French conquests in Indochina begin.

**1865:** The Russians capture Tashkent in Central Asia.

**1876:** Leopold II of Belgium establishes a colony in the African Congo.

**1882:** Germany, Austria, and Italy form the Triple Alliance.

**1884:** The Berlin Conference stipulates rules for colonizing Africa.

**1907:** France, Russia, and Britain organize the Triple Entente.

**1912:** Balkan wars begin and continue into 1913.

**1914:** The First World War erupts.

**1916:** The battles of Verdun and the Somme occur.

**1917:** The United States enters the European war on the Allied side.

**1918:** An armistice on November 11 ends the First World War.

**1919:** Germany signs the Treaty of Versailles.

*Europe's lengthy process of modernization climaxed in the late 1800s and early 1900s. The countries of this region achieved peak strength with the emergence of a system of nation-states empowered by industrial economies, well-organized central governments, massive military forces, and broad citizen involvement in public affairs. Whatever great achievements other cultures of the world had realized by this time, these circumstances meant that none had the power of Modern Europe in the latter 1800s.*

*From the 1870s to 1914, Europeans used their exceptional strength to seize control of much of the rest of the world. During these few years, they conquered virtually the entire African continent, large Asian territories, and islands scattered throughout the Pacific. In addition to territories taken in these forced annexations, Europeans subordinated other areas, including vast portions of China and the Middle East, by*

*political and economic arrangements extorted under threat. The United States joined the Europeans in the imperial reach into Asia and also encroached on Caribbean islands and Central America.*

*The imperial onslaught slowed somewhat during the early 1900s. Crises then began to erupt in southeastern Europe in the Balkan Peninsula. Imperial rivalries, struggles to maintain or increase state power, fiery nationalist attitudes, the tensions between two competing alliances, and a raging arms race generated these conflicts and led finally to a cataclysmic war among the Europeans in 1914.*

*The four years of carnage that followed this outbreak drastically altered the history of Modern Europe. Even before the war ended, the German imperial government and the Austrian and Russian Empires collapsed. Then, the victorious powers gathered after the fighting stopped and attempted to arrange an enduring structure of peace. After negotiating for months, they finally completed treaties to implement the peace plans they had conceived. And they hoped. In most respects, they longed in vain for the success of their peacemaking efforts, as the aftershocks of the war continued to reshape events in ways they could neither anticipate nor control.*

## ■ THE COLLAPSE OF THE CONCERT OF EUROPE

For twenty-five years after the French Revolution began in 1789, the European state structure underwent rapid change as France conquered, politically transformed, then lost most of the continent. In the Vienna Congress, 1814–1815, conservative powers set up a post-Napoleonic international order. They also developed the **Concert of Europe,** a system of diplomatic cooperation intended to suppress revolution and preserve the Vienna territorial settlement. It stabilized the international order until mid-century. The European states also kept peace among themselves through these decades, an unusually long season without military conflict.

The Concert faced great difficulty, however, in its effort to resist liberal and national revolt. Both politically threatening reform movements and revolutionary upheavals came with exceptional frequency between 1815 and 1848. The most widespread and severe attacks by liberal and national militants broke across the continent in 1830 and 1848. The revolts in 1848 especially endangered the conservative state system. Russian and British fears that liberal nationalist uprisings in Germany and Italy in that year might change the continental state structure in ways that would destroy the European balance of power led these two countries to work closely together to control and eventually reverse the effects of these rebellions. The British and Russians had taken on most of the international stabilizing task of the Concert of Europe and had felt threatened by developments within the other Concert powers: Prussia, Austria, and France.

After the 1848 revolts, European leaders showed much less patience for diplomacy and a greater willingness to resort to force in conflicts with other states. This changed attitude helped to ensure that the Concert of Europe would collapse soon after mid-century. The first dramatic sign of a disintegration of the conservative coalition came in the region now known as the Middle East but then called the Near East.

### The European States at Odds in the Near East

In the decades after Napoleon's defeat in 1815, there was a potential for a clash among European states over policies and actions related to the **Near East,** the region between the Caspian and Mediterranean Seas. Nothing serious came of these international tensions, however, until the 1850s.

### European Near Eastern Interests

France and Britain saw the Near East as a vital link to parts of the world where they had imperial or trading interests. The tsars had expanded in that direction for years and longed eventually for a standing there that would give Russia secure water routes from the Black Sea into the Mediterranean.

The Ottoman Turkish Empire stretched across this region on the southeastern borders of Europe. This Muslim state contained large groups of Orthodox Christians and Catholics. Russia claimed protective rights over the Orthodox populations there as the French did for Catholics. Because Turkey was in decline and thus more and more vulnerable to encroachment from the outside, the chance that the competing interests of the Europeans might lead to conflict gradually increased. If the Turkish power vacuum permitted a strengthened Near Eastern presence by either Russia or the Western powers, the side that moved in first might tempt the other to attack it.

## The Crimean War (1854–1855)

The incidents that led directly to the first European war in nearly forty years began in the Turkish Empire in 1850. A conflict erupted between Orthodox and Catholic Christians in the Turkish realm over access to sacred sites in the Holy Lands, a region that also belonged to the Ottomans. France proclaimed its intention to support the Catholics there, and Russia responded in kind for the Orthodox Christians. Turkey and Russia began a lengthy struggle over this issue that finally led to war between them in October 1853.

In Britain, public hostility toward autocratic Russia and sympathy for presumably "liberal" Turkey rose quickly. This mood, perhaps more than strategic interests in the region, led the British government the following March to announce support for Turkey and to declare war on Russia. The French, with their Catholic connection to the crisis and concern about falling into Britain's shadow in the Near East, joined the fight against the Russians.

Once the British and French entered the war, a few small-scale naval actions occurred as they made coastal attacks on Russia. Heavy and protracted battle then followed on the Crimean Peninsula in the Black Sea. Russian defensive preparations and strategies at the Crimean port of Sevastopol held against the combined assault forces for nearly a year.

By the time the Russians abandoned the city in September 1855, their cause was lost. All the combatants suffered heavy casualties: one hundred and sixty-five thousand of the six hundred thousand fielded by the powers against the Russians died, and Russia lost four hundred and fifty thousand of the eight hundred and eighty-eight thousand people mobilized. Disease took about eighty percent of the lives, despite the medical care efforts that brought fame to one nurse, Florence Nightingale. Both the conduct of the Crimean campaign and this deadly outcome indicated serious organizational and military failures by all the countries that fought. The war also made the backwardness of Russia's economic, political, and military institutions especially evident.

### The Treaty of Paris

Tsar Nicholas I of Russia had died in March 1855, as the battles raged at Sevastopol. To his successor, Alexander II, the condition of his country was obvious. The new tsar wanted peace at once. The treaty negotiated at Paris during February and March 1856 ended Russian control of important territories on the

Danube River and denied Russia the right to have Black Sea naval forces or fortifications. The defeat was complete, and the Concert of Europe was dead.

## From Internationalist Concert to Nationalist Confrontation

Russia's determination to continue its drive for strategic gains in the Black Sea region and the quest of both Prussia and Imperial France for greater power in continental affairs made the Concert of Europe impossible to maintain after the Crimean War. These three countries would no longer join with Austria and Britain in efforts to keep the balance of power as they had since the Congress of Vienna. The wars and deceitful diplomacy associated with the struggle toward the unification of Italy and Germany during the 1860s intensified the mutual suspicions and conflicting interests among European states still more. The completion of Italian and German unification in 1870 and 1871 and the resultant drastic revision of the political map of Europe meant that in this distrustful atmosphere, countries had to find a new approach to international relations. The pursuit of this goal in an age of militant nationalism and *Realpolitik* led to a struggle for power that, over the next several decades, made Europe into a camp of highly armed and hostile states ready for confrontation, ready for war.

## ■ THE NEW IMPERIALISM

The international environment after the collapse of the Concert system caused national leaders to become especially concerned about having secure supplies of the materials needed to build and maintain economic and military strength. Each European state also wanted to ensure its potential to field a larger army and conduct more successful naval operations than any rival, and thus project its power abroad.

For many Europeans, a global empire seemed an effective way to help meet these strategic needs. They thought that from new colonies their countries could take vital raw materials, men to swell the ranks of their armies, and sites on which to build military bases. Such beliefs helped to drive the Europeans into a new era of vigorous empire-building.

## The Rebirth of the European Imperial Spirit

European encroachments on the outside world launched in the Early Modern era never completely stopped, but aggression against other societies waned for about a century before the 1870s. A renewed, more forceful, and more successful imperial attack surged out of Europe in the latter 1800s. In addition to the national power and security interests that heightened European aggressiveness toward the larger world at that time, several trends converged to raise this fever for global conquest.

### *The Profit Motive for Empire*

Britain, Belgium, the Netherlands, Germany, and France had well-developed industrial systems by the 1870s, and economic modernization had begun in other European states. Many businesspeople somewhat unreasonably feared that natural resources and markets for products might soon become insufficient to sustain economic growth as Europe became mostly industrialized. The belief that their nations must acquire territories that contained both essential raw materials and captive customers for factory products led some industrialists to campaign for imperial conquests.

Large investment firms increasingly controlled European industrial enterprises and economic development during these years. As the modern economic system began to mature, financiers and individual investors had a strengthening desire for profitable ventures that Europe seemed too small to satisfy. There was a world of financial opportunity abroad.

### The Nationalist Passion for Colonies

Government leaders, such as Bismarck, sometimes at first opposed this imperialist urge from business and other quarters, and then yielded. The susceptibility of government officials to these demands resulted in part from the need of the now maturing nation-state system to win and sustain the support of the business community and other segments of the middle class that shared their outlook. Without the favor of these richest, most educated, and most politically active social forces, even the authoritarian nations would suffer reduced strength. The democratic states had to follow the will of such influential pressure groups even more energetically.

Nor were all governments resistant. The new nationalism of this era burned in the hearts of political leaders even as it inflamed the souls of businesspeople, intellectuals, religious leaders, and many other citizens. Convinced of the superiority of their national cultures and the states that embodied them, enthralled leaders and masses stood ready to join in a common imperial adventure and prove their greatness by conquering and colonizing foreign lands.

### The Desire to Subdue Presumed Inferiors

Social Darwinism and racism exerted a powerful influence on Europeans by the latter 1800s and fed their passion for empire. Distortions of Darwin's theories encouraged the commitment to a global struggle among nations to prove their superiority—the "fittest" state would triumph over the inferior people it went out to conquer and would surpass its European rivals in imperial competition. Social Darwinism and other intellectual currents of the era also fostered racism, the belief that certain races are innately superior. Certain of the supremacy of their white race (or German or British race, as some thought), European racists proclaimed it their duty to send the best of their breed to subdue "lower" humans abroad.

Other Europeans, who did not exhibit such overt Social Darwinist or racist attitudes, simply became convinced that their civilization surpassed all others materially, morally, and spiritually, an achievement that obligated them to "uplift" backward people elsewhere. That is, they supported the extension of European power in order to take to these unfortunates the comforts, humane values, and faith of superior civilization. Imperialist impulses of this kind persisted even when the intended recipients of the new ways resisted and had to be forcefully conquered and sometimes brutally suppressed.

## The Completion of Europe's Global Conquest

When the European imperialist wave rose in the 1800s, it struck with greatest force in the regions where Europeans previously had made their power only slightly felt—Asia, the islands of the Pacific, and Africa.

### The British in India

Portugal led the early modern imperial attack on India, but British private-enterprise interests, organized as the **East India Company,** moved in and dominated the continent by the late 1700s. Company

control depended on the loyalty of native troops (**sepoys**) who policed the Indian territories exploited by the British. In the Great Rebellion of 1857–1858 (known to the British as the **Sepoy Mutiny**), these native armies joined in an attempt to overthrow the colonial company. Superior imperial forces subdued the rebels and brutally punished them. (Depictions by contemporary artists show captives tied to cannon barrels to be shot.) Thereafter, the British government ended the reign of the company and took direct control of the colonies in India.

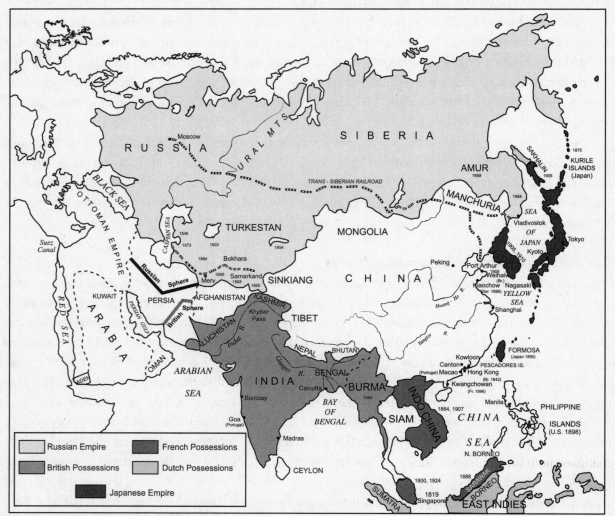

*Figure 9.1: Imperialism in Asia to 1914*

During the late 1800s and early 1900s, a few thousand British administrators and about half a million native civil servants erected a colonial bureaucracy that governed about two-thirds of the huge subcontinent and indirectly influenced public affairs in the rest of India. A subjugated population of 200 to 300 million both benefited and suffered from policies over which they had no control.

British rule, for example, accelerated the development of modern governmental, economic, and medical practices. These changes soon improved the health and enhanced the civil security of small numbers of people. Imperial authorities also attempted to end certain traditional practices, such as **suttee,** the

burning of living wives along with the bodies of husbands who predeceased them. Potential victims of *suttee* might have appreciated this alteration of custom, but assaults on tradition generally provoked a negative reaction. British racism and exploitative economic practices probably incensed Indians even more. The resultant sense of oppression inspired an Indian nationalist movement by the latter 1800s, and it soon gained massive support.

### Russian and French Annexations in Asia

A Russian Orthodox Christian chaplain, with cross raised high, rushed into Tashkent in the vanguard of warriors who conquered the city in June 1865. They had captured this Muslim center for Tsar Alexander II, his first city in a large Central Asian region known then as Western Turkistan. Within a decade, the Russian Empire absorbed this entire Muslim Turkic territory.

By 1875, Russia also had obtained additional holdings east of Central Asia. Under simultaneous pressure from Britain, France, and Russia, China signed treaties in 1858 and 1860 that surrendered territory to the tsar. Russia then ceded a chain of small Pacific islands to Japan in return for the southern half of Sakhalin, a large island near the southeastern Russian coast. Imperial expansion under Alexander II climaxed a long history of conflict between the Russians and the Turkic and Asian peoples of this region. The imperial invaders had loudly proclaimed their religious motives, but they probably cared mostly about profits and border security. Regardless of the Russians' intentions, life in the region had changed very little by 1914.

As Alexander II expanded his empire into North Asia, Napoleon III secured a new colonial realm for France in the south. A show of force by his navy at Saigon, a coastal city on the peninsula of Indochina, signaled the beginning of a French imperial campaign in that region in 1859. The Emperor's forces ruled all of Indochina ten years later. Imperial agents of the Second Empire and the Third Republic made a more concerted effort to convert native Asians to the European way of life than did the Russians or British. The French, however, treated the Indochinese as conquered and inferior people.

Anti-colonial nationalist movements soon emerged in Indochina, as they had in India, and fought the European invaders until the French withdrawal in 1954. The United States had supported France in its effort to stay in Indochina, and in the latter 1950s, took charge of a drive to defeat Marxist nationalists whom they viewed as part of a world Communist threat. The war that ensued in Vietnam on the east coast of Indochina continued until the last United States forces left in 1975, ending a century of Western power there.

### China's Loss of Sovereignty and the Rising Power of Japan

Business activities conducted by the British East India Company in the early 1800s included taking opium into China to sell. The rulers of China tried to stop this trade, and the British countered with military force, a war to perpetuate drug sales. Britain won these **Opium Wars** (1839–1842) and wrung a partial surrender of sovereignty from China. The victors extorted the extraterritorial rights to continue their opium business, set tariffs on British goods sold in China, and apply British rather than Chinese law to British citizens in China.

Subsequently, France, Russia, and the United States further humbled China by taking the same tariff privileges and legal rights for their citizens. The Japanese probably would have suffered a similar reduction of sovereignty if they had not "westernized" their economic and military institutions sufficiently to

fend off the Europeans and Americans. Japan's advance in power even enabled this Asian nation to begin its own empire-building in the region and to defeat a European giant in the Russo-Japanese War (1904–1905).

## The Colonization of Africa

In 1800, a little over three hundred years after the Portuguese and Spanish first began taking small coastal colonies in Africa, Europeans still held very little of the continent and knew almost nothing about its physical or social geography. They gradually increased the tempo of their learning and conquests during the next seventy years, and then joined a competitive rush to take the entire continent.

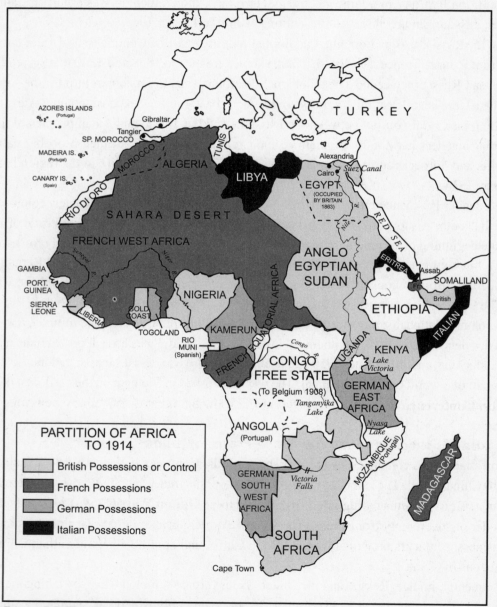

*Figure 9.2: The Partition of Africa to 1914*

## Onset of the New Imperialism in Africa

Dutch imperialists in the Early Modern period secured a large colony, the **Cape of Good Hope,** on the southern tip of Africa. In 1806, the British acquired Cape Town, a port in this region, and began to expand inland. Dutch settlers (**Boers**) chafed under the control of the new imperialists, especially after the British decreed an end to slavery in 1834. Boers migrated inland to escape the British (the Great Trek of 1835–1837); there they organized two republics. Conflicts persisted between the old and new European intruders. Superior British force eventually settled these differences in the brutal **Boer War** (1899–1902).

A French invasion that began on the coast of North Africa in Algeria in 1830 brought an even more hostile reaction than Britain faced in the south at this time. Thirty years of difficult struggle with the Algerian Muslims followed before France gained a sure hold on the region's coastal fringe. Napoleon III's Suez Canal project, completed in 1869, indicated the broader African imperial interests of the French. Britain, however, immediately challenged the movement of France into the northwest corner of the continent and even took control of the Canal (1872). Franco-British rivalry intensified dangerously in the area thereafter.

As British and French forces pressed into North and South Africa, Belgian King Leopold II (reigned 1865–1909) plunged in to take the heart of the continent as his personal possession. Dr. David Livingstone, a British medical doctor and missionary, had entered Central Africa in 1841. As a device to entice readers, the New York *Herald* sent H. M. Stanley to search for Dr. Livingstone, a task he completed in 1871. Stanley then began to promote ventures in the Congo River territories he had explored. By 1876, Stanley had convinced Leopold to take a large area south of the Congo and develop rubber plantations as a private business activity. France at once charged in to claim territory north of the river. A massive imperial assault had begun.

## The Fall of Africa

Leopold's new Central African realm was a personal colony, not a Belgian possession. It contained lands also claimed by France, Britain, Portugal, and Germany. European leaders decided to hold a conference to resolve these differences and regulate the colonization of sub-Saharan Africa.

**The Berlin Conference of 1884.** In their discussions at Berlin, the participants agreed that Leopold's African colony belonged to him personally and would not be controlled by Belgium or any other state. The diplomats also defined mutually acceptable perimeters for Leopold's personal colony. The conferees declared that in the future, imperialists could claim only the areas that they actually occupied.

**The Belgian Congo.** After the Berlin Conference, Leopold continued as before to operate his rubber plantations with barbaric forced-labor methods. Reports on conditions in his **Congo Free State** filtered out over the years and led to an international investigation. The continuing critical attention of the world community to the king's project finally led his government to take charge of the colony in 1908. It became known as the **Belgian Congo.**

**The Final Conquests in South Africa.** The frantic land-grab that precipitated the Berlin Conference continued after its adjournment. The British colonized northward from the Cape until they encountered territories taken by the Germans, Portuguese, and Belgians.

**The British and French Triumph over North Africa.** North of the band formed by German East Africa, the Belgian Congo, and Portuguese Angola, Britain took two more colonies (Kenya and Uganda) and forced Egypt and the Sudan into subordination as protectorates. Most of East Africa thus belonged to the British. France brought almost all of the western two-thirds of the continent into its empire and would have continued eastward to the Red Sea if not blocked by Britain.

**The Lesser Powers in the North.** Spain, Germany, and Italy held relatively small territories in North Africa. The Italians had possessed nothing at all until 1911, when they conquered Tripoli (which they renamed **Libya**). After the fall of Tripoli, only Ethiopia in East Africa and Liberia on the west coast remained independent. The Ethiopians remained free after defeating Italian invaders in 1896. The imperialists left Liberia, a state established for freed slaves from the United States, untouched. The Europeans had conquered most of the world by 1914. Then they began to conquer themselves.

## ■ THE GREAT WAR

In the late 1800s and early 1900s, Europeans glorified violent struggle and believed it to be right for "superior" nations to dominate inferior peoples. These attitudes encouraged the new imperialism, and empire-building strengthened such beliefs still more. Most of the societies in which this mood prevailed had well-developed industrial economies that greatly increased their potential for destructive combat, as their imperial assault on the world proved. These circumstances alone made the early 1900s very dangerous times.

### The Origins of the War

The conditions that increased the probability of military conflict did not make a multinational European war inevitable. Such a large-scale struggle came about, however, especially as a result of intense nationalism and the influence of two rival alliance systems.

#### *Nationalism and the Austro-Russian Conflict*

Militant nationalism affected circumstances in Southeast Europe in a particularly dangerous way. Germanic Hapsburgs had created the Austro-Hungarian Dual Monarchy in 1867 to placate Magyar nationalists. Austrian leaders believed, however, that similar concessions to any of the numerous other nationalities within the empire would foment independence movements and shatter the Hapsburg state. South Slavs under Austrian power posed the gravest threat, because Serbia stood on the southern border of the empire as a model of the Slavic nation-state they wanted to form.

Russian support for the national ambitions of the Slav minority in Austria magnified the threat beyond calculation. The tsarist empire created an especially explosive problem simply by standing as a great power behind the South Slav nationalist movement. Russia further elevated the risk to Austria by the evident

motive for this pro-Slav policy. Romanov officials not only expected to free the ethnically related South Slavs from Hapsburg control but also dominate the Balkan Slavs and thereby gain supremacy in the region south of Austria. Such an outcome would be a doubly severe blow to the Hapsburgs.

Fervent nationalism had a critical influence on the Austro-Russian conflict in the Balkans, and this clash brought war between these powers in 1914. The extremely militant nationalist spirit that had captivated the Germans, French, British, and Italians since 1848 ensured that the war would not remain a small East European affair.

### Defensive Alliances as an Incitement to War

The combination of Russian might and South Slav nationalism posed a threat that the Hapsburgs alone could not counter. But Austria had a powerful ally in Germany. When the German Empire emerged in 1871, it was at once the strongest nation on the European continent. Because Imperial Chancellor Bismarck had achieved the place for Germany that he wanted, he set out to protect the nation's interests by setting up an intricate system of alliances designed to guard against France, in particular.

**The League of Three Emperors.** While he was in power, Bismarck managed to keep both Austria and Russia tied to Germany, thus denying France a strong ally on the continent. He achieved this result through most of the 1870s by organizing the **League of Three Emperors,** a loose association of Germany, Austria, and Russia. Conflicts between the Romanov and Hapsburg Empires caused Russia to bolt from the League in 1878, but Bismarck found another way to prevent a Franco-Russian association.

**The Dual Alliance.** German interests required, above all, the maintenance of ties to Austria. Bismarck, therefore, arranged a secret **Dual Alliance** with the Hapsburg Empire in 1879. The two powers pledged to fight together against Russia if that country attacked either Germany or Austria.

**The Triple Alliance.** In 1882, Italy joined the Austro-German diplomatic structure, creating the **Triple Alliance.** The secrecy of these agreements and skillful diplomatic maneuvers enabled Bismarck to keep Germany and Russia on very friendly terms throughout the 1880s, even though the Alliance designated the Russians as potential enemies. The security system changed quickly and dangerously, however, after Bismarck's retirement in 1890.

**A Franco-Russian Alliance.** Bismarck's successor, Leo von Caprivi, had no interest in continuing friendly relations between Germany and Russia. He allowed the understandings with the Russians to lapse, and in 1894, the tsarist government formed an alliance with France. From the 1890s onward, Germany used the Dual Alliance to promote aggressive Austrian moves rather than to restrain them. As a result, Austria's treatment of Russia became more reckless.

**The Triple Entente.** The evolving power structure on the continent posed serious problems for Britain. Imperial rivalries had kept the British in conflict with the Russians and French, but Germany's rapidly growing military power and its great advances in international trade eventually concerned Britain above all else. In 1904, therefore, the French and British arranged the **Entente Cordiale,** a mutual defense

understanding but not technically an alliance. These two nations formed similar ties to Russia in 1907 and, thus, created the **Triple Entente.** The great powers of Europe were now divided into two alliances. This diplomatic structure almost guaranteed that if any nation plunged into the abyss of war, all the rest would follow.

### A Season of Crises—the Immediate Causes of War

A series of rapidly developing international crises encouraged the formation of the alliances designed to yield greater security for the member states. As clashes continued, they affected the relationships within and interactions between the rival groups—the alliances tightened and the two sides became more belligerent.

**The Moroccan Crises.** France's African empire included most of Morocco on the northwest coast. Emperor William II of Germany traveled to Tangier, Morocco, in 1905 and pronounced his commitment to Moroccan independence from France. He intended to demonstrate that in such a confrontation, the French could not count on support from Britain, their partner in the new Entente. An international conference in Algeciras, Spain, in 1906 proved the contrary to be true. Britain not only fully supported France's right to control Morocco but also began to plan ways to cooperate militarily if war with Germany erupted. A similar Franco-German clash over Morocco in 1911 further strengthened the Entente's military relationship and increased its hostility toward the Triple Alliance.

**The Balkan Powder Keg.** The international conflicts that precipitated the Great War in 1914 occurred on the Balkan Peninsula in Southeast Europe. The region thus earned its description as the **Balkan Powder Keg.** The components in this "bomb" included the struggle of small states (Greece, Serbia, Bulgaria, and Montenegro) to expand their power or territory at the expense of one another, Austria, or Turkey; the Ottoman Turks' fight to keep as much of the Balkans as possible; Russia's attempts to increase its influence in the region; and Austria's battle to preserve itself against the threats of Russian and nationalist forces in the Balkans.

**The Bosnian Crisis.** The first Balkan crisis began with Austria's abrupt annexation of Bosnia-Herzegovina in 1908, a move intended to block Turkish or Serbian ambitions in the area. Serbia could do nothing because Russia, weakened by a recent war with Japan and the Revolution of 1905, offered no assistance. German forces, however, stood ready to fight for Austria if necessary, and the Hapsburg venture succeeded. This outcome made Austria even less cautious and the Hapsburg Empire's enemies more hostile.

**The Balkan Wars.** After four years of relative quiet in Southeast Europe, two Balkan wars flared up in quick succession. The first came in 1912 as Serbia, Greece, Bulgaria, and Montenegro combined forces to win lands from Turkey. Within a month after fighting stopped, strife over the division of spoils brought war between Bulgaria and its allies. Bulgaria lost. Austrian threats, however, kept the Serbs from benefiting from this victory as they wanted. Serbia viewed this outcome as another affront, and the Balkans became still more explosive.

### *Militarism and the Advance toward War*

During the decades before the battles began in 1914, Europeans adored the idea of military power as never before in their history. This enchantment derived in part from the emotional pleasure of watching military display and knowing that massive forces supported the country's interests. Experience also suggested practical reasons for this devotion to military power. Wars since the end of the Crimean conflict had seemed quick and decisive affairs that brought desired results at a relatively low cost in funds and lives.

Confidence in the great value of military power led European states to enter an arms race that produced the largest and most lethal forces ever. The size and industrial-age equipment of these armies necessitated careful planning for their mobilization; alliance commitments added other complexities to strategic designs. German leaders, for example, had to prepare for a two-front war. They assumed the necessity of defeating a fast-moving France first, and then turning all their forces against Russia.

These circumstances resulted in the planning of intricate and rigid strategies and mobilization procedures that would be difficult to alter once started. Even if the purpose of this martial competition was primarily defensive, this combination of circumstances intensified national fears and hatreds, and also magnified every crisis. Europe had massive forces ready for a great war by 1914 and stood ready to march.

## The Conflagration (1914–1918)

The Balkan crisis that led to the First World War began on June 28, 1914. On that day, in Sarajevo, Bosnia, an assassin killed Archduke Franz Ferdinand, heir to the Austrian throne. Austria blamed Serbian-inspired Slav nationalists for this terrorist act and made demands on Serbia designed to provide an excuse for war. The Hapsburg government had decided to smash the Slav threat forever, and Germany once more promised to back its Austrian ally. Russia could not fail its South Slav associates again and assured support to Serbia. Exactly one month later, the Great War began in a chain reaction of mobilizations.

Austria's declaration of war on Serbia on July 28, 1914, prompted Russia to order the movement of its armies toward the borders of Austria and Germany on July 29. Two days later, Germany demanded that France announce its intentions and sent a sharp warning that Russia must stop mobilization. Because the tsarist government ignored this message, Germany declared war on Russia on August 1.

On the same day that Germany and Russia went to war, French forces began to mobilize. Germany launched its strike through Belgium toward France two days later. The British proclaimed that an 1829 treaty required them to defend neutral Belgium and entered the war against Germany on August 4. The war plans of all these combatants assumed swift victories and thus a short war. The projections proved tragically wrong.

### *The Wartime Alliances*

When the Triple Alliance and Entente powers unleashed war, Italy at first remained neutral. Germany and Austria found other allies, however. Turkey joined them in November 1914. Then Bulgaria allied with Germany and Austria the following year. These four **Central Powers,** grouped together in mid-continent, had the strategic advantage of relative ease in coordinating military operations. A more significant disadvantage was the draining effect of a two-front war.

On the Western Front, where the outcome of the war was decided, Germany faced three of the **Allied Powers**—France, Britain, and, after May 1915, Italy. The United States became an **Associated Power** on the Allied side in 1917. Other Allied and Associated Powers by 1917 included Romania, Greece, Portugal, and many Latin American states. On the Eastern Front, Russia bore the brunt of the fighting for the Allies against the Central Powers.

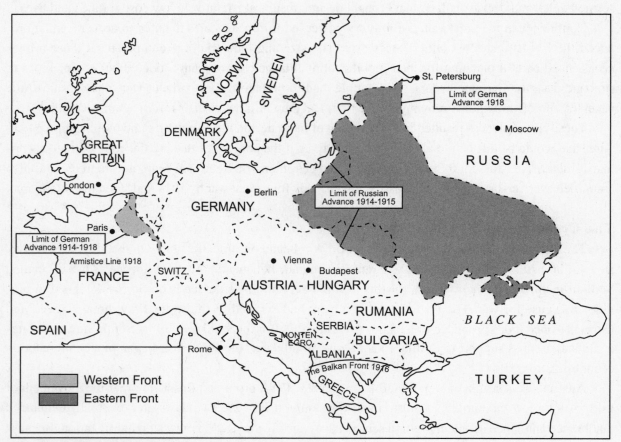

*Figure 9.3: World War I; the Western Front, 1914–1918*

### The Western Front

Within a few weeks after the invasion of France, the failure of the German offensive on the Western Front became apparent. The French army stopped the Germans, and then drove them into retreat in the Battle of the Marne in September 1914. The Germans then halted and took up defensive positions against the Allied forces of France and Britain. A long grinding stalemate with little movement and much slaughter had begun.

The opposing armies dug a series of trenches that stretched for about five hundred miles through eastern France. They faced each other across a no-man's-land of shell-churned soil, over which lay coils of heavy barbed wire. Machine guns, called the **queens of the trenches,** were positioned to cover the lines with cross fire that made assaults extremely deadly. Heavy-artillery barrages, the weather, and rats made the ditches a virtual hell on earth. (Survivors still offered such descriptions in interviews in the 1970s.) New military technology such as poison gas, tanks, and airplanes compounded the horrors of trench warfare.

**The Battle of Verdun.** Two of the most important battles on the Western Front illustrate the nature and consequences of combat under these conditions. After vicious and costly fighting throughout 1915 with virtually no movement of battle lines, the German command decided in 1916 on an attack at Verdun designed more to kill French troops than to break through. Almost a year of assaults bled France as intended, taking nearly three hundred and fifty thousand lives. But the Germans bled themselves, too. They lost almost the same number.

**The Battle of the Somme.** As the battle raged at Verdun, Britain launched an offensive on the Somme River in northern France on July 1, 1916. Seventy thousand British soldiers died before the first one reached German lines. A Canadian battalion lost ninety percent of its eight hundred men on its first day in combat. The Allies never advanced more than seven miles, won nothing of importance, and lost over six hundred thousand lives in the six-month Somme campaign. Germany lost almost seven hundred thousand. The terrain where these soldiers fought is still disfigured from the explosive force of this battle.

### The Eastern Front

A more mobile war raged on the Eastern Front. During the first year, however, results differed little from those in the west—heavy losses and no clear victor emerging in the struggle between Russian and Austro-German forces. By 1916, the tide seemed to turn in favor of the Germans (who carried the brunt of the Triple Alliance effort). As the Russian economy, and then its sociopolitical order, began to collapse in 1917, it appeared that Germany soon might be free to move all its troops to the Western Front.

### The Sea War

Britain ruled the surface of the seas almost from the beginning of the war and used this control to blockade the Central Powers. Eventually, shortages of raw materials and food seriously hampered the German war effort and caused real hunger. German submarines dominated beneath the seas and had the potential to blockade Britain but only by unrestricted war on all ships, including the vessels of neutrals such as the United States. Germany had long hesitated to allow its submarines to conduct this kind of war, because attacks on the ships of noncombatant nations almost certainly would cause the Americans to declare war on the Central Powers. But as prospects for victory for Germany improved in 1916–1917 and the effects of war began to exhaust the German people, unrestricted submarine warfare began.

### The Entry of the United States

The United States declared war on the Central Powers in April 1917, and the conflict became "a moral crusade," reflecting President Woodrow Wilson's attitudes toward this military campaign. Wilson depicted the war as a struggle for democracy, "freedom of the seas," national self-determination, and a world governed by honest and open diplomacy under the guidance of a **League of Nations.** He summed up such ideals in his **Fourteen Points,** and promised that this conflict would be a "war to end all wars" and "make the world safe for democracy."

### Russian Defeat on the Eastern Front

A revolution in Russia in March 1917 replaced the autocracy with a government that seemed headed toward parliamentary democracy. The new leaders, however, had little popular support and no

other foundations for power. They erred also in staying in a war no longer tolerable to most Russians. Thus a second upheaval came in November 1917 and brought to power a communist government committed to withdrawal from the war. Russia surrendered in early 1918.

### Allied Victory and the Armistice

Even with no war on the Eastern Front, Germany could not win against the combined forces of the western Allied Powers. A German offensive in the spring and summer of 1918 stopped fifty miles from Paris, and then an Allied counterattack began. This offensive led to victory by autumn. On November 11, 1918, Germany signed the armistice that ended the war.

## The Peace of Paris and the Aftermath of War

President Wilson went to Paris to join in the peace negotiations as head of his nation's delegation. Wilson took this unprecedented step for a president of the United States because he intended to ensure that his peace goals would be embodied in the treaties. French Premier Georges Clemenceau, however, represented a nation determined to punish the defeated Germans. Wilson's idealistic plans stood in the way of such a punitive treaty. British Prime Minister David Lloyd George came to Paris with intentions more compatible with Clemenceau's than with Wilson's.

### The Treaty of Versailles

The Peace of Paris that emerged resulted in five documents, beginning with the most important, the **Treaty of Versailles** with Germany, signed June 28, 1919. This settlement, and those with the other Central Powers, embodied many elements that Wilson believed necessary. But the attitudes of the French and British, as well as other problems, prevented the full realization of Wilson's goals. The intermingling of national groups across East Europe, for example, prevented consistent application of his idea of national self-determination.

The extent to which Wilson succeeded can be measured in part by a review of the main provisions of the Treaty of Versailles. Wilson wanted a peace with as little punishment in it as possible; that vindictive spirit was reduced by his efforts but not removed. The treaty arranged for the victors to occupy the industrially and strategically valuable German Rhineland for fifteen years. Altogether, the settlement caused Germany to lose territory containing one-tenth of its people. In addition, the German military was to operate without a general staff and no more than one hundred thousand troops. Germany was barred from the new League of Nations, and imperial colonies had to be surrendered to victor and League control.

Versailles Treaty Article 231 dealt the Germans an especially severe blow. They had to accept a clause declaring German responsibility for all the war destruction. Germany also had to promise to pay **reparations** for this destruction. When the German delegation objected to these terms, the Allied Powers ordered them to accept. Embittered German nationalists soon began to attack this humiliating, "dictated" treaty. They also denounced their government for accepting it. Whatever Wilson's intentions, the Germans certainly felt punished.

### The Treaties with Germany's Allies

By the time the diplomats finished their work, nationalist forces had succeeded in shattering the Hapsburg Empire. The Allied Powers required Austria, now one-fourth its former size, to sign the Treaty

of St. Germain and the new state of Hungary to accept the Treaty of Trianon. These documents contained punishing and restrictive provisions similar to those in the Treaty of Versailles. Turkey and Bulgaria received the same treatment.

### The Immediate Consequences of the Great War

When the First World War ended, it had taken about ten million lives and cost almost $400 billion. Russian losses were especially great. In fact, the death, destruction, and expense suffered by the Romanov Empire made its survival impossible. The collapse of tsarist Russia then led to the emergence of Soviet Russia as the first communist state, while enabling Poland, Lithuania, Latvia, Estonia, and Finland—formerly within the Russian empire or under its control—to become independent countries.

The war shattered a second large state, the Austrian Empire. South Slav minorities thus were freed to merge, forming the new state of Yugoslavia. The Czech minority also broke from Austria and established a new nation, Czechoslovakia. An old dynastic state had disappeared from Central Europe. The region had assumed the nation-state structure that would endure until the 1990s.

*Modern governmental and economic systems provided late nineteenth-century Europeans extraordinary power. The mood of the times—elitist, racist, militarist, aggressively nationalist—helped to inspire the use of this strength in a new surge of imperialism, beginning in the 1870s. With exceptional swiftness, explorers, merchants, missionaries, imperial administrators, and conquering navies and armies lunged into the non-European world. By 1914, Britain held India; the British, French, Russians, and Americans controlled most of the rest of Asia; and Britain, France, Germany, Portugal, Belgium, Italy, and Spain had taken Africa.*

*The new imperialism brought limited economic, technological, and political modernization to the new colonies. The subjected peoples in these conquered lands perhaps realized certain improvements in their lives. For the most part, however, European imperialism again proved to be brutal and exploitative. The inability of the Europeans to establish and maintain these empires without force and violence indicated that many colonists did not think that life improved after foreigners took their land.*

*The imperialist nations exhibited intensified hostility toward one another as they competed to take over the world. Yet they fought relatively little in their colonial realms; in fact, they usually succeeded in ending contention diplomatically, as in the Berlin Conference in 1884. In contrast, the resolution of their conflicts in Europe proved exceedingly difficult to achieve by negotiation. The most intractable problems developed in Southeast Europe in the Balkan Peninsula. There, Serbia struggled to take in all territory inhabited by South Slavs, an action that threatened to fragment the Austrian Empire. Austria's determined fight against Serbia and Russia's support for Slavic national independence made the Balkan powder keg truly explosive.*

*A blowup involving Austria and Serbia might have remained a local conflict. Even a war that drew in the Russians could have occurred with little effect on the rest of Europe. Instead, in 1914, a crisis in the Balkans ignited a conflagration that engulfed all the great powers. This larger war came as a result of the virulent nationalism that inflamed all Europeans, the existence of two rival alliances that connected most nations to the conflicting Southeast European states, and the widespread confidence in military solutions to international differences.*

*In the First World War, the Central Powers (Germany, Austria, Turkey, Bulgaria) and the Allied Powers (France, Russia, Britain, Italy, and later the United States) fought tenaciously for four years.*

*Battle lines moved little and losses in lives and resources were exceptionally high. These sacrifices broke Russia first. In the throes of a revolution, this nation surrendered to Germany in early 1918. But with enemies on two fronts for most of the war and with coasts blockaded by the British navy, the Central Powers eventually could not sustain a campaign so costly in human and material resources.*

*The victorious Allies convened in Paris after the armistice in November 1918 to decide treaty terms that they would force the Central Powers to accept. European Allied leaders wanted reparations and revenge included among the rewards of victory. American President Woodrow Wilson hoped that his idealistic Fourteen Points would shape the settlement and ensure against another world war.*

*The Peace of Paris completed in 1919 did reflect Wilson's influence, especially in the provisions for a League of Nations. Yet vindictiveness was much more evident than such idealism, especially in clauses blaming the Central Powers for the war and charging them for its costs. These treaties and the larger consequences of the war drastically affected events in Europe for the next seventy years. That the Great War was a watershed in Europe's history became most immediately evident in Russia, where a new Communist state rose in the social and political rubble left by the Great War.*

## Selected Readings

Ashworth, Tony. *Trench Warfare, 1914–1918: The Live and Let Live System.* New York: Holmes and Meier, 1980.

Fay, Sidney B. *The Origins of the First World War,* 2nd Edition. New York: Free Press, 1966.

Frantzen, Allen J. *Bloody Good: Chivalry, Sacrifice, and the Great War.* Chicago: The University of Chicago Press, 2004.

Fromkin, David. *Europe's Last Summer: Who Started the Great War in 1914?* New York: Knopf, 2004.

Halsall, Paul, ed. *Internet Modern History Sourcebook: The End of European Hegemony—World War I.* (Access this source at *www.fordham.edu/halsall/mod/modsbook4.html#World%20War%20I.*)

   *Internet Modern History Sourcebook: Responses to Economic Growth—Imperialism* (The URL for this site is *www.fordham.edu/halsall/mod/modsbook3.html#imperialism.*)

Hoehling, Adolph A. *The Great War at Sea: A History of Naval Action, 1914–1918.* New York: Crowell, 1965.

Joll, James. *The Origins of the First World War.* New York: Longman, 1984.

Lafore, Lawrence D. *The Long Fuse: An Interpretation of the Origins of World War I.* 2nd Edition. New York: Lippincott, 1971.

Leed, Eric J. *No Man's Land: Combat and Identity in World War I.* New York: Cambridge University Press, 1979.

Porter, Bernard. *The Lion's Share: A Short History of British Imperialism, 1850–1893.* New York: Longman, 1984.

Robinson, Ronald E., John Gallagher and Alice Denny. *Africa and the Victorians: The Official Mind of Imperialism.* New York: St. Martin's Press, 1961.

Schmidt, Bernadotte E. and Harold C. Vedeler. *The World in the Crucible, 1914–1918.* New York: Harper & Row, 1984.

## Test Yourself

1) Western Front combat during most of the Great War could best be described as
   a) a deadly stalemate
   b) a series of highly mobile and heroic campaigns
   c) a contest between sharp shooting riflemen
   d) a struggle between armies of tanks

2) He promised that the Great War would be a "war to end all wars."
   a) British Prime Minister David Lloyd George
   b) French Premier Clemenceau
   c) Russian Tsar Nicholas II
   d) United States President Wilson

3) A part of the world mostly unexplored by Europeans in 1870 and almost all within their empires by 1914 was
   a) Central America
   b) South America
   c) China
   d) Africa

4) The text description of Western Front combat in the Great War suggests that when battles promise to be very destructive with little hope of territorial gain, those in charge will
   a) not attack an enemy
   b) launch attacks anyway
   c) not use new devices that make fighting more deadly
   d) make a swift negotiated peace the top priority

5) Which of these events could best be described as the spark that ignited the Great War?
   a) the assassination of Alexander II of Russia
   b) the dismissal of Otto von Bismarck
   c) the assassination of Franz Ferdinand of Austria
   d) Britain's decision to defend neutral Belgium against Germany

6) The collapse of the Concert of Europe was first clearly indicated by
   a) the Berlin Conference of 1885
   b) the Crimean War
   c) the Russian and British responses to the revolts of 1848
   d) Bismarck's reckless war-making after 1871

7) Circumstances that probably helped to encourage the onset of a new wave of very active European imperialism beginning in the latter 1800s resulted from
   a) a twenty-year decline in European industrial production
   b) the persistence of Asian and African piracy attacks on European commerce
   c) the break up of the Concert of Europe
   d) European determination to stop opium trafficking out of Asia and India into Western countries

8) Which of the following might have had an influence on Europe's movement toward the Great War?
   a) the Seven Weeks' War
   b) Bismarck's mistake in pushing Russia into an anti-German alliance with France
   c) German Emperor William II's tendency to keep European leaders from knowing his war-like attitudes
   d) Russia's consistent refusal to back Serbia in Austro-Serbian conflicts

## Test Yourself Answers

1) **a.** Tanks made their first appearance in the Great War, and millions of soldiers carried rifles, but tanks and snipers (the latter suggested by the wording of choice *c*) did not greatly influence the overall character of combat on the Western Front. A number of circumstances combined to make it for years a very deadly stalemate, or, as it is usually called, a war of attrition that took lives proportionately on all sides.

2) **d.** President Wilson differed markedly from other war leaders in his idealistic perception of the purposes and possible outcomes of the conflict. This question calls for recollection of this important aspect of the history of the First World War.

3) **d.** The rare historical phenomenon of the conquest of such a large part of the globe so quickly and the resultant division of Africa into imperial territories makes the point emphasized by this fact-oriented multiple-choice problem particularly significant.

4) **b.** This quiz item focuses on a widely recognized distinctive trait of the way political and military leaders conducted the First World War, a characteristic that made the great loss of life perhaps even more psychologically and sociologically damaging to the countries involved than if the sacrifices had not so often seemed in vain.

5) **c.** The dismissal of Bismarck perhaps influenced the coming of the war, because German policy makers after him fanned the flames of war in ways that he had avoided. The German attack through Belgium gave Britain justification for entering the war, and so could be cited as affecting the scale of the conflict (although the British would have entered soon whatever happened to Belgium). The wording of the introductory line, however, calls for the event that immediately provoked the change from European peace to the plunge into the First World War, and the assassination of the heir to the Austrian throne by a Serbian brought an Austro-Serbian war that quickly pulled all the leading European powers into battle.

6) **b.** The Russian and British reaction in 1848 probably extended the influence of the Concert system instead of revealing its demise. The Berlin conference provides an example of European international problem-solving after the end of Concert relationships, but does not clearly show its collapse as does the much earlier Crimean War when former Concert partners fought each other. Choice D is a false statement of circumstances.

7) **c.** None of the optional completions except the one that refers to the collapse of the Concert of Europe reflects the reality of the history of the period. When the states that had formed the Concert in 1815 stopped cooperating after mid-century, thus ending the influence of this system in promoting international harmony, the increasing sense of insecurity felt by European leaders helped to make empire-building seem necessary as a way to get the economic and military strength needed to discourage threats from rival powers.

8) **a.** The Seven Weeks' War between Prussia and Austria, along with other brief military conflicts, appeared to be very effective instruments for the achievement of Italian and German national unification. The text indicated that such wars encouraged the belief among Europeans that short and not overly costly war could advance state interests, an attitude that helped to set the course toward a long and unimaginably destructive war. The other possible completions are reversals of the actual aspects of history to which they refer. For example, Bismarck worked diligently to keep Russia tied diplomatically to Germany.

# Soviet Russia—the First Communist State (1917–1941)

---

**March 1917:** The Romanov autocracy falls to popular revolt.

**April 1917:** Lenin presents his April Theses to the Bolsheviks.

**November 1917:** The Bolshevik Revolution occurs.

**March 1918:** Russia surrenders to Germany at Brest-Litovsk.

**Mid-1918:** The Allies intervene in Russia, and civil war begins.

**July 1918:** The tsar and his family are executed.

**1920:** Communists win the Civil War.

**1921:** Lenin establishes his New Economic Policy (NEP).

**1924:** Lenin dies.

**1928:** Stalin begins his rule.

**1931:** A famine strikes Soviet Ukraine.

**1934:** Kirov's murder marks the onset of Stalin's purges.

**1936–1938:** Stalin carries out his Great Purge.

---

*The Russian Ancien Regime remained nearly intact throughout the Modern era. No other European state had such antiquated institutions. Severe stresses built up during the 1800s as this system became less and less adequate to meet the needs of Russian society. Reformers and rebels tried to change or destroy the tsarist structure, and by the latter 1800s, even the imperial government took up the cause of modernization. Industry progressed rapidly as a result, but sociopolitical institutions remained too archaic. Revolutionaries and the ruling regime continued their brutal fight.*

*The persistence of backward conditions in Russia in the early twentieth century and the bitter struggle of forces contending to save, reform, or destroy the old regime made the state extremely fragile. In this*

*weakened condition, the empire marched enthusiastically into the First World War in 1914. This great conflict killed masses of Russians, depleted national resources, and wrecked the economy. Under the strain of this crisis, the autocratic state collapsed in early 1917.*

*The leaders who first took charge after the overthrow of the tsarist system favored the construction of a parliamentary and capitalist state. Within months, a Bolshevik revolution swept this liberal regime from power. The victors then began to build the world's first Communist state.*

## ■ WAR AND THE RUSSIAN REVOLUTIONS OF 1917

The First World War opened in Russia, as elsewhere in Europe, to the joyous shouts of patriotic citizens of all classes. The cheering soon died, however.

### An Old Regime in a Modern War

Russian attitudes changed because the reality of the coming storm quickly confronted the country. Perhaps as many as thirty percent of the imperial army's soldiers met the stark truth of this opening moment of the war by going to the front without rifles, staying unarmed until they could take the weapons of fallen comrades. The toll in combat mounted to staggering proportions. Over fifteen million people had entered service by the end of the war. Nearly four million suffered nonlethal wounds, about two-and-a-half million were captured, and over one-and-a-half million died. No other state in the war had so many casualties.

### *A Suffering Society under an Incompetent Government*

The horrible spirit of the war visited civilians, too. The losses at the front were their losses. War damage reached into Russia in other ways as well. By 1917, the empire's industrial, agricultural, and transportation facilities were in desperate shape. Hunger and cold haunted many people, as food and fuel supplies dwindled to painfully low levels and living costs skyrocketed. To make matters still worse, bad government became disastrous government.

Nicholas II had shown little talent to rule since becoming emperor and, a year after the start of war, he took the opportunity to demonstrate his incompetence in military affairs. In August 1915, the tsar assumed direct control of the war effort. He departed from the capital to live nearer the front and left Empress Alexandra with the commission to "be his eyes and ears in the capital." Alexandra acted for Nicholas also, especially in the selection of incompetent people for several top government positions.

Gregory Rasputin, a peasant religious mystic with no competence to govern and a well-deserved reputation for corruption, promiscuity, and drunkenness, assisted Alexandra in the bad governing decisions she made. He had won almost unqualified trust from the royal couple ten years earlier by convincing them that he could control the bleeding of their hemophiliac son. Although Rasputin had less political influence than rumored, the reality of his effect on Alexandra and on government was harmful enough to warrant public hostility. The actual and imagined destructive work of Alexandra and Rasputin and the belief in many quarters that their German sympathies inspired this evil brought the autocracy to the point of desperate crisis.

### *The Assassination of Rasputin*

Nicholas' regime seemed so dangerously flawed that even leading aristocrats decided to resort to terror against the government. In December 1916, a group of nobles assassinated Rasputin in an effort to

bring the Romanovs to their senses and save the old regime. This act also indicated that all segments of society had abandoned the tsarist system as it then functioned.

## The Fall of the Autocracy (March 1917)

The end for tsardom came quickly. Ordinary people, not disgusted aristocrats or fanatic professional revolutionaries, delivered the fatal blow to the old regime. Inadequate supplies of bread and fuel led the hungry and cold population of Petrograd to go on strike. (Soon after the outbreak of war with the Central Powers, the government had given the capital the Russian name "Petrograd" instead of the Germanic "St. Petersburg.")

### The Petrograd Workers' Strike

The forces of popular revolution surged into the streets of the capital on International Women's Day, March 8, 1917 (February 23 on Russia's Old Style calendar, which stayed in effect until after the Communist Revolution). A contingent of women acted first. They took up protest banners and marched, even though the leftist parties, including the Bolsheviks, had advocated caution and opposed the action. Army units ordered to stop such behavior joined the strikers. Even the usually dependable Cossack horsemen, when called to suppress the rebellion, not only refused to act but sometimes attacked the members of the militia who tried to stop the protests.

Almost ninety thousand demonstrated on the first day. Then, on the second day of protest, twice that number filled the streets. Soon, most of the city's workers stormed through the avenues—about two hundred and fifty thousand laborers. Middle-class people and university students cheered them on and sometimes joined the marchers. Government officials and the police fled.

### Abdication of the Tsar

The government tried and failed to suppress the revolt with force. On Alexandra's advice, Tsar Nicholas resorted to his ultimate weapon—he simply ordered the rebels to stop. They ignored him. Then leaders of the Duma (parliament), which always before had been a pliant tool of the tsar, took action against their ruler. On March 12, they organized a **Provisional Government** with about twenty members. Most of these men were bourgeois liberals, but the group included a prominent moderate Socialist Revolutionary (SR), Alexander Kerensky. These leaders intended to end autocracy and establish parliamentary government. Nicholas II had no choice; he abdicated on March 15.

### The Petrograd Soviet

On the day of the creation of the Provisional Government, a competing power center emerged: the Petrograd Soviet of Workers' and Soldiers' Deputies. As in the 1905 rebellion, popular forces established this revolutionary city council as an agency to express their will. The Petrograd Soviet began with the backing of impressive numbers of workers and soldiers, but it did not try to seize control of Russia. Instead, the Petrograd Soviet accepted the Provisional Government as the correct political authority for that time. Members of the Soviet had a moderate socialist outlook but, in keeping with Marxist ideology, believed that Russia had not then reached the stage at which a socialist revolution could succeed.

Yet the Petrograd Soviet exerted much influence over events. Its power extended especially to the military. Because the war had brought a flood of peasants and many urban workers into the army, the rank

and file military identified with the Petrograd Soviet and obeyed it. They complied, for example, with the Petrograd council's **Order Number One,** issued on March 14, 1917. This decree called for soldiers to elect representatives to command their units, except in combat, when officers could take charge. The Petrograd Soviet also instructed the soldiers and sailors to obey Provisional Government orders only when the Soviet also approved its commands.

### The First Congress of Soviets

Soon, similar revolutionary Soviets formed across Russia. Representatives from these local councils met at Petrograd on June 16, 1917, in the first All-Russian Congress of Soviets. The members of this assembly (two hundred and eighty-five SRs, two hundred and forty-five Mensheviks, one hundred and five Bolsheviks, and a few other socialists) set up a Central Executive Committee to act as its continuing leadership. The Soviets that called this congress together had a significant popular following. The Provisional Government did not.

## The Failure of the Provisional Government

The Provisional Government won little support as a result of several policies and an inability to cope with persistent serious problems. The new leaders, for example, offered land reform in the future rather than at once, as many peasants wanted. Everyone continued to suffer, moreover, from rampant inflation, plunging industrial production, and a wrecked transportation system. Above all, the government alienated the populace by its commitment to the Great War, despite Russia's increasingly evident inability to win. As the Provisional Government continued policies that drove the people to oppose it, the Bolsheviks tried to position themselves to take control.

### The Beginning of the Bolshevik Challenge

When the revolution erupted in March 1917, most Bolshevik Party leaders got news of it while in jail or in forced exile. Many languished in prisons or Siberia because the government had declared them threats to a nation at war. The collapse of the autocracy freed them to go quickly to the centers of revolutionary action.

Lenin, who enjoyed a more comfortable voluntary exile in Switzerland, found the German government at first hesitant to grant his request for passage across its territory on a journey home. He finally gained permission to travel by train to Sweden. Lenin continued his journey from there to Petrograd in April 1917. A day after arrival in the capital, he revealed his **April Theses** to a gathering of Bolshevik comrades.

### Lenin's April Theses

The document that Lenin carefully voiced (subsequently published in *Pravda,* the Bolshevik newspaper) opened with his insistence that the party must no longer accept involvement in the Great War, a "predatory imperialist war." This call for peace in Lenin's view not only required withdrawal from combat but also the accompanying "overthrow of capital," a shift from the "imperialist" war to a fight against the bourgeoisie. Such a revolutionary struggle could not take place just within Russia.

The April Theses also demanded that Bolsheviks stop supporting the Provisional Government and plunge into a proletarian revolution that would establish not a bourgeois parliamentary government, but the

socialist rule of the Soviets of Workers' Deputies. This statement, summarized by the slogan "All Power to the Soviets," meant that Bolsheviks had to win the Russian class war without the aid of other revolutionary factions. The thesis also assumed that Bolsheviks would gain dominance in the revolutionary councils springing up in Russia. (The party did not yet control them, but its influence in the Soviets was growing.)

As further revolutionary steps, Lenin called for the nationalization of all banks and the socialization of "all lands in the country" so that the agricultural workers' councils could then distribute farm fields equitably among the peasants. A second slogan that captured the spirit of Lenin's April Theses emphasized both this idea of rural revolution and the critical demand to quit the war—"Peace, Land, and Bread."

Several of Lenin's theses pointed toward a wrenching redirection for the Party, and they met strong resistance from the Petrograd Bolsheviks. Many of his colleagues believed that a socialist revolution such as he now demanded could come only after passage through a capitalist era. (Lenin himself had taken that position as recently as 1914.) With difficulty over the course of many weeks, Lenin convinced the party to accept his April principles.

This Bolshevik platform had the potential for a broader appeal to Russians than did the policies of the Provisional Government. From April into the summer, party membership did increase strikingly, especially in cities such as Petrograd, where workers flocked to the organization. The Bolsheviks even began to become more popular among peasants who lived near urban centers—word of Lenin's program appeared to be reaching them, and to good effect. The Bolsheviks were winning an ever-stronger following among those whom Lenin defined as **proletarian**—factory workers and the poorest peasants.

### The July Days Revolt against the Provisional Government

The Provisional Government's problems reached serious proportions as early as May 1917. By then, economic troubles and an impossible military situation led to a change in the composition of the leadership group. More socialists came in, and Kerensky, the SR, took over the ministries of the army and navy. He soon launched an offensive on the southwestern front. Disaster followed there. At the same time, rebellion seethed among the national minorities. In rural Russia, a socioeconomic revolution was underway as peasants seized estates and landlords fled. Ethnic non-Russians and the farmers would not wait for a constitution, then a new government, and then reform legislation.

Even more ominously, food shortages created utter turmoil in the cities, the critical centers of government control. Soldiers in military units stationed away from the front, as in Petrograd, were especially militant and shared the peasants' impatience for a drastic response to Russia's crisis. A regiment in the capital began an assault on the Provisional Government on July 16, 1917, with a demand for change to a proletarian soviet system. Civilians soon followed the soldiers into the streets for large anti-government demonstrations. The Bolsheviks, still a minority influence in the soviets and not ready to seize power, reluctantly joined the rebellion. By July 18, the revolt collapsed. The arrival in Petrograd of troops loyal to the government, the disastrous effect of the Petrograd Soviet's support for the Provisional Government, and inadequate public interest in the coup sealed the fate of the **July Days** rebels.

Not only did the revolt fail, as the Bolsheviks expected, but the government also charged the party with treason, using the outbreak as an excuse to spread the false assertion that the Bolsheviks had German support. This traitorous image made it easier for Provisional leaders to suppress these enemies on the Left.

### The Kornilov Affair

Bolshevik popularity dropped sharply for a while after July 1917. Events soon reversed the fortunes of the party. Alexander Kerensky became Provisional prime minister in July, and the following month, he sent a military force under General Lavr Kornilov to the capital. Kerensky perhaps aimed to suppress the Petrograd Soviet. Kornilov probably wanted personal power and the restoration of a more traditional authoritarian government.

Whatever the intentions of the general and the prime minister, by the time Kornilov reached Petrograd with his forces, Kerensky had decided that the general was an enemy. The prime minister called on the people of Petrograd to stop Kornilov and prevent his destruction of the revolution. Petrograders prepared to defend their rebel stronghold as Kornilov approached. Local authorities freed Bolshevik leaders from prison, and the party took up weapons to join the revolutionary guard. They never had to fight the general. Facing strong citizen resistance, Kornilov gave up the cause before reaching Petrograd. The affair left the Bolsheviks more popular and rearmed. Provisional Government support plummeted.

## The Bolshevik Victory

Within weeks after the Kornilov affair, the Bolsheviks won a majority in the Petrograd and Moscow Soviets, though not in the Central Executive Committee of the All-Russian Congress of Soviets. Across the country, as well, their popularity increased.

### The October Revolution

Lenin, hiding out in Finland after the failed July revolt, sent messages after the Kornilov debacle, urging his Party to take over the country. On November 5, he returned in disguise to Petrograd and after a struggling effort, got the other Bolshevik leaders to go along with the idea of an armed insurrection. Leon Trotsky, a long-time Marxist but recent convert to Bolshevism, proved to be Lenin's most enthusiastic supporter in the quest for immediate revolution.

On the night of November 7, 1917 (October 25, on the Old Style Russian calendar), rebels took control of the centers of transportation and communication in the capital. In the early morning darkness of November 8, a **Red Guard** formed by city workers, a Petrograd army unit led by Bolsheviks, and militantly proletarian sailors from the nearby Kronstadt base attacked the Winter Palace, where the Provisional Government had set up its headquarters. They encountered almost no opposition. In a coup with relatively little bloodshed, the Provisional Government fell, and working-class forces took over. Despite this gentle collapse, a brutal transition was in store for the Russians.

### Formation of the Communist Government

Throughout the months from the March to the November revolutions, the Provisional Government had officially led Russia, but the revolutionary councils, and especially the Petrograd Soviet, had assumed partial control. The Bolshevik Party also became an increasingly important center of authority before the autumn revolution. Once the Provisional Government fell, the Bolshevik Party and the network of Soviets that it eventually dominated completed the transition to power.

Although the new ruling system remained in flux throughout the twentieth century, the fundamental structure of the new state emerged during these early years and persisted thereafter. The party and the Soviets evolved as dual, overlapping hierarchies, with the party reigning supreme and authority in both pyramids concentrated at the top.

**The Communist Party.** In March 1918, the Bolsheviks renamed their organization and became the **Communist Party.** Three small groups held the uppermost positions in this organization. These executive agencies were the Political Bureau (**Politburo**), the **Secretariat,** and the Organizational Bureau (**Orgburo**). The Politburo and Secretariat typically possessed the highest authority, even though Party rules stated that a larger Central Committee controlled them. Theoretically, the mass of party members selected and guided these leaders. Beginning in small local party organizations (**cells**) at the bottom, Communist Party members supposedly chose delegates from their group to act for them at the next higher level through a succession of tiers to the large national Party Congress and its smaller Central Committee. In practice, the top authorities designated Party leaders above the local level and decided policies without regard to the wishes of lower-ranking people.

**Soviet Government.** Although the party wielded supreme power after the revolution in November 1917, the structure of Soviets technically comprised the government. In July 1918, the leaders of the new state adopted a constitution that described the formal system of this **Russian Soviet Federated Socialist Republic** (RSFSR) that had replaced the autocracy and the Provisional Government. Soviet government organization and its operating principles repeated those of the Party in that lower councils, in theory, sent delegates to successively higher levels up to the national All-Russian Congress of Soviets. Once more, however, top officials actually controlled most elections and policy making. By the time the party finished work on this new Russian socialist republic, Communist Party leaders had decided to move the capital from Petrograd to Moscow.

**Party-State Relationships.** Because the Soviet Congress met only periodically, it elected a Central Executive Committee and a Council of Peoples' Commissars (**Sovnarkom**) to work as permanently operating governing agencies. (The Council of Peoples' Commissars roughly paralleled a cabinet of ministers in a parliamentary system.) The members of these two Soviet executive agencies ranked high in the Party. Lenin, for example, led both the Party Politburo and the government Sovnarkom. This practice blurred distinctions between the two systems at the top, but the party dominated the government and controlled the Soviet state.

### Enactment of the Revolution

During its first months in power, the new government decreed a socioeconomic revolution. It finished the dissolution of the old regime by outlawing titles of nobility and seizing the property of aristocrats, some middle-class people, and the churches. Communist leaders also began to socialize the economy by taking farm land for the state, turning control of factories over to the workers, and converting all banks and large industries into government enterprises. These and other more revolutionary measures enacted by 1921 often were not fully implemented, but a drastic transformation had begun.

Such sweeping changes decided by a single party provoked opposition. Communists responded by suppressing all parties other than the leftist Socialist Revolutionaries by the beginning of 1918. Within months thereafter, the SRs became too independent, and Soviet leaders decreed that only the Communist Party could legally exist. As a further guarantee of power, the government established a security force, the **Cheka,** in December 1917. This organization, headed by Felix Dzerzhinsky, was the parent of "secret police" agencies that operated under various titles until the demise of the KGB in 1991.

### *The Constituent Assembly*

Lenin's party and government had strong support among the 500,000 Russian city workers and among rank-and-file members of the military. By late 1917, the Communist Party had won a significant peasant following, but most of the one hundred and twenty-two million rural people still backed the Socialist Revolutionaries. Because most voters were peasants, the elections sent over four hundred SRs, one hundred and seventy Bolsheviks, thirty-four Mensheviks, and one hundred other socialists to the Constituent Assembly that met in January 1918.

From the Communists' point of view, the party represented the proletariat, the class to which every citizen would belong in the future. The SRs and others had won more votes from the 1917 citizenry, but support of non-proletarian classes still tied to the past meant nothing in the opinion of the Communists. They dissolved the Constituent Assembly on the day it first met, January 18, 1918. For the next seventy-two years, the party would share power with no other political organization.

### *The Treaty of Brest-Litovsk with Germany*

The new Communist state had one overriding international concern at first—to end the war with Germany. Trotsky, as Commissar of Foreign Affairs, led a delegation to Brest-Litovsk in western Soviet Russia to hold peace talks with the Germans. The harsh terms that Germany offered shocked the Soviet negotiators. Trotsky and many other Party leaders opposed acceptance. Lenin believed, however, that the insecure position of his new government at home and the complete inadequacy of the Russian military allowed no choice but surrender. On March 3, 1918, the Treaty of Brest-Litovsk ended the devastating war, but also took away one million square kilometers of territory with over fifty million inhabitants and many valuable industrial facilities.

## ■ THE ERA OF CIVIL WAR (1918–1920)

After nearly two decades of struggle, Communists finally won power with relative ease in November 1917. The coup itself, moreover, caused few deaths and little destruction. Peace with Germany the following March required acceptance of humiliating terms but ended a costly siege. Despite these mostly promising developments, a civil war erupted in Russia in mid-1918. A desperate struggle ensued that caused more widespread suffering than the Great War and very nearly destroyed the new government.

### The Enemies of the Russian Communists

No single group or movement could equal the political and military strength of the Communist Party in Russia's great cities by late 1917. The party gained additional power from the solid support of the

working masses in these urban centers. These circumstances enabled Lenin's forces to take control, but an array of enemies fought them from the outset, attempting to ensure that the party would not continue to govern Russia. The **Whites** who opposed the Communist **Reds** included liberal reformists, leftists such as the SRs, and reactionaries who wanted to return to the old sociopolitical system. This combination of opponents posed a formidable threat to the party.

### The Splintered Whites

The fighting forces of the Soviet government's enemies emerged in many different regions around the Communist Party stronghold in central Russia. General Anton Denikin took command of White troops in southern Russia early in the Civil War. Several White factions appeared to the east of the Russian heartland. The most important of these groups, led by Admiral Alexander Kolchak, operated in western Siberia at the beginning of the conflict. In Estonia in the northwest, General Nicholas Yudenich directed a White movement that eventually threatened Petrograd itself.

These White factions, and others that formed as the war proceeded, shared little but their opposition to the Communist Party. Beyond these sentiments, they had no common beliefs about a new order to establish in place of the Soviet state. Despite such handicaps, the Whites had the potential to destroy the Red regime. Other opponents lacked this deadly strength but did heighten the danger to Communism.

### The Rebellious National Minorities

Among the nearly two hundred national minorities within the Romanov Empire in 1917, those on the southern, western, and northwestern borders exhibited an especially strong desire for independence. They began their drive to separate from Russia during the tumultuous transition after the Bolshevik Revolution. Nationalist rebellions broke out in Central Asia and in the southwest in a region the tsars had organized as the Transcaucasian Federation. The Soviets quelled these revolts by the mid-1920s, but they could not suppress outbreaks in Lithuania, Latvia, Estonia, Byelorussia, Ukraine, Poland, and Finland. All of these western and northern nationalities won full independence except Byelorussia and Ukraine. By 1919, the new Polish state had sufficient power to invade Soviet territory and, for a time, to occupy parts of Byelorussia and Ukraine.

### The Diverse Foreign Invaders

Soviet Russia's exit from the Great War in March 1918 gave the other Allied Powers an excuse to send troops into the Communist state. For France and Britain, the main objective of Allied intervention was the overthrow of the Party, even though official statements claimed the goal of preventing German seizure of military goods. The declared rationale for entry somewhat more accurately reflected the motives for American intervention. Twelve other countries also sent in troops, most of them in an attempt to seize territory.

The foreign forces that heightened the danger to the Communist government involved these contingents: sixty thousand from Japan; forty thousand from Britain; a Czechoslovak legion of thirty thousand or more that had fought for the tsar in the Great War; a contingent of ten thousand from the United States; several units from France and Greece, and smaller numbers from nine other countries. The Japanese and Czechs fought the Reds, but the other powers opposed the party mostly by providing money and supplies to the Whites.

## The Reds and Whites at War

The Communist Party and the Whites engaged in full-scale war from mid-1918 to late 1920. Red forces had the advantage of a consolidated territory and strong commitment to a cause. Even so, the scattered Whites almost conquered the Communist state in the first year of the struggle.

### The White Offensive

Leon Trotsky demonstrated genius as the organizer and commander of the Red Army, but in the early stages of the Civil War, his talents seemed to matter little. The Whites pressed in on the Reds from several directions and greatly diminished their territory. One anti-Communist operation in July 1918 brought a combined White and Czech force near the place where the Soviets held the tsar and his family. On orders from Lenin, the Romanovs' captors executed Nicholas II, Empress Alexandra, and their five children. The Whites continued their advance and by October 1918, Yudenich's army approached Petrograd as Denikin's troops neared Moscow. Soviet enemies thus stood poised to take the two major Russian cities.

### The Red Victory

Fortunes then changed for the Red Army. Under Trotsky's guidance, the Soviet military had improved rapidly. Yudenich's attack on Petrograd failed. The Reds dealt Kolchak a smashing blow before the end of 1919. Then the Reds drove Denikin back far to the south in early 1920. At that point, Poland attacked Russia, forcing the Reds to ease pressure on Denikin. Thereafter, General Peter Wrangel replaced Denikin as leader of the Whites in the southwest. Wrangel began an offensive in that region that at first made progress. By autumn 1920, however, Poland quit the war, and Wrangel began to lose ground. The Allied Powers' navy operating in the Black Sea subsequently evacuated Wrangel and his army. The Reds had secured their victory by the end of 1920.

### War Communism

The Communist state quickly took a tentative form as Reds and Whites fought the Civil War. During this bitter struggle, party ideology and the events of the battle to hold onto power had a profound effect on the evolution of the Soviet system, but, as Lenin admitted, Russia's authoritarian tradition also helped to determine the political shape of the new order. All these forces drove the Soviet government toward dictatorship. Two of these influences—Bolshevik dogma and especially the extreme crisis of the struggle against the Whites—stampeded the despotic party into governing devices that it described as **War Communism.**

Before the Civil War, Soviet leaders had acted on their commitment to the formerly oppressed working classes by turning control of factories over to the laborers and accepting peasant land seizures. The party decided early in the battle with the Whites to abandon this trial of the Communist dream. In a raging civil war, the managerial incompetence of factory workers and the freedom of farmers to do as they would with the products of their fields threatened the survival of the regime.

The era of War Communism thus dawned. The party decreed an end to proletarian management and declared that the government thereafter would own and control virtually all industrial and financial institutions. In order to provide the food and other farm goods needed by factory workers and the Red Army

during the Civil War, Soviet leaders also commanded that peasants surrender all products that the government considered to be surplus. Rural War Communism produced especially serious abuses, as government agents seized even necessities from farmers.

### The Crisis of 1920–1922

Red Army operations and the implementation of War Communism gave the Soviet government its Civil War victory but left Russia on the brink of disaster. Industrial and farm production had dropped sharply. Prices had spiraled rapidly upward. Severe dry weather produced a famine in 1921–1922 and greatly intensified the misery. The combination of Great War and Civil War combat, hunger, and disease killed about ten million Russians between 1914 and 1922.

Finally, the suffering became unbearable, and the toiling masses revolted against the self-proclaimed workers' state. Peasants turned to armed rebellion. An especially serious revolt came in Tambov in the area south of Moscow.

To the north, near Petrograd, the naval garrison at Kronstadt delivered the Soviet government a staggering blow. Communists had recognized the sailors at this base as some of the greatest heroes of the Bolshevik Revolution. In March 1921, the Kronstadt garrison revolted. Trotsky led the Red Army in a brutal suppression of these proletarian rebels. The conditions and events of 1920–1921 stunned Lenin. He responded with a drastic revision of Soviet policy.

## ■ THE FORMATION OF THE USSR (1921–1928)

Even though Communist Party leaders had to deal with the crisis of 1920–1922, the end of the Civil War made it possible also to devote much more attention to the further construction of the governing system. By the end of the decade, they had largely completed the formation of their new state, the **Union of Soviet Socialist Republics** (USSR). Communist authorities for many years thereafter had an extremely powerful government to execute whatever policies they chose.

### The New Economic Policy

In 1921, Lenin proposed extreme measures to end the suffering and turmoil left by the Civil War and War Communism. He called his plan the **New Economic Policy** (NEP), and it horrified many Communist Party leaders. NEP repelled members of the party command because it entailed a retreat from the extremes of War Communism to a system that combined dictatorial socialism and capitalist private enterprise. Lenin's opponents finally yielded to his arguments that nothing but this adoption of limited bourgeois practices would restore the economy quickly enough to save the Soviet state.

### Industry and Commerce under NEP

The 1921 reform program permitted the resumption of private retail sales, both in shops and on the streets, by **Nepmen** who bought and sold almost everything—practices punishable by death during the Civil War. The NEP even restored the right to operate small private industries, although these enterprises could hire no more than twenty employees. Lenin refused to end government ownership of large factories,

the banking system, public transportation, and wholesale and foreign trade, but his policy did reduce the authority of state bureaucracies over these enterprises.

### Agricultural NEP

The change for peasants from the days of War Communism was even more drastic than for urban workers and entrepreneurs. The forced requisitioning of produce ended, replaced by a provision for farmers to pay taxes (at first in produce; later in money). NEP rules also allowed peasants to use or sell everything they produced in excess of tax obligations. Before the end of the 1920s, peasants gained the right to lease land and hire workers (a practice previously condemned as wage slavery). Under these conditions, the number of relatively prosperous farmers (known as **kulaks**) increased, but they remained a small fraction (under one million) of Soviet Russia's one hundred and twenty-two million peasants. About one million farmers still had no land and, so, worked for others. Life for most of the one hundred and twenty million middle peasants significantly improved under NEP influence.

The overall effect of NEP meant that Soviet Russia's twenty-five million farm households operated under a private enterprise system, despite the theory that the state owned the land. Lenin's plan succeeded remarkably well. It brought a quick end to the famine conditions of the early 1920s, and by 1928, the amount of land under cultivation exceeded 1914 levels for the first time since the Great War began. Industry recovered in a similar fashion.

## The New Political Union

By the end of 1922, nationalist rebels in Byelorussia, Ukraine, and the Transcaucasian Federation had lost in their effort to follow the path to independence opened by Poland, Lithuania, Latvia, Estonia, and Finland. The three subdued nationalist territories accepted their status as **republics,** annexed to Soviet Russia to form the Union of Soviet Socialist Republics. Communist leaders then revised the 1918 constitution to describe the structure and laws of this new larger union.

### The Constitution of the USSR

The constitution adopted in 1924 provided Soviet government systems for the new republics patterned after Russia's, as described in the 1918 constitution. The addition of these three regions to the state necessitated changes in the central institutions of government. The All-Russian Congress became the All-Union Congress of Soviets, and its Central Executive Committee (CEC) changed to a two-part agency consisting of the Council of Union and the Council of Nationalities. The Congress with more than 2,000 representatives met annually but had no real authority. The CEC with its hundreds of members also did not truly administer Soviet affairs. Instead, two smaller CEC committees—the Presidium and the Sovnarkom—led the government but took their orders from the top party agencies.

### Dictatorship and Liberty in the New Soviet Union

Not a word about the Communist Party appeared in the Constitution of the USSR. Despite this omission, the 472,000 Party members ruled the nation of 150 million in 1924. The party, moreover, decided who entered its ranks. These half million self-selected Communist Party members, although supreme

among the citizens, possessed very uneven powers within the party. A national Party Congress held ulti-
mate authority, according to stated principles, but in practice, a few leaders (under one hundred) in four
small executive agencies exercised dictatorial control over the Party and the state. The most important of
these party chiefs were the General Secretary and the members of the Politburo (seven people in 1924).

The denial of political influence to almost all the millions of Soviet citizens meant that several
impressive constitutional provisions, such as the right of free speech, had limited meaning. These articles
in the 1924 document, however, suggested a very new social reality that lasted until the end of the
1920s—greater personal liberty for the masses than Russians had ever enjoyed. Literature, art, the cin-
ema, theater, and especially music benefited from this greater freedom of the early Soviet years.

## Lenin—from Twilight of Power to Dawn of Glorification

Through the long revolutionary struggle and the first years of building the new Communist govern-
ment, Lenin wielded far more power in the Party and the Soviet state than anyone. His phenomenal per-
suasiveness, force of character, resourceful mind, and resultant respect enabled him to hold sway. Lenin
also used mass killings when he thought it necessary in governing Soviet Russia. Among his Communist
Party comrades, though, Lenin dominated without brute force, even when his wishes were ignored or
challenged, as they were many times. This exceptional if rivaled power in the party waned in Lenin's last
two years, and in his death, the party encouraged his adoration in a way that he never would have
approved, a post-mortem denial of his authority.

### Lenin's Final Struggle

Lenin fought through his last months against severely debilitating illness. He suffered a stroke on
May 26, 1922, but recovered enough to resume a few duties until late in the year. His condition worsened
after another attack on December 16. The Bolshevik leader still fought to drive the party to greater power.
According to notations on the document, the ailing leader managed soon after his second stroke to dic-
tate a directive message to the party in segments dated from December 23 to January 4. The opening sec-
tions of this testament contained specific admonitions about organizational changes that Lenin thought
vital to party strength in the future and observations about a few of his comrades.

Lenin's comments about party members referred to six Bolsheviks and implied or directly indicated
their potential as future party commanders. He suggested disapproval but not harsh judgment of actions
by Gregory Zinoviev and Lev Kamenev on the eve of the Bolshevik Revolution, offered a few words of
warm praise for and moderate criticism of Nikolai Bukharin and Gregory Pyatakov, and commented at
somewhat greater length on the qualities that he saw in Lev Trotsky and Joseph Stalin.

Lenin implied that Trotsky and Stalin already had stronger positions in the party than anyone else. His
observation that Trotsky was "perhaps the most capable" person in the twenty-five-member Communist
Party executive committee suggested that he deserved his position at the top despite having an exaggerated
sense of self-confidence and an overly bureaucratic mind. Lenin apparently ranked Stalin as one of the two
chief Communist figures because as Secretary General, he had gained "unlimited authority." He also made
the surprisingly pointed assertions that Stalin was too reckless to have such power and too "rude" to be
Secretary General. No one lived up to Lenin's prideful standards for leadership, but Trotsky came closest.

Lenin apparently composed his testament as a guide to the prevention of divisions and conflicts among Party leaders. He also intended to shape important decisions about the nature of the party and its leadership after his death, which came a year later. A third stroke on March 10, 1923, left Lenin an invalid and unable to speak understandably except, supposedly, the few simple words that he could utter to his wife, Nadezhda Krupskaya. A massive brain hemorrhage killed him on January 21, 1924.

Hordes of ordinary people braved severe cold weather to join in a display of public mourning. Even though Bolsheviks ridiculed the idea that they needed a single great leader, most of the prominent party members joined in the ceremonial grieving that made Lenin seem to have been a superior form of humanity. They also already were involved in a struggle to take his place, and a long and uncertain battle for supremacy lay ahead.

### The Contenders in the Fight to Become Lenin's Heir

In the rivalry for power, Trotsky appeared to have the greatest advantages. Communists especially valued intellectual brilliance and persuasive speaking and writing ability, a very picture of Trotsky. These traits did much to catapult him to the top of the party with exceptional speed—he had not joined the organization until 1917. After Trotsky further enhanced his image with his masterful work as commander of the Red Army in the October Revolution and the Civil War, only Lenin inspired more awe among Communists. He had to be careful, however, about his aura as war leader. Bolsheviks thought they should never allow a "Bonaparte" to take charge.

Few Communist leaders other than Lenin recognized that Stalin could seize control of the party. He had climbed slowly to his powerful position. At seventeen, Stalin quit clerical studies to begin to work for revolution. He soon joined the emerging Bolshevik movement and fought daringly for it, robbing banks to provide party funds. Such operations often landed him in jail. He always returned to the struggle. His dedicated party work placed Stalin among the leaders in the revolution and Civil War. He left these battles at the end of 1920 without Trotsky's impressive image, but by then he had more influence over the rapidly swelling ranks of full-time party workers than anyone, even Lenin. These functionaries and many other delegates selected by them voted in decisive party meetings during the struggle for succession on issues that could chain the organization to Stalin.

Even if Stalin's colleagues had recognized his forceful potential, it would have caused little alarm. He impressed them as more moderate than Trotsky and less likely than the Red Army commander to take too much power into his hands. Stalin also did not have the handicap of being Jewish, a disadvantage for Trotsky and several other leadership contenders in a society with an enduring heritage of anti-Semitism.

### The Issues in the Rivalry for Power

Policy debates gained much attention in the struggle for power. Rivals fought by claiming to know the right course for the Party to take. Trotsky and Stalin conflicted most sharply over whether Communism could succeed in Soviet Russia without also having a global Marxist revolution in the near future. The traditional Party belief that success in the USSR required a worldwide proletarian victory appealed to Trotsky. He defended the view vigorously. Stalin countered that Communism certainly could succeed in the USSR with a triumph abroad in the distant future. An increasingly nationalistic Soviet Communist Party found Stalin's idea of "socialism in one country," as he called it, very appealing. The evident failure of Communist

revolts elsewhere intensified the allure of Stalin's doctrine. Relatively few party members wanted to believe that world circumstances doomed their cause.

Trotsky and Stalin clashed over another issue—whether to continue NEP or force a rapid change to complete socialization in the USSR. This question had the utmost significance for the future of Soviet Russia. It received less attention in the leadership fight, however, than did ideas about world revolution. Nevertheless, Stalin's support for NEP helped his cause. The stand he took placed him in the camp with Bukharin and several other important party veterans. Trotsky opposed them and called for hasty socialization. Many Communist Party officials who had joined the organization in 1917 and after agreed with Trotsky, but these novice bureaucrats owed their jobs to Stalin and wanted him at the top of the structure.

### The Victor

By 1924, Stalin held more high positions in the government and Party than any of his rivals— Commissar of Nationalities, member of the Politburo and Orgburo, and General Secretary of the party. It was the latter three offices that gave him control over party organization and the appointment of the Communist Party bureaucrats who could decide Lenin's successor. They chose Stalin.

Loyal Stalinists carried their champion to power by voting with him on critical issues in the meetings of top party organizations in the mid-1920s. The final victory came in a Party Congress in December 1927. The deputies at this session ruled that no one could vary from party policy as defined by Stalin. His rivals adopted his positions or were expelled at least from office and sometimes from the party. Trotsky suffered complete exclusion and fled the Soviet Union in 1929. Stalin had him assassinated in 1940.

Stalin's supporters wanted him alone to decide Party policy in part because they thought that no one else could divine the present-day meaning of the spirit and teachings of Lenin, the ultimate source of truth. As Stalin put it, he would follow "Lenin's commandments" while others, such as Zinoviev and Trotsky, "have broken with Leninism" and would "cast his commandments into oblivion." Stalinists believed these words, spoken in August, 1927, even though he had influenced a party congress decision to ignore Lenin's commandment to dismiss him as Secretary General. By 1927, many Soviets almost worshipped Lenin's memory, his writings, and his mummified body on display in Red Square. Stalin would make the fullest use of the power that came from being accepted as the heir of this glorified Lenin.

## ■ THE STALINIST SUPERSTRUCTURE (1928–1941)

Soon after Stalin began to run the party in early 1928, his actions indicated that he was prepared to force the rapid development of a state with a completely socialized industrial economy. Stalin's methods revealed almost as quickly that he would exercise absolute control over the government, its economy, and every other aspect of life that he could. By 1941, the new Soviet dictator had largely achieved this goal of building a totalitarian system. The political, economic, and social superstructure that took shape under his command during the 1930s changed significantly after Stalin died in 1953. It remained mostly intact, though, until the late 1980s.

### Soviet Russia's Industrial Revolution

By the late 1920s, manufacturing had finally returned to 1914 levels of production. This recovery, however, still left Soviet Russia an almost completely agricultural nation. The NEP farm system ensured

a relatively slow transition to an industrial economy. NEP allowed rural households to tend their lands and, for the most part, dispose of their crops as they wished. Poorer peasants produced enough to take care of themselves. The more prosperous and productive farmers fed the relatively small population of urban workers. But the farm system in the late 1920s would neither take care of a more highly urbanized society nor supply products to sell abroad and pay for an industrial buildup. Peasants might eventually change voluntarily and fulfill the needs of a modern economy, or, in time, Soviet leaders might teach them these new ways. Stalin decided that he would not wait for an evolutionary process to occur.

### Economic Socialization as an Instrument of State Power

In the struggle with Trotsky, Stalin had demanded the perpetuation of NEP. He reversed his position in 1929 and ordered a swift expansion of industry, a change that would require complete socialization. Stalin at the same time decreed farm collectivization. This policy meant that the twenty-five million farm households would end their private enterprise ways as soon as possible and work on factory-like state farms (*sovkhozy*) or the less radically socialized collective farms (*kolkhozy*). Although the party wanted a largely *sovkhoz* system, Stalinist collectivization left most peasants in their present villages and homes with their household plots merged into *kolkhoz* fields.

Stalin and his supporters wanted agricultural collectivization so that the government could more easily take the products that would supply the food and capital funds for the rapid industrialization of the Soviet Union. Lenin had used similar methods during the Civil War, but then restored private farming in the NEP era. Even near the end of his life, he still seemed unwilling to turn toward rapid, forced collectivization. Bukharin and other party veterans also wanted NEP and a slow change to socialized farms. But neither Lenin's stamp on NEP nor the views of important theorists such as Bukharin mattered anymore; Stalin and his new bureaucrats ruled the party.

Elaborate statements of goals and timetables confronted everyone involved in Stalin's projected industrial transformation. Soviet leaders presented these economic schedules regularly for the next six decades, almost always as **Five-Year Plans.** They served mainly to increase government control over the economy and the citizenry rather than to provide general material prosperity. The party would drive the economy, not plan it.

### The First Five-Year Plan

Stalin decreed his first Five-Year Plan in 1929. It contained these projections for 1933: collectivization of twenty percent of peasant farms; an increase of about two hundred and fifty percent in steel production; and an advance from the manufacturing of one thousand three hundred new tractors per year to one hundred and seventy thousand. The Plan called for equally incredible increases in the output of iron, cement, cloth, electricity, and other goods.

The 1929 economic schedule and all subsequent ones until the late 1980s strongly emphasized the development of heavy industry. This policy meant a concentration on the production of electricity, oil, industrial and construction machinery, modern hauling systems, military hardware, and large mechanized farm implements.

## Farm Collectivization

Most Soviet farmers hated collectivization. Ukrainian peasants who tilled the richest agricultural land especially despised the new policy. Farmers across the country stubbornly resisted; they ate and otherwise consumed everything they could to prevent requisitions. They destroyed farm animals, equipment, and other property in an effort to wreck the collectivization drive. Farmers even attacked and sometimes killed local officials who directed the change.

The soldiers of the Red Army who were ordered to force submission would not always fire on the peasants. They had good reason not to shoot, because many soldiers came from farms and sympathized with the protesters. When other means failed, Soviet officials sent in OGPU security troops. These forces of the agency formerly known as the Cheka used whatever measures necessary to bring compliance with the policy.

The control tactics included military sweeps of resisting villages, systematic execution or Siberian exile for all presumed kulaks, and the mass murder of many other peasants. Stalin also purposely made a famine in Ukraine more horribly deadly. In 1931–1932, this government-fostered disaster killed an estimated six million. The total death toll from collectivization reached an estimated ten million and perhaps was much higher. Stalin meant to have his way.

Stalinist methods brought the collectivization of nearly two-thirds of the farms by the end of the first plan. Virtually all agricultural land belonged to collectives by the end of the 1930s. From then until the collapse of the Soviet Union, the small private garden plots allowed by the government usually totaled only two or three percent of the farmed area.

## Industrialization

Soviet Russia's economic masters intended under the first plan to improve all old industries and establish many new ones to manufacture cars, trucks, airplanes, plastics, and other products typical of a modern society. They also bent every effort and spared no lives to construct hydroelectric dams, highways, railroads, canals, and the rest of an urban-industrial infrastructure.

The directors of this gigantic project encountered tremendous problems: the inevitable mismanagement caused by controlling a massive industrialization process from the center of the world's largest nation, the extremely small numbers of both skilled and unskilled factory workers, and the difficulty of industrial training and supervision in a mostly illiterate society. (By the end of the 1930s, government educational programs made most of the Soviet population at least minimally literate.)

The barriers to success ensured that the Soviet Union would not achieve the very high goals of the first plan. Steel production, for example, fell about forty percent short of the projected ten million tons. Tractor output missed the mark even further with the manufacture of fifty-one thousand of the planned one hundred and seventy thousand. Similar shortfalls occurred in nearly all plan categories. Stalin ignored the failure to achieve anticipated results and proclaimed that industry had met its goals in January 1933, nine months ahead of schedule.

Stalin's lie simply magnified an important truth. The Soviet Union had experienced fantastic industrial growth, even if the plan had not been fulfilled. Iron production had nearly doubled, the generation of electricity almost tripled, and steel mills yielded about thirty-seven percent more in 1933 than in 1928. Overall, the advance meant that an industrial revolution had begun.

The second Five-Year Plan (1933–1937) brought the economic transformation almost to completion. When the Second World War interrupted the third plan in 1941, the Soviet Union had become a leading industrial nation. The USSR ranked third in factory production volume, behind the United States and Germany but ahead of Britain.

This remarkable achievement required drastic measures. The government turned away from early Communist ideals about economic equality and used pay raises, medals, and other special benefits to promote high production. As an additional labor incentive, officials trumpeted the faked superhuman output of workers such as the coal miner Alexsei Stakhanov, and then rewarded them with extra wages and other favors. They developed this practice into a continuing program of **Stakhanovism.**

Threats as well as rewards influenced employee effort. Tardiness and other bad work habits brought penalties, usually financial but sometimes much more severe. Very persistent violation of rules could result in jail sentences or execution. Forced labor by millions of people imprisoned for economic and political offenses, in fact, became a prominent part of the Stalinist industrial system. Thus, although peasants suffered the most in this decade of accelerated industrialization, factory workers felt the pain of the effort, too. Living standards for all working-class families also declined between 1928 and 1941.

## Stalinist Terror

The chain of **forced labor camps** that helped build the roads, canals, dams, and factories of an industrial nation served another purpose for Stalin. Because anyone, even the wife of Stalin's closest associate, could disappear into this system with its literally deadly living and working conditions, the camps inspired universal fear. This dread immeasurably strengthened Stalin's dictatorial power. Before the end of the 1930s, he had many other instruments of terror to enforce his will.

### *Stalin's Murderous Assault on the Party*

Stalin had many admirers both in the Party and in the nation at large by the end of the first plan in 1933, despite the pain of industrialization. A Party Congress early in 1934 gave Stalinists an opportunity to praise themselves warmly, but critics also took action, an indication of the growing discontent in the USSR. These Communist Party opponents of Stalin tried to elect Sergei Kirov as General Secretary instead of Stalin. Their effort failed, but Stalin's enemies persisted. When the 1,200 delegates selected the 139 members of the Party Central Committee, Stalin received more negative votes than any other candidate. His favorable ballot count still enabled Stalin to join the committee, but the outcome indicated a possible threat to his power.

Stalin responded decisively and characteristically with actions to subdue the party thoroughly. After the murder of Kirov in December 1934, probably on Stalin's order, the General Secretary charged members of the secret police organization (renamed NKVD in the 1930s) with partial responsibility for this killing. The party held a secret trial and executed thirteen of these men and nearly 100 other members of the Communist Party. Stalin also blamed and imprisoned several top party officials. Eventually, more than 30,000 citizens of Leningrad (the former Petrograd), where Kirov had lived and had a large following, were sent to forced labor camps.

## The Great Purge

Most of the people purged in 1934 belonged to the party. Soon, the organization faced a much greater wave of terror. Stalinists began a siege of treason charges, trials, executions, and imprisonment that struck down tens of thousands of Communist Party members between 1936 and 1938 in what became known as the **Great Purge.** These victims included Bukharin, Zinoviev, Kamenev, and most other founders and early leaders of the party.

Stalin concentrated his assault on the party, but his terror reached far beyond it. The arrest and punishment of someone usually led to similar treatment for his or her family, friends, and other associates. Before it ended, this Great Purge also swept members of the artistic elite and most Red Army officers into NKVD execution chambers or labor camps. Finally, Stalin accused the NKVD chief of going to extremes in the suppression campaign and had him killed. The public trials then stopped. Mass murder continued, leaving hidden **killing fields** around many major cities. Mass graves near Minsk in Byelorussia, for example, contained the remains of more than one hundred thousand people by 1941.

## The Reign of a Terrorist

Stalin's practice of ruthless terror and the governing machinery that he developed in the 1930s gave him extraordinary dictatorial power. Industrialization under the Five-Year Plans and the events of the Great Purge revealed the exceptional and terrifying authority that Stalin had over economic and political institutions.

## The Stalin Constitution

As Stalin built his structure of total dictatorship, he also presented a new Soviet constitution that promised the citizenry extensive personal freedoms and the provision of every material need. Officials explained that the conversion of the USSR to a fully socialist economy necessitated the replacement of the constitution adopted during the NEP era. The **Stalin Constitution,** released in 1936, actually gave the Soviets none of the liberty and little of the welfare program it described. It did contain at least one very meaningful section, however: the article that specified the supremacy of the Communist Party in the USSR.

## One Man's Culture

Stalin extended his direct control far beyond the typical areas of government concern. His strong influence in education, science, and other aspects of life, in fact, indicates the truly totalitarian nature of his reign. Large numbers of university professors who seemed insufficiently devoted to the ruler's doctrines were sentenced to the work camps. Even scientific theory, especially in biology, had to agree with Stalin's uninformed views. Because it suited the Party chief's beliefs about the way changes in Soviet conditions could alter Soviet people, leaders of the Communist academic world denied the truth of the great genetic discoveries of Gregor Mendel about how heredity determines traits through the generations. The pseudo-biologist Trofim Lysenko became the revered spokesman for the idea that environment fully controlled this process. Thus, for example, keeping a heavy-coated female dog quite warm supposedly would cause her to produce puppies with a light mantle of hair. Stalin's desire for social and cultural control was almost boundless. He welcomed the new "truth" from Lysenko.

### *From NEP Arts to Stalin's Socialist Realism*

The party had left the creative world mostly to its own devices in the 1920s. Daring painters, writers, and musicians for a time took stunning new directions. Wassily Kandinsky, Kazimir Malevich, Marc Chagall, and other artists jolted the viewers of their revolutionary work on canvas. A few writers also similarly shocked the reading public. Mikhail Bulgakov in his *Heart of a Dog* imagined a criminal with a replacement canine heart becoming the perfect Soviet government functionary. Yevgeni Zamyatin's novel *We* (1929) used a futuristic story to describe and condemn the totalitarian system that he saw emerging. (Two famous Western novelists copied Zamyatin's fictional device in the 1930s and after.) Composer Dmitri Shostakovich left the Soviet rulers alone, but stirred the devotees of serious music perhaps unpleasantly with the discordant sounds of his First Symphony that he produced at about age twenty.

Other creative NEP-era geniuses, unlike the bold individualists such as Malevich, strayed at least at times away from the bohemian route of "art for art's sake." Vladimir Mayakovsky could shock audiences as he read his **Futurist** poetry attired in a gaudy sports jacket, sometimes with a carrot affixed to his lapel. He also threw himself vigorously, however, into the production of poems, plays, and posters that he believed could serve as instruments to help bring the proletarian revolution to a successful climax. Such works by Mayakovsky exemplified the efforts of an important artistic contingent of the 1920s. Late in that decade, though, rapidly strengthening pressures to make art conform to party standards disillusioned many of the leading creative figures and led one poet to suicide. Mayakovsky also killed himself but probably for personal reasons.

Creative expression, or at least the public display of it, virtually ended when Stalin established the abrasive new world in which he intended to control the arts as he did government, the economy, and academic life. Creative works in every field had to measure up to the ruler's vague standards of **socialist realism.** In practice, this policy meant that written and visual works had to convey Communist Party propaganda messages and that music had to have tunes that Stalin liked. Failure to satisfy Stalin's artistic tastes meant loss of career and income, imprisonment, or even death.

The poet Anna Akhmatova had a life typical of many of her artistic peers. She could not publish her deeply sensitive poetry of life and love, but instead in secret wrote it by hand on cigarette paper to be passed among friends to be read, memorized, and burned. As punishment for her sin of simply existing as a widely admired romantic lyric poet, Akhmatova and her son suffered long imprisonment as an enemy of the people.

Osip Mandelstam felt the more direct pain of death in a Siberian prison camp for privately reading to associates a poem he had written that jokingly disparaged Stalin. Shostakovich produced an opera in 1936 that brought sharp criticism from Stalin and a *Pravda* review that marked him, too, as the people's enemy, but he survived. (The arbitrary nature of Purge-era arrests and executions seemed to be intentional.) The next year, the deeply sad sounds of Shostakovich's Fifth Symphony touched the emotions of an audience in Leningrad. Stalin never knew that the composer wrote this work as a tribute to the victims of the Great Purge, which had struck Leningrad with special severity. Even Stalin could not fully control the arts.

## The New Communist State and the Capitalist Powers

Stalin claimed that the extreme danger of a capitalist invasion made his policies necessary. He argued that bourgeois leaders would not long tolerate the existence of a Communist state. Therefore, the USSR had to have a modern industrial economy at once; in no other way could the Red Army have the power to defend the nation. This swift economic and military build-up, moreover, could occur only if the ruler

kept every aspect of the nation's life under iron discipline and dealt ruthlessly with anyone who hindered the transformation. As they looked out to the most dangerous world that Stalin saw, citizens had to take great care not to commit economic, political, or cultural treason.

### Soviet Diplomatic Relationships

Stalin broke from NEP practices and turned to his new policies of forced industrialization and military development to make Soviet Russia safe in a capitalist-dominated world. In his quest for security through diplomacy, however, Stalin continued the approach of the NEP era. Foreign Ministry officials through the 1920s and 1930s used mostly traditional methods for dealing with other countries. For example, they pursued and finally secured formal diplomatic recognition from the same capitalist nations that party doctrine identified as enemies.

Diplomats of the young Communist state achieved other successes in addition to this official international acceptance. They arranged a special relationship with Germany (the Treaty of Rapallo) in 1922 and a nonaggression agreement with Estonia, Latvia, Poland, and Romania in 1929. By 1935, the Foreign Ministry completed an even more important negotiation and signed a mutual security pact with France.

Soviet officials combined these diplomatic steps toward security with a strong drive for disarmament and international cooperation for peace. The latter effort led finally to Soviet membership in the League of Nations in 1934. As recently as the late 1920s, Soviets had shunned the league as a bourgeois club, and capitalist states had barred their admission. The USSR in many respects had lost its image as a renegade state by the mid-1930s.

### The Comintern

Although the USSR depended mostly on economic development, the Red Army, and diplomacy for its security, Soviet leaders took another, more unorthodox approach to the promotion of its interests abroad. In 1919, they founded the **Comintern,** a new Communist international organization that attempted to get Communists everywhere to weaken capitalist states and back Soviet policies. This self-proclaimed subversive purpose conflicted with the Foreign Ministry's traditional diplomacy and sometimes hindered the development of good relations with capitalist nations.

### The Common Front

When Fascist governments in Germany and Italy began to appear extremely threatening to the Soviet Union in the mid-1930s, the Comintern became less openly hostile to capitalism. The organization then proclaimed a **Common Front** policy, urging all political forces opposed to Fascism to fight together against this new menace. In practice, Comintern activity in both its subversive and Common Front phases was of little importance to the global standing of the USSR. When Communists and Fascists finally clashed in 1941, Soviet industry and the modern Red Army stood between the Soviet state and disaster.

*When the whirlwind of the Great War struck Europe, it delivered the Russian old order a fatal pounding. The already strained institutions could not withstand the extreme pressures of this long siege. As the tsarist system finally collapsed early in 1917, few Russians mourned its fall. A Provisional Government took charge and promised democracy soon. But the leaders kept the nation at war, a grave mistake.*

*In November 1917, a second revolution brought to power a Communist government led by Vladimir Lenin. Competing forces resisted, and a devastating civil war exploded across Russia, lasting through 1920. Victorious Communists thereafter began to transform life in the vast region they had taken. The new government established a proletarian dictatorship and carried out a program of extensive but not complete economic socialization during the 1920s. The nation began to recover from the material destruction of war and revolution.*

*The leaders of the new Communist state struggled through a difficult power transition after Lenin's death in 1924. Joseph Stalin finally emerged triumphant by the end of the 1920s. He immediately accelerated the economic revolution, forcing peasants into a collectivized system of farms and ending private enterprise. Farmers died in the millions as they resisted the change.*

*Despite stiff opposition, the economic transformation came quickly. The nation went through its industrial revolution in a single decade, from the late 1920s to the late 1930s. At the same time, Stalin drastically tightened his personal control over the state, a feat accomplished in part by the execution of nearly all the leaders of the Communist Revolution and the officers of his army.*

*The emergence of this first Communist state and the simultaneous strengthening of similar movements in other European countries stimulated the growth of the extremely violent counterforce of Fascism. This and other repercussions of the rise of communism profoundly influenced the course of world history for the rest of the century.*

## Selected Readings

Carr, Edward H. *The Bolshevik Revolution* (three volumes). New York: Macmillan, 1951.

Conquest, Robert. *The Great Terror.* New York: Collier Books, 1973.

Filtzer, Donald. *Soviet Workers and Stalinist Industrialization.* Armonk, NY: M. E. Sharp, 1986.

Fitzpatrick, Sheila. *The Russian Revolution, 1917–1932.* New York: Oxford University Press, 1982.

> *Everyday Stalinism: Ordinary Life in Extraordinary Times: Soviet Russia in the 1930s.* New York: Oxford University Press, 1999.

Halsall, Paul, ed. *Internet Modern History Sourcebook: Russian Revolution.* (Access this source at *www.fordham.edu/halsall/mod/modsbook39.html.*)

Hindus, Maurice. *Red Bread: Collectivization in a Russian Village.* Bloomington: Indiana University Press, 1988.

Kennan, George F. *Russia and the West under Lenin and Stalin.* Boston: Little, Brown, 1961.

Lewin, Moshe. *The Making of the Soviet System.* New York: Pantheon, 1985.

McDermid, Jane, and Anna Hillyar. *Midwives of the Revolution: Female Bolsheviks and Women Workers in 1917.* Athens, OH: Ohio University Press, 1999.

Medvedev, Roy. *Let History Judge: The Origins and Consequences of Stalinism.* New York: Columbia University Press, 1990.

Volkogonov, Dmitrii. *Autopsy for an Empire: The Seven Leaders Who Built the Soviet Regime.* New York: The Free Press, 1998.

## Test Yourself

1) During the Civil War that followed the Bolshevik Revolution, the Red Army commander was
   a) Lenin
   b) Trotsky
   c) Kerensky
   d) Zinoviev

2) _____ indicated a strong negative working-class reaction to circumstances in the early years of the Soviet state.
   a) The Kornilov campaign
   b) Order Number One
   c) War Communism
   d) The Kronstadt revolt

3) Stalin's desire for a swift moving industrial revolution in Soviet Russia led him in the late 1920s to
   a) reject Lenin's New Economic Policy
   b) oppose the policy of "socialism in one country"
   c) replace the Five-Year Plan system with a One-Year Plan program
   d) delay collectivizing agriculture

4) The Soviet peasants' reaction to Stalin's farm socialization was
   a) resistance by trying to use up or destroy farm property
   b) non-violent demonstrations against it but careful avoidance of violent protest
   c) passive acceptance of it everywhere even though they opposed it
   d) enthusiastic support for the program

5) In their actual practices, Communists in the 1920s and 1930s most consistently showed their commitment to
   a) socialist economic principles
   b) international working-class revolution
   c) dictatorial methods of government
   d) a big-government welfare program for the poor masses

6) Decide which conclusion can be drawn most logically from these aspects of Soviet history, 1917 to 1930: factory control policy just after the Bolshevik revolution and before the Civil War; the treatment of artists and writers in the NEP era; and the way farms functioned in the 1920s.
   a) They show the almost unqualified oppressiveness of Communist Party rulers.
   b) They are examples of powers or freedoms granted to citizens.
   c) They reveal the consistent Communist hostility toward factory workers, artists, and peasants.
   d) They show that Communists favored party members with most of their policies.

*For the next two quiz items, complete this introductory-level critical-thinking exercise: Use the indicated Internet sites to examine documents that pertain to Chapter 10; review the related chapter sections; and then write an assessment of the accuracy with which the text reflects the contents of the documents. (Write about a page for each of these quiz items.)*

7) Examine the document at this site *www.marxists.org/archive/lenin/works/1917/apr/04.htm*, and then evaluate the text use of it in the chapter section titled "Lenin's April Theses" on page 212.

8) Review the portion of Lenin's "Testament" located at this site, *www.marxists.org/archive/lenin/works/1922/dec/testamnt/congress.htm*, and write an assessment of the text's reflection of its contents in the section headed "Lenin—From Twilight of Power to Dawn of Glorification" on page 226.

## Test Yourself Answers

1) **b.** Trotsky's very effective leadership of the Red Army in the Civil War had an important effect on the course of Soviet history and on his position in the Communist Party. Lenin certainly had much to say about the conduct of the war, and Zinoviev was among the very top party leaders, but neither of these people led the army. Kerensky belonged to the Socialist Revolutionary Party.

2) **d.** Although there are connections between War Communism and worker attitudes, only the Kronstadt naval garrison revolt involved mostly working-class people turning against the regime. The other two optional completions had no relevance to this question.

3) **a.** Stalin's reversal of position and decision to end NEP in 1929 illustrated his way of playing power politics and marked the beginning of a radical transformation of Soviet Russia's socioeconomic order, both important aspects of the history of the USSR in these years. The other three choices were complete fabrications.

4) **a.** The scale and extremes of the revolt against forced farm collectivization reveals a vital reality of Soviet history in Stalin's era. The other three options were simply wrong as generalizations about the reaction.

5) **c.** Although socialism, world proletarian revolution, and, eventually, the welfare of the masses were important to Soviet Communists, they acted in these years and after as if all other goals depended on dictatorship of the party elite.

6) **b.** Communists used oppressive methods in these years, at times they exhibited contempt for peasants (mainly the more prosperous ones), and they idealized urban industrial workers. The aspects of history to which this item refers, however, all pertain to the early freeing and empowering influences of Soviet Communism.

7) This critical-thinking exercise could proceed as follows: After carefully reading both the text section and the Lenin document, take notes or use some highlighting procedure to identify the most directly related content in both sources and to facilitate intensely focused thought about and commentary on these parts of the text and document. Then discuss the April Theses material, considering questions such as these: Which theses did the text refer to, and which did it omit, if any? Were omissions justified by the focus of discussion in the text or by their relative lack of importance to the account of events? Were the quotations accurate? Are the paraphrases close or more generalized, and in either case do they capture the sense of the document? Were points in the document presented in a rearranged or compressed form? If so, were alterations of this kind warranted by such considerations as the logical interrelationship of the points? Overall, does the section of the text pertaining to the April Theses effectively indicate the content of the document?

8) The purpose of the discussion in the part of the text related to Lenin's testament makes a much smaller proportion of the Lenin document relevant, but if this point is kept in mind and adjustments in the critical review are made accordingly, an essay for Question 8 could be carried out about as suggested for Question 7.

# Fascist Europe (1918–1939)

**January 1919:** German nationalist forces crush the communist Spartacist revolt.

**March 1919:** Mussolini organizes his first Fascist combat group in Italy.

**July 1919:** The Weimar (German) Republic completes its constitution.

**1921:** Hitler assumes command of the German Nazi Party.

**1922:** Mussolini becomes Premier of Italy.

**1923:** Hitler attempts to take over Germany (the "beer-hall *Putsch*").

**1929:** The Great Depression begins.

**1930:** Hitler becomes Chancellor of Germany.

**1932:** Antonio Salazar becomes dictator of Portugal.

**1933:** The Enabling Act establishes the Nazi dictatorship in Germany.

**1935:** Nazi Germany establishes the anti-Semitic Nuremberg Laws.

**1936–1939:** The Spanish Civil War brings Fascist Francisco Franco to power.

*In the late 1700s and early 1800s, the Left emerged in Europe as a movement determined to reverse the values of the* Ancien Regime *and bring equality for all people in wealth, social standing, and political power. Communism arose during the 1800s as the most extreme leftist movement, at least in theory. When Lenin and Stalin subsequently founded the first Communist state, they violated the principle of political equality and secured absolute authority for the ruler. Yet Soviet Communism remained leftist in the socioeconomic leveling accomplished by state ownership of all farm, industrial, and commercial property. This Communist dictatorship also promised, however deceitfully, that all citizens would enjoy equality in every sense when the new proletarian system matured.*

*The triumph of the Left in Russia inspired working-class militants across Europe to hope for and sometimes openly fight for a Socialist or Communist victory. But most Europeans to the west of the Soviet Union were enraged or terrified by the rising leftist forces. In their mood of wrath and fear, many welcomed a new extremism of the Right: Fascism. The founders of this right-wing movement proclaimed the inherent inequality of humanity. They vowed to crush the Left and end the threat of class war that would make everyone proletarians. They promised to bring security, power, and glory for citizens of all classes. They pledged to defend private property and stand up for the nation against the socialist and internationalist campaign of the Left. With such messages offered by leaders and parties adept at high drama, Fascists gained enough support to dominate the continent by 1939.*

## ■ THE BIRTH OF FASCISM IN ITALY

Italy's young and often shaky liberal democratic system remained intact under the strains of the Great War. Italian democracy proved too weak, however, to withstand the burdens left by that conflict. Within four years after the First World War ended, Italy gave birth to Europe's first Fascist dictatorship.

### Repercussions of the Great War

Italy deserted the Triple Alliance in 1915 and entered the war on the side of the Allied Powers. This diplomatic change enabled Italian Premier Vittorio Orlando to join the leaders of Britain, France, and the United States as one of the Big Four executives in the peace negotiations in 1918. Military victory and great-power status, however, did not lead to progress for Italy after the war. The nation, on the contrary, sank into despair and became torn by the worst strife since its violent struggle for unity ended in 1871.

### *The Peace of Paris as an Italian Defeat*

The urge to expand had driven Italy into the war in 1915. The Adriatic Sea that separated the Italian and Balkan peninsulas had territory along its northern and eastern shores that strongly tempted Italians. Expansion into these areas could increase the nation's security and add to its wealth. Italians, moreover, populated part of the region. When the Allied Powers promised this Austrian land as a reward for joining the war against the Central Powers, Italy accepted the offer.

In the Paris negotiations, however, the Allied leaders denied Orlando this territory. They argued that the unexpected fragmentation of the Hapsburg Empire removed the Austrian threat to Italian security. Allied diplomats also decided that the region contained too many Slavs to permit Italian rule. Italy had sacrificed five hundred thousand soldiers and spent itself into a crippling debt for this territory. Despite these costs of victory in the war, the government had no choice but to accept this "defeat" at Paris.

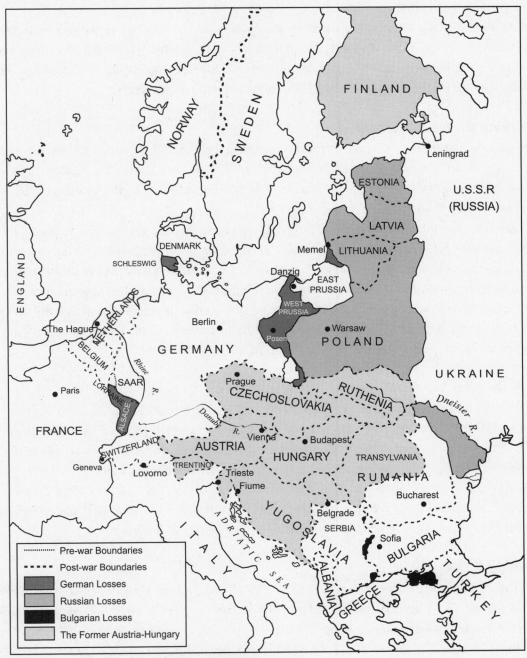

*Figure 11.1: Central Europe After World War I*

## D'Annunzio and the Conquest of Fiume

Gabriele D'Annunzio, a militant Italian nationalist poet, believed that he had a choice about the lands on the Adriatic. In September 1919, he marched his private nationalist army into the Adriatic port of Fiume and declared it his kingdom. Many Italians less inclined to dramatic action adored D'Annunzio for his patriotic feat and felt a killing rage toward their own leaders for their cowardice at Paris.

### A Faltering Government

Italian parliamentary institutions rested on shaky foundations even before the weakening shock of the Paris treaty. Since unification in 1871, national leaders had not solved the problem of economic backwardness in the south. They also had not overcome regional loyalties that hindered effective government. As a result, support for the national political system weakened over the years.

### The Working Classes in Rebellion

The government tried to increase its following during the war with promises of land reform to help poor peasants. When national leaders did not carry out this promise soon after victory, their inaction dashed the hopes of Italy's large farm population. The peasants tried their own solution. They began to take land away from its aristocratic owners.

Industrialists and urban workers found little more to please them in government policies than did the peasants. Business owners and laborers had made drastic changes in the manufacturing system to meet the needs of a nation at war. At the end of the struggle, they expected government assistance to ensure continued business profitability and employment during the transition to peace. Legislators again proved incapable of satisfying their constituents. Direct action suited urban laborers as well as it did the farmers. Workers in northern centers took over their factories. Industrialists and the owners of farm estates now had another bitter complaint, the loss of their property.

### Partisan Deadlock in Parliament

Changes in the party system hindered the ability of the government to respond to citizen needs. New Socialist and Catholic parties had emerged and gained great strength in the parliament. Both parties wanted reform. Divisions within these organizations, however, reduced their power to take action in the legislature. Furthermore, the four leading parties—Liberals, Democrats, Catholics, and Socialists—would not cooperate with one another. With the parliament so divided, it could not form a strong executive cabinet. Italian leaders, therefore, hardly led at all. Their reaction to illegal land and factory seizures was typical: They approved the peasants' theft and ignored the urban labor action.

### A Mounting Crisis

A crisis came quickly after the war. In June 1919, Italian diplomats signed the Paris treaty giving up their territorial claims. A wave of strikes and property seizures crested in 1920. Industrialists and aristocrats faced these horrors and also expected the hated Socialists in parliament to enact many unwanted reforms. Inflation struck all segments of society, but especially the middle classes, harder and harder after the war. By 1920, Italian money had lost eighty percent of its buying power compared to 1914. To make economic matters worse, large numbers of returning veterans could find no jobs. The crisis climaxed in December when the government shelled Fiume to drive out D'Annunzio, the hero of Italian patriots. In this state of misery, the nation longed for a savior.

## The Response of the Political Right to Chaos

The two-year crisis after the Great War prompted many rabid nationalists to arise with claims that they could save Italy and lead it to greatness. They organized bands of tough street fighters and prepared

to enact their programs by force if necessary. The figure of Benito Mussolini overshadowed all other nationalist militants.

### Mussolini (1883–1945) and Fascism

Mussolini began his political career as a member of the Socialist Party before the First World War. His writing and speaking skills soon earned him a leadership position in the party, and he became the editor of its journal. Despite his success on the Left, Mussolini broke with the Socialists. They continued to oppose all nationalist combat after the Great War began in 1914, but Mussolini wanted Italy to fight against the Central Powers. When Italy entered the war, he acted on this belief and volunteered for duty. By the end of the war in 1918, Mussolini had moved to the far Right politically. Soon he was ready to fight for his new principles. In 1919, Mussolini organized his *Fasci di Combattimento* (Combat Groups) for street war with leftists, the force he now considered Italy's great enemy. *Fasci,* the particular Italian word chosen to emphasize that these were solid units of political fighters, gave the movement its name—**Fascism.**

### Fascist Ideology

Many scholars deny that European Fascists had an ideology. But even if many theorists recognize no structure of political doctrine, Mussolini and members of his Italian Fascist Party vividly expressed the beliefs and attitudes for which they fought. Fascists depicted their most important principle with the movement's symbol, the **fasces.** They borrowed this image from the ancient Roman imperial design of an ax protruding from a bundle of tightly bound rods. Originally, this symbol represented the unity, power, and glory of the state at a time when ancient Italians ruled the world. Without words, the Fascists thus promised dedication to Italian tradition and a repetition of the Roman achievement. The speeches and actions of the Fascists constantly reinforced this ultranationalist and imperialist spirit.

In keeping with their determination to make Italy supreme, Fascists appeared to be viciously intolerant of anyone who pursued individual or class interests. Such divisiveness in their view weakened Italy. Fascists denounced liberalism and democracy as ideologies that glorified personal rights above national duty. They expressed even greater contempt for the leftist doctrines of socialists and communists. The Marxist campaign for international working-class revolution posed the ultimate threat to a triumphant nation.

Fascist tirades against liberal democratic institutions focused especially on the evils of the parliamentary system of government. Mussolini's forces charged that legislators debated but did nothing to achieve the greatness Italy deserved. Fascists would end the talk and drive the nation forward.

In this frantic advance, however, the Fascists promised never to destroy the true Italian legacy. The Fascist Party would preserve a hierarchy of classes rather than grind everyone into the proletariat. They would defend private enterprise and profits for industrious Italians. They would not nationalize property. The street war on Marxists reflected the movement's commitment to these principles.

Fascists declared that success in their crusade required the total submission of all Italians to them. They believed that they deserved this unquestioning obedience because of their exceptionally pure national spirit. Then everyone, party members and ordinary citizens alike, had to look to the leader of the Fascist Party as their ultimate authority. No one else so completely embodied the traits of an Italian—courage, forcefulness, discipline, and a spirit of self-sacrifice.

### The Appeal of Fascism

The Italian Fascists' ideology quickly made them the favorites of aristocrats and the lower middle classes. Fascism also attracted some industrialists. These segments of society shared the fascist spirit of super patriotism and hatred for socialists and communists. Fascists also provided useful and sometimes brutal services to factory owners and aristocrats. Mussolini's *Fasci* (also called the **Black Shirts**) attacked strikers and protected property from seizure. Ironically, these violent tactics caused most Italians to view the Fascists, rather than the government, as the leading force for law and order in an increasingly chaotic society.

## The Fascist Struggle for Power

Mussolini's right-wing warriors continued their combat against strikers and land grabbers in 1921. They also intensified their struggle to gain political power. In May, the Fasci used threats and violence to influence elections to the legislature. The Black Shirts assaulted leftist politicians. Beating opponents and force-feeding them huge quantities of castor oil became common practices. The police and courts approved and did nothing about the brutality.

### The Fascist Party on the Attack

After months of street warfare to prepare them for government responsibilities, Mussolini organized his followers into a political party in November 1921. This new Fascist Party already had about three hundred thousand people in its ranks and thirty-five representatives in the legislature. As Fascist power spread from public squares to the halls of government, Socialists tried to counter their enemies on the Right by increased labor militancy. The Socialists ordered a general strike for August 1922, but it failed because too few workers had responded to the call.

Fascists ignored these signs of weakness on the Left, raised the alarm of impending Communist revolution, and went on a rampage against the Left. The Black Shirts wrecked Socialist and Communist Party presses. They destroyed opposition-party buildings. In several cities, Fascists took even bolder steps. They threw out duly elected Socialist leaders and took charge themselves. This violent right-wing campaign against an exaggerated threat succeeded remarkably well. The Fascists' power and popularity expanded rapidly.

### The March on Rome

As defenders of private enterprise, public order, and the Italian flag, Fascists appealed to an ever larger public. Responses to the Fascist struggle for power revealed that by mid-1922 the party's following included more than aristocrats, the lower middle class, and a few industrialists. Fascists had by then become the heroes also of military leaders, the Catholic Church hierarchy, and the Italian king, Victor Emmanuel III (reigned 1900–1946).

Mussolini knew his moment had arrived. In September 1922, he began talks with royal officials and others to arrange his accession to power. The Black Shirts strengthened their leader's bid for control by threatening a mass march on Rome on October 28, 1922. Government leaders wanted to stop the Fascist action by force. The king refused to sign a martial law decree, then offered to make Mussolini Premier of Italy. When these developments made the way to Rome completely clear and safe, Mussolini arrived in the capital and took charge of Italy. No armed march on Rome took place except in the imaginations of those who loved the tough heroism of Mussolini and his Fascists.

# ■ GERMANY IN TRANSITION

Until the last days of the First World War, most Germans expected to win. Word of their country's military defeat and impending surrender plunged Germany into despair and chaos in October and November 1918. Revolts broke out and quickly spread. Emperor William II abdicated on November 9, 1918, and the Moderate Socialists in Berlin declared Germany to be a republic. Despite the declaration, the nation had only begun its difficult transition to self-government.

## The New Republic

The Moderate Socialists who led the new government did not plan to enact radical leftist reforms. They stood for democracy and the gradual development of an improved life for the masses. Before they could launch any programs, however, the republican leaders had to fend off rebels and at the same time organize their machinery of government.

### The Spartacist Revolt

Beyond the circle of Socialists who supported the new republic stood others who wanted to follow the path of the Russian Bolsheviks. One of these revolutionary Marxist forces, the **Spartacist Union** led by Rosa Luxemburg and Karl Liebknecht prepared to overthrow the new government even before it was fully formed. The Spartacists struck their blow for proletarian revolution on January 5, 1919, but suffered immediate and crushing defeat. German troops smashed the rebellion, arrested its two leaders, and murdered them on January 15.

### The Weimar Constitution

German military leaders had used their army to stop the Spartacists because they hated the Left. These militarists cared little for the idea of a republic. Supporters of representative government needed to construct effective political institutions if they were to have any chance of success in Germany. They met in a constituent assembly at Weimar from February to July 1919 and completed the fundamental laws of the German Republic.

The **Weimar Constitution** provided for an elected president empowered to appoint a chancellor. A cabinet of ministers under the chancellor formed the government's executive office. The Weimar document also established a legislative house, the **Reichsrat,** comprising representatives from the nation's eighteen states. Another parliamentary body, the **Reichstag,** had members elected for the nation as a whole rather than as representatives of districts. The constitution of the Weimar Republic gave Germany its first truly democratic government.

### The Arts in a Democratic Germany

The first decade after the Great War brought a wildly creative flowering of the arts that spread from Soviet Russia to the Iberian Peninsula. Bold new trends that started before the war became dominant among creative people and widely accepted by the part of the public oriented to the arts.

Germany contributed in an especially important way to this maturing phase of cultural modernity. The novels of Hermann Hesse and Thomas Mann probed German life to striking effect and, in the case of Mann's works, strongly influenced writing elsewhere. Paul Klee's abstract painting and writing about this art form became a fundamentally shaping force in Western visual arts. Walter Gropius and his

Bauhaus school of arts similarly affected the world of design and architecture. Because the Bauhaus spirit could be seen in products as diverse as kitchen utensils, housing, factories, and public buildings, few creative people of his era touched lives as closely as Gropius did.

## Weimar Germany in Crisis

Although in the 1920s Germans enjoyed unfettered cultural freedom and the new republic for the first time permitted real citizen influence, these circumstances lent little strength to the young Weimar government. It faced crisis after crisis. The constitution made it very difficult for a chancellor and cabinet to govern. If the executives could not pass laws, they had to overcome the stalemate in one of two ways. They could resign, and then the president would appoint a new chancellor who would try to win votes in the *Reichstag,* or a chancellor unable to pass bills could dissolve the *Reichstag* and hope that the subsequent election provided a working majority. The multitude of political divisions in Weimar Germany meant that chancellors could get an effective majority only by arranging the support of a group of parties, but these coalitions seldom lasted long. On the average, cabinets fell apart every eight months. Under these conditions, successful self-government was very difficult to achieve.

### The Versailles Treaty Crisis

Passionate German militarists despised the Weimar Republic especially for its acceptance of the Versailles Treaty. They strongly objected to the document in part because they believed that the article specifying Germany's responsibility for the war and requiring reparations disgraced the nation. Above all, treaty restrictions on armaments and the size of military forces enraged the officer corps. Military leaders did not intend to accept these provisions that would so weaken the nation's forces. They attempted to nullify the treaty's military clauses by financing private armies to sustain the armed force and heroic spirit of Germany.

### The Kapp Putsch

In March 1920, the republic began to carry out the military limitation clauses of the Versailles Treaty. Troops that the government ordered to disband refused to obey, however, and took over Berlin. They elevated Wolfgang Kapp to leadership of their newly declared German state. The legal government then fled the capital. This **Kapp Putsch** (coup) collapsed when labor forces countered with a general strike that shut down Berlin. The Left took heart from this success against right-wing militarists and rebelled in other cities. German army units suppressed these new working-class outbreaks as they had the Spartacists. The Weimar Republic remained in power, but it survived again because its right-wing enemies defeated the leftist opposition.

### The Battle over Reparations

Military clauses in the Versailles Treaty had maddened German officers and inspired the Kapp *Putsch.* Reparations provisions of the peace settlement also endangered the government. Paris negotiators left the size of Germany's penalty payments unspecified. After an extended dispute, Germany and the Allies decided that the total owed was one hundred and thirty-two billion marks (between forty and over five hundred billion in twenty-first century dollars, depending on the standards used for conversion). Compliance presented staggering economic problems for the republic, but Weimar leaders adopted a "fulfillment" policy. They would pay as much as they could, another sin against the nation from the Right's point of view.

The steps taken to meet reparations obligations produced a devastating inflationary trend. The value of German money (the **mark**) plunged to historic lows and continued downward. When declining economic conditions made it impossible to meet the reparations schedule, France and Belgium decided to punish nonpayment. In January 1923, French and Belgian troops occupied an important German mining and industrial region, the Ruhr valley. Laborers in the Ruhr stopped work to protest the foreign takeover, and the government pumped in funds to support the workers. As a result, inflation reached cataclysmic proportions. In 1914, 4.2 marks equaled a dollar. War effects made the dollar worth 32 marks by 1919. The Ruhr crisis caused German currency values to plunge so low that a single dollar equaled 4.2 trillion marks by 1923. The German economy was wrecked, and everyone suffered.

As this crisis developed through the early 1920s, the growing right-wing opposition forces blamed all the nation's woes on the Weimar government. Militant nationalist organizations targeted the republic's leaders for assassination. Matthias Erzberger had signed the armistice ending the First World War. Assassins felled him in August 1921. Walther Rathenau, a brilliant Weimar leader associated with the policy of fulfillment, died at the hands of fanatic nationalists the following June. Then the crisis worsened.

## Adolf Hitler (1889–1945)

During the early 1920s, the south German state of Bavaria became a stronghold of belligerent nationalist movements committed to the destruction of the Weimar Republic. By 1923, the reparations and inflation crisis so weakened the government that nationalist leaders in Bavaria assumed they could easily overthrow the Weimar Republic. They planned to march to victory in the same way that Mussolini had the previous autumn. The German conspirator with the strongest attack force was Adolf Hitler.

### An Immigrant Superpatriot

In 1913, when Hitler was twenty-four, he moved from his native Austria to Munich in the Bavarian region of Germany. As an ethnic German who believed passionately that everyone of that nationality should live in a unified state, he felt ecstatic and at home. Hitler viewed the outbreak of the Great War the next year as a blessing. He could fight for Germany. In heroic service as a message carrier at the front, Corporal Hitler suffered wounds and earned a prestigious medal, the Iron Cross. The end of the war confronted Hitler with dull civilian life in the horrible atmosphere of a nation that had surrendered.

### Hitler's Ideology

The beliefs that Hitler held dear made acceptance of Germany's fate difficult. He claimed that his experiences as a young ethnic German living in Vienna (1908 to 1913) gave him a rock-like structure of principles that never changed. These convictions included not simply nationalism but a racist form of the ideology. Hitler preached that true Germans belonged to the **Aryan super race,** a group destined by their superior genetic traits to rule the world. As a believer in such myths, Hitler found much to despise about Weimar Germany.

Hitler's conviction that Jewish influence predominated in Weimar intensified his hatred of the existing order. A supremely vicious anti-Semitic ideology, in fact, formed an inseparable part of Hitler's racist nationalism. He described Jews as a parasitic race with the potential to pollute pure Aryan blood and weaken the superior Germans. In his view, Jews destroyed culture; Germans created it. Hitler always demanded drastic solutions—at first, the expulsion of all Jews from Germany, and later the extermination

of all Jews everywhere. He would be able to make good use of this racist nationalist creed in Munich; such ideas were widely popular there.

### Formation of the Nazi Party

When Hitler returned from the war, he entered the ranks of the militant nationalists committed to destruction of the Weimar Republic. He joined the **German Workers Party,** a small right-wing group, and rose quickly in the organization. His racist nationalist message and hypnotic speaking ability helped to swell party membership. In July 1921, Hitler's party made him its all-powerful leader (**Fuehrer**). The organization now used the title **National Socialist German Workers Party.** Although Hitler rejected true socialism, this right-wing party hoped the title would win laborers away from the Left.

Hitler's **Nazis** (from the German words for "National Socialist") magnified their influence by political violence. As Fuehrer, Hitler commanded a brown-shirted political combat troop with two regular responsibilities—to shut down the meetings of opponents and protect members of the party. These **Storm Troopers** (**Sturmabteilung** or SA) also stood ready for the special duty of a revolutionary assault on the government. Hitler, other Bavarian nationalists, and right-wing political officials in that region thought that they could take over the country with such forces behind them.

### The Munich "Beer-Hall Putsch"

Concessions by Weimar leaders caused the conservative officials in the Bavarian government to change their minds about an autumn 1923 revolt against the German Republic. Hitler did not change his mind; he would lead the revolution of the Right. On November 8, 1923, as his formerly rebellious Munich associates held a meeting in a beer hall, Hitler burst in, shot the ceiling with his pistol, and demanded that the Bavarian officials support his seizure of power in Germany. They agreed, but their compliance meant nothing. They were ready to stop the Nazis at the first opportunity.

When Hitler and the Storm Troopers paraded into a central Munich square on November 9, they encountered police officers, soldiers, a hail of bullets, and immediate defeat. Fourteen Storm Troopers died in the gunfire. Hitler flattened himself on the street, avoided injury, and fled. After his arrest several days later, the Fuehrer was tried for treason and received a five-year sentence.

In certain respects, victory lay hidden behind this Munich defeat. The Nazi dead became useful martyrs in subsequent propaganda campaigns. The Fuehrer's very light sentence for treason also revealed the favor this racist nationalist found among many officials, including those in the judiciary. Court sympathies permitted Hitler to enter a relatively comfortable prison environment, write a book, *Mein Kampf,* and enjoy release after less than two years. The *Putsch* and prison experience made Hitler recognize the steps he needed to take to seize Germany. *Mein Kampf* also became an important Nazi propaganda tool that helped Hitler in his struggle for power. Mussolini's surprising success and Hitler's qualified victory at Munich had brought fascism to life in Europe by 1923, although nazism seemed to lack vigor until late in the decade.

# ■ FASCIST ITALY

During their struggle to achieve power, Fascists asserted that they came as nationalist revolutionaries to end the established system of parliamentary liberalism and crush the Communists who threatened to take Italy for the Left. Mussolini assured the nation with his first words as premier that Fascists could have destroyed the parliamentary system but did not want to, "for the present."

## The Transition to Dictatorship

In the beginning, members of the other parties joined the Fascists in the parliament and in the executive cabinet. Mussolini and the Fascist Party seemed tamed by the responsibilities of office. Non-Fascists in the government thus agreed to give the new premier extraordinary executive authority for one year.

Mussolini began at once to transform the system by putting Fascists in charge of the government bureaucracy and the upper legislative house (the Senate). He also gave the party power over the police and converted the Black Shirts into an official force on the public payroll. Despite this greatly increased strength, the Party still did not fully rule the important lower house of the parliament (the Chamber of Deputies) and faced serious opposition there.

### The Acerbo Bill

Before the legislative elections took place in April 1924, Fascists secured passage of the **Acerbo Bill,** an electoral law that doomed parliamentary government. The act provided for the party with the most votes above a minimum of twenty-five percent to take two-thirds of the Chamber seats. The Acerbo Law and the Black Shirts' talent for voter intimidation ensured Fascists a two-thirds majority in the Chamber after the spring elections. Their next step was to silence the minority.

### The Matteotti Murder

Giacomo Matteotti, a Moderate Socialist deputy, boldly fought Fascism with words. In the parliament, he vehemently condemned Mussolini and demanded that non-Fascist deputies stop cooperating with the Fascist leader.

Matteotti also reached out to a larger audience with explosive information. He published a book that documented many cases of Fascist violence and lawlessness. On June 10, 1924, Fascists abducted Matteotti and murdered him.

Public outrage over the assassination kept Mussolini's government on the brink of collapse for the rest of 1924. Opposition deputies tried to hasten the fall by boycotting parliamentary sessions. Unwittingly, they had given up their last lever of power. Mussolini reasserted himself in January 1925. He publicly accepted responsibility for the murder and released his Black Shirts to attack anti-Fascists. Soon Mussolini purged the government of non-Fascists, outlawed all parties except his own, and brought the press fully under Party control. With these actions, the Fascists approached totalitarianism.

## The Fascist State

The trend of Mussolini's government toward absolute dictatorship weakened in the latter 1920s. The Italian Fascist state, in fact, never became fully totalitarian, even though Mussolini kept his powerful dictatorial grip on the nation. The ruler's failure to exercise more complete control resulted in part

from the ability of traditional authoritarian institutions, such as the monarchy, the government bureaucracy, the military, the Roman Catholic Church, and certain business interests to remain somewhat independent within the state.

### The Ruling Party

Despite Fascism's less than totalitarian power, Italy still operated under a one-party dictatorship. The ruling Fascists structured their party in a hierarchy much like the Communist Party in the USSR. Instead of local cells, the Italian party had *Fasci*. The organizational pyramid above the *Fasci* extended to a Fascist Grand Council at the top.

True to the Fascists' right-wing belief that authority should be concentrated in the hands of a few leaders, Mussolini exercised dictatorial power over the Grand Council and the rest of the one million lesser party members. As Il Duce's (Mussolini's) chief agents, the Fascists, in turn, in theory and to a large extent in practice reigned supreme over the life of the nation.

### Fascist Government

Formal government structures remained unchanged under the Fascists. The king kept his position as technical head of state. Daily executive functions of government continued to be carried out by a premier and his cabinet. The two-house legislature still met. Citizens, moreover, retained the right to vote for Chamber deputies. But this system was largely a sham. Under Fascism, the king became a figurehead until Mussolini's government began to collapse during the Second World War. Mussolini served as permanent ruling premier, and the members of a single docile party sat in his parliament. Italians who voted had the meaningless choice of accepting or rejecting a candidate list presented by the Fascists.

## The Fascist Socioeconomic Order

Fascist Party and government mechanisms denied political control to Italy's thirty million citizens, who, nevertheless, stayed loyal. The party found it relatively easy to keep the support of most segments of society. Fascist policies, for example, ensured the continued social and material well-being of the traditional privileged classes. The lower middle class did not get such concrete rewards but remained devoted to the Fascists as a bulwark against Communism.

### Propaganda and Social Control

Fascist propaganda techniques also excited and attracted the masses. From his balcony and in other settings, Mussolini spoke to huge crowds and swayed them with his oratory. His generally dramatic flair enhanced this effect in public addresses and appearances. Il Duce's words and images reached a nationwide audience through the press, radio, and the cinema. The mass media, in fact, constantly bombarded Italians with propaganda designed to bend the citizenry to the Party's will.

### Corporativism

The ideology, policies, and actions that drew large segments of society to Fascism left many industrialists less than enthusiastic about the party through the early 1920s. Fascist leaders pursued the support of this important group in a special way once the party achieved power. In 1925, Mussolini's government

recognized a combination of industrialists as a corporation and granted it extensive economic power. Subsequently, the party also set up corporations for large-scale employers in trade and agriculture. The party then arranged similar organizations for labor and the professions, but without giving them economic influence.

By the 1930s, the Fascists began merging these corporations with government institutions, claiming to have created a new **corporative state,** in which socioeconomic classes lived and ruled themselves in harmony. The government promised that this system would yield prosperity for all classes. In reality, **corporativism** (sometimes also called **corporatism)** was a myth covering state-approved economic supremacy for propertied interests. It guaranteed a material advance for the upper classes only.

### The Lateran Treaty

By 1929, the Fascists decided to court the Catholic Church as they had business. This action, too, would benefit their cause by helping to unify and win the loyalty of a Catholic society. The party worked through difficult negotiations and finally arranged the **Lateran Treaty** (February 11, 1929) ending the state of non-recognition that had existed between the popes and the government since the completion of Italian unification. This agreement accepted the pope as the ruler of his own territory, Vatican City in Rome. He, in turn, gave up Church claims to other territories in central Italy. The Lateran Treaty enabled the Fascist state and the Church hierarchy to maintain an officially cordial but not warm relationship. More importantly, the agreement endeared Mussolini to the masses of Italian Catholics.

## ■ THE TRIUMPH OF NAZISM IN GERMANY

Enormous problems associated with the Versailles Treaty threatened to destroy the Weimar Republic during its first five years (1918–1923). This time of danger for the new government climaxed with the foreign occupation of the Ruhr valley that began in January 1923 and Hitler's beer-hall *Putsch* the following November.

## The Recovery of the Weimar Republic

Gustav Stresemann held office as chancellor during most of 1923 and thereafter was foreign minister until his death in 1929. In these positions, Stresemann implemented policies that gave the German republic its most secure and prosperous years.

### The Dawes and Young Plans

Stresemann led Germany from its ruinous inflation to economic recovery and greater political stability by a series of well-conceived actions. He quickly started to bring Germany's rampant inflation under control by drastically cutting the money supply and ending the costly Ruhr work stoppage. With the cessation of resistance in the Ruhr, Stresemann also signaled the Allied Powers that he wanted to cooperate to end the reparations conflict, the underlying cause of many of Weimar's problems.

Negotiations with the Allies then produced the **Dawes Plan** in early 1924. This agreement reduced reparations payments for the next five years and had a very beneficial effect on the German economy. When the Dawes Plan expired, Stresemann secured even better payment terms in the Young Plan. He also

won an Allied promise to withdraw troops from the German Rhineland, which they had occupied since the end of the Great War.

When Stresemann died in October 1929, he had brought a remarkable political, economic, and diplomatic renewal for Germany. Through all Stresemann's struggles to restore Weimar, however, Hitler and other militant nationalists fought against the republic with a vengeance. Every agreement Stresemann reached with the Allies simply strengthened the nationalists' view of him as a traitor, and of Weimar as a government worthy only of destruction. So long as the progress of the republic brought by the Stresemann government continued, the attacks of the Nazis and other right-wing critics had little appeal.

### The Great Depression

In the month of Stresemann's death, the New York stock market crashed. Business shares plunged to half their original value within a few weeks. Soon, many enterprises and banks failed. Numerous other financial institutions stood on the brink of collapse. They began to demand repayment of huge loans contracted by European nations in the wake of the Great War. As a result of the especially heavy debts of Germany and Austria, these countries quickly followed the United States into a deep economic slump.

By 1932, this **Great Depression** had spread to virtually every European nation. It created masses of jobless people, many of whom were ready for extreme measures to end the crisis. The especially severe shock of the Depression in Germany made the nation highly susceptible to the Nazi idea of a dictatorial nationalist savior.

### Hitler's Resurgence

Hitler left prison in late 1924, convinced that the Nazis should never again attempt a coup. He had had enough of facing bullets and sitting in cells. Legal victory over the republic became the new party watchword. Hitler at once began to convert the Nazis into a party designed to win *Reichstag* elections.

Soon, Hitler had an effectively organized movement with a national structure similar to the Italian Fascist Party's. After slow growth for several years, the Depression hit in 1929, and party membership surged. It soon became the strongest party in Germany. Hitler's brown-shirted warriors multiplied also. Desperate jobless men flocked into the Storm Troopers for action and wages. The Depression drove voters to Hitler, too. In the July 1932 *Reichstag* elections, the Nazis took two hundred and thirty seats, one hundred more than the second-place Socialists.

### The Destruction of Weimar

Industrialists, aristocrats, and officers in the military comprised the moderate Right leadership in Weimar Germany. The crisis produced by the Depression made these conservatives fear a surge in strength for the Left. From 1929 to 1933, Defense Minister Wilhelm Groener and his adviser, General Kurt von Schleicher, spearheaded the battle of the moderate Right to gain control over the government and completely nullify the Socialist Party's influence.

### Hitler's Invitation to Rule Germany

Groener and Schleicher pursued their goal at first by getting President Hindenburg to appoint moderate right-wing chancellors, who then tried to obtain a majority in the *Reichstag*. They selected Heinrich Bruening as chancellor in March 1930, but after fourteen months, his government failed. When Franz von

Papen, their second choice, lasted only six months, Schleicher himself became chancellor (December 2, 1932). His cabinet collapsed in less than two months.

Schleicher and his moderate Right supporters thought they had only two choices at this point—Papen or Hitler. Schleicher considered Papen too willing to cooperate with Socialists. Hitler would never befriend Marxists, but he presented problems, too. Many people of the moderate Right disliked the outrageous display and bullying tactics of radical Right groups such as the Nazis. This behavior made the Nazis unpleasant associates, but it did not make them unacceptable.

Schleicher felt confident of the course to take. Because the Nazis had more *Reichstag* deputies than any other party, Hitler could control the necessary votes. The moderate Right political professionals thought that they, in turn, could control him. The Schleicher faction pressured Hindenburg, and he invited Hitler to become chancellor on January 30, 1933.

### The Reichstag Fire

Hitler built his dictatorship with lightning speed once he took office. A fire set by a lone Dutch Communist arsonist that destroyed the *Reichstag* building in late February 1933 provided the Nazis with an occasion to act. They fed public fears with stories of a looming revolution plotted by the Communists with the fire intended as an igniting spark. Nazis implicated the German Communist Party, despite its lack of involvement in the arson, and outlawed the Marxist organization. Chancellor Hitler also issued a decree, signed by President Hindenburg, to suspend freedom of expression and public assembly and the right to private communication by mail and telephone. The crisis atmosphere enabled government and Nazi Party armed agencies (such as the SA) to arrest thousands of Communists and Socialists who were guilty of nothing but being leftists.

### The Enabling Act

In *Reichstag* elections the month after the fire, Storm Troopers unleashed the most extreme siege of threatening behavior ever. Even though the Nazis won only forty-four percent of the votes with these tactics, Hitler easily dominated the new assembly. He made deals that secured the support of all parties except the Socialists. Then on March 23, 1933, Hitler presented the **Enabling Act,** a law granting him dictatorial power until April 1, 1937. Socialists cast the only negative votes, too few to matter.

### The Night of the Long Knives

Legal opposition to Hitler had ceased to exist, but resistant factions remained. Influential moderate rightists such as Schleicher worried the Fuehrer. They might not support him strongly enough. Members of the radical Right bothered Hitler, too. These troublesome militants included many Storm Troopers (the SA) and their leader, Ernst Roehm. The SAs wanted a nationalist version of socialism, to which Hitler only gave lip service. They also insisted on taking the place of the army as the supreme security force. Hitler had to have the support of conservatives who opposed the SA idea of nationalist social revolution, and, even more, he wanted the German military on his side. He especially needed the army leadership's backing in order to inherit the title of president from the seriously ill Hindenburg. The SA had become a threat to Hitler's ambitions.

The Fuehrer struck on June 30, 1934. A wave of arrests and summary executions began on this **Night of the Long Knives** and continued for several days. This purge snuffed out the lives of Roehm and

many other SAs, Schleicher, a few Catholic activists, and several people who were just personal enemies of the executioners. The attack subdued the SA and increased the prominence of Hitler's personal guards, the **Schutzstaffel** (**SS**), the killer force that carried out the murders. This special agency thereafter became one of the chief instruments to implement Hitler's every wish.

## The Nazi State

In the process of smashing Weimar institutions and sources of possible resistance to Nazism, the party forged its new state. Nazi actions in May and June 1933 closed all independent trade unions and replaced them with a single Labor Front under party control. In July, all opposition parties were outlawed. These measures against parties and unions removed two important nongovernmental structures that could have limited Nazi authority.

### Government Reorganization

At first, much of the upper structure of government remained unchanged under the Nazis. Germany still had a president (Hindenburg), chancellor (Hitler), cabinet, and two-house legislature. Hitler, however, wielded all the authority in this system. As one indication of the Nazi leader's supremacy, when Hindenburg died (August 1934), Hitler became president as well as chancellor.

The Nazis made more obvious changes in governmental institutions at other levels. The Fuehrer issued a decree in April 1933 requiring the removal of all civil-service personnel not absolutely loyal to the Nazis. This action to tighten control over central government bureaucrats coincided with steps to subdue officials in territorial subdivisions such as Bavaria and Saxony. These and other German states had kept significant power over local affairs since the unification of Germany. Laws passed in April 1933 and January 1934 gave the central government dominance over bureaucrats at lower levels.

The Nazis also seized supreme authority over law enforcement. Hitler empowered himself and other Nazis to interfere at will in the operation of the courts. In April 1933, the party organized the **Gestapo** (the Secret State Police) under Heinrich Himmler. This covert force and a special security division of the SS had unlimited power to arrest and punish citizens. Hitler and his party were the law in the Nazi state.

### A War Economy

The Fuehrer had made it clear on the Night of the Long Knives that the word Socialist in his party name meant nothing. He would not take the money, goods, or enterprises of the wealthy. His economic obsession was to give the Nazi state the ultimate war machine. Financiers, industrialists, merchants, and farmers could own and profit handsomely from their businesses or land, so long as they served this singular purpose. Hitler governed. The business classes obeyed and grew rich.

## Hitler's Social Vision: One Folk

Hitler expressed in fiery speeches his dream of a nation made up of "one folk," a country in which everyone belonged to the superior "Aryan race" and lived in complete loyalty to Nazi principles. His vision required a transformation not just of the state but of German society as well.

### The Arts and Education in an Aryan Nation

In their effort to possess the souls of all Germans, the Nazis established the **Ministry of Popular Enlightenment.** Joseph Goebbels (1897–1945) directed this agency as it tried to instill the spirit of Nazism in all publications, radio broadcasts, films, plays, and works of art. The creative spirit that flourished under Weimar had to end. Both Thomas Mann and Walter Gropius found refuge in the United States. Others, too, took their talents away from Hitler's Germany.

Although some people fled their changing homeland and others stayed to resist the Nazification of Germany, almost the entire cultural and scientific elite cooperated in Goebbels's campaign to present a thoroughly racist-nationalist view of life. Schools at every level slanted education to serve Nazi purposes. They taught absolute obedience to the leader. They urged faith in his Aryan and anti-Semitic myths. Indoctrination continued beyond school hours in the **Hitler Youth,** the nation's only legal organization for young people. (Everyone who was ten to eighteen years old belonged.) The party staged massive rallies, especially at Nuremberg, to deepen the nationalist trance of young and old alike.

### Religion under Nazism

From the perspective of the Nazis, their attack on Jews was a "racial" rather than a religious matter. Despite this myth, the Nazi attempt to remove all Jews from Europe and erase the influence of Judaism constituted an attempt to destroy both an entire ethnic group and a religion fundamental to European civilization. Nazi leaders showed more tolerance toward Christianity, so long as Christians displayed absolute loyalty to Nazi dogmas. Christians did not have to die, if they at least seemed to allow Hitler to possess their souls.

### The Nuremberg Laws

Immediately after taking power, the Nazis unleashed their assault on Jews. The Party began to seize their property and excluded them from businesses and professions. Much of the early anti-Semitic legislation was incorporated as **race law clauses** in codes affecting the press and other aspects of life. The **Nuremberg Laws** in September 1935 contained a more sweeping attack. They ended Jewish citizenship in Germany, outlawed marriage between Germans and Jews, and made sexual intercourse between members of these "races" a crime.

### Crystal Night

Another anti-Semitic surge occurred in late 1938. A Jewish youth embittered by the deportation of his parents from Germany to Poland killed a German Embassy official in Paris on November 7. A wave of anti-Semitic destruction broke out across Germany. Mobs smashed through Jewish districts, destroying their shops, torching their homes and synagogues and, according to probably understated official accounts, killing thirty-six people and seriously injuring that many more.

The trail of broken windows left by this attack inspired the description of this time of violence as **Crystal Night.** After a government review of the event, officials fined the Jews one billion marks for the damage done by the rioters who had attacked them. An intensification of the campaign to herd Jews, especially "healthy males," into concentration camps also followed Crystal Night.

## *The Christian Response to Nazism*

Many Christian leaders offered no objections to the actions of the Nazis. Their silence induced Hitler to allow the churches to stay open. His spirit of compromise toward a faith that he personally rejected even included a formal agreement with the Catholic Church (July 20, 1933) to tolerate its operation of schools and other organizations. Thereafter, the Nazis gradually escalated their program to diminish the influence of Christianity. Their struggle against this religion and other actions by the party led Pope Pius XI (1922–1939) to issue sharp official criticisms of the Nazis. His successor, Pius XII (1939–1958), proved more tolerant of Nazism.

Protestant leaders also exhibited diverse attitudes toward Nazism. In late 1933, a group of 8,000 pastors split over whether they should support or oppose Hitler. Three-fourths of them formed a movement against Nazism. Many of these resistant ministers eventually suffered greatly for their stand. The other Protestant leaders kept their faith in the Fuehrer, as did most of the members of the German Christian churches. In fact, many German Christians responded quite positively to Hitler and his doctrines of brutally oppressive anti-Semitism and imperial warfare.

## ■ THE BORDERLANDS OF FASCIST EUROPE

The First World War and the Peace of Paris left the former Austrian territories and the Balkan States with ineffective governments, gigantic economic problems, and severe social conflicts. These conditions in East Europe ideally suited the growth of extremist movements. In several societies in this region, Socialists and Communists soon attempted to seize power on behalf of the downtrodden working classes. Then the rising force of Fascist and other similar right-wing movements pushed the left-wing extremists aside, and by the 1930s, Fascists ruled every East European state except Czechoslovakia. Events followed a somewhat similar pattern in Spain and Portugal, thus completing a wide band of Fascist nations around the great Italian and German dictatorships.

### Fascism in East Europe

New, restored, or restructured nations covered the map of East Europe because of the collapse of the Russian and Austrian Empires at the end of the Great War. Strong authoritarian political traditions gripped the region, however, except in Czechoslovakia. All the formerly autocratic countries had new self-governing systems that they had to learn to use. At the same time, they had to solve the serious problems left by the war.

### *A Restored Poland*

Poland provides a good example of the political difficulties of the region. After more than a century in subordination, the Poles won independence from Russia as the Great War drew to a close. Allied peacemakers then arranged a favorable territorial settlement for the restored nation. Poland proceeded to establish a parliamentary democracy, turning away from monarchy for the first time in the nation's long history. The legislature, in fact, had such power that it could virtually ignore the president.

Despite such seemingly favorable political circumstances, the Polish government faced economic and national-minority problems that threatened to destroy the new system. No governing agency except the all-powerful **Sejm** (lower legislative house) could overcome these difficulties, but its members

debated endlessly and did nothing. One critic said that the flies in the chamber died of boredom during the meaningless discussions.

Poles gave up on their democratic experiment by 1926 and accepted a military dictator as ruler. Centuries of authoritarian government had not equipped legislators for their difficult tasks, but they had prepared the nation to yield to an autocrat.

### The Victory of the Right in East Europe

Although the specific circumstances varied in the other countries of East Europe, almost all of them had political traditions and problems that encouraged the failure of young self-governing institutions. The experience of Estonia, Latvia, and Lithuania (the **Baltic States**) very closely paralleled Poland's. Events in Austria took a similar course, up to a point. This small remnant of the Hapsburg Empire also made the transition from democracy in the 1920s to a right-wing dictatorship by 1934. Then in the late 1930s, the new Austrian rulers developed a system with much more strongly Fascist traits than Poland's.

Hungary turned to a rigid authoritarian government more quickly than the other states of the region. Hungarian Communists led by Bela Kun attempted a revolution at the end of the Great War. After the failure of this rebellion in late 1919, Hungary began a decade under a dictatorial government that attempted to restore *Ancien* traditions. By 1931, more modern authoritarians won control. Hungarian Fascists established a regime much like Hitler's. Right-wing dictatorships also supplanted feeble parliamentary systems in Bulgaria, Albania, and Greece by the end of the 1930s.

## Iberian Fascism

Neither Portugal nor Spain, the two states on the Iberian Peninsula, had strong modern political and economic institutions in the 1920s. In both nations, the aristocracy, the Catholic Church, and the military leadership clung tightly to *Ancien* traditions. These sectors of society remained a powerful force.

### Salazar in Portugal

The parliamentary government that Portugal had established in 1910 fell to an army rebellion in 1926. General Antonio Carmona ruled until 1932 when Antonio Salazar (1889–1970) began his long dictatorial reign. Salazar brought to Portugal a variety of Fascism similar to Mussolini's, except less flamboyant and more truly committed to old traditions. Salazar devoted himself to the promotion of the Catholic heritage in particular.

### Franco in Spain

King Alfonso XIII (reigned 1886–1931) helped to establish Primo de Rivera as a Fascist dictator in Spain in 1923. Despite the strength of traditional forces in this country, liberals and leftists mounted an opposition movement that led to Rivera's departure in 1930 and the king's abdication in 1931. Alfonso's opponents then established a republic and proceeded to enact a liberal and socialist reform program.

Spain's extremely deep-seated social and economic problems presented almost insurmountable barriers to the success of these efforts to create a workers' republic. The very hostile reaction of the Right to this venture completely doomed it. The landed aristocracy, the Catholic Church, and the military had sufficient influence in political and other institutions to block most reforms. A more dangerous threat

appeared with the emergence of a new Fascist movement, the Falange. In 1936, General Francisco Franco (1892–1975) commanded these forces of the Right as they challenged the republic on the field of battle. The Spanish Civil War raged until 1939, when Franco finally destroyed the republic. By the time of Franco's triumph, three-fifths of the European states had Fascist governments. In many respects Modern Europe had become Fascist Europe.

*When the First World War ended in November 1918, almost all European states had democratic governments. Italians rejected democracy four years later and willingly submitted to the right-wing dictatorship of Benito Mussolini and the Fascists. By 1939, similar authoritarian regimes had taken charge in Germany, Portugal, Spain, and every East European country except Czechoslovakia. This political conversion was generally welcomed by the citizens of these Fascist states.*

*The Fascist and other right-wing dictatorships maintained their broad popular support in a variety of ways. They protected the privileges and property interests of the rural and urban upper classes and thus encouraged the loyalty of these elites. The lower middle and working classes did not do so well economically, but the Fascists offered much more that kept these groups devoted—huge military buildups that provided jobs and a sense of power, emotionally satisfying fanatic nationalism, and a leader with a god-like image.*

*The enticements offered by right-wing dictatorships to crisis-ridden societies with strong authoritarian traditions made the victory of Fascism over democracy relatively easy in most of Europe. But in a small circle of nations of the European north and northwest, the institutions of self-government survived through the 1920s and 1930s. None of these democratic states, however, exhibited the vibrancy of the Fascist regimes.*

## Selected Readings

Bullock, Alan C. *Hitler: A Study in Tyranny.* New York: Harper & Row, 1964.

Dawidowicz, Lucy S. *The War against the Jews, 1933–1945.* New York: Holt, Rinehart, and Winston, 1975.

Eyck, Erich. *A History of the Weimar Republic.* New York: Atheneum, 1970.

Fest, Joachim C. *Hitler.* New York: Harcourt, Brace, and Jovanovich, 1974.

Gay, Peter. *My German Question: Growing Up in Nazi Berlin.* New Haven, CN: Yale University Press, 1998.

Halsall, Paul, ed. *Internet Modern History Sourcebook: Benito Mussolini—What Is Fascism, 1932.* (This primary source is available at *www.fordham.edu/halsall/mod/mussolini-fascism.html.*)

Hitler, Adolf. *Mein Kampf.* Boston: Houghton Mifflin, 1962.

Kershaw, Ian. *The Nazi Dictatorship: Problems and Perspectives of Interpretation,* 4th Edition. New York: Oxford Press, 2000.

Mack Smith, Denis. *Mussolini.* New York: Viking, 1982.

Payne, Stanley G. *A History of Fascism, 1914–1945.* Madison: University of Wisconsin, 1995.

Rogger, Hans and Eugene Weber, eds. *The European Right: A Historical Profile.* Berkeley: The University of California Press, 1965.

Seton-Watson, Hugh. *Eastern Europe between the Wars, 1918–1941,* 3rd Edition. Hamden, CT: Archon, 1962.

Spielvogel, Jackson J. *Hitler and Nazi Germany: A History.* Englewood Cliffs, NJ: Prentice-Hall, 1988.

Tannenbaum, Edward R. *The Fascist Experience: Italian Society and Culture, 1922–1945.* New York: Basic Books, 1972.

## Test Yourself

1) One advantage Italian Fascists and German Nazis had in their efforts to gain and consolidate power that the communists did not have was the support of
   a) many Christians
   b) urban factory workers
   c) intellectuals
   d) an organized and dedicated party

2) The beer-hall *Putsch* was
   a) the meeting place in which the Nazi Party first rallied
   b) a revolt of generals against Hitler
   c) a large German communist rally in 1917
   d) Hitler's unsuccessful attempt to seize power by force

3) The Night of the Long Knives best supports which of these theories?
   a) A Fascist dictator is usually further to the Left than any of his followers.
   b) Murder was a fate Hitler saved for Jews.
   c) Totalitarian dictators get stronger by killing their own party members.
   d) Nazis hated everyone but other Nazis.

4) A tactic that Italian Fascists and German Nazis used to win a following was
   a) playing on fear of Communism
   b) assassinating prominent members of the Christian clergy
   c) promising massive welfare programs paid for by heavy taxes on the rich
   d) promising to cut military spending

5) By the late 1930s, the one East European country that rejected Fascism and remained democratic was
   a) Austria
   b) Czechoslovakia
   c) Hungary
   d) Poland

6) Which group probably felt the least able to pursue important life interests under Fascist dictatorship?
   a) Christians
   b) wealthy industrialists
   c) people of the middle class
   d) leading figures in the arts

7) The outcome of the First World War left Italy and Germany with a sense of injustice and loss that helped to encourage the growth of Fascism in both nations. During a crisis in Italy in the early 1920s, Mussolini became the country's leader and built a Fascist state. Hitler attempted to win control of Germany the following year under similar circumstances but failed. The Nazi leader ended up in prison instead of in charge of the government. Explain the differing results in these two struggles of Fascist leaders to achieve power.

## Test Yourself Answers

1) **a.** German and Italian communists and Fascists had significant support among factory workers, the backing of dedicated parties, and intellectual advocates who helped their causes. Christians in these countries, however, mostly opposed the extremely secularist Communists and lent strength to the Fascists movements.

2) **d.** The Nazi attempt to seize power by beginning a revolt in Munich in 1923—called the beer-hall *Putsch* because the action began in a tavern—was a very significant turning point in the rise of Hitler. His failure there caused him to take a "legal" approach to winning control of Germany.

3) **c.** On the Night of the Long Knives, Hitler had members of the Nazi Party killed. Many of the victims held more leftist views than their leader, and their assassination strengthened his control over the party and made Nazism more appealing to important right-leaning segments of German society.

4) **a.** Among the many appeals of Fascist movements to Europeans, one of the most important was the belief that these radical right-wing forces were necessary to defeat the Socialist or Communist revolutions that seemed to threaten revered traditions such as private enterprise. Fascists generally managed to avoid seeming very anti-Christian or anti-upper class during their struggles to achieve power.

5) **b.** In the 1920s, a tier of newly established parliamentary states stretched across East Europe. Only Czechoslovakia remained a democratic state with a legislative system by the latter 1930s. The unusually rapid changes in the political makeup of this region and the influence of war, socioeconomic crisis, and political tradition on this process makes this an especially revealing aspect of Modern European history.

6) **d.** Knowledge of the social groups that found Fascism acceptable and those that did not helps to reveal the character of this kind of right-revolutionary movement. The artistic elite, especially, as it was in the two decades after the Great War, and the Fascists with their demands for rigid sociocultural conformity were very incompatible. The other groups listed had a much more favorable attitude toward Fascism.

7) The following is one example of points to discuss in an analysis of the problem posed in this quiz item: Mussolini dealt with leaders in the central government, negotiating for power, while his followers threatened to march on the capital. He won appointment as premier by the person with authority to give him that position. In contrast, Hitler tried to work with leaders in a single German state to overthrow the central government. When these state officials decided against action, Hitler forced them to act as though they supported him as he attempted to start a violent coup in the capital of a south German state, away from the center of national power. Both of these Fascists led movements that rose as defenders of the nation and its traditions, but the nature of Hitler's actions in the 1923 coup attempt hardly agreed with that spirit. Mussolini's did, and he directed his more promising efforts toward Rome rather than toward some less vital political point.

# Democratic Europe (1918–1939)

**1918:** The Dadaist movement in art and literature begins in Switzerland.

**1919:** British troops attack independence demonstrators in Amritsar, India.

**1922:** T. S. Eliot publishes *The Waste Land*.

**1923:** The British Labour Party wins control of the government for the first time.

**1926:** A twelve-day general strike breaks out in Britain.

**1928:** All adult women in Britain gain the right to vote.

**1930:** Freud publishes *Civilization and Its Discontents*.

**1932:** Aldous Huxley publishes *Brave New World*.

**1934:** A right-wing attack on the French government leads to the Stavisky riots.

**1936:** The Popular Front, a French Left coalition, wins control of the government.

**1937:** Picasso paints *Guernica* as a war protest.

**1938:** Ireland gains full independence from Britain.

**1939:** European physicists split an atom for the first time.

*In East Europe, democracy endured through the 1920s and 1930s only in Czechoslovakia. Sixteen nations in that region and in South Europe turned from self-government to Right dictatorship in these two decades. Societies elsewhere in Europe resisted this transition to Fascism. A northern tier of states comprising Finland, Sweden, Norway, Denmark, and Britain preserved their democratic institutions throughout this period. France, Belgium, Holland, Luxemburg, and Switzerland formed another block of democracies directly south of Britain.*

*Among the North European democracies, the states other than Britain displayed striking vitality throughout these two decades as they developed and utilized the institutions of popular government. Four of the five democracies south of Britain recovered from the war and coped with economic depression in*

*the 1930s without serious difficulty, although they enjoyed somewhat less dramatic political success than the northern democracies. The political record of France, the fifth country in this southern group, varied markedly as the years passed.*

*French leaders responded in a truly impressive way to the destructive effects of the Great War, and the country was thriving by the end of the 1920s. When the Depression struck in the next decade, however, the government faltered seriously. By 1939, France was a dangerously weakened nation. Britain, the country with the most deeply rooted parliamentary tradition and a century of experience in successful reform, easily kept its democratic government intact through these two troubled decades. But the British accomplished little else. From the early 1920s onward, the leaders of Britain seemed at a loss as they faced the problems of the era.*

## ■ THE STRONGHOLDS OF EUROPEAN DEMOCRACY

Most of the smaller and less populous democracies governed themselves with remarkable success in the twenty years after the First World War. They demonstrated that coping with social crises such as the Great Depression did not require dictatorial leadership. In several of these strongholds of democracy, political trends, in fact, ran counter to the authoritarian currents of the time, as constitutional changes allowed increased popular influence over government.

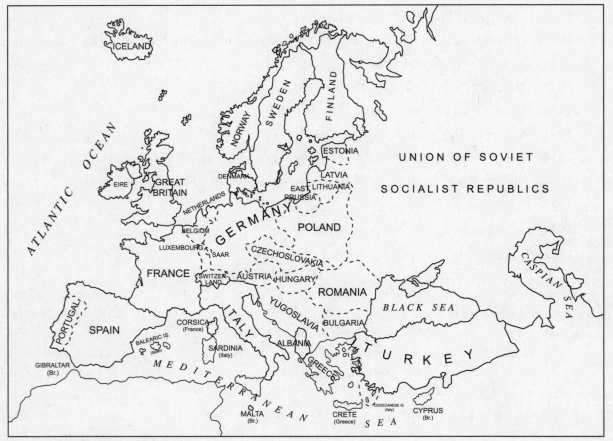

***Figure 12.1: Europe, 1924–1937***

## The Nordic Democracies

The most impressive advances for democracy during the 1920s and 1930s occurred in the Nordic countries: Denmark, Norway, Sweden, and Finland.

### *The Scandinavian Nations*

Denmark, Norway, and Sweden have many linguistic and cultural similarities, and historians often refer to the three nations as **Scandinavia.** The Industrial Revolution began in these countries in the closing decades of the 1800s, later than in most of Europe. Such a delayed transition to a modern socioeconomic system tended to retard the development of popular influence in government in other regions of Europe. This pattern did not occur in Scandinavia.

**Democracy in Scandinavia.** By the 1870s, all the Scandinavian nations had assemblies with a degree of influence over public affairs. Thereafter, these societies managed a very orderly transition to mature parliamentary systems. Norway completed this change to representative government in 1884, Denmark in 1901, and Sweden in 1917. Full political democratization came to Scandinavia almost as quickly as representative practices. Norway granted the vote to all adults in 1913, Denmark in 1915, and Sweden in 1921.

**Socialism.** The Scandinavians proceeded from the achievement of political democracy by 1921 to the development of socialism in the 1920s and 1930s. This movement toward the equalization of wealth took place in an atmosphere of constructive compromise, as had the earlier process of democratization. Instead of demands for the nationalization of enterprises, Scandinavian socialists cooperated with other political factions to organize and control the economy in a way that ensured the welfare of the masses without destroying private enterprise.

**The Response to Depression.** As a result of Scandinavia's transition to socialism, the Depression that swept over Europe in the 1930s caused minimal suffering in these three Nordic countries. Businesses failed and the number of unemployed people grew, but Scandinavian governments carried out extensive reform programs to prevent economic misery. Political leaders increased the coverage of previously established welfare programs and thereby took care of virtually all sick, disabled, and elderly citizens. These Nordic states also devised insurance systems to ease the plight of the unemployed. Sweden went even further and organized government work projects to provide jobs for displaced laborers. No other European governments equaled the success of these three states in their response to the Depression.

### *Finland*

The progress of democracy in Finland came under very different circumstances. Sweden began to annex parts of Finland in the 1100s and continued this process until the country became a dependent province. It remained subordinated to Sweden through the 1700s. In 1808, Russia replaced Sweden as the master of Finland and dominated the country until 1917. The people of Finland, however, persistently resisted this foreign authority.

Under the determined leadership of people such as Pehr Svinhufvud in the early 1900s, their struggle brought them increased control over their own affairs but not full independence from Russia. (Svinhufvud paid for his efforts—the tsarist government exiled him to Siberia for most of the years of the Great War.) As the Finns advanced by degrees toward autonomy, they also became pioneers of democracy. In 1906, they won the right to have a one-chamber parliament and gave the vote to all adults, including women. No other European nation allowed women to vote on parliamentary deputies at that time.

Finland achieved complete independence during the Russian revolutions in 1917. Finnish Communists and their opponents struggled for supremacy for months thereafter. Following the defeat of the Communists, the Finns continued the process of democratization. They approved a constitution in 1919 that institutionalized the self-governing systems they had begun to build even before independence. Finland's democratic leaders then began a program of socioeconomic reform. A law passed in October 1922 took land from large aristocratic estates and divided it among poorer farmers. One-third of Finnish peasants became landowners as a result.

With its moderate leftist approach to government, Finnish democracy remained strong, and the nation thrived throughout Europe's Fascist era. But Finland's government did face serious threats from the extreme Right and Left during the Depression. As president of the country from 1931 to 1937, Pehr Svinhufvud led the resistance to both a fascist movement and the Communist Party. The danger posed by fascism seemed especially serious, and the government met it by outlawing militaristic political organizations and the display of party uniforms and symbols.

## The Smaller West European Democracies

Although their social reform programs did not equal those in Scandinavia four small democracies in West Europe took important steps after the Great War to strengthen their institutions of self-government and enhance the lives of their citizens.

### The Benelux Countries

Belgium, the Netherlands (Holland), and Luxemburg form a triangle of states with frequently linked histories. Because of the often close relationship among them, they have become known (from the merger of portions of their names) as the **Benelux Countries.** These nations developed strong traditions of representative government in the 1800s. In 1919, all three countries altered their constitutions to increase the political authority of the citizenry. Belgium established universal male suffrage and gave the vote to portions of the female population. Luxemburg and the Netherlands extended electoral rights to all adults.

During the Depression, the governments of Belgium and the Netherlands intervened actively in the economy to ease the effects of the economic crisis. Even so, conditions in the 1930s became serious enough to encourage the rise of fascist movements in both these nations. The two governments responded with anti-Fascist legislation similar to Finland's. By the late 1930s, parliamentary election results in Belgium and the Netherlands revealed that the appeal of Fascism had dropped to insignificant levels. Democracy held firm in the Benelux Countries.

### Switzerland

A simple and practical form of democracy evolved in Switzerland as the country emerged in the late Middle Ages and Early Modern Era. By the mid-1800s, the Swiss had developed a system of government

that embodied the modern democratic principles of the High Enlightenment. Defenders of *Ancien* tradition in the 1800s considered Switzerland to be a center of radical democracy that threatened to infect all of Europe.

The Swiss maintained these strong traditions and institutions of self-government during the Fascist era. Radical Right movements, however, gained enough adherents in the Depression years to concern Swiss leaders. They countered Fascism with laws against militarist political organizations. The government also reduced the appeal of right-wing extremists with a program of Socialist legislation similar to Scandinavia's.

## Czechoslovakia—a Democratic Outpost in East Europe

The Allied victors sanctioned the breakup of the Austrian Empire during the negotiations in Paris at the end of the Great War. Czechoslovakia, one of the new countries that emerged in former Hapsburg territory, had a citizenry shaped by a society with a tradition of religious and artistic individualism. Democracy thus found a favorable environment for growth there.

### The Founders of the New Czechoslovak State

The leading figures in the development of Czechoslovakia's government, President Tomáš Masaryk and Foreign Minister Edvard Beneš, exhibited both political skill and a strong commitment to popular sovereignty. They took full advantage of regional traditions and built a vigorous democratic system in the nation's early years. Their policies also encouraged a surge of prosperity in the 1920s and early 1930s. The government achieved this success by enacting a rural land redistribution plan similar to Finland's and supporting the further development of the nation's already strong industrial economy.

### The Struggle against Economic Depression and Fascism

The Great Depression threatened to undermine Czechoslovak democracy and drive the nation toward Right authoritarianism as it had so many other European states. As conditions worsened in the 1930s, a large German minority within Czechoslovakia's western borders (in a region called the Sudetenland) grew increasingly restless. Pro-Nazi movements formed there and began to work for the merger of the Sudetenland with Germany.

Militant nationalist sentiments soon began to affect other ethnic minorities, such as the Slovaks. These nationalist groups began to court the support of Hitler for their cause. The government fought back with both anti-Fascist legislation and police attacks on right-wing extremists. These tactics succeeded until international circumstances beyond Czechoslovakia's control led to the absorption of the nation by Nazi Germany in 1939. By then, only the French and British had the power, if they were willing to use it, to defend Europe's democratic states, should fascists attempt to subvert or take them by force.

## ■ FRANCE (1918–1939)

The French Third Republic left the Great War as a grievously damaged victor. The nearly one-and-a-half million dead from the conflict included especially heavy losses among young men. Over half the males from age 20 to 32 in 1914 were dead by 1918. Two million seven hundred thousand soldiers suffered non-lethal injuries, but more than one hundred thousand of them lived with permanent disabilities.

France's enormous material losses included three hundred thousand totally destroyed homes in the region of heaviest fighting. Thousands of workshops, public buildings, bridges, farms, and other facilities also lay in ruins. Destruction on a smaller scale than France experienced left many European democracies too weak to survive.

## A Decade of French Ascendancy

The ravages of war did not bring the collapse of democracy in France as it had in Italy. Instead, France rebounded quickly and became the strongest power on the continent in the 1920s.

### The Quest for Effective Government

French leaders had to master a complex political apparatus at the same time that they confronted the staggering economic problems left by the war. The governing executive (the **premier**) had to secure a majority in the lower house (the **Chamber of Deputies**) in order to pass legislation. The chamber's six hundred members, however, were divided into so many political factions that premiers seldom could be sure of winning a vote. A defeat on an important issue left a premier no choice but to resign—the law prohibited dissolving the chamber and arranging an election to try to gain a majority.

A government leader who wanted to carry out constructive policies had to find a way to stay in office for an extended period in a system in which premiers, on average, remained in power for nine months. Political longevity, in turn, required the management of delicate coalitions. At times in the 1920s, leaders failed miserably at this task. For example, during a single year beginning in June 1925, France had six executive cabinets.

A few exceptional people overcame this tendency toward government instability. Raymond Poincaré accomplished the unusual feat of holding the premiership from January 1922 to June 1924 and from July 1926 to July 1929. He and two other premiers with somewhat shorter terms provided France capable democratic leadership. Their political achievement contributed greatly to the nation's remarkable economic recovery during the 1920s.

### The Economic Restoration

The government assumed that German reparations payments would enable France to retire its huge war debt and cover the cost of rebuilding the structures destroyed by the military conflict. French leaders thus decided to borrow heavily and proceed with the reconstruction of facilities and the improvement of the industrial system. The modernization of industry helped to bring prosperity within a few years. In the short run, however, this policy caused a financial crisis.

Germany's failure to pay reparations as the government had anticipated left France with a dangerously large and growing public debt. Financial institutions began to refuse to lend money to the government, thus threatening the recovery program. Premier Poincaré attempted to solve the problem by forcing reparations payments. He applied pressure by sending troops into Germany's Ruhr valley in 1923. The expense of military occupation, however, depleted public funds. As a result, investors lost confidence in French currency (the **franc**), and its value plunged. The greatly diminished buying power of the franc caused serious economic problems for much of the French citizenry.

The failure of Poincaré's Ruhr occupation plan led him to retire in 1924. After two more years of worsening economic conditions, he agreed to serve as premier again. Poincaré's careful management of

French economic policies from 1926 to 1929 produced a surge of prosperity. The strength of this recovery enabled France to avoid the effects of the Great Depression until about two years after the collapse in other industrial nations.

## Economic Depression and Political Decline

The Depression swept misery into the lives of multitudes of people in every nation that it struck. In France, as elsewhere, businesses and banks failed, the jobless rate soared, and vast numbers of people could not acquire even the most critical necessities. Thus, even though the French suffered less than the citizens of most other nations affected by the crisis, the nation did greatly need swift and effective government action.

### Government Deadlock

Although the Depression necessitated a dynamic response, the machinery of French democracy almost ground to a halt. Parliamentary elections in May 1932 appeared to give controlling power to two parties of the Left. But their philosophies differed too sharply for them to work together. One of these parties, the United Socialists, led by Léon Blum, wanted to nationalize large industrial and financial institutions and enact programs to create jobs. The other group, Édouard Herriot and his Radical Socialists, demanded a very different policy. Despite their name, the Radicals opposed the socialization of enterprises and insisted on strict control of government spending. The split resulted in a deadlock and the collapse of a series of cabinets (five within thirteen months).

### The Growth of French Fascism

Discontent over the government's inaction provided an environment for the strength of the radical Right to grow. Older authoritarian groups increased in militancy, and several new ones sprang to life. These Fascistic organizations included *Action Français* (French Action), the *Croix de Feu* (the Cross of Fire), and the *Jeunesses Patriotes* (the Young Patriots). Banking and industrial leaders provided funds for such Fascist groups and for radical right-wing newspapers that launched a sharp attack on the government. French democracy was under siege.

### The Stavisky Riots

A financial scandal sparked the climactic attack on the faltering government. In 1933, French officials arrested Serge Stavisky for fraudulent activities as a dealer in stocks and bonds. He escaped and either killed himself or was murdered. The right-wing press charged that the police assassinated Stavisky to cover up his ties to government leaders. These newspapers also urged opponents of the republic to force its transformation. Fascist organizations added their support to the campaign against the French Republic.

The enemies of the republic continued their efforts until they got the kind of response from the public that they wanted, a march on the legislature on February 6, 1934. The struggle to invade the chamber's meeting place became a night of riots that left twenty-one dead and hundreds injured. In the wake of these **Stavisky riots,** another premier and his cabinet resigned.

## Governments Right and Left

The parliamentary invaders during the Stavisky crisis included Communists, but most of the opposition came from the extreme Right. For two years after the riots, the premiers and their cabinets somewhat

reflected the mood of this anti-democratic Right instead of the attitude of voters in the last parliamentary elections (1932). Two of the premiers during this period shared the Fascist hostility toward representative government, even though these men were executives in such a system.

### The Popular Front

The right-wing attitudes of government leaders in the mid-1930s drove French leftists together. By the end of 1935, the Radical Socialists, United Socialists, and Communists had formed an official association that they called the **Popular Front.** This leftist coalition won the parliamentary elections in May 1936. Léon Blum took office as the Popular Front premier during a heightened economic crisis, accentuated by strikes involving three hundred thousand workers. Blum immediately implemented extensive reforms. For distressed laborers, the Popular Front granted a workweek shortened to forty hours, provided paid vacations, and arranged other benefits. In an effort to control the economy better, the government also nationalized the Bank of France and the war ammunition industry.

### Red-Scare Tactics

This program of the leftist government shocked the Right. The enemies of the Popular Front fought back by raising dire warnings that Blum was leading France to Communism. The militant Right also insisted that the premier's supposedly pro-communist spirit ensured hostile relations with Germany. Critics of the Popular Front warned that a war with the Nazi state could result from Blum's policies. In the view of the premier's detractors, such a fight spelled disaster, because it would seriously weaken France and Germany, leaving Soviet Russia dominant in Europe. The French Right's slogan became "Better Hitler than Blum."

### A Nation Divided

In a battle over domestic policies, Blum lost the parliament's support after a year in office. He resigned in June 1937. Blum returned in 1938 in an attempt to unify France on foreign policy questions, but in a few months, he accepted defeat and quit again. The unity of the Popular Front parties had weakened greatly by 1938, and the Left coalition collapsed before the end of the year. A Right-oriented government took power once more, but it, too, lacked solid support in the parliament and among the citizenry. Irreconcilable political conflicts had split the nation by 1939. A powerful and united Nazi Germany began its conquest of Europe that year.

## ■ BRITAIN (1918–1939)

The First World War took about half as many British lives (six hundred thousand) as French. Moreover, because Britain had no battles on its own soil, the island kingdom entered the peace with all its homes and factories intact. Yet the war still struck Britain hard. The nation had lost many men in the prime of life, with an especially heavy toll among the upper classes that provided most of the society's leaders. The war also hastened the disintegration of the British Empire and the decline of Britain's economy.

## The Fragmentation of the Empire

Surges of empire building over a four hundred-year period brought about one-fourth of the earth into Britain's realm by the 1920s. The Empire contained about five hundred million people, over three hundred million of which were in the single colony of India.

### The Dominions

Most of the nearly seventy million imperial citizens of European origin lived in Ireland (the Irish Free State after 1921), Canada, Newfoundland, Australia, New Zealand, and South Africa. These territories, known as **dominions,** had controlled their own domestic affairs since the 1870s. Britain still had the technical authority but not the power to take the entire empire to war in 1914. The dominions voluntarily supported Britain with troops and resources, but their sacrifices and the national spirit inspired by the war convinced them to complete the process of independence.

Under growing pressure from the dominions after the war, Parliament passed the Statute of Westminster (December 1931) granting freedom to the dominions. They accepted a new status as members of the **British Commonwealth of Nations.** Thereafter, economic interests, cultural and emotional ties, and a pledge of loyalty to the monarchs ensured a close relationship between the former dominions and Britain. But these independent states no longer belonged to the Empire.

### India

India's struggle for independence strengthened rapidly in the late 1800s and early 1900s. Then, in India as in the dominions, the Great War intensified national feeling and the urge for liberation. Indian leaders sent troops to fight for Britain in the European war in part to win more freedom as a reward for the support. The British offered small compensation. Official recommendations in 1918 indicated plans to extend only extremely limited political rights to a very small minority of Indians.

The Indian Congress Party, led by Mahatma Gandhi (1869–1948), stepped up its nonviolent campaign of protest against British control. Brutal repression followed, especially at Amritsar. Imperial troops killed almost four hundred and wounded one thousand and two hundred unarmed demonstrators in the **Amritsar Massacre** in April 1919. Most British leaders condemned this action, but imperial control remained tight.

Gandhi continued his nonviolent struggle, and masses of people joined the effort. Other Indian nationalists answered British force with assassination and terror. Parliament tried to weaken the resistance by extending a few more rights to Indians in 1935. The opposition to imperial control did not diminish. Britain was losing the struggle by the end of the 1930s but would not yet surrender.

### The Middle East and Egypt

British imperialism also met fierce resistance in Egypt and elsewhere in the **Middle East** (territories east and southeast of the Mediterranean) during the 1920s and 1930s. The British had subdued Egypt before 1914. The First World War settlements ended the authority of Turkey over several states (such as Iraq) east of the Mediterranean and left Britain in charge of them. Nationalist attitudes bred among these subject peoples by the Great War ensured that they would fight for independence. By the late 1930s, Britain had almost completely yielded to nationalists in the region. The more rigorously controlled people in Britain's African colonies had no chance for a similar victory until the 1950s and after.

## *Ireland*

Nearer the center of imperial power, a revolutionary battle raged against the British even before the Great War ended. In April 1916, an Irish nationalist party, the **Sinn Fein** (Ourselves Alone), led an uprising meant to gain full independence from the Empire. The British government crushed this **Easter Rebellion** and executed fifteen of its leaders. This bloody encounter intensified Irish hostility toward Britain so much that the partial liberty offered in Parliament's 1914 Home Rule plan (see Chapter 8) was no longer acceptable.

In the 1918 parliamentary elections, the Irish districts selected mostly Sinn Fein candidates. These new legislators refused to attend Parliament in Britain. They established the **Dail Eireann** (Parliament of Ireland) and chose Eamon De Valera, a militant nationalist, as president of their newly declared Irish Republic. Britain considered all of these steps to be illegal and continued the repression.

In Ulster, a small northern section of Ireland, the mostly Protestant population also bitterly opposed the movement for Irish independence. Separation from Protestant Britain would leave Ulster Protestants as a minority within Catholic Ireland. This circumstance stiffened British resistance to liberation.

In 1921, after three violent years, Britain and moderate Irish nationalists arranged a compromise. The treaty they signed left Ulster united with Britain but gave southern Ireland dominion status and control of domestic affairs. Militant Irish nationalists ignored this settlement and fought on until 1938 when they won complete freedom for all of Ireland south of Ulster. With Ulster still attached to Britain, very hostile relationships existed between the Protestant majority and Catholic minority in that region. Later in the century, a virtual civil war erupted there between Protestants and Catholics.

## The Decline of the British Economy

The disintegration of the Empire weakened the British economy. As territories pulled away from Britain, they accelerated the development of their own industries. Markets for British goods thus shrank. Many other changes within Britain and abroad added to the economic woes of the nation.

### *An Aging Industrial System*

As the first nation to industrialize, Britain enjoyed many economic advantages until the latter 1800s. Then Germany and the United States began to forge ahead. These nations had more abundant resources and newer manufacturing systems that gave them a competitive edge. British industrialists made matters worse for themselves by clinging to old ways in management and production.

### *A War-Damaged Economy*

The Great War sharpened the economic decline of Britain. The country had to concentrate so completely on the manufacture of war material that its customers in the global market turned to the United States. After the war, the still-declining British industrial system could not win back these consumers. Even the peace settlement hurt Britain. German reparations to France included payments in coal. The loss of former coal customers who now purchased the mineral from France seriously crippled one of Britain's most important industries.

British workers felt the effects of these historic and global trends in a very personal way by the early 1920s. Almost seven hundred thousand had to sign up for unemployment benefits in 1920. Six months later, jobless numbers had tripled. Unemployment figures stayed above one million for the rest of the decade. Then the Great Depression came.

## Muddling Politicians

In popular mythology, the British government has a reputation for "muddling through." This image suggests that when leaders confront problems, they simply struggle along at their usual pace with few if any clear ideas about solutions. Britain's record of highly effective reform throughout most of the Modern era contradicts this view of the system. But the governments of the 1920s and 1930s did "muddle," and they barely made it through the difficulties of the era.

### *Parties in Trouble and Transition*

A coalition of parties had formed an executive cabinet to conduct the war. This mixed cabinet under Liberal Prime Minister David Lloyd George continued in office after the war until 1922. In these years, the economy needed serious attention; Lloyd George knew little about such matters and devoted most of his time to foreign affairs. A fully Conservative cabinet replaced the coalition government in 1922. Stanley Baldwin, the new prime minister, had a talent for presenting mediocre ideas in impressive speeches. His flawed plan for economic improvement—quick payment of war debts to the United States—made bad conditions worse. Britain's economy needed stimulation. His program further burdened an already sluggish system.

**The Rise of the Labour Party.** The moderate socialist program of Britain's Labour Party gained steadily in appeal throughout the early 1900s. By the 1920s, Labour and the Conservatives dominated British politics. The Liberals took a third-party position and continued to weaken. When the 1923 elections gave Labour control of the government for the first time, Prime Minister Ramsay MacDonald showed no interest in a socialist economic program. He preferred to continue Baldwin's conservative financial plan. Labour charted a course in foreign policy, however, that led to a conflict with the Conservatives.

**Recognition of the Soviet Government.** Labour leaders wanted no socialism at home, but they sympathized with the struggling Communists in the USSR. The MacDonald government thus arranged a diplomatic recognition treaty with Soviet Russia. Labour lacked the votes to pass the treaty. This failure of support in the House of Commons forced MacDonald to schedule elections.

**The Zinoviev Letter.** As the campaigns for House seats drew to a close in October 1924, foreign ministry officials reported discovery of a message from a Soviet leader urging British Communists to undermine their government. This **Zinoviev letter,** a forgery prepared by anti-Communists in Britain, made MacDonald's Soviet recognition plan seem dangerous. It weakened Labour's already slim chance of victory in the elections. Baldwin and the Conservatives won, and immediately blocked the recognition treaty.

### *Slipping into Depression*

In his second term, Baldwin tried to strengthen the economy by raising the value of the nation's currency (the **pound**). As the worth of the pound climbed, so did the cost of British products. As a result, business leaders cut their laborers' wages in an effort to reduce prices and stay competitive in

world markets. The muddling British leadership left workers with no hope of a reversal of their fortunes. The slide into economic depression continued.

### The General Strike

British coal mine operators reacted to the faltering economy with a plan to cut wages and reduce workers' hours. Mine unions threatened a massive strike. The Baldwin administration tried to arrange a compromise settlement. It failed. The miners struck on May 1, 1926, and other worker organizations joined them, taking forty percent of all unionized laborers off the job.

With almost twenty percent of the total work force (union and nonunion) idled, the government still managed to defeat the general strike. Volunteers kept transportation and communication systems in operation and distributed critical supplies such as milk. Sympathy strikers yielded and resumed work on May 12, 1926. Coal miners refused to surrender until the end of the year. The outcome left labor more passive and the government complacent about the economy.

## The Great Depression in Britain

After a decade of gradual decline, the Great Depression took the British economy into a breathtaking plunge. The sale of British goods abroad dropped fifty percent between 1929 and 1932. In the same period, the painfully high 1929 unemployment rate of ten percent more than doubled. Seven million of Britain's forty-five million people had no income but government welfare by 1932.

### The Stymied Socialists

In June 1929, the Labour Party and Prime Minister MacDonald resumed control of the government. These Socialist leaders decided to ease the fall into economic depression by a reduction of government spending, including cuts in benefits to the jobless. Most of the Labour Party flatly rejected this conservative plan from its own leaders. Because MacDonald could not deliver Socialist votes in Parliament, he had to resign his position as prime minister in August 1931.

### A Timid Coalition

The day after his resignation, MacDonald returned to office and organized a new governing executive coalition with Conservative, Labour, and Liberal members. The Labour Party expelled MacDonald and the other executive-branch Socialists from its ranks, an action that expressed party displeasure but could not remove these people from the new Cabinet. This **National Coalition Government** remained in power through the rest of the 1930s. Even though MacDonald kept his position as prime minister until 1935, Conservatives such as Baldwin and Neville Chamberlain increasingly controlled government policies. Finally, they took charge officially—Baldwin became prime minister in 1935; Chamberlain in 1937.

Under the influence of these Conservatives, the government tried somewhat more active measures to improve the economy. Coalition leaders began by a reversal of the currency policies Baldwin had established in the mid-1920s. This change expanded the money supply, lowered currency values, and made it easier for struggling citizens to pay debts. Then the cabinet arranged a more drastic shift in economic practices. In an attempt to protect British farmers and manufacturers, the government abandoned its ninety-year-old doctrine of free trade and established a tax on foreign wheat and certain industrial imports.

Through additional anti-Depression legislation, the government provided aid to the extremely depressed shipping industry and assisted in the movement of jobless workers to locales with better opportunities. The economy eventually began a slow climb, but these cautious programs had far too little effect to lift Britain from the depths of the Depression.

### British Democracy under Crisis Conditions

Emergency circumstances during the Great War encouraged the growth of government controls and the centralization of political authority. This experience did not weaken the British commitment to democracy, however. One month after the end of the war, the government extended the right to vote to more people. Older laws allowed all males over twenty to vote. The new law included women (those over thirty) in the electorate for the first time. A further change in 1928 provided for women over twenty to vote. Persistent economic troubles in the 1920s and the crisis conditions of the Great Depression did not undermine these still growing democratic institutions in Britain.

Britain thus stood as a firmly democratic state at the end of the 1930s. Yet the nation had declined sharply in economic and military strength since 1918. The British were at war with the fascist states by September 1939. Within months, Britain was the only European democracy left to carry on the fight.

## ■ ARTS AND IDEAS IN THE DEMOCRATIC STATES IN AN ERA OF CRISIS

Europe entered a long siege of military and socioeconomic crises in 1914. The shock of these events wrecked many democratic governments and seriously strained others. The troubles of this era, especially the horrible slaughter of the Great War and the rise of dictatorial regimes that enforced cultural conformity, also deeply affected European art and thought. Many artists and intellectuals fled their homelands and, once abroad, sometimes used their talents to speak of the traumatic events that so deeply affected their world.

### Artistic Visions of Despair

The strong lure of Berlin for artists in the 1920s did not lessen the enduring appeal of Paris for many of Europe's leading creative figures who gathered there from the far reaches of the continent—Pablo Picasso from Spain and Wassily Kandinsky from Russia by way of Germany among them. These two painters gained special fame in the contingent of artists who began important creative trends before 1914 that became dominant in the 1920s and 1930s. The **abstract art** of this era then continued as a leading influence in visual expression into the twenty-first century.

### Dadaism

The general mood of despair born of the Great War immediately affected the arts. In 1918, a group of painters and authors in Switzerland began a campaign to express their view that everything in life was meaningless. They even gave their movement a meaningless name, **Dada,** to emphasize this attitude. The Swiss and other European Dadaists made their mood widely known. They gave speeches and produced works of literature and art that were intentionally and provocatively incomprehensible. Paradoxically, **Dadaism** did convey a very clear message—these members of the artistic elite despised the inhumanity of their era.

## Surrealism

The spirit of intense social criticism evident in Dadaism also was reflected in **surrealism,** another literary and artistic movement of the post World War I period. Surrealist works owed much to the inspiration of Freudian psychology. The artists and writers in this movement presented distorted visions that suggested a dreamlike or nightmarish state of mind. They depicted the near madness that personal traits or social conditions could bring into anyone's life.

The Spanish painter Salvador Dali (1904–1989) joined the Parisian art world in the latter 1920s and became a most prominent and productive surrealist painter. He completed numerous highly acclaimed works between 1929 and 1937, including the especially noted *Persistence of Memory.* In this painting, Dali scattered a mystifying collection of items, including three melted watches, around an eerie landscape. It suggested a bleak and strange world.

## Abstracts of the Times on the Eve of a Greater War

Early in the century, Kandinsky declared his intention to divorce his art from the world of natural sights. His declaration of independence from visual reality became fully apparent in the abstract works he painted after the Great War. Throughout the 1920s and 1930s, Kandinsky's new geometric style in painting effectively captured the wildly free spirit of the art of this age. Although he perhaps did not mean it as an intentional statement on the changing times, Kandinsky also caught the mood of the 1930s as his depictions grew darker—from the bright background of *On White II* in 1923 to the stark black of *Composition X* in 1939. Picasso spoke very consciously and vividly of his times with abstracts that he produced in the late 1930s and during the war years that followed. His *Guernica* (1937) earned especially great fame as an artistic condemnation of attacks by German bomber and fighter aircraft that killed civilians during the Spanish Civil War. (The European and American democracies at that time publicly condemned aerial bombardment of non-military targets as barbaric.) When German troops occupied Paris early in the Second World War, Picasso distributed copies of *Guernica* throughout the city as a protest against Nazi war horrors.

## Literature, Formal Thought, and Science—the Inspiration and Making of Tragedy

The tragic conditions of the Great War and the severe economic distress that followed it destroyed European governments but at the same time encouraged outstanding achievements in writing as well as art. Many of the greatest literary works of the twentieth century appeared in the 1920s and 1930s as authors responded to the traumas of the era.

## Stories of Ruin, Madness, and Oppression

T. S. Eliot (1888–1965), an American who immigrated to Britain, suggested in his works that humanity faced nothing less than doomsday. In *The Waste Land* (1922), Eliot expressed in complex poetry his vision of teeming barbaric invaders devastating the civilized world. Other writers envisioned survival, but in a world made so oppressive by machines or bureaucracies that life seemed meaningless. Franz Kafka (1883–1924), an ethnic German living in Czechoslovakia, wrote works that described a world with opportunity for neither liberty nor comprehension of the life one lived. The societies that Kafka imagined in *The Trial* (1925) and *The Castle* (1926) made freedom virtually impossible through the operation of absolutely powerful bureaucracies that no one could understand. The vast and rigidly

controlling machinery of government deeply troubled Aldous Huxley, as it had Zamyatin in Soviet Russia, and he used the Russian's method in expressing his views. Huxley's *Brave New World* (1932) and novels by others after the 1930s denounced the new dictatorships with fictional depictions of the insane and inhuman political world that Communists and Fascists were preparing for the future.

## Doomsday Scholarship

Several important scholarly publications that appeared in the two decades after the First World War reflected the same mood of despair found in much of the art and fiction. Before his native Austria turned from democracy to nazism, Freud reflected on the sociopsychological implications of the Great War. In *Civilization and Its Discontents* (1930), Freud indicated that the inherent traits of humanity would forever jeopardize the very existence of the social order. Carl Jung (1875–1961), a Swiss psychiatrist and disciple of Freud's who became an intellectual opponent, expressed similar doubts about the future of humanity. Other leading European scholars displayed the same anticipation of doom.

In 1934, American scientists arranged a conference to review expert opinion on the possibility of making nuclear bombs. European physicists unraveled enough of the mysteries of the structure of matter to split an atom by December 1939. This experiment proved that scientists could produce nuclear weapons. News of the test results led one of the physicists who contributed to its success to contemplate suicide. Almost six years later, the United States brought the Second World War to a close by dropping atomic bombs on two Japanese cities. Europeans and Americans thus had gained the knowledge to carry out the destruction of civilization feared by so many artists and intellectuals during the 1920s and 1930s.

*The remembrance of war and the experience of economic crisis and collapsing democracy in the 1920s and 1930s left many European artists, writers, and scholars feeling hopeless. They communicated their sense of impending doom in strangely new varieties of painting or in works of fiction and scholarship. When government leaders in France and Britain confronted severe economic problems in these years, they often appeared to struggle on with as little optimism as the intellectuals and artists displayed.*

*The failure of democratic governments in France and Britain to cope with the Great Depression left many citizens in misery and gave the masses every reason to share the despair of their leaders. French society seemed especially torn and weakened by the end of the 1930s, even though the nation had shown great vitality only a decade earlier.*

*Despite the apparent problems in the two nations usually viewed as the most powerful democratic states, both France and Britain remained firmly committed to representative government after suffering through the decade of the Great Depression. Many smaller and less populous democracies, moreover, achieved remarkable political and economic successes during the 1920s and 1930s.*

*European democracy had hardly thrived in these decades, but many self-governing states had proved their power to endure. In 1939, the Europeans in both dictatorships and democracies faced a six-year war that would test their capacity to survive as it had never been tested in modern history. The Fascist states began this struggle at a moment when the other European nations could not match their military strength.*

## Selected Readings

Aldcroft, Derek H. *The European Economy, 1914–1970.* New York: St. Martin's Press, 1978.

Bowker, Gordon. *George Orwell.* London: Little, Brown, 2003.

Carroll, Donald and Edward Lucie-Smith. *Movements in Modern Art.* New York: Horizon Press, 1973.

Childs, Marquis W. *Sweden: The Middle Way.* New Haven, CT: Yale University Press, 1961.

Dangerfield, George. *The Damnable Question: A Study in Anglo-Irish Relations.* Boston: Little, Brown, 1976.

Graves, Robert and Alan Hodge. *The Long Weekend: A Social History of Great Britain, 1918–1939.* New York: Norton, 1963.

Greene, Nathanael. *From Versailles to Vichy: The Third French Republic, 1919–1940.* New York: Crowell, 1970.

Halsall, Paul, ed. *Internet Modern History Sourcebook: An Age of Anxiety.* (Links at this site can be accessed at *www.fordham.edu/halsall/mod/modsbook40.html.*)

Hamilton, George H. *Painting and Sculpture in Europe, 1880–1940.* Baltimore, MD: Penguin Books, 1972.

Kindleberger, Charles P. *The World in Depression, 1929–1939.* London: Allen Lane, 1973.

Mowat, Charles L. *Britain Between the Wars, 1918–1940.* Chicago: University of Chicago Press, 1955.

Pawel, Ernst. *The Nightmare of Reason: The Life of Franz Kafka.* New York: Farrar, Straus & Giroux, 1984.

Payne, Stanley G. *A History of Fascism, 1914–1945.* Madison: University of Wisconsin, 1995.

Sontag, Raymond J. *A Broken World, 1919–1939.* New York: Harper & Row, 1972.

Taylor, Alan J. P. *English History, 1914–1945.* New York: Oxford University Press, 1965.

## Test Yourself

1) Which of the following in the first decades of the twentieth century indicated that Britain had not given all citizens a sense of having self-government?
   a) the Indian Revolution of 1905
   b) the refusal of Parliament to consider the Irish Home Rule Bill
   c) the failure of the 1928 voting rights law
   d) the Easter Rebellion

2) This European country first gave full political rights to women.
   a) Czechoslovakia
   b) Finland
   c) France
   d) Britain

3) This twentieth-century event indicates why certain scholars think of oppressive imperialism as a particularly noticeable trait of modern European states.
   a) the Peterloo Massacre
   b) the signing of the Kellogg-Briand Pact
   c) the Amritsar Massacre
   d) the Statute of Westminster

4) This large group is still a minority in the Northern Ireland region of Ulster.
   a) the Welsh
   b) Protestants
   c) Catholics
   d) Sikhs

5) To someone who subscribes to Dadaism, what is the meaning of life?
   a) Life is abstract but meaningful.
   b) Being is achieved through contentment.
   c) Life is the culmination of all events.
   d) Life is completely absurd.

6) Franz Kafka wrote novels that expressed his view that freedom in human societies is denied by
   a) bureaucracy
   b) the unequal distribution of wealth
   c) impersonal economic forces that are beyond intelligent control
   d) the inadequacy of education for the masses

7) The Stavisky riots indicated that Fascist-like forces threatened the government of
   a) Czechoslovakia
   b) France
   c) Britain
   d) Poland

8) According to the account of events in this chapter, what did Masaryk, Beneš, Poincaré, and Svinhufvud have in common?
   a) They were founders of surrealism.
   b) They led Fascist movements in the smaller democracies.
   c) They failed in their efforts to build really strong parliamentary systems.
   d) They were effective political leaders.

9) The history of the European democracies in the 1920s and 1930s supports the validity of which of the statements in the following sets of options?

   a) Once in power, Socialists are not consistently pro-labor or inclined to nationalize businesses.

   b) Socialist governments are consistent in little other than their support for the nationalization of businesses.

   c) The narrowly ideological nature of Socialists causes them to stand alone as a party unwilling to join governing executive coalitions.

   d) Socialist policies increase the misery of the citizenry when economic depression strikes.

10) The history of the European democracies in the 1920s and 1930s supports the validity of which of the statements in the following sets of options?

   a) Fascism loses its appeal during economic hard times.

   b) When governments establish socialist programs, Fascists gain in popularity.

   c) When parliamentary governments falter in crises, Fascist movements get stronger.

   d) When governments try to stop Fascists by police action, Fascist movements get stronger.

## Test Yourself Answers

1) **d.** Only this option for completion has to do with an event that actually occurred, and this Easter 1916 revolt came as Irish nationalists fought for self-government.

2) **b.** As the text noted, Finland led the way in giving the right to vote to women in 1906, whereas Britain did so in age group stages in 1918 and 1928. The years for women's suffrage in Czechoslovakia and France, 1920 and 1944, respectively, were not mentioned in the chapter.

3) **c.** Although the reference is brief, the text's information about the Amritsar Massacre in India in 1919 adequately depicts the extreme violence that Europeans, in this case the British, sometimes used in order to keep huge imperial populations under their control in the modern era. This tragic event at least suggests why certain historians maintain that the history of imperialism must hold a central place in accounts of Modern Europe's past.

4) **c.** The population of Ireland as a whole is largely Catholic, but the northern region known as Ulster has a Protestant majority and a large Catholic minority. Ulster remained a part of the United Kingdom (Britain, or England, as most people call it) after the rest of Ireland became an independent country in 1938. This is a circumstance that still has a very important influence on events in that area.

5) **d.** Apart from whatever influence it might have had at the time, Dadaism is significant as a vivid reflection of the effect of the Great War on the outlook of Europeans. People in the arts who became Dadaists wanted to stun the larger society into sharing their conviction that the horror of the World War revealed emptiness at the core of their civilization that could be filled only with a drastic redirection of European life. The other choices for completion had no specific relationship to Dadaism.

6) **a.** Writers in the latter 1800s began to turn away from realism to literary forms that exposed the depths of the human psyche. This trend became dominant in the works of eminent novelists such as Kafka in the post 1918 era. His novels conveyed the lost and hopeless feelings of people so trapped by the social structures and practices of their day that they found themselves not only without freedom but unable even to comprehend their virtually insane world. Problems of the distribution of wealth or the public's education might have concerned Kafka, but he wrote with special emphasis of the damaging effects of modern bureaucracy.

7) Even though the name associated with the event suggests a Slavic locale for the Stavisky riots, they occurred in France and are of historic note as an indication of the appeal and power of Fascism throughout Europe in this era.

8)  **d.** Masaryk and Beneš showed great skill as founders of the Czechoslovak government, Poincaré dealt effectively with the difficult political and economic problems of France in the 1920s, and Svinhufvud led the struggle to free Finland from Russia before 1917 and fought successfully to make its government function well during the decade of the Great Depression. The other answers listed were false options.

9)  **a.** Events in the Scandinavian countries support this response and disprove choices *b* and *d* as completions. Socialists in both Britain and France joined governing coalitions with non-Socialists.

10) **c.** During their struggles for power, Fascist movements typically are strongly anti-parliamentarian, and they express such views especially when legislatures appear incapable of responding to serious social problems. The history of the democracies in this era clearly shows that when crises began to overwhelm representative governments, Fascists won more followers.

# Plunging into a Greater War (1939–1945)

| | |
|---:|:---|
| **1921:** | The Washington Conference sets limits on the navies of eight nations. |
| **1928:** | Countries begin signing the Kellogg-Briand pledge to give up war. |
| **1936:** | Germany militarizes the Rhineland in violation of the Versailles Treaty. |
| **1937:** | Germany, Italy, and Japan organize the Anti-Comintern Pact. |
| **March 1938:** | Germany annexes Austria (the *Anschluss*). |
| **September 1938:** | The Munich Conference enables Germany to take part of Czechoslovakia. |
| **August 1939:** | Germany and the USSR agree not to fight each other. |
| **September 1939:** | The Second World War begins in Europe. |
| **1940:** | France surrenders to Germany. |
| **June 1941:** | Germany invades the USSR. |
| **December 1941:** | The United States enters the Second World War. |
| **1943:** | Italy surrenders to the Western Allies. |
| **1944:** | The Western Allies invade northern France on D Day. |
| **February 1945:** | Churchill, Roosevelt, and Stalin meet at Yalta. |
| **April 1945:** | Mussolini is executed by Italian anti-Fascists, and Hitler commits suicide. |
| **May 1945:** | Germany surrenders to the Allies. |
| **August 1945:** | Japan surrenders after the United States drops atomic bombs on Hiroshima and Nagasaki. |

*The Great War left all the European states desperate for security. Despite this common desire, serious international conflicts persisted throughout the early 1920s. The struggle between France and Germany over reparations payments even led the French to send troops into the German Ruhr region.*

*After a compromise on reparations in 1924, the European states entered a period of improved relations that lasted nearly a decade. They settled border disputes, arranged better trading relationships, and established limits on naval armaments. During this era of harmony, France and the United States proposed that the nations of the world swear not to start wars of aggression. More than twenty states quickly signed such an agreement (September 1928). Almost three times that number eventually took this peace pledge.*

*Eleven years after the French and Americans completed their visionary treaty, Europe plunged into a war of much greater destruction and horror than the First World War. Nazi Germany had steadily led the European states on a six-year march to the abyss that they reached in September 1939. The British believed almost until the last moment that they could help Hitler realize his goals for Germany and stop the rush to war. They were wrong. The Fuehrer's aim was the conquest of Europe.*

## ■ TOWARD SECURITY AND PEACE

During the peace negotiations at the end of the Great War, French representatives worked diligently to arrange buffer zones and military restrictions that would make their country safe from future German aggression. Geography protected Britain quite well, but the British usually agreed that security on the continent required the customary defensive measures preferred by France.

The United States accepted most of France's protective plan, but President Wilson doubted the value of such traditional security arrangements. Wilson struggled vigorously to incorporate into the Paris treaties the peacemaking ideals he had expressed in the Fourteen Points. (See Chapter 9.) In the decade after the Paris negotiations ended, the Europeans tried both France's time-honored approach to security and Wilson's visionary peacemaking strategies.

### The Implementation of the Paris Treaties

The Allied Powers concluded the Peace of Paris in June 1919. During the following year, they implemented its provisions for an international peace and security agency.

### *The Establishment of the League of Nations*

The League of Nations assembled for the first time at its headquarters in Geneva, Switzerland, in November 1920. It met, however, without representatives from the United States. None would ever attend; the U.S. Senate had objected to the internationalist character of the League and rejected the treaties that Wilson signed at Paris.

The U.S. decision against participation left the League under British and French domination. These two nations soon developed conflicting views of the proper role of the agency in world affairs. French leaders urged the League to stand ready for swift intervention to stop aggressor states. The British stubbornly objected. They insisted that the League should encourage international understanding through dialogue and avoid attempts to control nations, especially by direct military action. During most crises, the League usually did little or nothing, as Britain wished.

### The Attempt to Weaken Potential Aggressors

The Paris treaties set strict limits on the military power of the defeated nations. After the war, the victors began to enforce these treaty articles. The imposition of military limits somewhat reduced the war-making potential of Germany, Austria, Hungary, and Turkey. Before very long, however, they began secretly rebuilding their military forces.

## New Arrangements for Security and Cooperation

The formation of the League of Nations did not drastically alter the conduct of international relations. Most countries continued to have direct interaction with other states as they always had.

### Defense Alliances

At the time of the Paris peace negotiations, the United States and Britain concluded a separate agreement with France. They pledged to aid the French if Germany ever attacked. Several months later, the Americans and British withdrew their promise of assistance. France quickly built a new system to restrain Germany by arranging defense treaties with Belgium (1920) and Poland (1921).

### The Quest for Improved Relations

French and British leaders convened a general economic conference at Genoa, Italy, in April 1922. They hoped to stimulate European economic recovery by getting the Soviet government to pay foreign debts left by Imperial Russia. The positions taken by the negotiators made a resolution of their economic conflict impossible.

**The Rapallo Treaty.** Before the Genoa conference ended, the Germans and Soviets revealed that they had recently met in Rapallo, Germany, to sign a treaty of friendship and economic cooperation. A common status as outcast nations had drawn Germany and the Soviet Union together, but their closer association worried the other European states.

**The Locarno Agreements.** In 1925, European leaders held extended negotiations in Locarno, Switzerland, that produced much better results than had the Genoa meeting. These Locarno conferences led to a series of treaties that ended disagreements about the location of German, Belgian, and French borders. These three nations decided to accept existing boundaries. They also promised to settle all future disputes among themselves by peaceful means. The Locarno agreements left many international problems unresolved, but they increased European harmony sufficiently to inspire a widespread belief that an era of peace had dawned.

## The Campaign against Weapons and War

Even though the confidence in forceful means of protection remained strong after the First World War, disarmament and antiwar movements made unusual progress in the 1920s.

### The Disarmament Drive

In November 1921, the United States opened the Washington Conference for a consideration of naval armaments and Asian issues. The representatives of six European and two Asian states joined the Americans for three months of negotiations. They concluded two agreements on Asian affairs and one on naval armaments. The United States, Britain, Japan, France, and Italy signed the naval arms treaty. They accepted limits on the size of their heavy warship fleets and pledged not to build any of these large vessels for ten years. These same five nations met for the London Naval Conference in 1930 and agreed to limits on smaller vessels, including submarines.

The League of Nations established a commission in 1926 to prepare for a conference that would bring a much larger group of nations together to arrange limits on the full range of military forces. This effort led to a series of Geneva Disarmament Conferences that began in February 1932 with sixty states in attendance. Negotiations continued without success until Hitler's withdrawal of Germany from the Conference effectively stopped this drive for disarmament in October 1933.

### The Kellogg-Briand Peace Pact

After the completion of the Locarno agreements and the organization of the League's disarmament preparatory commission, optimism about the possibility of establishing truly peaceful international relations became unusually strong. An agreement arranged by Frank Kellogg, the American secretary of state, and Aristide Briand, the French foreign minister, reflected the spirit of the times in an especially vivid way.

The pact presented to the world by Kellogg and Briand on August 27, 1928, proposed that nations pledge to stop using war to deal with conflicts or to achieve their goals. Virtually every state with the power to wage war on a significant scale signed this **Kellogg-Briand Pact** (formally known as the **Pact of Paris**). Even though this promise of peaceful behavior had no discernible effect on international relations, the pact symbolized the significant steps toward ensuring peace that took place in the decade after the Great War.

## ■ TOWARD WAR

The hopes for tranquility fostered by developments in the 1920s faded rapidly in the early 1930s. Gustav Stresemann had set Germany on a course toward peace in 1924, but Hitler's accession to power succeeded in reversing his country's direction in foreign affairs, a change that soon transformed the environment of European international relations.

## The Resurgence of the German Threat

Hitler intended to have a vastly more powerful German military force and an expanded empire within Europe. The implementation of these policies immediately heightened the threat to peace in Europe. Hitler quickly made his country's aggressiveness apparent. In October 1933, nine months after he became German chancellor, Hitler withdrew his country from the Geneva arms talks and the League of Nations.

## Germany's Nullification of the Versailles Military Limits

Hitler considered the military limitations placed on Germany by the Versailles Treaty to be even more insufferable than League membership. In March 1935, he openly proclaimed that Germany no longer recognized the validity of the Versailles arms limitations clauses. Officials from France, Italy, and Britain met to consider possible responses to Germany's violation of the treaty. They did nothing, however, largely because the British had decided years earlier that the Versailles restrictions were unrealistic and overly harsh.

## The Remilitarization of the Rhineland

A year after the easy rearmament triumph, Hitler won another and more striking victory. The Versailles Treaty required the demilitarization of German territory on the Rhine River. Hitler ordered troops to return to the Rhineland in March 1936. The Fuehrer's generals opposed this move because they feared a French attack that Germany was too weak to resist.

Hitler's forces again met no opposition. French and British leaders had long assumed that this remilitarization would occur and did not strongly object. British and French officials certainly had no interest in waging war as a means of resisting such an action. Hitler's success in the Rhineland, however, made it more difficult for German officials and European leaders to resist Nazi aggressiveness in the future.

## The Formation of the Rome-Berlin Axis

Despite the similarities between Italian Fascism and German Nazism, Mussolini viewed Hitler as a threat to Italian interests until 1935. Hitler's reaction to an Italian imperial war that began that year changed Mussolini's attitudes and opened the way for the Fascist states to build a much closer relationship.

## The Italian Conquest of Ethiopia

Italy tried to conquer Ethiopia during Europe's imperial campaigns in Africa in the late 1800s. The Ethiopian triumph over Italy's troops in 1896 stopped this venture and humiliated the Italians. Mussolini longed to take revenge for this defeat. He also claimed that a Mediterranean-African empire was Italy's destiny. These incentives led to an Italian attack on Ethiopia in October 1935.

Hitler supported this aggressive act, to Mussolini's great pleasure. The members of the League of Nations, however, condemned Italy and voted to impose economic sanctions. The League decision meant that member states were to stop trading with Italy so that resource shortages would force an end to aggression. The sanctions failed to have this effect because of the League's inability to prevent the shipping of petroleum to Italy. Ethiopia fell in May 1936. Mussolini's victory under these circumstances marked the virtual death of the League of Nations. Because Italy and Germany had stood together against the world during the assault on Ethiopia, the Fascist states were virtual allies by 1936.

## Fascist Supremacy in International Affairs

Neither the League nor democratic countries dominated relationships among European states after the mid-1930s. The two leading Fascist powers had taken charge of events. In 1936, when Franco and the forces of the extreme Right began their war to destroy the Spanish Republic, Mussolini and Hitler jointly supplied military aid to the Fascist rebels. This assistance made it possible for Franco to win by 1939. In contrast to the action of the Fascist states, the democracies declared their neutrality and denied help to the

Spanish Republic. Soviet Russia sent advisers to assist the Spanish government. The presence of these few Communists, however, had no significant influence on the outcome of the civil war in Spain.

Even in the early months of the Spanish conflict, the ability of the Italians and Germans to cooperate gave them a new sense of power. Negotiations between Italy and Germany conducted in October 1936 resulted in a strengthened Fascist relationship that Mussolini called the **Rome-Berlin Axis.** The Italian leader announced this association on November 1, 1936, and boasted that the new power alignment would subsequently control the turn of events in Europe. In November 1937, Fascist Japan joined with Italy and Germany to form the **Anti-Comintern** (Anti-Communist International) **Pact,** an indication that these three nations dreamed of world domination.

## To the Brink of War

By the time the fascist nations organized the Anti-Comintern Pact, the strength of the right-wing dictatorships and the weakness of the democracies made it relatively easy for Hitler to begin a vigorous campaign to build his empire in Europe. The Fuehrer's drive to expand also pushed Europe toward war.

### The Anschluss—Hitler's Annexation of Austria

Hitler's doctrines emphasized the Nazi plan to build a new German **Reich** (empire), the third in history. This Third *Reich* would rule the world and endure for one thousand years, according to the Fuehrer. The realization of this destiny required that the great German people have **Lebensraum** (living space), so the nation had to expand. Since the early 1920s, the Fuehrer had proclaimed in shouts and publications that this enlarged Germany had to include Austria, his homeland.

After the Austrian Nazis tried to overthrow their moderate right-wing government in 1934, their party was declared illegal. Hitler began his **Anschluss** (annexation) campaign in February 1938 by ordering Austrian Chancellor Kurt von Schuschnigg to allow the revival of the party and add Nazis to the Austrian cabinet or face a German invasion.

Schuschnigg submitted to these demands and announced plans for a plebiscite in which Austrians would decide whether to remain independent. Nazism and the idea of Austro-German unity appealed to many Austrians, as such a vote probably would have shown. Hitler would not wait for a plebiscite. He prepared to invade and told Schuschnigg to turn the government over to Arthur von Seyss-Inquart, an Austrian Nazi. When Britain and France refused to assist Schuschnigg, he resigned, and Seyss-Inquart became chancellor. The new Austrian leader invited German forces to enter his country, presumably to establish order. Hitler's troops marched in and found welcoming citizens along the streets. Austria merged with Germany on March 13, 1938.

### The Czechoslovakian Crisis

The Sudetenland, a well-fortified highland region in Czechoslovakia, stretched in a narrow semicircle around the border next to Germany. Most of the Sudetenland's population was ethnically German. In March 1938, Hitler induced these Sudeten Germans to begin a campaign for complete control over government within their part of Czechoslovakia. Because compliance with this demand would nullify Czech power in an area critical to national defense, a Sudeten German victory on this issue would make Czechoslovakia more vulnerable to a Nazi attack. Hitler expected a Czech refusal, which he meant to use as an excuse to invade.

As the Czech government tried to resolve the conflict with the Sudeten Germans, Hitler gathered his forces for an attack. The Czechs had two defense treaties that promised them protection. One required France to aid Czechoslovakia if any aggressor invaded. The other obligated the Soviets to assist in Czech defense whenever the French did. British leaders feared that these agreements would lead to a general European war that Britain was not at all prepared to fight. Pressure from Britain convinced France not to aid Czechoslovakia, regardless of treaty obligations. Without French support, the Czechs could expect none from the Soviets. Czechoslovakia thus was alone in the struggle. In early September 1938, the Czech government surrendered authority over the Sudetenland to its German inhabitants.

Even though the Czechs had yielded, the crisis did not end. Hitler responded to every Czech concession with a more extreme demand. This process continued until late September 1938, when the Fuehrer insisted on the annexation of the Sudetenland to Germany and the surrender of all fortifications in the region to his armies. Czechoslovakia refused to comply. An intense war scare gripped Europe.

**Appeasement.** Neville Chamberlain (1869–1940), the British prime minister beginning in 1937, had encouraged repeated Czech surrenders to Germany during the Sudetenland crisis. The British leader believed that Europe could avoid war by a policy of appeasement—calming Hitler by submitting to most of his demands. In Chamberlain's opinion, the Fuehrer would insist on nothing more, once all German regions were added to the Nazi state. Edouard Daladier (1884–1970), the French premier, agreed with Chamberlain and joined the chorus for appeasement. When Czechs would concede no more to Hitler, the British and French leaders surrendered for them.

**The Munich Agreement.** On September 29, 1938, Chamberlain, Daladier, Mussolini, and Hitler met in Munich, Germany, to discuss the conflict over the Sudetenland. They did not invite Czech and Soviet representatives to the conference, even though the crisis threatened the existence of Czechoslovakia and involved vital Soviet security interests. In the discussions at Munich, the four leaders quickly arrived at a simple solution. They offered Hitler everything he wanted. He accepted the gift of the Sudetenland and its forts.

**The German Annexation of Czechoslovakia.** Chamberlain and Daladier went home to tell their relieved citizens that the Munich agreement guaranteed "peace in our time." They believed that the settlement fully satisfied Hitler, because it gave him the last European territory with a German-majority population. In mid-March 1939, less than six months after the Munich conference, Germany took control of all Czech territory under the pretense of stopping political disorder.

### The Decision to Fight Aggression

The cynical demonstration that Hitler intended to rule more than German populations ended the policy of appeasement. Because territorial disputes clearly indicated that Hitler soon might threaten Poland, Britain and France now tried to ensure peace by vowing to defend the Poles if they came under attack. If these West European states could convince the Soviets to threaten Germany from the east, Hitler would face extreme risks in any further attempts to expand.

### The Nazi-Soviet Pact

Moderate Right West European leaders, including Chamberlain, exhibited a certain fondness for Fascism. Fascists, after all, supported capitalism and fought Communism with a vengeance. This tendency of both Fascist and democratic governments in West Europe to have an extremely hostile attitude toward Communism made it difficult for British and French leaders to cooperate with the Soviets even when the fate of Czechoslovakia hung in the balance. Stalin was aware of these sentiments among Western leaders and somewhat justifiably suspected that they appeased Hitler in order to turn Nazi aggression toward the USSR.

Britain and France became much more hostile toward Germany after the fall of Czechoslovakia, but the democracies made only a halfhearted effort to entice the USSR into an anti-Nazi alliance. Hitler, however, temporarily suspended his campaign of hatred against Communism and energetically pursued an agreement with Stalin. The Soviet leader was surprisingly receptive to these Nazi advances.

The German and Soviet dictators both realized that they could benefit by temporarily ignoring their opposing ideologies and striking a deal. Germany and the Soviet Union wanted to regain territory lost to Poland at the end of the Great War. They could take this land by combined action. If they opposed each other, they risked a costly war and reduced their chances of making territorial gains. Stalin saw an additional advantage in reaching an understanding with Hitler. The Soviet leader expected Germany eventually to attack the Soviet Union, but he wanted to delay this invasion as long as possible in order to prepare defenses.

With Fascist and Communist passions somewhat subdued by the spirit of *Realpolitik,* Hitler and Stalin accepted a pact arranged by their top diplomats. On August 24, 1939, German foreign minister Joachim von Ribbentrop and Soviet foreign minister Vyacheslav Molotov announced the signing of a ten-year **Treaty of Non-Aggression.**

This **Nazi-Soviet Pact** contained public pledges that Germany and the USSR would neither attack each other nor join any group of nations hostile to the cosignatories of this agreement. Secretly, Stalin and Hitler arranged for the Soviets to annex Latvia, Lithuania, Bessarabia (part of Romania), and a section of Poland, and for the Nazis to take the Polish territory they wanted. This agreement removed the last barrier to Hitler's attack on Poland and left Europe poised on the brink of war.

## ■ ON THE ATTACK

In the Great War of 1914–1918, armies slaughtered each other mostly in Europe along nearly immobile lines. On September 1, 1939, a stunning attack by Germany on Poland began a deadly new season of European warfare that lasted six years. The conflict that erupted in 1939 became part of a larger military conflagration that had started in Asia with Japanese aggression in the early 1930s, had expanded to Europe during the Spanish Civil War, and would spread to even more of the globe in the early 1940s— truly a *world* war. In the European theater of this Second World War, the battles moved like a swift storm across vast stretches of land, causing death and destruction on a much more horrible scale than in the First World War.

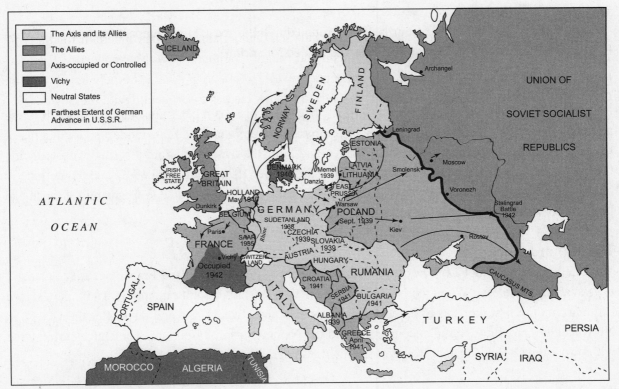

*Figure 13.1: Axis Expansion to 1942*

## The Nazi and Soviet Campaigns in Northeast Europe

The German invasion of Poland brought French and British declarations of war on the Nazi state within two days. Italy did not enter the war at this time. Overwhelming German military power quickly decided Poland's fate.

### Blitzkrieg *in Poland*

Nearly two million Nazi soldiers divided into massive columns behind powerful mobile armored forces drove into Poland from three directions. Waves of attack planes supported the invaders on the ground. Within less than two weeks, these ***Blitzkrieg*** (lightning war) tactics subdued most of Poland. Alarmed by this formidable military display, the Soviets rushed into their assault on eastern Poland in mid-September. The Polish government surrendered and the state disappeared before the end of the month. The Soviet Union and Germany each took about half of the conquered territory.

### The Winter War—a Soviet Campaign against Finland

Soon after the Soviets secured their holdings in Poland, they forcibly annexed the Baltic coastal states of Estonia, Latvia, and Lithuania to provide an expanded security zone in the northwest. The USSR attempted to make its borders near Leningrad more secure also by taking Finnish territory north of Leningrad. The Finns refused to allow this annexation and prepared for war. From late November 1939, until early March 1940, Finland won the admiration of the anti-Communist world by fighting the USSR to a standstill. Then the Soviet army broke through, and Finland sued for peace. After this difficult **Winter War,** Stalin got his strip of Finnish territory.

## Germany's Triumph in Western Europe

As Stalin struggled to seize security zones around the Baltic coast, Hitler prepared to take all of West Europe. The Nazi leader gathered his forces and waited for spring.

### The Phony War

Britain and France were at war with Germany beginning in September 1939, but for six months these nations did not fight. During this **sitzkrieg** or **phony war**, Britain engaged in a modest strengthening of its military forces. After the Great War, France had built the **Maginot Line,** a series of forts facing Germany. The French rested behind Maginot from September 1939, until April 1940, and did nothing to increase the nation's military power. With armaments and armies about equal to Germany's, France had little incentive for a frantic multiplication of forces and weapons.

### The Fall of France

Neither the Maginot Line nor a numerical balance of forces promised France security against a *Blitzkrieg* from the east. When the Nazis launched their westward assault on April 9, 1940, they seized Denmark on the first day and conquered Norway within three weeks. Several days after the victory in Norway, German armies simultaneously invaded the Netherlands and Belgium. The Dutch surrendered within four days (May 14), and Belgium fell ten days later.

**The Miracle of Dunkirk.** During the attack on Belgium, the German army crashed through the Ardennes Forest, penetrated French border defenses, and rushed across northern France to the shores of the English Channel. This German thrust through Belgium and across northern France trapped the Belgian army, along with hundreds of thousands of British and French troops sent in to help the Belgians. A British armada of military and private vessels had to evacuate nearly four hundred thousand soldiers from the beaches of Dunkirk. This **miracle of Dunkirk** saved a vast corps of military professionals that Britain desperately needed.

**The French Surrender.** The fall of Belgium opened France to the crushing blows of extremely well organized invading armies. After this entry in the north in mid-May 1940, the Germans swung south behind the Maginot Line. As Hitler's armies approached Paris, Mussolini decided to declare war on France and Britain. The Germans needed no help in France. They took Paris by mid-June and continued south against disorganized and demoralized defense forces. France surrendered on June 22.

**Vichy France.** Although the Germans occupied and directly controlled most of France, they left a southwestern quadrant of the country under a puppet government led by Henri-Philippe Pétain and Pierre Laval. Because Pétain and Laval established headquarters in Vichy, this Fascist remnant of the state became known as **Vichy France.** Many French citizens who opposed surrender to the Nazis joined underground resistance groups or fled to Britain. The anti-Fascist French in Britain organized the Free French movement under the command of General Charles de Gaulle (1890–1970).

# ■ IN A BATTLE FOR SURVIVAL

The fall of France in June 1940 left Hitler supreme on the continent. In swiftly moving battles, his armies had conquered six nations. Finland, Sweden, and Switzerland remained neutral and posed no threat to Germany. All other continental states were fascist, except Soviet Russia. Only Britain and the USSR stood between Hitler and the complete dominance of Europe.

German onslaughts against the British and Soviets in 1940 and 1941 forced these enemies of Nazism into a fight to survive. When the Nazis invaded the Soviet Union, they quickly conquered most of the highly populated part of the country. Hitler's armies then occupied territories that contained nearly all the Jews of Europe. The Nazis immediately began to implement their plans to exterminate Jews. Hitler had repeatedly sworn that every one of these "subhumans" would die. During the rest of the war, the Jewish people faced a more brutal struggle than any other group in Europe.

## The Battle of Britain

With France subdued by June 1940 and the Soviets still honoring their nonaggression pact with Germany, the Nazis could concentrate on the defeat of Britain. A *Blitzkrieg* across the English Channel, however, posed special problems. The **Luftwaffe** (German air force) had to drive Britain's **Royal Air Force** (RAF) from the skies before German armored units and armies could move onshore to conquer the island nation. Hitler's previous campaigns, especially in the Netherlands, indicated that a lightning war from the skies possibly could defeat the RAF and leave Britain exposed.

### *Winston Churchill in Command in Britain*

Chamberlain resigned, and Winston Churchill (1874–1965) became the British prime minister in May 1940. This new leader gave the nation inspiring direction throughout the war. As soon as Churchill took charge, he challenged the citizenry to prepare for the sacrifices necessary to ensure victory.

### *Hitler's First Defeat*

The RAF and *Luftwaffe* fought the Battle of Britain with increasing fury from August until November 1940. Attacks diminished during the winter months, but other hard strikes came in May and June 1941. Thereafter, the air raids subsided as Germany gave up the plan to invade Britain and turned its forces against the Soviet Union.

By the end of the war, German air raids had killed sixty thousand British civilians and left four million of the nation's thirteen million homes severely damaged. An additional five hundred thousand houses were destroyed or wrecked beyond use. The Battle of Britain caused most of these losses. But the air war in autumn 1940 also cost the Nazis dearly. They lost almost half of their one thousand and two hundred and ninety-one bombers. This loss seriously weakened the German air force for the duration of the war. More important, Britain was not only unbowed but aroused to the cause of war against Germany. A Nazi blitz had failed for the first time.

## The Balkan and North African Campaigns

Soon after the Battle of Britain began, Mussolini decided to expand his empire. He provoked wars with the British in North Africa in August 1940 and with the Yugoslavs and Greeks in the Balkan Peninsula in October of that year. But by December, the Italians were losing badly on all these southern fronts.

Because a Fascist Italian collapse would expose Germany to a British attack from the south, Hitler had to send forces into the Balkans and North Africa. The Germans quickly conquered Yugoslavia and Greece. In North Africa, General Erwin Rommel, called the Desert Fox, led his forces to victory over the British in Libya. Then Rommel threatened British positions in Egypt.

By June 1941, these operations in the Balkans and Africa gave Hitler the security he needed in the south. But the Battle of Britain and the wars started by Mussolini had reduced Germany's military resources and forced Hitler to delay the invasion of the Soviet Union. The schedule alterations especially worried Nazi leaders, because seasonal weather patterns could determine the success or failure of military operations in the Soviet Union.

## The Great Patriotic War—a Soviet Triumph

For more than fifteen years before the Second World War, Hitler emphatically publicized his conviction that the German "race" could realize its destiny as world rulers only by having the grain, petroleum, and other resources of the Soviet southwest. The Nazi-Soviet nonaggression pact (1939) in no way reduced Hitler's commitment to this vision of an Aryan empire. Germany had to fight Soviet Russia.

### Preparation for the Ultimate Blitzkrieg

In late June 1941, a Nazi strike force of about three thousand tanks, five thousand planes, and three million soldiers stood ready for **Operation Barbarossa,** the invasion of the Soviet Union. Since February, British, American, and Soviet intelligence services had warned Stalin of an impending attack. He refused to believe the reports and, according to General Georgi Zhukov, "resisted all attempts by the military leadership to put the troops on alert on the western frontier." Stalin believed that signs of preparation for combat would only provoke Hitler to invade.

### The Soviet Collapse

On June 22, 1941, the Nazi invasion began along a two-thousand-mile front. Numerically, the Soviet forces were not badly outmatched, and they fought with courage. But the quality of their equipment and military leadership in no way compared with Germany's at this stage of the war. During the first ten days, the Nazis advanced more than one hundred miles inside Soviet borders, took one hundred and fifty thousand prisoners, and destroyed seventy-five percent of the Soviet air force.

The invaders continued their incredibly rapid advance throughout the summer. In September 1941, Nazi forces reached the outskirts of Leningrad and Moscow. They thus threatened to seize the two largest and most highly industrialized cities in the nation. German troops took Kiev, the third largest city, on September 19, and within ten days began to exterminate Jews. Nearly thirty-five thousand died in the first two days of killing. The slaughter did not end in Kiev until the Nazis withdrew over two years later. Almost no Kievan Jews were left alive.

### Resistance

The Soviet public almost never saw or heard Stalin during the 1930s. On July 3, 1941, eleven days after the invasion began, he spoke to the nation by radio. Startled Soviet citizens heard their all-powerful leader appeal to his "brothers and sisters." Stalin urged them with a warmly personal and deeply patriotic

message to rise and destroy the invaders. The Soviets responded. Their stiff resistance stopped the Nazi line of advance in the north and central regions by the beginning of autumn.

In late 1941 and throughout 1942, the nation rallied to the cause of resistance. **Partisans** (underground fighters) battled the Nazis in occupied territory. The Soviets relocated factories and work forces eastward beyond German reach. War production rapidly increased. The Red Army expanded, reorganized, and went on the attack.

### The Counterattack

Distance and weather in the Soviet Union somewhat blunted the Nazi invasion drive during the last two months of 1941. The great length of German supply lines and axle-deep mud slowed the pace of the *Blitzkrieg*. Then bitter cold began to take its toll on Nazi troops and equipment. The German forces had not come prepared for the extremely low temperatures they encountered (sometimes forty below zero Fahrenheit) because Hitler had planned to start Operation Barbarossa early enough to defeat the Soviets before winter. The price of delays to attack Britain and conquer the Balkans quickly became evident.

In December 1941, the Red Army mounted its first counterattack along the entire front. This winter offensive pushed the Nazi lines in the center of the nation westward away from Moscow. The Red Army drive failed in the south. The Germans continued to advance there until September 1942, threatening to cut the Soviet Union in two. Then the Soviets stopped them and inflicted a punishing defeat at Stalingrad. This battle, which raged from August 1942 until the end of the following January, delivered a first stunning battlefield defeat to Nazi forces and turned the tide of war in East Europe. The total cost in lives perhaps surpassed one million—the Soviet military lost five hundred thousand, the German dead numbered one hundred and fifty thousand, and tens of thousands in the armies of Germany's allies were killed. At least forty thousand Soviet civilians died in the city during the battle of Stalingrad and an uncounted number of others in the surrounding region.

In the north, Nazi lines held firm around Leningrad until early 1944. When this nine-hundred-day siege ended, one-third of the city's three million citizens had died, most of them from starvation, disease, and cold weather. The Soviet counterattack finally began to succeed in the north in January 1944. This assault on the Nazis near Leningrad opened a series of strong Soviet offensive drives. During 1944, the Red Army liberated almost all Soviet territory and pursued the Nazis into Poland, Czechoslovakia, Hungary, Romania, and Bulgaria.

### The Holocaust

The Nazi occupation of Poland in 1939 followed by the invasion of the USSR in late June 1941, brought the prospect that during the latter months of 1941 virtually all European Jews would fall under Hitler's power. This circumstance meant that the time had come for Hitler's most trusted Nazi leaders to take action. *Luftwaffe Reichsmarshall* Herman Göring, whom Hitler had designated as his successor, sent a message on July 31, 1941, to Reinhard Heydrich, the chief assistant to Nazi SS leader *Reichsfuehrer* Heinrich Himmler. The dispatch ordered Heydrich to carry out "the Final Solution" of "the Jewish problem." These code words meant that the SS could undertake the murder of every Jew in Nazi-controlled Europe. Heydrich quickly organized special SS units to begin the killing of an entire genetic group (to commit **genocide**). This atrocity eventually involved such massive and brutal slaughter, often including the burning of victims or their bodies, that it has become known by a word that means complete destruction by fire: the **Holocaust.**

## The Extermination Decision

In public speeches and private conversations from the early 1920s onward, Hitler expressed his commitment to the removal of all Jews from Europe. The words he used until the latter 1930s might have meant their expulsion from the continent. The certainty that many of the approximately eleven million European Jews would not or could not leave their homelands left Hitler's message clear—if he gained the power to decide their fate, Jews who did not leave would die. When European circumstances seemed explosive in January 1939, the Fuehrer proclaimed that if war came, it would be a step in the Jewish campaign to destroy Aryans and dominate the world. The war, he declared, instead would bring the extermination of the Jews.

Although Hitler started the war, he carried out his threat to the Jews. The Holocaust began with Göring's order in July 1941. Himmler, Heydrich, and other Nazi leaders then implemented the command through a chain of subordinates, certain of whom took great initiative in the slaughter in areas they controlled. In later war-crime trials, a typical response of the actual executioners was that they felt nothing as they watched victims suffer and die, because they were only obeying superiors.

## Terror and Slave Labor

Nazi terror in Poland began immediately after the occupation of conquered territory in 1939. The invaders seized academic and religious leaders and imprisoned or killed them. When action by the Poles or other conquered peoples led to a Nazi death, German officials typically ordered the execution of one hundred of these jailed civilians for each Nazi casualty.

At the Wannsee Conference in Berlin in January 1942, Heydrich met fifteen Nazi officials to tell them the plan for Jews in Poland and other eastern territories. Most were to be worked to death. Extermination would await the strong ones who managed to survive these slave-labor conditions. Occupying forces in Poland began to implement the plan by herding all Jews into walled or fenced-off sectors of their cities—the Jewish **ghettos.**

On starvation diets, ghetto residents were forced to work at a cruel pace in war production plants. Jews tolerated these conditions too well to suit their captors, however. The Nazis thus decided to begin shipping them to death camps. The ghetto in Warsaw had a population of four hundred thousand people in mid-1940. Slave labor and deportation for extermination took all but seventy thousand by April 1943.

When heavily armed SS units entered the Warsaw ghetto on April 19, 1943, to slaughter these remaining captives, the Jews rebelled. Squads of Jewish men and women used gasoline bombs and light weapons they had smuggled in to fight the SS troops. It took a month to crush the rebellion. Almost all the Jews died fighting or were shipped to death camps.

## Death Squads

**Einsatzgruppen** (Special Action Groups) operated in occupied Poland and followed the German army into the Soviet Union during Operation Barbarossa. The assignment of these units was the mass murder of Jews. These death squads used gunfire and carbon monoxide vans to slaughter hundreds of thousands of people, mostly Jewish but also Communist Party members, resistance fighters, and others. Mass killing came to villages and cities all over the western USSR. At times, the *Einsatz* troops in cities such as Kiev killed people more rapidly than the special death camps.

## Concentration Camps and Death Camps

Nazi occupying forces in every conquered territory from France to Soviet Russia deported huge numbers of Jews to concentration camps. The Germans sent Jews to several compounds built before the war, but most went to new prison centers in East Europe. Almost thirty camps, including Dachau and Buchenwald, were organized to provide slave labor. The horrible conditions in these institutions ensured that inmates would live in great misery and die rapidly.

The Nazis constructed several camps that had no purpose but the swift mass murder of Jews and other "sub-humans," such as Roma (Gypsies), and homosexuals. They built the five largest extermination centers in Poland and equipped them with gas chambers for the mass murders. The Nazis also constructed huge furnaces to burn the bodies. Auschwitz, the largest of all the death camps, destroyed six thousand people a day when in full operation. Victims went naked into concrete rooms expecting "baths." With people of both sexes and all ages crowded close together, SS executioners dropped in pellets from above that released suffocating gases. The victims died excruciating deaths, tearing at the walls and ceiling with their bare hands.

## The Final Victory

The Nazi Final Solution took the lives of about six million of Europe's eleven million Jews. Only ten percent of the Jewish children living in German-occupied territory survived the Holocaust. The ninety percent who died numbered one-and-a-half million. Information about these mass murders began to reach the outside world early in the war, but most leaders doubted the stories at first.

By the summer of 1944, however, Britain, the United States, and the Soviet Union knew about the large extermination camps but did nothing. Jewish leaders urged the Western Allies to bomb the gas chambers and the railroads leading to the camps. British and American leaders rejected these pleas. They said such attacks were impractical and might make conditions worse for the Jews.

Several European nations saved the Jews within their borders by refusing to deliver victims as ordered by the Nazis. The Danes and Finns rescued virtually all their Jewish citizens. Even Fascist Italy protected many Italian Jews from deportation to death camps. Individuals all over Europe risked their lives to rescue intended victims of the Holocaust. Millions of Jews saved themselves through their own struggles, concealment, or flight. In these ways, about four to five million Jews lived through the Holocaust and won an agonizing victory over the most brutal enemy they had ever faced.

# ■ IN A FIGHT TO THE FINISH

In mid-summer 1943, the Nazis and Fascists ruled most of the continent. This position of power over so much of Europe meant that Hitler still posed an extreme threat to the well-being of Britain and Soviet Russia and to the existence of the Jewish people. During July and August 1943, the three greatest military powers in the world other than Germany mounted attacks and began to recapture Europe from the Fascists. Hitler now faced enemies committed to the total defeat of the Nazis and their allies.

## The Anti-Fascist Coalition

From the beginning of the Second World War in Europe, the United States provided support to Britain. America's **Lend-Lease Act** formally established and expanded this assistance program in March

1941. Soon after the Nazis invaded the USSR in June 1941, Britain and the Soviets signed a mutual aid agreement. Then the United States began lend-lease assistance to the Soviet Union the following November. In response to Hitler's escalating war in Europe, an anti-Fascist coalition had begun to emerge.

### The Atlantic Charter

During the early months of the war, Churchill and U.S. President Franklin Roosevelt discussed broad peace aims as well as the practical matter of military aid. These leaders held a conference at sea in August 1941 that produced the **Atlantic Charter.** This declaration contained a pledge to stop aggressors and ensure the right of all nations to choose their form of government. Britain and the United States also promised to advance the welfare of societies without exploiting them in any way. As British and American leaders pursued peace during the next four years, the firm alliance indicated by the charter never weakened, despite the conflicts that sometimes developed between these two nations.

### The United States at War

The United States provided aid to Britain and the USSR early in the war. At the beginning of December 1941, however, more than two years after the Second World War erupted in Europe, the United States was not fighting. Then events in Asia transformed the European conflict into a truly global war with the United States as a main participant on both sides of the world.

Leaders with attitudes similar to those of the European fascists rose to supremacy in Japan during the 1930s. Under militant nationalist influence, Japan conquered territory in China in 1931 and 1937. The outbreak of the war in Europe in 1939 weakened the grip of European imperialists in Asia and gave Japan new opportunities for expansion. Japanese leaders expected to make gains in British India, French Indochina, and the Dutch East Indies (Indonesia).

For almost a century before the Second World War, commercial interests had led the United States to become increasingly involved in Asian affairs. An extremely powerful navy made the Americans intimidating competitors for any nation that wanted influence in Asia. In 1898, for example, the United States fought and defeated Spain, then seized the Philippines, formerly a Spanish colony.

The United States remained a formidable influence in Asia in the 1930s. Japanese imperial ambitions thus placed them on a collision course with the Americans. With an air attack on the U.S. Pacific fleet at Pearl Harbor in the Hawaiian Islands on December 7, 1941, Japan intended to end the power of this rival in Asia. Because Japan's Italian and German allies declared war on the United States on December 11, the immediate effect of the aerial strike was that America entered the war in Asia and became a fighting ally of Britain and the USSR in Europe.

## The Allied Campaigns in North Africa and Italy

American strategists decided early in the war to devote most of their resources to the European military struggle until the Allies (the United States, Britain, and the USSR) defeated the Fascists in that region. In 1942, as the Soviets pounded against Hitler's forces in East Europe, the British and Americans opened their combined West European campaign with a year-long air war against Nazi military, industrial, and population centers on the continent.

The Americans also joined the British war against Rommel in North Africa in November 1942. Two weeks before the United States entered this desert conflict, British forces under General Bernard

Montgomery had turned the tide at El Alamein. The Western Allies completed the victory in North Africa by May 1943.

### The Casablanca Conference

Stalin had insisted throughout 1942 that the Western Allies open a second front in West Europe so that the Soviets would not have to fight the ground war on the continent alone. As British and U.S. troops battled toward victory in North Africa, Roosevelt and Churchill met at Casablanca, Morocco, to consider war plans, including the possibility of invading West Europe.

When their ten-day conference ended on January 24, 1943, the Western Allies had publicly proclaimed their decision to fight Italy, Germany, and Japan until these enemies surrendered unconditionally. Roosevelt and Churchill also secretly agreed to invade southern Europe through Sicily very soon.

Critical military circumstances in the Soviet Union had prevented Stalin from accepting the invitation to attend the Casablanca conference, but Soviet representatives attended and informed their leader of the outcome. The plan to open a second front in the west pleased Stalin, but he strongly preferred an attack across the English Channel into northern France.

### The Defeat of Fascist Italy

The Western Allies developed a new military technique during 1942, the **amphibious assault.** These attacks over water and onto enemy shores quickly became a U.S. and British specialty. On July 10, 1943, only weeks after the Allied victory in North Africa, the United States and Britain launched massive amphibious invasions of Sicily and began intensive bombing in Italy. The Fascist Grand Council, which had always passively obeyed Mussolini, met in mid-July and ordered their leader to surrender command of the army. King Victor Emmanuel III reasserted his authority and dismissed Mussolini as premier.

Pietro Badoglio, the new premier, took action at once to avoid an Allied invasion and a land war in Italy. He ordered the Fascist Party to disband and opened peace talks with the Western Allies. Negotiations continued until September 3, 1943, when the Badoglio government agreed to unconditional surrender. On the previous day, the first Allied troops had invaded southern Italy.

The collapse of the Fascist state and Italy's surrender did not end the battle for control of the peninsula. Hitler had anticipated the defeat of his Italian ally and rushed troops in to hold central and northern Italy. The Fuehrer also sent a special-forces group to rescue Mussolini, who had been under arrest since his dismissal as Italian premier. The Nazis then reestablished Mussolini as the head of a German puppet state in northern Italy. Bitter fighting between the Western Allies and the Nazis in northern Italy continued until the end of April 1945. As the Nazi defeat in Italy neared, Mussolini tried to escape to Switzerland. Members of the Italian anti-Fascist resistance forces captured and executed Mussolini and his mistress on April 28, 1945.

### The Liberation of West Europe

Allied war production capacities expanded rapidly during 1942 and 1943. The anti-Fascist coalition also advanced steadily on battlefields in Italy and the Soviet Union throughout 1943. Allied leaders thus began to consider war and victory plans in more detail.

### The Teheran Conference

In October 1943, American, British, and Soviet diplomats held a conference in Moscow. They agreed to continue to cooperate to defeat the Nazis. The Allies also pledged to nullify the power of Germany to wage war and punish Germans who committed war crimes. Churchill, Roosevelt, and Stalin then met in Teheran, Iran, for their first Big Three conference, from November 28, 1943, to January 12, 1944. They reaffirmed the agreements made in Moscow in October, decided the timing of a cross-Channel invasion, and promised to form a new world organization after the war.

### D Day and Beyond

By late spring 1944, 5,000 vessels waited in British ports to carry over two million Allied soldiers across the English Channel for a landing on the Normandy shores in France. Success required that the Allies' twelve thousand planes establish control of the skies over northern France. Strategists selected June 6, 1944, for the invasion date (code-named **D Day**). The location and timing of the attack surprised the Nazis, but they mounted a fierce resistance. Despite the stubborn defensive battle, the Allies secured a sixty-mile-wide section of beach within a week and brought the force of more than two million into northern France during the next three months.

### An Allied Front in Southern France

The Allies intensified their growing threat to the Nazi position in West Europe by opening still another front. On August 15, 1944, French and American troops invaded the southern coast of France. As the Allied armies in the north and south battled their way toward the heart of France, resistance fighters escalated the struggle behind Nazi lines. Parisian citizens also joined the fight and won control of their city during a rebellion in late August 1944.

### The Battle of the Bulge

In northwestern Europe, Allied gains continued during the autumn and winter after D Day. They drove the Nazis from Brussels, Belgium, on September 2, 1944, and crossed the German border ten days later. Then the advance halted. In December, after three months with static fronts, Hitler ordered a counterattack toward Belgium.

The Nazi offensive in December 1944 pushed the battle lines in the region back into a great bulge that almost divided the Allied forces in northwestern Europe. Inexperienced American soldiers finally stopped the German offensive during the ten-day **Battle of the Bulge** that ended December 25, 1944. American, British, and French forces then resumed their massive drive toward Germany and completed the liberation of West Europe by early 1945.

## The Soviet Conquest of East Europe

Eighteen months of slow and deadly combat brought Soviet troops into a small northeastern pocket in Bulgaria by June 1944. From that position north to the Baltic Sea, Germany still held a border strip of the USSR. Soon after the Western Allies landed at Normandy (June 6), Soviet forces charged into Nazi lines in the east. For a month, the front moved rapidly westward toward Romania and Poland.

### The Anti-Nazi Uprising in Warsaw

On August 1, 1944, underground forces in Warsaw, Poland, revolted against the German occupiers as the Red Army neared the city. The Nazis waged war on the desperate rebels for two months. The Soviets were forty miles away but immobile. German troops crushed the rebellion, killed two hundred thousand Poles, and completed the destruction of Warsaw by early October 1944.

### The Drive to the Borders of Germany

The Soviet army took Warsaw three months after the Nazis completed their brutal war against the city. Poles charged the Soviets with allowing the extermination of the Warsaw underground in order to weaken their nation. Red Army leaders insisted that after a long offensive, their forces lacked the strength to attack between August 1944 and January 1945. Once the Soviets resumed their attack, they continued the hard fight westward, reaching the borders of Germany within weeks.

## The Yalta Conference

On February 7, 1945, Churchill, Roosevelt, and Stalin met at Yalta on the Soviet Crimean Peninsula in the Black Sea. The anti-Fascist coalition urgently needed to make decisions about the restoration of the states that the Allies had recently liberated in East and West Europe. Furthermore, because the conference opened with Allied armies converging on the last stronghold of Nazism, the three leaders wanted to plan the final steps to victory, decide the postwar fate of Germany, and consider global peace-building methods.

### The Agreements on East Europe

Stalin came to Yalta with the Red Army in control of most of East Europe. With this powerful advantage, he proceeded to make several demands. Stalin insisted that the Soviets must keep the territory acquired from Poland in 1939, that the Poles should be compensated with the annexation of eastern German lands, and that Poland must have a government friendly to the USSR. Because Poland and Russia had a long history of extremely hostile relations, the insistence on a pro-Soviet Polish government meant that Stalin did not want to allow Poland to choose its leaders freely. The Soviets thought their need for protection from invaders from the west justified this demand.

The Western Allies won only minor modifications of Stalin's plan for Poland. Roosevelt and Churchill accepted the Polish border changes in principle, but left the precise boundaries between Poland and Germany unspecified. The three leaders agreed to establish a government in Poland led by the **Lublin Poles** (a pro-Soviet group). Stalin, in turn, yielded slightly and accepted the inclusion of a few members of a pro-Western Polish faction in the government.

In keeping with American demands, the three allies also pledged to provide for the free election of democratic governments in nations liberated from the Fascists. The position of Soviet forces in East Europe made it possible for Stalin to ignore his promise for free elections. The Western Allies had no way short of war to force strict Soviet compliance with this agreement.

### War Plans

Although the Yalta agreements included understandings about victory strategies in Germany, very important war plans approved at the conference pertained to the struggle in Asia. The United States expected an extended battle with Japan and believed that it was critically important to have Soviet help

against this enemy. The Japanese and Soviets were still at peace in February 1945, but the USSR promised to declare war on Japan within three months after the defeat of Germany. In return for this important concession to the Americans, Roosevelt agreed to Soviet territorial gains in Asia, including the acquisition of the Japanese Kuril Islands.

## The Fate of Germany

Stalin believed that the future security of the USSR and the peace of Europe required that Germany be demilitarized, divided into smaller states, and stripped of its industries. Although the United States had previously proposed a very similar plan, by February 1945, Roosevelt favored much milder treatment of Germany. Churchill took an even more lenient position toward Germany than did Roosevelt. The British leader also argued forcefully for French participation in the postwar control of Germany. Churchill's aim was to give the Germans and French sufficient strength and influence to counter Soviet power on the continent.

In the negotiations on German issues, Churchill and Stalin fought to achieve their aims. Roosevelt considered the maintenance of Allied solidarity so important that he was willing to yield more to Stalin than the British thought wise. Despite the American president's attitude, Churchill more nearly achieved his goals than did Stalin.

The Allies decided to divide Germany into four zones of occupation. Churchill and Roosevelt had ignored Stalin's objections and given France an area to control. Although Berlin was sixty miles inside the Soviet zone, the negotiators also arranged for each of the four occupying nations to take charge of a section of the capital. The four allies pledged that once they took charge in Germany, they would nullify Nazism and militarism in that nation.

In punishing Germany, the Western Allies would not go beyond occupation, de-Nazification, and demilitarization. They refused to accept the Soviet plan to strip Germany of its industry and split the nation into separate states. Germany would remain much stronger than Stalin had intended to allow. Churchill and Roosevelt also rejected Stalin's demand that the Germans pay a large reparations sum to the Soviet Union. The Western leaders agreed only to discuss that issue in the future.

## The Commitment to Form the United Nations

Before the Yalta discussions ended on February 12, the Big Three expressed their support for the plan to establish a new global association to replace the League of Nations. The Allies promised to participate in a **United Nations** organizational conference scheduled for late April 1945 in San Francisco.

## The Conquest of Germany

Allied armies arrayed along broad fronts in both East and West Europe had advanced steadily toward Germany during the last six months of 1944. The final stage of the Second World War in Europe began the month after the Yalta Conference as U.S. troops poured across the Rhine River into the heart of Germany and the Soviets gathered for an assault on Berlin. Despite the inevitability of defeat, Hitler would not allow his nation to surrender. Germany would fight until the Third *Reich* and its founder were destroyed.

## The Air War against Germany

The destruction of German cities began during the earliest days of the war as the British RAF flew night bombing raids over the *Reich*. As soon as the United States entered the conflict, American bombers began to carry out daylight attacks that concentrated on the ruin of German industry and transportation. These aerial assaults intensified throughout the war. By mid-1944, the Western Allies had so completely overwhelmed the German air force that they could attack repeatedly anywhere in the nation. Most German cities, including many with no important military or industrial targets, were struck time after time until they lay in ruins. An especially devastating series of attacks directed at Dresden during the Yalta Conference killed an estimated one hundred and fifty thousand to two hundred thousand people, almost all of them civilians.

## The Allied Breakthrough in West Germany

The western portion of Germany extends about five hundred miles from north to south and almost three hundred miles from east to west. The Elbe River separates this western region from a smaller eastern sector with Berlin at its center. The Rhine River flows northward along the nation's western border near France. In early March 1945, the armies of the Western Allies under the command of U.S. General Dwight Eisenhower attacked east out of France toward the Rhine.

As the Allied offensive began, Nazi armies in west central Germany withdrew after destroying all the Rhine bridges except one. This single structure enabled Eisenhower's forces to cross the river with exceptional speed and drive through the heart of West Germany. They reached the Elbe River, sixty miles from Berlin, by April 11.

On April 12, Roosevelt died. Eisenhower had to decide his next moves in Germany before Harry Truman, the new U.S. president, had time to become involved in war strategies. Churchill wanted to keep the Soviets out of East Germany. He urged Eisenhower to cross the Elbe and continue on to the German capital. The American general refused. In Eisenhower's judgment, the best course to military victory was for the Western Allies to swing into southwestern Germany, while the Soviets conquered eastern Germany.

## The Destruction of the Nazi Reich

As Eisenhower completed the campaign in West Germany, the Soviets advanced through the rest of East Europe and into East Germany. Vienna, the Austrian capital, fell to the Soviets on April 13. The Red Army forces under Marshal Georgi Zhukov then began their offensive sixty miles east of Berlin on April 16, 1945.

A few Soviet units entered the outskirts of Berlin on April 20. Other Red Army contingents fought on westward and met the Americans at Torgau on the Elbe on April 25. Hitler remained hidden in a bunker in Berlin as Allied forces swarmed over Germany. With the Red Army fighting the last Nazi defenders of Berlin in the streets above the Fuehrer's stronghold, Hitler killed himself on April 30.

The delivery of messages of submission by several Nazi commanders on May 7 inspired Truman and Churchill to declare victory in Europe on May 8. Because the Nazi high command surrendered on May 9, Stalin designated that date as the day of triumph. The Fascist era in Europe had finally drawn to a disastrous close.

## The Asian Conflagration

After the attack on Pearl Harbor, Hawaii, in December 1941, the Japanese and Americans fought each other with special ferocity. Japan conquered the Philippines and advanced toward Australia until March 1942. The Americans then devastated the Japanese navy the following May in the **Battle of the Coral Sea** and in early June at **Midway Island.**

The United States conducted a relentless offensive after Midway, taking island after island in extremely deadly combat. American forces sustained heavy casualties as they attacked well-entrenched and determined Japanese defenders. But intense U.S. naval bombardments, aerial assaults, and ground attacks with flame-throwers, tanks, and massive infantry forces almost totally exterminated the Japanese forces on islands such as **Tarawa, Peleliu,** and **Iwo Jima.**

By June 1944, the U.S. Army Air Force opened its war on Japan. The bombing continued with mounting fury for over a year. Naval vessels also joined the attack on Japanese cities. Thousands of tons of bombs and heavy artillery shells rained down on the island nation, incinerating heavily populated urban centers.

A very different kind of aerial attack then occurred on August 6, 1945. Residents of **Hiroshima** watched as a small flight of U.S. planes passed over their city. Because they saw no mass of bombers, they assumed the aircraft were on a reconnaissance mission. Instead, a B-29 had dropped a single nine-thousand-pound atomic bomb that plunged toward the city in a forty-three-second fall. When it exploded two thousand feet above ground, a small purple flash instantly changed into a massive fireball with a temperature of fifty million degrees Centigrade at its center. Eighty thousand to one hundred thousand people died instantly. The number of deaths from this bomb doubled during the next five years.

Stalin acted on his Yalta pledge on August 8, 1945, and declared war on Japan. On the following day, the United States dropped an atomic bomb on **Nagasaki**, Japan, killing about sixty thousand people. Japanese leaders indicated within two days that they wanted to surrender. They officially yielded on August 14 and signed the surrender documents on September 2.

President Truman told the world that he had ordered the use of atomic bombs to hasten the end of the war and save the lives of the estimated five hundred thousand troops that an invasion of Japan was expected to take. Critics of his decision charged that Japan would have surrendered soon even without an invasion. They believed the nuclear attacks on these cities were unnecessary. A few scholars later argued that Truman ordered the nuclear attacks in order to demonstrate U.S. power to Stalin or to stop the war before the Soviets could advance very far into Asia.

*In the 1920s, Europeans joined people from every quarter of the globe in a concerted effort to prevent a second plunge into world war. They pursued security and harmony by establishing the League of Nations, negotiating arms limitations, and arranging protective treaties. The hope for peace strengthened throughout the 1920s, but the dreams faded in the next decade as Fascist aggression increased in spite of all the peacemaking efforts.*

*British and French leaders had a great dread of the war that seemed to be approaching during the latter 1930s. In a vain effort to maintain peace, they made concessions to Hitler, the most militant Fascist dictator. These attempts to appease the Fuehrer did not end Nazi aggression, however. Only war could give Hitler what he desired—the annexation of East Europe and a chance to deport or murder every Jew on the continent.*

*In September 1939, German armies struck into Poland with lightning speed and ignited the Second World War in Europe. The Nazi military storm then raged across the continent during the next two years, overwhelming all opposition from western France to the outskirts of the Soviet capital. These conquests gave Hitler and his Fascist allies control of most of Europe by late 1941. As soon as the Nazis took East Europe, they began to exterminate Jews and other "sub-humans." The slaughter did not stop until British, Soviet, and American forces blasted their way into the heart of Europe and defeated the Italian Fascists and German Nazis.*

*After the Allied victory in Europe in May 1945, the war continued against Japan, the Asian member of the Fascist alliance. The defeat of the Japanese required a deadly war of island invasion and aerial bombardment that climaxed in the atomic infernos at Hiroshima and Nagasaki in August 1945. Even before these last battles of the Second World War, a Cold War had begun between the Western Allies and the Soviets. This conflict soon created a threat of nuclear holocaust that haunted the world until the last decade of the century.*

## Selected Readings

Calvocoressi, Peter and Guy Wint. *Total War: The Story of World War II*. London: Allen Lane, 1972.

Churchill, Winston S. *The Second World War* (six volumes). Boston: Houghton and Mifflin, 1948–1953.

Davidowicz, Lucy. *The War Against the Jews, 1933–1945*. New York: Holt, Rinehart, and Winston, 1975.

Delzell, Charles F. *Mussolini's Enemies: The Italian Anti-Fascist Resistance*. Princeton, NJ: Princeton University Press, 1961.

Feis, Herbert. *Churchill, Roosevelt, and Stalin: The War They Waged and the Peace They Sought*, 2nd Edition. Princeton, NJ: Princeton University Press, 1967.

Hastings, Max. *Overlord: D Day and the Battle of Normandy*. New York: Simon and Schuster, 1984.

Klemperer, Victor. *I Will Bear Witness: A Diary of the Nazi Years, 1933–1945* (two volumes). New York: Random House, 1998–1999.

Krakowski, Shmuel. *The War of the Doomed: Jewish Armed Resistance in Poland, 1942–1944*. New York: Holmes and Meier, 1984.

Sherwin, Martin J. *A World Destroyed: The Atomic Bomb and the Grand Alliance*. New York: Vintage Books, 1977.

Weinberg, Gerald L. *World at Arms: A Global History of World War II*, 2nd Edition. Cambridge, UK: Cambridge University Press, 2005.

*World in the Balance: Behind the Scenes of World War II*. Hanover, NH: University Press of New England, 1981.

Weitz, Margaret Collins. *Sisters in the Resistance: How Women Fought to Free France, 1940–1945*. New York: J. Wiley, 1995.

Wright, Gordon. *The Ordeal of Total War, 1939–1945*. New York: Harper & Row, 1968.

## Test Yourself

1) The Munich agreement enabled Germany to
   a) take part of Czechoslovakia
   b) annex Austria
   c) take the Polish corridor
   d) remilitarize the Rhineland

2) The Second World War in Europe began when Germany attacked
   a) France
   b) Britain
   c) Poland
   d) Soviet Russia

3) During the Nazi campaign to kill all Jews, the important sources of resistance to this killing included
   a) U.S. bombing of death camps
   b) protective action by Danes, Swedes, and Italians
   c) the refusal of the Vichy French government to deport Jews to death camps
   d) Pope Pius XII leading a moral crusade against Nazi anti-Semitism

4) The Battle of Britain was
   a) a full-scale land invasion of Great Britain by the Germans only
   b) a joint landing of troops in Britain by Germans and Italians
   c) a naval battle involving the H.M.S. *Britain* and the German *Junker*
   d) an air battle over Britain

5) Since the Second World War, political leaders in particular have referred to the appeasement policy of France and Germany as a lesson from history that shows the error of trying to compromise with aggressors—appeasement of Hitler, that is, led to the Second World War when it could have been avoided by early forceful resistance to the Nazi leader. The text account indicated that
   a) If not for appeasement, the war would not have come.
   b) Appeasement was the main cause of the war, but there were several other important influences.
   c) Hitler's drive for an empire in Europe made war very likely; appeasement was a minor influence.
   d) Appeasement did not encourage Hitler's aggressiveness.

6) Certain of the studies of the Holocaust tend to fall into one of two categories of interpretation—the "intentionalist" view, emphasizing that for a long time Hitler intended to exterminate the Jews and carried out this aim when he had the power, and the "functionalist" view, which attributes the extermination to other people and circumstances, especially to the influence of lower-level Nazi leaders acting on their own impulses and responding to war-time conditions in their locales. Intentionalists

recognize that Hitler did not act alone, and functionalists acknowledge that Hitler influenced the Holocaust, but they see the main responsibility differently. What position did the text take?

a) a mostly unqualified intentionalist position

b) strongly intentionalist with recognition of a degree of functionalist validity

c) strongly functionalist with recognition of a degree of intentionalist validity

d) a mostly unqualified functionalist position

7) After selecting an answer for Question 6, read the related annotation in the "Test Yourself Answer" section, review the relevant sections of the chapter, and discuss the extent to which the text effectively expresses the author's indicated position on the intentionalist-functionalist debate.

## Test Yourself Answers

1)  **a.** In the Munich Conference in 1938, Britain and France accepted Hitler's demand that Germany should be allowed to annex the Sudetenland, a portion of Czechoslovakia in which many ethnic Germans lived. This agreement eventually brought much criticism of the West European leaders because they yielded to Hitler even though the Czechoslovaks were excluded from the conference and because the agreement did not bring the anticipated lessening of Nazi aggressiveness.

2)  **c.** Although the great powers that eventually fought in the Second World War in Europe entered in stages from the time of the German conquest of Poland in autumn 1939 to the days just after the Japanese attack on Pearl Harbor in December 1941, the invasion of Poland marked the beginning of this part of the global siege.

3)  **b.** Information in this chapter indicates that choice *b* is valid and that choice *a* is false. The text does not describe the actions of the Vichy government, but the Vichy French did cooperate with the deportation of Jews to camps in East Europe. A previous chapter notes that the statement about Pope Pius XII is false.

4)  **d.** Although the long tradition of referring to the air war against the United Kingdom as the Battle of Britain suggests something more, this important part of the story of the Second World War was a German aerial attack on the British Isles.

5)  **c.** The introduction for the chapter concludes with these sentences: "The British believed almost until the last moment that they could help Hitler realize his goals for Germany and stop the rush to war. They were wrong. The Fuehrer's aim was the conquest of Europe." This generalization should convey the view that Hitler made war very difficult to avoid, regardless of the actions of other national leaders. The reference to his goal as "the *conquest* of Europe" suggests that the war was not caused by allowing Hitler to get away with a series of aggressive moves that made him think he could have what he wanted without war. The account of events leading to the conflict agrees with these introductory lines, but they also add information that highlights the important but relatively minor influence of appeasement as an incitement to Nazi aggression. An example of the most direct indication of this effect of appeasement is the following statement that concludes discussion (page 283) of Hitler's remilitarization of the Rhineland in violation of the Versailles Treaty: "Hitler's success in the Rhineland, however, made it more difficult for German officials and European leaders to resist Nazi aggressiveness in the future."

6)  **b.** The historic details included in the
    introductory paragraphs for the section on
    the Holocaust emphasize the "intentional"
    interpretation. Information in the opening
    lines pertain to the onset of the extermination
    and indicate the decision by Hitler carried
    into effect by his "most trusted" associates
    in the upper Nazi bureaucracy. Comments
    on how this decision came about that
    follow focus also on the Fuehrer's leading
    influence, especially in noting his early
    commitment to removing Jews and the
    near impossibility that all European Jews
    could leave the continent and thus avoid
    extermination. The implication is that Hitler
    must have known than his anti-Semitism
    policy meant mass murder. The "functional"
    view's lesser but important degree of validity
    is recognized in information and phrasing
    such as this: "Himmler, Heydrich, and
    other Nazi leaders then implemented the
    command *through a chain of subordinates,
    certain of whom took great initiative in the
    slaughter in areas they controlled.*"

7)  This quiz essay should develop in more
    detail a commentary of the kind illustrated in
    the annotation for Question 6, but with an
    emphasis on whether the details and wording
    in the chapter conveyed a viewpoint on
    "intentionalism" and "functionalism" and
    whether the perspective does seem to be
    "strongly intentionalist" with a recognition
    of a certain degree of "functionalist" validity.

# The Superpower Spheres in Europe (1945–1968)

| | |
|---:|:---|
| **April 1945:** | A meeting at San Francisco founds the United Nations. |
| **July 1945:** | Allied leaders hold their final war conference at Potsdam, Germany. |
| **March 1947:** | The Truman Doctrine promises anti-Communist aid to nations. |
| **June 1947:** | The United States begins Marshall Plan aid to rebuild Europe. |
| **February 1948:** | Communist triumph in Czechoslovakia completes the Sovietization of East Europe. |
| **June 1948:** | The Soviets begin an eleven-month blockade of Berlin. |
| **April 1949:** | Western nations form the North Atlantic Treaty Organization. |
| **1950:** | The Korean War begins. |
| **1952:** | The United States explodes the first hydrogen bomb. |
| **1953:** | Stalin dies. |
| **1956:** | Khrushchev emerges as leader of the Soviet Union. |
| **1956:** | A Soviet invasion ends the Hungarian revolt against Communism. |
| **1957:** | Six West European states organize the Common Market. |
| **1958:** | The Soviets orbit the first earth satellite, *Sputnik*. |
| **1962:** | The Cuban missile crisis takes the world to the nuclear brink. |
| **1964:** | Soviet leaders force Khrushchev into retirement. |

*From Early Modern times until 1945, Central and West Europeans exercised mastery over their continent and much of the rest of the world as well. For more than two decades after the Second World War ended in 1945, Europeans not only lost their supremacy, but found themselves under the domination of the Soviet Union and the United States.*

*The Soviets held ultimate authority in East Europe by the late 1940s. They transformed the governmental and economic systems of almost all the states of this region with little consideration for the wishes of the East Europeans. In West Europe, the United States dominated foreign and military policies but largely left the states in this area in control of their own internal affairs.*

*The division of the continent into these superpower spheres strongly affected European and world affairs until the 1970s, and did so to a lesser extent until the last decade of the century. This influence resulted in part simply from the ability of the Soviets and Americans to hold sway over these regions. But the change in the international power structure after 1945 shaped the course of events in Europe and the larger world even more, because each of the superpowers struggled in every way except open war to dominate the other. One of the particularly important effects of this Cold War was to place Europe, and perhaps the rest of the world, under the threat of a nuclear holocaust from the 1950s to 1980s.*

## ■ THE AFTERMATH OF EUROPE'S GREATEST WAR

Six years of searing warfare between the Axis and Allied Powers in Europe destroyed governments and drastically altered the international balance of power, took away whole villages, turned huge cities into rubble piles, drove multiple millions from homes and homelands and scattered them across the continent, left more millions clinging to life in prisons and death camps, and killed tens of millions more. The ravages of this world war reached beyond Europe, too, taking millions more people, scorching more of the land, and breaking down once powerful structures that had, for good and ill, long ordered the non-European world.

### An Altered World Order

In addition to the material and human losses that the Second World War caused in the non-European world, this violent struggle ensured the sudden death of European empires and transformed many former colonies into new states that had to find their place in a much changed world order. The states, both old and new, would interact in many respects in the same ways that countries always had, but most also would become part of an expanded and stronger world organization, the United Nations.

### *The Collapse of the European Empires*

Asian, African, and Middle Eastern peoples struggled to liberate themselves from European control throughout the imperial era. Japanese success in taking Asian colonies from the Europeans during the Second World War weakened the western imperialists' grip on that region. The war also awakened a worldwide anti-colonial spirit that made it difficult for the Europeans to keep any of their subject territories after 1945.

These trends led to a rapid collapse of European empires. India won independence from Britain in 1947. France, which lost control of Indochina during the Second World War, began a deadly fight to regain the region in 1946, but in 1954, surrendered the territory to liberation forces led by the Vietnamese. During the 1950s and 1960s, independence movements in Africa drove the Europeans from that continent. The long era of European imperialism was over.

The end of European empire left a changed global political structure in the 1960s. The capitalist states of North America and West Europe (the **First World**) no longer possessed global empires but dominated world affairs because of their military and economic power. The **Second World** of Communist nations, although in conflict with one another, challenged the capitalists for world supremacy. The nations of Asia, Africa, and Central and South America that refused to align with either side in the Cold War formed a **Third World** bloc of mostly poor but increasingly important states. Europe had experienced great losses in the Second World War and its aftermath. The Third World, however, gained its freedom.

## *Establishment of the United Nations*

The Americans, British, and Soviets coordinated their assault on the European Fascists effectively enough to deliver a crushing defeat to their enemies in Europe and Asia. At the end of the war, however, the political conflicts between the Western Allies and the Soviets made it impossible for the victors to gather for a peace conference. Eventually, the foreign ministers of the conquering nations negotiated treaties with all the defeated states except one. They never arranged a formal settlement with Germany. They did cooperate, however, in one significant effort to build a more peaceful world.

The failure of the League of Nations to prevent the explosion of another world war in the 1930s and the ruinous effects of that war strengthened the movement to build an effective global organization. During the latter stages of the conflict in Europe, the Allied leaders met to discuss the pursuit of victory over the Axis powers, but they also pledged in their conferences to work together to form a new international institution. The work began in the San Francisco conference in April 1945. This meeting led to the formation of the **United Nations (UN).** The UN founders committed the new international organization to the pursuit of peace, improved living standards, and equal rights for all the people of the world.

The idealism of the UN organizers did not blind them to certain political realities. Churchill, Roosevelt, and Stalin had agreed that the successor to the League of Nations could make critical decisions only if the great powers remained united. The **UN Charter,** therefore, gave supreme authority to a **Security Council** comprising representatives from the United States, the Soviet Union, Britain, France, and China. Each of these states could block any request for extraordinary UN action, such as military intervention in conflicts between nations.

## A Devastated and Divided Europe

The Second World War gave the nations of the world good reason to attempt to organize for peace. Europe had suffered truly incredible losses. The dead numbered about forty-five million, with approximately equal numbers of military and civilian casualties. (The war in Asia killed an additional twenty million.) This massive violence had a crushing effect on many who survived. Almost every Soviet and Polish family "had someone missing from the table" at the end of the war. Thirty-five million people injured by the war suffered not only the wounds but the prospects of little or no medical care. The war also destroyed about one-fourth of all dwellings in Poland, the USSR, Yugoslavia, and Greece and smaller percentages in many other nations. The sweep of combat and other war circumstances, such as the Nazi practice of using slave labor, drove tens of millions of **displaced persons** from homes and homelands. Critical shortages of food, clothes, medicine, and fuel added to the misery. Damage to industry, transportation, communication, and agriculture made the prospects of rapid recovery bleak.

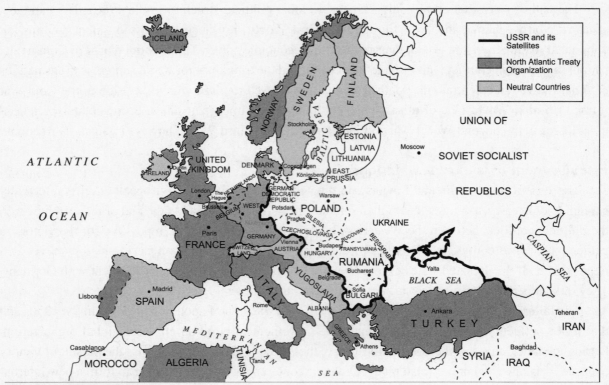

*Figure 14.1: Divided Europe*

## The Superpower Spheres

Among the nations that suffered the most in the Second World War, none was in a better position to guarantee against a recurrence of these horrors than the Soviet Union. Stalin's drive to defeat the Nazis brought a Red Army of eleven million into East Europe. This military force gave the Soviet leader power over a band of states that covered the entire region just beyond the western border of the USSR. He intended to protect this boundary by converting these nations into a pro-Soviet buffer zone. Stalin's military position in East Europe made this goal almost certainly obtainable.

Friendly states on the western Soviet border mattered to Stalin, but the safety of his country depended much more on making certain that Germany could never again strike eastward. The Soviet leader planned to end this threat by keeping Germany unified, controlled by its wartime conquerors, and completely demilitarized. Because the Soviets jointly occupied Germany with the Americans, British, and French, Stalin had no chance of achieving this objective unless the Western Allies cooperated with him.

The United States held a position of strength in West Europe similar to that of the Soviets in the east. The Americans not only occupied much territory in West Europe, but also had armed forces of twelve million, exclusive possession of atomic weapons, the world's most highly developed industrial economy, and an undamaged homeland. The United States certainly had the power to prevent Stalin from carrying out his intentions in Germany. The Americans even could have prevented Soviet expansion westward if the Communist leader had intended further European conquests, as certain Western leaders erroneously assumed. In still other ways, the United States had the potential to influence the fortunes of West Europe.

**The Origins of Soviet-U.S. Hostility.** Although a cooperative effort against the Fascists drew the superpowers into their adjacent European spheres, the two nations had a history of antagonistic relations. They had begun to clash in the latter 1800s as Russia extended its empire toward North China and the United States sought to capture markets in the same region. Relationships worsened after the Bolshevik victory in 1917 and subsequent U.S. intervention in the Russian Civil War. Soviet-American cooperation during the era of the most serious Nazi threat quickly ended as victory approached in Europe. Most of the issues that brought about this renewal of conflict pertained to East Europe and Germany.

**The Tightening Soviet Grip in East Europe.** Soviet forces drove the Nazis out of Poland during January 1945. As the Red Army continued the battle against German troops elsewhere in East Europe during the spring, the Soviets took steps to give the pro-Communist Lublin group (see Chapter 13) dominance in the coalition government in Poland. Stalin accomplished a similar strengthening of pro-Soviet elements in the governing coalitions of Romania, Bulgaria, and Hungary by the end of 1945.

**The American Challenge to the Soviets.** President Truman angrily condemned these actions and told the Soviets to keep their Yalta pledge of free elections to determine the traits of government in liberated nations. Stalin had assumed that Western leaders viewed the election promise as he did, as a public relations device. Furthermore, Britain and the United States had rejected his insistence on having influence in Italy when they conquered that nation in 1943. Stalin thus ignored Truman's demand for a voice in East European affairs. With the Soviet military fully in charge of most nations in the region, little could be done to change Stalin's policy of ensuring friendly border states, whatever the attitudes of the populations within them.

## The Potsdam Conference

On July 17, 1945, Churchill, Stalin, and Truman met for the final Big Three conference at **Potsdam,** a suburb of Berlin. The results of the negotiations gave little evidence of the developing split between the Soviets and the Western Allies.

### Policies toward Japan and Germany

Stalin quickly reaffirmed that the Soviet Union would declare war on Japan as promised at Yalta. The three leaders also announced continued support for the Yalta plan to demilitarize and denazify Germany. The Allies agreed, furthermore, that they would promote democracy in Germany, accept the Soviet proposal to annex part of East Germany to Poland, and punish Fascist war criminals. In 1946, twenty-one Nazi officials stood trial before an international court at **Nuremberg.** The Allies convicted eighteen and executed ten of these people.

### Zones of Occupation in Germany

The Big Three nations had agreed at Yalta that each of them would occupy a zone in Germany. Stalin also accepted the proposal to allow France a sector to control. The three Western Allies occupied zones west of the Elbe River. The Soviets took charge in the smaller eastern region. Berlin, in the heart of the Soviet zone, was divided among the four powers in the same way. At Potsdam, the Allies decided that they would keep Germany economically unified.

### Reparations Plans

Several of these agreements suggested greater harmony than actually existed. The decisions on reparations indicated the tendency toward conflict. The Western Allies rejected the Soviet plan to take farm products and dismantled industrial facilities from all the occupation zones. Western leaders would only affirm that the Soviets could take ten percent of West Germany's industry as in-kind reparations and an additional fifteen percent in exchange for East German agricultural products. Because the Americans and British could not control Soviet actions in East Germany anyway, they agreed that the USSR could decide how much to take from the eastern zone for transfer to the Soviet Union.

### The Allies at the Moment of Departure

Truman had come to Potsdam after Allied victory in Europe but with his nation still at war in Asia. The U.S. president arrived, however, armed with the recent report of a successful test explosion of the atomic bomb, which would be used on Japan within weeks thereafter. Exclusive possession of the weapon seemed not to strengthen Truman's hand in the conference. The overall military and economic power of the U.S. mattered more to Stalin. That circumstance and the Soviet Union's armed might in East Europe largely determined the outcome of the Potsdam Conference.

Although the Soviets and Americans had become the unrivaled great powers by 1945, British military strength and Churchill's diplomatic skill enabled the United Kingdom to have a very important effect on the course of the war and its outcome. The British continued to have significant influence at Potsdam, even though Churchill lost an election after he left for the conference and had to quit the negotiations. Clement Attlee, the Labour Party leader, became prime minister and represented Britain from July 28 until the meetings ended on August 2. This change in leadership, however, had little effect on the proceedings.

Neither the conflicts evident at Potsdam nor the willingness of the Allies to resort to power politics made East-West cooperation impossible after the conference. Soviet, British, and American leaders still expected to work together in Europe. They arranged for a joint **Allied Control Commission** to supervise the occupation of Germany. Stalin, Attlee, and Truman also agreed that their foreign ministers would negotiate treaties with the defeated Fascist states. When the Allied leaders left Potsdam, Soviet-American rivalry had not yet become a struggle for supremacy.

## ■ THE BEGINNING OF THE COLD WAR

In the latter months of 1945, Western leaders became increasingly concerned about the trend toward tighter Soviet control over East Europe. By January 1946, Truman gave up on cooperation with Stalin. Churchill's views about post-war Europe still commanded attention even though he had left office. He expressed extreme alarm about the Soviets in a public address in the United States in March 1946. In a speech at Westminster College in Fulton, Missouri, Churchill issued an ominous warning. The British statesman depicted the Soviets as enclosing East Europe behind an "iron curtain."

Superpower rivalry intensified throughout 1946 and 1947. George Kennan, a State Department expert on Soviet relations, had an especially important influence on the U.S. shift to military confrontation. In a famous **Long Telegram** from the U.S. embassy in Moscow in the spring of 1946, he made a persuasive case for a policy of "containment." He argued that instead of trying to "reason" with the Soviets, the United States should face them with "the logic of force" whenever they tried to extend their influence in

the world. The Truman administration adopted this policy and began to pursue a military buildup so that the United States could ensure Soviet containment.

In a book titled *The Cold War,* Walter Lippmann, a prominent American journalist, criticized this emerging policy of intimidation. The Truman administration ignored such concerns, and the turn toward containment by confrontation continued. By early 1948, the Soviets and Americans were locked in a struggle for dominance that involved almost every tactic other than armed combat. Lippmann's book influenced only the name for the conflict. Although the main battleground of this Cold War was Europe, the first encounters occurred in a tier of states at the northeastern end of the Mediterranean.

## Superpower Conflict in the Eastern Mediterranean

In order to secure the main supply route for U.S. aid to the Soviet Union, Red Army troops occupied northern Iran during the Second World War. Soviet forces ignored their scheduled departure date in early 1946 and briefly supported a local rebel group. After a few threats from the United States and Iranian offers of very favorable oil trading rights in return for their departure, the Soviets left. Then Iran canceled the oil deal.

### The Greek Crisis

Events in Greece that climaxed in 1947 agitated the United States even more than the Iranian crisis had. The oppressive policies of a right-wing authoritarian government in Greece provoked a strong left-wing revolutionary movement that seemed near victory by February 1947. In March, the British decided that economic problems at home required an end to their decades of involvement in Greek affairs. They informed the Americans that they would have to replace the British as supporters of the right-wing Greek government.

### Foreign Intruders in Greece

The Truman administration was ready for drastic action. U.S. leaders considered the entire region north of the Black Sea to be threatened by Soviet aggression. Stalin appeared to have tried and failed to expand into Iran. Then the USSR began to pressure Turkey to allow passage of Soviet ships between the Black Sea and the Mediterranean through Turkish waters. By March 1947, both Turkey and Greece appeared to be at risk.

U.S. leaders had an exaggerated sense of the danger. They assumed Soviet involvement in the Greek revolution and worked feverishly to get Congress to approve funds for the defense of the Greek government. In reality, Communist Yugoslavia supported the Greek rebels, but the Soviet Union did not. Furthermore, the revolution in Greece had no connection to Soviet policy toward Turkey. The already dense atmosphere of the Cold War prevented most Western leaders from seeing the possibility that these Eastern Mediterranean problems were not the result of an interconnected plot designed by Moscow to advance the Soviets along an endless road of expansion.

### The Truman Doctrine

On March 12, 1947, Truman proclaimed to an emergency session of Congress his doctrine (called the **Truman Doctrine**) that the United States had to support any free nation threatened by "armed minorities" or "outside pressures." More immediately, Truman called for $400 million to save Greece and

Turkey from the imminent danger of totalitarian revolution or conquest. Administration officials asserted during congressional hearings that if these Eastern Mediterranean states fell, the revolution would spread into Europe, perhaps even as far as France. Within two months, heavy majorities in both houses voted to grant the money.

## Early East-West Conflicts in Europe's Heartland

The presence of the Red Army enabled the pro-Soviet minorities in Poland, Romania, Bulgaria, and Hungary to begin their climb toward power in 1945. These East European Stalinists advanced steadily in strength thereafter. In Poland, Romania, and Bulgaria, the pro-Soviets surpassed all their opponents in strength by 1947. Communists in Hungary made gains during 1946 and 1947, but their competitors remained a serious challenge. Later, the Soviet-supported factions achieved exclusive control in these four states and Czechoslovakia as well.

### An Economic Barrage from the United States

Beginning in early 1945, the U.S. communicated increasingly strong objections to the Soviets about the transformation of East European governments. The Truman administration also demanded that Stalin open the region to world trade and used economic weapons in an attempt to force Stalin's compliance with these demands.

In January 1945, the Soviets requested a loan of $6 billion to begin rebuilding their country. The United States replied that when the USSR treated the East Europeans properly, the possibility of aid would be discussed. Stalin's course of action remained unchanged. The Americans increased the economic pressure. In May 1946, they violated a Potsdam pledge and blocked the Soviets from taking industrial hardware from the U.S. Zone in Germany. During 1947, both the Soviets and the Western Allies continued this struggle by converting their German occupation zones into separate economic units, again in violation of the Potsdam agreements.

### The Marshall Plan

George Marshall, the U.S. Secretary of State, introduced the ultimate weapon in the economic Cold War in June 1947. Marshall feared that Communists might soon be able to take control in more Central and West European states as ruined economies caused governments to fall. He proposed that the United States establish a large-scale aid program to promote the rapid economic reconstruction of Europe.

The United States invited all European states, including the Soviet Union, to apply for aid under the **Marshall Plan.** Stalin discovered, however, that provisions in the plan would enable the United States to gain detailed information about the Soviet Union. He would never allow any foreign nation to learn how severely the war had damaged the Soviet industrial system. Stalin also concluded that the program would make East European countries subordinate to the United States. Neither the Soviet Union nor any East European state would ever accept this assistance. West European leaders welcomed the aid offer and began to plan an administrative system to manage the use of funds.

### Cominform and Comecon

For a year before Marshall proposed his plan, Stalin had slowed his consolidation of power over East Europe. His view of the dangers of the U.S. aid program led the Soviets to move more quickly in

strengthening their grip on the region. In July 1947, they organized the Communist Information Bureau (**Cominform**), the fourth in a series of Communist international organizations that Marx and Engels had begun in the latter 1800s. The Soviets intended to use Cominform to gain more effective control over Communists in all European countries, especially in the eastern sphere. Another step toward increased power came in 1949, with the establishment of the Council for Mutual Economic Assistance (**Comecon**) as an agency of economic influence in East Europe.

### 1948: Czechoslovakia and the Division of Europe

In early 1948, Soviet dominated dictatorships already ruled Poland, Hungary, Romania, and Bulgaria. The Czechs still had a coalition government that included prominent non-Communists such as Foreign Minister Jan Masaryk. But Czech independence had been doomed since July 1947, when the government indicated its interest in accepting Western aid under the Marshall Plan. On February 25, 1948, the Czech Communist premier, Klement Gottwald, acted on Stalin's orders and created a one-party dictatorship. In mid-March, Masaryk was found dead after jumping or being thrown from an upper-floor window.

These events in Czechoslovakia occurred as the U.S. Congress considered legislation to implement the Marshall Plan. Masaryk's death made passage of the act more certain. In late March 1948, Congress approved the establishment of the **European Recovery Program** (the formal title of the Marshall Plan). West Europeans received almost $75 billion in Marshall Plan aid before the end of the 1950s. (The aid would amount to more than $500 billion in early twenty-first century dollars.) These funds enabled the participating states to use their own vast resources effectively in a program of rapid economic reconstruction. The Marshall Plan also tied West Europe more closely to the United States and completed the division of the region into U.S.- and Soviet-dominated spheres. For more than forty years, there would be two Europes.

## The Militarization of the Cold War

As the Marshall Plan went into effect, the character of the Cold War changed. The Truman administration continued to employ diplomatic and economic weapons against the Soviets, but in 1948, the United States began to depend on military power as the main instrument for the containment of communism in Europe.

### The First Berlin Crisis

American opposition to Stalin's control over East Europe resulted in the Truman administration's economic warfare against the Soviets. This campaign included the beginning of efforts to restore the industrial strength of West Germany and to unify the economic systems of the three western occupation zones. On such foundations, a new and powerful West German state could rise.

### The Berlin Blockade

In June 1948, Stalin attempted to force a reversal of U.S. policies in Germany by closing all ground routes from the west into Berlin. Because the city was isolated inside the Soviet zone, this action threatened the control of the Western Allies over their sectors of this important administrative center. A surrender of control or a reversal of U.S. policy in West Germany would give Stalin an important Cold War victory.

**The Berlin Airlift.** The Western powers neither yielded to Stalin nor launched a military attack. Instead, they decided to fly in all the food, fuel, and other supplies needed by the more than two million residents of Berlin. As the massive airlift continued through 1948 and early 1949, the Soviets harassed the flights with blinding searchlights and small arms fire, but they used no weapons that clearly threatened to bring down airplanes. Truman left little doubt that any Soviet military assault would lead to war. He had ordered B-29s with atomic bombs to bases in Britain to wait out the Berlin crisis. In May 1949, Stalin ended the blockade. The Soviet attempt to cut off Berlin had failed, and the effort had heightened the threat to the USSR.

**The Cold War Alliances.** Stalin's forceful severance of routes to Berlin and Truman's atomic threat to the Soviet Union dramatically revealed the militarization of the Cold War. The transformation to an armed confrontation had begun earlier, however. In 1946, Soviet leaders proclaimed their intention to use science and technology to vastly increase their nation's military power. Furthermore, as a result of uneven postwar force reductions, the Red Army seemed more threatening in 1947 than it had in 1945. The Soviets had over three million troops in East Europe two years after the war, and the United States had dropped its force level below two million.

**The Western European Union.** The sense of a growing Soviet threat caused West European leaders to be concerned about their security. The conversion of Czechoslovakia to a Communist state prodded them into action. In March 1948, Britain, France, the Benelux Countries (Belgium, the Netherlands, and Luxemburg) signed the **Brussels Treaty,** a mutual defense pact that established the **Western European Union (WEU).**

**NATO.** In April 1949, Italy, Denmark, Norway, Portugal, Iceland, the United States, and Canada joined the nations of the WEU to form an enlarged western military alliance. The twelve nations in this **North Atlantic Treaty Organization** (**NATO**) pledged that if any one of them were attacked, they all would join the fight against the aggressor. This anti-Soviet alliance indicated the completion of the Western powers' shift to a policy of Communist containment predominantly by military threat. Because the Soviets considered an armed Germany one of the greatest possible dangers to their security, West German entry into NATO soon after becoming fully independent in 1955 made the western alliance still more ominous to them. The USSR responded swiftly.

**The Warsaw Pact.** The Soviet Union's subjugation of East Europe ended the independence of the armies of Poland, Hungary, Czechoslovakia, Romania, Bulgaria, and East Germany. Stalin allowed the armed forces of these states to exist only as part of a larger military structure that he commanded. In 1955, after West Germany joined NATO, Soviet leaders formally established this involuntary alliance system as the **Warsaw Treaty Organization** (or **Warsaw Pact**).

## Two Germanies

Once Europe was frozen into superpower spheres with two groups of states in hostile confrontation, the reunification of Germany became impossible. The occupying forces in practice had converted the defeated nation into two states by 1948. In the following year, the Cold War competitors took the final

steps in the division of Germany. The Western Allies founded the **Federal Republic of Germany** (West Germany) on May 23, 1949. Soviet Russia then hastened to complete the establishment of the **German Democratic Republic** (East Germany) on October 7, 1949.

### The West German Constitution

An assembly of German leaders drafted the constitution of the new Federal Republic. After the Western Allies and local governments in West Germany approved this document, it went into effect. At first, American, British, and French military commanders kept partial authority over armaments, foreign relations, and several other aspects of West German public affairs. The Federal Republic became fully independent in1955, and in May of that year joined NATO.

West Germany's constitution established a parliamentary democracy. The founding law gave the chancellor broad powers over the central political system, but it also left local governments enough authority to restrain the federal executive. The new state structure made it unlikely that either the immobility of the Weimar government or the dictatorship of the Third *Reich* could recur.

### A Pro-Western Leader for West Germany

After the West Germans held their first legislative elections, the representatives chose Konrad Adenauer (1876–1967) as chancellor. Adenauer, an elder statesman famed for his stand against Hitler, needed above all to convince other nations that West Germany had left its Nazi past behind. The chancellor at once began to work for firm and friendly relations with the western democracies, including France. At the same time, Adenauer tried to maintain a diplomatic association with the Soviets. These policies soon made the Federal Republic highly respected in the West without completely alienating the USSR.

Adenauer achieved equally impressive results in domestic affairs. His party, the Christian Democratic Union, advocated an extensive welfare program and government economic intervention. But the Christian Democrats opposed the nationalization of economic enterprises. This combination of policies worked well. When Adenauer left office in 1963, West Germany was a prosperous welfare state. Despite criticism of Adenauer's authoritarian methods, this success helped to keep his party in power to the end of the 1960s.

### A Stalinist Leader for East Germany

Europe's strongest Socialist and Communist movements emerged in Germany in the late 1800s. After the Nazi era, Marxist ideals still appealed to many Germans. But when East Germany became a state in 1949, the citizens would not have elected a Stalinist to lead their "Democratic Republic." Yet, German preferences mattered little. Walter Ulbricht, a devoted Stalinist, led the German Communist Party when the new government emerged in the eastern zone. Although others held the titles of president and premier, Ulbricht wielded supreme power in East Germany.

### The Superpower Arms Race

At the end of the Second World War, the United States and the Soviet Union ranked far above every other nation in industrial capacities and military power. Both nations sharply reduced the size of their armies until the late 1940s. The superpowers then began to expand their military forces again, although the number under arms remained low compared to the war years.

Throughout the Cold War, the Soviet Union maintained larger ground and air forces than did the United States. The combined armies of NATO, however, more nearly matched those of the Warsaw Pact by the time both alliances reached full strength. Despite this rough balance in troops, the United States held an unchallenged lead in overall military power at least until the late 1970s. Superiority in armaments, especially nuclear weapons, gave the Americans this advantage, an edge they intended to keep. Soviet Russia, however, entered the Cold War fully committed to achieving armament superiority. A long and costly arms race had begun.

### Atomic Bombs after Hiroshima

When the Second World War ended, the United States continued to manufacture atomic bombs. The stockpile probably numbered more than one hundred by the late 1940s. Because of the power of these bombs, even this small arsenal posed an awesome threat to the Soviets. The softball-size uranium mass in the Hiroshima bomb exploded with a force equal to twelve thousand tons of TNT. At Nagasaki, the blast equaled twenty thousand tons. Although most U.S. weapons specialists expected the American atomic monopoly to last a decade or more, Stalin's determination to counter the special threat of atomic weapons led to a successful Soviet test in September 1949.

### The Super

During the late 1940s, U.S. officials and scientists had secretly debated whether to develop a **hydrogen bomb.** This weapon, which they called **the super,** had many times the power of an atomic bomb. (An atomic bomb served as the trigger for a hydrogen weapon.) A few scientists thought that the H-bomb might start a nuclear chain reaction that would burn away the earth's atmosphere.

Despite disagreements and concerns, the Soviet A-bomb (atomic bomb) test convinced Truman to proceed at once with the hydrogen bomb. He called a news conference in January 1950 to announce that he had ordered the production of the super. On November 1, 1952, the United States tested its first H-bomb and the durability of the atmosphere. The Soviets exploded their first hydrogen weapon the following year.

### The First Nuclear Strike Forces

For many years, the typical hydrogen weapons had the power of one million tons of TNT. The United States deployed its first jet bombers (B-47s) in 1950. The B-47 could carry four of these one-megaton bombs to the USSR. In the early 1950s, the Soviets had a few propeller-driven bombers that could reach the United States. The planes lacked the range to return to the USSR, however.

### The Asian Cold War Front

Although the superpowers confronted each other most directly in Europe, their rivalry affected events far from that continent. The arms race generated by the Cold War also heightened the danger of many non-European conflicts. Thus, as Mao Zedong's Communist rebels in China moved toward victory over the Nationalist government in the latter 1940s, they feared U.S. military intervention. A confrontation did not come, however, as the Communists finished winning in China in mid-1949. Both Truman and Stalin did little to affect events there. The first serious Cold War crisis outside Europe developed, instead, in Korea.

### The Outbreak of the Korean War

When the defeat of Japan brought the liberation of Korea in 1945, the Soviets occupied the half of the peninsula north of the thirty-eighth parallel, and U.S. forces took control in the south. Both nations withdrew their troops by the end of the 1940s. They left behind, however, a Communist dictatorship in the north and an anti-Communist dictatorship in the south. Although the North Korean leader wanted control of the entire peninsula and stood ready to take the south by force, Stalin at first opposed an attack. He approved only after he became convinced that North Korea would win, yielding an Asian Cold War advance to balance against setbacks in Europe. He could have anticipated victory in part because a speech by U.S. Secretary of State Dean Acheson in early 1950 suggested that the United States would leave South Korean defense to the South Koreans. In June 1950, the North Koreans invaded South Korea and quickly conquered most of the peninsula.

### U.S. Intervention in Korea

President Truman ordered U.S. forces to join the fight against North Korea. He also asked the United Nations to condemn the aggression of North Korea and support the South Koreans. As a protest demonstration meant to bring the Communist Chinese into the UN in place of the defeated Nationalists (now on the island of Taiwan), the Soviet representative had temporarily stopped attending Security Council sessions. The Soviets thus missed their chance to veto UN involvement, and the council agreed to back South Korea. This decision changed the military character of the war very little, however. Most of the anti-Communist troops were American and South Korean. The United States turned the tide and conquered almost all of Korea by autumn 1950.

China, now under Mao's control, allowed North Korean military units to cross the border for refuge. President Truman declared that he would permit neither the use of atomic weapons nor any attacks on the People's Republic of China. He asserted that such actions would provoke a nuclear war with the Soviets. General Douglas MacArthur, the U.S. commander in Korea, opposed Truman's policies and threatened action against China. Truman dismissed him.

### Chinese Intervention in Korea

Mao Zedong had supported his North Korean comrades' expansion plans much more enthusiastically than had Stalin. When the collapse of the North Koreans brought U.S. forces to their Yalu River border, the Chinese launched an offensive into Korea. They drove steadily southward, and the war settled into a stalemate at Korea's thirty-eighth parallel. An armistice signed in July 1953 ended the war. U.S. forces remained at that border more than fifty years later. They had not won a military victory, but Stalin, who died the previous March, also had not realized a Cold War success.

## ■ WEST EUROPE'S MIRACLE RECOVERY

Although West European nations tended to rely on military force for their security after the Second World War, and especially after the Korean War, many western leaders on both sides of the Atlantic also urged European unification as a vital part of the effort to encourage peace and prosperity on the continent and beyond.

## The First Steps toward European Unification

The advocates of unity included several of Europe's best known public figures—Robert Schuman (France), Konrad Adenauer (the Federal Republic of Germany), Alcide De Gasperi (Italy), Paul-Henri Spaak (Belgium), and Winston Churchill (Britain). Despite such strong support, progress toward political union was very slow. Significant steps toward economic integration occurred by the 1950s, however.

### The European Coal and Steel Community (ECSC)

Two French officials, foreign minister Robert Schuman and finance minister Jean Monnet, shared the conviction that peace on the continent depended especially on the relationship between France and Germany. In the 1950s, they led an effort to arrange a form of economic unification that they believed would make war between the French and Germans virtually impossible. They supported a plan to end the ability of these two countries to have independent control over resources critical to the conduct of war.

In 1951, six nations negotiated an agreement based on this principle. France, the Federal Republic of Germany, Italy, Belgium, Luxemburg, and the Netherlands agreed to merge their coal, iron, and steel economies in a structure called the **European Coal and Steel Community (ECSC).** This first important step toward European unity greatly improved the prospects for peace among the members of the ECSC.

### The Common Market and EFTA

The six nations in the ECSC quickly realized that this organization yielded remarkable economic benefits. This awareness led them to begin work on a more comprehensive system of integration. In 1957, the countries in the ECSC signed the Treaty of Rome establishing the **European Economic Community** (**EEC** or the **Common Market**).

EEC members agreed that by 1967, they would stop charging customs duties on goods that they traded among themselves. In addition to the establishment of this customs union, the EEC nations promised to advance toward greater economic unity and higher living standards within their territories. The treaty also expressed a commitment to work for global harmony and prosperity. In a separate agreement, the six Common Market members established **Euratom,** a joint organization responsible for the unification of their atomic energy development programs.

Britain did not join the EEC, but instead led the way to the establishment in 1960 of a more loosely joined group, the **European Free Trade Association (EFTA).** Denmark, Norway, Sweden, Austria, Switzerland, and Portugal joined Britain in this organization committed to the removal of trade barriers among the member states. EFTA did not project the realization of the more complete economic union planned by the EEC.

## Socialization of the West European Economy

West Europe's progress toward economic unity helped to bring about such rapid economic recovery that western observers soon described the change as a "miracle." Governmental alterations at the national level also contributed to this remarkable economic surge.

### Economic Control and Planning

The Great Depression and home-front experiences during the Second World War convinced most West Europeans that nations had to control economic development in order to ensure the well-being of

their citizens. This outlook caused postwar political and business leaders to devise varied systems of national economic management.

Most West European nations attempted to direct their economies by greatly increasing state intervention. Governments that took this approach typically nationalized the largest banks and other big enterprises such as coal mines, utilities, and mass-transit systems. Several states established economic control through the close cooperation of public and private agencies without a drastic increase in government ownership of enterprises. As these states heightened economic control, the governments in almost all of them also began long-range planning to guide economic development.

### The Welfare State

After the war, a vast expansion of public welfare programs became typical for West European governments. They established reforms intended to give virtually all citizens housing, education, and health care, regardless of their level of income. The welfare state pioneered in Denmark, Norway, and Sweden during the Great Depression soon emerged in almost every West European nation.

### Recovery and Prosperity

Central management of state economies in West Europe brought a quick recovery from the war and fostered decades of phenomenal growth. In order to replace the homes lost during the war and provide residences for an expanding population, governments funded massive programs of home construction. In the more populous states such as Britain, builders erected several hundred thousand homes each year. West Germany provided ten million new dwellings between 1948 and 1958. This building boom helped to spur overall economic expansion.

A few West European countries returned to prewar industrial and agricultural production levels by the late 1940s. Most others achieved this recovery by the mid-1950s. Annual production rates then continued to climb at an unusually fast pace into the late 1960s. This expanding economy made jobs available for almost everyone, and incomes soared upward. By the 1960s, West Europe had moved through postwar restoration to prosperity.

### The Democratic States of West Europe

Most of the governments that guided West Europe's miraculous recovery were constitutional democracies. Dictators ruled in only two countries, Spain and Portugal. Political factions in the democracies extended from Communist and Socialist parties on the Left to anti-Marxist authoritarian groups on the Right. Usually, only the center and moderate Socialist parties had the power to govern.

In several states, Christian democratic movements developed into the strongest centrist parties after the Second World War. Christian democrats typically supported economic planning and government welfare programs. They favored the interests of the business community, however, and wanted to avoid extensive nationalization of enterprises. The Communists and Socialists gradually dropped their revolutionary programs and became simply reformist parties. These leftist factions then differed from the center mostly in the extent of nationalization and welfare they favored.

### The Smaller Democracies

The eight small and less-populous democracies of North and West Europe that exhibited such exceptional political and economic strength during the Depression years continued to thrive after the Second World War. The governments of Denmark, Norway, Sweden, Finland, the Benelux Countries, and Switzerland provided effective leadership as they confronted the demands of the postwar era. Rapid economic development brought these societies to new levels of prosperity. In the Scandinavian states, socialist economic policies, including extensive welfare programs, distributed the benefits of economic progress to all citizens. Developments in Sweden illustrate circumstances in Scandinavia, with Sweden also exemplifying the generally remarkable success of the smaller democratic states.

### Social Democracy in Sweden

Sweden's Social Democrats (socialists) led the nation in the expansion of democracy and the construction of a Socialist economy before the Second World War. They continued to extend both democratic rights and socialism after 1945. The voters indicated their strong approval of this policy by keeping the Social Democrats in power until 1970. From 1946 to 1969, the party and the nation continued to back the same leader, Prime Minister Tage Etlander. His party ordinarily held about half the seats in the **Riksdag** (parliament) and usually kept the support of the Center Party as well. Several other parties divided the remainder of the seats.

**Private and State Enterprises.** Private enterprise thrived under Sweden's Socialist government. Ninety percent of all businesses remained privately owned and vigorously active in both domestic and international trade. The state planned and directed the economy, but owned less than three percent of the nation's enterprises. Members of the Cooperative Union, a non-government organization, jointly owned the rest of Sweden's enterprises.

**The Welfare Program.** Sweden's very extensive public care system reflected the Socialist spirit of the nation in a more obvious way than did business ownership practices. The Riksdag expanded Sweden's welfare program in 1946 with the provision of health insurance for all citizens. Legislation in the 1950s and 1960s guaranteed an adequate income for the elderly and families with dependent children. Social democracy brought the Swedes complete and lifelong care but also heavy tax payments. Still, they had incomes sufficient to buy more cars and television sets per person than in any other European state.

### The Larger Democracies

From 1945 to the late 1960s, Socialists in Britain, France, West Germany, and Italy did not dominate government as they did in Sweden. Christian Democrats usually led the governments on the continent. From 1951 to 1964, the Conservative Party held power in Britain and followed moderate reformist policies similar to those favored by continental Christian Democrats.

Despite their minority status, Socialists still exercised an important influence in the larger democracies. The Labour Party governed Britain from 1945 to 1951 and again in the latter 1960s. Both the Communist and Socialist parties were very strong in Italy and France for a few years after the Second World War. During the 1950s and 1960s, Italian, French, and West German Socialists significantly influenced political developments, sometimes as members of governing coalitions led by Christian Democrats.

These centrist and leftist parties joined forces after 1945 to develop socioeconomic institutions that were moderate versions of Scandinavian Socialist democracy. Britain, for example, nationalized the Bank of England, coal mines, railroads, and the steel industry. France and Italy followed similar policies of partial socialization. West Germany avoided such direct government control, but political, business, and labor leaders cooperated to manage the economy very effectively. Welfare systems in all four states provided a full range of social services for all segments of their societies.

# ■ THE SOVIET UNION AND THE TRANSFORMATION OF EAST EUROPE

During the 1930s, Stalin had condemned many Russian traditions, especially the historic Russian Orthodox faith. Stalin, as war leader, rallied the Soviet people with patriotic appeals, urging citizens to remember the heroes of Russia's past and use them as models. The government even eased the suppression of the Russian Orthodox Church, an important indication that an era of greater personal liberty had arrived. When the war ended, many Soviets expected the new tolerance to continue.

The Soviets made great sacrifices to complete their industrial revolution before 1940. After the hardships of the 1930s, they experienced the destruction of *Blitzkrieg* and occupation. The war destroyed seventy thousand villages, almost two thousand towns, and large sections of many major cities. The Soviet people anticipated that peace would bring an end to the painful deprivations as well as greater liberty.

## The Renewal of Stalinist Repression (1945–1953)

Contrary to the citizens' expectations, no relaxation of dictatorship and economic hardship came with the triumph over Nazism. Stalin kept absolute power and used it to force a further expansion of heavy industry. When Stalin sensed a challenge to his authority in the early 1950s, he began to prepare for a new terror purge. Stalinism had not changed.

### An Economy for Steel Eaters

After the war, central control of the economy continued under new Five-Year Plans. The promotion of heavy industry remained the overriding concern of the leadership. Stalin indicated in the first postwar plan that he intended to have a fifty percent increase in industrial production within five years. Consumer goods would not become more plentiful.

The Soviet people had no choice but to accept this policy dictated by the **steel eaters,** as they called the advocates of heavy industry. But even Stalin could not stop the spread of popular expressions that reflected the discontent he caused. People complained that under Communism, their country had learned to cook steel but not cabbage.

### The Zhdanovshchina

Any dissent more daring than jokes among close friends remained as difficult after 1945 as during the purges of the 1930s. From early 1946 to mid-1948, Stalin entrusted many duties, including the strict regimentation of political and artistic expression, to Andrei Zhdanov.

During the two-year **Zhdanovshchina** (time of Zhdanov's affairs), leading scholars, writers, artists, and composers suffered vicious public condemnation whenever they produced works that did not agree with extremely vague official standards. (Akhmatova's poetry of deep personal emotion still carried "the venom of savage enmity toward Soviet power.") People thus denounced usually lost all opportunities for income-producing activity. In an apparently random way, Stalin also at times ordered imprisonment or execution for "offenders." Although this new time of repression became associated with Zhdanov's name, the policy was Stalin's.

### The Persecution of Minorities

Stalin suspected that many of the Soviet Union's ethnic minorities were insufficiently loyal to him. As a result, his most cruelly repressive blows in the 1940s and 1950s struck these groups. A few Crimean Tatars supported the Nazis during the German occupation. In 1944, Stalin forced almost the entire population of two hundred and fifty thousand Tatars to move from their homeland near the Black Sea to Soviet Central Asia. Large numbers of these people died from the extreme hardships of careless resettlement. Other ethnic groups suffered similar deportations.

In the late 1940s and early 1950s, Stalin decided that Soviet Jews were beginning to love the new state of Israel more than the USSR. He ordered long Siberian exile or execution for more than two dozen of the most brilliant Jewish intellectuals and cultural leaders. Then Stalin turned on Jewish members of the medical profession.

### The Doctors' Plot

In 1952, the Soviet government falsely charged that a group of doctors, most of them Jewish, had conspired to assassinate Stalin and other top officials. These innocent medical specialists and their spouses disappeared into Stalin's prison system. The spreading circle of persecution suggested that a new purge was about to strike. Even people at the pinnacle of the party knew they could die.

### Stalin's Death

By the early 1950s, several of the younger Communist leaders who favored moderation of Stalin's harsh system started to position themselves for an opportunity to succeed the aging leader. Stalin probably intended to exterminate these upstarts, along with the "treasonous" Jews. This purge never occurred. Stalin died on March 5, 1953, before he could carry out a new wave of murder.

## Stalin's East European Empire (Late 1940s to 1953)

By the end of the 1940s, most East European states had become dependent Soviet territories under Stalinist dictators. Soviet officials, local Communist parties, and the Soviet Army served as Stalin's imperial staff and enforcement agents. They imposed Soviet-style governments on Poland, East Germany, Czechoslovakia, Hungary, Romania, and Bulgaria. Austria remained jointly occupied by the Soviets and the Western Allies.

### *The Emergence of Communist Socioeconomic Systems*

In the late 1940s, traditional social structures and agricultural practices still prevailed in East Europe. Communist governments could not destroy these remnants of the *Ancien Regime* as quickly as they had removed the old government machinery.

The long reign of relatively wealthy propertied upper classes soon ended, however. East European governments also proceeded with the rapid development of state-owned industrial economies and partly collectivized farm systems. When Stalin died in 1953, the reshaping of the six East European societies according to his design was well advanced. In one Balkan state, however, the ruling Communists by then had purposely erected a system with fewer traces of Stalinism.

### *Yugoslavia under Tito*

The Red Army drove the Nazis from most of East Europe but not from Yugoslavia. Anti-Fascist resistance forces within Yugoslavia fought the Nazis throughout the war and liberated the country in 1945. Josip Broz Tito (1892–1980), a Communist, led the strongest of these guerrilla forces (the Partisans). When the Second World War ended, the Partisans used their military power to defeat rival Yugoslav groups. This forceful action enabled Tito to seize control of the country and establish a Communist government in November 1945.

**The Strength to Resist Soviet Imperialism.** Stalin tried to force Yugoslavia into his East European empire but failed. With the Partisans rather than the Red Army in control of Yugoslavia, Stalin could apply little force. Tito had the further advantages of popular support and geographic separation from the Soviet Union. Under these circumstances, Yugoslav Communists could follow an independent course.

**The Yugoslav-Soviet Split.** Stalin insisted that Yugoslavia remain an agricultural country and supply farm products to the Soviet Union; in contrast, Tito ordered the industrialization of Yugoslavia. The Soviet leader demanded that Tito not support Communist rebels in Greece in 1946; Yugoslavia backed the revolt anyway. In 1948, Stalin expelled Yugoslavia from the Communist International (Cominform). The barriers between Tito and Stalin had become insurmountable.

**Yugoslav Communism.** In 1947, Tito's first actions as Yugoslav president hinted of Stalinism. He began to organize a highly centralized Communist system with collectivized farms and state-controlled socialized industry. But when it became apparent that such changes were ill-suited to Yugoslav society, Tito made drastic adjustments. By the mid-1950s, Yugoslavia had a moderately decentralized government, state-aided private agriculture, and a nationalized industrial system that allowed limited worker control in the factories. Yugoslav Communists permitted no rival parties to exist, but in other respects their system differed significantly from Stalin's.

## Khrushchev and the Era of Reform (1956–1964)

During the years that Tito developed his divergent form of Communism, Georgi Malenkov and other Soviet leaders also indicated their desire of a "new course" for the USSR. After Stalin's death, policy debates among the contenders for leadership revealed that the new-course advocates wanted less repression,

more emphasis on consumer goods production, and a less hostile relationship with the West. Even Lavrenti Beria, the head of the feared secret police, argued for these changes.

Despite the potential public appeal of these proposals and their agreeability to certain of the party leaders, both Malenkov and Beria quickly lost their bids for power. Beria's leadership of the secret police made him seem too dangerous to his associates. In December 1953, they had him shot. Malenkov lacked sufficient support in the upper party bureaucracy. In 1953, his opponents forced him to surrender party leadership (the office of first secretary) to Nikita Khrushchev (1894–1971). Malenkov remained in the post of government premier, which Stalin had made a power center for a time, but he lost that job, too, in 1955.

### Khrushchev's Emergence to Power

In the struggle to succeed Stalin, Khrushchev rose to a still somewhat precarious position at the top by 1956. The new leader had proved his willingness help enact Stalin's brutal policies. He also had earned a reputation as a typical Stalinist steel eater and continued the emphasis on heavy industry. Yet Khrushchev in many ways ruled quite differently than Stalin. He first revealed his contrasting attitudes with a shocking attack on the record of Joseph Stalin.

### De-Stalinization

Khrushchev opened a **de-Stalinization** campaign at the Twentieth Party Congress, a gathering of more than one thousand party members in February 1956. In a four-hour late-night speech to these hundreds of party officials, the new leader poured out descriptions of Stalin's brutal deeds. Khrushchev's indictment concentrated on the bloody purges of the party in the 1930s, the persecution of minorities such as the Crimean Tatars, and Stalin's costly mistakes in the conduct of the Second World War. He largely ignored the masses of non-party victims of political imprisonment and summary execution.

This speech and Khrushchev's later policies indicated that he had adopted a moderate version of the new-course policy and tied it to a battle against the hard-line Stalinists and the Stalin legend. For the rest of the Soviet era, Communist leaders tended to divide into Stalinists who wanted to keep most of the old system and reformers who fought for a less rigid dictatorship. Under Khrushchev, the reformers had their moments. Aleksandr Yakovlev, a young Party member in the audience stunned by Khruschev's de-Stalinization speech, had much to do with giving reformers much more than a moment during the administration of Mikhail Gorbachev (see Chapter 15).

### The End of the Terror

Stalin's government had charged millions of innocent people with political offenses and sent them to Siberian work camps. Death rapidly emptied the prisons; new arrests constantly refilled them. More than eight million lived in this **gulag archipelago** (chain of prison islands) at the time of Stalin's death. Demands for an end to political imprisonment had begun to flood the party before the de-Stalinization speech. Despite the efforts of party leaders to keep the details of Khrushchev's attack on Stalin from the public, the news spread across the country and increased the pressure to do away with the gulag. By the latter 1950s, the prison camp populations had dropped by almost nine-tenths. Strict controls on political activity continued, but the terror had ended.

### *Khrushchev's Early Reforms*

Before Khrushchev took supreme power in the Soviet Union, he was the party's top agricultural official. He attempted to raise farm productivity by opening grasslands to cropping (the Virgin Lands project) and by pushing for the consolidation of collectives into huge agricultural cities.

Khrushchev's most widely known revisionist tendency began to affect Soviet life soon after the attack on Stalin in 1956. At that time, Khrushchev began to allow creative writers to express themselves more freely, especially about the era of Stalin. Throughout the rest of his years in power, Khrushchev periodically permitted these "thaws" for all the Soviet arts.

### *Administrative Decentralization*

Khrushchev inherited a government organized to give the Soviet ruler maximum power over every aspect of life in the nation. In the late 1950s, he reduced the authority of this highly centralized system in several important ways. First, Khrushchev shifted judicial control to lower administrative levels by abolishing the national bureau that had supervised the court system. A similar reform of economic institutions followed as Khrushchev ordered the decentralization of industrial management and agricultural administration. These changes modified the dictatorship but left it extremely powerful. After the economic reforms, for example, Moscow still had complete control over agricultural and industrial goals. Khrushchev also later restored much of the central government's authority over economic administration.

### *Reduced Privileges for the Party Elite*

The cultural thaw and the reduction of central authority disturbed many Party leaders, but Khrushchev caused still greater agitation with other reforms. He dictated changes in Communist Party election procedures that would force the periodic replacement of one-fourth or more of the officers. Because only the four percent of the citizens who were members of the Communist Party voted in party elections, this reform promised no more than a slight shift toward democratization within the elite organization, and none beyond it.

Party officers who faced the prospect of losing their high-level jobs and privileges despised even this small step toward popular authority. Khrushchev added to their rage by making the children of the Communist elite compete equally with others for access to higher education. These and other reforms made powerful enemies for Khrushchev in the party hierarchy.

## The Struggle for Liberation in East Europe

East Europeans resisted Soviet domination from the beginning of occupation until the collapse of the system in 1989. Stalin stopped prominent political leaders in the region from openly opposing him, but the hidden forces of dissent grew stronger. Within three months after Stalin's death, the rage exploded as Czechoslovaks and East Germans rioted (June 1953). The Soviet Army quickly suppressed these outbreaks, but the forces of two larger rebellions were already gathering elsewhere in East Europe: Khrushchev's moderation of the Stalinist system in early 1956 encouraged these East European dissenters to act more boldly.

### The Poznan Riots

For three years after the Czechoslovak and East German riots, discontent increased among Polish artists and intellectuals. Many approved of Marxist principles but despised the Stalinist variety of communism established by their government. Polish Communist leaders faced a still greater threat when de-Stalinization and hard times combined to provoke a violent labor protest. On June 28, 1956, workers in Poznan rose in a revolt so massive that the government brought in the army to stop it. The crisis then worsened because the soldiers refused to shoot the strikers. Large contingents of security police finally ended the riots.

### From Protest to Autonomy in Poland

The Poznan riots drove Poland's Communist leaders to consider changes that would reduce the discontent. By October 1956, the deliberations of the party **politburo** (executive committee) began to reflect the influence of Wladyslaw Gomulka, a Communist who preferred independence from Moscow.

Khrushchev and several other Soviet leaders arrived unexpectedly, joined the policy discussions, and raised objections to the reform plans. Rumors of a Soviet Army invasion began to spread but had little effect on Gomulka and his associates. The preparation of Polish workers and security forces to resist the Soviet troops probably did influence the Soviet leader's attitudes, however.

Khrushchev grudgingly accepted Gomulka as first secretary (leader) of the Polish Communist Party and yielded control over Poland's internal affairs to him. In return for this grant of autonomy, Poland had to remain a Communist state and a member of the Warsaw Pact. Under Gomulka's leadership (1956–1970), the government of Poland kept industry fully socialized but emphasized consumer goods production and ended forced collectivization of farms. Gomulka also permitted the Catholic Church to take a more active role in national affairs.

### Anti-Soviet Rebellion in Hungary

In his position as Hungary's Communist premier (1953–1956), Imre Nagy was a vigorous anti-Stalinist reformer. In February 1955, the Soviets arranged Nagy's dismissal. Erno Gero, a more repressive ruler, replaced him as premier. The **Petofi Circle,** an organization of Hungarian cultural leaders, led a campaign of militant opposition to the Gero government. In 1956, Khrushchev's attacks on Stalinism and the movement toward autonomy in Poland inspired a great intensification of the Hungarian movement for reform.

On October 23, 1956, dissenters poured into the streets of Budapest, Hungary's capital, to express their support for Communist reformers in Poland. The demonstration quickly changed to a protest against Hungary's Stalinist government. Gero answered with a threatening radio address and a police attack on the protesters. The antigovernment forces then rioted. Gero countered with a request for Soviet troops to suppress the revolt. His action transformed the riots into an anti-Soviet rebellion backed by units of the Hungarian army.

### The Hungarian Revolt Crushed

Khrushchev attempted to restore peace by a series of steps. He withdrew Soviet forces, accepted Imre Nagy's return as premier, and placed János Kádár in charge of the Hungarian Communist Party. Khrushchev intended for Kádár to control Nagy's reform impulses, permitting only enough change to

pacify the Hungarians. Khrushchev's plan failed. Recent events left the citizenry unwilling to accept Communist dictatorship or Soviet domination. Nagy reestablished a multi-party political system, pledged to allow elections, and on October 31 announced Hungary's withdrawal from the Warsaw Pact.

Soviet troops returned to Hungary on November 4 and launched a furious attack on the rebels. Thousands of Hungarians died in a week-long fight against the Soviets. Hungary could not win against the Soviet Army. After the defeat of the rebels, the Soviets placed Kádár in full control, arrested Nagy, and executed him in 1958.

Kádár perpetuated Communist dictatorship in Hungary and kept his country in the Warsaw Pact. But he also reduced government repression and implemented economic reforms. The government promoted a more consumer-oriented commercial economy and developed an agricultural system of mixed private and cooperatively owned farms. These reforms gave Hungary the most prosperous East European economy by the late 1960s.

### The Varieties of East European Communism

The suppression of Hungary violently demonstrated Soviet opposition to the dismantling of Communist governments or to the weakening of the Soviet security system in East Europe. But Soviet leaders accepted the necessity of national variations in Communism. Gomulka and Kádár deviated from the Soviet pattern of Communism, especially in economic practices, without interference. Poland and Hungary used their limited autonomy to develop somewhat more moderate Communist systems than that of Soviet Russia.

In Romania, Gheorghe Gheorghiu-Dej followed a course of moderate reform similar to Hungary's until the latter 1950s. Then he reverted to more Stalinist policies. Gheorghiu-Dej's successor, Nicolae Ceauşescu, perpetuated this more rigid Communism after 1965. Czechoslovakia took the Polish-Hungarian path away from Stalinism and, unlike Romania, continued on the new course. By the late 1960s, Czechoslovak Communists began to implement policies very similar to Nagy's in 1956. The Soviets watched with growing concern.

## ■ THE CLIMAX OF THE COLD WAR

Stalin's successors had conflicting opinions about Cold War policies. Beginning in the early 1950s, several insisted that the hostility toward the United States and its allies had to end. They argued for a policy of **peaceful coexistence**. Other party officials demanded a continuation of Stalin's hard-line practices. They thought that the American threat required a counter-threat.

Khrushchev shifted between the Stalinist and anti-Stalinist positions, partly in an effort to keep the support he needed from different factions in the party presidium. (The party executive committee, usually with a membership of about a dozen, was called the politburo until Stalin changed the name to **presidium** in 1952. It became the politburo again in 1966.) This split in the presidium and the efforts to keep the support of equally divided Communists in other nations caused the Soviets to shift unpredictably from peacemaking actions to threats.

Until 1962, the United States more consistently followed a hard-line policy toward Soviet Russia. The Eisenhower administration (1953–1960) expanded its hydrogen bomber fleet and promised "massive

retaliation" for any Soviet aggression. A force of one thousand and six hundred long-range airplanes with over seven thousand nuclear bombs backed up this threat by 1962.

During John Kennedy's presidency (1961–1963), the United States began the rapid development of an intercontinental nuclear rocket force; it increased from one hundred and fifty-six in 1962 to one thousand and fifty-four by 1967. Although this buildup triggered an arms race of unprecedented proportions, a close brush with nuclear war in 1962 led Kennedy and his successor, Lyndon Johnson, to practice their own version of peaceful coexistence. This change caused the United States to mix war threats and peace-making efforts as the Soviets had since the mid-1950s.

Because the Soviet Union and the United States continued to dominate European international relations until the late 1960s, the interactions between the superpowers often dramatically affected circumstances and events within their spheres on the continent. The East Europeans discovered through Hungary's bitter experience that they could do little to increase their influence at the international level. The West Europeans always had a significant degree of control in foreign affairs. During the 1960s, the nations of West Europe began to act with even greater independence. This increased influence still left the states in the American sphere with almost no power to control the risk of a nuclear war that could incinerate the continent.

## Coexistence and Competition

Soviet leaders who wanted to break away from Stalinism began to affect events in Europe by 1955. Moscow informed the Western Allies that the Soviet Union wanted to cooperate in the arrangement of a peace settlement with Austria. Since 1945, this former Nazi-dependent state had remained divided into zones occupied as in Germany. Cold War attitudes had made all previous negotiations concerning Austria futile. Soviet Russia now offered to withdraw its troops, if the other powers would remove theirs and leave Austria neutral. The West agreed. On May 15, 1955, the four Second World War Allies signed a peace treaty with Austria.

### The Geneva Summit

Soviet Russia intended for the Austrian settlement to encourage other peacemaking steps. Another cooperative effort quickly followed but without concrete results. For the first time since the meeting at Potsdam in 1945, the leaders of Britain, France, the Soviet Union, and the United States met for a summit conference. They convened at Geneva, Switzerland, in July 1955 to discuss the arms race and the future of Germany. Progress on policies toward Germany proved impossible. The Soviets insisted that their security required a disarmed Germany that belonged to neither superpower sphere. The Americans demanded a reunified Germany, armed and tied to NATO. Near the close of the summit, Eisenhower presented an **open skies** plan that he claimed would reduce the threat of nuclear war. He proposed that each superpower allow the other to fly over and photograph its military bases in order to watch for war preparations. The American public media already provided Soviet Russia with most of the information they could gain from over-flights, so Eisenhower had offered his adversaries very little.

The Soviets considered secrecy a fundamental security instrument and did not even publish accurate maps of city streets. Open skies would give the United States much new data. Soviet Russia rejected Eisenhower's proposal. The Cold Warriors had negotiated in a friendly atmosphere at the summit, but they left with this **spirit of Geneva** as their only accomplishment.

## The Suez Crisis

From 1919 until 1945, Britain and France dominated the Arab states in the eastern Mediterranean region. Arab nationalism and the weakened condition of France and Britain at the end of the Second World War forced the West Europeans to surrender this part of their empire. The final withdrawal occurred in 1955 when the British left the Suez Canal zone. Britain and France still owned most of the Suez, however. Furthermore, Europe needed more and more oil, most of which had to pass through the canal. Such interests ensured a reaction by the Europeans when Egypt nationalized the Suez in July 1956. In November, Britain and France invaded Egypt in an attempt to seize the waterway.

Virtually every nation in the world, including both superpowers, condemned British and French aggression. Before the invasion, the Eisenhower administration had led the effort in the United Nations to get international condemnation of the developing Soviet repression in Hungary. The United States also was actively pursuing better relations with the Arab nations. The European attack on Egypt threatened these policy efforts and prompted American opposition to the assault on the Suez. From the Soviet viewpoint, France and Britain had committed an act of capitalist imperialism. Before the crisis ended, a message from Moscow warned British and French officials that they risked a "rocket attack" if they did not withdraw.

France and Britain called their troops home. The Soviet missile threat meant little at the time, because no nation had yet demonstrated a nuclear rocket potential. Furthermore, the West Europeans probably assumed that the Soviets would not risk a third world war to drive them from the Suez. But France and Britain had to withdraw because of their economic dependence on the United States, the superpower that dominated their sphere.

## Hard-Line Pressures in the Communist World

In August 1957, the Soviets successfully tested an **intercontinental ballistic missile (ICBM).** They demonstrated missile superiority more dramatically two months later by orbiting *Sputnik,* the first artificial earth satellite. The rocket threat during the Suez crisis had been more than bluster.

These grand achievements left Khrushchev still dissatisfied with Cold War circumstances. Soviet Russia had serious problems with China. They shared a long and disputed border, on either side of which stood massive armies that engendered concerns about attack. Chinese Communist leaders also considered the Soviet challenge to western capitalism to be too weak and demanded a more militant Cold War policy. Soviet Stalinists agreed with China. Khrushchev needed a more impressive Cold War victory.

## The Final Berlin Crises

During the 1950s, growing numbers of East Germans fled the poverty of their Communist state for the prosperous world of West Germany. The Western Allies' control of West Berlin made these escapes easy to accomplish. East German leaders desperately wanted to close this avenue to the west. The emigration robbed them of much-needed talent and gave their state a negative image.

Khrushchev attempted to solve this problem and secure a Cold War triumph by forcing the Western Allies to withdraw from Berlin. The Soviet leader succeeded only in driving the superpowers closer to the nuclear brink when he pushed this issue in 1958 and 1961.

The era of Berlin crises ended, however, in August 1961. At that point, the Soviet and East German governments began the erection of the infamous wall that separated East and West Berlin. Because it

sealed in the East Germans, the wall almost completely stopped the escape of Germans to the West and thus snuffed the spark of the Berlin crises.

## Confrontation—the Cuban Missile Crisis

John Kennedy's first year in office (1961) brought a Cold War escalation from the American side. His administration arranged an invasion of Cuba in an attempt to overthrow Fidel Castro's new Communist government. The American-backed Cubans who attacked at the Bay of Pigs failed miserably.

The invasion fiasco enhanced Castro's image and tarnished the Kennedy administration's. Both factors encouraged Khrushchev to boldness in Cuban affairs. His threats about Berlin had brought no Cold War victories for the Soviets. Although the western nations somewhat fearfully awaited Khrushchev's next move in Germany, he turned his efforts toward the Caribbean. In early 1962, the Soviets began to place nuclear-armed rockets in Cuba. The missiles they first installed had a range of one thousand and one hundred seventy-five miles. Others aboard ships on the way to Cuba could travel more than two thousand and five hundred miles.

Khrushchev probably intended for this dangerous step in the arms race to reduce the great gap between Soviet and American nuclear military power. He also might have expected this new threat to force U.S. concessions in Germany. The Soviets always claimed that the leading motive for missile placement was the defense of Cuba.

### The Most Dangerous Cold War Moment

On October 22, 1962, President Kennedy shocked the world with a dramatic television broadcast that revealed the presence of Soviet rockets in Cuba. He also proclaimed a naval quarantine of the island. This policy meant that the U.S. navy would blockade Cuba and prevent the arrival of military supplies. (Kennedy described the action as a "quarantine" because a "blockade" is an act of war.)

The Cuban showdown presented the Soviets with the risk of attack by jet bombers loaded with almost six thousand and five hundred hydrogen bombs. One hundred fifty-six ICBMs based in Midwestern states, one hundred forty-four additional missiles on submarines, and still more rockets at West European bases and in Turkey could deliver another one thousand nuclear warheads to Soviet targets within minutes after launch.

Before the missile placement in Cuba, war-ready Soviet nuclear forces included forty-four ICBMs, twenty submarine-based missiles, and airplanes that could carry about two hundred fifty hydrogen bombs. In late October 1962, the Soviets expanded their nuclear threat by placing thirty-six rockets in Cuba. Each could deliver a one-megaton warhead to a target almost anywhere in the eastern United States. Missiles with twice that range were scheduled to reach Cuba before the end of October.

Despite the relatively small size of the Soviet strike force, it could have blasted up to four hundred American sites with weapons more than fifty times as powerful as the atomic bombs used on Japan. The U.S. threat to the USSR was sixteen times as great as the Soviet threat to America. At the height of the crisis, President Kennedy confided that he thought the chances of total nuclear war were fifty-fifty.

### Resolution of the Crisis

Two frightening days followed Kennedy's quarantine speech. Then, on October 24, Soviet ships steaming toward the blockade stopped. Several more very tense days followed as U.S. and Soviet leaders struggled toward agreement. Finally, Khrushchev secured a public pledge from the Kennedy administration that the United States would not invade Cuba. Kennedy also communicated to the Soviets an

unpublicized agreement to remove nuclear-armed missiles from Turkey. In return, the Soviets promised to take all the missiles out of Cuba.

### The Post-Crisis Thaw

The mutual retreat from the threat of nuclear disaster provided momentum for improvement in Soviet-American relations. Superpower leaders became much less inclined to use threats to influence the course of the Cold War. Formal agreements also helped to reduce tensions further. Within less than a year, Britain, Soviet Russia, and the United States arranged the **Limited Test Ban Treaty** banning all nuclear tests except underground. The superpowers also set up a **Hot Line,** a special teletype system, to speed communication between Soviet and American leaders during crises.

### The Arms Race in the Late 1960s

The thaw after 1962 did not bring a warm relationship between the superpowers, nor even a reduction in the intimidating nuclear arms. Soviet leaders accelerated their rocket development program. They never again wanted to be caught in such relative weakness as in the Cuban crisis. By 1968, the Soviets had increased their ICBM fleet from forty to eight hundred and fifty.

This Soviet expansion still left the United States far ahead, however. The Americans had two hundred more ICBMs than did the Soviets. In other categories of long-range nuclear weapons, the United States had an even greater lead, providing a total bomb and warhead arsenal five times as great as the Soviet stockpile. Whatever the superpowers had learned in the Cuban missile crisis, they had not discovered how to slow the nuclear arms race.

## ■ FROM KHRUSHCHEV'S REFORMS TO BREZHNEV'S STAGNATION

The Soviet Union desperately needed a conversion from the highly centralized Stalinist dictatorship to a system better suited to the changing needs of a diverse and increasingly educated population scattered over a vast land. Khrushchev successfully diminished the image of Stalin, but most of Khrushchev's reforms failed. They were not well-planned or thoughtfully implemented.

Both the progress in de-Stalinization and the attempted reforms infuriated the many party leaders who wanted only to end Stalin's terror and keep the rest of his system. The dangerous and humiliating result of the Cuban venture strengthened the opposition to Khrushchev and probably sealed his fate. The party presidium and most of the central committee (an executive group of about 200 Party leaders) decided to end Khrushchev's "harebrained schemes." They forced Khrushchev to retire in 1964.

The new rulers began as a collective leadership group—a dictatorial committee with Aleksey Kosygin (1904–1980) and Leonid Brezhnev (1906–1982) in the chief positions. By the early 1970s, Brezhnev became dominant but remained more attentive to the wishes of his associates than Khrushchev had been. Under Brezhnev, life in the USSR became more stable or "stagnant," as the Soviets later described it. This success in preserving much of the old system doomed the Soviet Union.

The outcome of the Second World War completed the process of weakening the once-great powers of Central and West Europe and elevating the Soviets and Americans to supremacy. Germany's defeat and division especially contributed to this change in the balance of forces. Hitler's war destroyed the German state and severely damaged France and Britain. The collapse of Germany then brought the capitalist and Communist superpowers into confrontation in the heart of Europe at a time when the states in the region could exercise but little influence on the Soviets and Americans.

These conditions created the Cold War, an era of intense American and Soviet competition to dominate the world. In their quest for western border security and Cold War victory, the Soviets kept six East European states subdued and eventually forcibly converted them to Communist societies. The United States decided the main lines of West European foreign and military policy in the 1950s and 1960s, but left the nations in its sphere free to govern their own societies so long as they did not choose Communism. The democracies elected to build welfare states with government-controlled economies. They prospered.

Until Stalin's death in 1953, the Soviet Union maintained its rigid dictatorial socialism and police-state terror. Khrushchev's crusade of de-Stalinization weakened old-style Communism and freed almost all political prisoners. His reforms, however, failed to decentralize political and economic control sufficiently to draw on the talents and strength of the Soviet people, a change the society much needed in order to thrive.

Many Communist Party leaders opposed Khrushchev because his reforms took privileges away from Party officials. Stalinist hard-liners also feared that moderation of the dictatorship weakened the nation's ability to compete with world capitalism. These Communist opponents brought down Khrushchev. Brezhnev and his associates then reverted to a form of Communism somewhat more like Stalin's.

Before Khrushchev's fall, he had attempted to change Cold War policies as well as the Stalinist dictatorship. The Soviets began to pursue peaceful coexistence with the western powers. Too often, however, Khrushchev combined peacemaking gestures with belligerent ventures, especially in Berlin. The darkest Cold War hour arrived during one of these threat attempts, as Khrushchev took his missiles beyond Europe to Cuba.

The Cold War reached a terrifying climax during the Cuban missile crisis. A few leaders in the Soviet Union and the United States made the decisions that determined the outcome of that confrontation. More than one hundred million Soviets and tens of millions of Americans probably would have died if nuclear war had occurred in October 1962. The nuclear holocaust also would have taken many millions of victims in the European states that stood between the two great powers. The nations of East and West Europe had no significant influence on the critical October decisions on which the fate of the continent hung. Such was the condition of Europe during the decades when Europe was divided into the two spheres of the rival superpowers. After the 1960s, the Soviet and American grip on the continent loosened, and an ultramodern Europe began to emerge.

## Selected Readings

Baldwin, Peter. *The Politics of Social Solidarity: Class Bases of the European Welfare State, 1875–1975.* Cambridge, UK: Cambridge University Press, 1990.

Brzezinski, Zbigniew. *The Soviet Bloc, Unity and Conflict,* Revised Edition. Cambridge, MA: Harvard University Press, 1967.

De Porte, Anton W. *Europe between the Superpowers: The Enduring Balance.* New Haven, CT: Yale University Press, 1979.

Ellwood, David W. *Rebuilding Europe: Western Europe, America and Postwar Reconstruction.* New York: Longman, 1992.

Holloway, David. *Stalin and the Bomb: The Soviet Union and Atomic Energy, 1939–1956.* New Haven, CT: Yale University Press, 1994.

Kornai, Janos. *The Socialist System: The Political Economy of Communism.* Princeton, NJ: Princeton University Press, 1992.

Levering, Ralph B. *The Cold War, 1945–1972.* Arlington Heights, IL: Harlan Davidson, Inc., 1982.

Mastny, Vojtech. *The Cold War and Soviet Insecurity: The Stalin Years.* Oxford, UK: Oxford University Press, 1996.

Medvedev, Roy A. and Zhores A. Medvedev. *Khrushchev: The Years in Power.* New York: Columbia University Press, 1976.

Oracle Education Foundation. *Fourteen Days in October: The Cuban Missile Crisis.* (Access this source at *http://library.thinkquest.org/11046/?tqskip=1.*)

Weisberger, Bernard A. *Cold War, Cold Peace: The United States and Russia Since 1945.* New York: American Heritage, 1984.

Yergin, Daniel. *Shattered Peace: The Origins of the Cold War and the National Security State.* New York: Penguin Books, 1990.

## Test Yourself

1) One of Nikita Khrushchev's reforms
   a) cut party leaders' salaries by thirty percent
   b) allowed all citizens to vote in lower level Communist Party elections
   c) made the ruble "convertible" currency
   d) reduced the party elite's privileged access to university education

2) In 1957, six European nations took an important step toward unification by establishing
   a) the Common Market
   b) the EuroUnion 57
   c) the Geneva spirit agreement
   d) the open skies plan

3) A country that by the end of the Second World War already was a model for the European welfare state:
   a) the German Democratic Republic
   b) Norway
   c) France
   d) the United Kingdom

4) U.S. aid to help rebuild Europe after 1945 was offered in
   a) Comecon
   b) the Truman Doctrine
   c) the Marshall Plan
   d) the NATO Fund

5) The European democracy in which more than 90 percent of business is privately owned but has a welfare program that cares for virtually everyone
   a) Britain
   b) France
   c) Italy
   d) Sweden

6) Stalin wanted the Soviet Union's superpower sphere in East Europe mainly in order to increase the USSR's
   a) prestige
   b) security
   c) chances of world domination
   d) chances of taking West Europe

7) When the United States told the USSR to remove Soviet missiles from Cuba, the United States
   a) had no rockets but had thousands of nuclear bombers
   b) had nuclear rockets in the United States that could reach the Soviet Union but had none outside the United States
   c) had nuclear rockets in Turkey, a country on the Soviet Union's border
   d) had rockets near the USSR and in the United States but none equipped with nuclear warheads

8) Accounts of past events reflect interpretations (as noted in the quiz for Chapter 13) and are shaped by decisions about what to include and omit. Chapter 14, for example, did not discuss Khrushchev's visit to the United States in September 1959. Use these Internet sites to read about the event: chronology at *http://history.acusd.edu/ gen/20th/kitchendebate.html*; Cold War context at *www.globalsecurity.org/military/ ops/berlin.htm*; subjects of U.S.-Soviet discussion at *www.coldwar.hu/html/en/ chronologies/borhi2.html*; Khrushchev's arrival at *www.tfhrc.gov/pubrds/03may/ 05.htm*; arrival/departure at */www.gwu.edu/ ~nsarchiv/coldwar/interviews/episode-8/ goodpaster4.html*.

Use these sources to write a summary of Khrushchev's visit. In doing so, show how to fit this aspect of Soviet history effectively into the chapter. Indicate the section of placement, quote a sentence or two that precedes the point of insertion of new material, and write the summary of the visit with transition sentences that link it to the textbook account.

## Test Yourself Answers

1) **d.** The change that Khrushchev made in university admission practices promised benefits to Soviet citizens. This reform, however, cost Khrushchev support in the party, one of many steps he took that weakened his hold on power. The other options are false.

2) **a.** The establishment of the European Economic Community or Common Market in 1957 began a long and very significant movement toward greater European unity. The Geneva spirit and open skies references pertain to actual aspects of the history of the period, but have nothing to do with the opening line of this quiz item. Choice *b* is a false completion.

3) **b.** The welfare state became a central feature of West European life after the Second World War, and Norway was one of the Scandinavian states that provided an early model of this sociopolitical phenomenon.

4) **c.** Although the miracle recovery from the physical destruction and economic damage of the Second World War depended more on Europe's own resources than on outside aid, the Marshall Plan funds from the United States provided vitally important capital that contributed to the rapid rebuilding that took place. Comecon was a Soviet program, the Truman Doctrine had to do with Cold War military aid, and there was no NATO Fund.

5) **d.** Socialists believe in sharing the productive wealth of a society, a goal that often has led to support for public ownership of business enterprises. In Sweden and the other Scandinavian countries, however, the extensive social support system for all citizens was built while leaving almost all businesses privately owned. The other countries listed as possible completions have welfare states also, but they aid citizens less than Sweden, and the other countries listed nationalized a larger proportion of enterprises.

6) **b.** Although many people in anti-Soviet countries probably believed that Stalin and the USSR wanted above all to take West Europe and perhaps as much of the world as possible, the Communist leader's strongest policy motivation in the early Cold War years was national security, which did not depend on conquering more of Europe or territory beyond the continent. Prestige mattered to Stalin but very little so in comparison to his desire for security.

7) **c.** Even though U.S. leaders denounced the placement of missiles in Cuba as a dangerous escalation of the threat of nuclear war, in April 1962 they had placed nuclear armed rockets in Turkey very near the border of the USSR. At that time, they also had such weapons in Italy and Britain. Khrushchev's claim that this circumstance justified sending missiles to Cuba did not matter to the Americans. Their nuclear military superiority enabled them to order removal of the Soviet rockets and get compliance, a very revealing aspect of Cold War military history.

8) An account of Khrushchev's visit to the United States could be added in this way: Omit the reference to the 1961 Berlin ultimatum in the last sentence of the second paragraph in the section titled "The Final Berlin Crises" on page 331; follow with a paragraph or two on Khrushchev's U.S. visit that begins with a transitional comment on Soviet-American attempts to negotiate about policy differences; use transitional remarks about the failure of the trip as an effort to resolve conflicts; note that Khrushchev issued another Berlin ultimatum in 1961; and conclude the section with the text content on the construction of the wall (pages 330–331).

# Toward an Ultramodern Europe (1968–Present)

**1967:** The Soviet and U.S. governments sign the Nuclear Non-Proliferation Treaty.

**1968:** Rebellions by students and other dissenting groups flare across Europe.

**1973:** Britain, Ireland, and Denmark join the European Economic Community.

**1979:** The Soviet Union invades Afghanistan.

**1985:** Gorbachev becomes the leader of the Soviet Union.

**1986:** A nuclear power plant disaster occurs in the Soviet Union at Chernobyl.

**1987:** The United States and USSR agree to destroy intermediate range nuclear weapons.

**1989:** The fall of the Berlin wall and the collapse of all East European Communist governments occur in the latter months of this year.

**1991:** The USSR ceases to exist as a state.

**1992:** Yugoslavia splits into separate states and civil war erupts.

**1993:** The European Community becomes a single market.

**2004:** Ten new members join the European Union.

**2005:** French referendum stops adoption of a constitution for the European Union.

*After centuries of gradual and uneven social change, most of Europe became fully modern in the late 1800s. The most fundamental characteristic of modernity at that time was an industrial economy based on the production of coal, steel, energy, and machines, especially large-scale devices. This system of heavy industry still served a vital function after the Second World War. During the latter part of the twentieth century, however, high-technology enterprises, particularly in electronics, became increasingly important in the European economy. The relative importance of smokestack industries sharply declined.*

*A trait associated with modernity almost as frequently as industry is a centralized state with a politically mobilized population. In modern Europe, such political institutions existed almost everywhere by*

*the latter 1800s, usually in the form of the nation-state. Most West European governments in that era drew their citizens into public affairs through democratic practices. Other states depended on special institutions and programs to win or force broad support for authoritarian leaders. The modern states ruled by popular dictatorships found ways to give citizens a sense of self-government; a parliament with no real power was a typical device.*

*Modern Europe's popular authoritarian states resembled the* Ancien Regime *more than did the democracies. States with this modified authoritarian character lasted until the mid-1970s in the Iberian Peninsula. Most East Europeans replaced such mass-supported authoritarian governments with democratic institutions only in the late 1980s and early 1990s. This expansion of democracy in the 1970s and after warrants describing European government as more truly modern by the latter twentieth century. In the last decades of the 1900s, most other traits of modern European society changed with unusual rapidity along with the economic and political systems.*

*The emergence of Europe's more highly modern, or "ultramodern," technology and institutions in the latter 1900s involved a less drastic transformation than the shift from* Ancien *to modern ways in the 1500s and 1600s. Yet this late twentieth-century transition, especially as affected by information and communication technology, altered many aspects of European life more than usual in so few years. In the 1990s and early twenty-first century, this fast pace of change continued, particularly in the ethnic make-up of Europe and in the institutions of the "European Union."*

# ■ 1968—YEAR OF REBELLION

After the liberal and national revolts ended in the 1870s, popular uprisings occurred infrequently in Europe. Even in the social wreckage left by the Second World War, West Europeans showed little inclination toward rebellion. East European societies exhibited more discontent under the weight of Soviet oppression. Within the Soviet Russian sphere, however, the outbreaks before 1968 were relatively small, except in Poland and Hungary in 1956. In 1968, a wave of rebellions suddenly swept across Europe, a result in part of the transition to an ultramodern way of life that had been developing since the end of the Second World War.

## The Children of Fascism as Left Radicals

The children of people who had come to maturity in Fascist Italy and Nazi Germany flooded into Italian and German universities in the 1960s. By the middle of the decade, this gigantic population surge contributed, ironically, to stunning leftist youth rebellions in both homelands of pre-war right-wing radicalism. Violent repercussions from these revolts continued to shake Italy and Germany through the 1970s. This revolutionary attack from the Left began in the universities of Italy.

### A Movement for Classroom and Working-Class Revolution in Italy

One leading Italian university that usually enrolled five thousand had a student body six times that large in 1968. Other universities experienced similar growth in the 1960s, but they changed very little except in size. The students found themselves crowded into huge classes (about ten times as many students for each teacher as in the United States), dominated by authoritarian professors, overloaded with assignments that they thought had little to do with important issues of the day, and graded in ways that they considered unfair and meaningless.

The models of racial rights and student protest movements in the U.S. helped to inspire militant action to change such conditions. In 1965, university students in Milan and Trent launched demonstrations demanding more control over their institutions and more opportunities to study subjects that they considered relevant. The struggle escalated thereafter. In 1967, more than one thousand students seized the University of Turin's administration building and occupied it for a month. Outbreaks followed in several other major cities, including Florence and Rome. By 1968, the cry among students was not for educational change but for destruction of the existing social system.

This urge toward broader revolution arose from a kinship that students in northern industrial cities such as Turin and Milan felt for rebellious factory workers. Masses of laborers had poured in from southern Italy since the 1940s, and they faced hard conditions in their workplaces, especially in the factories of the new technical and chemical industries. Existing laws gave them little protection. Established labor organizations showed few signs of concern. Young radicals in the universities responded differently. Militant students and laborers alike fought against oppressive conditions imposed by small sets of powerful people who ignored their pleas for change. The call for revolution raised by Italian students in 1968 announced their devotion to the cause of both factory comrades and university classmates.

The young revolutionaries proclaimed their spirit in organizational names such as **Lotta Continua** (Continuous Struggle). By 1969, violent repercussions had begun. One of several bombs planted in Milan in December that year exploded in a bank, killing more than a dozen people and injuring about one hundred. Three terrorist blasts occurred at the same time in Rome causing injuries but no deaths. Right radicals probably carried out the latter attacks, but leftist extremists, such as the **Red Brigades,** joined in this siege of destruction and killing into the early 1980s. By then, the violence had turned a public, once somewhat supportive of the leftist rebels, strongly against their cause. The violent Right found more sympathy.

### A Movement for Militant Socialism and Uncompromising Democracy in Germany

West German youth uprisings began in 1966 as an attack on trends in government. Leftist student organizations struck first. They organized protests against the German Socialist Party decision to enter a coalition government with the centrist Christian Democrats. In 1967, more widespread outbreaks came when the Shah of Iran, a right-wing dictator, visited Germany. The demonstrations became riots, resulting in the death of one student protester. This killing inspired massive demonstrations throughout the Federal Republic.

These events led young rebels to fight still harder to wreck the established system. They stirred violent protests in Berlin, Hamburg, Munich, and other major cities in 1968, prompting the government to pass repressive laws and the public to fear the collapse of the state. Large-scale demonstrations subsided at the end of the decade, but the **Rote Armee Fraktion** (Red Army Fraction or **Baader-Meinhof Gang**) maintained a high level of terrorist violence into the late 1970s. This group fully intended to complete the revolution dreaded by the citizenry. The youth rebellion and its terrorist aftermath, however, actually altered West German public institutions hardly at all. As a result of the disturbances, students gained a much stronger voice in university affairs, including a great deal of influence over curriculum and teaching methods. Little else changed.

### The Children of the French Bourgeoisie as "Communist" Rebels

From 1946 to 1958, the legislature of the French Fourth Republic overshadowed the executive branch of government. In 1958, Charles de Gaulle won his twelve-year campaign for a new constitution

344 Modern European History

that provided for an extremely powerful executive. He then took office as the first president of the new Fifth Republic. De Gaulle gained his great authority democratically. Once elected, he governed as a "republican monarch."

### The Students against de Gaulle

De Gaulle used his executive power to implement policies that reduced America's dominance over French foreign policy and made his nation a more powerful force in European affairs. His administration also tried to push France toward the more highly technical and large-scale form of industry that it believed the nation needed to produce greater prosperity and power.

By 1968, these and other trends in the Fifth Republic provoked a protest movement among university students. At first, they expressed opposition to de Gaulle's obsession with foreign policy and neglect of circumstances within France, including conditions in higher education. Student complaints about the universities focused on serious problems of governance and curriculum as well as seemingly insignificant matters such as a shortage of telephones and television sets. Eventually, the dissent took on a much more serious tone and focused on the nature of French institutions themselves. The young critics demanded that the power of the masses replace the authoritarianism of the government and the universities. They rejected capitalism and called for socioeconomic leveling to accompany the change to complete popular sovereignty.

### The People against the Government

Clashes between right-wing students and others protesting the American war in Vietnam at the University of Nanterre, a Parisian suburban institution, climaxed in the arrest of left-wing protest leaders on March 22, 1968. Students fought back by seizing university buildings. The government closed the institution. This action incited revolt in other universities, especially at the Sorbonne in Paris. In early May, police violence against Sorbonne students brought a massive and viciously angry response. Rebels filled the streets, ripped up and threw paving stones, and built barricades. Such battles, lighted by torched vehicles, continued throughout the month. Attempts at repression created a wave of public sympathy for the rebels and hostility toward the government. Workers joined the revolt. A few observers later concluded that France teetered on the brink of revolution.

### De Gaulle against the "Communists"

De Gaulle kept the support of the military, but he needed to win back his following among the citizens. In a television address on May 30, he erroneously depicted the student and worker rebels as "Communists" and called for the nation to choose either Communism or Gaullism. France chose de Gaulle. Soon after the crisis, public attitudes changed. De Gaulle could keep public support neither with his authoritarian methods nor with his promise to modify them. He resigned in 1969. French leaders thereafter responded to the revolt by granting moderately increased student influence in the universities and somewhat greater authority for workers in the factories.

### The Prague Spring—a Czechoslovakian Liberation Movement

The early months of 1968 witnessed even more startling events in Prague, Czechoslovakia, than in West Europe. During this **Prague Spring,** the Communist leaders of Czechoslovakia started an anti-Stalinist "thaw" that soon became a reform movement with the power to destroy the Communist state.

### *Dubček's Liberal Movement*

Soviet Stalinists accepted the Communist principle of economic equality and practiced it moderately well. They rejected the liberal ideal of individual rights. Czechoslovak Communist Party leaders believed that they could promote both equal wealth and personal liberty, blending communist economic ideas with liberal political and cultural principles. Alexander Dubček (1921–1992) became the champion of this effort to liberalize Communism during the Prague Spring.

In the early 1960s, Dubček emerged as a reformist leader of the Slovak branch of the nation's Communist Party. He assumed control of the Czechoslovak organization in December 1967. In the following March, Ludvik Svoboda replaced Antonín Novotný as Czechoslovak president. Svoboda supported Dubček's liberal Communist reform movement. These leaders ended government censorship, reduced the power of the security police, began to operate the Communist Party democratically, and offered Czechoslovaks the right to form noncommunist political parties.

### *Soviet Invasion—Return of the Communist Winter*

Soviet leaders watched Dubček and his sweeping reform effort very carefully. They assumed that this process of liberalization would lead to Czechoslovakia's withdrawal from the Warsaw Pact. Dubček pledged loyalty to the alliance, but Soviet leaders refused to believe him. On August 20, 1968, Soviet troops invaded Czechoslovakia in force. All the Communist states of East Europe except Romania supported this suppression of Dubček's "socialism with a human face." The Soviets removed Dubček as Czechoslovak party leader, but they did not execute him as they had Nagy in Hungary in 1956. For the next twenty years, the Czechoslovaks had to live without the liberal changes they had anticipated for a few months in 1968.

## ■ STAGNATION IN THE SOVIET UNION (1968–1985)

During the Czechoslovak crisis, Communist officials in Moscow publicly declared their intention to send troops to "rescue" any Warsaw Pact government, whenever liberals such as Dubček threatened to stray from the Soviet political path. This policy became known as the *Brezhnev Doctrine*. No significant liberalization of Communism occurred thereafter until the 1980s. The sudden collapse of these systems between 1989 and 1991 indicated that the result of this conservative Soviet policy was stagnation rather than preservation.

### Leonid Brezhnev's Ascendancy

From 1964 until 1971, a small group of Communist Party officials held executive authority in the Soviet Union. Leonid Brezhnev, Alexey Kosygin, and Mikhail Suslov emerged as the chief figures within the ruling group and appeared to share power equally. At the Party Congress in 1971, it became evident that Brezhnev had risen to supremacy over the other "collective leaders." Like Khrushchev, however, Brezhnev could stay in power only if he kept the support of others at the top of the party.

### The Struggle to Reform the Economy

The Brezhnev administration continued the effort to provide more consumer goods but without great success. The state also significantly increased spending on agriculture; yet in this area, too little improvement in productivity followed. The attempt to reduce the emphasis on heavy industry was hampered by continued high spending on military and defense programs. Because the Soviet Union could not afford both "guns and butter," the consumer economy suffered. But the sacrifices gave the Soviet leaders what they apparently thought they had to have—military power approximately equal to that of the United States by the mid-1970s.

### The Authoritarian System under Brezhnev

Brezhnev indicated, as had Khrushchev, that he wanted to modify the extremely centralized command economy built by Stalin. His policies, however, gave the authorities in Moscow more economic control than they had when Khrushchev left office.

Brezhnev centralized power in another way. He gradually brought the ruling bureaucracies under his personal command. By the mid-1970s, he had developed a political machine of loyal followers that appeared to give him greater authority in party, government, and military affairs than Khrushchev had possessed. Brezhnev maintained this position by giving his favorites, especially men from his home district, secure and highly rewarding positions in the bureaucracy. This method of rule made Brezhnev a personal dictator but without completely nullifying the spirit of collective leadership. It also perpetuated a very top-heavy bureaucratic system controlled by a virtually permanent and ever less effective elite.

### Brezhnev and the Soviet Decline

Soviet leaders in the late 1980s viewed the Brezhnev years as a time of stagnation, especially economically. Industrial productivity and the quality of goods seriously declined. Even worse, a mismanaged farm system kept the nation always on the brink of an agricultural crisis. Crop failures forced the government to import huge quantities of grain in 1972 and 1975.

### The Failure of Leadership

In the latter 1970s, Brezhnev's health failed rapidly. Illness seriously diminished his ability to govern. Yet he clung to all his offices and powers. The other aging bureaucrats that Brezhnev had raised to high positions followed his example. They kept their jobs and privileges, and did little to solve the nation's disastrous problems.

### The Passing of Stalin's Generation of Leaders

Yuri Andropov (1914–1984) succeeded Brezhnev in November 1982 and led the USSR until February 1984. He died after many months of ill health that hampered his struggles to reform the economy and end corruption. Konstantin Chernenko (1911–1985), a leader with no interest in reform, took charge in February 1984. After just over a year in office, he died in March 1985, the last Stalinist ruler of the Soviet Union.

# ■ WEST EUROPE AT THE END OF A MILLENNIUM—A COMMUNITY OF STATES

In the late 1960s, significant and sometimes troubling divisions still existed within the countries of West Europe. The nations of the region also remained further apart than many leaders of the European Economic Community (EEC) wanted. Furthermore, the rebellions of the late 1960s hinted of the mounting social and economic problems that awaited in the years just ahead. During the next thirty-five years, however, West Europeans continued to build quite effectively on the foundations for unity and prosperity laid since 1945. On the eve of the twenty-first century, these nations in many respects were a community of states. An especially important barrier to West European unity disappeared in the 1970s when both Spain and Portugal changed from dictatorships to democracies. The entire region was then democratic.

## The Struggle for Unity and Prosperity (1968–1990)

The movement to unify the West European nations made notable progress economically during the 1960s. From the early 1970s to the mid-1980s, this process of integration virtually stopped. Harder times encouraged governments to pursue policies of national self-interest rather than programs related to European unity.

### OPEC and the West European Economic Slump

Until the early 1970s, West European governments succeeded remarkably well in bringing prosperity through economic controls and welfare state programs. But during the early 1970s, the economic miracle stopped. The severe recession that came then resulted in part from actions in 1973 by the **Organization of Petroleum Exporting Countries (OPEC)**. This association of mostly Middle Eastern nations sharply raised the price of oil, eventually doubling its cost. The economic shift away from the old coal and steel form of industry since the 1940s had made Europe much more dependent on petroleum, so OPEC's policy made living in West Europe suddenly much more costly. Despite this and other problems, the economic picture brightened a great deal by the 1980s.

### The European Community

The economies of the countries in the European Economic Community grew with unusual rapidity in the 1960s. This success attracted other European nations to this thriving group. Britain, Ireland, and Denmark entered the EEC in 1973, Greece gained admission in 1981, and then Spain and Portugal became members in 1986. By this time, the organization had become known informally as the **European Community (EC)**.

In the early years of the EC, its leaders established an administrative structure that they hoped would evolve into a European government. These institutions included the European Parliament, the Court of Europe, and two executive agencies—the Commission and the Council of Ministers. Despite the existence of this framework, by the mid-1980s, the EC had achieved only partial economic integration and almost no political unity.

### The Single Europe Act

During the thirty years after its founding in 1957, the twelve EC members had tied themselves more closely together economically by removing a major barrier to trade. They had arranged for producers in

each member state to be able to transport goods to markets in the other eleven without paying entry taxes (customs duties). But hundreds of national regulations, such as differing product safety standards, still prevented the free flow of trade. The EC had become a customs union, but it remained divided into twelve national markets.

In 1985, the EC devised a plan to remove all trade barriers and form a single market by January 1, 1993. Community members then signed the **Single Europe Act** (1986), an agreement that made it easier to change all the national regulations that blocked the movement of commerce within the EC.

The advance toward both political and economic unity became surprisingly rapid by 1990. Whether realistic or not, a particularly grand vision of the possibilities for union was revealed at an EC summit in late April 1990. At this meeting, the twelve EC members declared their intention to achieve political as well as economic integration by January 1993. The member states strongly emphasized this goal of truly unified governance in a 1991 treaty that referred to the **European Union** instead of the European Community.

## West Germany—a Policy of Reconciliation (1968–1989)

Willy Brandt (1913–1992) assumed office as the first Socialist chancellor of West Germany in 1969. His administration demonstrated that national leaders as well as international organizations could bring European states closer together, even when these nations are in opposing superpower spheres.

On a trip to Poland in December 1970, Brandt visited the memorial to the four hundred thousand Jews who died in the Warsaw Ghetto during the Second World War. The chancellor went beyond the typical placement of flowers. He knelt on the wet stones in front of the monument and cried. Brandt's behavior in Warsaw foreshadowed his policies as chancellor. As the leader of the nation that spawned Nazism and now stood at the center of the Cold-War battle zone, Brandt took steps that helped heal the wounds suffered by nations that Germany had attacked. The chancellor's diplomatic initiatives resulted in significant progress toward harmony between West Germany and most East European states.

### *Brandt's* Ostpolitik

Brandt devoted his strongest efforts in foreign affairs to the improvement of relations with the German Democratic Republic (East Germany), Poland, and Soviet Russia. In pursuit of this *Ostpolitik* (Eastern Policy), Brandt decided to reverse West Germany's previous stand and accept the boundaries of East Germany and Poland that the Soviets had established in 1945.

The chancellor signed treaties with the USSR (January 1970) and Poland (December 1970) formally expressing the new border policy. Brandt's *Ostpolitik* accomplished more than greater harmony between the Federal Republic and these two eastern neighbors. In the treaty with Poland, for example, German nationals who were left behind Polish borders by the 1945 boundary changes won the right to move to East or West Germany.

In 1972, Brandt completed a treaty settling differences with East Germany. Again, the agreement not only reduced tensions between the states, but also involved arrangements that helped ordinary German citizens. This treaty gave West Berliners at least limited opportunities to visit family members in East Berlin. (All such movement had stopped after erection of the Berlin Wall in 1961.) Before Brandt left office in 1974, he established better diplomatic relations with almost all East European countries as he had with Soviet Russia, Poland, and East Germany.

### The German Socialist Reform Program

German Socialists encouraged greater harmony within the Federal Republic as well as abroad. In 1959, Brandt's party made a public commitment to the achievement of social justice through reform rather than revolution. This change in policy brought the Socialist Party closer to the position of the Christian Democrats and reduced the conflicts between these leading political groups.

Despite this adjustment in Socialist philosophy, Chancellor Brandt's extensive social reform plan encountered stiff resistance. He proposed an expansion of women's rights, fewer restrictions on abortion, and increased government spending on welfare and education. Brandt also called for labor to have as many representatives as management on corporate boards.

Conservative opposition and an economic slump that reduced government income prevented the implementation of the full reform program. Yet Brandt succeeded in building a stronger welfare state structure in Germany. Helmut Schmidt (born in 1918), Socialist chancellor from 1974 to 1982, eventually won passage of the Brandt measure that had provoked the strongest opposition, the law giving labor an equal voice in corporate policymaking. Schmidt had little interest in other social reforms. He concentrated instead on keeping West Germany economically stable during and after the recession of the early 1970s.

### The Kohl Era

In 1982, the Christian Democrats returned to power under the leadership of Chancellor Helmut Kohl (born in 1930). Schmidt had stopped the drive begun by Brandt to develop a more extensive welfare state system; Kohl implemented a moderate reduction of such government programs. The spending cut enabled the chancellor to reduce taxes.

In a decade when the West European economy remained sluggish, the Christian Democrats' conservative policies stimulated an expansion of private enterprise and strengthened the nation's financial condition. Asian competitors continued to cut into international markets previously dominated by West Germany, but Kohl's program enabled his nation to remain the largest exporter of goods in the world.

Laborers benefited also from the country's relatively great economic strength. They enjoyed a workweek of less than forty hours and more vacation time than the West European average of five weeks per year. West Germany did, however, pay a price for this conservative method of dealing with the economic conditions of the 1980s—growing unemployment.

### Extremists—Left, Right, and Green

From the late 1960s to the early 1990s, West Germany's stable political system and sound economy kept most of the nation unified and loyal to the government. Small opposition groups, however, continued their struggle for drastic change in the republic. The Baader-Meinhof gang, for example, expressed its radical leftist hostility to the established order by numerous, shocking acts of terror. Right-wing extremism also occasionally strengthened enough to increase support for parties or terrorist groups with Nazi tendencies.

The Green Party, the most important movement of dissent in West Germany, emerged as a formal organization in 1980 under the leadership of Petra Kelly (1948–1992). Kelly's group took a very strong stand for environmental action and against nuclear power plants and weapons. Although a faction in this new party considered the existing political system so corrupt that they would not participate in the West German government, others campaigned for office.

In 1983, the Greens won enough votes to send Kelly and twenty-six other members of her party to parliament. The movement gained fifteen more seats in 1987. Three years later, however, the Greens failed to win the five percent minimum popular vote required for representation and lost all their seats in the legislature. The weakness of the anti-establishment Left, Right, and Green factions indicated the unity that had become typical of West German society by the end of the 1980s.

## Sustaining Welfare-State Democracy

The West European democracies varied considerably in the extent to which they nationalized their economies after the Second World War. For example, governments in Sweden and the Federal Republic of Germany took over almost no enterprises at all, Italy and Britain nationalized many more, and France socialized more businesses than the other four (about twelve percent by the 1970s).

In 1981, France elected a Socialist president, François Mitterrand (1916–1996). He intended to socialize an additional five percent of the French economy, but he soon dropped this plan. As he governed the country during the 1980s, Mitterrand followed economic policies that differed little from those of European centrists such as the Christian Democrats. Mitterrand's shift to more conservative practices was typical of the Left in other European democracies in the mid-1980s.

The democratic states of West Europe exhibited even more similarities in other economic policies. All of them except Britain engaged in long-term planning. Until the 1980s, the democracies other than Britain also intervened very actively in their economies to maintain full employment and prosperity. Central control policies became less popular everywhere in the 1980s. All these states, including Britain, developed extensive welfare state programs after 1945. They continued these social aid systems thereafter, but several governments began to reduce welfare funding by the 1980s. The pattern of events in Italy after 1968 illustrates these general trends in most of the West European welfare states.

### The Moderation and Popularity of the Italian Left

The political Left appealed strongly to Italian voters throughout the 1970s and 1980s. During the first of these decades, the Communist Party won control of many city governments and secured numerous seats in the national parliament. The popularity of the Socialist Party then rose sharply in the 1980s, as the following of the Communists declined. Both left-wing groups gained this wide support in part by rejecting their traditional commitment to revolution. By the early 1980s, the Socialists even declared their opposition to the nationalization of more enterprises. The Communists made an equally drastic transition and ended their opposition to Catholicism and NATO.

### The Italian Center and Moderate Left in Charge

Even though the Left parties learned to endear themselves to Italians, no Communist led the government during this period. Bettino Craxi was the only Socialist premier (1983 to 1987). The inability of the Socialists and Communists to join forces enabled the centrist Christian Democrats to hold the chief executive position most of the time. Because all the premiers had to govern through a coalition of parties (usually five factions), these centrist and moderate leftist leaders had difficulty carrying out their responsibilities.

## Italy's Immobile Government in Troubled Times

The immobilizing effect of coalition politics caused the Italian government in the 1970s and 1980s to earn a reputation for "muddling through" when problems developed, as they frequently did in these years. In the early 1970s, recession struck. Italian leaders had to contend with the lagging economy while they continued to struggle with the rebellious forces unleashed in the mid-1960s. The social turmoil in the 1970s evolved from mass public demonstrations into terrorist acts by extremists on the Right and Left. The leftist Red Brigades became especially notorious. In 1978, this group kidnapped former premier Aldo Moro, murdered him, and left his body bundled in the trunk of a car. From the late 1960s to the early 1990s, the government also faced the seemingly insoluble problems of Mafia violence and the tightening grip of poverty on southern Italy.

## The Nominal Transformation of Italian Politics

The Italian officials who did so little to meet the challenges of the quarter century that ended in the early 1990s did a great deal to help themselves during that era. An aggressive investigation begun by a magistrate in Milan in 1992 revealed a plague of corruption that had spread throughout the upper reaches of the Italian sociopolitical system at an astronomical cost in bribes given to corporations, political parties, and influential individuals. The scandal caused the collapse of four of the nine national parties, including the Christian Democratic Party, which had governed for most of the preceding forty years, and the leading opposition group, the Socialists.

Observers began to refer after the upheaval of the early 1990s to a **Second Republic** that had emerged with new parties—the center-right Italian Force organized by Silvio Berlusconi, the center-left Olive Tree Alliance led by Romano Prodi, and many other smaller groups. A wide array of these recently organized parties and the five older ones operated under obviously useless new election procedures meant to prevent the multiplication of splinter parties.

Except for a few months in 1994 when Berlusconi served as premier, left-oriented governments, usually headed by Prodi, held power from 1992 to 2001. Then Berlusconi returned to office for a five-year stay. In late 2005, Prodi's coalition, renamed The Union, appeared to have enough voter support to unseat Berlusconi in the April 2006 elections. These centrists who governed after 1992, whether hyphened left- or right-, perpetuated without drastic change the welfare state democracy built by the Christian Democrats and Socialists of the First Republic.

## The Continued Success of the Welfare State in Italy

Through the sometimes troubled years after 1968, much also happened that pleased the great majority of Italians. The government reduced a few social assistance programs but largely maintained the welfare state system. Italian legislators also passed widely approved divorce and abortion rights laws, despite the opposition of the Catholic hierarchy.

Most impressive of all, the Italian economy grew at a record pace in the 1980s. Italy entered the 1990s with an industrial system that produced more than Britain's and only slightly less than France's. A nation with a mostly agricultural economy in 1945 had joined the ranks of global industrial leaders and still firmly held such a position in the early twenty-first century. By 2006, Italy had the fifth largest industrial

economy in the world. The maintenance of such economic strength in recent years resulted in part from Italy's adherence to inflation rate and government debt standards established by the EC. Italy also bene-fited from its turn toward a more market-oriented private enterprise system, a change of policy supported by government leaders who described themselves as Communists or Socialists as well as by conservatives.

## Attacking the Welfare State in Britain

From Italy to Scandinavia, the continental democracies had even more in common in the early twenty-first century than in 1968. They all had planned but not rigidly controlled economies, relatively few nationalized industries, and welfare programs that covered all fundamental needs even in the several countries that had significantly reduced benefits in recent years. Despite the similarities among these states, the United Kingdom did stand noticeably apart with the depth of its welfare cuts in the late 1960s and thereafter.

### A Labour Government with Conservative Policies

In the latter 1960s, Britain's aging industrial economy continued to lag behind the systems of the continental democracies. The Labour government of Prime Minister Harold Wilson (1916–1995) that took office in 1964 dealt with the nation's economic problems in a surprising way. Despite Labour's socialist philosophy, Wilson enacted measures usually viewed as favorable to the rich rather than the poor. The government reduced taxes, deflated the currency, and lowered spending on welfare. These actions brought a slight improvement in the economy by 1969. That same year, the Conservatives won the par-liamentary elections.

### Civil Violence in Northern Ireland

Edward Heath (1916–2005), the new Conservative prime minister, faced a serious crisis during his first year in office. In 1969, violent battles erupted between Northern Ireland's Catholics and Protestants. Heath sent troops into this six-county portion of Ireland that remains united with Britain. Instead of bringing peace, the British military force joined a vicious civil battle that did not begin to subside until the mid-1990s.

### A Conservative Government at War with the Unions

Heath's effort to ease Britain's economic woes produced other social disruptions. His government attempted to restore economic health by a campaign against the higher wages and other concessions demanded by labor unions. The workers responded with a wave of strikes, some of which Heath settled by agreeing to sharp increases in wages. The inflation rate shot upward as a result of these developments.

In this atmosphere of worsening social and economic conditions, the Labour Party returned to power in 1974. Wilson resumed office as prime minister until 1976, when James Callaghan (1912–2005) replaced him. Both these socialist leaders continued to follow conservative economic policies, as Wilson had in the late 1960s. Their methods failed. Prices went higher and more people lost jobs. In 1979, Labour again lost control of Parliament.

## From Militant Conservatism to New Labour

Margaret Thatcher (born in 1925) led the Conservatives to victory in 1979 with a campaign for fewer public enterprises, less government economic intervention, a smaller political bureaucracy, reduced welfare programs, and lower taxes and prices. Her commitment to privatization and deep cuts in welfare differed sharply from Conservative Party policies of the past thirty years. Thatcher's uncompromising pursuit of the new program earned her the nickname, **Iron Lady,** a label she proudly wore. She held power for ten years, longer than any twentieth-century prime minister. John Major (born 1943), her much less colorful protégé, succeeded Thatcher in 1990 and kept the Conservatives in power until 1997. Then Tony Blair's New Labour Party won a large parliamentary majority. Blair (born 1953) promised policies much like Thatcher's, except with welfare benefits from a heart seemingly softer than iron.

### The Battle against Inflation

During Thatcher's first years as prime minister, she concentrated on the problem of inflated prices. She attempted to deflate the economy by raising interest rates and reducing government spending on health, education, and housing. Thatcher also cut taxes on the rich, began selling government enterprises to private investors, and encouraged business leaders to resist employee demands for higher pay. Prices began to drop, as the prime minister intended. But the policies also caused unemployment to rocket upward, from just over five percent in 1979 to more than twelve percent in 1982. Thatcher's popularity dropped sharply.

### The Falklands War

When Margaret Thatcher became prime minister, one of the few remnants of the British Empire was a small group of islands known to the British as the **Falklands.** The islands, home to two thousand mostly British inhabitants, lie in the South Atlantic about five hundred miles from the coast of Argentina. In April 1982, Argentine military forces landed on the *Islas Malvinas,* as they name these dots of land in the ocean. The troops had come to act on Argentina's long-standing claim on this territory. Thatcher ordered a British amphibious assault to prevent the loss of the Falklands. After a two-month war, Argentina accepted defeat. The Argentine toll stood at seven hundred and fifty-five dead, eleven thousand and three hundred thirteen wounded, while the British human cost was two hundred and fifty-five killed, seven hundred and forty-six injured. A sudden patriotic fervor gripped the UK. The British prime minister's support among her citizens increased dramatically. In 1983, Thatcher's party beat Labour decisively in the parliamentary elections. Thereafter, the prime minister continued her "war" at home on the welfare state.

### The Welfare State under Siege

For several years after the Falklands War, Thatcher kept strong voter support because her conservative policies seemed to bring economic progress. The prime minister's popularity gave her a long term in office that enabled her to continue to reduce the scope of government enterprise ownership and welfare assistance. The problem of inflation struck again, however, by the late 1980s. A high unemployment rate persisted also. As Britain's problems increased, Thatcher's public and party support slipped rapidly. In 1990, the Conservatives selected John Major to replace the prime minister. Under his Conservative administration (1990–1997), the assault on the welfare state subsided with its structure greatly diminished but not destroyed.

### The New Conservatism of New Labour

Tony Blair became the leader of the Labour Party by the mid-1990s and gave it a vigor and public appeal greater than ever in its history. He accomplished this feat with a bold campaign to abandon the Party's long-standing commitment to government ownership of the economic system and with a promise, not usually voiced by Labour leaders, to launch a tough campaign against crime. In 1996, the party accepted this turn toward a path already opened by Margaret Thatcher and began to use the name **New Labour.** In the 1997 elections, Blair won with an exceptionally large majority of Parliamentary seats for his party.

Soon after the victory, Blair pledged to establish "one of the great radical, reforming Governments in our history." The Labour Party reformation he envisioned would give Britain a prosperous market-based economy, an efficiently restructured and more democratic government, a truly modern system of welfare and services, low levels of crime, and a position in the European Union and the global community that would spur progress toward a cleaner environment, prosperity, and peace.

Blair did not transform British government during the next eight years, although his administration made a few significant changes in the country's political system. The latter included the establishment of legislative assemblies in Wales and Scotland, and the passage of laws to expand individual rights. In the provision of public services, Blair's administration also had a less impressive record than predicted in 1997. Expenditures on health and education increased, generally to good effect. Blair did even better in the delivery of other welfare benefits. These advances came, however, largely by the enhancement of efforts begun in the Thatcher-Major years. The Labour government continued the Conservative policy of conversion to a privatized transportation system propped up by generous government subsidies. The rail and subway portions of this reformed system operated just as miserably, by European standards, as the state-owned structure of enterprises that had offered these services before 1996. Data and press commentary on rail performance in late 2005 indicated that this weak link in the transportation system at last might have begun to strengthen.

Blair realized his greatest success in pursuit of the party's economic goals. By 2004, Britain had the highest employment rate ever, the lowest interest on loans in forty years, and the lowest level of inflation in thirty years. Global economic changes that created a very profitable environment for British service industries made such progress easier. Labour Minister of the Treasury Gordon Brown also contributed greatly to this prosperity. He made an economic program very similar to Margaret Thatcher's work exceptionally well.

If the New Labour Party had not carried out a "great radical, reforming" domestic program by 2006, year by year it had built an impressive record of achievement under an appealing prime minister. The Conservatives could find neither a leader nor a program that offered a significant challenge. Voters returned Labour to power again in 2001 and 2005, making Blair the longest-serving prime minister in the Party's one-hundred-year history.

### Blair as Peacemaker and Warrior

Tony Blair focused attention on the Protestant-Catholic conflict in Northern Ireland early in his first term. His efforts quickly helped to bring an advance toward political stability and peace in that region. His quest for a more harmonious and productive relationship with the states of the European Union (**EU**), however, brought no real change in eight years. During this time, Blair missed opportunities to improve

Britain's position in the EU. Despite strong stands for resolving conflicts between Arabs and Israelis in the Middle East and for more effective steps to lessen global warming, Blair also could claim little progress toward these foreign policy goals by 2006. On these problems, he had promised more than a British prime minister could deliver.

Blair could take Britain into the wars that the United States launched in Afghanistan (2001) and Iraq (2003). He did that. In the case of Iraq, he ordered the attack against the will of the British public and over the objections of many Labor Party leaders. About twenty percent of the two hundred thousand members of the British military joined a battle in Iraq, the consequences of which a British prime minister could do little to control.

## ■ THE END OF THE COLD WAR AND THE EUROPEAN COMMUNIST STATE SYSTEM

From the late 1960s to late 1980s, the leaders of neither the West European nor East European states had the power to influence significantly the threat of rapid destruction of their societies in a nuclear attack. This incomparably frightening prospect hung over Europe because of the continuing Cold War. Furthermore, the escalating Soviet-American arms race in the 1970s and 1980s kept increasing the risk of annihilation for Europeans. For the first time, Cold-War weapons also posed an equally great danger for the United States. A new sense of urgency began to affect the arms control policies of the Americans and Soviets.

### The First Arms Control Agreement

By 1967, the United States knew that Soviet Russia was building an **antiballistic missile system (ABM)** to protect Moscow. The development of weapons that could counter existing strike forces threatened to provoke a rapid escalation of the arms race. U.S. President Lyndon Johnson called for talks on ABM development. He also urged discussion of nuclear proliferation, because the Americans and Soviets had begun to fear the spread of this military technology to nations with leaders whom they trusted less than themselves.

### *The Glassboro Summit*

A Soviet-American summit at Glassboro, New Jersey, in June 1967 resulted in improved personal relations between Johnson and Brezhnev. The meeting failed, however, to bring progress toward arms control. Soon after the summit, the United States began work on an ABM program of its own.

### *The Non-Proliferation Treaty*

The drive to limit main-force nuclear weapons continued. In July 1968, the United States, Soviet Russia, and Britain adopted the Nuclear Non-Proliferation Treaty, which almost two hundred nations eventually signed. The document included a pledge to prevent the spread of nuclear weapons to nations without them and a promise by nuclear powers to take steps to disarm. The completion of this treaty accelerated the movement toward negotiations on offensive and defensive weapons limitation.

## Détente

In the late 1960s, the Brezhnev administration worked for improved relations with the United States and the other Western powers. Soviet leaders wanted to end the dangerously threatening Cold-War confrontation and begin an era of more peaceful competition or *détente.* The near equality in nuclear strength that the Soviets had achieved by the late 1960s made them feel safe enough to pursue this policy.

Soviet Russia needed *détente* in order to develop active trading relations with the West and thereby ease serious economic problems in the Communist state. The chances for a productive *détente* improved when U.S. President Richard Nixon took office in 1969. Prospects brightened because he wanted such relations. Furthermore, his reputation as a Cold-War hard-liner enabled Nixon to begin such a venture with little fear of political attacks by his country's right-wing political forces. With both superpowers in favor of *détente,* the discussion of arms limitations that began during the Johnson administration became an official negotiating process.

### The Strategic Arms Limitation Treaties (SALT)

The Strategic Arms Limitation Talks between the Soviets and Americans opened in 1969. After three years of difficult negotiation, the superpowers finally concluded their first limitation **Strategic Arms Limitation Treaty,** SALT I. This agreement, signed May 26, 1972, established an upper limit on antiballistic missile systems and on the number of intercontinental nuclear rockets that each nation could have. It did not, however, establish controls on the number of warheads that could be placed on each intercontinental ballistic missile (ICBM). (The United States already had Multiple Independently Targetable Reentry Vehicles or MIRVs—single missiles that could deliver several warheads to scattered sites. The Soviets had them under development.) As a result of this loophole, during the 1970s both sides vastly multiplied the warheads that they could deliver to targets without increasing the number of missiles in their arsenals. The SALT II agreement, concluded June 18, 1979, partly corrected this problem but still allowed the arms race to continue at a slower pace.

### The Helsinki Accords

The Cold-War thaw of the 1970s brought the superpowers together for the first arms-control agreements. This new international atmosphere also inspired a grander peacemaking effort. In 1973, representatives from Canada, the United States, and every European state except Albania began to meet in Helsinki, Finland, to discuss many issues affecting Europe in the Cold War era. This **Conference on Security and Cooperation in Europe** (CSCE) completed its work and signed a thirty-thousand-word Final Act in August 1975.

The agreements in the Final Act, known informally as the **Helsinki Accords,** committed the thirty-five participating countries to acceptance of existing national borders in Europe. Because the only significant boundary disputes involved changes made by the Soviets during the Second World War, this accord was an important concession to them. This agreement on frontiers was especially significant since it approximated a Second World War peace treaty.

Several provisions of the Final Act pleased the Western nations almost as much as the boundary provisions did the Soviets. The accords included a pledge that CSCE members would not intervene in the affairs of other countries. This provision implied a condemnation of Soviet actions in Hungary and Czechoslovakia. An entire section of human rights accords similarly suggested criticism of the USSR. It affirmed individual freedoms that the Soviets regularly violated.

Western critics of the accords claimed that these idealistic statements about nonintervention and human rights meant nothing, since the CSCE had no way to enforce these standards. Dissenters in Communist nations, however, gave these human rights clauses substance by using them to judge the conduct of their governments. When Communist officials denied the personal freedoms they had sworn to allow, their critics (**dissidents**) found ways to publicize these violations to the world. Concern about global public reactions to these exposures did affect the behavior of Communist governments.

## The End of *Détente*

Although the Helsinki Accords indicated reduced East-West tensions and the SALT agreements moderated the arms race, the superpowers' stockpiles of weapons grew throughout the 1970s and 1980s. As a result of this arms race, in 1982 the United States had two thousand and thirty two bombers and missiles carrying eleven thousand warheads. The Soviets had two thousand and four hundred ninety rockets and long-range planes with the ability to deliver eight thousand warheads. Despite the differences in these arsenals, by the mid-1980s, the superpowers were in a state of "rough equivalency" in nuclear war fighting strength. The balance changed little after that time, although each country continued to advance in destructive power. This race kept the foundations of the Soviet-American *détente* weak. Brezhnev's actions in 1979 completely wrecked this fragile structure.

## The Soviet Invasion of Afghanistan

In the late 1970s, conditions on the southwestern borders of the USSR confronted Soviet leaders with both grand opportunities and potentially serious problems. They gained an ally in the region when a Communist government took power in Afghanistan in 1978. This change gave the Soviets a chance to extend their influence toward the Persian Gulf, an oil-rich and strategically located region. Unfortunately for the USSR, anti-Communist rebels threatened to overthrow the pro-Soviet leaders in Afghanistan. When the Soviets sent in advisers to help the struggling Communist government, Afghans often violently attacked them.

The collapse of a strongly pro-Western dictatorship in Iran in early 1979 increased the prospects for the Soviets to gain greater influence in the region near the Persian Gulf. Once more, however, a new problem appeared. A revolutionary Islamic group had won control of Iran. This development heightened the possibility of independence movements among the millions of Islamic people in nearby Soviet republics. An unusual combination of opportunities and dangers lurked along the southwestern border of the USSR. The Brezhnev administration decided to invade Afghanistan in late 1979.

When a rebel Communist faction overthrew the pro-Soviet leader of Afghanistan in December 1979, this event provided the opportunity for the Soviet Union to send in an army of more than one hundred and ten thousand. Soviet forces killed the new Afghan leader and replaced him with a more dependable Communist. Anti-Communist Afghans rose to challenge both the Soviet military and the government it established. Almost ten years of fierce guerrilla warfare ensued, a struggle that killed about twenty thousand Soviet soldiers and ten percent of the people of Afghanistan.

The invaders left in early 1989, with anti-Soviet forces in control of almost the entire country. A decade of death and destruction had benefited neither the Soviets nor the Afghans. The intervention brought the condemnation of the Soviets by a multitude of nations, drove the superpowers from *détente* to Cold-War-crisis, and, because of the bitter lesson of failure in Afghanistan, made it almost certain that

Soviet leaders would not make full use of its military forces to preserve its empire in East Europe or within its own borders.

## The Euromissile Crisis

The Cold War intensified in 1979 not only because of the invasion of Afghanistan, but also as a result of the Soviet deployment of a deadly new intermediate-range mobile missile (the SS-20) in East Europe. The ability of these weapons to avoid detection and strike without warning made them a special threat to Western forces. NATO leaders decided to place even more lethal U.S. weapons in Europe—the Pershing II and Cruise missiles. With these **Euromissiles** that the United States began to deploy in December 1983, NATO could strike with extreme accuracy and little warning almost anywhere in the western USSR. (The Soviets charged that the Pershing II could hit Moscow. U.S. officials said that the missiles could not travel that far.)

The new Soviet and American intermediate-range missiles and the belligerent attitudes of both superpower leaders after President Ronald Reagan took office in 1980 brought the Cold War to its most dangerous level since the Cuban missile crisis. This atmosphere lasted until Mikhail Gorbachev (born 1931) took charge in the USSR in 1985 and began a drastic alteration of domestic and foreign policies.

## Gorbachev's Revolution from the Top (1985–1991)

Mikhail Gorbachev became the Soviet leader in March 1985. This vigorous and relatively young party general secretary soon brought into his administration numerous associates who shared his commitment to reform, an attitude that resulted in part from Khrushchev's influence. Gorbachev's approach to change was pragmatic—very flexible responses to developing conditions. The Twenty-seventh Party Congress in February 1986 offered a description of the transformation of the Soviet system anticipated at that time. Party leaders affirmed the importance of "advancing Soviet democracy" and made Gorbachev's concern about economic renewal especially clear. From his first year as party general secretary, he emphasized the problems of poor labor habits and bad management caused by the Stalinist command economy and the corruption prevalent among system bureaucrats. Gorbachev promised great change that would end the extreme centralization of the economy and the resultant failure in quality, production, and distribution. The problem of poor quality could at times make obvious the deeper crisis caused by the economy.

## The Chernobyl Revelations

The Soviets finished the Mayak Chemical Combine, the country's first nuclear weapons plant located about one thousand miles east of Moscow, in 1948. The U.S.-Soviet arms race fostered haste and carelessness in the construction and operation of Mayak, a recipe for disaster. A Mayak cooling tank for nuclear polluted wastes blew up in 1957 and exposed almost three hundred thousand people in nearby villages and the cities of Kyshtym and Cheliabinsk to levels of radiation higher than Hiroshima averages when the atomic bomb hit.

Officials still had not informed Soviet citizens, even the victims, about what happened at Mayak when a nuclear power plant reactor exploded at **Chernobyl** in the Ukrainian region on April 26, 1986. It

took two days to determine that the accident had hurled radioactive material into the atmosphere. Two days later, the Gorbachev administration began telling millions of Soviets and Europeans about the nuclear fallout spreading over them. The delay of the announcement brought criticism from abroad, especially from the United States. The publicity about Chernobyl compared to the secrecy about Mayak, however, revealed the change in the Soviet Union brought by Gorbachev.

Soviet leaders opposed to Gorbachev's new policy direction feared the consequences of openness about Chernobyl and stiffened their resistance to reform. The poor construction that accounted for these nuclear tragedies and the existence of more than a dozen other Chernobyl-like reactors in the USSR only hinted at the infrastructure barriers to Gorbachev's promise of economic renewal. Most of the people who built, worked in, and ran the gigantic Soviet industrial and agricultural system, of which the Chernobyl power plant was a typical part, feared the anticipated cost of its transformation, even when they knew it sometimes killed them. In Gorbachev's first year as leader, Chernobyl made the need for reform and the difficulty of it painfully evident.

## Glasnost, Demokratizatsiya, *and* Perestroika

In order to make the need for sweeping and possibly disturbing change apparent and acceptable, a few months after the Chernobyl disaster Gorbachev proclaimed a policy of *glasnost* (openness). This declaration meant that the public media, and eventually the citizenry in general, would be allowed much greater freedom to describe and criticize conditions and events in the USSR. Gorbachev also tried to gain public support for reform by the encouragement of citizen participation in government. In a televised speech in January 1987, he called for *demokratizatsiya* (democratization), a reform that would include allowing multiple candidates for Communist Party and government offices. (He never advocated multiple parties.) Later in the same year, Gorbachev began using the word *perestroika* (restructuring) as the label for his most important program under way since his first year in office, the drastic reshaping of the economy. He said that *perestroika* meant "revolution."

### *Storming the Economic Fortress*

The pace of economic reform quickened in the months after the Chernobyl explosion as the Gorbachev administration produced a flow of decrees, resolutions, and laws. A Law on Individual Labor in November 1986 urged an end to restraints on "spare-time" employment in the production of goods such as clothing and furniture and the provision of services such as typing. This law came at the same time that a commission in Moscow worked to promote the development of cooperatives that would enable small groups of people to carry on similar profitmaking activities. Then the government in early 1987 announced the first of several measures to bring foreign interests into joint business ventures with Soviets.

One of the most important steps of *perestroika* came with the passage of the Law on State Enterprises in mid-1987. This act indicated that Gosplan, the state planning agency, would no longer rigidly control state industries and other corporations. The new law allowed enterprises to make production decisions within certain boundaries, encouraged competition among these agencies, permitted workers to elect managers, and, with certain protective provisions, required the corporations to succeed or risk closure. The possibility of business competition and risks increased when the work on non-governmental enterprises climaxed with the passage of a Law on Cooperatives in May 1988. This statute did not permit hiring workers, which would violate a fundamental communist principle, but encouraged egalitarian

groups to form businesses to provide a wide range of products and services. Despite these actions to stimulate a vigorous state economy and non-governmental socialist enterprise, the reforms did not bring much change in the economy in the late 1980s and early 1990s. Gorbachev found it much easier to make substantial alterations in the political system.

## Tempering Dictatorship

In early 1988, Gorbachev intensified the campaign to give ordinary citizens an active role in local government and in the workplace. His administration also advanced plans in June 1988 for a new parliament that would enable the masses to have a voice at the national level. The next year, even though procedures ensured the seating of many Communist Party members, Soviet citizens for the first time elected a governing body, the first **Congress of People's Deputies.** This new assembly included many outspoken critics of both the old system and of the Gorbachev government. Moreover, they spoke out in widely viewed televised sessions. In March 1990, on the recommendation of the Communist Party, the Congress of People's Deputies voted to end the one-party system and allow multiple political parties to emerge. With this change, democratization began to have real meaning in the USSR.

## Gorbachev's New Thinking in Foreign Relations

*Perestroika* did not stop at Soviet borders. Gorbachev accepted the leadership of close associates, such as Aleksandr Yakovlev and Edvard Shevardnadze, as he carried out sweeping changes in military and international affairs. An especially strong incentive for this "new thinking," as he described it, was the realization that to salvage the Soviet economic and political systems, the costs of military and foreign commitments had to be cut. The Gorbachev government thus made revolutionary foreign policy changes. The leaders of the USSR ended their tradition of insisting that the Soviets alone had the correct idea of what constituted international relations. Gorbachev even dropped the Marxist notion of class conflict in global affairs and began to emphasize "common human interests."

This new thinking led to other drastic changes. The Soviet government lifted barriers that had prevented Jews from moving to other countries, ended its war in Afghanistan, and in December 1987 agreed with the United States to do away with all intermediate range nuclear weapons in Europe. The superpowers soon began to destroy the Euromissiles. Work continued on efforts to negotiate cuts in long-range nuclear missiles and to arrange mutual reductions of conventional military forces in Europe. By 1991, the arms discussions produced agreements to reduce long-range weapons by thirty percent.

Before the end of the 1980s, the USSR acted alone on the policy of troop deployment in Europe. Gorbachev in a speech to the United Nations on December 7, 1988, declared that a portion of the Soviet forces in East Europe would withdraw. He linked this announcement to the assertion that every state should decide its form of government. His message was clear. The Soviet Army would not deny such freedom to East Europeans.

## 1989—the Liberation of East Europe

In the 1970s, the Soviets continued to try to integrate the economies of the USSR and East Europe, but the effort generally failed. Increasingly, the East European states, especially Poland and Hungary,

went their own way in certain respects—toward more economic ties with the West and a less socialized economy.

### Solidarity and the Polish Independence Movement

More dramatic change eventually followed subdued economic adjustments, especially in Poland. Public outbursts over sharp price increases came there in 1970, 1976, and 1980. The visits of Pope John Paul II, a native of Poland, to his homeland, and his open encouragement of opposition to Communism in East Europe strengthened the drive of Poles against their government. During these upheavals, **Solidarity,** an independent labor movement led by Lech Walesa (born 1943), emerged in the vanguard of the attack on the system.

The Polish government fought back with cycles of repression and modest reforms. At first, it outlawed Solidarity, jailed leaders, and declared martial law. Security forces even killed a dissenting priest. The periodic turn toward concessions included releasing jailed dissidents and surveying the public about policy preferences. Still, the government proved unable to rule effectively and agreed to an election in June 1989 in which opposition candidates could participate. Solidarity won decisively. The Communist leader, Wojciech Jaruzelski (born 1923), considered using force to stay in power. In a telephone consultation, Gorbachev told him to accept the election decision. In August, Jaruzelski appointed Tadeusz Mazowiecki (born 1927), a member of Solidarity, as prime minister. A non-Communist government thus took charge of Poland, the first such change in East Europe since the late 1940s.

### November 9, 1989

An incredible sequence of events followed as, one by one, the Communist governments ended their monopoly of power in Hungary, East Germany, Bulgaria, Czechoslovakia, and Romania. From early November to late December 1989, all these nations became non-Communist and began to develop multiple-party elective governments and some form of market economy. The beginning of this revolution came with breathtaking suddenness on November 9, 1989, with the opening of the Berlin Wall. The dancing on top of this structure, which a few months earlier would have meant the risk of instant death, proved to be a fitting symbol of the transformation that had come to East Europe. This change would not have occurred this soon if the Soviets had not decided to release their grip on the region. The events that Gorbachev's foreign policy helped to foster in East Europe and East-West relationships more generally made it evident by 1989 that the Cold War had ended.

### 1991—the Collapse of the Soviet Union

Gorbachev's Communist reform program finally became an effort to guide the Soviet people through a gradual transition to democratic socialism. Despite this additional radical step, he failed to realize his dream of preserving in some way the Soviet socialist system in which he believed.

### The Failure of Perestrokia

The policy of *perestroika* yielded greatly increased personal liberty for the Soviet people. From the spring of 1987 on, citizens enjoyed a new freedom to express themselves informally, in the public media,

and in the arts. Gorbachev also led in the establishment of a structure for partially democratized government. He found it impossible, however, to replace the dictatorial system of economic controls with a market-sensitive productive apparatus. Gorbachev could order freer expression and more democratic government; he could not order a Stalinist economy to operate differently. This economic failure virtually ensured that the national minorities and, eventually, the Great Russian majority in the Russian Republic would tear the union apart.

### The Nationalities at War with the Center

The more than one hundred nationalities that formed the Soviet Union migrated and mixed throughout modern Russian and Soviet history. Even so, in 1991, the administrative structure of the USSR reflected the continuing territorial grip of leading national groups. The Soviet state was organized into fifteen Union Republics, one for each of the largest national groups. Smaller nationalities had territorial subdivisions within the fifteen republics.

Ethnic Great Russians and the Russian Union Republic dominated the entire Soviet system. Russia before 1917, the Soviet Union after 1917, and East Europe after 1945 were really Russian empires. The Gorbachev administration decided to release the Soviet Russian imperial territories in East Europe. Many of the Soviet republics, especially Estonia, Latvia, and Lithuania, wanted independence as desperately as had the East Europeans. The liberation of East Europe inspired these republics to struggle harder for liberation from **the center;** that is, from Moscow and the Russians.

A thriving Soviet economy that benefited the national minorities might have encouraged loyalty to the union. The Soviet government, however, had not only controlled the economy from the center, but also applied policies that caused the national minorities to feel economically exploited. The miserable economic failure of the Brezhnev administration and the inability of the Gorbachev government to reform the system left the republics with the prospect of evolving from exploitation to ruin. They chose independence.

### August 19, 1991—the Antireform Coup

Gorbachev resisted the dissolution of the Union. He threatened military force against any republics that attempted secession except through very gradual procedures that he specified. Break-away movements in the Baltic republics and Georgia subsequently brought about small-scale but brutal military suppression. Liberation movements simply grew stronger. These events caused Gorbachev to lose support among both the more determined reformers and the advocates of harsher repression. Finally, he offered the republics a treaty that would allow them autonomy within a union held together mostly by economic interdependence and a common foreign policy.

On August 19, 1991, the day before the scheduled signing of the new union treaty, eight leading members of the Soviet government placed Gorbachev under arrest as he vacationed on the Black Sea peninsula of Crimea. These Communist officials announced the suspension of Gorbachev's authority and prepared to reverse the process of political and cultural liberalization and union dissolution.

## A Reformist Countercoup

The borders of the Russian Republic encompassed about seventy-five percent of Soviet territory and more than fifty percent of the country's population in 1991. In the most democratic large-scale election in Russian or Soviet history, this republic chose Boris Yeltsin as its president in June 1991.

Yeltsin (born 1931), a former top Communist bureaucrat who had left the party, risked his life to lead the resistance to the anti-reform coup. The Russian Republic's parliament and thousands of Russians in Moscow, Leningrad, and other Soviet cities joined in the opposition to the coup. The leaders of several other republics then publicly denounced the rebels who had seized Gorbachev. When important military and security police units refused to support the eight rebel leaders, their revolt collapsed. Gorbachev's "suspension" ended on August 21. During the coup, he had lost more than time in office.

## The Last Days of the First Communist State

The coup leaders' attempted revolt made the survival of the Communist Party and the Soviet state impossible. The end came quickly. Yeltsin had support among the one hundred and fifty million people in the Russian Republic before the coup. His success against the rebels strengthened his following among these people. Yeltsin used this increased power immediately. He decreed an end to Communist Party and secret police (KGB) activity in the Russian Republic. Soon, Yeltsin took control of the Soviet military forces, organizations, and offices within his republic. He also committed the Russian Republic to sweeping economic reforms that would lead to market systems similar to those in West Europe. In effect, these steps created a new Russian state comprising three-fourths of the territory and about one-half of the people of the former Soviet Union.

Gorbachev struggled to save the Communist Party by converting it to a fully democratic organization. It collapsed anyway, as Yeltsin and the leaders of other republics banned its activities. Gorbachev also tried to keep the Union intact, at least as a single economic system. This effort failed, too. With the Soviet government on the brink of bankruptcy and the state's production and supply apparatus rapidly failing, a centralized system could offer the republics virtually nothing economically except disaster.

Politically, the Soviet state had never appealed to many of the people in the fifteen Union Republics. The three Baltic republics left the Union before and during the coup. By early December 1991, the other twelve republics informed Gorbachev that they would not sign a unification treaty. Within a few days thereafter, eleven of the twelve republics that had belonged to the USSR since the 1920s formed a new **Commonwealth of Independent States** (CIS), a very loose association with little political meaning. The Republic of Georgia even refused to join the CIS. On December 26, 1991, the Congress of People's Deputies voted to dissolve the Union of Soviet Socialist Republics. The Soviet state ceased to exist on December 31.

## ■ A NEW EUROPE AND A NEW MILLENNIUM

The end of the Cold War in the late 1980s, the collapse of all the Communist governments of East Europe in 1989, and the disappearance of the Soviet Union in 1991 mark these few years as an exceptional moment in modern European history. During the early 1990s, East Europeans built new governments and many new countries emerged from the broken Soviet empire. The multiplication of states continued as Czechoslovakia divided into two countries and Yugoslavia violently splintered. Although

authoritarian rule in some form survived in certain cases, almost all of the new states developed more democratic systems. This sudden expansion of self-government, an accompanying dramatic shift from state-manipulated to market economies with more advanced industries, and the continued movement toward a larger and more integrated European Union suggest that, in a sense, a new Europe emerged in the 1990s and first years of the new millennium.

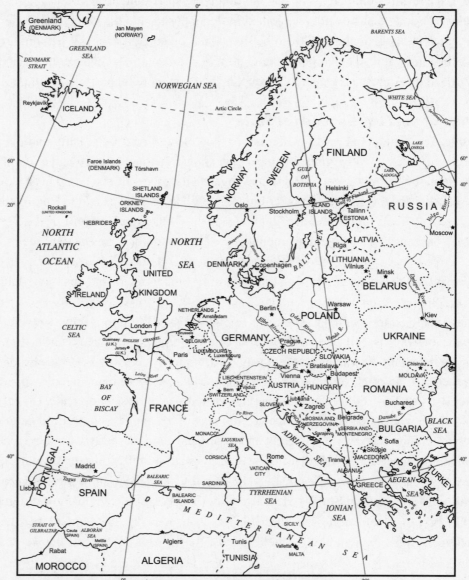

*Figure 15.1: Europe at the Beginning of a New Millennium*

## East Europe without Imperial Masters

Through most of the modern era, the people of East Europe lived within one of several imperial realms. After the Soviet Union's Cold War version of empire in the region disappeared in 1989, the states there under the shock of sudden independence began to form new governments.

### Germany—a Peaceful Unification

The people who stormed the Berlin Wall and flooded west into the Federal Republic of Germany in November 1989 did not stop in the months that followed. Most returned to their homes in the German Democratic Republic (GDR), but many stayed. The number of East Germans who took up residence west of the wall grew in 1990. When GDR citizens had a chance to vote on whether the two German states should merge, almost half supported the Christian Democrats who favored union. The Social Democrats who did not take a clear stand for unification won fewer than twenty-five percent of the votes, and the former Communists who wanted the GDR to remain separate drew sixteen percent of the ballots. The Soviets and Americans could have kept the Germans apart. However, they decided not to interfere. The Soviets emphasized their attitude by pledging to remove their three hundred and sixty thousand-member army from the GDR and accepting the entry of a unified Germany into NATO. The German states united on October 2, 1990. East Germans entered a democratic capitalistic welfare state.

Kohl's Christian Democratic government at once began spending heavily to transform the economy of the eastern region and to move the living standards of citizens there toward the level of the rest of Germany. The chancellor chose to let the government sink into debt in this rebuilding effort, which then caused the German economy to weaken and unemployment to rise. Kohl kept sufficient support, however, to win reelection in 1994 and continue as chancellor of a united Germany until 1998. Gerhard Schroeder (born 1944) then led the Social Democrats to power.

### United Germany in Transition

No drastic policy changes followed with the replacement of the center-right Christian Democrats by a center-left government. Schroeder's support fell somewhat over the years, but his party won again in 2002. Opposition to certain Social Democratic policies grew stronger thereafter. By the late summer, 2004, massive protests erupted when the Schroeder government, despite its Socialist philosophy, decided to follow the pattern of other West European states in the reduction of welfare state benefits. Faced with these disruptions, persistent high unemployment and government debt, and the loss of a vote of confidence in parliament, Schroeder decided to hold elections in September 2005. The Christian Democrats (CDU) won narrowly with thirty-five percent of the votes, to thirty-four percent for Schroeder's Socialists (SPD).

Because neither party could form a coalition with a smaller group, such as the Greens, to gain a parliamentary majority, in November, the CDU and SPD parties agreed to join in a "grand coalition" government under the chancellorship of Angela Merkel (born 1954), a Christian Democrat, the first woman to hold that office. Merkel also became the first former East German citizen to lead the government. Her rise to that position by a democratic vote symbolized the change brought to Germany by unification. Merkel's promise to reduce welfare state benefits further indicated another shift coming in Germany, a turn in the direction Margaret Thatcher had taken Britain.

### The Soviet Successor States—a Peaceful Transition Led by Poland

Gorbachev's decision to allow East Europeans the freedom to form governments of their choice opened the way for the Solidarity movement in Poland to spearhead the political and economic transformation of the region beginning in 1989. By the end of 1990, Poland had become a parliamentary democracy with Lech Walesa, the founder of Solidarity, as president. Solidarity held power until 1995 when

former Communists, reorganized as a center-left party committed to democracy and welfare state capitalism, took charge for a decade.

Under the leadership of both these groups, Poland made a wrenchingly rapid turn from command economy socialism to a privatized market system. Almost all price controls and subsidies to industries ended, enterprises had to face competition with foreign producers, and the government carefully managed its spending and the value of currency. Inflation dropped from above five hundred percent per year in mid-1989 to a still high but much better fifty percent by the end of 1990. Production, especially by private enterprises, shot upward. Prices spiraled higher, too, though, and wages did not. Most Poles suffered through hard times until the mid-1990s. Then they enjoyed better circumstances with a still growing economy that only began to slow in 2005.

In the latter months of that year, the right-center Law and Justice Party won both parliamentary and presidential elections. The new government promised to continue building the market economy but with more attention to regulations and welfare programs that would help the struggling masses of Poland. Other social policies of the winning party made the right-wing orientation of this government more evident. Law and Justice leaders advocated restoration of the death penalty and voiced opposition to abortion and homosexuality, positions that set this government far apart from almost all others in Europe.

### The Multiplication of Democratic States in East Europe

In the decision to replace Communism with democratic government and a private enterprise economic system, Poland took a path also followed by Czechoslovakia and Hungary. Post-Communist Czechoslovakia converted its economy somewhat more slowly than Poland to avoid the shock of lost jobs and the sudden extreme surge of prices. Hungary kept even more of its state economic system in place but did gradually adopt market practices. Political leaders in the Slovak region of Czechoslovakia preferred economic policies similar to Hungary's and were inclined toward more authoritarian rule. As a result of these tendencies, Slovakia became a separate country on January 1, 1993.

### Lingering Authoritarianism in East Europe

Politically and economically, this new Slovak Republic at that point became similar to the restructured states that emerged in Romania and Bulgaria after the collapse of Communism, with governments and economies under strong central authority. These three countries on the southeastern edge of the band of territory dominated by the Soviets in the Cold War had a much harder struggle to build effective systems after 1989 than did the new states to the north. In contrast to the transition elsewhere in East Europe, Romania had the additional burden of recovery from the violent battle that brought an end to the Communist era there in 1989.

### New States on theBorder of Russia

Six Soviet republics that formed the western border of the USSR became independent countries in 1991. Latvia and Lithuania suffered small-scale repressive attacks at first in their drive for independence, but Estonia, Belarus, Ukraine, and Moldova did not. Belarus remained closely tied to Russia after the collapse of the Union and kept a dictatorial government with an economy little changed from the Soviet era. Until 2004, the tinge of Soviet-era authoritarianism also lingered on Ukraine's government, but leaders in this large state tried, without much success, to transform the command economy. A late 2004 popular

protest movement, known as **The Orange Revolution** for the colors used to symbolize the campaign, reversed a rigged Ukrainian presidential election. This rebellion brought Viktor Yushchenko (born 1954) into office and pushed Ukraine toward democracy. The achievement of a thriving economy will require a longer and harder push. Elective parliamentary systems in Estonia, Latvia, Lithuania (three states on the Baltic coast), and Moldova have produced governments with the strong central authority typical of states that were in the Soviet Union. These four countries also have developed predominantly privatized economies, which operate adequately in the Baltic states, but Moldova remains quite poor.

### Yugoslavia—a Violent Fragmentation

The people of the Balkan Peninsula on the northeastern rim of the Mediterranean have lived as imperial subjects through most of their history since ancient times. The Great War settlement in 1919 established a kingdom in the region that took the name Yugoslavia, the country of the "south Slavs," in 1929. After the Second World War, Joseph Broz Tito led this Balkan state into a new era as the Communist federation of Yugoslavia, comprised of six provinces—Serbia, Montenegro, Macedonia, Bosnia-Herzegovina, Slovenian, and Croatia. Tito's dictatorship kept the country free of foreign dominance, unified if not ethnically harmonious, and relatively prosperous for many years. Economic problems and ethnic conflicts intensified by the 1970s, however, and worsened still more after Tito's death in 1980.

**Divisive Nationalism.** When the East European Communist state system north of Yugoslavia collapsed in 1989, the administrative divisions of Yugoslavia also changed from provincial governments determined by Communist Party leaders to elected systems. In that year, Slobodan Milošević (1941–2006) became the Serbian province president. He soon revealed his aim to enlarge Serbia by annexing parts of other provinces that had sizeable numbers of resident Serbs. The Yugoslav budgetary system also gave Serbia economic advantages that other provinces had begun to resent. These circumstances inspired an intolerant province-level nationalist spirit that spread throughout Yugoslavia. The country began to disintegrate.

**Religious Factionalism.** As Yugoslavia fragmented, provincial hostilities intensified from the effects of a complex pattern of religious divisions. Most Croats and Slovenes professed Catholicism. The majority of Serbs, Montenegrins, and Macedonians adhered to Christian Orthodoxy. Bosnia-Herzegovina had a large Muslim minority (forty percent), almost as many Orthodox Christians (thirty-one percent), and a smaller but significant number of Catholics (fifteen percent). These ethnic and religious differences that had not caused serious conflicts in the Tito era proved to have a very lethal potential in the 1990s.

**Wars of Secession.** The first serious crisis developed when Slovenia and Croatia declared independence in 1991. The Yugoslav government, dominated by Serbia, then used military force in an attempt to prevent these secessions. This conflict subsided by 1992, but an even larger war erupted when Bosnia-Herzegovina announced its secession. Bosnian Serbs fought to stop the separation, battling mainly against Bosnian Muslims and Croats who favored independence. A long, devastating Serbian siege of the Bosnian capital of Sarajevo followed, Serbs tried to force Muslims out of the province (a process called **ethnic cleansing**), and Bosnian Muslims and Bosnian Croats battled each other in the countryside. The European Community and the United Nations tried to arrange a settlement but to no avail. U.S. pressure

on the warring parties led to an agreement signed at Dayton, Ohio, in November 1995 (the **Dayton Accord**). This understanding stopped the fighting in that province and divided Bosnia-Herzegovina into Serbian and Muslim-Croat regions. This temporary system remained in place in early 2006, with provincial peace kept by a European Union force.

### NATO Intervention in Yugoslavia

The quiet of a ceasefire in Bosnia in 1995 did not signal peace for Yugoslavia. Almost a quarter million Serbs who lived in Croatia began to flee in 1995, afraid of living in a state severed from and hostile toward the Serb controlled remnant of Yugoslavia. In 1998, the many Albanian residents of the Kosovo district in Serbia began a fight for independence and suffered violent attacks from Kosovo Serbs. When Milošević's Serbian administration ignored U.S. and NATO pressure to protect the Kosovo Albanians, NATO launched an air war on his terriory in March 1999. The attack brought an end to the immediate crisis in Kosovo. Milošević tried to ignore an election loss in July 2000, but public protests and strikes drove him from office soon thereafter. His successor, after a delay, turned Milošević over to a UN court to face genocide and war-crimes charges. He died in prison in March 2006, while his trial was still under way.

All the warring groups forcibly deported, brutally assaulted, and murdered civilians in the course the Yugoslav struggle. Foreign powers and international agencies considered the Milošević government to be guilty of especially horrible acts. One of the most notorious atrocities occurred in Srebrenica, Bosnia, in July 1995. Many Muslims had taken refuge there in a UN safe area guarded by a peace force of four hundred. A larger contingent of Serbians arrived, took seven thousand and five hundred unarmed Muslim males (some as young as thirteen) into nearby fields and killed them over a four-day period.

A decade of warfare in Yugoslavia left about three hundred thousand dead, perhaps eighty percent civilian. The battles also made refugees of countless millions of people. During the struggle, Yugoslavia disappeared as a state. The secessions in the early 1990s really ended its existence, although the Serbian and Macedonian provinces kept the name until 2003. That year, these two parts of Yugoslavia formally became the new loosely federated state of Serbia and Montenegro. Against its southeastern border stood Macedonia. The states of Bosnia-Herzegovina, Croatia, and Slovenia were beyond Serbia to the northwest. Europe had this new complex of Balkan countries, born of violence from what had been Yugoslavia.

## Russia without Tsars

Russian sovereigns for four hundred years had in their long list of titles, one very special designation: *tsar.* This Russian word for Caesar proclaimed their boundless and sometimes terrible power to rule, as had the Roman emperors, with the authority of god on earth. The Soviet leaders reigned with the absolute power of tsars, and more, but had no interest in divine sanction. The disintegration of their Communist realm in 1991 brought fifteen states into existence. The largest of these, the Russian Federation, emerged with half of the people and three-fourths of the land of the Soviet Union. These one hundred and fifty million Russian citizens lived without tsars. A new and sometimes difficult road opened before them.

### Hard Times at the Beginning

A democratic election, unique in Russian and Soviet history, brought Boris Yeltsin into the presidency of the Soviet Union's Russian Republic in 1991. He continued as president when it became an

independent country, the **Russian Federation,** in 1992. He then governed a sovereign parliamentary state under a constitution established for the republic in 1978. Despite the hindrances of government machinery inherited from the Soviet era and the opposition of many political and economic leaders who opposed economic reform, Yeltsin and his academically qualified but politically inexperienced advisers fought hard to force Russia through a quick transition from socialism to welfare state capitalism.

They sold state enterprises to shift to a privatized system. Certain people in positions of political and economic influence took the businesses at extremely low prices and became enormously rich. Yeltsin ended price controls on almost all consumer products. The average cost of retail goods doubled every month throughout 1992. Buying power and sales dropped sharply. Production spiraled downward. With inflation taking away the value of capital funds, businesses invested or banked abroad instead of spending to build up their enterprises.

The economy improved significantly in the mid-1990s, but then faltered badly again in the last two years before Yeltsin finished his second presidential term in 2000. By then, he had replaced the poverty of socialism with the poverty of capitalism, but Russia also had the foundations for a private enterprise and market economy that might work, eventually.

## A Siege in Moscow

Yeltsin had pushed through a surge of economic reform in 1992 using special executive power that parliament gave him in late 1991. This authority lapsed in December 1992, and a struggle followed between a weakened president and a now dominant legislature. Yeltsin demanded continued rapid movement to a decentralized market economy. Anti-reform deputies in parliament firmly resisted. The struggle over economic policy escalated into a more dangerous battle for a new constitution. Yeltsin advanced a document meant to ensure presidential supremacy. Opponents planned a system ruled by parliament. At the point of angry stalemate in September, 1993, Yeltsin called for a popular vote on his constitution and disbanded parliament. One legislative house, the Congress of People's Deputies, voted to remove Yeltsin and advance Vice President Aleksandr Rutskoi to the presidency.

A military force appeared at the White House (the parliamentary building in Moscow) on September 27, a more drastic way to express Yeltsin's order for the dissolution of the legislature. Almost two hundred deputies stayed to resist. Sheltered behind White House barricades, Rutskoi, Ruslan Khasbulatov (the leader of parliament), and other Yeltsin foes called for their citizen supporters to help remove Yeltsin from office and dispatched armed bands to seize the main Russian television center. Khasbulatov said they would need to take over the Kremlin, too. Yeltsin gave his parliamentary opponents until October 4 to surrender. The day dawned with no end to the siege. Tanks arrived to blast the upper White House floors, and a special forces group invaded the levels below. Rutskoi, Khasbulatov, and their comrades marched out to their waiting captors.

The Russian Federation then got the new constitution that Yeltsin wanted. It established a very strong presidential system similar to the government developed in France by de Gaulle. The document also gave Russians extensive guarantees of legal rights and social benefits—a promise of a thoroughly democratic welfare state. It proved easier to depict this grand dream for citizens than to make it real, but Russia did now have a democracy in some form under a powerful president who favored social programs.

### A Seige on Russia's Southern Front

The first election of a parliament under the new constitution took place in December 1993. Communists and right-wing nationalists, groups surprisingly similar in their anti-reform attitudes and much else, made a strong showing. President Yeltsin displayed his nationalist spirit during the next year, especially when he launched a war against separatist rebels in the Russian republic of Chechnya on the country's southern border. This small predominantly Muslim region with much oil beneath it had declared independence before the collapse of the USSR, and in 1999, had competing governments, one for secession and one for union with Russia. Forty-five thousand Russian warriors invaded in November 1994 to defeat the break-away faction. They failed miserably.

Almost two years of brutal warfare still did not bring Russia the victory that the defense minister had said could be won in hours with a single paratroop unit. The tens of thousands of Russians and an uncounted number of rebels stopped fighting in 1996, and Yeltsin withdrew his forces in early 1997. Chechen separatists flaunted their victory by holding an election to replace the president killed by the Russians.

The Yeltsin government assumed that terrorist bombing in Russia in 1999 signaled more viciously the Chechen determination to leave the Federation. A rebel invasion into the neighboring Russian Republic of Dagestan made the threat worse—Chechens wanted to lead the fight to build a growing militant Muslim state on Russia's southwestern border. Vladimir Putin (born 1952), Yeltsin's recently appointed prime minister, took command of a new Chechen war. He went after the rebels with a vengeance and a force of one hundred thousand. Soon, the Chechen capital of Grozny lay in ruin, and Putin became the obvious choice to succeed Yeltsin as president of Russia.

### State of Emergency

Yeltsin resigned from office on December 31, 1999, named Putin acting president, and scheduled an election for March 2000. Putin won easily and received 71 percent of the votes for a second term in March 2004. Despite government dominance of television and radio networks and the bias of these media toward Putin, independent European election observers declared the votes in both years to be "free and fair."

Putin began his first presidential term just a few months after explosions, presumably caused by Chechen terrorists, leveled apartment buildings in Moscow and Rostov, leaving about seven hundred dead. In the first three years of his presidency, intense fighting continued in Chechnya, killing about five thousand Russians according to the government. An organization of Russian soldiers' mothers estimated that twice that many had died. Chechen deaths probably numbered in the tens of thousands by 2003, most of them civilians. Although the level of violence dropped during the next two years, the war did not end.

**Terrorism.** Rebels throughout this second war in Chechnya also took the battle into Russia. In October 2002, about fifty Chechens seized a Moscow theater and threatened almost eight hundred hostages with explosives. Gas released in the building to disable the rebels and an armed attack that followed killed all the Chechens and more than one hundred hostages. Separatist militants invaded a school in Beslan in southern Russia on September 1, 2004. A rebel ultimatum said that Russia had to quit the war in Chechnya or one thousand and two hundred hostages, many of them children, would die. A bomb carried into the school by the raiders exploded, possibly by accident. Then other detonations and gunfire

followed, killing more than three hundred and thirty hostages, about half of them children. Other smaller attacks in Russia added to the toll year after year.

**Militant President.** Putin has led Russia in a time of troubles. Deadly war in Chechnya and related terror in Russia contributed to a sense of emergency. Despite significant progress in controlling inflation and reducing government debt, severe economic hardships persisted into a second decade after the country's founding. The president campaigned against the rich **oligarchs,** who had seized so much of the economy during privatization, taking wealth that could have benefited struggling citizens. He achieved only limited success in this effort, however, and critics charged that he brought down and sometimes jailed only the oligarchs who were political enemies. The president did not make life good, but in Chechnya and on the home front, he stood and fought threats to the country in a way that won Russians to him—independent surveys indicated typical approval ratings above seventy percent until dropping to sixty-five percent in 2005.

**Powerful President.** During five crisis-ridden years as president, Putin greatly increased his executive authority, a common pattern for the leader of a state in threatening times. Yeltsin's Constitution of 1993 provided for a strong president, yet, ironically, he agreed to let the governors of Russia's eighty-nine districts take significant powers away from the central government. Putin took it back. He finished this process with a law that made the governors presidential appointees rather than elected officials. Putin, who has a KGB background himself, also increased the political influence of his security bureau and other control-oriented agencies.

The Putin government's concern for strictly ordered governance has led to even greater state influence over the public media than in the Yeltsin years, a development criticized abroad. Both Russian liberals and international observers raised especially strong warnings of growing authoritarianism in January 2006 as parliament enacted laws to limit the influence of foreign **nongovernmental organizations** (NGOs)—private agencies that focus attention on issues such as human rights or provide health or charitable services. After passage of the NGO restrictions, the Russian government claimed to have evidence that foreign espionage agencies had connections to these organizations.

Western critics of Putin's power-building charged that the Russian president endangered democracy. His specific responses to this criticism included noting that, unlike circumstances in the United States, his people elected him directly and observing that India is praised as "the largest democracy" even though the executive there appoints governors. Putin correctly implied with such remarks that observers abroad apply a double standard, ignoring practices in their own countries that they condemn in Russia. Russia could yet have another autocrat who comes to power by some means other than divine appointment, but in early 2006, the country was still without a tsar.

## Europe without Borders

The Single Europe Act passed by the European Community in 1986 brought rapid movement toward full economic unity. The act provided for the conversion of the twelve member states into a **single market,** a union without economic borders, by January 1, 1993.

## A Closer Union

As the implementation of the Single Europe Act proceeded, European Community leaders began to work to achieve political as well as economic unity by 1993. The sudden establishment of democratic governments in the states of East Europe after 1989 made them eligible for EC membership, a development that also spurred Community officials to try to make their more tightly unified system more open to new countries. The advocates of greater unity and expanded membership signed the treaty on the European Union (**Maastricht Treaty**) in the Netherlands on December 11, 1991. This agreement promised open borders within the EC to all who lived in a member country, the use of a common currency within the union, the establishment of a central banking system, and the development of a unified foreign and security policy for nations of the Community. The single market envisioned in 1986 became a reality on January 1, 1993, and the following November the Maastricht Treaty took effect. The EC had become the European Union (EU) in name and to a significant extent in practice as well. Growth accompanied this progress toward union.

## A Larger Union

Austria, Finland, and Sweden began steps to enter the European Union in the early 1990s and joined on January 1, 1995. The interest of still more countries in membership led the EU to complete the Treaty of Amsterdam (June 1997) and the Treaty of Nice (December 2000). These documents revised the Maastricht Treaty to ease the expansion process still more and enhance the central institutions of the Union. The EU grew dramatically. On May 1, 2004, Estonia, Latvia, Lithuania, Poland, the Czech and Slovak Republics, Hungary, Slovenia, Cyprus, and Malta joined the Union. Bulgaria, Croatia, Romania, and Turkey at that time continued to work toward admission to the Union.

## A Difficult Union

With four hundred and fifty-seven million people within its borders in 2006, the European Union had a population larger than any country except India and China. Almost all the twenty-five EU nations were within an area five hundred miles wide and one thousand miles long—small compared to the United States. A few of the member states, such as Ireland and the United Kingdom, share a language, but the EU still has twenty official languages. Nations must have democratic governments for admission to the EU, but their political systems, laws, and economies still differ in many ways. Much else about the culture of these countries also sets them apart.

Despite these barriers to unity, by the early twenty-first century, the EU had accomplished a remarkable advance toward integration. Most member states allowed EU citizens to cross national borders without a glance at passports. Goods, services, and capital funds moved throughout the EU as though the twenty-five states were a single country. The **euro** had become the common currency for most EU states, and the Union had a central bank. The EU also had made significant progress toward a common foreign policy and had taken minimal steps toward organizing for emergency military action, especially for service as peacekeepers.

EU officials turned their attention in the new millennium to the conversion of its organizational treaties and other agreements into the fully developed constitution that such a large and merging group of nations seemed to need. Leaders of the Union governments signed the draft of this constitution in Rome on October 29, 2004. Its similarity to the U.S. constitution reflected the intention to achieve the

ultimate stage of political union and the aim to become another democratic global power center. Every EU state had to ratify this Treaty of Rome for the constitution to take effect. Nine countries approved it within a few months. Then, on Sunday, May 29, 2005, the French rejected the constitution by a vote of 55 percent to 45 percent. The Dutch said no three days later with a crushing 63 percent opposing the constitution. France and the Netherlands, with four other countries, founded the EU parent organization in 1957. In 2005, French and Dutch voters stopped this attempt to establish a mature political union.

Opponents of the constitution in these countries voiced concerns about the loss of national identity and democratic citizen influence in a larger and more powerful Union. They also expressed fears that more thorough union with poorer countries in East Europe might have a damaging economic effect, especially by causing an influx of cheap labor that would force wages down and unemployment up. For some citizens of the European Union, the borders had become too open.

### A Magnetic Union

War-torn Europe, with its shrunken and aging population, desperately needed workers after 1945 to build a new economic order. From beyond the continent often out of colonies and then former colonies, the laborers came, most of them young and Muslim people of color. Driven by hard conditions in their homelands and drawn by European opportunity, the worker influx continued, and then growing numbers of asylum-seekers joined their ranks as they fled from oppressive regimes. These great waves of immigrants entered a very white West European world where almost everyone was Christian, at least in name. The newcomers contributed beyond calculation to the miracle recovery from war, giving in ways from hard labor to fine art. West Europeans gave back, especially in the years after welfare state systems emerged. A few countries showed an exceptional concern for these new Europeans, making special provisions to provide health care, housing, and education and language instruction. France informed new arrivals that the country saw no differences in races or creeds. The French welcomed them at once, in word more than deed, as French people, too, with all the rights the name carried. Britain did not declare the immigrants to be British. They celebrated the different cultures and faiths, an attitude that mostly worked well.

Few evident problems came with this transforming influx in the postwar decades. Even when further immigration and a high birth rate rapidly multiplied the population of new Europeans to perhaps forty million by the 1990s, most old inhabitants saw no signs of trouble. Circumstances developing by the latter part of the century that should have concerned Europeans remained mostly unseen, in part because the old and new societies lived and worked in isolation from each other. Much of the majority population did not know or did not care that the immigrant second and third generations in the 1980s and 1990s lived in apartment blocks decaying into ruin, could find only menial work or no jobs at all regardless of qualifications, and harbored deep resentment born of feeling—rightly or not—that European and American leaders had begun to view their native cultures as evil.

The new Europeans who felt the most extreme rage occasionally erupted into violence. Their plight or their attacks drew some attention before the end of the 1980s. Then, as the economy lagged, jobs disappeared, and the clash of world cultures and faiths intensified, the explosions of anger came in ways and numbers impossible to ignore. Spanish Moroccans blew up trains in Madrid in March 2004, killing almost two hundred and injuring more than one thousand and four hundred. British Pakistani suicide bombers blew up three subway trains and a bus in London in July 2005. More than seven hundred suffered wounds and about

fifty died. Weeks of rioting exploded in early November 2005 in the ring of Parisian suburbs populated mostly by the new Europeans. The firestorm of burning vehicles and buildings that began there spread to hundreds of French communities, a shocking destructive wave that, remarkably, took few lives. The social pressure of these events intensified still more in West Europe as the expanding EU opened borders to workers from East Europe. Russia began to experience similar tensions as immigrant labor flowed in from former Soviet republics. By mid-December 2005, both hate-group demonstrations and counter protests against bigotry broke out in Moscow.

All across Europe, the violence of these two years had profound effects. Ethnic hostilities increased, strengthening both Muslim militancy and European right-wing nationalist movements. The determination of Europeans to undo the wrongs that spawned the troubles also grew stronger. Events of the 1990s and early twenty-first century made it evident that past progress toward the EU goals of continental and global peace and prosperity was not enough. Greater harmony and a better life more equally provided required more effort at home and abroad. What Europeans had done since 1945 did not prove that they could further advance peace and prosperity in the new century, but the history of the postwar era demonstrated the possibility of much more progress in Europe and the potential for a contribution to peace and enhanced living elsewhere.

*After three centuries of gradual development, modern institutions matured in portions of Europe by the late 1700s and early 1800s. The industrial economic order that emerged first in Britain in the latter 1700s had an especially strong influence on the formation of other modern European systems. The industrial economy also vitally affected the interaction of European states and the course of global affairs throughout the 1800s and 1900s.*

*Politically, Modern Europe developed into a region consisting of nation-states that drew the masses into public affairs. These states gained citizen support through the operation of parliamentary democratic or popular authoritarian institutions. Bourgeois social classes or a combined middle-class–aristocratic elite with bourgeois values dominated these states. The power provided by modern institutions and practices enabled the Europeans to conquer much of the world beyond their continent by the early 1900s.*

*The European industrial nation-state system and its global imperial structure remained intact until the Second World War. When that conflict erupted, however, a transformation of Modern Europe already had begun. The process of change accelerated during the war and continued still more rapidly after 1945, affecting most of West Europe and, in a somewhat hidden way, portions of East Europe. An especially important development was the shift toward a new form of industrial economy, one based on high-technology enterprises rather than heavy industries. Other changes, some even more profound, accompanied this economic transformation.*

*The nation-state endured as one of the strongest of modern European institutions throughout the latter 1900s. In one of the most drastic adjustments, however, Europeans began to strive for an integration of these states into new supranational structures. By the 1960s, the West Europeans made significant progress toward economic unification and took the first hesitant steps toward political union.*

*An important change also occurred within these nations as West Europe became more united. Most states greatly increased government control over their economies and developed welfare systems that ensured the well-being of almost everyone. By the 1980s, West European leaders began to reduce government economic authority and assistance programs, but this change did not alter the fundamental character of the postwar welfare state.*

*After the collapse of the East European Communist state system in 1989, countries in this region, too, began to move toward the development of institutions more similar to those in the West. A number of Eastern states also entered the European Union, and still more applied for membership. For all their continuing differences, some that could erupt into waves of destruction or mass murder, at the dawn of the twenty-first century Europeans had drawn closer together than ever in modern times.*

*The loss of European empires after 1945 opened the way for this new, ultramodern Europe to develop a very different relationship with other regions of the world. Europe gave up its role as imperial master, and became a leader in creating a new global financial and trading network and a continental model of political accord that helped draw the world toward greater unity and perhaps peace.*

## Selected Readings

Ash, Timothy. *The Polish Revolution: Solidarity.* New Haven, CT: Yale University Press, 2002.

Brown, Archie. *The Gorbachev Factor.* New York: Oxford University Press, 1996.

Caute, David. *The Year of the Barricades.* New York: Harper & Row, 1988.

Crampton, R. J. *The Balkans since the Second World War.* New York: Longman, 2002.

Gaddis, John L. *We Now Know: Rethinking Cold War History.* New York: Oxford University Press, 1997.

Gillingham, John. *European Integration, 1950–2003: Superstate or New Market Economy?* Cambridge, UK: Cambridge University Press, 2003.

Ginsborg, Paul. *Italy and Its Discontents: Family, Civic Society, State, 1980–2001.* New York: Macmillan, 2003.

Halsall, Paul, ed. *Internet Modern History Sourcebook.* (Links at this site on Europe since 1945 can be accessed at *www.fordham.edu/halsall/mod/modsbook49.html* and same URL 50.)

Hobsbawm, Eric. *The Age of Extremes: A History of the World, 1914–1991.* New York: Vintage Books, 1996.

Judah, Tim. *The Serbs: History, Myth, and the Destruction of Yugoslavia.* New Haven, CT: Yale University Press, 2000.

Judt, Tony. *Postwar: A History of Europe since 1945.* New York: The Penguin Press, 2005.

Juergensmeyer, Mark. *The New Cold War? Religious Nationalism Confronts the Secular State.* Berkeley: The University of California Press, 1994.

Larkin, Maurice. *France since the Popular Front: Government and People, 1936–1996.* New York: Clarendon Press, 1997.

Malia, Martin. *The Dream that Failed: A History of Socialism in Russia, 1917–1991.* New York: Maxwell Macmillan International, 1994.

Merrill, Christopher. *Only the Nails Remain: Scenes from the Balkan Wars.* Lanham, MD: Rowman & Littlefield Publishers, 1999.

Pulzer, Peter G. J. *German Politics, 1945–1995.* New York: Oxford University Press, 1995.

Reid, T. R. "The New Europe," *National Geographic Magazine.* (Sources on this topic and an introduction to this article are accessible at *www7.nationalgeographic.com/ngm/data/2002/01/01/html/ft_20020101.3.html.*)

Wu, Ona. *The Nobel Prize Internet Archive.* (Use this URL to find links to sources on Mikhail Gorbachev: *www.almaz.com/nobel/peace/1990a.html.*)

## Test Yourself

1) The leader of Solidarity when it emerged to prominence in the 1980s was
   a) John Paul II
   b) Lech Walesa
   c) Erich Honecker
   d) Wojciech Jaruzelski

2) In Western Europe in the 1970s, one sign of a trend toward spreading democracy on the continent was the change in the governments of
   a) Britain and West Germany
   b) France and Italy
   c) Yugoslavia and Bulgaria
   d) Spain and Portugal

3) *Glasnost* means
   a) giving the vote to all citizens
   b) moving toward free enterprise economics
   c) openness in the discussion of public affairs
   d) changing into a multiparty system of government

4) The economic recovery in West Europe after 1945 had no serious setbacks until
   a) the announcement of the Marshall Plan
   b) the formation of NATO
   c) OPEC's 1973 oil price increase
   d) NATO's collapse

5) The information provided in this chapter indicates that among the many causes for the collapse of Communist governments in the USSR and East Europe, the most important influence was
   a) U.S. President Ronald Reagan's intensification of the arms race
   b) the subtle undermining actions of dissenters in every Communist country
   c) the emergence of highly educated publics and the resultant intolerance of dictatorship
   d) the failure of Communist economic systems

6) Gorbachev era reforms before 1991 included
   a) abolishing the KGB
   b) barring Communists from the new Congress
   c) a decision to end the Communist Party political monopoly
   d) a nationwide Soviet presidential election

7) The Single Europe Act, the Maastricht Treaty, the Treaty of Nice, and the Treaty of Rome all suggest
   a) persistent dedication to European Union
   b) the lack of serious interest of European leaders in having an effective European Union
   c) that political unity is easier to achieve in Europe than economic unity
   d) that the main concern of the European Union is a common foreign policy

8) Which of the following generalizations is best supported by the history of Europe since 1968?

a) The European public is more tolerant of political violence by the Left than by the Right.

b) Large-scale public protest inspires several years of violence by terrorist groups.

c) Youth rebellion usually comes as "copy cat" actions inspired by the revolt of workers in the older generation.

d) A movement to overthrow a government or split a country has little chance of success.

9) From 1968 into the early twenty-first century, Europe was becoming

a) less socialist and more democratic

b) more socialist and less democratic

c) less democratic and less socialist

d) more democratic and more socialist

10) The text surveys a region about the size of the United States that contains, at the end of the twentieth century, more than fifty countries, and so must emphasize events in certain of these states and provide little or no information about others. The text makes important references to Switzerland in other chapters, but in the final chapter does not mention Switzerland. As an exercise in historical thinking, incorporate comments on Switzerland using the same approach as in the essay problem (Question 8) in Chapter 14. For information on Switzerland since 1968, consult sources such as these: A brief historical overview at *http://en.wikipedia.org/wiki/Modern_history_of_Switzerland*; and current data survey at *www.cia.gov/cia/publications/factbook/geos/sz.html*.

## Test Yourself Answers

1) **b.** The question relates to Poland. *a, b,* and *d* cite people important to this country in these years, but Walesa was the Solidarity leader.

2) **d.** After decades of dictatorial government, Spain and Portugal quickly made the transition to democracy in the 1970s, thus making all of West Europe self-governing.

3) **c.** Among the many reforms of the Gorbachev years in the USSR, the decision to permit much greater freedom of expression probably captured the widest notice in West Europe and the United States.

4) **c.** The Oil Producing and Exporting Countries' use of a petroleum price rise to try to influence the policies of West European governments contributed to a sudden lag in the economies of that region. Marshall Plan aid benefited the Europeans economically, the formation of NATO had no particular negative economic effect, and NATO did not collapse.

5) **d.** Reagan's arms policies burdened the Soviet economy but in neither that way, nor any other, did the U.S. president influence the collapse of the USSR to the extent that some observers in the West imagined, and such policies certainly affected even less the disappearance of other Communist governments. Dissenters did have a significant effect in East Europe and the Soviet Union, and an increasingly educated public probably weakened support for the Soviet Communist system, but the information in the text clearly supports the view that economic failure had the most influence on governmental change.

6) **c.** The decision to end the one-party system was a stunning change. Gorbachev did not disband the KGB, prevent Communists from entering parliament, or allow a national Soviet presidential election.

7) **a.** All these actions had to do with efforts to increase economic and political unity, and with each step, the emphasis shifted more and more to the especially difficult matter of political unification.

8) **b.** Widespread political rebellion in the late 1960s, begun by the young and then joined by labor elements, inspired continuing sporadic terror for a decade by groups such as the Red Brigades in Italy. Left revolt met a warm public reception at first, but then attitudes turned more negative. Right rebellion bothered Europeans somewhat less. Although successful revolts are rare in Modern European history, in this period the division of states and the collapse of governments occurred with unusual frequency.

9) **a.** In the last three decades of the twentieth century, a dramatic shift away from state ownership of enterprises took place all over Europe and governments reduced welfare state programs—all indicative of the region becoming "less socialist." The rapid multiplication of democratic governments on the Iberian Peninsula and in much of East Europe was an equally remarkable change.

10) The information about Switzerland in the first source cited in this question suggests adding a few lines about this country in the section titled "A Magnetic Union" on page 372. After the third sentence in that section ("Driven by hard conditions in their homelands and drawn by European opportunity, the worker influx continued, and then growing numbers of asylum-seekers joined their ranks as they fled from oppressive regimes."), a brief discussion of Swiss demographic changes in recent years would effectively and concretely illustrate the influence of a surge of immigrants into Europe. This commentary could complete the opening paragraph, which would be followed by the text content without further change.

# Index